W9-DAV-466

THE TOTEM POLE

By the same author

Deep Play: A Climber's Odyssey from Llanberis to the Big Walls

THE TOTEM POLE
and a whole new adventure

PAUL PRITCHARD

THE
MOUNTAINEERS

 Published by
The Mountaineers
1001 SW Klickitat Way, Suite 201
Seattle, WA 98134

First published in Great Britain 1999
by Constable and Company Limited,
3 The Lanchesters, 162 Fulham Palace Road,
London W6 9ER
Copyright © Paul Pritchard 1999
The right of Paul Pritchard to be identified as author of this work
has been asserted by him in accordance with
the Copyright, Designs and Patents Act 1988

Library of Congress Cataloging-in-Publication Data
A catalog record for this book is available at the Library of Congress

ISBN: 0-89886-696-0 (North America)

Set in Monotype Bembo 11.5pt by
Rowland Phototypesetting Limited
Printed in Great Britain by
St Edmundsbury Press Ltd,
both of Bury St Edmunds, Suffolk

To all those who have suffered the horror
and confusion of traumatic brain injury and their families

Contents

LIST OF ILLUSTRATIONS

ACKNOWLEDGEMENTS

First must come my family: for putting you through this I am deeply sorry. Then I owe a debt of gratitude to Celia Bull for saving my life. I am eternally indebted to Neale Smith, Sergeant Paul Steane and Ian Kingston and his crew for executing the rescue so faultlessly and Andrew Davidson and Tom Jamieson for staying with me those long hours. My thanks go to Mr Van Gelder, Nicola Mackinnon, Dawn Lewis, Marge Conroy, Stormont Murray, Penny Croxford, Vera Simpson, Barbara Hartfall, Joy Hughes, Sian Hughes, Tricia Rogers, Jill Chappel, Lise Satherley and Fiona Parry for fixing me up so well; to Sue Duff for support and understanding; and to Jane Boucher for putting me right on a thing or two – I am grateful. There are too many nurses and helpers to mention here or even remember, but I thank you all.

My thanks to the film crew, Dave Cuthbertson, Mark Diggins, Meg Wicks, Richard Else, John Whittle, Brian Hall and Keith Partridge, who shepherded me back to the Totem Pole and to Steve Monks and Enga Lokey who climbed it for me. I am also indebted to Rod Staples for the loan of a boat.

I also owe my appreciation to Charlie Diamond, Gwion Hughes and George Smith for reading the script, to Maggie Body again for doing such an excellent job of editing the text. Karen Plas Coch, thank you for giving me the book on tarot cards, I am appreciative.

For the photographs a big 'cheers' to Simon Carter with thanks again going to Dawn Lewis, Brian Hall and Celia Bull. I am also grateful for the photographic inclusions of Sean Smith and the Royal Hobart Hospital. I must also thank Janet Smithies for her excellent ortwork on the cover. To Ben Lyon I am respectful of his unceasing patronage.

Finally my warm wishes to the patients (or clients) of Wirral Neurological Rehabilitation Unit.

Paul Pritchard
Llanberis, May 1999

Now I was free — morally free, as well as physically free — to make the long trek, the return, which still lay before me. Now the moral obscurity and darkness was lifted, as well as the physical darkness, the shadow, the scotoma. Now the road lay open before me into the land of light and life. Now, unimpeded, without conflict or blocks, I would run this good road, swifter and swifter, into a joy, a fullness and sweetness of life, such as I had forgotten or never known.

Oliver Sacks,
A Leg to Stand On

1

ICU

My eyelids fluttered open, leaving behind a greasy, blurry film
obstructing my vision. All I could make out was a blinding
white light shining on me, penetrating my being, or whatever
was left of it. It wasn't my time to die. I knew it.

Marilyn Manson,
The Long Hard Road Out of Hell

It was about that time the staff nurse tried to kill me. It was so
real that it is now etched on my conscious memory, like the
engraving on a headstone, like it actually happened.

There was this very stocky nurse, who was of Malaysian origin.
She had her hair balanced on top of her head in a bun, like black
bread, and was wearing horn-rimmed spectacles. And then there
were these six orthodox Jews. They had been visiting an old
woman for a few days, presumably the mother of the woman who
was married to the man.

And there was a little girl, too, with red hair and big blue eyes
sitting on a sofa, obviously the daughter. She was wearing a blue
dress and stared at me intensely, much more intensely than you
would expect of a little girl. This strangely perturbed me and I
remember thinking what piercing blue eyes she had. She was
wearing white socks pulled up to her knees, her feet didn't reach
the floor, and she seemed curiously ancient, ghostly in her
appearance.

They decked out the old woman's bed in flowers and hid the

1

child in a cupboard. Then they had a funeral for the grandmother, there and then, while she was still alive, and they marched towards her bed singing 'Ave Maria'. She was moaning as if she was in great pain. There were six others with them now. The nurse, who was looking particularly fearsome, came last, syringe in hand. They stood around her, bouquets of roses and carnations all about them. The lethal injection was administered, slid through the skin in the crook of her elbow, and she drifted off into a peaceful and deathly slumber.

I was shrouded in a grey drizzle of horror. The old woman passed away without a word. I was a witness to murder. I curled up under the sheet and tried to make myself as small as I could or even invisible, which was impossible and I only succeeded in hiding my face. They all climbed into bunk beds and were each put to sleep by the same nurse. Not the long-term sleep that I feared, just diazepam deep.

Then they were all standing around me and I was sure I recognised their faces. I felt the same cold, lethal injection enter my jugular vein through the tube. I tried to fight off the terminal moment, but the pain falling from my body was too pleasant to resist. After fighting the drug for one . . . two . . . three . . . four . . . fi . . . seconds I drifted happily into oblivion.

It was difficult to recognise the moment when I came round. It could have been two minutes or two days ago. I didn't know where I was. Where was up? Where was down? Where were all these tubes and wires going? Up my nose. Into the jugular vein in my neck. Into the vein in my arm. Onto a peg on the end of my finger. Nurses kept coming over to my bed to administer drugs and I could feel their icy trickle flowing down my neck or up my arm. Then, as if by magic, my pain would disappear, would run off me like water and once again I would drown in a nice kind of way in that warm fluid.

The flexible plastic tube up my nose began choking me and my first thought was to get rid of all this stuff. I began ripping all the piping from out of my nose and arms and neck. I remember

noticing that the tube in my nose just kept on coming, as if infinite in length, and was covered in a thin coating of yellow bile.

When the nurses came back around and saw what I had done they certainly weren't pleased. They told me off severely, I was scared, and then it was more painful having the tubes re-inserted afterwards. I had to swallow, gagging, as she pushed it up my nose, otherwise I felt the tube hitting the back of my teeth and saw it coming out of my mouth.

The first thing I remember was the induced darkness, like twilight, and the bleeping of the heart rate monitors. Then a male nurse came and sat by my bedside, wrapped the first joints of my fingers around a pencil and squeezed tight. He had an evil look on his face and seemed sinister to me. I only know he was squeezing the hell out of my fingers because I could see him. I could see his muscles flexing. I felt absolutely nothing. I tried to cry out but no sound came. I tried to pull my arm away but it would not move. It was heavy, leaden. He said something about shocking the system back into working. Anyway it didn't. A rising wave of panic swept through me. What was happening to me? Why was I here? Where was I anyway?

The whole ward was tilted in a rhomboid shape and all the beds and drip stands and trolleys tilted with it. And then I was falling and falling and spinning and spinning. Faster and faster. The bed was being spun around on its wheels at high speed and the next minute it was being rolled and tumbled. I held on tight with my hand and hooked my foot under the cot sides in fear that I was going to be pitched over the foot high guardrails on each side of the bed. I then vomited bile, cream in colour, over the clean white sheets.

I came around again and felt down below my waist with my left hand, as my right arm was like wood, there was no feeling in it at all. I felt down past my cock, which had a tube coming out of it as well, stretching it. I then felt lower down the bed. My left leg was intact, all the feeling of a normal leg and I could move it,

3

too. Bend it at the knee and hip, pull my ankle up and drop it down again, wriggle my toes.

But where the hell was my right leg? I frantically felt around the mattress groping, unseen. I couldn't sit up to see what they'd done with my leg. A thousand thoughts ran through my head. They've amputated the fucker! Am I going to be in a wheelchair for the rest of my life or could I get by with a wooden leg? Images of me walking down the pavement on my prosthetic limb started to flash through my brain. *'What in fuck's name have you done with my leg!'* I screamed out silently to a passing nurse.

I intended to ring the bell but the plug came out of the wall and there was no way I could work out how to plug it in again. For an interminably long time I waited for the nurse to come and make everything better. But I knew she couldn't, this was my own private nightmare.

After an eternity the nurse came in and I tried asking her what she'd done with my leg, but nothing came out of my mouth. I tried the most powerful scream my lungs could muster. Still nothing. She walked straight past. Confused and bewildered, I couldn't work anything out.

Why do no words come out of my mouth? Not even an unintelligible sound. I became desperate. Then she came back and I beckoned to her frantically with my only functioning hand. I could tell she didn't understand, so I pointed to where my leg used to be. She threw the sheets back and gasped apologies.

She asked me how long my leg had been like that. I couldn't answer and anyway I didn't know what the hell she was on about. There was no leg there to be 'like that'. Then as if by some miracle my leg appeared again, now you don't see it, now you do. I was amazed. It had the appearance of someone else's leg. I didn't recognise it at all. In fact, I knew what it was; it was a corpse's leg. It was pallid, a deathly grey, like no other limb I ever saw. A funny looking splint on it made me think that I'd broken my leg. I couldn't care less.

I wept and wept and wept. I tried my damnedest to move my

4

leg but it wouldn't budge. There was no feeling in it and I couldn't tell where it lay. My arm was the same. No feeling in it at all and I didn't have a clue as to where it was. It felt like it wasn't there at all when I had my eyes shut and when I opened them again, and I could see where it was, it all became so obvious.

Then, all of a sudden, there was Celia's face, full of compassion and sorrow. She shed a tear and hid her face behind her hands. Again, I tried to speak. I wanted so much to comfort her. 'Don't worry. It's going to be all right. Just fine.' I hadn't a clue what had happened to me. I couldn't even remember the last place we had been. 'And by the way, I love you.'

Nothing came out. I began to panic as frustration set in. I couldn't even ask the nurse whether I would be like this for the rest of my life. It just seemed obvious at the time that this should be the first thing they tell you. It didn't register that they couldn't give me an answer. They just didn't know. And there was Celia not knowing either and wondering what kind of a vegetable she was going to have to live with for the rest of her life.

She left the room and came back with a piece of card with about twenty different pictures on it. The choice seemed bewildering at first. There were drawings of a dinner, a red cross, an ambulance, a needle, numbers from 0 to 9. I had double vision and the card seemed like a mosaic of tiny squares and patterns. I realised what I had to do. Eventually I managed to block off my right eye with my left hand and focus on the plastic laminated card for long enough to point to the symbol for house and the word PLEASE – Home, please.

With a lot of difficulty we developed some semblance of sign language. Thumb up meaning yes, thumb down meaning no, and a circle symbol joining thumb and index finger. Well, I never really grasped what that was supposed to indicate. That only confused me and, frustrated to hell, I would break down in tears. I would shake my head as furiously as it could be shaken, trying, without words, to explain about the nurse who tried to kill me. Celia would ultimately leave, to get a drink or something to eat, and I would

be left with the nurse, who I was becoming significantly terrified of by now. She would prey around the foot of my bed and cackle.

Now I could no longer feel my left leg working, even though it was probably waving all over the place. I couldn't see it. Maybe it was the blurring of my vision, but I couldn't feel it either. So I perceived that I had nothing from the waist down. And of course my right arm didn't exist. I only had a sense of my left arm and my head. Abject horror gripped me as I lay with my left ear on the pillow, observing my one functioning limb. I pictured bloody entrails coming out from my waist, with organs, the pancreas and the liver, spilling out, tendons trailing out of my shoulder socket. I couldn't even sit up to look at myself because my legs weren't there and the weight was all to one side of my fulcrum. Like a torso with one arm I thrashed around under the sheet, utterly terrified. It reminded me of the movie where the guy gets sedated and wakes up with a leg missing, screams, the nurse sedates him again and when he wakes up next time another limb is missing, and so on.

We are now in the bottom of an infinitely tall, twilight-dark lift shaft and there are pipes and tubes rising all around us. We are swaying around, pitching and yawning like we're on a ship. Wait . . . I can hear the engine. We are on a ship! We can feel the vibration of a loud clanging, like an empty drum being hit with one of those mallets you see at strong man contests. Perhaps it's a crane lifting crates into the hull and banging them against it occasionally. And if you listen carefully, inside the din of the banging and engines and crates knocking together. If you put your ear to the side of the lift shaft, you can just make out a soft lapping of the waves. Like when your head's under water and you can hear the bubbles rising. And when you shout it sounds like someone else.

There's all these cables covered in thick black grease that start coiling around us. And another noise. Let's place it, shall we? It starts off high in pitch but then lowers and stops. Every time it stops we find more cables around us, until we can't even climb

over them. The filthy black grease covers our hands and clothes but that's the least of our worries.

The ceiling is coming down towards us floor by floor, slowly, step by step, until it is right upon us. The floor of the lift, that is also the ceiling of the ward, crushes my right side and I can't escape. This is no dream, this is for real. You haven't got away so lightly. Your head is smashed in and your brain is oozing out.

Then I realise that I'm looking at myself and get mighty scared. Still the pitching and rolling and that noise of engines and clanging, and the ever more distant sound of the waves. I wait with you till dawn, which isn't really a dawn at all on the Intensive Care Unit, just a vague lightening through the curtains. And you evaporate, but the crushing of the lift remains, even though the room is back to its normal dimensions.

I thought I would be back to the mountains and crags in no time. It didn't occur to me then, it never had done, that I probably wouldn't go climbing again. Ever. I had built a life of rock climbing for myself. I was passionate about it. I had been a full-timer, living for the rock. I'd been all over the world with one motivation – climbing. Pakistan, India, South and North America, the Pamirs. I'd been to those places which dreams are made of. The midnight sun summit of Mount Asgard on Baffin Island, straddling the top of the slender pole that is Trango Tower in the Karakoram mountains, or with the puffins on the summit of the Old Man of Hoy in the Orkney Islands, looking down because all the world's below you, when everyone else is looking up. It didn't once occur to me that I might never climb again.

Celia is attempting to communicate with me. She is saying that I am in Tasmania, in the Royal Hobart Hospital, and that I was trying to climb the Totem Pole, on the Tasman Peninsula.

'You've been hit on the head by a rock and you have just gone through six hours' surgery.'

It doesn't make any sense. I understand the words but it just seems weird that I can be on the Tote one minute and then here, in hospital, with all these tubes coming out of me the next. I put

my left hand to my head and have a feel around. It feels as though it's caked in congealed blood and it has loads of sticky tape on it. My hairstyle is like a monk's, bald on top but long on the sides and I can feel there's loads of blood matted into my hair, which makes it impossible to run my fingers through.

There's a huge squishy hole just left of the centre on my skull and I can feel metal staples through the tape. My neck hurts like hell. Any movement, an inch to the left or right leaves me in agony. At first I couldn't understand why, then it dawned on me that it must be the whiplash from the stone.

I remember the day now. Waking up in the tent, breakfasting on mangoes, bananas and oats and walking the eight kilometres out to the Totem Pole. I remember the Tyrolean rope traverse onto the Pole itself and rappelling down it.

There I hear the roaring of the waves like distant bombs exploding. I remember clipping the belay bolt at the end of the first pitch and carrying on down. There was a two-foot square dry piece of rock in all that turbulent swell; I can still smell the seaweed, like iron tastes.

I had no sooner got to it than I was up to my waist in the sea. Soaking wet. I shouted to Celia to come on down, but to stop at the ledge and tie the rope off there. At least we'd get a stab at the second pitch. I remember putting my rope ascenders on and making two moves on the rope before swinging to the left . . . Then nothing. I don't remember anything about the next fifteen minutes.

Then all the rest of it comes flooding back to me. Kinabalu, on the island of Borneo, the Malaysian Peninsula, Kuala Lumpur, Sydney, the Blue Mountains, Mount Buffalo, Melbourne and, finally, Tasmania. Our round the world trip. What had become of it? I was going to spend two months in the American desert, in Utah, two weeks of which Celia would be there with me. After that Dave Green was going to meet me and we were going to drive up the Alaskan Highway towards the Lightning Spur on Mount Thunder. Another summit that dreams are made of.

There. I see the Totem Pole. The void below the Tyrolean. Tying the knots in. Feet walking down the wall above the tossing swell. Aiming for that two-foot patch of dry rock. Taking the descender off and putting the clamps on.

The next moment I can remember I am shrugging my rucsac off into the sea. Celia is shouting at me, saying that I've got to help her if we're going to get out of this. I'm being held upright in slings, the grunting and laborious haul up, and now I'm getting dragged onto the ledge over that right-angled edge, making noises that sound nothing like me. I am realising for the first time that my right arm and leg aren't functioning.

In a state of delirium I began thinking that my pyjama trousers had all the makings of a fine shark-fin soup. I had all my things around me. Pots and pans, ladles and stirring spoons, a pot-bellied stove and a stack of firewood and the right ingredients. I managed to get my left trouser leg off but my leg brace was keeping my right one from coming off. And the fact that I couldn't move my leg meant that I had to resort to straining on tiptoes with my left to try and remove them. The catheter tube going down my trouser leg didn't help matters either. I rang the bell for assistance.

The nurse came in and I declared, 'Ark fin oup, yamas.' They were the first words I recall uttering. She pulled my trousers back up whilst, with some dismay, she asked the other nurse in a low voice what I'd been drinking. I seemed to be ringing that buzzer every five minutes on the ICU, asking other deluded and incomprehensible questions, the vast majority of which I've completely forgotten.

Then there was the time when a herd of Friesian cows walked past on the ceiling, which had turned from white, I think, to meadow green. There were lots of long shadows like trees close to sunset. And dry stone walls, stretching as far as eyes can see, in near perfect quadrangles. It was as if I was floating in a hot air balloon across farmland, looking down on the world from my airy basket.

It's now time for my bed bath. The hot towels feel wonderful

down my whole left side. I do not feel any temperature down my right side, hot or cold. Now they flip me over and wipe my back down. I feel the cool draft on my back and, now, my front as they remove the towels. They fold me over as clean sheets are slid under me and over me. They fluff up my pillows and put new pillowcases on them. I have to lie on my back in here. It makes me feel clean and fresh to be out of those sweaty sheets, though my headache doesn't improve. It feels like a wild animal, a serval perhaps, trying to claw its way out of my head.

2

SUMMIT OF BORNEO

*If you think you're something special in this world, engaging
in a lofty inspection of the cosmos from a unique vantagepoint,
your annihilation becomes unacceptable. But if you're really
part of the great cosmic dance of Shiva, rather than a mere
spectator, then your inevitable death should be seen as a
joyous reunion with nature rather than as a tragedy.*

V. S. Ramachandran
Phantoms in the Brain

I had to win the Boardman Tasker award with *Deep Play* if I was
going to go on this round the world trip. It was the most prestigious
award for mountain literature and my immediate future depended
on it. The prize was a cheque for two thousand pounds and if I
won I could visit a place I'd always dreamed of, Borneo. If I did
win, and it was a big if, I would continue my trip to Australia,
another country I'd always wanted to see, and then on to America.
A grand for the air ticket and a grand spending money for six
months sounded reasonable but I was up against the toughest
opposition in the history of the award. And never before had six
books been shortlisted.

As it included a Krakauer, a Simpson and a Perrin I surely didn't
stand a chance. I could only hope that the judges, two of whom
were big name alpinists, would, perhaps, be bored with reading
books about Everest. It didn't occur to me to wonder why the
Boardman Tasker Trust had invited me to bring a bunch of friends
down to London from Llanberis. I thought that they just wanted

an injection of youth through the sober portals of the Alpine Club.

I took a team of the loudest girls you could imagine and as they laid into the sparkling white they only became louder. Peter Gillman's speech was unbearable. As chairman of the judges he dissected everyone's books and pulled mine apart the worst, saying that it had 'a banal first line'. The women made pistol-shooting impressions with their hands and he had to pause frequently to wait for them to quieten down.

Adrenaline was rushing through my arteries. It had only just occurred to me they would want to have the winning author present. Two shortlisted authors were North American and were not attending. It suddenly occurred to me, as I'm a bit slow on these matters, that there was only Joe Simpson and myself there of the six. I thought, ravenously excited, that it was a toss up between Joe and me.

I was already intoxicated and when the moment came I could hardly believe my ears. 'The winner of this year's Boardman Tasker award is . . . Paul Pritchard.' To the screams of my entourage I walked forward to collect my certificate and gave a very short speech because I was told to. 'Ta, I'm made up' was the extent of it. It turned out that Simon Yates' book, *Against the Wall*, about a trip he made with me to Patagonia was a very close second.

I posed for photos with my publishers. With Celia by my side I felt I had it all. We went crazy at a salsa club in Brixton, squirming and gyrating to the strains of the Lambada, rolling home in the daylight of early morning. And I knew that I was surely going on my round the world trip. Nothing could stand in our way now.

Celia surfaced from the wash. It was dawn and she was practising her dives off the jetty. Kinabalu was an ever-present entity that dominated the skyline like no other mountain I have seen. At sunrise, about 5.30 a.m., the mountain was silhouetted against reds and oranges, the shades of which you only witness on the equator.

We had decided to go snorkelling on the coral islands of Mamutik and Sapi before going on the mountain. We were a little

stressed out by life at home and felt we needed a short holiday before committing ourselves to it. I'd never seen anything like the islands. Shoals of thousands of stripy fish, fish of all colours and sizes swam amidst equally brightly coloured coral. But it was far from paradise above the swell. An air compressor run by a generator put air in the divers' tanks. This was on all night and we couldn't get any sleep in our little tent. After two days we returned to the mainland exhausted.

We had found digs in Kota Kinabalu for fifteen ringets a night each, that's about two quid. Due to the economic crisis in Asia at that time the cost of living was very inexpensive for us but it meant all sorts of problems faced the Malaysians. Half-finished hotel blocks stood ghostly quiet in the hot afternoon sun. The tourist trade would have been booming were it not for the palls of smoke rising into the atmosphere from enormous forest fires in Kalimantan. We made a grand tour of the market places. Toads lurked in fish tanks with their eyes just above the waterline and crabs likewise; sea cucumbers, lobsters and eels were all alive. You could buy shark's fins and any manner of exotic fruit. The market places stretched for a good mile.

We bought a selection for our trip, packing the produce into two big hessian sacks – mangoes, melons, all sorts of vegetables, plastic bags of lentils and rice and beans, biscuits, savoury and sweet, bread, fat and suntan lotion. We only made a couple of mistakes, namely confusing some kind of fish dumpling for tofu. Then we loaded the stuff onto a bus and left the hot and sticky coast for the cool high villages of the Dusun, hair-pinning up and up through the deforestation towards Mount Kinabalu.

I sat next to a guy who worked for the Sultan of Brunei as an architect. He seemed to spend all his time building swimming pools and Jacuzzis for him. He explained to me about the traditional way of building houses on stilts here so that you get maximum air circulating and somewhere shady to work in the heat of the day. Brunei is the wealthiest country on earth and the Sultan even has Radio City, a London station, transmitted to apparently all his subjects.

13

There was a great waterfall up to the left that came off Kinabalu, and an open-topped wagon in front of the bus with a group of teenage boys in the back who kept slinging their empty beer cans into the road. This inflamed my anger until I noted that everyone was throwing cigarette packets and Coke cans out of the bus windows. This wild, tortuous road over the mountains was lined with refuse. But I soon became aware of the futility of my anger. I thought, it's no good preaching superficial tidiness when the West is responsible for the massive deforestation leading to the vast fires.

We passed a sign shaped like the mountain saying 'Welcome To Kinabalu National Park, Summit of Borneo'. There was a swish hotel and private chalets with restaurants and there was a bunkhouse, which is where we would stay. There were also miles of forest walks and a rainforest garden, which we paid to enter but, because we had no personal guide, it looked just the same as all the other forest. We tried to latch on to some Japanese tourists and listen to what their guide was saying, but he soon got wise and politely asked the tourists to make way for us. The line parted and we had to walk, slightly embarrassed, through.

We had dinner, a stir-fry, in one of the restaurants and I drank a glass of extra strength Guinness that tasted like gravy. I awoke in the dead of night feeling feverish. We arose at 5.30 a.m., packed and ate a hearty breakfast of cold greasy fried egg and beans, before boarding a bus to be shuttled the four miles up the steep climb to the start of the path. The first thing we saw was a sign of the record times for running up and down Kinabalu. 4 hours 34 minutes was the fastest time for the full 6560 feet of ascent all the way up to Low's Peak and then down again. It is a local Dusun lad who holds the record.

That day was hell for me. I would have given anything for it to end. Ahead was the biggest flight of steps I'd ever been asked to climb, 2000 metres of them, and here I was with a fever, feeling like I was going to pass out any time. Celia left me, at my insistence, and ran all the way to the summit. At least she was fit. She dumped

14

her bag at the West Gurkha Hut and returned to the halfway hut, Gunting Lagadan, just as I was arriving.

Diary entry 31st December 1997

I am sitting in a hut halfway up Kinabalu, the Gunting Lagadan Hut (11,000 feet). I feel like shit. My nose is always blocked and I have terrible nights' sleep. My ears ache and my throat hurts. I must have picked something up snorkelling on those bloody coral islands. People have brought their guitars up and it looks like there will be New Year celebrations tonight.

We have hired three guys to help porter our stuff up the mountain and carried hefty packs ourselves. As we passed through the many altitude zones we discovered different forms of plant life. At about 8200 feet we got into pitcher plant territory. They're such outrageous plants they deserve some special mention. Picture a thin branch about the diameter of a bootlace and attach a litre container, a shapely vase, to the far end of it. Put a lid on it, hinged only at a narrow point. This is then used for drowning and digesting insects and small mammals.

Tomorrow we will watch the first sunrise of 1998 from the summit of Kinabalu. I can imagine it, being up there, the sun blinding us and casting long shadows. The shadows getting shorter as the heat of the sun intensifies. Her by my side.

As I lie here on the bed feeling grim, Celia is cranking, working hard carrying loads up to Sayat Sayat Hut with our two porters Spine and Jimmy. They earn 3 RM per kilo and carry 20 kilos to Sayat Sayat. They said 8 RM for a carry to the West Gurkha Hut, which is almost the same altitude but the other side of the plateau, so we decided on the Sayat Sayat option.

Spine is lithe with short-cropped, black hair, nylon flares and a colourful shirt with a massive collar. The skin on his face is dark

15

yellow with a short nose dead centre; sizeable lips frame teeth as perfect as though they were made of porcelain. Apart from the hair he is the spit of Jimmy Hendrix. When we hired him he was just a few minutes off the record for running up and down Kinabalu. Jimmy was dressed similarly but with an even more colourful shirt, a flower pot hat and an absolutely trashed pair of trainers. He has the same look, typical of the Dusun, but a shocking set of teeth, like fence posts rotting in a muddy field.

We had been told by everybody that we would come up against a stone wall of bureaucracy if we said we wanted to climb on this mountain. Sam Lightner, in his article for the American *Climbing* magazine, stated that climbing was totally banned, ever since the British Army fiasco in Low's Gully. Najib Tahir, President of the Malaysian Alpine Club, told us we would be able to climb, as long as it wasn't anywhere near the Gully. Brian Hall, who was making a film about one of the soldiers who got lost in the Gully, said he had all sorts of problems getting permission to go down there. Robert New was the first person to descend it, all 13,125 feet of it to sea level. The Army, in their version of events, fail to mention this, but the less said about that episode the better.

So, we turned up and said, sheepishly, that we wanted to go climbing. We were sent to talk with the head of the park, James Liew, resplendent in full military dress and medals, who smiled at us and told us in a very friendly manner, 'No problem. Just a couple of formalities.' A form to be filled in and park insurance worth 3.50 RM – about fifty pence!

When we asked where we should meet our guide, because all trekkers must employ one, we were answered with another jovial question.

'Tell me, are you not experienced climbers?'

'Well . . . Yes.'

'Therefore you do not need a guide.'

Never once did he check our credentials. Our plan was to stay in the remote West Gurkha Hut for ten nights and climb around the plateau picking off several of its summits. In the perpetual fog

16

which shrouds the mountain we wondered if we would be able to find this hut on the mile-broad plateau and we asked at the ranger station, 'Excuse me, do you have a map of Kinabalu?'

'Of course we do,' came the answer.

We were handed a very rough photocopy of a sketch that had no West Gurkha Hut marked on it at all.

'Where is the West Gurkha on here?' we asked in unison. 'Can you point to the position of where it is, even approximately?'

The ranger answered, 'Just follow the piles of stones down from the other side of the summit. There is no water at West Gurkha. Are you aware of this?'

That could present problems.

'We are taking bottles up,' we lied.

Well, I didn't see that sunrise from the summit of Kinabalu. I was dry retching. Celia came back that evening, having carried a load all the way to the Gurkha Hut. She was tired and not interested at the prospect of a 2 a.m. start to see the first dawn of the year. I had deteriorated and could barely get myself out of bed. We both awoke around midnight in our little dorm and wished each other happy new year, me grumpily. What a crap start to '98.

We breakfasted together and Celia left to carry loads from Sayat Sayat to West Gurkha. It started to rain torrentially. The waterfalls coming off the slabs opposite had to be seen to be believed, and it happened virtually the instant it started to rain. A wave of white water came over the top of the slab and then crashing down. If you happened to be climbing there when it started, God help you. There was such a roar from the weight of water, I found several trees washed down from up on the slabs. Celia later informed me that the rivers formed by the run off threatened to wash her into Low's Gully. I was really fretting.

She almost became lost on the plateau in a whiteout and when, soaked, she eventually found the hut, she couldn't get the key to work in the door. Eventually, crying with despair, she kicked the door and it unlocked. That night she slept alone up there, whilst

I sank into the depths of fever and misery in my six by six foot box. I wished I could be Superman for her but I failed at moments like this.

That night my epiglottis swelled up to the size of a slug, which I kept choking on, it was touching the back of my teeth, and I lapsed into delirium. 'Where is Celia?' I would mutter, thinking that she had forsaken me, though in reality I knew she was better off up on top of the mountain humping loads. 'Where is Celia?' . . . I dreamt back to Patagonia . . .

'There it is, the Shark's Fin.' That was the first time we had climbed alone together. A great dorsal blade of granite rearing up out of the French valley in a range of mountains called the Paine. We approached the mountain, coming up out of Antarctic beech forest and strolled across bouncy meadows of guanaco shrub with purple calafate berries scattered here and there. The silver threads of rivulets all had the same matrix, a distant glacier, but after only a short while dissipated as a premature delta before rejoining again to pour into the main artery.

We climbed without the rope for the first 800 feet but I felt increasingly worried should she fall. I knew this to be irrational because Celia wouldn't climb anything she might come off. She was always well in control. If she didn't feel that she was, then she'd back off or ask for a rope. We arrived at a ledge below a steep crack and made a joint decision to rope up. This crack was obviously the crux of the climb and I wanted her to lead it. It is the most gracious thing a mountaineer can do, offer your partner the hardest lead on the climb. I can hear her saying eagerly, 'I'll have a bash at it!'

She was up it in a flash, all knees and elbows, and we halted to survey the scene. We were poised on a knife-edge, slabs running convexly out of sight to our left and an overhanging 2000-foot wall to our right. A rock cornice, like an overhung deck of cards, projected a full ten feet out into space. We noticed this only when we went towards the edge on our hands and

18

knees and found just a few inches of biscuity granite separating us from certain death. As we traversed the knife's edge we kept seeing summits which weren't summits at all, only false ones. And then there we were, standing together on the real summit, a block that looked like it could sheer off down the overhanging face at any moment. We looked around at the Fortress, the Cathedral, the Spade and the Leaf and we laughed and laughed and laughed . . .

. . . until I woke myself up.

In the heat of my fever my body became an engine with various organs hanging around my cell, my liver throbbing and my heart beating like there was no tomorrow. Pipes and pistons linked these. With each breath I could feel the hydraulic pump of my lungs, my arteries and veins were rubber hoses. My head was way out in the top corner of the cell looking down on everything. That was a long, long night.

Celia came again in the morning and she informed me of what a horror show she'd had with the lock. We cuddled for a while on the bed and then she went back up. It began raining again and I desperately hoped, after a third night, that I would make it up there tomorrow. Days were blending into nights into days again and my dreams had become absurd, usually frantic struggles against the wind or away from pursuers.

The hut has a cafe and hot showers but after six days it becomes a little wearing. We had no antibiotics; we'd forgotten them. The manager, a young lad who spoke no words of English, had no antibiotics either. So I had a choice: stagger back down the thousands of steps, and then get on a bus to the hospital or stay and weather the illness. I chose the latter. It was the easier yet more dangerous option.

Each day I would go down two hundred odd steps to the cafe and eat one meal, always a dinner of cheese sandwiches or noodles. Cold sweating, I would ask the new faces, whom I hadn't already asked, for antibiotics. They would never have any, so I resorted

to staring aimlessly at the faces, feeling lonely. This is the most popular mountain in South East Asia and attracts all nationalities, especially from the rich countries of the world, Americans, Europeans, Aussies, Japanese.

There was the Kiwi who had a school group with him. He had a pretty comprehensive medical kit, which he rummaged deep in, but no antibiotics. All he could give me were throat lozenges. Then there were the Japanese in their droves, with bandannas, ski poles and expensive cameras. They didn't have any either. I started to get angry with all of them but I knew I was angrier with myself for making such an elementary omission.

I was getting to know the staff quite well after six days. Or rather they were getting to know my face and habits and would pre-empt my orders for food. They were young and smartly dressed in cheap clothes, and Bornean in physical features, quite small and, way back, of Chinese origin. I would have to climb back up all those wooden steps after I had eaten my meal, wheezing and feverish. And then I would prop myself up on the veranda and watch the milky coin of the sun sink in the South China Sea behind the islands of Mamutik and Sapi and all the stars race each other for pole position in the darkening sky. The clouds were like the spokes of a bicycle wheel converging on the half sunken golden droplet. One could bathe in the air of the evening, it was so clean but the temperature soon dropped to freezing the moment the sun's bulb died out.

Celia returned in the evening, after dark, and, as I was feeling a little more human, we made plans for our ascent the following day. We weren't bothered about seeing the sun rising and so set off walking at 8 a.m. The tourists looked at us as if we were irresponsible, setting off so late in the day. They were on their way down from the summit just as we were leaving Gunting Lagadan. I climbed up out of the tree line and onto bare rock.

I closed my eyes, the touch of the rock's surface felt like reading Braille, it was so bumpy and rough. I hadn't felt rock for God knows how long. I soaked it up, read it, digested it. I'd felt the

plastic of the artificial climbing walls plenty of times recently, but that's no substitute for real rock. It had a friction like no other rock I'd ever touched.

We climbed slowly, up fixed ropes, onto the plateau, Celia holding back for me, like a fit dog straining at the leash. We stopped at Sayat Sayat to load up with what was left, though Celia had already taken just about everything. The clouds were way below us as if we were in a jet plane, soaring, as we passed over the lens of a plateau. That would be a familiar pattern. I trudged wearily past the Donkey's Ears and Low's Peak, without even bothering going to the summit, even though it is the highest point in South East Asia. It seemed strangely irrelevant.

The West Gurkha Hut is down the other side of the lens, below an overhanging phallic piece of rock known as Tetsujin Peak, ideally situated in a perfect cwm with the Dewali Pinnacles on the one side and Nameless Peak on the other. Celia and I planned to climb as many of the twenty-odd peaks as possible during our stay in the West Gurkha. Time was running out for me, having wasted five days being ill, but Celia had climbed quite a few already, though only the ones she could scramble up.

The hut was a pre-fabricated triangle of aluminium with two beds and floor space for two more. We took the floor to be nearer to each other and because of the severely restricted headroom that sleeping on the beds entailed. By pulling the mattresses down from the beds we were able to build a nest for ourselves. There was storage under the beds, the cupboards were well stocked with candles, fuel, spaghetti, rice, and in a locked cupboard Robert New's climbing gear. Contrary to what the ranger told us, there was a generous water supply from two butts filled by run-off from the roof.

I felt stronger right away. Perhaps it was the new surroundings or the illness had run its course, I don't know. The very next morning we got up in darkness, stepping through the ice skinning the puddles like Japanese crackers, and made an attempt on the North West Buttress of Victoria Peak – a 1000 feet of perfect

granite the like of which I had never before experienced. Sheer Velcro. You had to peel the shoes off the rock to reposition them. Not even in North America have I touched such rock. I recalled the natural grit edges of the Peak District in Derbyshire, in particular Higgar Tor, rougher than all the other edges, stickier for the shoes.

Celia led off and cranked up to a place about 130 feet directly above me. She wasn't at the right belay and couldn't find it. I began to get irritable immediately and quietly castigated myself for doing so. Climbing second I came up enjoying the movement, though not enjoying taking the camming devices out. They scuffed my knuckles, which I knew would take weeks to heal. I then swung through and got to a ledge twenty feet further on. We got thoroughly professional when we were climbing together and I knew she felt bad about missing the belay ledge but I kept my mouth zipped shut.

I struggled up a thin crack, still feeling the effects of my illness, and belly-flopped onto a ledge. Celia made much easier work of the next pitch, climbing up blocky ground and then thrutching up a chimney where she landed at a spacious sofa. You could see the whole of the South China Sea from that ledge; at least that's how it seemed to us.

'Look. You can see those coral islands where we were. What are they called? Sapi and Mamutik?'

It was my turn again and I was faced with a blank slab fifty feet high. The lower-angled ground beyond gave the whole thing a convex appearance. I stepped onto the rock, feeling the friction with my fingers, which were outstretched, like a pianist's about to perform a concerto. My right foot pedalling the face.

Sharply inhaling I began, sticking to the wall more through faith than any ability I might have. Ever so gently and grotesquely pronated, I pushed the slab away from me to get more weight onto my feet.

Celia mentioned, 'You look very odd.'

I just said, 'Thanks!'

22

It is important that you trust to friction. Once the seeds of doubt creep into your mind, you can trip on a stumbling block, which could send you off, falling through space. I stayed on, shaking like Mick Jagger, and found easier, blocky ground which led straight to the top. That moment between knowing that you've cracked it and topping out is the moment that climbers search for. That moment when the pulse begins to race and the joy overwhelms you and you slow down wishing that the feeling will never end. That is *the* moment.

Celia joined me and we hugged, all alone on this remote plateau, on the summit of a pointed mountain, at the closing of the day.

I quickly attempted to climb to the South Summit of Victoria Peak without a rope, solo. I rushed at it and wasn't in tune with the rock and when I looked down to find a foothold I suddenly became aware of a 3000-foot chasm below my feet, straight into Low's Gully. I panicked and was forcefully reminded of the occasion when I was soloing on Dinas Mot, in Snowdonia. At that time the rock and I were dancing to different songs also. I set off and, at first, the climbing was easy but then, as it steepened, the grade got progressively more difficult. My palms began sweating and my slippers were having difficulty finding purchase on tiny edges. I very nearly shook myself off the rock. Elbows out, I was sowing the seeds of doubt. With sewing machine legs, I began hyperventilating in an effort to steady myself. I was hundreds of feet above the Pass of Llanberis and though there were climbers, dotted here and there, on different routes, I was thoroughly alone. It would take them hours to get to me and effect a rescue. It would take a fraction of a second to peel off. I was a mere pimple on the back of a giant.

I once saw a tiny male toad spread-eagled on the back of a gigantic female, about as big as a frying pan, in Iguaçu, Brazil. This is how I felt now, high on a summit, above the rainforests of Borneo, arms and legs spread wide on the back of a great big female toad. I could even feel her back's texture, hard and coarse

23

and even spiky to the touch. If I made one wrong move that displeased her, she could toss me off her back with more ease than a bull-rider off a bull. On Dinas Mot I regained my composure and climbed on that day on the Super Direct but here, with the void below me, I reversed off the toad. The time wasn't right and I knew it.

It's a little like reading poetry, soloing is. If I am relaxed, I have no trouble and the words flow but if I am tensed up, it all goes to pot and I begin to stumble over lines. Like trip wires for the tongue. One has to be supremely pacific to move with the grain of the rock and not against it.

The following morning we set off early to explore the slender buttress sweeping down from the summit of Nameless Peak. We failed to climb it after just 130 feet of its 650-foot height. It needed a bolt or bravery to bypass a particularly treacherous wall, and we had neither. That will be one of my biggest regrets, not climbing that pillar. It was the most beautiful piece of rock you could imagine and now, thinking that I'll never climb it, hurts like hell. Perhaps I'll get a team of friends interested in it and have them climb it for me. Maybe, one day, I'll be able to make it up there again and watch, taking photos.

We climbed other peaks around the hut but the most enduring memory for me is scrambling up Victoria Peak in the dark: We set off from the hut under an Indian ink black sky pierced with millions of tiny lights, our head torches by far the biggest. The sound of boots and heavy breathing dominated.

I was doing a sacred *Om* with each exhalation, as an Indian friend taught me, as it would give me more power. Dawn was upon us as we neared the summit and seeing the headlamps of the crowds over on Low's Peak made us giggle and, dare I say it, gloat.

There wasn't a cloud in the sky as we stood on that knife-edged ridge with the whole world below us, arms out, flying in the wind. Even the sun bathed us in its red light from below, as if it were worshipping us, rather than us it. And as it rose higher it cast an

24

immense triangular shadow in the rainforest, 14,000 feet below to the west of the mountain.

This was the start to our round the world tour that I had dreamt of for years. Maybe not the being ill bit, but I had soon forgotten about that. Next stop Australia and then Utah, and so to Alaska. This was the life, a grand in your pocket, six months on the road and not a care in the world.

3

TOWARDS THE TOTE

———————

The man who comes back through the door in the wall will never be quite the same as the man who went out.

Aldous Huxley,
Doors of Perception

Celia always got scared flying and coming in to land at Sydney was no exception. She had her head on my chest and her eyes shut tight. I dreamt back to that time when we were taking off in Punta Arenas in Chilean Patagonia: The wind raged across the runway and we saw the aeroplanes shuddering in the face of it. Wires clattered against sheet metal. As we sat up in the viewing area drinking coffee we watched one of the planes coming in to land. The thing was tilting violently to the left and to the right as it caught the wind. I watched her face as she stared in horror out of that window. Her frailness touched me then, as it did now. She could be so hard sometimes, so impenetrable and these glimpses of her fallibility communicated so much more to me than all her armour.

After we touched down, we got a courtesy bus to a cheap hotel, rented a room with a balcony, showered the journey from us and went straight out to buy a car on the underground car market. The Basement was a peculiar sort of cave, the home of troglodytes for the duration it takes to sell their cars. They were all travellers who breathed diesel fumes for air and squinted as they came up into the light.

26

We bought a big white Ford Falcon off a German couple who had done the grand tour of the continent in it and were only sentenced to a week down there in the dark before encountering us. There were others who had done six weeks in that dungeon, attempting to sell a car that had taken more of a hammering than Frank Bruno. They were all lined up in ranks, the Austrians with the Datsun, the Irish good time girls with the Nissan and the Swiss with the VW camper. There were about forty of them partying around bottles of beer and joints that made the atmosphere even denser than it was already.

Tourist attractions were ignored one after the other. Even I made a move to see the Opera House, I who had been in Delhi on countless occasions and had yet to make the detour to visit the Taj Mahal. But that was voted against. That's what I loved about Celia, she refused to conform to any rule, had no interest in what the tourists wanted to do.

We cruised off in our big white shed on wheels to our first destination, the Blue Mountains. Only 120 kilometres north of Sydney, the Blueys have a much more remote feel, though they are virtually a suburb of the big city. We spent a week cragging at such places as Cosmic County and Mount Piddington. They reminded me of the Lancashire quarries where I began climbing. All dusty edges and orange and green lichenous rock, square, angular, arêtes and corners, nuts and pegs. One climb in particular put me in the time machine and suddenly there were all my old mates from a decade ago – Nelson, Grids, Shaps, Tim and Big Pete, calling and laughing in the dense and tangled forest, shouting, barracking and taking the piss from the bushes on the deck. Briefly, I missed their broad Lancastrian accents and coarse manners.

Then this American guy, called Bill appeared and invited himself to climb with us. 'There's nobody else here so it looks like I'm climbing with you,' he barked. He had greasy black hair pasted to his balding head and sandals. He was incredibly lanky and climbed with a little black book, which he wrote in every time he did a route. There are these climbers who are obsessive and,

just like train-spotters or twitchers, they must record everything.

Pretty soon he was hogging the leads and telling Celia how she should climb. It came to a head when the lead was hers and he started scoffing at her as if it were obvious how she should execute a move.

'You just need to climb straight up there,' he remarked.

Celia damn near bit his head off when she replied, 'I would do if I could reach!' He went strangely quiet.

He was a schoolteacher from the tough side of San Francisco and we reasoned that he was used to ordering the kids around because that's the only way he'd get them to do anything. It's just that it didn't work so well with adults. He had been on several road trips to Australia and we met a fair few people who knew him and made every attempt to steer clear of him. But he had cunning ways of trapping the unsuspecting climber. He changed his vehicle for every trip he did and he had a knack of just looming up out of the foliage. In fact he was the king of the unsuspected loom.

We shook him off eventually. Well, we ran away really, cutting our time short in the Blueys, and cruising off into the sunset. We drove all night and pulled in for breakfast at a Red Rooster, a neon cockerel pointing the way. The food came in cardboard boxes and it was difficult to ascertain where the box ended and the food began.

After an abortive attempt to climb at the Point Perpendicular sea cliffs, where only one route was ascended, we were unceremoniously kicked off. We wondered why we were the only tent on a most beautiful campsite, with its own private beach and private wallabies and kookaburras. Pretty soon a helicopter was hovering over us and a loudhailer was screaming at us, saying that we had ten minutes to clear the area. The Australian equivalent of the RAF were practising their bombing technique and wanted us to shove off. We hurriedly folded up our tent and chairs and cooking stuff and complied. They were practising for a whole week and so even though it was the best weathered, most perfect

sandstone we had come across anywhere we thought it wise to leave it to the jet planes. We were not having the luck we were used to.

Lolloping off to Mount Buffalo in South Australia was like crossing the Patagonian Pampa; all rolling hills scorched brown under a searing sun. Cattle and sheep wandered amongst the burnt tree stumps. We arrived in the dead of night and, climbing up the hairpins, surprised a wombat in our lights. We rolled into the campsite to discover it virtually full. Putting up the tent whilst trying not to make a sound was impossible and with our giggling I'm sure we roused lots of campers.

We woke up early because of the cold and were surprised to see snow for we had just come from the baking plains. We watched in awe as tortoise domes and elephantine boulders came to life as shadows shifted with the low sun. We cast our shade onto the surrounding plain. This mountain, being a national park, is heavily forested and there is something quite energising about wandering around in a damp cool forest of eucalyptus, mosses clinging to granite and trunk. But the cool temperatures didn't last very long and it was soon baking at 7000 feet.

Mount Buffalo is a granite mountain not unlike Kinabalu, the difference being the vegetation and the rock texture. No giant pitcher plants or rafflesia here, but there's plenty of eucalyptus. Kinabalu had the most perfect granite either of us had ever climbed on, whereas Mount Buffalo was not dissimilar to a cheese grater, so sharp and big were the crystals. We found this out to our horror on the age-old classic Where Angels Fear to Tread. The route is graded a very moderate 16 and is about nine pitches long.

It begins with a battle up a wide crack on the first pitch which Celia, some might say sensibly, backed off. This didn't put her in a particularly good mood for the rest of the ascent and adding to this was the intense still heat, like an oven. This made our feet swell in our purposefully small shoes and they hurt beyond belief. Our throats parched as we dehydrated and the sweat poured off us in little rivulets. As the tape wore off our hands the cuts started

to show and the pain when we attempted a jamming move made us nauseous. I remember the cool updraft on the gorge rim as we emerged, battered, but not beaten, yet.

There was a hang glider taking off from a special ramp on the gorge rim and a sign that read 'NO HANG GLIDING WITHOUT A VALID LICENCE' nailed to a tree. It must have been 3000 vertical feet to the road below us. I remember thinking, God, that looks exhilarating, as she ran into space, fell for a little way, stalled and continued, like a leaf falling from a tree.

During our seven days there we climbed lots of other routes, until our hands were in tatters and we decided to be on our way and visit Melbourne. We had an old friend there.

Glenn Robbins met us on a garage forecourt at night. It was like a shady drugs deal. Both Celia and I were nervous as hell about meeting him. We had parted on bad terms, or not so much bad terms but just with things left unsaid. It was Glenn who had scraped me up and pulled me out of the water at the Gogarth sea cliffs on Anglesey in 1993.

I had fallen whilst climbing in Wen Zawn, a huge amphitheatre of rock the colour of snow, site of such classics as A Dream of White Horses, on a giant slab to one side, and Conan the Librarian on the arch opposite. I was trying to ascend the direct start to The Games Climbers Play, which goes up the impending, jagged wall between these two routes. It was graded modestly at E4, but no one had made a second ascent to confirm this. Normally a climber makes a second ascent to confirm grade and quality, stuff like that, but this climb hadn't been repeated for ten years since it was first done. The route 'belongs' to Pat Littlejohn who is a very good climber and also notorious for his undergrading. So, even though it was graded easy, by my standards, it should have been treated with respect. Over-confidence and a lack of respect was to be my undoing.

Dew or rain was on the grass on top of the crag. No choughs about. Drizzle filled the air. Amidst this miasma Glenn and I abseiled

down the damp rock face. The situation felt wrong somehow. But I went along with it, disregarding the now all too obvious signs. Lacing my boots all I could hear was the infernal noise of the waves, crashing into the Zawn. Other times, for I was a regular visitor here, I'd got a kick out of that noise. Uncoiling the ropes, I felt my heart beating in my head like you get when you're coming up on some drug or other. I climbed up ninety feet thinking, this is wrong. I shouldn't be here. And then, sketching on wet rock and pumped to hell, I jumped to avoid falling awkwardly. I wasn't scared because I'd got loads of protection in, the last piece being by my feet. What happened next was a fluke of engineering. As the ropes came tight the nuts, that were on too short quickdraws or slings, lifted out of their placements. Six camming devices ripped from their cracks in the loose rock and the one bomber nut snapped. Afterwards the nut was retrieved by Fred Hall of the equipment manufacturers DMM and the wire examined under a microscope. This revealed that the quickdraw was too short on this nut as well, and when it lifted, as the piece ripped above it, it was sliced through on the sharp edge of the crack.

The result of all this was I hit fins of rock feet-first and then somersaulted into a narrow cleft head-first. This cleft wasn't wide enough for my shoulders to fit into but it was full of water. Glenn had to free himself from the system and climb down to me, which would have taken five to ten minutes. He then had to pull me out feet-first and resuscitate me. I was having some sort of near death experience, because I had practically drowned, but none of it included any lights at the end of any tunnels. Maybe I hadn't gone far enough down it, though it felt as if I had. I was lying in summer grass; I could tell it was summer because the evening was warm and the grass very long. Hedgerows were all around me and I could hear the buzzing of bees and children playing. Then it began to grow dark, very dark and it felt like there wasn't anything there, like the opposite of a religious experience.

In reality there was effectively no way out. We had abseiled in

31

and were planning to climb out again. And anyway how could he leave me alone, for all he knew I could have been dying. It must have been a desperately worrying time for Glenn, who luckily for me is a trained lifeguard. He had wrapped me in his own jacket and waistcoat to stall the hypothermia but could do no more. We were the only people in Wen Zawn and the chances of being rescued before dark were virtually non-existent. As night time came, we would be noticed by our absence and friends would ask, 'Where the hell are Glenn and Paul?' For five hours we were down there, where that rock met the sea, before Olly Saunders, out walking his dog in a spot where not many dog-walkers venture, spotted the frantically waving Glenn. Another hour and air, land and sea rescue services were called into action. On top of the crag were the butcher, the baker, the ferry-money taker from Holyhead, all out just in case. There was a lifeboat in the swell and a helicopter in the grey mist also.

I was strapped into a stretcher, handled into a dinghy by men who were strangely expressionless and, through the swell, taken to a waiting lifeboat. I was then winched onto the deck and almost immediately winched up into a hovering helicopter. An oxygen mask was snapped onto my face and the chronic pain stabbing at my chest disappeared. Within twenty minutes I was in hospital being wheeled through long corridors on a stretcher. In my hypothermic state the blanket felt toasty. I remember puking on Zoe, like a baby fulmar when it feels threatened. She was my landlady but also an old friend who came straight down the moment she heard about my fall.

The list of injuries were numerous and significant. I had broken my ankle, dislocated both my shoulders, fractured my skull and aspirated Holyhead's finest seawater. The Irish Sea on which Holyhead is a port is renowned for being the dirtiest sea in Britain and I had drowned in it. For two weeks I was in hospital with a badly infected chest.

One day the hospital secretary handed me the telephone and there was Glenn on the other end. He hadn't been in to see me

the last two weeks and I wondered why. Apparently he had taken to drinking heavily since the accident; he was in deep shock and needed some kind of trauma counselling. That's what I'd heard from my other friends.

'Royt, you cant. What's all this about moy clawthes, thin?' he ranted. 'Me black jackut and black woistcawt, what's happened to thim?'

The doctors had cut them off me, as is normal, so they don't have to drag your limbs everywhere. They were in a black plastic bin bag, all cut up. Confused, I couldn't answer him. Only now, in Melbourne, did I find out that the clothes didn't matter to him. He was lashing out at me because I was getting all the attention and he was virtually being ignored. That's how it seemed to him, anyway. I had hung up the receiver and started to blubber like a child. So muddled was my brain that I didn't know what was going on. I learned that he was behaving peculiarly towards everyone who thought of him as a friend, slagging mates off behind their backs and ignoring others in the pub.

I discharged myself, against the will of the nursing staff, thinking that I would be fine at Zoe's house. I was still suffering heavily from concussion and the drunken binges that followed weren't to help matters. Eventually my mum came to the rescue and, finding me languishing on some beanbags, took me in. It was dreamy to sleep in my childhood bedroom and I think it made my mum feel useful again after all these years, being able to cook for me and spoil me.

Glenn flew home to Victoria in late '93 and we hadn't heard anything about him since. He was similarly nervous about meeting us, I could sense it. He had totally and purposefully distanced himself from the climbing scene ever since and because of that accident. He spends his time now making ceramics and tending to his bonsai trees with the same vigour and discipline he used to put into his climbing photography.

Glenn soon relaxed and so did we. It was just like old times again. He showed us the sights of Melbourne, namely the tallest

33

building in the city and the biggest mall in the world. And we vegged out to what he termed splat movies like *Natural Born Killers* and *Hellraiser* on the video. But after a couple of days one gets fed up with city life and yearns for a fix of wilderness again. Mount Arapiles, near Natimuk, was to be our next destination but the temperature was an incredible forty-five degrees celcius there. So that is when we decided to go to Tasmania and wait for Arapiles to cool down some.

We took an overnight boat across the Bass Strait and watched from the deck as we came in to port. It looked almost exactly the same as coming in to dock at an Outer Hebridean port like Stornaway on Lewis. This made us feel at home for we've travelled and sailed throughout these islands.

The arrival in Tasmania was followed by a six-hour drive straight to Fortescue Bay on the southern tip of the Tasman Peninsula. Parking up at the bay campsite at 3 p.m., we located the trail, and sprinted straight off. We knew Alun Hughes, Caradog and Deri Jones were making a film about the Totem Pole right about now for S4C, the national television station for Wales. We had made a date to meet them on the Pole. We ran virtually all the eight kilometres. I took the rucksack and sent Celia running ahead. She was still fitter than I, with all the load carrying she had done on Kinabalu while I was ill in that cell. I had been slow to regain lost strength but apparently it isn't good to get it back too quickly.

You can't even see the Totem Pole until you are literally upon it. You peer over the cliff edge lying on your belly, scared to stand upright in case you should teeter and fall. And there's this narrow cleft with seawater flushing through it, well over 300 feet below. About 130 feet away, across the cleft, stands the Candlestick, another sea stack which is even higher than where we were standing. Between the two is a pinnacle that I found hard to believe was the fabled Totem Pole, so insignificant is it compared to the cliffs around it.

Looking down a full 200 feet I could make out the figure of Caradog, or Crag to those that know him, standing on a ledge

just below the top of the thing. I was so excited that I shouted, without thinking of Alun, who could have been filming. But when I apologised he said not to worry, the waves were louder than I was.

Once I'd scrambled down the track to where Celia was waiting I could get a better impression of the stack. Only twelve feet wide and 200 feet high, it certainly is the most slender sea stack in the world. It's hard to believe it has remained standing for so long. Its days must be numbered. I could see in my mind's eye the waves that must come crashing through that narrowing in the rock. If you took a needle and enlarged it proportionately to 200 feet this is what you've got. I mentally threaded the Free Route up it. From the sketch I had studied so often I could make out the start from the dry rock, the traverse, the belay ledge and the arête. There is a certain joy to doing this, you get a feel for the route and it gives you something in return to visualise. You build up a relationship. You and the rock.

This route would be all consuming now, would captivate me, until I did it. But there's something else. You can see where the routes don't go. This makes it possible to spy out imaginary new lines, ways you would like to climb. I can't resist sussing out new routes. For me it's one of the joys of rock climbing.

It was handshakes and hugs all round. We hadn't really expected to meet these guys from back home all this distance away. The chances of meeting up on a remote sea stack miles from anywhere are pretty slim and to get the timing right is leaving even more to chance. We were introduced to their two Tasmanian helpers, and we climbed into an aluminium motor boat, driven by a real Boy Racer who would try to get air off each wave, which meant that we would come crashing down into the troughs. After the eight-kilometre ride we all had sore arses and necks. He approached the jetty going at high speed and, telling us to hold on tight, performed an emergency stop, rather like a hand brake turn, just short of the wooden structure.

There then followed miles of driving, in convoy down typical

Australian dirt roads. For the amount of people using these roads it isn't worth surfacing them, so the whole continent is threaded with tracks of red earth. An invitation to stay with the guys was readily forthcoming, and we jumped at the offer, the alternative being the rather expensive campground at Fortescue Bay. Once on the surfaced road we drove past Port Arthur. This tourist attraction was an old penal colony, where Martin Bryant had a brainstorm and killed thirty-five people back in '96. Everybody seems to know someone who has a relative who was murdered by that guy, there are so few people living in the place.

Once inside the chalet we realised just how small it was and decided to pitch our tent on the balcony to give the others some space. There was a guy who we hadn't seen before who had shoulder-length blond hair, a cut-off shirt so typical of many Aussie males, an immensely muscular torso and upper legs leading to matchstick thin lower legs supported by callipers. He was wearing shorts and I couldn't keep my eyes off his legs. He was definitely the leader of the team, the elder, and talked about walking in to Mount Brown and Frenchman's Cap. Frenchman's is a twelve-hour hike from the roadhead through bog and tussocks and he seemed to have climbed every route there. So obviously his disability didn't stop him in any way.

He was very cagey at first and I remember thinking, has this guy got a chip on his shoulder or what? I only asked him if he knew of any new routes to go and attempt and I remember being shocked at his reply. 'There's plenty of existing routes to do before you start looking for new ones.'

It was as if he was trying to put me off the scent, trying to steer me away from the new routes. This only served to fire me up more. 'So there *are* new routes up there?'

'Are you one of these guys who wants to make a name for yourself?' I thought about that for a second. I didn't need more than a second because I knew that I was. 'Because Tassie's not the place for it.'

I think that head on response is the Tasmanian way. Every

Tasmanian we had met during our stay there had a certain brashness about them. They were very kind though and absolutely refused to let us buy any food in. The Boy Racer cooked us abalone, which was exquisite. Living in such close proximity to the sea every family has a fishing boat and every child goes on fishing trips.

I later found out the blond guy who was giving me a hard time was called Pete Steane. When he left I asked the Boy Racer about him. 'What happened to his legs? A climbing accident?'

'Yeah, he took a fall while climbing on the Pipes. He landed on his back and the trigger bar of a Friend punctured his spinal cord.'

The Organ Pipes, I discovered, is a climbing area on the flank of Mount Wellington, above Hobart.

'How long ago was the accident, then?' I probed.

''Bout ten, maybe more, years. He was paralysed in the whole of his legs at first but then slowly, over years, he's regained movement.'

Morning broke and we got up seriously early for the filming to take place. We were to hitch a ride with them to the Moui, a much stumpier sea stack than the Totem Pole, across the other side of Fortescue Bay. The Moui, which is the name given to the Easter Island statues, though of less stature than the Totem Pole, is still an incredible stack. Perched on a plinth, it doesn't take the tide like the Tote but is much more remote, especially if you have to bushwhack.

We were landed at the base of the Moui and got ashore by grabbing hold of seaweed roots and scrambling up greasy rock. The boys then left us to ourselves. Celia uncoiled the ropes on a clean bit of basalt, sat on her trainers and, lacing her climbing shoes up tight, chose the protection she needed for the route by looking up at it and then down at her rack. We had travelled light on this climb and chose just the bare essentials, one set of cams, one set of nuts and ten quickdraws. She climbed first, moving gracefully up the tower and I followed, revelling in the act. Before

abseiling off she showed me a school of dolphins cutting through the sea in perfect arcs.

I chose a harder line because it involved laybacking with the right hand, exactly the same moves as the Totem Pole. I figured that if I practised this enough the Tote would be no problem. Anyway I fell off it but felt that I was close to doing the moves. A second try proved me right. We didn't have to wait long for the pickup and we were back on the Boy Racer rodeo again. I swear, up until a week later, I'd never had such pain in my neck, back or arse.

We then took off in our Ford Falcon across the Tasman Peninsula to Hobart, and then up to Mount Wellington. Mount Wellington overlooks Hobart with its expansive natural harbour; you can drive to the very top. It is a popular viewing spot for the tourists and appears to have a large rocket on its summit that is a mast. Tasmania has extremes of climate like no other place I've visited (and Patagonia is said to be 'el Pais de Quatro Estaciones' or 'the Country of Four Seasons'). It can be sunny and baking one moment and suddenly a wind will blow up from the south, the clouds will roll in and the climate will turn truly icy.

We set up home in a hut, about halfway up the mountain, which is used by picnickers when just such an icy wind blows in. Some kind soul had even left us firewood and we got a blaze going in the fireplace. Unfortunately, a team of possums, perhaps led in by the warmth, had the same idea and cuddled up to us in our sleeping bags. We got worried that they might be host to fleas and spent the entire evening scratching with paranoia. What more could we want, a roof over our head, fire in the grate, food in our bellies and, if we shuffled to the edge of the car park, a superb view of the city at night.

We climbed all the next day and the day after that on not such perfect rock as we had come to expect from our tour of Australia. But the situation and positions we found ourselves in more than made up for any failing in quality. From a belay on Neon God, one of the routes we climbed, we saw the QE2 coming in to

dock. The funnel was taller than any building in Hobart, which is saying something about Hobart rather than the *QE2*. Then came the tall ships on their round the world voyage. We had to descend to the city to see those up close. Salamanca, the local street market, was overflowing with people, all there to enjoy the spectacle, and the harbour was crowded with dinghies buzzing around to get a better view. The Malaysian Navy were dressed in pirates' garb and swarming all over the rigging. Folk on the quayside threw sweets to the crew as they played frantic pipe music. We ate ice creams and wandered in and out of the crowd who were cheering the ships off as they left.

Next day we were back on Mount Wellington and, like a man obsessed, I was busy choosing arêtes to ascend. I found a couple that involved right-handed laybacking but I think I exhausted the possibilities of climbs requiring this technique. The moment could not be put off any longer. I knew that the tides were just about perfect and I felt ready for the Tote.

4

THE TOTEM POLE

Whatever way one cares to look at it the Tower brings bad news. There is definitely going to be some sort of loss, even a calamity of some kind. Security, as the questioner has known it in the past, is going to be destroyed and the troubles are going to come amazingly quickly when they start. There will be a questioning of previously accepted beliefs, trust will be destroyed. There could even be some sort of disgrace.

Julia and David Line,
A Guide to Fortune Telling with Tarot Cards

The day dawned cloudy and blustery. Celia and I ate banana, mango and oats, filled the Nalgene bottles from the outside tap of the toilet block, slung our rucsacs on our backs and walked off up the narrow track. The path wound all over the place and up and over fallen trees. We met Bristol climber and now Australian resident Steve Monks and American Enga Lokey soon after we had left the campground. Steve was a member of the only team to have free climbed the Totem Pole in 1995 with Simon Mentz, Jane Wilkinson and Simon Carter, and we were going to attempt a second ascent. I knew Steve quite well, though Celia better than I. This pair were incredibly muscular and I was struck by how alike they looked with their aquiline profiles and cheery smiles as they wished us luck, Steve still with his Bristol harmony and Enga in her New Orleans twang.

As soon as we climbed up a steep hill we were rewarded with fantastic views of the ocean. It was well worth the gasping effort

of getting up there. Through a gap in the forest we could see the whole, eight-kilometre length of Cape Hauy beneath us. And beyond, there was only the Southern Ocean separating us from the great continent of Antarctica. I imagined icebergs drifting up, but knew they didn't reach as far as here. We were on the look out for killer whales and sharks, as I had heard of sperm whale sightings hereabouts.

I ran down the wooded hillside in my sandals, almost twisting both my ankles again and again as I picked up speed in my urgency to get to the Pole. I was so excited. Ever since I'd seen Simon Carter's photograph published as a poster in *High* magazine I knew I was going to be there. One day. It just had inevitability about it, as it had been inevitable that I was going to give Mount Asgard on Baffin Island my best shot, or that it was Trango Tower, in Pakistan, that held my attention for twelve years.

It was John Ewbank and Allan Keller who made the first ascent of the Totem Pole back in 1968. Their route is a masterpiece of its time. 'I wish some day to make a route and from the summit let fall a drop of water and this is where my route will have gone,' said the Italian 'artist of the mountains' Emilio Comici, and this is what Ewbank and Keller have done.

There were just the two of us on the trail that day. I turned around and Celia was out of sight, behind me. I opened my water bottle and took a deep draught, all the time conscious of preserving the litre of water that I was carrying. There would be no more water from here on in and we would have to ration it. She wasn't very far behind and when she pulled up she sat down too and took a swig from my canteen. Our tee-shirts were soaked in sweat.

The trail wound back on itself and, at times, it would go under a tree trunk too high to climb over and too low to walk under comfortably. This problem I solved by taking the rucsac off my back and pulling it behind me whilst squeezing underneath. At times the path went right along the dizzy edge of the huge cliffs which ring this peninsula. If the ancient aborigines had built

41

promontory forts this would have been the perfect place as it is guarded on three sides by 400-foot walls of columnar diorite.

Thinking I was being smart I took a short cut but the narrow track petered out after only a 150 yards of steep downhill. A choice presented itself, retrace my steps climbing onto tree roots and loose leaves or forge onwards through dense undergrowth. I never liked retracing my steps, especially if it's up a hill. So, ever the eager explorer, I chose the latter. Much to my chagrin, it appeared easier only because it was downhill. Celia was much more sensible and stuck to the path we knew. Needless to say she was waiting at the racking up spot for a good half-hour while I was battling through dense undergrowth. I was all cut up and sweating buckets when I finally emerged to greet her.

We racked up in silence. It's always a tense time, racking up. You tell yourself that you're sure you've forgotten something. You double-check the hardware of which there was painfully little on this route, only the minimum of carrots. Carrots are an Australian speciality that you don't find any place else. That is because there is no cheapskate like an Australian climber. We felt like we were getting the hang of these after a month in Oz. A quarter inch hole is drilled and filled with a steel bolt but no hanger or eye is fitted to it. So you don't have anything to clip the rope to for your safety. You must carry keyhole hangers in your chalk bag, which you slip over the top of the carrot before it is clipped. Many a climber has taken a whipper due to running out of strength whilst fiddling in vain to get a carrot clipped. Or fumbling and dropping the last hanger whilst throwing a whitey.

There are the ropes to be checked for nicks. You put your legs through the harness leg loops and synch up the belt. You check that you've enough chalk in your bag and count the hangers. Make sure your bootlaces are done up nice and tight and, if you are wearing one, make sure your helmet is fitting OK. A last check of your rack and you're off to begin climbing.

Celia was nervous. I attempted to make conversation – 'We seem pretty lucky with the weather' – but she wasn't having any

of it. It was then that I realised that she didn't want to be there at all. She was doing this for me and me alone. I had been so selfish that I hadn't seen it in her or, to put it more succinctly, chose not to see it in her before, such was my obsession. Whenever I was involved in a climbing project I was completely obsessed, from the beginning until its completion. I scrambled down to the viewing boulder where I could see if the tide was submerging the only dry rock or not. The rock was dry.

There was still a Tyrolean rope traverse set up across the narrow gap to the summit of the Totem Pole. It's not normally there, just for filming purposes. In my selfishness I traversed first to reach the top of the climb that was to be my chief prize on this trip. Suddenly I was 200 feet above a thrashing swell, not knowing to what the other side of the rope was attached or if the previous climber knew anything about tying knots. I trusted the Welsh guys though. Almost instantaneously I found myself halfway along because the first half is downhill. Fortunately, Celia had the presence of mind to belay me on an extra rope and it was just as well as the existing rope chaffed alarmingly on the edge of the ledge, which protruded below the knot.

The tormented water had the consistency of a creamy head of beer and lumps were breaking off and flying round and round in the wind that was rushing through the narrow channel. I felt nervous for the first time. It was a mad perspective from where I was hanging. The tower's twelve-foot width seemed to taper to nothing at the base and it felt strange that it should still be standing. If you know anything about rope techniques you will be aware that a Tyrolean traverse puts huge amounts of stress on the anchors, much more than a straight hang. I started to have visions of my pulling the Totem Pole over and the whole ensuing catastrophe.

Clamping the jumars on the rope I rushed up the remaining distance as if there were some demonic force at my heels. Celia pulled the jumars back across the rope and then followed, sliding down to the lowest point and taking some photos. We were in a happier mood now that the exhilaration had taken hold of us and

43

we both chattered without hearing what the other was saying. It seemed rather strange to be on the summit first and then to descend from it only to climb up to it again. But the alternative was far more hazardous, or so we believed. This involved rappelling down the cliffs opposite, which appeared to be covered in loose rocks, and hopping from boulder to boulder to reach the base of the stack. At least we were now on the most wave-blasted, wind-sculptured, solid piece of rock on the planet.

The rope danced in the updraft as if it were some uncontrollable serpent as we cast it loose. I put my descender on the rope and slid over the edge, watching Celia's face depart. Down the arête I went, quickly so as not to see anything. It is said to be a far better ascent when there is no prior knowledge of the climb. The more intimately you know each hand hold and foot hold, the less your ascent is rated by the cognoscenti. I arrived at a ledge, about twelve feet by three, which was to be used as our only belay, the climb being two pitches long. Putting a long sling on a carrot as a directional, to hold the rope where I wanted it, I carried on down the last 100 feet. I could look all I wanted now, as the existing climb goes around the other side of the stack. This was new rock, a line which I'd seen from above, a thin crack petering down to nothing. The start looked horrifying and smooth.

There was one arête out of the four that I had to swing around and it took me a couple of tries, down below the high water mark. I was aiming for a two-foot dry patch on a half-drowned boulder alongside the Totem Pole – dry meaning damp but not submerged. As soon as I landed I commenced fighting for my balance on the seaweed-greased rock, first sticking my crotch out and then my arse. All the while my arms behaved like the crazy cop in the silent movies who is trying to stop Harold Lloyd's motor car.

The next minute I was up to my waist in the sea that was flushing through the narrow channel. I couldn't believe my bad luck. We only had one try at this and I had just blown it. I would be hypothermic soon if I didn't get out of these soaking clothes

and, besides, my boots and rope were wet and my chalk bag was full of water.

I shouted up to Celia at the top of my voice, 'COME DOWN TO THE LEDGE AND TIE THE ROPE OFF.' I figured that if we were to be denied the first pitch we might as well have a stab at the top one. But she couldn't hear me and I could just make out a distant 'Wha-a-at?' carried away on the wind. The difficulty in hearing each other was due to the crashing waves which sounded like a whole pride of lions roaring. After screaming at each other for a while longer she understood and rappelled down to the halfway point, tying the rope off there. I fixed my jumar clamps onto the line and took in the slack, which is about two moves on the rope. I cut loose in a swing off the greasy seaweed-covered boulder. I had to tuck my knees up to avoid getting my feet in the water as I flew around the arête . . . And that is the last thing I remember – until I came around with an unearthly groan.

When I regained consciousness I was upside down, confused and there was blood pissing out of my head. I was immediately aware of the gravity of the situation. I needed to get back upright if I was to stem the flow of blood, so I concentrated on shrugging my pack off. Once off, I tried again and again to get myself sitting up in my harness but failed miserably. I was too weak and strangely uncoordinated. I gazed despondently down from an obtuse angle at the orange stain spreading in the salt water. I had a moment to reflect on what seemed to be my last view: a narrow corridor of pale grey cloud flanked by two black walls, with the white foam of the sea, which was turning quickly red, right there by my head as a ceiling to my fear. I could feel the life's blood draining out of me, literally, and there was nothing I could do about it.

Suddenly Celia was there, by me, telling me sweet lies about how it was all going to be OK.

'I heard a splash,' she said in her Buckinghamshire-cum-Yorkshire accent. 'You've taken a little rock on your head but you've had worse.'

It's funny but those untruths are extremely comforting in moments like these. It's like you want to believe them, so you do. I was still hanging below the high water mark and had an irrational fear about my blood attracting sharks, never mind drowning when the tide turned. Imagine being engulfed by the tide and, ever so slowly, being overcome as the water rises inch by creeping inch. I was now in a fluffy dream world with cotton wool inside my head. Muffled voices were all about me and yet I was sure that only Celia was present. She fought to get me upright in slings and put her helmet on my head when she saw what a mess I'd made of it (several months later, in the back of an ambulance, I happened across the surgeon's report which stated that there was 'much brain oozing out').

She prussiked the 100 feet back up to the ledge and rigged up a simple two-way pulley system through a karabiner. When I say simple, what I really mean is anything but simple, especially with only one bolt to use. It is just the simplest pulley system you can have. Now I weigh ten and a half stone (147 pounds) and she weighs nine stone (126 pounds), so you may ask how is this humanly possible? You must have heard about the child who lifted a car off her father who was being crushed when a jack failed. There are numerous such stories of superhuman strength fuelled by adrenaline. I can only put this in the same category. She says it was hard, but it had to be done, she had no choice in the matter. She either did it or I died. So there was no decision to make.

Celia struggled in desperation for three hours to get me up to the ledge but faltered at the last hurdle. There was a right-angled edge to be surmounted to get me onto the ledge and the harder she pulled the tighter the rope became without moving me.

'You've got to help me here if we're to get you out of this,' she barked. It was the first time I'd heard her lose her composure over this whole episode. I tried to placate her by telling her not to worry but a tired moan was all that came out of my mouth. Then was the first time I noticed something amiss with the limbs on my right side – well, I couldn't so much tell which side it was.

I only knew that they had no feeling in them at all and however much I tried I couldn't move them. My arm was being thrashed around like a rag doll's and my leg was sustaining deep wounds as shinbone scraped sharp rock. I looked down at my leg and couldn't work out why it wasn't able to move. It was like a piece of wood, a cricket bat, for instance, being knocked on the edge of a stone tabletop. I remember thinking that it was just a temporary lapse in control of my body and I would soon be back to normal. With my left arm and leg I fought my way onto the ledge, first my chest, then my belly, then my legs. I lay exhausted on my front and all I could think about was going to sleep.

Celia put me in the recovery position (essentially lying on your front with your head turned to one side, a position that keeps your airway open and is sure to eject vomit). She gave me a hug, then told me she was going to have to leave me and get help. I was terrified that it was the last time I was going to see her but I didn't show my feelings. She was probably thinking the same thoughts. Celia then jumared back up the final 100 feet of the stack and crossed the Tyrolean traverse where I heard her shouting encouraging words. I answered with a groan, which she certainly could not hear.

The first time I met Celia was on a remote Scottish island. We went crazy. It was midsummer and light virtually all night long. It feels, in my vague memory, like we never slept, just partied round the clock. We soon got a reputation as the party crew, locals would turn up on tractors, their trailers loaded with ale at six o'clock in the morning. We joined the football team, playing on a cow field by the beach, with a dark silhouette of the Cuillin of Rhum just across the water. Eigg vs Muck. Taking part in the village ceilaidh, we spun each other drunkenly around until we stopped spinning and only the room was left revolving.

Ed Stone and I had a plan to free climb the 'last great aid route' in these islands, the Sgurr of Eigg. The Sgurr is a huge prow of columnar basalt, looking not so dissimilar to Venezuela's Mount Roraima, the fabled Lost World of Conan Doyle. Our ascent ended

spectacularly when I fell off, clutching a colossal block. We decided to admit defeat and enjoy the midsummer madness for the rest of the week.

I fell hopelessly in love with Celia as soon as I set my eyes on her. It was her moodiness that intrigued me and I made notes about her in my little green book. She has high cheekbones, steel blue eyes, full lips and a wonky nose. Back then she had permed blond hair. We gazed at each other across the campfire and went skinny-dipping on our private beach. She would often climb up into a tree and sulk about I didn't know what and didn't like to ask. It would be a further two years before we got it together.

The seven hours that followed on the Tote were a fight to stay awake when all I wanted to do was drift into unconsciousness. But I was convinced that if I went to sleep I would surely die. Blood was pooling on the ledge from under Celia's helmet and I was blinded in my left eye. I foolishly put my hand under the hard hat to feel the damage for myself, and when I removed it, amidst the blood, there appeared to be a clear liquid which only served to confuse my already addled brain. I began talking to myself: 'Hmmm, what have we here then?' I answered myself: 'It looks as if you have a mighty hole in your head there, Mr Pritchard.' I remember having the image of a soft-boiled egg and toast soldiers just before blacking out for the first time.

Meanwhile Celia was running the eight kilometres back to the campsite, not knowing whether I was alive or dead. She met a couple of New South Walean climbers on the path who were coming to have a look at the Totem Pole and she pleaded with them to come down to be with me. As they had all their equipment with them they were very willing to oblige. They shouted, to see if I was still alive from the cliff top, but I still couldn't answer. I suspect it was a corpse they were expecting to encounter when they finally rappelled in to me. Later I learnt their names from the Tasmania Police report: Tom Jamieson and Andrew Davidson. I don't remember their faces but I felt their presence and heard their kind concerned voices.

I could now hear the all too familiar sound of helicopter rotor blades on the wind. The wind had been steadily picking up speed since we arrived and was now blowing through the narrow canyon with some force. I don't know the exact sequence of events. They appeared completely irrelevant to me and yet directly concerned me at the same time. I had chosen probably the most difficult place to get rescued on the whole coastline of Southern Tasmania. A twelve by 200-foot sea stack in the middle of a 160-foot channel with 400-foot cliffs on either side. And I was stuck on a ledge exactly halfway up it. A helicopter rescue was out of the question; it was just too dangerous, the rotor blades coming perilously close to the sidewalls.

Neale Smith, the only climbing paramedic in the whole of Tasmania, happened to be on duty that day and this was to be my one and only lucky break. He set about traversing the Tyrolean rope bridge and rappelling down to the New South Walean climbers and me. Meanwhile a rescue boat was radioed and on its way from Nubeena, about twenty-five kilometres away, that was our only hope of a rescue before dark. He sat by me for a couple of hours, with reassuring words, until I heard, as if in a dream, the screeching sound of a motor boat in the channel below. The boat handler had to negotiate submerged rocks at a depth of just a few feet. He then had to steer the craft in to the very base of the stack so that Neale could abseil down with me clipped to him, all the while trying not to disturb my head.

I remember being in the vertical again, not knowing at the time that here was the only guy of the paramedic team who knew how to perform such a technical operation. A blurred black wall was passing me by for what appeared to be an eternity. I remember being handled into the aluminium tub by the crew. What felt like a hundred hands groped me and attempted to make me comfortable. 'Cut his harness off him,' I heard one of the rescue team say as the driver skilfully slalomed in and out of the sunken rocks. Ian Kingston, the pilot, has since been nominated for a medal by the Tasmania Police Force, as has Celia for her bravery and skill.

It wasn't as pleasant a ride as we had taken with the Boy Racer and that is saying something. We battered up and down on each wave with people trying to hold me still in an attempt at stopping me being flung from the boat. The deafening whine of the outboard as it tore through the water still haunts me. There are times, as I write this book, when a lawn mower passes by the Rehab Unit window that for apparently no reason a shiver will run down my spine and I begin shaking. At the beach in Fortescue Bay I knew I was going to see Celia and made an attempt to compose myself and straighten my hair, which consisted of smearing the blood all over my face. Obviously she still didn't know if I had made it and it was with a certain relief that she saw me still hanging in there.

A stretcher was carried out of the boat and in to a helicopter, apparently with me in it, and it flew to the Cambridge Airport, about 100 kilometres distant. We couldn't fly direct to the Hobart Great War Memorial before getting picked up by ambulance, as is normally the case, because it is illegal to fly around the city after dark. I was then rushed by 'ambo' across the Tasman Bridge to the Royal Hobart Hospital. I had seen this place many times because it is right there on the street corner; you pass it every time you leave or enter the city. I just have this image of concentric rows of windows and a fountain outside the main door. The stretcher was then put on a trolley and wheeled into the hospital. I recall the ceilings of corridors and lots of distorted faces as they stared down at me from twelve inches; ever so bright pen torches being shone into my eyes.

The paramedics decided against a morphine injection as it depresses the nervous system. Apparently they never administer opiates with head injuries. I wasn't in pain as such anyway, just out of it from blood-loss; I'm told there are no pain receptors in the brain. The surgeon's report reads that: 'On arrival the patient was still conscious but grossly dysphasic with right sided hemiplegia', or to put it more simply, unable to speak and paralysed down one side. Celia arrived a couple of hours later, alone and

by car. Again she expected to be told, 'Sorry we've lost him. We did all we could.' But I was in the operating theatre and still hanging on in there. When the nurses were preparing me for surgery they took Celia's helmet off me and found that my brains were literally hanging out of the ten by five-centimetre hole in my skull. I was still in wet clothes and the doctor rebuked Neale for not undressing me. I don't know what he could have dressed me in alternatively. My long hair had to be shorn and two litres of blood transfused. The surgeon worked for six hours, in the dead of night, picking shards of bone and rock from the inside of my head.

The accident occurred on a Friday, which also happened to be the 13th February. As a rule I'm not a superstitious person and I still am not. I will walk under ladders or do dangerous things on the 13th just to tempt fate. Nothing has changed, only that I feel a slight uneasiness on subsequent Friday the 13ths. This new day was Saint Valentine's day. While lovers were exchanging pink gifts I was on the operating table having an 'intracerebral haemorrhagic contusion' removed from my brain with a little vacuum cleaner in an operation known as an osteoclastic craniotomy. There were scans taken before and after the operation. The post-operative scan showed the 'removal of bony fragments over the vertex after the evacuation (Hoovering) of a left fronto-parietal lobe haematoma (clot)'.

Celia began the grim business of telephoning our friends and family to warn them that I might not make it. It was morning back home. She was careful to get the news to my parents first so they wouldn't hear it second hand. My friends' attempts to ration-alise their sorrow manifested itself in a number of ways. Possibly the most bizarre attempt was Adam Wainwright's going climbing that very day on Craig Doris, perhaps the loosest sea cliff in Wales and not wearing a helmet! I climbed Trango Tower in the Karako-ram with Adam, which makes him a particularly good friend. One can't go through something like a major climb without some special bond developing. My father, mother, sister and brother all

51

cried when they heard the bad news. Tracey, my sister who lives in Lebanon, offered to fly out to Tasmania with my mother. They all knew there was a chance I could die and they prepared for it in a number of ways.

Later my mother described how it felt like the bottom was falling out of her world, and how she lay on the bed shaking and sobbing at the prospect of losing a son. Afterward this was my deepest regret, more than never being able to climb again or run or even walk. Putting her through such a traumatic event was unforgivable. She telephoned my dad who did weep but he's much too much of a man to admit it. He went about his allotment with a hollow feeling in his stomach and lost weight through worry. Tracey prayed for me, and her husband, Kim, contacted Greg, a parson friend of his in Hobart who would shortly come and visit me. In fact there were people praying for me in Malaysia, where Kim's parents live, in Lebanon, where my sister and her husband work as missionaries, in Bolton, my home town, and in Hobart itself where Greg the parson's Taroona church congregation would pray for me whenever they met.

Obviously I wasn't aware of any of these goings on, as I was unconscious or hallucinating wildly for the best part of four days. When I awoke on the intensive care unit I had no idea where I was or that the course of my life had been drastically altered in one second. That's all it takes for a rock to impact.

5

HDU

A sudden relinquishment, and perhaps exhaustion, of feeling –
for profound and passionate feelings were no longer needed, no
longer suited to my changed and, so to speak, prosaic position
– so different from the tragedy, comedy and poetry of the
mountain. I had returned to the prose, the everydayness, and,
yes, the pettiness of the world.

Oliver Sacks,
A Leg to Stand On

As if by some cruel joke my bed was placed dead opposite the
window, which looked straight over the roof tops, with a full
view of the Organ Pipes. There was a skate boarder on a billboard,
pulling a one-handed handstand on the lip of a half pipe, whilst
advertising Coca-Cola with the other. He was grinning at me
from his upside-down stance. I was in the Neurological High
Dependency Unit of the Royal Hobart Hospital.

After a few days I could make out the routes I had climbed a
week previously, they were so close – the arête and the corner,
the crack and the chimney. I could see the blurred and winding
road curling up there and just make out the shed which we slept
in with the possums. Higher up, on the summit, I could see,
through a haze, the antennae like a space rocket.

It had been five days since the Accident and I was starting to
get a clearer picture of what I'd done to myself. I'd had two other
hideous accidents but neither of these could remotely compare to
what I was going through now. Neither could be said to be a

capital letter Accident. But I believe that without that previous experience of trauma I would probably have died. I would have expired alone on that ledge were it not for the fighting to stay awake while the life's blood drained out of me. I relaxed and didn't panic, conserving my energy, that was the fight. That's what I'd learnt that day at Gogarth with Glenn Robbins and on Creagh Meaghaidh with Nick Kekus, that you have to put yourself into a trance-like state, slow down, although this possibly happens naturally, if you are to survive.

I still couldn't speak or move my right side. My face felt numb, like the right-hand side wasn't moving. I rang for a nurse and embarked on an almighty game of charades, but she didn't understand all my pointings at a plate, at my reflection in the stainless steel cot side and back at my face. All I wanted to ask for was a mirror. I was left exhausted. She thought I wanted food and then something to do with the cot sides. I think she was just as frustrated as I was at not being able to guess what I was on about.

I was desperate to see my face. It felt numb and swollen, my eye was almost closed and I still had blurred vision. I was dribbling saliva out of the right side of my mouth and I could just make out the looks on the faces of my few visitors, which registered pity and compassion or shock and horror. I felt like a real life Quasimodo.

Tubes still came out of my neck and nose and cock. As painkillers and liquid sustenance fed into my head, the waste would come in a steady trickle down the tube emanating from my bladder and down my pyjama trouser leg. I still hallucinated every night and day, but that was getting less severe.

In the dead of night I felt a grinding pain in my abdomen. It seemed as though I was dying. I thrashed about in the clutches of my agony. With not an inkling of what it could be I rang the bell and the nurse came hurrying in. He put hot wet towels on my stomach to stave off the cramps, all to no avail, and told me not to worry, that it was just trapped wind. After an hour, where I was seeing all manner of coloured patterns on the big screen of the inside of my eyelids, the pain dissipated.

The night staff had to turn me over whenever I rang the bell, which was about ten times a night. I became agitated and impatient if they didn't come straight away. It was only possible to lie on my left side or my back. I had to have a pillow between my knees, two pillows behind my back and one pillow to cushion my right arm, which lay out in front of me like a pauper I once saw on the pavement in Delhi begging for alms. An electric fan kept me cool, even though only a thin sheet covered me. A big Australian in the next bed asked the nurse to ask me if I could turn it off because he was chilled. Why he didn't ask me directly I don't know. I then proceeded to swelter and sweat my way through the long night. Just another long night of many.

I had some idea of what had happened to me now and I just kept breaking down in tears. Why me? Hadn't I been through enough these last five years? Two major accidents from which to convalesce, taking a year apiece, four illnesses, hepatitis, pericarditis, amoebic dysentery, and fatigue syndrome. I was weary and if I could I would have screamed out, 'amputate the damned legs, they're fucking useless to me now. I'm better off without them.'

If there'd been someone around with a saw I wouldn't have hesitated to have them lopped off. After all I couldn't feel a thing in them. In fact it was the opposite of the phantom limb phenomenon, where the leg or arm is amputated and for months, even years, after there is a ghostly feeling of the limb still in its place. The amputee will jump out of bed convinced that he has two legs and promptly fall over. My situation was the exact opposite. I could see I had the leg and the arm when I was looking at them, but when I averted my eyes they completely ceased to exist.

The last two accidents were my fault but this . . . I didn't even see it coming. I was aware of nothing. One minute I was jumaring, the next I was upside down on the end of the rope, trying to shrug my rucsac off my shoulders. One moment I was penduluming in a sweeping arc and fifteen minutes later coming round and wondering what all this blood was doing gushing from my head and staining the water crimson.

55

Lying there however I could now see how all three major accidents might be seen as subconsciously, subliminally self-inflicted. I had become bored with a pretty extreme lifestyle. What hope for me was there if I was disenchanted with doing just what I wanted, going right there to the edge of life and screaming, 'You can't touch me, you bastards!' I never had anyone telling me what to do, never had a career apart from climbing, never worked nine to five. Most people have a climbing career that spans perhaps ten years and the rest is steadily downhill. There are some notable exceptions to this but even they would agree that there was a decade when they achieved most. For the last three years I was doing what I thought I should be doing and not what I really wanted to do. By continuing to climb I wasn't learning anything new, wasn't breaking into higher levels of consciousness or know-ledge. So I knew something had to snap. I could feel it in my bones.

The first falling and drowning incident in Wen Zawn at Gogarth in '93 was because I was screwed up over a girl and thought she might notice me if I hurt myself. Let's put it this way, she was on my mind when I fell off, ripped all my gear and wiped out. It wasn't a conscious thought, but I'm sure it flashed across my mind.

The second, on Creagh Meaghaidh, in the Highlands of Scotland, was because I was desperate to change my life. I fell 200 feet off an ice climb. I was tired of it all and I recall breathing a sigh of relief when I awoke in hospital. There was a huge release of pressure. No more climbing, no more routes, no more egos, no more grades, no more sponsors trying to tell me what to do, no more weight crushing down on me and saying, 'Excel!' Even if that pressure came from within. I didn't know what else to do at the time to find a replacement. That was the problem. So I drifted back onto the climbing treadmill. And so it all began over again.

I put myself in that situation purposefully but without knowing it at the time. I didn't wilfully throw myself off the ice but I wouldn't have got myself into that situation – soft eggshell ice, miles out from an ice screw – if I was thinking rationally.

And this latest and final accident was because I felt trapped. I had it all, or that's what the majority of my friends figured – big house with a beautiful garden, nice car, as many holidays as I would care to take. Happy at home with Celia. Basically, I was very comfortable. I was taking too many risks and I didn't know why. Why was I not wearing a helmet? If there's a rock climbing situation which warrants wearing a helmet it was surely then. Why didn't I glance up and see the rock coming? I normally would have been much more aware of my surroundings. The only conclusion I can come to is that I was stressed out by my relationship and by climbing also, but on a subconscious level, without really mentally coming to terms with what I was challenging in my lifestyle.

Try as I might, I couldn't get a crap out. The reason for this constipation was that I had such an energetic life before and now I was lying immobile in bed. Plus I was lying flat on my back with a bed pan under me, which isn't conducive to a good shit, especially if you are used to going in the woods, squatting. It was a week before my first shit and that wasn't without several false starts and enemas. When the pretty blonde nurse, Melissa, bunged my arse with an enema I felt every shred of self-dignity vaporise and, you know what, it didn't matter to me one little bit.

Nicola Mackinnon and Dawn Lewis were my physiotherapists and they were a light-hearted pair. The trick is to get you moving from day one or as near as damn it. First lesson would be sitting on the side of the bed, which may sound easy, but with hemiplegia it isn't. I toppled over to the right again and again until I learnt how to balance on my left buttock. Though I would often get caught unawares and occasionally overbalance for weeks to come.

Once I'd vaguely mastered how to sit upright, I was whisked off to the physio gym where there were all manner of torture implements. Parallel bars, blocks, rubber balls from three inches to three feet in diameter, tilt boards, cupboards full of every terrible thing, splints, casts and slings, items that were going to become as

familiar as the hairs in the ditch in my head over the coming months.

There they had me rolling a big ball whilst sitting down, my good hand holding my bad hand down. I would move it side to side and backward and forwards. Next I would be taught how to turn over, completely rotating, while lying down. Simple movements have a habit of becoming fights in desperation with a 'dense hemi', as the doctors call my condition.

It was then that I saw that guy in the mirror at the end of the parallel bars. I didn't recognise the man in front of me. Half his face was black and blue and he had a haemorrhaged eyeball. I knew this term because I'd had one before when my ice axe hit me in the orbit around my eye during the 200-foot fall on Creagh Meaghaidh. His whole eyeball was a deep cherry red, as if he'd been using cochineal eye drops. He was thin beyond belief. With the shaved head he resembled a Jew in the black and white Pathe News film footage of the liberation of the concentration camps. I couldn't take my eyes off the man in the mirror as I couldn't take my eyes off that black and white film. His head was poorly shaved with long bits on the sides and he still had matted blood in it and falling off sticky tape on top. He also had a 'golden purse' with him, a catheter bag full of deep orange piss, which he hung on the parallel bars. That had to be emptied before every session but it soon filled up with the exercise.

Presently Marge Conroy the speech therapist tested me for swallowing ability. A kind, interested woman who had me sipping orange juice and eating ice cream by the teaspoon. I was then controlled for a number of days, eating little bits of easy to swallow food and tasting protein drink. Pretty soon I was being force fed, 'to get my weight up', three massive meals a day, plus five protein shakes. My dietician would come round and make sure I was eating and drinking all I should. Celia told them that I had always been this weight but they seemed not to believe her. How could anyone look this emaciated? They obviously had not seen other climbers I could mention.

I was complaining to the nurse, by pointing at my throat, about my naso-gastric tube and how it was choking me. Burnt chillies, that's what it was like. It was getting to the point where I couldn't even breathe any more without breaking into a coughing fit. Jane Boucher, a kind nurse, pulled it out because she felt sorry for me, but then faced stiff reprimands from the dietician who thought he was the one who should say whether it stayed or went. It was a momentous occasion. With the sliding out of that tube I suddenly felt free, the whole world was mine.

I preferred the chocolate to the banana milkshakes, but after a couple of days I got sick of the sight of either. I couldn't feed myself so well with my non-dominant hand. It would take more than an hour, lying down, and I would get most of the food down my front and onto the blue napkin. But it was bliss to be eating on my own rather than with the tube. My favourites were kidney bean casserole, followed by green jelly or ice cream. Celia brought me boxes of mixed bean salad in to ease my constipation but I still hadn't been for a week. I was on my third or fourth enema when I finally shat with great relief. They had been shovelling food into me all week and up till then nothing had come out the other end.

Marge's full title was speech and language therapist and she had me doing exercises with my mouth, making different shapes with it and saying 'aaaaah' or 'oooooh'. She also made me look at picture cards and asked me to say what they depicted. I stared long and hard at a picture of a pen and raised my hands in disbelief. Then a picture of a house brick. 'Don't know,' I struggled to utter. An elephant, a horse, a shovel, a book, all manner of items and animals. I recognised them but just could not think of their names.

'We've all forgotten someone's name now and again and it's just a profound version of that,' said Marge. 'Anomic asphasia it's called.'

My left from my right I persistently got confused and I had lost the actual concept of time. I couldn't say what clocks did. As the days passed, I found that I slowly came to understand, but there

was still no way I could tell the time. So it was back to junior
school for me with pictures of clocks and 'The big hand is pointing
to the nine and the small hand is pointing towards the three. No,
Paul, it's not five to six!'

Then she would test my mental processing power and speed.

'Name all the animals you can think of in the farmyard in a
minute?' she asked in her soft Tassie lilt.

'Er, pig . . .' There was then a long pause until the minute was
up.

'OK, this time I want you to think of as many words as you
can beginning with the letter "C".'

I looked around the ward, hoping to cheat and there it was, as
if in neon lights, 'Australia's no. 1 Catheter provider'. She knew
what I was up to straight away. I recognised the C and then the
rest of the word as I stuttered out, 'C-ath-et-er.' And my minute
was up.

Pretty soon the telephone started ringing and hardly stopped –
my mother, father, brother, friends. I couldn't talk to them, so
had Celia put their fears to rest as best she could. Faxes came in
a steady stream. Indeed, the Outside Shop in Llanberis had its own
free fax service to me. In all I received seventy-five faxes and it
was these that kept me going. Knowing that I was not forgotten
while I was halfway around the world was crucial if I was to
remain positive. And every fax that came was a piece of home
and got pasted to the wall of the ward until you couldn't see the
paintwork.

After about a week my voice began slowly to return, though I
had no control over what came out of my mouth. Celia reminded
me that the first word that she heard me utter was 'OK'. On the
phone to Llanberis I told Gwion Hughes that 'One had to take
one's leave for one had laundry to do.' That was a strange period
for me, perhaps the strangest period. I had such a limited vocabu-
lary that I couldn't construct sentences the way I wanted to. With
the royal we or one it was much easier to say what I wanted to
say (although I never had any laundry). When Noel Craine rang

me up I told him, 'Not to worry for we would soon be having sex.' This was right there in front of Celia and it made us both break into hysterics. I wonder what Freud would have made of that one.

Celia was shocked to hear me ordering the staff about. It was as if I didn't know how to be polite and we joked about how my politeness lobe had been wiped out by the rock. I would only say 'Food' when I was hungry and 'Drink' when I was thirsty. I was desperately trying to do better, at Celia's insistence, and managed the odd time to get out 'Pass me food' or 'Shut the window.' That still wasn't polite enough for Celia and it is due to her and her wrist-slapping every time I slipped up that I have my current amount of politeness. Basically, I was slightly disinhibited but not to the same extent as some patients I would see during my journey through rehab. After only two weeks I was using please and thank you every time I wanted something.

The Dribble Queen, as the urinologist is affectionately known in Australia, was assigned to me when I came off the catheter and suffered a retention of water in my bladder. My belly swelled up like a football and hurt me a great deal, yet, try as I might, I still couldn't piss. Steaming towels laid on my stomach and taps running to imitate the sound of urination were all to no avail. Five times I had to have the catheter re-inserted and in my mind the nurses seemed to be getting frustrated and angry with me. I'm sure that was just paranoia though.

The consultant considered putting a suprapubic catheter in. This gruesome device goes through the muscle of the abdomen and into the bladder wall. I tried extra hard to pee when I heard this discussed but I only succeeded in straining a muscle. Each time the catheter tube was threaded up into my bladder the relief I experienced was incredible. As I watched my belly deflating I could only picture a car tyre with a puncture. It is normal for someone to want to go and piss when they are carrying 350ml in their bladder. I was frequently carrying 1400ml in mine and it stretched the thing. Anyway the docs finally decided to leave a

catheter in until I returned home, thereby palming the problem off onto someone else. And, let's face it, that was the least of my worries.

Pete Steane, who had challenged my pursuit of new routes, came in to see us about that time. He knew about survival of course and shared his anecdotes about lack of bladder control. About how he found it hard to get partners for his climbs because he couldn't get used to the leg bag and so did without. His partners had to endure a steady golden rain coming from up above as the offensive liquid trickled down his shorts leg. He always carries a bicycle pump around with him and one day I asked him why. He self-catheterises whenever his bladder gets full and the bicycle pump holder is just the perfect length to fit the tube in. Self-catheterisation is something with which I was going to become very familiar during my time in Bangor.

Celia asked the doctor whether she could take me outside for half an hour and he agreed, as long as she promised to have me back for lunch. To get out into the big wide world we had to negotiate a corridor that went on for at least a mile with one particular photograph in it of a child burn victim. I remember he was bandaged from the neck down and appeared to be doing physiotherapy in some form. He looked incongruous because he was laughing and I would have expected him to look miserable. That is until I became crippled. I now felt ecstatically and unexplainably happy. Perhaps it was the thrill of having survived a near fatal accident that the boy and I had in common. Celia and I had to descend a floor by lift, cross a foyer, and then we were out.

I'd been out of intensive care for about a week and the bruising on my face, and red eye was still very apparent. This I could tell by the horrified stares that some of the passers by were giving me. Obviously at that time I hadn't developed a strategy for putting them off, like staring back at them until they got the gist. I just felt embarrassed for my looks.

It was unbearably bright so we went straight to Salamanca, the local market, to buy sunglasses. I bought a pair of five-dollar shades

and soaked up the atmosphere. There were people everywhere crowding the street. When I heard 'El Condor Pasa' played by an authentic South American pipe band the tears rolled down my face. I asked Celia for a dollar and threw it in the hat. The hustle and bustle put the life that had been missing back into me. I know it sounds clichéd but that market woke me up and made me want to live again. Before I was an over-emotional being, crying all the time but with no feeling. Not sad nor happy, not depressed nor suicidal, but confused and labile.

We sat at a table on the pavement where we had arranged to meet Sue Duff who had taken us under her wing and cared for us a great deal. Chris Bonington had put her on to us when he heard of our predicament and we couldn't have been more grateful. I instantly warmed to her as she came into the hospital ward with her essential oils and tonics for the brain and a small cylindrical pillow for my whiplashed neck. She also brought in a little bean bag to shut out the light from my over-sensitive eyes and a relaxation CD which I had trouble listening to. Celia had gone out and brought me the compact disc player and lots of Shostakovich and Sibelius but I was finding music hard going. It just sounded like noise at first. Had I lost my appreciation of music? This really saddened me. Would it ever come back?

Sue is a guide in Tibet. She takes people around Mount Kailas when she is working and was also in the process of building a new timber frame house. Later she would take us into her home and give us tea and cake. Then we would go through to her bedroom and Celia and I would lie in her bed and receive visualisation therapy from her. Amidst the many Buddhas, including one given to her by His Holiness the Dalai Lama, I fell asleep. When I awoke Celia was accepting a relaxation massage from Sue because, 'She had undergone a trauma as well, you know!'

They drank coffee and I orange juice, all the while under the penetrating stares of passers by, and so we went to see the fishing boats and yachts. They took it in turns to push me along the pavement and found that the streets of Hobart were not designed

for wheelchair-users or their pushers. Sometimes pavements could be a foot high with no ramps onto or off them. Being under the ozone hole the sun had an intensity about it that was ferocious and I had to smother my face in sunblock, so I looked shockingly pale. I especially had to hide my head wound under a hat. I expect I might have looked like Frankenstein's monster with thirty staples in my shaven head without it. I would certainly have attracted even more attention to myself.

We stopped at an ice cream shop and I can still taste the pistachio, six months afterwards. I looked at my reflection in the ice cream shop window and thought that I looked like the guy out of *Natural Born Killers* with my new shades on. Celia joked, 'More like Stevie Wonder.' I recall the lobster pots piled on the quayside, woven together using willow, so intricately. I recall fishing vessels of all colours, shapes and sizes, ghostly quiet and gently bobbing on the swell, not a soul in sight. I recall feasting on fish and chips bought from a boat, not giving a second thought about being back in the hospital for lunch, and polishing off the lot. I recall the clinking-clanking of the yachts' rigging on the masts and out in the harbour, dinghies racing. And I recall that smell of fish and seaweed that only comes from harbours with their piles of nets on the quayside. I can smell it still, now. And then, all too soon, it was time to go back, past the skate boarder and through the doors into the stupefying atmosphere of the hospital.

Marge, my speech therapist, came every day, as did all my other therapists, including Rebecca, my occupational therapist. She showed me how to put my shirt on whilst supporting my arm, which didn't hurt because there was no feeling in it, but which was quite obviously dislocated. She taught me how to put my trousers on with only one arm by crossing my affected leg over my good leg so that my foot was suspended. Then I could pull the trouser leg up my own leg. She also brought me slings for in the shower or bath and slings for out, and non-slip matting which was going to keep my plate still while I was eating,

64

instead of it running away with me like a glass on an ouija board.

My favourite part of the day was seven o'clock in the morning, shower time. The nurses soon went from giving me bed baths to taking me for a shower, to get me up in a wheelchair as quickly as possible. It is imperative that they establish a degree of independence straight away. Melissa or Richard would put my arm in the sling, to stop it subluxing (dislocating), and wheel me in on a plastic shower chair. The day's sweat would come washing off me under the hot jet as I was helped with difficult bits. Sometimes I could have a bath, which involved an electric hoist coming onto the ward, a bit like one of those cranes you see changing street light bulbs. I would shove over in my bed until I was on the platform and then be wheeled through reception to the bathroom. There I'd be lowered into a waiting bath of barely tolerable water with a sharp intake of breath.

We had another visitor about this time – my rescuer, Neale Smith, the only paramedic with any climbing experience. He told me the story of how it was too difficult for the helicopter to land and so it dropped him and Sergeant Paul Steane (Pete's brother – it's a small world in Tasmania) off in the undergrowth, how he tackled the Tyrolean rope traverse and abseiled to one of the two New South Waleans and me (the other of the pair was on the mainland and on hand to give any assistance). Neale had the kindest face you can imagine, consoling eyes, and a soft Australian voice. He told me of how Hobart had been his home all his life, of his beachside house, of his family troubles and his little boy. He reckoned I was lucky that he was on duty because he usually goes out with his son to some pretty wild places. And even though he would have been on call he probably wouldn't have got to the Tote before dark.

Celia's sister Elaine flew all the way out from England because she knew her little sis was in distress. It was very strange seeing her walk through that door. We hugged a hug as firmly as I could muster. She cried and I cried. She brought me a personal cassette player, which I could just about tolerate by now, and two copies

of my first book. I remember signing a copy for Neale, the first of many signed left-handed, and it being illegible.

Later Phil, my oldest and dearest friend, flew in all the way from the UK, too. OK, so he was in Australia for work purposes anyway, but I was touched how he cared. He didn't have to come all the way down to Tasmania. I thought that I'd dreamt about making the arrangement with him so that when he walked onto the ward I was convinced that I was hallucinating again. He brought mail and warm wishes from old Lancashire friends, some of whom I hadn't seen in a decade. He was generally like a breath of fresh air and always had a smile for us.

Nerves were getting frayed between Celia and myself. When I tried to explain to her that Nurse Moy had tried to kill me she hit the roof. The words burst forth out of my mouth in a splutter, just like they always did when I was attempting to speak. 'Nurse Moy tried to murder me,' I shouted stiltedly. Celia began weeping and then I saw out of my right eye that Nurse Moy was actually in the room. Celia stormed out of the ward scarlet with embarrassment whilst I was left to stew in my own juice, still terrified of Moy. I was confused to say the least. For two weeks I had been trying to hold this event in my memory, forgetting it completely and then desperately struggling to recall it. As soon as I thought I could say the words, they just came splurging out. As far as I was concerned it was totally true; she had tried to kill me. It was more than paranoia; my own grey matter had deluded me.

Nicola cried out, 'I saw a flicker.'

'Where?' I asked excitedly.

'In your quad. Your thigh muscle I mean,' she corrected herself to simplify it for me.

We were in the neuro-gym, between the parallel bars. I was stepping up on to a box, which basically involved Nick lifting my leg up for me and placing my foot on the box. It was a highly emotional moment and I couldn't contain myself, even if I hadn't

actually seen it. I thought that my leg would never work again
and then, right there, was this glimmer of hope. I was going to
have these moments again and again, where I had been trying for
a certain movement for so long that I never thought it would
come. And then, all of a sudden . . . I got quite blasé about them
later but not now. The tears welled up and rolled down my face.
Nick, who was kneeling before me controlling my knees, said
with water in her eyes, 'If you don't stop it I'm going to start
crying too.' I went back to my room completely made up and
couldn't wait to tell Celia the good news.

Later, as I lay in my bed, the speech therapist came on her daily
visit. Marge asked, 'What is five plus seven?' After a pause that
seemed to go on forever I retorted that I hadn't a clue.

'Twelve,' she said disappointedly, 'is the answer. Let's make this
a little easier for you. Can you tell me the answer to one plus
two?'

After an interval of a full five minutes I thought I had the
answer. 'Five,' I exclaimed proudly.

She answered 'Nooo, three,' in a sympathetic tone. She then
went on to explain how 'dyscalculia, that's the high-flying term
us therapists give to difficulties in performing mathematical oper-
ations, is a common symptom of an injury to the left hemisphere
of the brain.' That I shouldn't worry because, 'These things have
a habit of settling down in their own time.'

There was a Canadian guy who had had a tumour removed
from his brain asleep in the next bed. I liked him. He was sociable.
In fact I only met one patient, nurse or doctor who wasn't
extremely sociable and she had lost her long and short term
memory in a car smash. They went into the Canadian's brain
through his nose, which had been bandaged with a big pad of
wadding which was seeping blood. He was ordered not to sneeze
or blow his nose, as there was a hole directly into his brain. If he
sneezed I supposed his brains would fall out of his nostrils. There
was this hauntingly beautiful girl who kept walking past the ward
door every five minutes invariably followed by a nurse who tried

67

to coax her back into bed. She had no memory and didn't even know her mother and father's names. I remember pondering in my confused state on the unbearableness of it all for them, and thinking, her life isn't worth living any more. Everytime she woke she didn't know where she was or how long she had been there. She was only sixteen. I later thanked my lucky stars that I only had hemiplegia and that I had most of my memory intact, a problem of the motor cortex instead of anything cognitive. During my voyage through rehab these thoughts would change radically.

I was slowly coming to terms with the fact that I may never go climbing again. This realisation was aided by Dr Khan's insistence that I would never be able to walk again, never mind climb. He looked a bit like a hare and had a little paunch squeezed into his expensive silk suit. 'Just think yourself lucky that you still have one arm and one leg. Some persons have only their mouth that is usable.' His remark made my heart sink and I began weeping. He came from Peshawar, near the Afghanistan border, and I wondered if he had grown up in a crueller environment than I had – a rocket launcher can be bought over the counter in Peshawar.

Once a day all the doctors and surgeons would come on a ward round. It could be any time. There was Mr Van Gelder, my personal surgeon, Dr Khan, Dr Liddell and the ward sister whose name I forget. They would all hover round the foot of the bed and make notes on their clipboards: 'suprapubic catheter', or 'nasogastric feed out'. I would stammer out my hello before any of them had a chance to beat me to it and they would, without fail, read my new faxes that I had received overnight. Some of them were very funny indeed. George Smith, a close friend from Wales, sent me numerous cartoons he had drawn with expertise and there were all manner of paintings and cards arriving all the time. And so they would all troop out in a line just as quickly as they had entered, muttering to each other under their breath.

Van Gelder wore round spectacles, had a square jaw and the air of a Thunderbird about him. He was a climber himself, a damn fine one. He had climbed a couple of 8000-metre peaks, including

Kangchenchunga in Sikkim, and Broad Peak in Pakistan. He was on K2 in 1986 when Julie Tullis and Al Rouse died in a ferocious storm. He knew his stuff, that is for sure, but he gave all that up to become a neuro-surgeon, finding he could get the same kicks without the risk to his own life. That out-of-body experience which you search for all your climbing life and only pick up about five times during your whole career, he now finds in surgery. He described looking down on himself at work just as a climber does when she or he is having one of those rare 'special moments', usually in a very scary situation. He also thought that he could do more good saving people's lives than in the selfish act that is mountain climbing. Undeniably, I was indebted to him for having saved my life. He quietly voiced the opinion that, 'There is too much senseless wasting of lives in climbing. I had to get out before it got me.' I liked to think he took a little extra care because he knew we shared a love of the mountains, but I know that he uses the same expertise with all his patients.

He was interested in the use of helmets in climbing and discussed helmet design in great detail with Celia. He ruminated on the notion that I could have been in a worse state had I been wearing a helmet. Many motorcycle accidents result in quadraplegia because, when a smash happens, the motorcyclist breaks his cervical spine, whereas if he wasn't wearing a helmet he would have a head injury – the same as me. Obviously neither option is particularly appealing but at least I was 'just' a hemiplegic. At least I had one good arm and one good leg. Had I been wearing a helmet maybe I would have been quadrapleged also.

Celia came onto the ward in the night-time. She was distraught and weeping. What could be troubling her? She had been allowed to sleep in a little room that the hospital staff use for such cases as ourselves, people from foreign lands who have had grim accidents. It turned out that someone had shouted at her while she was asleep and when she awoke, startled, they were gone. When daylight came it proved to be a simple case of double-booking and when

the worried, sleep-deprived relative of the other patient looked in and saw Celia asleep she lost her temper.

The nurses pleaded with Celia to stay but she thought it would be better for all if she moved out. Nurse Jane Boucher was fast becoming a close friend of Celia's by now, having taken a lost waif under her wing; she even ended up buying the Falcon because Celia was desperate to get shot of it. Now she kindly offered to let Celia stay with her. One evening we went to dinner at Jane's house. She cooked everything vegan and I, having been on an ice cream diet for two weeks, just shovelled anything into my mouth. We laughed when I commented, with my mouth full of cream, 'Oh, I was vegan.'

Soon afterwards we took a drive up Mount Wellington. Since Nick, my physio, had taken me to the hospital car park and shown me how to transfer from my wheelchair in and out of the car, there was no stopping me. I just had to take extra care to protect my head from the smacking against the doorframe. Up the switchbacks we motored until we reached the Organ Pipes. I asked Celia to stop and gazed mournfully up at what I knew I had lost.

It wasn't just the physical act of climbing a rock but the whole event: the crack with your mates before you tie into the rope, before you put on your serious cap; in the pub afterwards (where a good day's climbing invariably ends) discussing this move or that move; wild nights that you felt entitled to because you had burnt up so much energy during the day. And then there was the travelling which meant so much to me. I felt that I would rather die than not be able to go on expeditions ever again. Fifteen years of my life I had spent going on expeditions or 'trips' as we called them, more or less back to back. I had witnessed flying saucer clouds from halfway up a wall in Patagonia, a plume of dust rising for thousands of feet during a gigantic rockfall, seen from the top of a mountain in Kirghizstan. And all of them watched, in awe, with special friends. I buried such memories and told Celia to drive on.

When we arrived at the summit of the mountain I transferred into my chair and took deep draughts of the rarefied air at 4000 feet. We wheeled down a plank-walk to the viewing gantry from where we could survey the whole of the Derwent estuary, its harbour and the city of Hobart. I could see the hospital from up here, model-like, and the Tasman Bridge, so clear was the atmosphere. It was a moving experience to be looking down upon the land and sea again instead of staring up at the ceiling from my hospital bed. To the west the Atlantic Ocean disappeared over the horizon, unchecked, as at 40° South, it peaked and troughed its way a clear half around the globe. In my over-emotional state I shed a tear at the vastness of the world.

Roxanne Wells and Chris Piesker came in to see us. They were scheduled to be filming on the Totem Pole the very next day after the accident. It was an all-star cast that also included Steve Monks and Enga Lokey, whom we had met walking in, rigging the stack with ropes for the various camera angles. We had ruined their plans because the rescue team had dropped the Tyrolean rope traverse, which meant they had to get the rope back over there before they could start the filming. They had to spend the day re-climbing the Tote, which they did and got some excellent footage by all accounts. Chris wasn't just in the hospital to visit me. He also had an accident, a severe compound fracture to his middle finger that needed pinning. It too had been caused by a falling rock. Both of them were of a typical climber build, lean and muscular, and he wore as much jewellery as she did. When they departed I remember him holding my head up, as though it were a chalice, and kissing me on the forehead.

Greg the parson offered to pray for me and I accepted. That was the first time I had ever asked for prayer. Perhaps it was his soothing manner or the fact that I believe in the power of prayer because hundreds of folk putting their hands together must have some positive effect. Perhaps I have belief buried deep down inside me or maybe it is just conditioning. But tell me of the person

who isn't going to ask God for forgiveness on his deathbed. OK, so I'd come through the worst of it and knew that I wasn't going to die (not unless I had a haemorrhage or a fatal seizure) but as far as I could make out I would be a severe cripple from now on. I've heard that virtually everyone asks God for forgiveness when dying, even if they're non-believers, 'just in case'.

Celia was busy finding out when we were to leave the hospital and be repatriated. We had been there nearly three weeks now and she was convinced they were telling us cock and bull stories to delay us.

'He has to be in a stable condition,' Dr Khan kept reiterating. 'Who knows what effect going up in a plane will have? The cabin is pressurised to 10,000 feet and that is a hell of a lot.' He was correct, it had to be said. I didn't want any complications like a burst head if I could help it. Imagine the pressure differential between the inside of your head and at 10,000 feet.

Having the staples removed from my head was OK, or so I thought. Then the nurse hit a particularly difficult one to extract and began twisting the pliers into my skull while I broke out in a sweat and gritted my teeth. It was a job that needed doing before I could fly anywhere. There were only three staples that were hard and painful to get out. And she told me encouragingly, 'The head has less pain receptors than anywhere else on the skin's surface.' Now I have all thirty of them in a little glass jar waiting to be melted down and made into a pendant or earring.

There was a date being bandied around, the 8th March. I did not believe that we would leave then, it seemed too good to be true. All I wanted, more than anything, was to see my friends and family back home. I had given them the shock of their lives and they had responded with a barrage of beautiful words, whether it be by fax or letter or sometimes painted.

'As well as long-term physiotherapy,' Mr Van Gelder advised, 'I can only recommend the support of your family and friends.'

Because of all the letters and faxes I had received I knew that I could count on them. He also mentioned, 'When your head

settles down, perhaps in a couple of years, you could have cranioplasty, a plate fitted in your skull.'

These are some notes from the discharge letter to the consultant who would be taking me on back in the UK:

This 30 years old patient was admitted on 13th February 1998 after head injury. He was a rock climber who was hit in the head accidentally with a rock. He had no helmet.

Neurological examination on 16/02/98: Right-sided hemiplegia, severe expressive dysphasia.

During his stay on the ward, the physiotherapist, speech therapist and occupational therapist treated the patient. Occasionally patient needs reinsertion of his IDC. Bladder function remains one of the problems. On the 28/02/98 speech pathologist report showed that mild/moderate anomic-asphasia [inability to name objects] was resolved, but dysgraphia [inability to understand the concept of writing], dyscalculia [inability to do simple arithmetic], right/left confusion, finger agnosia [inability to name your fingers on either hand] and mild visuo-spatial difficulties [missing a cup when you reach out for it] were present. Cognitive function is largely preserved.

The physiotherapist noted some improvement in right lower limb function, including some muscle power in pelvic muscles.

Hepatitis B (surface) Antigen: NOT DETECTED, Hepatitis A Antibodies: NOT DETECTED.

HIV EIA: NOT DETECTED.

On discharge from hospital, the patient is in a stable condition, and able for the air transport home.

6

RETURNED EMPTY

There is no returning game between a man and his stars.

Samuel Beckett,
Murphy

She was not at all what one would have expected of a Scottish doctor. An old matronly woman or middle-aged professional man perhaps. But not an oddly attractive six foot Amazon, squeezed into a black mini skirt, with make-up by the shovel full, breasts held firmly in place with a Wonder Bra under a tight red tee-shirt. This willowy glamorous doctor entered the ward with the look of Betty Boop about her. She was to be my escort for the flight home. She carried the scent of jonquils, that springtime smell, and was from Edinburgh. You could tell this by her guttural, while at the same time mellifluous and caring accent. Her name was Susan.

All the nurses and therapists huddled together for a photograph. It makes me warm in my heart to look at those pictures now. All those smiling faces. Moy and Jenny whom I kept confusing, Herbert the Swiss who cycled to hospital every day, blonde Melissa, Richard with his ponytail, Ian who once bought three kilos of chocolate because it was on sale, Jane who competed in the Cradle to Coast Race. I can only recall the faces of the others who did just as good a job; it's just my impaired memory that makes me forget some names.

We were to be driven to the airport by Neale the climbing paramedic, to whom I'd already said my emotional farewells. He

74

pushed a stretcher trolley into the room where Celia was busy taking down all the faxes. As I was strapped in I took one last look around me at the now bare room. It held some good and some painful memories that room. The constant headache for the first week was a bad memory but my mate Phil and Celia's sister Elaine turning up out of the blue from England and the cheerful, accommodating faces of the nursing staff were good ones.

I was wheeled outside in the stretcher, much to my annoyance. Why I couldn't use a chair I didn't know. The chill air bit into my clean-shaven face as I was shoved in the back of the wagon. Susan and Neale sat with me in the ambulance, which careered round bends with me all strapped down.

We were soon at the airport and I posed self-consciously, for photos with the back doors of the ambulance open. I was wearing my raggedy baseball cap and now when I look at those photographs I see a haunted, gaunt face staring back at me, trying to smile. Phil helped Celia weigh our numerous hefty bags whilst I reclined in the ambulance. Jane arrived to say farewell and I gave Phil a goodbye hug with one arm, which felt awkward and stupid.

We bypassed officialdom and drove straight onto the runway. A truck with a lift, a kind of cherry-picker affair, came to meet us and I was wheeled from one vehicle to the other. It is a small runway at Hobart with just a handful of aeroplanes on domestic flights; ours was bound for Melbourne. As the truck reversed up to the plane, the noise of the jet engines worried me. It started to lift and when the box was level with the jet a door opened and I was pulled in. The cabin was empty, apart from the few stewards hanging around, waiting to be useful. I was handled roughly into a wheelchair by so-called trained paramedics and pushed down the aisle to my stretcher. This wasn't as wide as I would have liked. In fact it was so damned narrow I only had room to lie flat on my back. I hoped that the following thirty hours to London would be more comfortable.

No sooner had we taken off, than we were flying over the Bass Strait and touching down at Melbourne. When we did Susan

realised that my catheter bag was full to bursting. It must have been an effect of the change of pressure on my bladder.

The same procedure as loading me on was followed in reverse on disembarkation. We were wheeled to a sick bay with no coffee but at least I could sit up and psyche the scene for two hours before the next seven-hour leg to Singapore.

There were eleven seats booked on the insurance: one for the doctor, one for the nurse, one for Celia and eight for me. I was loaded up again, first on, and strapped down in a harness affair that parachutists use with an extra strap for good measure around the thighs. I was supposed to wear this all through the flight but the thought of ditching into the Sea of Timor off Sumatra and still being strapped in to a stretcher was too terrifying, so I persuaded my Scottish doctor to take it off. This was until I fell off my stretcher, and went crashing down into the seats below, because it was much too narrow.

The curtain was supposed to give me some privacy but I insisted on having it open so I could see what was going on. Celia said, 'I bet people are jealous that you're lying down, in repose, while they have to sit in cramped seats.' But I knew better and grew paranoid that they were staring at me because of my looks. The bruising had virtually disappeared from my face but I still sported a skinhead with a sticker on the top advising 'HANDLE WITH CARE: BONY DEFECT', and a bright, glowing red 'Terminator' eyeball. All the passengers could tell I was in a mess and the falling off my stretcher incident didn't help my appearance either. Anybody that made eye contact with me I scowled at with all the vehemence my happy-go-lucky nature could muster.

I was turned the other way from the telly so I was the only one of 400 people who couldn't see the thing. This I wouldn't have minded but there are times when even the most patient patient gets bored during a long-haul flight. Alan, the nurse, kept a careful eye on me, monitoring my pill intake, that is feeding me two paracetamol every four hours, and making sure to empty my catheter bag. He was especially careful about protecting my head,

which was still very squishy and vulnerable on top. At that time it wouldn't have taken a very large blow to the head to put it into trauma again.

All I remember about Singapore airport, besides the heat, was that it had Damon Hill's Formula One racing car in the transit lounge on a revolving podium. The Melbourne Formula One race had just taken place and all the drivers were in first class. Stewardesses were chatting excitedly about their famous cargo. Names I'd never heard of were rippling in whispers up and down the cabin.

It was heaven to get upright in a chair again, even if it was only for a couple of hours. Pretty soon it was time to get back on the merry-go-round of ambulances and lifts and stretchers and wheelchairs again for the ten-hour leg to London. Alan returned home to Australia and was replaced by an ageing English woman called Dora. She was as heavily made up as Susan and when they both stood over me, and stared intensely down, just checking everything was all right, I was reminded of the phantom masks one finds in Bolivia and Peru.

I swallowed two paracetamol and attempted to sleep but the pain in my neck was too great. At least they cured my throbbing headache. Thirty-five hours after leaving Tasmania we touched down at Heathrow where it was cloudy and fine, if colder than I would have liked. We were to be driven by ambulance the five hours to Wales. After a wait in the sickbay, where I was given hot sweet tea, I was wheeled back out into the biting cold and what I saw next appalled me. It wasn't the type of ambulance I was anticipating, no mini bus, but an estate car or station wagon with Celia busily squeezing haul bags into the back of it. I was too tired to kick up a fuss. I was squashed in the back, along with several haul bags and a peroxide blonde nurse who sat beside me the whole journey.

With her lippy and eyeliner she not only looked like a Barbie doll, but her name proved to be Barbie, too. Yet this outrageously artificial-looking woman spent her time raising money so that she could go to Bombay and distribute presents to orphans. Celia took

her address and promised to send her some old rupees we had spare from our last trip there. She talked of the children with a genuine warmth and it was difficult to picture her, so clean and sentimental, in the filthy gutters of Bombay. Apparently the TV had already made one film documentary of her work there and were going to do a sequel as soon as she could raise the funds.

Wales was as beautiful as ever and spring was all around us. At the risk of over-quoting Beckett: 'What sky! What light! Ah in spite of all it is a blessed thing to be alive in such weather, and out of hospital.' Wonderfully familiar landmarks passed us by: the Marble Church, the Great Orme and the castle at Conwy. There was snow on the whale's back of Carnedd Llewelyn and the millions of daffodils on the central reservation past Llanfairfechan were in full bloom, a yellow ocean. After what felt like an eternity in hell we had finally made it home. Well, to Ysbyty Gwynedd, the hospital in Bangor.

It was said of colonial bishops who had come home from their dioceses that they had 'returned empty'. This description struck a chord with me. I could well be a bishop coming back from Tasmania, drained to the bottom.

7

BANGOR

My cocoon becomes less oppressive, and my mind takes flight like a butterfly. There is so much to do. You can wander off in space or in time, set out for Tierra del Fuego or for king Midas's court.

You can visit the woman you love, slide down beside her and stroke her still-sleeping face. You can build castles in Spain, steal the Golden Fleece, discover Atlantis, realise your childhood dreams and your adult ambitions.

Jean-Dominique Bauby,
The Diving-bell and the Butterfly

We arrived at Ysbyty Gwynedd and were brought through the back door to a tiny cell looking out on a brick wall only a foot or so from the window. We sat on an unmade bed, in Bueno Ward, with no pillows and were ignored while the nurses attended to more urgent business. The room was dirty and, though I had a private toilet, that was filthy, too. The nurses were run off their feet and had no time for mopping up the piss when my catheter bag burst or even bringing me a cup of tea.

I reflected on the state of NHS hospitals in this country and on how long a way we were from the Royal Hobart Hospital in both distance and quality. A male nurse came and gave me a wet shave with an old Bick razor. He was in such a rush to get it over and done with he plucked most of the hairs clean out and I was left with a bleeding rashed neck. He missed clumps too, so I felt like a plucked chicken.

Visitors keen to see us instantly besieged us. David my brother came immediately from Ireland to visit. He looked handsome as ever and a little lighter than in his weight-lifting days. I had rarely seen him since we were kids. He used to take me and Judd, my mate from school, to the gym in his clapped out blue Bedford van. We used to train really hard but without proper coaching. I would swell with pride in front of Judd when my big brother won competitions. I used to love the smell of sweat on him. I could never sweat like that, but I was into all that iron and strapping, the stairway up into the top floor of the old mill, the swinging doors, the smell of old carpets, sweat and athlete's chalk.

All the memories of a childhood came back to me – Dave night-fishing with all his high-tech gear, the isotope floats, the quiver tips and swim-feeders. He was a good fisherman and won plenty of matches. He would cast his eight-ounce line into the reeds in the dead of night and always pull out a tench or carp. But piking was our favourite game. We would all head up to Killington Lake in Cumberland, in a VW Dormobile, with my dad and a bunch of his mates. Tents would be set up and we would cook the pike we had caught on an open fire. We used live bait, roach, so the bung would get towed all over the place for what seemed like ages and, suddenly, disappear. The excitement of playing a big pike in is incomparable. You strike hard and can feel, there's no question, if you have it or not. It plays dead until you've almost got it to the bank and then, just at that moment when its eyes meet yours, it turns and runs. The ratchet screams out and you fight to keep the fish under control. Too much tension and the line will snap, too little and the fish will run all your line out. This happens again and again until you have tired the pike out, and all that's left is to net the thing and disgorge the treble hook. They have the fiercest teeth of all coarse fish; concentric rows of needles all pointing inwards. You need to take great care not to skin the flesh off your fingers as you struggle to get the hook out.

I remember having a recurring fishing dream about this time,

that I was doing just this. That I was using both my hands, oh so dextrously, tying on the treble hook and pushing it through the roach's dorsal fin. I was casting the line out with the index finger of my right hand and watching the bung bobbing around; striking, not too hard and not too light; playing the fish by reeling the line in with my right hand also. I am feeling the power of the fish as it runs out 300-odd feet of line; using the landing net to get the pike onto the bank and then disgorging the hook, carefully . . . carefully, with my right hand so as not to skin my knuckles.

When Dave left to get his ferry we both wept uncontrollably, just as if we were children again. Through the weeping my brother told me, 'You gave us a real fright, you know. We seriously thought you were dead.'

I promised never to put my family through that again, but they were hollow words somehow. I didn't know what the future held for me now; it was all up in the air. All I knew was that I couldn't know anything. According to the doctors all brain injuries are different, no two are the same, so looking at case histories would do no good.

At times not all the visitors could fit in the little room. At one point there were fifteen visitors which made me really tired and confused in conversation. It felt good to know I had so many friends but it was an exhausting time.

It was an emotional meeting with my mother for the first time since the accident. We had talked on the phone but judging by the sound of me, she expected I would be looking a lot worse. She said, as I have heard time after time, that she had never seen me looking so well. The five protein drinks I had been supping daily, since I had got rid of the naso-gastric tube, plus the three meals were all carefully monitored by the dietician. I had put on a stone in weight and was heavier than I ever had been. My face had lost virtually all its bruising, apart from a slight touch of rouge on the cheekbone and a patch of red on the white of the eyeball.

It wasn't that I dieted down to preserve my weight to be a climber. I was a vegetarian and I guess I ate healthily. Now my

usually gaunt face had fattened out and so had my middle, which I became very self-conscious about. At six foot and weighing in at ten and a half stone you could say that I was a bit of a beanpole. I wouldn't say that I had a washboard stomach, but I did have some muscular definition. Now there was none, just puppy smooth fat.

My mum cried and gave me a big hug. She and my dad were the only ones who didn't want to know about the accident. It was refreshing not to have to talk about it. It was as if they instinctively knew that I was tired of it all and if I needed to rest I could do so without feeling guilty. It took me a few months to be able to say, 'No, I don't want to talk about it' to the many naturally inquisitive people.

I was in quarantine because I'd come from another hospital and might just be carrying that scourge of all hospitals, MRSA (Multi-Resistant Staphlacochus Aureus). The nurse came in and asked my friends politely to leave. She stuck a cotton bud right up my nose, under my armpit and inside my groin. To be used for swabs, she said. It's an infection that predominantly old people get, after hip replacement operations and things like that, and it is furiously resistant to antibiotics. Only two can treat it and if you use them without first making sure you've got the MRSA infection, you've effectively burnt your bridges.

After a week in quarantine, which was a joke because all and sundry were walking in and out of that door, and I would even be allowed out to the canteen and to physio, I was released. I was moved from the bowels of the hospital up to the immensely bright and cheerful Prysor Ward. It was good to get into the land of the living again. I'm a sociable man by nature and longed for company. There were six other men on Prysor.

There was Doug with his bionic arm, a strange device that he fitted every hour and it mechanically moved his arm for him. Then there was Mark who'd fallen off scaffolding straight through a conservatory. His feet were bruised to all hell and he couldn't stand on them, so he had to keep lying down. There was a very

funny Cockney, Diamond Geezer, we called him, who had fallen down a flight of concrete stairs. He liked to have a joke and kept asking the nurses when the eggs and rashers were coming. Only the abnormally skinny and enfeebled would get a full breakfast and that only applied to just one person on the whole ward, who was isolated with the dreaded MRSA infection. This was Bernard who kept throwing his full set up and Diamond Geezer thought this a dreadful waste. Bernard was just across the corridor, so we could hear it all, every last heave. It sounded like somebody drowning. All Diamond could say was, 'It's a shame to blow 'em.'

Everybody was overweight on Prysor Ward and I mean well overweight. I dreaded night closing in because night-time was the domain of the snorers. One snorer you could say was normal, two unlucky, but five snorers on a ward of six was downright unimaginable. It was like trying to get a night's sleep amidst a herd of buffalo. Well, I don't know whether buffalo would make that much noise. Perhaps a pneumatic drill to the one side and a generator to the other would be more a fitting comparison to our cacophony of alto whistles and baritone growls. I was off all drugs now except anti-convulsants and I would plead with the nurses to dose me with some sleepers so I could get some shut-eye. The nurses refused to listen.

After a full six weeks without an erection I was thinking that I had lost my ability to have sex. Celia had asked Mr Van Gelder in Tasmania whether I would ever be able to have a family and the answer was that, as far as he knew, yes, he would. She didn't say anything to me, preferring that I raise the issue. But I was too frightened to hear a negative answer and so let it go in a swamp of worry. I was still worrying six weeks later when, one night, I had a wet dream. When I awoke from my fantasy it was the dead of night and I was still in the land of the dreaded snorers. But I couldn't contain my excitement, telling the night nurses and friends that came to visit the next day. I felt human again. Apparently it is the trauma of a severe head injury that is responsible for penile

dysfunction and it usually rights itself after a few weeks. So I need not have gone through all that stress.

The view of the mountains from Prysor Ward was wondrous after staring at a brick wall for a week. You can see all fourteen peaks above 3000 feet from the ward window. The Carneddau, the Glyderau, including Tryfan and finally Yr Wyddfa, the highest mountain in Eryri and so in Wales. It has to be the best view of any hospital in the British Isles and it cheered me up no end. I would spend hours staring at that view from my wheelchair and wishing, just wishing. Tracing routes up the mountain ridges, I would go running along their tops and scrambling up their scree-covered slopes, diving into cold lakes and climbing gullies in the last remnants of the snow.

Friends would come visiting and I would strive to concentrate. Johnny Dawes came to see me and said, with a grin, 'You'll just have to start climbing one-handed. I'm doing 6a one-handed now.'

'How about one-handed and one-legged?' I replied.

As friends came in to visit me in hospital, I tried to remember the last time that I spent time with them prior to my accident. It was a way I could test my memory, but more often than not I had forgotten those moments completely: Trish, with a 'Hi' from behind the counter in Pete's Eats Cafe; Merlin, at home in Cae Canol, expounding some theory or other; Charlie with her velvet flares on Llanberis high street; Manuel with a goodbye hug for us on our round the world trip; having dinner with Anna and George and the kids the evening before we left; Noel and his ever so slightly envious expression as he shook farewell; Ali with her generous kisses and 'Ta-ra's'.

Gwyneth, the hospital urinologist, came in and, taking one look at my golden purse, declared, 'We'll have to get rid of that thing, won't we?' She explained in detail how I should go about self-catheterising myself and then told me to repeat her instructions, just in case I had missed anything. Then she handed me a clutch of straws and a tube of KY jelly. The nurse came in and re-

moved my catheter and I was left to wait in nervous anticipation.

Dave Green came to see me and with one look at his tanned face I was instantly transported back to the Kirghizstan expedition, where we had been the previous summer.

There was a group of horsemen, fierce and with large moustaches. Each had a rifle slung over his shoulder. They decided to play a game involving a dead goat and ten or more furious equestrians. I was chosen to be 'it' and given the dead goat to look after whilst the rest of the tribesmen chased me through a dense apple orchard. When I say chosen, what I really mean to say is that I was the only volunteer. Johnny said he was far too whacked from the Khirgiz wrestling, Noel muttered something about being beaten at arm wrestling by a little lad (Noel stands six foot three and is twelve and a half stone), and Dave was nowhere to be seen, off reaping a certain five-leafed herbal remedy, no doubt. Up and down we galloped to the wide-eyed stares of my other team-mates, who didn't know I was this hot on a horse. I was keen to show off my equestrian skills and spun the horse around and around, until the whole world was a blur. Then I had the inevitable accident with a tree. A branch, too low, got in the way and swept me off my steed backward into the dirt. Apart from a few minor cuts and bruises I was unscathed and able to carry on with the expedition.

Stormont Murray was assigned to be my physiotherapist. He wasn't trained to be a neuro-physio but he knew a fair bit about the subject. Bespectacled, and black haired, he had the manner of a Clark Kent about him. He was also a keen climber and I think, when he could, he gave me much more than my allotted time in the gym. This was because I was a fellow climber but also because I was interested in my body and what he was doing with it. I was genuinely intrigued and asked why he requested me to slide curtain rails left and right or place cones on top of each other way over to my right. 'Standing balance,' he replied. I couldn't imagine people just doing what they're told, not questioning the basic principles of physiotherapy, not seeing that there was even a differ-

ence between neuro and orthopaedic physiotherapy. He was always keen to answer my questions. And he complained about how most people are overweight and it was hard to tell where a particular muscle was, the erecti spinae, for instance, or the obliques. I was like the illustrated man compared to these folk.

Barbara Hartfall was his senior and trained in neuro-physiotherapy to boot. She only had three days with me and then was going on a month's holiday. She was not happy to be missing out on such an interesting case. In a provincial hospital it's not that often physios get special cases through their doors. OK, so I was just a stroke case to all intents and purposes, but I was a very severe stroke. I made good progress during my month in Ysbyty Gwynedd and Stormont said that I would be walking before the month was out. That meant the end of April. We would see.

My first day out amongst the hills was like the very first time. No. More intense. I didn't cry when I was younger and let loose in the hills. It was all so new and exciting, that was the last thought on my mind. I know a certain amount of my present emotion was my lability but it was still real as far as I was concerned. Celia and I lived in the heart of the Welsh hills so just going home to Llanberis took us right through them. We went the top way home, where I could see the summits and cwms, the green fields and pastures filled to brimming with cotton wool sheep and the blue grey of the quarry holes with their cone slag heaps, looking like a Wild West scene rather than Welsh countryside.

The purple ribbon of the Llanberis Pass road with Crib Goch and Crib y Ddysgl sitting like giant slate fans to the south with the Glyderau to the north; the interplay of light and darkness in just the right balance, switching and shifting like pieces in a game of chess, as the clouds move; the ruined farms, of which there are many, standing about like castles on their last legs; the strangely shaped plates of gravy down below at the bottom of the hillside that profess to be lakes – it was the minutiae that grabbed me and beckoned me to notice them. The two holly trees on the island

in Llyn Glas that the sheep can't get to were planted by Celia's father who died a long time ago; the gate falling off its hinges; the boulder problem that I'd never seen before; the broken window in the school house at the top of Fachwen – it was as if I was trying to hold these minute things close to me and never ever let them go. Tears trickled down my cheeks from behind my cheap shades bought from Salamanca market.

At the farm, after Celia dragged me down the steps, I lay on the settee exhausted. We had an endless stream of visitors some of whom I hadn't seen since my accident. Sometimes I would have to send them all out of the room so that I could insert my catheter and relieve myself. Celia would cook me pasta pesto or carrot and coriander soup with a hunk of bread; it was a taste experience after the bland hospital food. Afterwards I would sit in the window and stare longingly at the mountains, wanting to turn the clock back, just a couple of months.

After two day visits home I was allowed out for the whole weekend. We put a bed downstairs, luckily we had a downstairs bathroom, and Celia could wheel me out into the garden to soak up the sunshine. From there I would while away the day attempting to read and appreciating the truly awesome view, punctuated with many naps on the bed. She said there wasn't enough space in the single bed for the two of us so she moved the futon downstairs to be near me. This touched me greatly. We would cuddle in the single bed and watch videos together or listen to music.

As my month in Ysbyty Gwynedd progressed I became more powerful in my left arm and leg while the recovery of my right side was frustratingly slow. I was so unsteady on my feet that if I ever stood up I could topple over at any moment, and frequently did so. After a couple of weeks spent self-catheterising I gradually wanted to piss more and more of my own volition. This was a dramatic turn of events and for a while I struggled, sometimes having to use the catheter and sometimes not. I had to learn to be patient, Gwyneth told me, and leave my bladder to fill at its

normal pace. Every time I went to piss I would have to measure the residual in my bladder by shoving that tube up my cock again and presenting the cardboard bottle to the nurses to have it recorded on a chart. This made me feel like a child – 'Look, nurse, at what I've done' – and I hated the procedure. So I failed to do it almost every time, much to the dismay of Gwyneth who chided me with a musical Welsh accent. In the end she brought a machine with a LCD on it and, putting jelly on my abdomen, proceeded to carry out an ultrasound scan. Then she took the handful of tubes from me and said, 'You won't be needing those any more, Mr Pritchard.'

A wave of anxiety swept over me. 'What if I can't go?' Images of my bladder swelling up like a football and bursting in a shower of blood and urine filled my mind.

'Just relax, you'll know when it's time to go,' she replied in an exaggeratedly sympathetic manner.

I still could not read to the end of a line on a printed page. It was as if only the left-hand half of the page existed; I couldn't even see the right-hand half so didn't think to read it. This hemianopia is a classic symptom of hemiplegia but I only learnt this much later by reading up on it. My reading skills still had some way to go and I worried that it would always be thus. Someone brought in the *Weekend Guardian* interview I did for Sabine Durant and I was surprised to read the headline 'Rocks in the Head'. I hadn't seen it before and I wondered if she knew something that I didn't. I asked her not to dwell too heavily on my previous accidents but that was basically all it was about. People do have a morbid interest in accidents and I guess it's only natural that she should concentrate on them.

Ruth was the social worker assigned to me. This caring woman helped us fill in the scores of forms for the Severe Disablement Allowance and Disability Living Allowance amongst others. We couldn't have done it without her. I was struggling to write any-thing with my left hand and the forms were bewildering anyway. Whenever I attempted to write it was an illegible mess, as if a

cockroach had dipped its feet into an inkpot and walked over the page. Ruth just whipped through them as only someone who is well practised at form-filling can. She was on the édge of retirement and soon to leave the area for a house that she and her husband had purchased on the Sound of Harris in the Outer Hebrides. Wearing short hair, cords and a checked shirt she looked as though she might have been a tomboy in her school days, if not still. She invited Celia and me to stay with her in the croft, which she'd had for years, waiting for this moment.

My good friend Sue Upton, who is a trained osteopath, came in twice a week at that time to give me cranial therapy. I'd had it before for all sorts of problems and found it very beneficial. Don't ask me to explain what it does, it's something about manipulating the cerebral spinal fluid. Anyway it makes you feel really weird for a while and, afterwards, much better. She said that my fluid was all pooling in the right side of my body and was basically all messed up. Pat Ingle also came to visit me; she's a masseuse. I can't begin to tell you how good it felt to have my leg and arm simply rubbed. They were still wooden but deep down they now had some feeling. I'm convinced that massage helps limbs regain lost feeling by sensitising them again.

A Dr Atara, my consultant, came in one morning and spoke to Celia as if I wasn't there. He was asking her questions about my condition while I was sitting right there in front of him. OK, so I must have sounded stupid because I stuttered somewhat but I felt I was totally coherent. Just because I'm in a wheelchair doesn't mean I'm not compos mentis and, even if I wasn't, he still could have made an effort to talk to me. Apart from Salamanca market where people behaved distinctly oddly with me, staring because I looked a right state, that was the first time I'd noticed the 'Does he take sugar' syndrome. Generally doctors know better and he was the last one to treat me in this way.

Tracey the occupational therapist came in that evening and made me transfer from my bed into a wheelchair that had weighing scales secreted under the seat. We had a laugh when I suggested

that she was weighing me for my coffin. She scribbled down eleven stone in her notebook, put me back in my bed and pushed the weighing chair away.

Shortly afterwards a beautiful nurse of Indian origin, came to give me my medication. This included two paracetamol tablets, a Nizatadine tablet to stop any excess acid being produced and thereby creating an ulcer, and an anti-inflammatory suppository. She donned the rubber glove and ordered me to roll over. I was used to having things shoved up my bum by now and even looked forward to it in a perverse sort of way.

I now had a place at Clatterbridge on the Wirral Peninsula, Merseyside. At sixty miles distance it was the nearest neurological rehabilitation unit to North Wales. The leaving date was earmarked for the 5th April and it was the 2nd already. I had been lingering in Bangor for a whole month, which was OK from the point of view that I got to see all my friends from Wales but not so good from the rehab angle. It was all something to do with the financial year ending on the 1st April and Ysbyty Gwynedd not being able to afford to send me to the rehab unit until the new financial year came about. I think. But that was OK, I could live with that and besides Stormont and his colleague, Penny Croxford, who I was going to see a lot of more than half a year later, were absolutely ace physiotherapists.

I was supposed to travel by ambulance but Celia talked them into letting me ride in the car with her. The most enduring image I have, as we burned down the coast road, were those daffodils on the central reservation past Llanfairfechan. Their faces seemed sadder and more raggedy than a month earlier but thousands of them were still keeping their heads afloat in the good loam.

8

CLATTERBRIDGE DIARY

People ask me what was it like, and I say yes, of course it was dramatic and graphic and all that stuff, but at times it was just kind of comic and strange. It was, I suppose, my life-changing story.

Ben Watt,
Patient

23rd April
Wirral Neurological Rehabilitation Unit, Clatterbridge

I don't know where to start this diary, so I'll start by describing the inmates. They're a mixed bunch, from the victims of vicious attacks with baseball bats to drink-drivers to victims of MS to a whole host of mystery illnesses. The one binding factor is that they all involve a neurological slant and the job of the staff here is to integrate the patient back into society. This job may take one month or it may take two years. Which one I would be I had no idea. I must say that I've been here since the 4th April but only now have I felt cognitively able to record my verbal diary into my dictaphone. (And I didn't begin typing it up until mid-June.)

There's Gary who walks on tiptoes, due to a shortening of his Achilles tendons. If you have spent a few months in a coma, like him, and you're not using your feet, this is inevitable. He has speech problems like I do. After a bottle and a half of vodka he went driving in his new Audi, rolling down an embankment and giving himself a brain injury. He's got a tribe of misbehaving kids

and a wife, he says, who is cheating on him. They are forever arguing. It hardly seems like the ideal environment for recovery. I grimace when his tribe comes in. They are ugly and cheeky brats who race up the corridor and around the day room.

He hasn't learnt any manners off his folks and he sure as hell isn't passing any on to his kids. He plays Hardcore, a type of techno-music with people shouting, at high decibels all day long, not giving a toss that I'm trying to work. He passes his photos of the wrecked car proudly round to all my mates. Stunned, they laugh nervously.

There's Smithy, a big-time drug-dealer who was being driven by a twenty-one-year-old girl who died as a result of a collision with a lamp post which then fell on top of them. He is bald on top, wears a beard and has no teeth bar a couple at the sides. He jokes that he left them on the dashboard of the car. Smithy's always one for chatting up the nurses and having rum and Coke brought in for him by 'the missus'.

He has hideous nightmares stemming from the accident which he can only steer away from by using a cocktail of drugs, twenty milligrams of Diazepam, Tylex and a couple of cans of Special Brew. They tried to cut him down to ten milligrams but, as he says, 'I can get as many Diazies as I want for fifty pee a piece off the bag-heads by us.'

He's got a 'dense hemi' of the right side as well, so it is pretty interesting comparing notes. But if one thing has become apparent it is that no two head injuries are the same, even if they have similar symptoms. Such things as length of time before emergency treatment (Smithy was only forty minutes, as opposed to my ten hours) and the severity of the injury are all-important factors. Smithy is well on the road to recovery now, while I am still in this wheelchair and our injuries were about the same time. It starts you thinking, what have I done to deserve this? But that would be wishing harm on yourself. You have to have faith in the brain's power to heal itself, you have to keep saying, yes I can get through this, and keep thinking positive.

There's Kevin, a seventeen-year-old lad whose friend was driving when he had his accident. As far as I can get the story straight the driver's sister was killed in the accident and he put Kevin in this sorry state. The driver was drunk and is now serving a two-year sentence. Doubly incontinent, Kevin can't walk without a rollater and shouts obscenities at any one who cares to listen, except his parents. He is what psychologists call 'disinhibited' which means that he'll swear like blue murder. Not all the time, some times he wouldn't say boo to a goose, but at others, especially when he's doing physiotherapy, he'll kick off. 'Get off my cock, you fucking cunt,' he will say to the nurses when they try to change his Convene, a condom which you piss into; or 'I'm not doing it, you hairy-arsed whore', to Sian Hughes the physiotherapist.

Then there's Bri, again a drug-dealer, but small-time compared to Smithy. He woke up one morning and found he had a virus on his spine. He's now in a motorised wheelchair at twenty-eight. He's got a skinhead and listens to Metallica and Slayer all day long. He is basically completely paralysed, apart from his left hand with which he controls a joystick to steer himself.

He seems to be having a relationship with Alison who is seventeen years old, and you wouldn't think a day older. She has milk bottle white skin and wiped her memory out in a car crash. She went driving with her then boyfriend and took a dive through the windscreen of a BMW borrowed from the lad's father. He was seventeen also. He never came in to see her once and she hates him and drenches him in scorn. When she first came in here she had to be taken to the toilet because she had forgotten where it was and, later, she would misplace all the nurses' names, even though she had been here months. It's sweet to see young love. Everywhere that Bri motored Alison would follow. She is totally physically able and just looks at odds following one step behind a guy in a motorised wheelchair.

Sheila who walks but only just is a pretty, proud woman who used to be in high-flying business until this dreadful affliction hit her. All the skin started to peel off her body, starting at her inner

thigh and, when I came in, she was skinless. It looked like she had a very good suntan, until upon closer inspection that is, and she had to wear a wig. She stayed in her room, watching daytime TV, most of the time. Then, like a shy animal, she started being tempted out of her den, to the vast empty spaces of the day room. It would be easy for us, the other inmates, to say, 'Don't worry about how you look, we're all in the same kettle to a greater or lesser degree.' But that would be to deny her sensibilities.

We have Tom who came off a motorcycle, (although he'd have you know it was a car crash,) in the Caribbean and hit a bollard. He's very slow and muddles his words and is always complaining to the doctors about when he will be let out of here. It's as if he doesn't realise his own problem. 'He's an architect, for God's sake. How will he get it together to do technical drawings and behave in a professional manner towards clients?' I heard Ms Caroline Young, the consultant neurologist for the ward, mention quietly in the corridor. Tom has a wife who is still out working in Jamaica and comes to visit him once every couple of months. It must be really sad and frustrating for him, being away from his home and wife.

There's also an old lady called Jean who is always trying to escape, which keeps the staff on their toes. She hasn't got any teeth and loves to do jigsaw puzzles. Her only visitor is her husband who looks Tibetan and smells of Woodbines. Jean is very disoriented and asks if anybody has seen the wooden horse, the coalbunker, or the Christmas decorations. One day she escaped out of the kitchen door, walked all the way around the building, and entered the Oncology Department before the nurses could scramble and go and find her.

4th May

I feel very resentful of able-bodied people who can just get up and walk or go where they want to. People who can still go rock climbing and surfing and sailing or simply just walking around and

feeling the fresh air. I don't know if I'll ever be able to do these things again. Of course I put a brave face on the situation and tell everybody that I'm doing fine but deep down I'm obviously not doing fine by anyone's stretch of the imagination.

I had an idea to photograph all the inmates, just take portraits of them all, but I don't know how they'll react to that. Apparently I need special permission off all the relatives involved, so I knocked that one on the head. We watched a sad movie called *Awakenings* the other night and I mean really sad. All I could do was laugh all the way through it and that upset Celia no end. She couldn't get to grips with the fact that I really wanted to cry but it came out in hysterics. Thank goodness it was on video and not at the cinema.

When I first came here I could stand, but that was it. I definitely couldn't walk and in the past four weeks I've come on a hell of a lot thanks to Sian and Nina, her helper. Sian has to put up with my giggling fits, at least it's more of a laugh than crying all the time, like I was before. I seemed to switch from crying to laughing overnight. It could be her infectious good humour that has had a healing effect. I never laugh with such vigour with any of my other therapists. I spat in Sian's eye today I was laughing so much and Nina had to fetch me a tissue to wipe it out with. This is still part of my lability and at times my laughter is inappropriate and it worries me a little. I was in hysterics when I heard the news about Linda McCartney's death on the television and Ella, an old patient with MS, who was trying to watch, said that it was disgraceful that I should laugh at a time like this. It's just when I'm nervous that it grabs me. There was one time when a friend of mine told me of her father who had a disease which made him fall over all the time. This was a really bad time to giggle or even grin but I did and went crimson with embarrassment.

Sian has the blonde side of red hair and her yellow belt at karate. She asks me things like, 'Is there anything functional you could do with your right hand previously that you can't do now?' It only took one glance at her for me to burst into laughter. She's

going soon as part of her four monthly rotations. I'm going to miss her and her look of incredulity every time I crack up.

I took my first few steps last week. Though they were undoubtedly Frankenstein's monster steps, they were steps nevertheless. That's three months after my accident. Alas, they put me back into a wheelchair because the pattern of walking was all wrong. If you start walking too early, as can be seen with patients who had their injury in the 'sixties, you could have a marked limp for the rest of your life. So it's back to the chair for me until I develop a style of walking that is usable.

My hip control is improving with every day that passes and the abductor muscles seem to be kicking in. I can tell that because my knee doesn't flop in as badly when I stand up. They're all good signs.

7th May

Fiona Parry, my neuro-psychologist, put me through a series of gruelling cognitive tests and intelligence tests for two whole weeks. Every day for one hour. Puzzles and mental arithmetic, recognising obscure shapes and doing word tests. Essentially IQ tests. She estimated that I was above average intelligence pre-morbid, before my accident, and well below average (an IQ of 90), post-morbid. She had some problems estimating this, as I have virtually no academic qualifications, so she just went on my previous book and a handful of O-levels. I described how I was having memory problems and concentration difficulties. I found learning new names particularly hard and I lost track whilst reading several times per page. My performance on PASAT, a test of sustained attention thought to be a sensitive indicator of the ability to return to work, was significantly impaired.

Yesterday we had patients singing along to Elvis Presley on the tape machine. It's astounding how many Elvis impersonators there are. I laughed till my stomach ached seeing Alison and Kevin

straining to find the chords of 'In the Ghetto'. Kevin was dead flat in a voice way too low for his seventeen years and Alison caterwauled at a piercing pitch.

There's a new patient here called Dave who's suffering from MS. He's hilarious and takes the piss out of every one mercilessly with his Marty Feldman eyes. He's had MS for twenty-five years and has been in a wheelchair for ten. His legs and feet are frozen out straight in a grotesque caricature of a ballet dancer in the *pas de deux*. He is waiting to have his ankles and knees snapped. But that won't be for a few years he says. Such is the NHS.

When he was in his twenties he worked the oceans as a merchant seaman. He has been everywhere, from Bombay to Buenos Aires, from Nairobi to New York. Then one night in mid-Atlantic, as he was changing watch, he went to descend a ladder and fell the full length of it. The captain, thinking he was drunk, put him in a locked cabin until the end of the voyage. When he still behaved like a drunk after a week in solitary the captain knew he had made a mistake. 'They put me in hospital,' he complained, 'but they couldn't find anything wrong with me. That's the strange thing about this disease, it's fuckin' hard to diagnose, and when they did find out, I was the last one to know about it. They kept it from me for ten fuckin' years.'

It shows true strength that he has kept his astonishing brand of humour in the face of overwhelming adversity. For the last ten years he has been in a first-floor flat day and night. People visit him when they choose to, though he doesn't have many friends and he certainly doesn't go out visiting. The ambulance women have to carry him downstairs in a stretcher.

'When you look like this people think it's OK to stare. They think you're stupid as well as deformed.' He breaks into a mock expression of an archetypal 'spastic'. 'So I'm not bothered about living on the first floor, who gives a flying fuck about goin' out anyway.'

Last night Jean got into bed with Smithy. He was asleep and thought that he was getting a visitation from his wife. When he

put his arm around her to give her a cuddle something mustn't have seemed quite right and he woke up with a scream.

'What the fuck!'

She calmly said, 'Shut up and budge up.'

The night nurses all came running when they heard the commotion and began bellowing with laughter. Gary and I slept through it. Smithy never tires of telling that story and each time it gets more outrageous. He blames Gary and me for not waking up.

I was looking on the timetable for weeks before I realised what S.a.L.T. meant. It wasn't until my first appointment with Siobhan, my speech and language therapist, that I got it. She was a bubbly woman who I couldn't stop grinning at. They're used to that though. Inane grinning is the least of their worries. They have to put up with verbal abuse regularly and sometimes physical assault. Siobhan said that I was well on my way to mental recovery and this was evidenced by the fact that I was contemplating writing my second book.

18th May

I had my leg cast this morning which is an attempt to stop me going onto tiptoes every time I straighten my leg – an associated reaction.

It's been boiling hot now for ten days and I'm getting a tan. All the nurses, physios, OTs and orderlies are out sunning themselves and eating their lunch at the picnic tables in the courtyard. It's a real garden party atmosphere, especially with music playing. It makes a real difference having the quadrant to sit in, even if it is caged off from the outside world. I couldn't imagine not having greenery about me. I'm sure it's one of the things that keeps me sane, along with writing this diary.

I named nineteen animals in a minute the other day, compared to three in Bangor. So that says something for my mental processing

speed. About twenty is the average, but I've been practising my animals, so I fear I wouldn't fare so well on the names of, say, fruits or foods.

The Wisconsin Card Sort, which I did with Fiona a few weeks ago, was kind of interesting. It goes like this: you have at least a hundred cards in a pack, which is divided into any number up to four, of squares, triangles, circles and stars. These are all different colours, too. Four cards are put in front of you. The rules are that you must match cards up by your own rules. At first it was easy, matching by shape, stars to stars, circles to circles, that kind of thing. Then she tells you that the rules have changed and again it's obvious what you should do. Match by number, four triangles to four squares, three circles to three stars. Then she tells you that the rules have changed yet again and that you have to guess how. It may seem obvious to you that they be matched by colour, but I couldn't grasp this. We turned and turned, me thinking up ever more unlikely combinations, until all the cards were gone.

It never occurred to me until Celia said, 'What about colour?' as if it were obvious. Being colour blind, I have never trusted colour as a way of categorising objects. I never see the colour of a person's eyes, even after I've known them for ten years. So even though those cards were the most familiar gaudy colours, I still didn't think to categorise by them. That's my theory anyway.

The occupational therapist specialises in one's functional ability and Lise Satherley had me doing similar tests but perhaps slightly easier. I had to build a coat hanger out of wire with written instructions and then build a tower following photographic instructions. It was elementary stuff, if you weren't brain damaged; I made some mistakes following the written instructions and trying to use the jig that was presented to me.

I had no trouble at all following pictorial instructions, though they were quite complicated. That's maybe because I spent a vast portion of my life following topo diagrams for climbs. So that may go part way to explaining why I've always been useless at following cookery recipes and yet have no problem with the visual

side of things. My climber's mind has always solved problems by vision.

I had a good memory for diagrams but not for stories, I had a good memory for pictures but not for writing. That has made writing this book doubly difficult. As soon as I get an idea for a sentence in the day room I have to come rushing back to my ward, in my wheelchair, only to find that the idea has completely evaporated.

'Who is the President of the United States? Who is the Prime Minister of the United Kingdom? What year are we in? What month is it? What date is it? What day of the week is it? What time do you think it is?' These are questions that Fiona and Lise ask me all the time, as if it is *prima facie* evidence I am demented if I don't know the answers. But I never know what day of the week it is anyway, and I've never had a watch to tell the time by in my life. These aren't things you need to know when you are a climber. You get up when the day dawns, regardless of which day of the week it is, and you go climbing. I have been known not to know which year we're in even before my accident.

An ECG was put on me this morning, ten shiny metallic stickers all linked up to a pencil that sketches the electric patterns of your heart. I had been taking Phenytoin ever since that rock hit me, to save me from convulsing, and in my last blood sample I had dangerously high levels of the drug. I had been complaining of feeling unusually drowsy and after my ECG the doctors cut my amount drastically, with a view to stopping it all together.

The pills were replaced straight away by an injection into my belly, a blood anti-coagulant, which I have to administer myself every morning. I have to wear sexy thigh-length stockings as well, again to prevent blood clots, veins thrombosing.

19th May

I can feel a nervous energy reaching my legs and feet, my arms and fingers. A nearly but not quite feeling.

It's funny how not only can I not move my limbs but also I have forgotten how to move them. I have forgotten the very concept of movement. My lefts limbs are working just as they should but on my right side things are far from normal. Spasticity tends to override every movement. When I walk just a few steps my arm comes up as if it's got a life of its own. And my leg tends to fix into a pattern of extension, standing me on tiptoe, the whole limb rigid.

Then, all of a sudden, my brain remembers how to use the pectorals, say, as if it had been using them all along, or had never forgotten in the first place. Then I'll forget again and it's lost. Occasionally I'll remember but not quite enough, so that I am tingling all over my foot and hand, all over my arm and leg, but still no movement. Like an electrical current when the fuse is blown, it reaches the plug but not the appliance.

Today in physio I was working on isolating the quadracep, the thigh, and tensing it. Previously my thigh and glute would just wobble like jelly, but in the last couple of weeks they've settled down, unless I've really pushed them – by that I mean ten minutes standing instead of five. I'm overworking the muscles that I do have on my right side to compensate for those which I don't have. These muscles then require constant massaging and loosening up to dampen the effect down.

When I first came to this place I felt like I'd walked straight into *One Flew Over the Cuckoo's Nest*. There was all the moanings of the Chronics, and all the droolings of the Disturbeds and plenty of Big Nurses. There was even a Bull Goose Loony. But now that I've been here a couple of months I've started calling it home. 'Take me home,' I'll say without thinking to whoever is to bring me back that weekend. It's as far as one can get from *One Flew*

Over the Cuckoo's Nest – the staff are all, without exception, selfless and kind.

What's called 'associated reactions' are something many people find surprising. When I yawn my arm rears up and my leg shoots out. People expect paralysed to mean just that, dormant, without any movement. That was the case for the first month but then weird things started to happen. If I'm not careful these could develop into severe spasticity. In my case it's a pattern of flexion in the arm and extension in the leg. At first I encouraged this because it was the only sign of movement in my crippled body. The only evidence of tone in the otherwise flaccid half of my person. But then I began to notice a tightening of the bicep and hamstring so I could no longer straighten my arm or leg.

I then began noticing, when I lay flat on my back, supine, my toes turn upwards, my foot points downwards and my whole leg tenses. It feels great to stretch out, but I have no control over it. Whenever I lie down it simply happens. I only have flexion tendons at the moment, flexion muscles. I have no extensors. This is most evident in my arm where, if I'm not careful to stretch it out, my wrist and elbow can curl up skywards, clawing up like the typical spastic pattern.

Again I encouraged the associated reaction in my leg so much so that the physio had to cast it. Sitting here with that cast on I realise my mistake. It creates a pattern, which is reinforced in your reptilian brain or brain stem, so that every time you yawn that's what will happen. The reptilian brain is, as the name implies, the most distant, evolutionarily speaking and deals with sweating, goose bumps and impulse reactions such as pulling your hand out of a fire. It's what we learn to toddle on and what creates these associated reactions.

A recurring dream grabs me and won't let me go. It is of running across fields, free, free from this nightmare that is still there when I wake in the morning. Free to take flight across meadows of long summer grass. Running, sprinting for all my life's worth. And that's it, just running. The wheelchair standing by my bed gives the

game away. Sometimes I think that I'm normal and healthy until I turn over and see *it* there. That cursed thing that I can't live without.

22nd May

A big day. The woman I love decided it would be best if we didn't see each other again on a romantic level. In other words she has left me. She broke the news in the van whilst bringing me back from hospital. She parked up in a lay-by because she couldn't see through the tears.

All I could do was break down into laughter. I laughed until I couldn't laugh any more. The laughter then turned to tears. Tears of sadness. There were a lot of good memories tied up in those six years of togetherness. And the fact that she saved my life must surely mean that I am eternally indebted to her.

Sitting on top of Shiprock in the four corners of the USA, on the summit of El Aleta de Tiburon (The Shark's Fin), in the Towers of Paine, Chile, swimming in the middle of the night on a midsummer Isle of Eigg, watching the sun rise up from the forests of Borneo on Kinabalu, alone, together, setting up the camera and taking your picture on the shoulder of Trango Tower in Pakistan, skinny dipping in Lago Nordenskold, Chile and you proposing we get it together by the bridge across the Ganga in Uttarkashi, India. All these memories make me warm inside my belly to remember.

But all I can think about now is the weight that has been lifted from me, as if I was being trapped in a gloved fist, and suddenly set free. All I have to look after now is myself. I don't have to think about anybody else. I can concentrate on the mammoth task of getting myself better. My rehabilitation has to come first. Sad as it may be, that's the way it is. There seems something oddly amusing about a life in ruins. Not only am I a raspberry ripple, a hemiplegic, but my girlfriend has left me as well. That's what it

seems like at first. When I told her that I loved her on the telephone there was only a terrifying silence for a response. It was like I was talking into a void, a black echoing box, where my own words were cast back at me.

'A psychic kick up the backside,' that's what Sue Duff in Tasmania had said. And she was right. I would still be carrying on the same life as before if it were not for this accident. Instead I was embarking on a whole new adventure, where nothing was certain. Just how I like it and will grow to accept it.

Celia took me down to Walton Hospital for an appointment with Mr Foy this morning. The first thing he did was to take a tape measure out of his pants pocket and assess the length and width of the wound.

'It's a jolly sizeable gash you've got on your head there,' he declared. 'About five inches by, let's see, two and a half. Now, Mr Pritchard, having seen your scans, there seems to be a very big shadow which would suggest to me that you have sustained a large amount of damage.' I thought, tell me something I don't know. He then 'suggested' to me in the same polite manner 'that your climbing days are almost certainly over'. I replied somewhat indignantly, 'We'll see about that.' What right has he to play God like that when he doesn't even know me? It is the first time he has ever met me. How can he say such a thing, when he doesn't know the will power I possess?

Anyway he also said that I wouldn't have my head plated for at least three years, if ever. Something about the risk of further trauma to the brain being too great. Apparently my scalp has healed directly onto my brain and a very precise surgical operation would have to be carried out to pare the two apart. It suits me if I never have it done. At least I will get to keep my party trick. I have discovered that if I hold my nose, and create pressure in my head, I can make my brain swell so that my scalp rises by about an inch. I call it flipping my wig.

At the end of March I wiggled my toes but only three times and then it disappeared, I couldn't wiggle them any more. I suppose

I'm scared breaking up with Celia will put my rehab back. I have to keep thinking positive which is really difficult at a time like this. The physios always stress the importance of positive thinking and that the right mental attitude will win through. I feel as though I'm cracking like a pigeon's fragile eggshell.

25th May

Fiona, the neuro-psychologist counselled me, and I told my story about our relationship break-up from start to finish. She said that numerous relationships break up after head injuries. Lack of sexual function that sometimes arises from a crack on the head is often responsible. Or the change in roles can be the cause, the breadwinner suddenly unable to work. It was neither of those things for us, we just drifted apart. The accident wasn't the cause of the break-up; rather the break-up was a symptom of the accident.

I went house-hunting today but it's a difficult task as many of the houses have steps up to them or only upstairs toilets. There are no bungalow in Llanberis but I couldn't live anywhere else. The true extent of non-wheelchair friendliness in towns and cities hits you like a lead banana when you're in one.

1st June

Andrew is a new admission who has a severe head injury and keeps repeating himself again and again. He is bearded, ginger-haired, balding. He doesn't smile and complains about the food all the time. From down the corridor he sounds like a horse race commentator when he's being disinhibited. Even Bazza, who helps with the serving of meals and is usually so pleasant with patients, comes back despairing when he has been to serve Andrew his dinner. His wife says that he has always been grumpy and that it

isn't a result of the car accident. He even has a sign on his door saying 'KNOCK BEFORE ENTERING' – in a hospital!

The whole right side of my body went into spasm today. I was lying on my bed when I sensed what I can only describe as an intense déjà vu, more intense than any I had felt before. I had definitely been in this situation before and I knew what was going to happen next. A rhythmic twitching in my toes soon began. I got off the bed because I knew Tricia Rodgers, my senior physio-therapist, and Lise were on the patio and I was keen to show them this latest phenomenon. I manoeuvred myself into my chair and wheeled out to them.

By the time I'd reached them I was experiencing something I hadn't felt before. It was a throbbing pulse, waves of tingling travelling up my right leg from my foot to my fingertips. My leg was still in a cast and when Trish tried to bend my toes up I screamed out in pain. It was like boiling water being poured into my pot.

She then attempted to straighten my leg but it was locked in a right angle, such was the flexion exerted by my hamstring. Then my arm began to feel detached. It floated out to the side; it wasn't mine any more. That was a feeling I haven't had for some time now, maybe three months. They wheeled me up the ramp, through the French windows and put me to bed. After an hour in bed I was on top of the world again.

Ever since the spasm it's like something's about to happen, some movement's about to start. Later that afternoon, about two hours after, I moved my ankle and then my knee. That was a massive step forward; not only did I have my upper leg but my lower leg is coming in now as well. I only moved them a fraction of an inch but that is a start. Things can only improve and get stronger.

It turns out that what I experienced was a seizure, an abnormal electrical discharge in my brain. A 'simple partial seizure' only affects the opposite side of the body to the damaged hemisphere of the brain. This was a 'late seizure', which is generally associated with more severe brain injuries, involving damage to the brain

surface. From what I can gather there were fragments of skull pushed onto the brain and blood leaked into the area, bathing the surface of the organ. This haemorrhage was especially irritating and likely to cause a seizure disorder. It produces what is known as the Jacksonian March. The attack begins with jerks of a single part of the body, such as a finger, and then spreads to other fingers and so to the whole hand and then the arm. This guy called Jackson noticed, in 1870, that wherever the lesion was in the cortex of the brain, the corresponding part of the body would fit.

So it's back on the Phenytoin for me which is less than ideal. It strips me mentally of all my creativity, makes me severely drowsy, robs me of life. The déjà vu bit is a common symptom of having fits. It's called the 'aura'.

We were watching a TV documentary this evening and it showed a ferret with cataracts. In a rehabilitation unit for brain-injured patients we were watching a programme about a ferret with cataracts! We simultaneously burst into laughter, Smithy spraying us with tea and toast as he has a habit of doing.

2nd June

I can't sleep because I'm brimming over with excitement. My whole right side feels like it's coming to life, tingling, and pins and needles. I'm wide-awake, perhaps it's the drugs making me more alert. I want to write everything down.

I have to inject myself every morning directly into my belly. This is to administer a blood anti-coagulant. It was rather unpleasant at first, needling myself in the stomach, but it got easier. The staff of this place have decided to let me administer all my own medication now. This self-regulation is supposed to give me that extra degree of independence and make me feel like I'm looking out for myself, making my own decisions. I don't think they realise just how independent I am but I'll humour them.

3rd June

I took a fall in the toilet when I twisted over on my ankle. It was a desperate struggle to get myself back up once I was down and, though the nurses' alarm cord was right in front of me, I was determined to get up without assistance. Perhaps I was also a little embarrassed to be down on the bog floor. There's a stainless steel guardrail, which is meant to stop you from falling. I somehow avoided it and landed, in my underpants, on the wet tiles. It was the rail that I climbed, hand over greasy hand; back up with my legs hugging the bowl like it was a tree that I was trying to save. When I eventually got to my feet, I needed a shower to wash off all that stale piss and God knows what else lurking around the base of a toilet bowl.

The dynamics of the fish tank are very interesting. It reminds me of going snorkelling with Celia round the coral reefs of Mamutik and Sapi. I spend hours a day watching the bullies and weaklings. There isn't any rhyme or reason to who's top fish. Sometimes it's a big angelfish bullying a little platty but just as often the king of the tank will be a little tiger barb. The gourami will often be the one to throw its weight around. They're silver with long trailers coming from their mouths. Apparently, so Fish Man says, they live in muddy water and survive in conditions that would kill all the other fish. The plec had nothing to do with such insignificance until they killed and ate it. You need a plecostamus to keep the glass clean because they hoover up all the algae that sticks to it. Fish Man, who comes in once a month to tend to the tank, brought a new monster specimen in this week, presumably one that could hold its own with the other fish. He had been growing it for three years and no sooner had he put it in the water, it turned from a black colour to a pale grey and looked rather ill. But the other fish don't want to mess with it because it's a big brute of a thing.

6th June

I'm now within the average range for verbal fluency. This is where you have to think of as many words as possible beginning with a certain letter in one minute. I thought of nineteen words beginning with the letter C: Chicken, chip, chat, chubby . . . that sort of thing. That's a dramatic increase, considering that while I was at Ysbyty Gwynedd I could only think of three words beginning with T and they were tea, tee and think!

I couldn't move my foot today, whereas yesterday I could, so that was a little disappointing. My knee would only move by invoking a serious reaction in my right hand but at least it would move. I should know better than to get all depressed but any time that I get a muscle working and then it stops again, as so often happens, I get downhearted.

Some people still don't know how to take me. They can clam up as one friend did when he came to collect me and drive me home from the Unit. He wouldn't look me in the eye and didn't know what to say, even though he was usually so talkative. 'I won't bite. You can look at me you know,' I said cruelly. He muttered some apologies and proceeded to meet my gaze more.

Those that don't know me see the chair first and foremost and they see me as an extension of the chair. They don't know how to relate to me and act kind of nervous. My friends see me first and they don't even notice the chair. So with a stranger it's hard to avoid talking about your disability and how it affects you. 'How did you get to be in a wheelchair?' they will ask. And usually I will answer just to avoid appearing rude. With my friends, well, they're already bored with hearing it and would prefer to talk about something else.

What is much more frustrating are those who pretend I'm not there. It doesn't happen often, but when it does I hate this chair and myself. Admittedly it's not my close friends that do this. It's more my acquaintances, those who I just know to say 'hi' to.

They look at you yet through you, they look into your eye but then find something much more interesting on your left shoulder. Then they turn away as if they never saw a thing. What kind of culture is it that breeds these cripple-o-phobes?

Alison had her accident on the same day as I, Friday the 13th February. Knowing this brought us closer together for a few moments, as if the common bond of a shared accident date actually meant something. But alas, no sooner had it become a fact, something tangible, than it was gone, a flight of fancy, along with each of the nurse's names and her memory of just about everything else.

When Celia and I split we hadn't been sharing a bed for perhaps four months because I was in various hospitals and institutions. So continuing in that way was by far the easier part. It was her support that I missed. I once said that she was my lover, my mother and my sister all rolled into one. It seemed as though I were devoid of anyone to talk to, to cry with, to laugh with, for there often are hilarious moments in these situations, to share my experience with. But my friends are being astounding, really rallying round. Not once have I got the ambulance to or from Clatterbridge because there is always Noel Craine or Adam Wainwright or Charlie Diamond, and many more there to take me.

I've been told that I haven't to walk. Tricia said that if I do it would create a wrong pattern of movement which, if I'm not careful, will persist and keep on persisting. 'So you have to be patient as well as determined.'

She thought intensely for a moment. 'A conflict of interest immediately presents itself. How is it possible to be patient and determined at the same time?'

I sat on the bench, just wearing shorts after one of our physio sessions and quietly asked, How?

'Find the determination and anything is possible.'

I replied irritably, 'But it's counter-intuitive to sit in a chair when you know you can walk, of sorts. If I had a serious leg injury you would get me standing on it as soon as you thought

safe. But I guess it's different with a brain injury. Are you going to keep me in the chair until you think I have a normal pattern of walking, which could be years from now?'

'You cannot bend your knee, you see.' I took a step and immediately saw. 'So you are hitching up at your hip. This is a bad pattern of movement and you do not want the leg to stay like that for the rest of your life. Do you?' I agreed I did not. 'The injured brain recognises the motor patterns that are most familiar and routes them from another place in the brain. There is a term for it, neuro-plasticity. The brain is a much more plastic organ than we previously thought. It is capable of adapting and learning as your environment changes.'

'So you're telling me that parts of the brain can learn how to do the job of the previous and now injured part.'

'That's exactly what I'm saying.'

15th June

Alison says I look twenty-one. She is seventeen and has a traumatic brain injury, so I don't think I can trust her judgement. But lots of people say how well I'm looking. Either they were expecting me to look horrific and were surprised to see that I wasn't or the stone in weight I've put on suits me. Thing is, I feel completely healthy, the healthiest I've felt in years. My injury was five months ago and, apart from being in this chair, I feel fierce. Ready to face the outside world square on.

When I asked Fiona Parry, my neuro-psychologist, whether it was worth putting off my grief about the disintegration of my relationship until I had healed, she said it was good to talk out my problems. But I have decided that I shouldn't let a bit of negativity enter my head. I've just got to keep thinking positive if I'm going to get through this. That's difficult when you've had a bad accident and you're in a wheelchair and you've split up with your girlfriend and everything is going pear-shaped. But it is possible.

But I will get through this. I may not be climbing again but I have a philosophical approach and know that I've had just about all the experiences that a climber could wish for. On mile high walls I have been, dangling my feet over the edge of a portaledge, shouting 'You can't reach me up here!' Feeling the adrenaline pumping on high dizzy sea cliffs. Walking in up vast deserted glaciers in the Arctic. On *the* perfect boulder, when the friction is just right, and I've pulled the move off and done the problem I've been trying for ages. Or watching the sun go down in the Welsh hills, my favourite place, turning all red under a cloudscape the likes of which you've never seen.

I'll always need a climbing replacement, something that gives me that norepinephrine buzz. Writing can replace that, and it helps to keep me sane here in rehab, helps me make what sense there is of it all. But I'll need action, as well, if I'm to get that adrenaline fix. I'm talking flying or diving or snowy mountaineering.

My scapula started moving this week. Jill Chappel, my other physiotherapist, lifted my shoulder blade and, digging under it with her fingers, helped it along with lots of massage. Jill is my senior therapist at the minute. She has short black hair and cold hands, a soft Yorkshire accent, being from Ilkley, and dark eyes. When I came back today, Jill said I was walking better than ever, probably due to my hamstrings beginning to kick in for the first time in five months. OK, so that's only postural, but I'm sure it helps with my walking also.

I also removed the hemi-cuff because there was increased tone in my deltoid. I had been wearing this or other slings to stop my shoulder dislocating ever since week one. The shoulder joint is the weakest joint in the body. A soft tissue joint, it is held together only by tendons and ligaments and a capsule of sinovial fluid. The hemi-cuff is a type of sling forming a tube for the upper arm to go inside. It is then passed under the pit of the opposite arm, the tape forming a cross pattern on your back. I was the only person that the therapists knew of who could put one on myself using a

Fastex buckle thrown from behind over the shoulder. The joint feels very vulnerable now though, like it's swinging around on a flimsy bunch of ligaments, which is exactly what it is doing.

There's always something fresh about the start of the week. Everybody asks, 'How was your weekend?' and patients roll in throughout the day. There are the ambulance workers, one driver and one aid, who wheel James in, even though he can walk with a rollater. They wear white shirts and grey trousers. Sometimes there are new patients and you have to treat them warily in case they fly off the handle with you. And then, of course, there's the MS folks in for respite care while their families take a break in Benidorm or Majorca.

This diary is transcribed from a Dictaphone which I always keep with me. The times when I've forgotten to take it to the day room or, more serious, home at weekends, I don't have much time before I have a complete memory departure. I can hold a fact in my head for perhaps a minute before I lose it utterly. If it comes back to me the feeling is as though from a past life, so my life right now is a constant string of déjà vus. But this is improving at a slow rate.

Meals always consist of something in a milky sloppy cheesy sauce if you are vegetarian. Milky slop and two tasteless overboiled veg. Tapioca or rice pudding, more milky slop, follows this again. This is bad news if you are allergic to dairy products as I tend to be. But if we are lucky we get cheese and biscuits or sponge and custard.

My favourite part of the day is physiotherapy. Where else to you get stripped to your underpants and massaged by two beautiful women? I would say that a high percentage of the guys on the unit have a thing about the therapists. I guess it's classic to fall in love with your physio, especially if they're all as wonderful and caring as our therapists are. Jill and Tricia, at the moment, have me weight-bearing through my arm, though they have to be very careful not to damage my shoulder. They also have me walking up and down the physio gym but I'm having trouble with my

knee hyper-extending. The gym is about sixteen feet in length and I can walk it four times. However, this damn knee keeps flicking back painfully.

15th June

The domestics, or stewardesses as they are now known, wearing pink dresses, are busying themselves around the ward this morning, sweeping, mopping and polishing the floor with something that looks like a vacuum cleaner. They come while we're still sleeping and give us fresh water jugs and when we wake up they bring us tea in bed. They serve us kak for dinner and kak for tea. But that's not their fault. It's the thin guy with the moustache sporting a heavily starched blue cotton suit pushing the insulated box. I've come to hate that moment when he pushes the blue box in through the sliding door.

17th June

The World Cup's been on for a week and each night we've crowded round the box watching it. Cheering on 'our boys'. Except those guys who've got money on some other country like the Netherlands or Argentina in the prize draw the Unit has set up.

I'm going through buying a house at the moment and there's talk of a council grant to put in a lift. If that happens I will own the only house in Llanberis with a lift shaft, a great big Tardis in the corner of the room. I could open it to the public. 'Roll up, roll up, come and ride the incredible, ascending lift.' Even though I can walk up stairs perfectly easily (kind of) the OTs, social worker and local council still have to play it safe and look on the most pessimistic side.

At first, when I'd just had my accident, I felt uneasy around

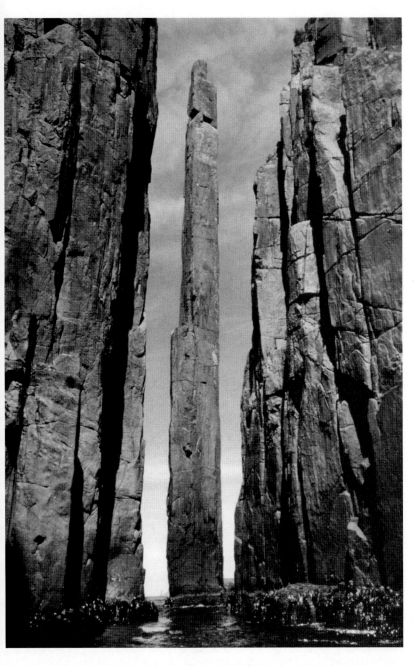

The Totem Pole.

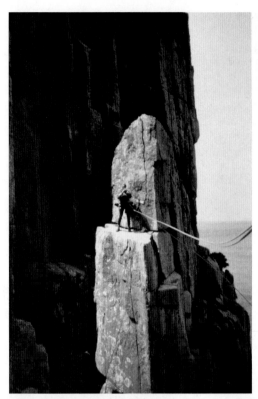

(Left) 'It seemed rather strange to be on the summit first and then to descend from it only to climb up to it again.'

(Below) 'Suddenly I was two hundred feet above a thrashing swell not knowing to what the other end of the rope was attached.'

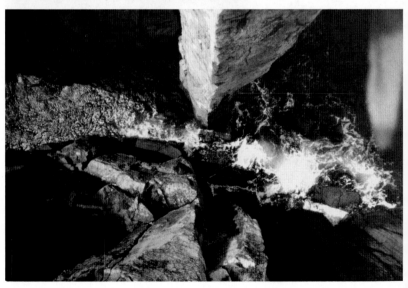

Some of the Tasmanian nursing team and therapists.
Back row, l-r: Kylie Burns, James Lloyd, Ian Watson,
Wendy Burton; *middle row, l-r:* Melissa Brodribb,
Moy Moy Pierce, Alanna McKay, Jenny Healy;
bottom row, l-r: Kris Clauson, Jane Boucher and Me.

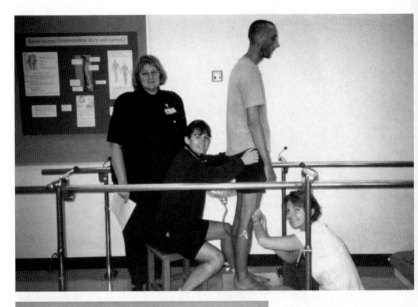

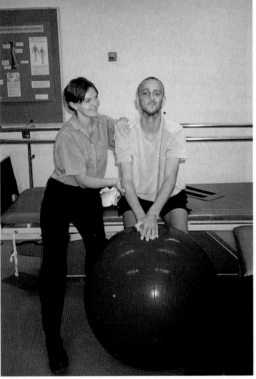

(Above) Physiotherapy with Dawn Lewis and Nicola Mackinnon. My speech therapist Marge Conroy standing by.

(Left) 'That smile seemed a grotesque caricature of my smile.' In the gym with physiotherapist Nicola Mackinnon.

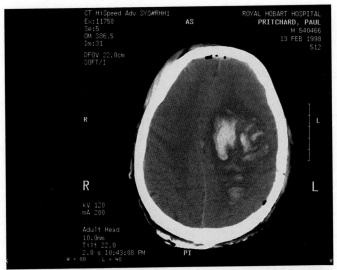

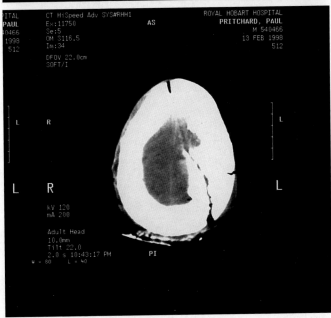

'The CT scans of my head from Tasmania looked
shocking. There was a fuzzy white patch virtually covering
the whole of the left hemisphere of my brain. The top scan
shows the midline shift of the brain and the bottom one
shows the compound fracture of the skull.

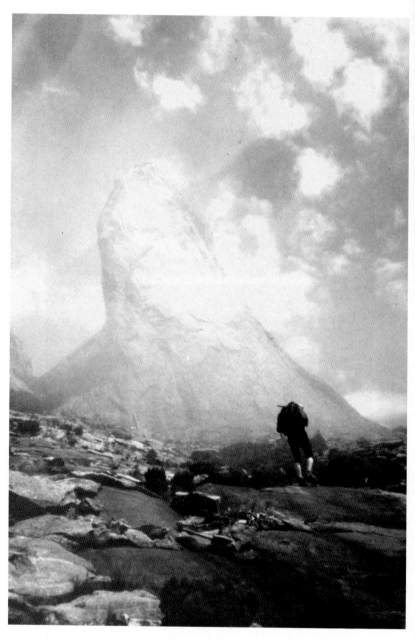

Celia approaching Nameless Peak. 'It needed a bolt or bravery to bypass a particularly treacherous wall, and we had neither.' January 1998.

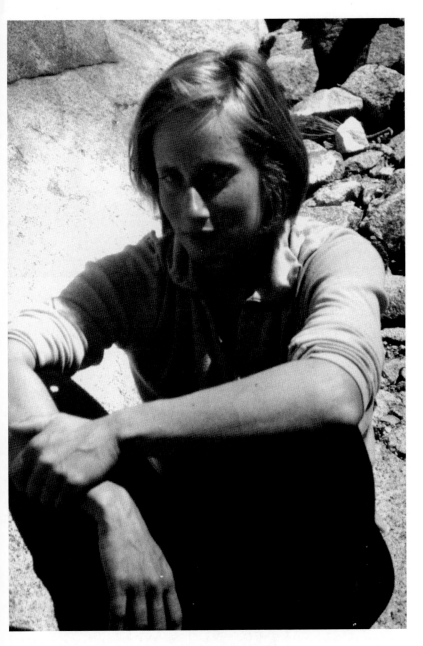

Celia Bull, January 1998.

'I quickly attempted to climb the South Summit of Victoria Peak without a rope, solo. I looked down to find a foothold and suddenly became aware of the 3000 foot chasm below my feet.' January 1998.

'I had been a full timer, living for the rock.' Bouldering at Tapovan in the Indian Himalaya. August 1990.

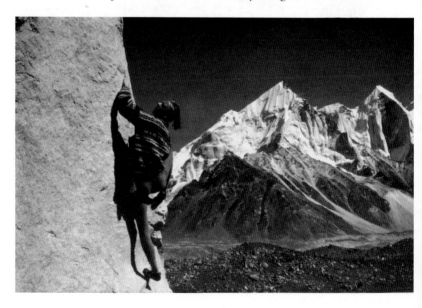

people in chairs. It was like I didn't see myself as one of them. In the beginning I was still shocked and it was like I wasn't in a wheelchair and they were, but of course I was in a wheelchair. I think I'm better equipped now to take people as I see them, take them at face value, instead of thinking they've got the plague or something. Everybody should be made to visit one of these places, if only to see just how lucky they really are. There would be a lot less people feeling sorry for themselves and wasting their lives away. It would put people's petty problems into perspective.

At 7.45 of a morning the day staff arrive to relieve the night nurses. There's usually three night staff and they don't have a moment's rest, so they say. We, the patients, have no way of telling, being tucked up, fast asleep throughout the night. They don't stop changing wet, soiled sheets the whole night long, and pacifying patients' nightmares. There are a lot of them, screaming and wailing in the dead of night.

Vera Simpson, the ward sister, tells of the night's fun and games to the day staff, how so and so fell out of bed and how such and such got the fear and wailed, and from then on had a restless night. In the dead of night they watch over you with their comforting eyes, and when you do wake up you can often hear the friendly click-click-click of their heels retreating up the corridor.

Seventeen-year-old Chris acts every bit his age as he swaggers about. He's from a very deprived family and was 'pissed and whizzing' when he fell over a balcony onto concrete stairs. He's had numerous dads and was brought up in a block of flats on the Ford estate, one of the more notorious in Birkenhead. He has to get his mother to read the letters of admittance for him as he mucks about. 'My family never gave a fuck about me, so why should I fucking give a fuck about anything,' moans Chris after getting caught smoking dope in the toilets on the Unit. The neuro-psychologist is despairing of him and couldn't even wake him up for his session once. If you show no interest in helping yourself, there is less will for the therapists to help you.

115

21st June

Andy Cave's stag do, Midsummer's Day
In my 'sedan chair' I was carried to Earl Crag, before the bash, over muddy puddles and dangerous crevasses. I was then plonked unceremoniously on a flat rock while all the lads went bouldering. I smoked a fat fag that one of the boys has rolled me earlier and chilled out, enjoying the closing of the day. 'Looking like Ray Charles' with my shades on, someone mentioned.

We had booked rooms in the Railway Inn near Ingleton, but when I turned up in my chair the proprietor suddenly had a change of mind and told us there was no room at the inn, thereby turfing us out into the cold night and leaving us to look elsewhere. My blood boiled. How could he treat a cripple like this?

'The truth is that we aren't insured for wheelchairs,' he said apologetically. So I gave a demonstration of how mobile I was out of the chair. But 'A wheelchair's a wheelchair. It's fire regulations,' he muttered. The whole affair seemed to be discriminatory to me. But it turned out that I saved myself twenty quid and had a better night's kip in Dave Barton's van in the car park of the Hill Inn.

There was much drunken revelry. I forewent my anti-convulsants for the weekend because they make me feel extra drunk off a small amount of alcohol and extra hungover. I don't often do this, as getting pissed makes you more susceptible to fits, but I thought that just this once I'd risk it.

Climbers don't tend to tie stag night victims naked to lamp posts on the other side of the country or leave them down a back alley with their trousers round their ankles and a condom hanging out of their rectum. We did nothing horrible to Andy, we all got on with having a good time. We also tend to have women along at these stag do's, so they're not actually an all male bastion at all. Everyone's welcome.

I remember being wheeled down a steep muddy bank in the pitch darkness by a totally inebriated Mark Wright, and him losing

his footing in his smooth-soled shoes, so that he was skiing, if you like, being dragged behind me. There was the flat-sided wall of a panel van down on the car park below us, but just in time he found his feet again and brought us under control.

The morning after we went en masse for a greasy fry up in Ingleton and left for the Bridestones, a collection of truly outrageous gritstone boulders of all shapes and sizes on the very top of a moor. There's one that's the exact shape of an egg that you can get rocking and one in the shape of a cow's horns. I had to be manhandled over fences and carried across tussock mogul fields. The groom-to-be fell right at the top of the Horror Arête and sprained his ankle. We all had visions of him walking to the altar in a pot leg.

After a complete traverse of Bridestones Moor the wheels of my chair were falling off. On the Monday I had to get it repaired by Nina, one of my physios, who laughed it off. She was less chuffed the time I went beach racing and, apart from the wheels dropping off, she had to clean the whole thing of sand.

22nd–26th June

The Bobath Course

I've never seen so many stroke patients in one place. It was great to witness. The patients, as long as they could walk, were in all stages of recovery. There were those that were pivoting around on a pin straight leg with their hand permanently clawing their chest. And there were those who were walking all right, apart from relying on a stick. First I had to present myself before about twenty students and show them what I could do. I walked, of sorts, for ten yards, turned, and came back to my seat. The students all made notes on my condition whilst Sharon, the chief, asked them questions that I couldn't understand. They answered in neuro-rehab speak that I couldn't understand either, all central key points and tonic, clonic whatever.

The patients then filtered into the gym and took their positions at numerous benches. Each had two physiotherapists by their side. Smithy and I were the only patients from the Neuro Rehab and had to have an ambulance booked every morning when it was time to go over to the Stroke Unit. The ambulance drivers were jealous of us being massaged by so many women and they, hilariously, pretended that their backs or shoulders were hurting them.

It was all senior physiotherapists on this course, so the quality of treatment we got as guinea pigs was far superior to any normal physio session. Plus you got two of them. I was assigned Lesley and Hanna to take me on a tour of the body, stopping at every major destination. They wasted no time targeting my hip flexor muscles as the key weak point on which to base further work.

I was totally tensing my stomach muscles whenever I wanted to kick the leg forwards. This pattern is a poor one and so I had to concentrate on moving my leg forwards without tensing my abdomen to hell. This the two women achieved through the week by a technique called prone standing. Prone standing is when you lie your top half on an electric bench, which is raised just to the height of your waist, thereby relaxing your abdomen. This leaves your hip flexor free to work without the abs kicking in. There was much more stuff than this done, but my Dictaphone was threatening to give up the ghost. Before it did I managed to get down a bit of the history of approaches to neurological rehabilitation.

Before world war two hemiplegics and other brain-injured patients would just be left to fester in bed. This led to thousands of people suffering with severe spasticity. In the early 'forties what was hailed as a great advance came about. Treatment was aimed at improving functional abilities by using the unaffected side of the hemiplegic only or concentrating on the patient's remaining abilities. This was achieved by putting a tripod stick in the patient's good hand. The goal of this treatment was to attain 'a safe but not a normal mode of travel'.

This treatment had its limitations from a functional and from an aesthetic point of view. Lots of activities are impossible without the use of both hands – opening a tin, sliced bread, grating cheese, chopping vegetables, placing protection with one hand whilst hanging onto the rock face with the other. And, of course, running, playing tennis, rock climbing and mountaineering would be impossible whilst trailing a gammy leg. The use of a tripod is now seen to be very short-sighted and, though it will aid walking in the short term, in the long term it will instil an abnormal gait pattern and so encourage spasticity.

In the late 'fifties massive steps were taken in the approaches to the rehabilitation of brain-injured patients. New physiological concepts began to be developed and in the early 'sixties Bertie Bobath was to the fore of these. Originally looking for a treatment for cerebral palsied children, she made use of the facilitation of 'normal postural reflex activity'. This isn't as complicated as it sounds and basically means the trunk providing a base for normal movement and the limbs following.

Once the therapist gets the 'central key point', the trunk, as a stable base from which to work the rest should, but doesn't always, fall into line. It depends on the amount of damage inflicted to the brain. The other key points are the proximal, the limbs. In the rehabilitation of hemiplegics lots of emphasis is placed on the correct alignment of the key points of a particular postural set, be it sitting or standing. The relief of spasticity, plenty of stretching, is an important part of therapy also.

Bertie Bobath trained at the Berlin school for gymnastics study-ing the analysis of movement. It was the 1930s and Nazism was getting its ugly claws into Germany. In 1938 she fled Germany for London where she married Karel Bobath, himself an eminent physiologist who was born in Eastern Europe. They worked together to develop a new form of physiotherapy which was, unfortunately, ahead of the physiological thinking of the time. Their followers had difficulty finding acceptance amongst the staid proponents of the old school. Eventually, though, they found

credibility and now their art, for physiotherapy is an art, is practised in all the corners of the world.

Obviously some techniques have been superseded and other disciplines, such as the Peto technique from Hungary, have come about. Ways of thinking have progressed enormously but the name Bobath is still well respected. In the early 'nineties, when in old age, the couple passed away quietly together.

28th June

I glide silently through corridors in my wheelchair with only the tap-tap of my one foot, which propels me.

A scream. I can tell it's Friday morning by that scream. Kevin is taking his weekly shower before the ambulance comes to take him home. Being scrubbed down by nurses in the most intimate places, his shouts go from a low rumble to a high-pitched squeal in one loud swear. He appears, looking smart in his new blue shell suit, with his ginger hair all washed and fluffy.

In the courtyard, with the warmth of the sun on my face, I close my eyes and feel the orange heat on my lids. It takes me back to a million places all at once, sitting on some dirty hotel's roof in Delhi, hanging belayed to rivets in the midnight sun on Mount Asgard, the brutal heat on the Baltoro Glacier in Pakistan, or simply to my beloved hills, lying in the grass where I can sniff its sweet scent below a crag in Wales.

30th June

The ambulance came just as Celia was dyeing my hair (pillar box red). Very embarrassing. I had to hold up the two ambulance men and two other patients while I rinsed it out. We were going to Walton for an ECG. I met this very pleasant bald-headed technician who explained everything that he was doing very well. He

put twenty monitors equidistant around my head with a sodium chloride gel to get rid of dead skin and two heart-rate monitors on the backs of my wrists. I asked him to turn the computer screen around so that I could see it also. With my eyes open the screen resembled the numerous false horizons you see on hazy days in the mountains, all spikes and deep valleys. If I shut them and open them quickly the input into my brain looked like the Himalaya through the screen. I came back on my own with the ambulance men and, there not being old people to offend, they got off on listening to some rowdy American comedian called Bill Hicks.

England was put out of the World Cup today on a penalty shoot out. They were down to ten men as Beckham was sent off for tapping an Argentinian player on the back of the leg with his boot. It was two goals all when Shearer fouled the goalkeeper just as Leseax put it in the back of the net. The goal was disallowed and so with all the time out it went to thirty minutes' extra time and the golden goal ruling. England put up an incredible fight, down to ten men, and the final whistle blew. They lost on penalties.

My last accident got my mum and my dad talking, on the telephone, for the first time since their marriage break-up seventeen years ago. Usually every negative event carries something positive along with it. This accident was no different.

I'd had a fall on Creagh Meaghaidh, ice climbing in winter. Two hundred feet I went, on to a poor ice screw, crampons and axes flailing as I cartwheeled backwards through clean air. I was working as a guide at the time and felt a guilt I had never experienced before or since. I had become over-ambitious, which is dodgy when you're with your climbing partner, never mind people who are paying you to work for them.

My clients Robert and Nick were excellent though. Robert was a doctor and so gave me an on the spot diagnosis. He said that I'd broken my back and that my difficulty breathing was probably due to a broken sternum. Nick Kikus, a very experienced guide working for the same company as myself, happened to be following

me up the route. He had two clients also, so had to lower the five of us down the gully for 1000 feet. The gully bed wrecked my back with every undulation, and when I was lowered down the numerous small cliffs the pain was so intense I feared I was going to pass out. My vertebrae were like a pig iron chain being pulled over a right-angled edge. This went on rope-length after rope-length. Nick tied the ropes end to end to lower us twice as quickly.

We hit the avalanche fan and I couldn't untie the knot. I had debilitating pain in my back and chest. I teetered around, my back feeling hinged, and walked down to a flat spot, were the helicopter would be able to pick me up. I then lay down flat on my back with my legs bent and cried. Nick's Dutch clients didn't know what to make of me and kept their distance.

The guys went in search of the mountain rescue box and after some trouble, due to map-reading, they found it. I soon had blankets piled on top of me and a surgical collar on my neck. Then the clients slogged back the six miles through the snow to call out the rescue team from some bar or other at dusk, while I lay there waiting to hear the throbbing of rotor blades.

I asked Nick if he had ever had any similar experiences, treading very carefully, because I knew that he had but never spoke about it. He started to talk slowly and deliberately about how his good friend and climbing partner had fallen near the top of a Himalayan peak. 'There was only the two of us that time, going fast and light, alpine-style. He smashed his head up and I had to lower him 3000 feet to the bottom of the mountain.' His friend was dead when they reached the foot of the face.

I remember saying something about being scared to die, not because of the pain of it. I knew it wasn't painful. But because I was sure there was nothing afterwards. No life after death. I felt I had proved that to myself in my earlier drowning incident on Wen Zawn.

The helicopter's whirring blades cut through the night air as it approached. I remember seeing the spot lights, two or three of

them sweeping the snow, and thinking this is just like *Close Encounters of the Third Kind*, when the alien space craft lands on Devil's Tower. Out climbed strange faces that were ruthlessly efficient. I remember extreme discomfort as one of them fitted the surgical collar more professionally to my neck.

The Lochaber rescue team loaded me up; I knew one of them and had a brief chat with him before the oxygen mask was planted over my nose and mouth. The ride was draughty but before I knew it we had landed at Fort William in Safeway's car park. There was no room at the hospital for a helipad so we were transferred into an ambulance to be driven the remaining hundred yards.

In Accident and Emergency I was dazzled by the light and lay there not caring that a strapping female nurse was snipping my clothes off me with scissors – my Gore-Tex jacket and salopettes, my Windstopper jacket and salopettes and finally my thermal underwear top and bottoms. I lay there naked apart from my neck brace until the warm towels came and covered me. I was so cold that they could have been at room temperature, but they still felt hot to me. Then it was a trolley ride with two orderlies in blue trousers and white shirts down to the x-ray department. The x-rays revealed four broken vertebrae, a broken sternum and a fractured right orbit. I had a haemorrhaged right eyeball into the bargain as well, which was a deep red.

If that accident was the first time my mum and dad had talked, this most recent accident was the first time I had seen my parents together for eighteen years. I studied them for signs of affection but, apart from a peck on the cheek, they just behaved like good friends. I couldn't believe that two people so different could find themselves together and married for twenty-four years.

It was the first time I'd seen my dad since the accident and the only time he's been to the Rehab Unit or the hospital. He felt uncomfortable with the Unit and my friends, whom he hadn't before met. Celia's sister, Elaine, was there and my mother happened to mention my painted toenails. Now my dad is a working-

class man in every respect, apart from his doctrine of not working if you can help it, with very traditional views. He started on a rant as only my dad can. 'A man's got to dress like a man,' and 'Only jungle bunnies wear that stuff on their nails.' I cringed with embarrassment in front of Elaine. My mum had heard it all before. That is essentially why she divorced him.

I knew from past experience that to challenge him would be a bad idea and that there would be no knowing what he could do then – rant and rave in front of the other patients on the ward or feign a heart attack, as he'd once done with my brother, or end up threatening a nurse, which was always a possibility.

Don't get me wrong though, he was a great dad, who had plenty of time for us kids. We played footie every evening and he would take us on fishing holidays and weekends, too. He would take my brother and me shooting also, shotguns at the ready as we stalked down dawn meadows hunting rabbits or anything that moved.

He took us to Spain all through the winter months which is how we missed most of our education. We would just go swimming in the Mediterranean or messing around in half-built apartment blocks. My dad made enough money as a property repairer (that's what he liked to be known as) in the summer to keep us comfortably off in Spain for the winter. He kept us away from school on hot summer days and that suited us down to the ground. The final straw for my mum was when he went to Spain for four months, taking David with him, and didn't tell my mother anything about it. She didn't want to go because she wanted at least some semblance of an education for my sister Tracey and me. It was too late for David, he was already sixteen and in line for the building trade – 'Bugger O levels.'

4th July

Simon and Jane's wedding
Ali picked me up from my mum's house and we hurtled up the M6, knowing that we were late. We arrived at Great Salkeld church after the service had started. You can just slip in unnoticed if you are on foot but in a wheelchair, not so. When the door opened the commotion created by entering the church meant all eyes were on us. Once all eyes were on us then it was time to roll over the door curtain in the chair and rip it down. A very embarrassing entry.

I stood up to sing hymns and outside after the service, there were lots of folk I hadn't seen for ages who wanted, naturally, to know how I was doing and all about the accident. This gets a bit tiresome, but they can't help it. It's not their fault. It's their only point of reference, the only thing they know what to talk about with you. Being in hospital, you have been out of the scene so long.

I can now sympathise with Simon Yates who works as a guide, climbing mountains in the Himalaya and the former Soviet Union. He's away from home for perhaps seven months of the year and complains about how no one talks to him any more about anything other than his work. They perceive it to be fascinating and can only dream of standing on his summits. But he would much rather be in his garden and spend his time talking about vegetables.

5th July

I dreamt that I stretched my fingers out last night, I just straightened them, that was it, and it was so real that I don't know whether it happened or not. I woke myself up in the excitement of it all, pulled my hand from under the sheet and tried desperately to repeat the movement. I strained and strained but all the straining

125

seemed to be coming from my abdominal muscles. It's like that, you use what muscles you can use and then suddenly, one day, you remember how to use the appropriate muscles and *voilà*. You're away. Ever so weakly away, but there's movement nevertheless. And you might again forget how to use the limb, but you can be confident that you'll remember how it works once more.

6th July

Paper clip as opposed to safety pin, spice jar, cotton bobbin, ball bearing as opposed to marble, bottle washer, nut and bolt, clothes peg, wooden ball, table tennis ball, big and small padlock, Yale key and mortice lock, darts case and all other manner of items. Today in the occupational therapy I had to identify numerous objects by touch with my eyes closed. This is easier said than done. When you can't manipulate an object in your hand, run it between your fingers, check out whether it's got any moving parts, and your hand is totally numb, but is getting less so by the day. I have to have Lise do the hand manipulating for me. Lise is Norwegian, from a little village near Stavanger and her accent is charming, in a high-pitched sort of way. My hand's getting more sensation in it all the time.

Last night I wheeled up to Andrew's table for dinner and asked him how he was. He answered, 'I'd be OK if you'd stop banging my table.' And then went into a repetitive rant. 'I would be if you'd stop banging my table. I would be if you stop banging my table. I would be if you stopped banging my table. I would be if you stop. I would be if you. I would be. I would be.'

And he was off into his horse race commentator mode again. You felt extremely sorry for him but even the nurses can't suppress a giggle when he kicks off, faster and faster, more and more garbled.

7th July

I can hear him screaming in a single ward they keep for the disturbed, whenever the nurses go round to give the guy with the bush baby eyes his injections. His screams echo down the corridor in the darkness as if he's being tortured. He was being wheeled about today and he told me that you must never give up fighting and that you will get there in the end.

The doctors told him he would never walk again and he says he told them 'politely to eff off, politely where to stick it.' He was a determined sort who kept saying splendid. He had been in the army in Northern Ireland and though he kept on repeating himself he was a friendly lad. 'I'm getting there slowly but surely' he would persistently declare. 'I'm not bragging or anythin' but I used to be a right nutter.' He will be squirming in agony saying that his leg is in a lot of pain and the nurses, who know best, will just leave him be. I will have to go back to my writing because it is unbearable to see a man in such pain, even if it is in his imagination. As he is wheeled back down the corridor I can hear him telling the nurse the story of how six blokes set about him with baseball bats.

His wrist was bent forwards, set permanently at a right angle. Both the tops of his feet were in line with his shinbones. But, far worse than these injuries, he had a shocking memory. You can do creative things, like write a book, if your brain is functioning vaguely correctly but if it isn't and you can't even see the problem, that is where the really sad cases of the neuro scene are. Imagine not being able to motivate yourself to get better because you're not even aware that anything is the matter with you.

But it isn't all sadness. There is some degree of hope in nearly all these cases. (I say nearly all because there isn't such a luxury for MS patients, only remission.) But I have seen completely mangled guys with a mental age of seven, incontinent, wheelchair-bound and completely disinhibited, come through here. And when

they leave they're in a much better state. Not totally recovered but far healthier.

10th July

I had a new patient in the bed opposite who was very confused and displaced. He had a head as bald as a cue ball and those glasses that make your eyes seem way bigger than they actually are. He kept shouting to an imaginary dog called Sam in the middle of the night. 'Get 'em, Sam. Who's there, Sam?' Cue Ball's bed had to be wheeled out into the day room at 5.30 a.m. because he kept us awake all night. He decided to perform a strip in the day room yesterday evening. Off came his shirt, his shoes, then his tracky bottoms and, finally, his underpants. The nurses fought with him but it was to no avail. Short of restraining him by tying his arms to the arms of the chair, which I'm sure the social worker would have a problem with, there was nothing they could do. So he was strapped in to the padded wheelchair, as he is always, and put up quite a struggle.

Because Smithy, young Chris and I all had head injuries it would take only the slightest thing to set us off hysterically laughing. I awoke from a deep sleep to see the Cue Ball naked on the floor. He'd somehow dismantled his cot sides and crawled out, head- or feet-first, I don't know, and was lying like an overturned beetle, legs and arms flailing. The others woke up too, after some prompting, and we got the giggles just like you do when you're kids. I rang the bell and the nurse came in bewildered, saying, 'He must have a degree in engineering or a tool kit in his bed to unbolt that cot side.'

I moved my arm today about eight inches in abduction and there was activity in my tricep, the first we've seen. It's wild stuff this neuro-plasticity thing. After three months of Lise constantly facilitating my arm, polishing the table or picking up cones and placing them down again, or dropping them, I now have move-

ment. Not much, admittedly, but where there's life, that activity can only get stronger. That has been my constant motto.

13th July

I went to a rave at the weekend. I had dinner with Charlie and then we went partying. We went up this winding track to a dam and there were a hundred cars lining the road, and two home-made marquees. There were generators and cables and fire dancers at 3 a.m. I was carried and pushed over open moorland to the marquee were I started to dance. There were some fantastic dancers there, and then there was me. Using only one arm to dance with I got some very strange looks, especially off the policemen who came to have a whip round for the farmer whose land we were on. 'How did the bloke in the wheelchair get up here?' I heard one of them say.

My legs started to shake as I danced the night away. I was moving my hips, too. My right arm was swinging limp and I was on rigid legs, though I did manage to bend them, slightly, as I got into the groove. It was like my legs were trying to dance without me doing anything about it. They were shaking roughly in time to the throbbing beat of the music as if they had some innate sense of rhythm. The heels were lifting uncontrollably and I would have to sit down for a spell in my wheelchair, which I had strategically positioned right behind me.

I watched the murky dawning in the pissing rain and was furiously happy to be alive. We drove back home, my head out of the car window, soaking up the beginning of the day and listening to 'Whole Lotta Love' by Lead Zeppelin, played loud.

When I got back to the Unit on Monday morning my body was in tatters. Associated reactions all over the place. My arm was bent in a permanent right angle, my hand was clenched in a fist, my wrist was flexed, very spastic, and the leg kept standing on tiptoe. I felt like Victor Hugo's Hunchback. In one evening I had

ruined all the good work that Jill and Tricia and Gulhan, the physiotherapists, had done.

There is lots of frivolity on the ward today, nurses hassling each other in a friendly way, gossiping intensely. Brenda's the main culprit, and Pauline's a fairly keen gossip as well. The whole of the UK is divided into Scousers and Woolly Backs. Paul's the only real Scouser here; the rest of us are Woolly Backs. That is the not too affectionate term for anyone outside Liverpool. Jenny, a pencil-thin kick-boxer who won her first fight against a woman who was training for England, threw water over Liz. Liz, who must be three times the size of Jenny, meant to retaliate but just as she'd filled up the water jug again and Jenny was hiding behind a curtain with only her face poking out, Vera, the ward manager, appeared and thwarted her attempt.

You have to laugh in a place like this; otherwise you'd go off your trolley. It seems cruel to laugh at the patients but you have to see the humour in it and anyway I am a patient. I am one of them. How can I laugh at myself if I can't laugh at the others around me? The nurses have a good laugh at the patients' expense, too, but they are laughing with them, not at them.

I am now approaching the six-month watershed in my recovery. The first six months are the time when the docs say the most intense period of recovery will happen. After that it will be a slow uphill struggle for the next two and a half years and then it should plateau out for good. There will be little plateaus all through my recovery and I have already experienced them from time to time. When seemingly nothing happens for three weeks to a month you start to get worried off your head and you start to think that that's it, you won't get any better. Then suddenly, out of nowhere, some movement happens and you get all excited for a few days. In fact, it is a really exciting time for me at this moment. It's not every day you get the use of a limb.

So I'm willing my fingers like mad to get them working, but they always end up going into flexion instead of extension. Flexion is the movement I've already got; it's the stretch and the extension

I need. It's the same with my elbow and wrist. I can pull them inwards, like I'm curling, but there's no straightening to be done.

Lise is working on soothing my over-tight muscles, teaching them how to relax. If my tendons and muscles are too tensed in my flexors, my bicep and forearm, she asks how can my extensor muscles stand a chance, fighting against that?

15th July

The nurses are preparing for the annual barbecue. Shifting rubbish that has been accumulating over the year, rotting tables and parasols that have woodlice under them. The primary nurse is filling up the pond and the orderlies are sweeping the patio and throwing bed sheets over the tables to make them look better. A completely spherical fellow lit the barbecue with lighter fuel.

When 7.30 arrived it was out with the tinnies and in with the feeding frenzy. Kids played football, there was a Brazilian team and a French team, they also fished for ducks in the pond, played the tombola and ate lots. The adults got steadily pissed and there was a certain disregard for the drugs they were on by the nurses. Smithy bought Kevin a pint of ale, which he didn't touch. There were wheelchairs everywhere, a right traffic jam at times. I couldn't get to the hatch where the beer was coming from and had to ask our ward manager's daughter to bring it to me.

Smithy's daughter excelled at the tombola and, amidst all the cuddly toys and porcelain ornaments, she won three bottles of booze for us. Smithy made short work of the whisky and started telling stories of how when he had the catheter removed the first piss he had was like 'the longest cum I've ever done'. He also told me the story about when 'the boys' came into hospital 'with a tin of Special Brew and a pipe packed full of grass'. It was only a month after his car smash. So he lay there drinking his beer through a straw and smoking his pipe. The smoke quickly filled the ward and just as quickly 'the boys' were ushered out of the hospital and

told not to come back. He looked like Charlie Chaplin with his stick as he walked down the corridor, drunk, later that night. I stayed up after all the other patients went to bed and had a crack with four nurses who told me all sorts of gossip. The only bit that comes to mind is about one very large nurse who must weigh twenty stones. She is the kindest and most selfless nurse on the unit and they assured me she ballet dances in a pink tutu. Aren't you supposed to believe everything a nurse tells you?

18th July

At the weekend I went to a house party. I made an entrance on my feet. I walked up the steps to the front door, opened it, and walked through. There were about ten good friends there and two strangers. One stranger had a skinhead with dreadlocks hanging off the back and homemade tattoos all the way up his arms – things like 'I HATE MY MUM' on his forearm and 'H-A-T-E' and 'H-A-T-E' on each knuckle. He had a hook-nose, a stubbly sharp chin and the look of an archetypal escaped psychiatric patient.

This evil-looking character grabbed my wheelchair and placed it down. This was a kindly enough action and he wasn't to know any different when he started pulling my right arm to guide me into it, but my arm was cripplingly painful and, in his lashed up state, he pulled it too hard. I gave out a cry and shouted, 'Leave it alone, will you.' Not meaning to cause offence, it was just the pain.

As soon as I'd sat in my chair he set about me, hitting me hard about the head. My instinct was to protect the hole in my head and I curled up with my hands on the top of my skull. He was dragged off only after he had got three or four blows in and my friends stood around me as a shield. I was then ejected out of the back door and into the potting shed where I had to calm myself by smoking something herbal.

It was the first time the hole in my head had been threatened

and I felt very vulnerable. I felt vulnerable also because, in my wheelchair, I couldn't retaliate. This made me angry to the point at which I could hardly stop shaking. Violence has never been a big thing with me but if I saw a guy in a wheelchair getting punched I wouldn't be able to help myself. In my fury I would attack. I had to quell my anger because there was absolutely nothing I could do about it. I could hardly stand up and say, 'Unhand me you ruffian or I'll punch your lights out.'

21st July

Went to Liverpool for a CT scan today or a computed tomography scan. Some people call them Cat scans. I was led down this corridor at the new wing of the Fazakerley Hospital, all stacked high with boxes and building materials. A mountain of a woman then led me into the treatment room, which was hardly finished, and I was the first patient to be treated there. They were still taping the lead to the windows. And then I was placed in this giant polo mint thing which zaps x-rays at you and builds up an image of your head in slices.

When I got the results back from my ECG they were fairly typical of someone who has suffered head trauma – irregular electric currents and wave patterns.

23rd July

A real breakthrough today. I held my tricep in tension for a full thirty seconds and even moved it throughout its full range. I was lying down and Trish held my arm vertically. She then let go and I held my own arm up for thirty seconds. When I relaxed it, the arm lowered down toward my chest and then, the most important point, I managed to isolate and tense my tricep, thereby extending my arm out again.

I'll miss Smithy when he goes; next week, he says. He has a knife-sharp wit on him and can make anyone smile. He got seventy year-old Kay laughing, and she looked at death's door. A crackhead who admits, 'I'm addicted to the rock,' Smithy has no teeth and a deep scar down the middle of his forehead. He loves drugs, I mean really loves them. He talks in a language I barely know of Peruvian flake, bars and keys.

There were probably three times during his stay here when I didn't see him smiling. That's when the psychotic Smithy appears. The seriously depressed Smithy. He's best left well alone when he's like that. I never saw him turn tables upside down or wreck the day room but I'm sure he was capable of it and it would have got a thing or two off his chest. More often than not, though, you would see the grin through that woolly beard, a monkey in a bush.

Cue Ball was hysterical tonight. Whenever you mention him getting all the attention off the nurses he breaks into a broad grin. He knows what he's up to. He even called Vera, the ward manager, a loose woman.

I cooked a spinach and tofu curry for lunch in occupational therapy and all the nurses had some. I miss cooking desperately. The preparation of food is very therapeutic – peeling, chopping and slicing, cracking eggs, adding spices well ground in a mortar and pestle, the sizzle as you add raw onion to hot oil. I got to cook two lunches a week in the OT kitchen but that wasn't enough. I wanted to cook every day. I started by cooking pasta pesto and graduated to lentil dahl. Now I'm making such varied delights as tofu and coriander Taiwanese-style, caldo verde or banana sponge.

It's not easy preparing food with only your left hand. I rely on tools such as the one-handed electric can-opener, the spiked chopping board and the rocker knife, as well as low surfaces, sink and cooker. The food I've had the most difficulty with is chopping and pressing garlic. When I chop it, it is liable to go all over the floor and when I use the press my right arm comes all the way

up into the archetypal spastic position. But I find that there is a solution to every problem.

25th July

A day trip to Dublin today with the Llanberis gang, Charlie, Sonic Sue, Chris Rhys and the Lentil. The Lentil began his life in Llanberis at Tydyn Sian, the Lentil Farm – a rather derogatory name for the local conservationists' dwelling. We had set out with the idea to visit galleries but soon, or rather I should say, as soon as we got off the boat, it degenerated into a drinking and shopping trip. With considerably more of the former.

I learnt a thing or two about the lateral stability of my chair, and the Lentil saved me from a certain spilling when I tried to mount a kerb and it didn't work. I was just about to give myself another head injury when the chair tipped over to the right. I couldn't have put my hand out to stop my face planting itself on the paving, but the Lentil, who must have been ten yards away at the time, sprinted and just caught me.

Then there was the struggle to find a pub to eat at where you didn't have to walk up stairs. We failed on that score and I fought my way upstairs in one bar, looking like Bela Lugosi, and almost nose-dived straight into a diner's lap. A friend who we met in a climbing shop by the River Liffy pointed us to the Zanzibar, which was a bit tacky but great for wheeling around in, and it even had wheelchair-accessible toilets.

There was a group of English and a group of Welsh on stag days enjoying misbehaving. On the train on the way back Sonic had to lend one of them her nail varnish. He painted a bright purple cross on the forehead of a man who was in the most paralytic stupor. The Welsh pissheads were more friendly than the English pissheads, who seemed to us to be rather sinister.

On the return crossing I met a friend I hadn't seen since childhood. He hadn't changed a bit, though now he was playing football

professionally. He always had something that none of the rest of us had. He tackled with a definite style and passed the ball spot on. When he left school he went to play for Bolton Wanderers and had since been to Oxford and Middlesbrough. I suddenly felt like that little boy again. Jimmy was a year or two older than I was and always cast that boyhood spell. Me being down in my chair and him standing above me only served to revive and accentuate my childhood feeling of inferiority to this Adonis, this footballing hero. I felt like a real cripple next to this giant.

In reality he stood no taller than I did, but I had been sitting down for half a year and had learnt to see the world from this perspective. I had grown accustomed to viewing everyone's bums in the pub and on the dance floor. Yeah, I felt like a cripple because that was what I was next to this paragon of health. No matter how much people tried to humour me, that is how I saw myself. I wheeled away angry, not with him, though that wasn't apparent at first, but with myself for being so weak.

It is an unusual fact that all people in wheelchairs are drunk magnets. All the drunks from miles around home in on the wheelchair user and, with genuine sympathy on their faces, ask if you are OK or if you need any help. If you needed help you would have asked for it and anyway, if your idea of help is being hauled up a flight of stairs by a pissed up punter, risking severe injury, when in reality you were trying to cross the road, then you're welcome to it.

Dublin was no exception. This awful bloke started to breathe on me and fondle my leg, asking in slurred English, again and again, if I was OK. I said, 'Yes, of course I was fucking OK. Why shouldn't I be?' And my outburst surprised me.

When we got back to Holyhead I was dying for a piss and waited outside one of the accessible toilets with an engaged sign on the door. It was funny because I usually am aware of the other passengers in wheelchairs and I hadn't seen any at all. Eventually the door unlocked and out walked one of the Welsh team with

136

a big fat spliff. We giggled at how the accessible toilets have their uses for everyone.

27th July

I was held under suspicion today in the WRVS shop. There was a guy in charge who I heard whispering to one of the women, 'Keep your eye on him.' I took offence and I asked him outright if he thought I was a shoplifter and what led him to come to his conclusion. Was it the Red Chilli hair colour or the emerald toe nails or the unshaven face because I'd forgotten my shaver? I got an apology out of the guy, which was all I was after. I'm sure he thought he would have a dangerous psycho wreaking havoc in his shop if he didn't apologise.

29th July

'I'll meet you on top of Everest before I'll work within a year,' spluttered Smithy. 'The neuro woman says I'll be working again in a year. I need at least two years off to get me head together. When I came out of that coma the doctors said I'd be all right. Lying bastards,' he laughs, spraying his beer all over me.

Tom, who I never got to know very well during my whole stay at Clatterbridge, came over and spoke with us. He garbled like a mad man about his whole experience but he owned up to driving a motorbike. He had never done that before. He had always said he'd been in a car when he hit that bollard in Jamaica.

Kathy, baby Angel and Philippa took me on a 'family day out' to the Tate Gallery in Liverpool today. Amidst the half-sunken boat 'SOS 1998', and the pile of mint Imperials, 'Portrait of Dad 1991', there was a Picasso entitled 'Seated Nude' which I stared at for ages, not knowing why, and then it became apparent. I saw myself in there. The male figure was seated, as I am, but also had

137

its arms twisted into the spastic position, knuckles facing up, wrist bent up and forearm turned in as if in a sling. The Cubist painting was built up of triangles and had no right side to the face, as I didn't have once. One ghostly eye was staring; the right side of its mouth was drooping at a horrible slant. Its right bicep was totally flat and without definition, but its trapezium and lats were working overtime.

The only difference was he was holding something tenderly, a baby perhaps or something more peculiar, to his chest. I couldn't have held anything tenderly if I'd tried. My hand is still clenched into a permanent fist unless I concentrate on relaxing for about a minute beforehand. Maybe he was releasing a bird? There were its wings. It stirred in me a sense of immediate hope. He came out from his background, a mosaic of browns through greys, and started to wheel towards me. I stood back and made way for him, as his chair rolled. I had always appreciated art, but now I craved it. I saw myself staring at simple objects, appreciating their simplicity.

It's the simple things I miss – hugging someone when they're feeling down. To do that you have to be on your feet with both arms working. I miss being hugged when I'm feeling down, too, and not feeling infantile because of being at a lower level. And there's scratching your left arm or picking flowers on your knees in a summer meadow.

31st July

I got drunk in the pub, just like my South East Asian consultant told me not to. She said that at Simon and Jane's wedding, not wanting to be a total killjoy, I could toast the bride. If she could see me now she would shake her head and say simply I told you so. I know drinking alcohol can greatly increase the risk of seizure, but it's my risk. Hell, you've got to have some fun and take a few risks. As far as I'm concerned that's what life's about, taking risks.

After six months you get a bit bored with trying to be a goody two shoes all the time.

I walked into this party with my spotter, Leigh McGinley, who was definitely more pissed than I was. I need a spotter when I'm walking, especially when I'm walking drunk. Anyway, he totally missed me keeling over; he was looking in the other direction. I slammed down hard, crossways, onto a chair with wooden arms and took a blow to my jaw and elbow. Obviously it didn't hurt at the time, due to the anaesthetic effect of the drink, but when I awoke it took me a while to realise why my jaw was killing me. Then I vomited.

1st August

Charlie and Sonic Sue had a very fine barbecue with heaps of meat to celebrate the Lentil's birthday. I spent most of the time in the kitchen listening to Smoo playing his harp. I was overawed to hear him play a rendition of 'Old McDonald Had a Farm', which is tantamount to sacrilege on such a delicate instrument.

Merlin then wheeled me home down a ridiculously steep hill at 2 a.m. When a motor car stopped to say good evening my chauffeur started to experience raging paranoia. The driver was dressed in a black suit and was only trying to be helpful, but Merlin clammed up and left me to do the answering. Afterwards he declared, 'It's the DS. I'm sure of it. Why else would "a suit" be driving around this late at night?' All the while I was striking matches to illuminate the road ahead.

3rd August

A new patient came onto the ward today. Chaz is a veritable ball of a man at twenty stone who had his car accident back in 1962. And he is still having treatment for it! He's a real joker but I can't

quite put my finger on it, his jokes don't always make sense. He asked me if my new-fangled computer can make my fingers longer. I pondered on this for a while, not wanting to negate the old man's ideas, but finally gave up and asked him what he had meant. He answered with a bizarre series of hand signals, which led me to believe the crash had left him a few shillings short of a pound. But as happy as a pig in shit. He walks with an appalling limp aided with a stick.

Chaz was in a coma for three months and can't remember anything about the preceding year. He says the saddest thing of the whole affair was that he took away a girl's virginity and can't remember anything of it. Nothing at all.

He passed me a piece of cheese this suppertime that he had been saving since tea. But it was all soft and warm and unappetising and I put it down the side of my seat when he wasn't looking. Then he posed the question, 'Do they swear in heaven?' He looked at me and laughed when he saw I had no idea. He answered with another question, 'Do they fuckin' hell?' and proceeded to break down into hysterical laughter.

He fell over this evening and it took three nurses and a hell of a commotion to lift him. Then he sat, all hippopotamus-like, looking dejected on the end of his bed. Sleep evaded me as the ward commenced to vibrate with the almighty racket of his pneumatic snore. I tried to sleep for three and a half hours before I saw that I just had to move wards. Once as far away from him as I possibly could be, his snores were just distant echoes and I slept with my usual soundness.

It's scary seeing in Chaz what I could end up like. Of course I'm more mentally together than he is but physically he's a mess. I'm not going to end up overweight like him if I can help it, but the stiff-legged bit I can do without. The only hope for me is that he has his hand working, but weakly. Nevertheless it is a functioning hand.

Chaz has such a dreadful limp and pivots around on a stick because he had dated methods of rehabilitation. He was one of

the ones that used to walk with a tripod. He can't ride a bicycle or go rock climbing, as I hope to one day, but he can cut bread and take lids off bottles, things that I can't do yet.

4th August

When you raise your right leg or arm you only use the left hemisphere of your brain and vice versa. But because it takes so much concentration to move my over-weak limbs I am using the right hemisphere also. This does not mean that my plastic brain is learning to use both hemispheres to move one side of my body. It just means that I'm cognitively processing the movement of my right side, instead of it just happening as a reflex.

5th August

I was having a chat with Chaz this evening and he began telling me about how he couldn't get it up any more. He told me about how they put him in a room with his wife and they were made to watch pornographic movies together. It didn't work though. He said I had twenty-nine years to go before 'the greatest pleasure known to man' would be taken away from me. I suggested letting Smithy get hold of some Viagra for him. Smithy can get hold of Blue Niagaras for twenty-five quid a go. Chaz is much more lucid than I first thought and I had an intelligent, if somewhat rude, conversation with him. We also chatted about all the places we've been, him sailing me climbing.

I had a toe wiggle this morning, the first for two months. It was great, better than the swelling and I couldn't wait to tell Trish and Gulhan about it. I was able to flex and extend my elbow, under controlled conditions, in physio today. That may not sound like much but believe you me it took an immense amount of effort.

Caroline Young, my consultant neurologist, deliberately tried to get me to blush this afternoon. And she succeeded. She asked me what I had to think about to get my arm to rise in an associated reaction. I didn't say anything. She then asked if it was dirty and told me all the dirty jokes she knew were too rude for me. I replied, 'Try me.'

7th August

It's a Friday. I go home every Friday. I cherish my weekends at home. You have company twenty-four hours a day in this place. So it's good to go home for some solitude, although the guys often have 'entertainment' laid on for me, like going to the boozer or taking me to watch them climbing. I will make myself a brew, put some Nusrat Fateh Ali Khan or Shostakovich on the CD and sit in an armchair, out on the veranda if the sun is shining, and just relax. Soaking up the solitude. Revelling in the aloneness of it all.

10th August

I went to Trev's birthday party this weekend. Trev's one of my oldest friends and climbing companions. Emily, Trev's partner, carried me up a flight of steps at 5 a.m. She's muscular with long flowing black hair, a real Amazon. They're probably the craziest couple in Llanberis.

I also went to dinner with a few new friends. I find I get bored with the climbing gossip these days. I don't have any interest in the handholds of the Cad as they're mimed out in front of me. I don't see any more reason to listen to the 'numbers on Tufty Club Rebellion'. When I'm taken to sit in my chair below a cliff all I feel is jealousy, jealousy at what they're doing, flexing and stretching as they make fun of me, saying with their movement, look at me. Look how special I am, as I do the splits, mocking me with the

fluidity of their gyrations, as they contort into ever more wonderful positions.

So I don't see why I should hang out with a group of intense climbers now. It's a challenge to get to know new people as well. It takes considerably more effort hanging out with comparative strangers than with your good friends, so it could be construed as therapy. Don't get me wrong. I still have my hardcore friends who will always be there for me and I for them. No, it's the acquaintances whose only point of reference with me is climbing, they're the ones who bore me in a crowded pub, as I can't even escape because of this damn wheelchair.

12th August

I visited the Tate again today because I just had to see the Picasso again. This time he looked like a woman and she is still how I feel.

I have figured out why my foot is shaking violently whenever I try to walk on it, or at least my physiotherapist has discovered why. Apparently the planta muscles on the arch of my foot are extremely tight and the only way to stretch them out is by walking on the foot as much as possible. But still only under controlled supervision.

13th August

A special day. Six months exactly since my injury. It feels distinctly odd to have come up against the six-month wall. They say that the most prolific recovery goes on in the first six months and then it slows down after that. I'm worried that it will be downhill from now on.

Tricia put my mind at rest. 'Obviously a therapist would include sitting up and turning from shoulder to shoulder in bed as recovery

in the first six months.' So I have come a long way. A hell of a long way. Lying there in my hospital bed, wishing they would amputate my limbs, calling out loud for them to amputate my leg, I do realise how far I've come, and I remember what she has told me about the plateaus when nothing is happening and the excitement when a muscle begins to tense or a tendon will start twitching. The emotional intensity every time I get something back is overwhelming.

They had a goal-planning meeting without me the other day. It was decided that I could completely take care of myself, what with self-medicating and preparing food, and so they thought that I could do my own washing and drying on the line and make my own bed. Just as long as they don't expect any hospital corners from me.

The nurses, Julie, Mo and Irene, are buzzing round the ward this morning, getting the patients up who are unable to get themselves up, making beds, one on each side, with a surgeon's precision, while Liz the domestic in her pink dress sweeps and mops the floor.

Julie, a slight, pretty nurse, is shaving Cue Ball. I can hear the peaceful sound of the razor swishing through the soapy water and her soft voice humming nondescript tunes, the chat about Preston North End and teeth-cleaning. The flat feet of Ann clopping down the corridor, leaning as if she's about to fall over; the click-clack of doors as they are opened and closed; even the wailing of Kevin or the mantras of Andrew, the distant screaming of Marty or the thrashing of Cue Ball on this peaceful morning, I shall miss when I leave this place.

17th August

My step-sister Geraldine married this weekend. That was the reason I had my hair dyed purple. I wanted to show them that I still had control over my life, even if it was only over my hair.

During the wedding disco I longed to be up there dancing. It didn't matter that the music wasn't my scene, I just had an overwhelming urge to dance. But I felt like an outsider amidst all the beautiful people. I had no reason to feel this, except for paranoia. I chatted to lots of people but the conversation always came back round to the wheelchair and why I was in it. But just as soon as I was in the depths of my paranoid state, an attractive woman offered to dance with me. We kind of danced for maybe five tracks, she on her feet and me sitting, before she took her leave.

I felt suffocated by love this weekend. I know they are all worried about me, my mother, sisters and brothers. My mother, it seemed, would not take her eye off me. But she had been through it, though never quite this bad, twice before. Not counting all the funerals I have mentioned to her, she knows the score.

I moved my thumb this week, which is a real breakthrough. My first digit to get moving. I can have all the movement in the world in my arm but what use is it without my hand. I have learnt that the same nerve that controls the thumb also controls the forefinger, so I think I will be able to grip objects one day.

Tricia tells me to calm down. 'That would be the case if the nerves were damaged peripherally. With a head injury the whole thing is turned upside down. There is a centre in the brain just for moving the thumb. That's why we can move our thumbs independently of our forefingers.' I sat, stripped to my undies on the bench, looking dejected and confused. She continued, 'So it in no way follows that we should be able to move both the thumb and the forefinger. Anyway your arm is very important for balance, even if your hand isn't functioning.'

The associated reaction in my arm resembles the mad flailings of a symphony conductor as he goes for the final moments of the 1812 Overture. It shakes and lifts, outstretched, as it signals for the cymbals to come in and now to the snare drums.

I see other couples coping with a head-injured man or woman together and wonder what I did wrong. Andie's so loving to Marty

and Lydia is equally as loving to Phil. Mopping their brows and fattening them up. I have developed an empathy with Fliss who was in a terrible car accident where she lost her husband and was told her two-and-a-half-year-old son would never walk.

I know that my tragedy in no way compares to hers but what we have in common is neither of us has a partner to share the distress with. We can talk all we want to friends but they don't really have an emotional involvement with us. They can just forget about it when they shut their eyes at night.

19th August

I had to do a walk in the Swedish knee cage yesterday. This may sound horrific, like medieval torture apparatus, but it is simply a splint to help a knee stop hyper-extending. Combined with my drop foot splint, my leg had the appearance of being completely built out of plastic and steel, like the bionic man. Anyway I succeeded in walking my first hundred metres.

Caroline, an outpatient, was here today. I always look forward to seeing her though she only comes in once a month. She's a brash woman who has had a stroke and was in a coma for seven months. She thinks she looks like something out of *Star Trek* but I don't notice. You can tell that she isn't being entirely honest with herself and that sometimes, in the dead of night, she will wake up crying tears for what she once was. 'I used to be a right stunner,' she said. 'I look in the mirror now and don't recognise what I'm seeing.'

Caroline says that she loves being a spastic so she can cause a scene whenever and wherever she likes, which she frequently does. She told a story of how she was in a crowded bar once and shouted out loud, 'I need a shit' to her boy friend. He, incidentally, has left her because he said that she wasn't the dollybird he went out with in the beginning, but a fat cow now. She retorted that she 'was still good in bed though'.

146

20th August

Lise put me through the first part of my three-monthly COTNAB (Chessington Occupational Therapy Neurological Assessment Battery) test today. I had had it before when I first came on the Unit. I recognised segments of the test but for the most part I hadn't a clue that I'd even seen it before. It's hard to imagine that my memory was ever that poor – my poor memory is just a distant memory.

There were sets of pictures, which I had to put in sequence, a plane taking off or a battery, for some reason, in the distance and getting nearer. There were angles, which I had to arrange from the most acute to obtuse, and dots getting bigger in size from microscopic to an inch in diameter. This first part of the test is entitled Visual Perception and, I suppose, is to let the therapists know if you are safe crossing a busy road, that kind of thing.

21st August

Excitement today as a BBC film crew was here, well Maggie doing the interview and a man whose name I can't remember behind the camera. They want to film my progress throughout the year and then fly me back to Tasmania. I was wary at first but that was because I didn't think I would be strong enough. Now I definitely know I will be fit, so I'm looking forward to it immensely.

Vera, the ward manager, and Ms Young seem to worry an awful lot about my laid back approach to film, book and mortgage contracts. I can see their concern because many head-injury patients seem to have not a care in the world, while I, on the other hand, have been like this all my life. It is convincing them of this fact that is the problem. Vera even asked my mother, 'Do you notice any changes in your son's behaviour?'

147

My mum, knowing me better than anyone, replied, 'He thinks more of his old mother now.'

The first filming to be done was Lise taking me for occupational therapy. I noticed that she had put eyeliner on. She said she was nervous about filming but on camera she appeared very relaxed. Next came my physio session. Tricia was worried about other physios criticising what she said and took her time over the answers but she spoke perfectly and with authority. I think we made a good team.

24th August

Continuing with the COTNAB test today, this time it's my constructional ability that's under investigation. I felt rushed and made a hash of what I did better at last time, three months ago. It was just building a model out of wooden blocks and it had to be exactly right. Oh well, you can't get everything right.

25th August

I had to put my hand in a black box this morning as part of this COTNAB thingy, to test my sensory motor, in other words touch. I guessed ten assorted items with my eyes closed and my hands being manipulated around them for me.

Then I had to make a coat hanger out of a piece of wire following written instructions. That was the only part of the whole test I was still impaired on. Following the diagrams was easy and I built a model of I don't know what in no time.

27th August

At last. My leg and foot are not as reactive. It didn't quiver and shake and try, like a hammer drill, to make a hole in the floor, as it has done. I walked up the corridor with much better hip control and so the knee followed. Tricia was almost as excited as I was.

Ms Young, my consultant, has come in to see me as I write this journal and told me, 'The tone in your arm is excellent but you shouldn't expect great things from your hand.' It was as though she had built up my hopes and then razed them to the ground just as quickly. She is a cheeky woman who always seems intent on making me blush. In fact I feel like a child before her. She seemed shocked when I suggested that I still wanted to climb or parapente. What else would I do if I couldn't climb? I would be happy just trekking, looking at the mountains, wandering about at their feet. As long as I can still be in the mountains, that's all I ask of fate.

4th September

'A stitch in time saves nine.' 'A bird in the hand is worth two in the bush.' 'A bad workman always blames his tools.' These are some of the proverbs I had to give translations for in OT. All I had to do was say what they really mean but I couldn't; I could only repeat what Lise was saying. I couldn't get my head around them at all. I knew what they meant but I could not find the words to describe them. It was as if I was taking them literally.

In neuro-psychology Fiona read me two stories. One was about a national park and culling a thousand elephants, the other about a band of gypsies who ram-raided shops and robbed bank cash dispensers. They were each four sentences long, but when asked to repeat them back I only retained twenty-five per cent of them whereas unimpaired folk would retain at least fifty per cent. What

149

I do retain I retain for a long time. In fact, I still remembered the gist of the stories she told me three months ago. You may think that this is contradictory to what I achieved in my COTNAB test, but I apparently have a better memory for words than anything else.

I have been through a range of emotions since being told I haven't to expect anything from my hand. From a furious what-the-fuck-does-she-know-about-my-body to a calm acceptance of events. Whatever happens happens kind of thing. I've been trying extra hard to get my hand moving ever since, trying till I'm blue in the face, literally. But it doesn't want to go.

Gulhan Tas, my Turkish physiotherapist, has been taking me all week. She always has a smile for you, wears spectacles on the end of her nose, is simply gorgeous, and would fit in a thimble, which belies her power. She talks with a strong Turkish accent, a bit like Countess Dracula. She leaves for her next four months in Respiratory in two days and I will be sorry to see her go.

5th September

I moved my forefingers in extension this morning. I can hardly contain myself. It only happened three times but after being told not to expect anything from my hand I think I was even more determined. I'm scared stiff that it will go the same way as my toes and ankle and not move again. I can live without use in my toes and ankle but getting some, even if limited, use of my hand back would be amazing.

Cue Ball's coming into his own now that he has recovered a little. He's still climbing out of bed and ending up on the cold floor but he's also more relaxed in his new surroundings. He's a dreadful flirt with the nurses. He asked Lou to show him her knickers and then, turning his head, grinned a toothless grin, eyes magnified by his jam-jar bottom specs.

7th September

This Monday I've come back to the Unit with a mystery illness. I have swollen glands and a fever, the usual kind of stuff, but what's confusing the doctor is hundreds of blisters covering my whole body. They itch like hell and if you scratch the top of them they burst in little puddles of water.

As I was lying there under the sheet, the nurses buzzing round, putting Cue Ball to bed behind a curtain, all I could hear, as they cleaned him up, was 'Shag me again' and 'Do it to me again!' They tried to repress their laughter, which came spluttering out. I wondered briefly if old women are as rude. I think not somehow.

7 a.m. in the morning I am wrapped in the sheet like a pupa, my face hidden. I am listening to the squeak of the cloth as Helen the domestic wipes down the surfaces, the chink of ice against plastic as she brings in the water jug, and that noise, barely audible, like a 'clip' as she puts down a cup of tea on the Formica. I wait five minutes, until the tea has cooled, and crawl out of my cocoon resembling a leper with boils all over my face and chest.

As I do my diary I am burning up, wanting to tear the skin off my face, my scrotum, my back, my neck. My guess is that it's chicken pox but the doc thinks not. Vera the ward manager, Carol the secretary, all the nurses and all my mates, in fact everyone but the doctor says it's chicken pox. The doctor, by the way, can't give me a diagnosis, though he has given me the usual antibiotics and anti-histamine syrup.

A middle-aged woman called Freda came in this week for respite. She has multiple sclerosis and she's originally from a village near me. She told me a touching story of how she met a fisherman at the wharf one day and fell in love with him. Her parents were not impressed and wanted their daughter to marry a professional man. When the lad went to Saudi Arabia to earn some money to keep her with she met a yachty at the Menai Straits regatta. After a one night stand she became pregnant and, as was the custom

in those days, was forced to marry him. Obviously her parents were delighted. A man who owns his own yacht, a professional man, a rich man. From her wheelchair she grinned and told me that she is still seeing the fisherman, who is married now with kids, too. For nearly forty years they have been carrying on a secret love. She says that one day she'll pluck up the courage to leave her husband and spend the rest of her life with her fisherman.

14th September

'I was being strong because I find courage in your strength,' my mother said to me. It was only a month ago when she found out that she had breast cancer, and only last week that she discovered she had to have a mastectomy.

'But I was being strong because I have a good role model in you,' I answered.

She had brought my sister and me up through our teenage years on her own. They weren't easy years and I was forever getting myself into trouble with teachers or police. She underwent numerous operations about that time; her health seemed to fail her right after her divorce from my dad. We then moved into a tiny flat above a hairdressers and I had to share a room with my mum and sleep on a camp bed.

I went to see Bolton Wanderers play Birmingham City on Saturday. We, the wheelies, were all shepherded into a glass box which was pretty high up, and so we had a good view of the game but, cut off from the noise of the crowd, it lacked the electric atmosphere when the Wanderers scored. There were about two dozen of us, each with a minder lined up behind the glass, the paralysed, the legless, the crippled, a jolly crew of Brummy and Wanderers supporters each shouting as their respective teams put a ball in the net. I began to wonder if there would be an outbreak of hooliganism in the box but there was a policeman standing

behind us just in case. Anyway we wiped the floor with them, three goals to Birmingham's one.

After the match I was sitting in the inevitable traffic jam when, without warning, I had a fit. I didn't lose consciousness but I did lose the ability to speak. I couldn't tell my stepfather that I was experiencing a seizure and he thought that I was going to be sick, because I was frothing at the mouth. This was a medium-sized fit and it scared me because I had no warning in the form of an aura. Vera says that they can last for two years after a head injury and then normality can reassert itself again. Or the fits can continue for life. I hope and pray the former is the case.

17th September

Simon had a brain tumour, which he had operated on two years ago. As a result of the injuries sustained during the operation he cannot speak and has to be pushed about in his wheelchair. He communicates by pressing a keyboard that synthesises an artificial voice. It's taken me five months to get to know him, mainly because he's an outpatient who only comes in for therapy but also because I was scared of him. I can't tell you what I was scared of. Maybe it's the way he constantly drools and has to have a box of Kleenex on his wheelchair shelf at all times. Or perhaps it's that electronic voice simulator that makes him sound inhuman.

It would be easy to dismiss Simon as a simpleton, but it would be your loss. He has a cracking sense of humour. He keeps asking me how I change the colour of my hair, saying that he would like to go blond. But his wife won't have any of it and says that he's got black hair and it's staying black. I like to wind him up about it and say that he should take control of his own affairs.

His wife, Tracey, who is the mother of his two children, is very beautiful and he must seem intensely ugly to the stranger in the street. She could have any husband she wanted, but has stood by him these two years. It goes to show that it takes more than

153

physical attraction to make a couple, and that family unity is a very strong thing, something that I know precious little about. He may be shocking to look at but, once you talk to him he is intelligent, witty and obviously loving to his family.

All I know is that relationships seem to fall apart in this place with monotonous regularity. Marty's engagement is now on the rocks and he is really cut up about that. You don't hear his filthy old man's laugh echoing down the corridor now, and you certainly don't hear his other more hysterical laugh that sounds like a booming foghorn. Time was when we thought there were two people in his room both laughing at the same TV show.

Kevin is playing footy with Bazza on the parallel bars and he's loving it. He holds himself up on the bars whilst giving a running commentary of the Liverpool squad. 'Fowler to Owen, back to Macmanaman, Berger with a nice pass to Owen who is running the length of the pitch, strikes, and it's in the back of the net.' Bazza, who helps serve our meals, is tapping the sponge ball towards Kevin and he is laughing and swearing as he tries to kick it back. 'I can't fuckin' do it. I'm shit since that bastard put me in 'ere,' he says, speaking of the drunk driver.

Phil walked straight in front of a bus and now staggers around expressionless, speechless. He isn't supposed to go walkabout but when the nurses are busy they can't stop him. Phil has what is called a peg, which is a feeding tube that goes straight into his stomach. He has to push a stand around with him all the time with a bottle of sickly looking liquid in it. I recognise the bottle from my naso-gastric feeding tube days. Anyway, he keeps tampering with the peg and disconnecting the tube and expensive pink fluid runs into the carpet. The built-in alarm on the stand sounds and the nurses come rushing to rectify the problem. That probably happens about twenty times a day.

Lydia, Phil's wife, who was a nurse herself, told me of the five stages to accepting your injury. Denial, anger, bargaining, depression and acceptance. She told me DABDA was how I could remember this. I've had the denial, where I refused to admit I was

154

like other people who used wheelchairs and thought that I would be resuming my round the world climbing trip once this little hiccup was dealt with. The anger has torn me up inside especially when Celia left me. I remember lashing out and telling her that she'd ruined my life. I've done the bargaining bit when I asked the question why didn't I go to Cochimo in Chile instead? That's where my friends were going and where I would have gone if it were not for this round the world trip which led me to the Totem Pole. I've had my moments of depression, but nothing to speak of. I just got bored with being depressed and snapped myself out of it. I don't seem to have a depressive streak in me. And I've calmly accepted my fate from about week six, apart from the denial, which has been a little harder to rub off. These five stages to acceptance can come in any order.

18th September

It is definitely chicken pox that I am suffering. The blisters are getting better but I scratched the tops off most of them before I knew of the scarring. I don't care, I've got more important problems to worry about. Don't ask me how I came about the pox which, incidentally, I had as a child. All I know is that I'm one of those rare cases who are capable of catching it twice.

I wiggled my middle two toes again today. There is a twenty per cent improvement in my memory for stories, word for word, and my concentration has considerably improved. That's the report from Fiona, my neuro-psychologist. My leg seems to have stopped trying to drill holes in the floor but I am now walking like someone from the Ministry of Silly Walks, with the knees very bent. This is in an effort to prevent that old chestnut, the knee flick-back, which is all it takes to start a forceful reaction.

I have been told that I'm going home in three weeks if all's well. I suddenly came over all nervous about life on the outside. I think I'm more institutionalised than I previously thought. I have

come to rely on my midweek time here. It gives me a total rest in preparation for the weekend once again. Having all my meals cooked for me, my bed made and fresh sheets put on, my bedroom (or ward) tidied, being bed bathed and showered, having your arse wiped, in Tasmania, and being thoroughly monitored twenty-four hours a day is bound to have some effect after eight months.

This level of pampering is needed at first but there comes a time when you need to stand on your own two feet again. Like a teenager leaving home for the first time you feel a great deal of apprehension as you step out into the cold.

I expected to be in here till the end of the year, although no one actually told me so. The 12th October seems very soon. I promised myself that I would be walking out of these sliding doors when I go and that seems impossible in three weeks. It's just a goal I set myself, that's all.

25th September

After six months, Vera came in to tell me that I haven't to have the injections each morning into my belly. That is one less drug I am dependent on and it feels very liberating. I am up on my feet more now and at less risk from blood clots and thromboses, though I believe that I could have done without them months ago. I guess Ms Young, the consultant neurologist, didn't know just how active I was at the weekend and I wasn't going to let on to her.

Moving into the new house was blissful. The boys had built me a ramp to get into the kitchen, shake-'n'-vac-ed the carpets, hung pictures, got a fire going in the hearth and generally made it homely. It is much smaller than the old house, has cat shit in the back yard and doesn't have the views of Yr Wyddfa and Clogwyn Du'r Arddu that I'm used to, but it is mine.

30th September

'Nervous centres represent movements, not muscles. From lesions of motor centres there is not paralysis of muscles but loss of movements.'
Hughlings/Jackson, 1958

I have been hassling Vera and Tricia for reading matter on the brain, anything to do with neurology really. The two of them have had to put up with my constant questions and incessant enthusing for six months now. On my desk there is a pile of books referring to brains which is two feet high and growing.

I cooked a Taiwanese dish yesterday. Tofu with red pepper and fresh coriander. I think I'm coming on in the kitchen. I asked Lise to get me the tools I will need to aid cooking in my new home: electric tin-opener, spike board, left-handed scissors, brush for washing dishes that sticks onto the side of the sink, extraordinarily sticky cloth for opening jars, knife with the handle at a right angle to the blade to ease grip, the list goes on.

Last night the Cue Ball was truly animated and his voice had a clarity that I'd never heard before. He was pointing at Marty, calling him rude, and laughing like a maniac, his cue ball head and oversized eyes behind his specs and single tooth adding to the effect. It was good to see. We all joined in their infectious laughter and pretty soon we were doubled over ourselves. There was Joy, Jill and Hilary of the night nurses, Hilda, Dawn, Karen and Marty of the patients.

Hilda was struck down with the Gillam/Beri virus, which affected her spine and left her paralysed for a short time. She's back up on her feet now though, another example of the hope there is in here. Dawn is a young girl, perhaps a teenager who wiped a car out. She has all her mental faculties about her but shuffles her feet, that's all. And Karen is suffering from multiple sclerosis for which there is no known cure.

157

I have been practising walking up stairs all this week. I can lift my knee but not without my lower leg rising also in a kind of goose step. This is because my hamstring is still refusing to function unless I surprise it. Then it works. But how do you surprise a muscle? By the time you've thought about surprising it, it is a surprise no longer. So I must not think about the hamstring, effectively ignoring it and then, suddenly, take action. Then it bends back as easy as pie. Until I can achieve being able to will my knee to bend I am stuck with having to trail my right leg up each step.

1st October

The day of the Case Conference

I felt like a schoolboy going into the headmaster's office as I passed through that door with my short pants on (I had just come out of my physio session). It is strategically positioned at the end of a long corridor so you see it there for what feels like miles as you are wheeled down. I felt as though I had to tell them everything. There were, perhaps, ten 'grown-ups' circled around a large table asking me questions like 'Who empties your commode for you?' and 'Who do you have to shop for you?' Most of them I knew pretty well. There was Lise and Tricia, Vera and Mark, Ann the social worker and Dr Shakespeare, but now they assumed a level of 'grown-upness' that was terrifying. I went red in the face and started to sweat. I tried to get a smile out of Tricia but she could not allow herself, in front of the others, the familiarity which is born out of spending an hour every day with me.

Coming clean about how many times I really climbed the stairs was a hard task, but I knew I had to do it if I was going to avoid having a lift put in. The lift would have been a good joke but hardly worth the ten-grand council grant. I told them that I didn't

need anyone to empty the commode for me because I didn't use it. And I told them that I did my own shopping. I was laughing nervously. They just looked at me as if to say, 'You'll be sorry when you come crashing down those stairs.' I felt stupid and it wasn't them that made me feel that way.

They decided to come and witness for themselves 'the great event' of me climbing the stairs and also getting in and out of a bath. When I told my therapists I could do this they looked aghast. A hemiplegic at this stage of recovery should not be able to have a bath without complex equipment but, being a climber, I have certain strengths that other folk don't have, namely good balance and the ability to push up with one arm.

6th October

The date for my release has been put back to the 15th. That's what they call it, a 'release', as if it were prison or something. I guess you can draw parallels with being inside but that wouldn't be helpful. I've been sentenced to six months' love and attention. It doesn't seem that way to some patients though. They can't wait to get out, even though their bodies patently aren't well. They grow bored, as prisoners do, with the monotonous regularity of traipsing down to the dining area for three lousy meals a day. Being confined, losing your freedom, having to sign an 'out book' whenever you want to go to the shop, not having an ounce of privacy, sleeping as I have done for the last eight months on wards, the small quadrant all fenced in and locked up, but perhaps the most enduring image of prison life are the nurses' paces up and down the dark corridor, just like a warder's.

The fear of institutionalisation is ever present and, indeed, I felt more than a grain of this when they told me I was free to go on 12th October. I became nervous and irritated and for some time I didn't know why. Then it became clear, I was becoming institutionalised and the release date was sooner than I expected. So I

told myself that I'd better make the break before becoming totally so – or rather they told me. The Rehab Unit's staff seem to know just about everything about anything relating to what's best for you. You don't see it at first; it only becomes apparent in retrospect.

I went to a fine party at the weekend to help warm a friend's new house. When I got home, about 3 a.m., and put the grill on because I had the munchies, I stumbled over the blasted wheelchair and fell on the concrete floor. I went over like a felled tree and my head missed the radiator by inches. When I fall, my body always topples to my right and my elbow, not my hand, automatically comes out to protect me thus transmitting the forcible blow to my already damaged shoulder. I lay there for about twenty minutes clutching at my paining joints, somewhat shocked, before I clambered up into my chair and took myself off to bed.

Back in the Unit I told Tricia that I'd gone off the kerb in my wheelchair, because I was terrified that they were going to delay my release date. This then made me feel overwhelmingly childish. I'm a grown man. Why do I feel the need to tell trivial lies? But it wasn't trivial to me. My future was in balance. Me on one scale and a giant organisation on the other. However many hospital dinners I ate I couldn't tip the balance in my favour. I didn't know what powers the National Health Service had to keep me inside. Was I becoming paranoid? I mean really. The very thought of it was absurd.

7th October

Stephen is a patient who does three days a week here and is pencil thin, as are many of the folk in rehab, those who aren't grossly overweight that is. They lose weight from the injuries they have sustained. His choice of vocabulary isn't always brilliant, so he tells me, and then proceeds to use words like 'anathema' and 'mammon' all the time. The only problem with his words is that they are perhaps too long and used in the wrong context. But he might

have always been like this. His right side feels heavy but you wouldn't know there was anything wrong with him. He would just be a 'strange fish' on the outside. He's a publican who was in a car accident, luckily on his own, near Abergele.

I'm really excited about my new life on the outside. Not only am I leaving hospital and leaving my home of three years but I've bought a new house and my relationship with Celia has ended. I've also had to quit climbing, which is a major life-changing event in itself. I've been climbing for fifteen years and now I've been put in a wheelchair. Now some may ask, what's exciting about that? Downright bad luck I say. But that would be missing the opportunity to learn from pain. I've learnt about inner strengths I was never aware of until fate put me in this situation. Some people would say that I lived for my climbing but I would say that I lived through my climbing. Surviving it obviously, but growing through it also. I'm confident things are going to work out OK, you have to keep a positive attitude. There's always something to focus on and you can take comfort, if you wish, in the knowledge that there is always someone worse off than yourself. That's not hard in here where there are several patients worse off than me. (The Cue Ball was stuffing his face with a plate of food yesterday and there wasn't even a plate in front of him.)

13th October

This is my last week at the Unit. My final full day, in fact I'm leaving tomorrow. In some ways I'll be sad to leave, it has become such a big part of my life.

In my semi-conscious state I can hear Margaret and Helen, the stewardesses, chatting about nothing in particular outside the French windows while they have their first fag break of the day. They're as regular as clockwork. My life is as regular as clockwork these last six months. I lazily rouse myself out of bed, it's 8.30, turn my computer on, open the curtains to look at the weather

161

from the safety of my double-glazed shield, wheel myself into the bathroom to douse my hair with cold water, clean my teeth, get dressed, go and make myself coffee in the OT kitchen. I then work on my computer for two hours, take my anti-convulsants which I should take the moment I get up but they make me too drowsy to work, and then it's time for lunch. Sometimes therapy interrupts my routine which can be a good thing if I've nothing to say and I'm staring at a blank screen but if I'm busy writing I get hacked off because I lose my train of thought.

Tricia allowed me to walk with a stick today. It felt so liberating after being in that chair for eight months. I walked for seventy metres from the physio gym across the dining room, past the office and down the corridors, passing all the wards. I think I'll walk to Pete's Eats Cafe tomorrow, imagine what the guys' faces will be like when I just walk in with only my stick for balance. Then I will go to the counter and casually order a brew, I can't carry full cups yet so I will have to get Sara to fetch it to the table. Then I'll sit down with my mates and sup it.

There was a veritable feeding time at the zoo at dinner tonight. There was Cue Ball eating an invisible plateful of food again and there was Marty complaining, 'I'm not eating this crap.' There was a tiny sparrow of a woman who I'd never seen before lying in her bed which was wheeled into the day room by the nurses. She cried like a sparrow chick. 'Cheep. Cheep. Cheep.' And then there was Kevin telling the poor woman to 'Shut up, will you.' There was Cue Ball shouting 'Everton, Everton,' even though he's a Preston North End supporter and Phil was stroking the sparrow woman's hand lovingly, trying to calm her.

14th October

'The sights you see when you haven't got a gun,' joked Brenda the nurse fresh back from her holiday in Hawaii. She was behind the curtain with other nurses, Burt and Jill, and referring to the

naked body of Rodney who lay, beetle-like on his back, with limbs waving in the air. That's the scene I woke up to this morning.

But I was content in the knowledge that it was my final day. No more nights in that hospital bed, no more Rodney rattling his cot sides in the dead of night, no more Kevin shouting in his disinhibited manner in the early morning, no more Marty screaming, 'Get off my leg! Get off my arm!' because of his hypersensitivity. No more nurses in white uniforms, no more ward sister in her blue uniform, no more sitting at this very desk, at this very laptop, tapping away. No more overcooked dinners and no more evenings spent in front of the TV watching whatever trash is on the screen because nobody can be arsed to change the channel. No more occupational therapy, no more neuro-psychology, and no more physio with Tricia. That I'm not too pleased about. No more sitting out in the quadrant with a tab of an evening in shirt-sleeves and no more reclining out there in the sunshine. No more plastic cups of tea brought round by Pat, Helen, Liz or Margaret. No more Joy, Jill, Margy, Pat, Sue, Vera, the two Marks, Jenny, Brenda, Bert, Carol, Pauline, Julie, the two Christines, Hilary, Jean, Shirley, Irene, Mo, Lou, Bert, Ev.

19th October

Fontainebleau
I left rehab on the Wednesday and took off, by way of celebration, to Fontainebleau on Thursday. My first trip for nine months. Memories of the nightmare repatriation flight came back to me, as I was crammed in the back of a transit with six other men, between two wheel arches. It was beautiful in the forest, although I did have a twinge of enviousness as I watched all my mates exercising on the boulders. Fontainebleau is renowned for being the best bouldering area in the world and I really did enjoy my bouldering before the accident. Climbing in its simplest form, just you and the rock. No ropes or hardware, no harnesses or slings,

no helmets getting in the way. Fortunately, it rained for two of the four days we were there which meant that I had playmates to do what I wanted to do with, that is sit in pavement cafes, sipping expressos and watching the world going by.

1st November

After over ten months without sex I started to seriously doubt whether I could get it up, and if I could get it up, would my crippled body perform? I mean not only had I not done it for ten months but I had a serious head injury to contend with as well. Last night it happened over a couple of bottles of wine and it has rejuvenated me and made me feel normal again. I knew that I wouldn't be able to get in to all the positions that I used to but there is something inherently submissive and humbling about lying on your back and being made love to. We stayed in all evening when all around were partying and the children were knocking on the door and trick-or-treating. That's just one more healing process complete.

10th November

Since coming out of the Rehab my walking has been improving at an exponential rate. I am toddling a full half mile now which, after nine months, I think, means I've picked this walking business up faster than a baby. That is encouraging because it is effectively what I am doing, learning to walk from scratch. I have progressed from lying on my back in my cot, legs and arms waving in the air, to crawling and scraping around on the floor, to toddling. Apparently the conscious brain tries to put a padlock on the brain stem and hinder your walking, so it becomes more difficult to learn to walk again the older and more set in your ways you've become.

I definitely felt like a baby, walking on Porth Oer, which is a beach on the Lleyn Peninsula, seeing things with new eyes. The colour of the mud was a vibrant orange, the sand had all shades of grey in it, and whistled too, and the sea was a truly beautiful shade of green. It seemed as though I were wandering inside a Benedict Bevan Pritchard painting under crazy apocalyptic skies on the shore of an ocean reaching out to me and licking my feet. After a quarter of a mile I turned at a huge white tooth sticking out of the sand and returned slowly to the car.

13th November

My old friend Penny Croxford described my predicament thus: 'Neural networks are like footpaths and the more frequently they're used the better condition they're in. If they are left to fall into dereliction they become overgrown and more difficult to walk down. So it's in your interest to keep trying, using that footpath.' Penny's my physiotherapist at Bangor whom I received treatment from for a whole month with Stormont Murray before going to Clatterbridge. After nine months I've found my conviction for doing the arm exercises ebbing, in fact I haven't done any for an entire month.

Barbara is her superior; she didn't recognise me when I walked in, so used was she to seeing me in a wheelchair. We had an assessment today to see what my needs were. More hand and arm movement seems to be the order of the day and more balance in walking. My arm will work, of sorts, for five or so moves and then gets tired and gives up.

I knocked on the workshop door of Joy Hughes, the OT. Upon entering I was astounded to see all the splints and casts covering a whole wall. At a glance there appeared to be racks and masks and iron maidens and other articles of anguish. With all the sprung splints and gloves and finger casts it looked like Madame Whiplash's torture chamber. And across the opposite wall were the machines

that did God only knows what, machines with pulleys and levers and switches, handles that turn rollers, keys that turn in locks, Velcro items that stick to other Velcro items, cones, putty of all colours in pots, abacuses and rubber equipment. I would be visiting this place twice a week from now on.

17th November

David Rosenbaum in his book *Human Motor Control* suggests how a patient might regain control of a limb by seeing an image of the limb with greater mobility than it actually has. He describes an experiment (Rock and Harris, 1967) where subjects were told that if they put their hand in a box they would be able to see it moving through a window. Unbeknown to the subjects, they were looking at the experimenter's hand and as long as it moved in synchronicity with the subjects' they couldn't tell the difference. So it makes sense that giving the illusion of a limb moving can provide the incentive for me to attempt to move the limb on my own.

I now have textbooks and papers on neuro-psychology, neuro-physiology, neuro-biology, basic neurology, motor control, learning and memory. Then there are lay books such as *How the Mind Works*, *No Ghost in the Machine*, *Phantoms in the Brain* and *Emotional Intelligence*. I find that I am in a much better position to get a handle on my predicament if I can begin to understand it. The human brain is the most complicated of organs with over a hundred billion cells and more possible connections than there are atoms in the whole universe, so no one can truly understand it. But you can have a pretty good go.

24th November

I visited Clatterbridge again today to be discharged by my final therapist, Lise. Fiona, Tricia and Siobhan discharged me when I left the Unit but Lise had to see how I was faring at home. I walked down a grass banking with Dave Green pushing my chair behind me. The chair, incidentally, hasn't been used for a month and I was taking it back today. I felt like I was marching at the front of a procession with a cheesey grin on my face and all the nurses and therapists looking on in a row from behind the glass door. Sitting in the day room watching TV were a few new faces. Kevin remembered my name and where I came from but couldn't remember what football team I support. It was good to see him. I know which pub he gets taken to by his father. I will go and drink a pint with him one day.

Marty didn't know who I was and it was as difficult as ever to engage him in conversation, as he talks at you rather than with you. His twisted wrist and feet look better after the corrective surgery. It is distressing not to be recognised by somebody who you have seen every day for two months. 'My name's Paul,' I said, but he just looked at me and replied, 'Have you just been home for the weekend?' attempting to mask his non-recognition. He had no idea that he hadn't seen me for six weeks. He'll get better though.

Cue Ball was out for the count, catching flies, with the back of his cue ball head resting on a pillow. Phil had his head on the table and seemed to be frustrated with something, agitated. I don't know if he recognised me but when I enquired how he was, he simply replied, 'I'm fucked.' There were a few less angelfish in the tank. Either they just keep dying or the monster plec keeps devouring them. It was good to see Jenny and Pauline and Mark and Vera and Lise, too.

27th November

It was the Lentil and Merlin who drove me up to Liverpool's
Fazakerley Hospital for a MRI (Magnetic Resonance Imaging) scan.
I was shown to a cubicle and had to change into a gown that tied
up the back, so I needed helping. I walked to the scanner barefoot,
which is always painful because my toes clench onto the floor so
tightly and unavoidably. Being led into a green room I saw a
gargantuan machine, like an industrial tumble-dryer. My ears were
plugged and head locked in place and I was slid into the tumbler.

The assistant cleared off behind a lead-lined glass screen so as
not to get too many radioactive rays. There was a lot of clicking
and whirring and, in the background, the sound of a jet plane
taking off. Then the voice of an air stewardess was asking me if I
was OK and comfortable enough over an intercom. Suddenly I
began to wiggle my toes and in the excitement of it all forgot to
keep my head perfectly still. The radiologist had to repeat the
photographs four times before she was happy with the result.

We then headed to the Salvador Dali exhibition at the Tate
Gallery in Albert Dock, a place I am getting to know rather well.
After having my brain dealt with in the scanner I was now having
it bent by the Dali paintings of dripping clocks and telephones on
crutches.

1st December

I have put ads in the cafe and shops and outdoor centres around
here, 'CLIMBING GEAR FOR SALE'. Two pairs of ice axes, two pairs
of crampons, literally hundreds of nuts, cams and karabiners, ten
pairs of rock shoes and four pairs of plastic mountaineering boots,
stoves, helmets, ropes, skis, sleeping bags, bivvi bags and assorted
clothing. Literally thousands of pounds worth of kit.

I had no idea how much it would hurt to get rid of my equip-

ment until the first guy showed his face at the door. It felt as though I was selling fifteen years of existence down the river. I was choking up as he was rummaging through my life, trying on my boots and checking my helmet for fit. I had to turn away and hide my tears when he asked me how much. With each piece of cloth or metal came another memory; those boots I wore climbing that gully on Meru, in the Garhwal Himalaya, and that rope created a thread between Celia and me as we moved together on L'Aleta de Tiburon, the Shark's Fin in Paine, Chilean Patagonia. And there on the window sill was the blood-soaked windproof which they had to cut off me when I was in pre-op. Don't ask me how it found its way back here. It was like some grisly holiday souvenir that was following me to the ends of the earth.

10th December

I threw all my notes on mountains away about three months ago. I didn't know what I was doing. All I knew was that I didn't want all this stuff cluttering up my life any more. I had boxes of information that only I have and now it's gone into the shredder – topos, diagrams, lists, photos, maps and drawings all on the garbage heap. When someone came around the other day to use my library, my mine of information, I guiltily told her, 'Look, I threw it away in a rage.' At least I didn't incinerate my slides, of which I have thousands. I must have been wearing some sort of self-preservation helmet.

15th December

Wirral Neuro Rehabilitation Unit Christmas party.
I caught the train for the first time since my injury and on my own, too. This may not sound like much but I was frightfully intimidated. Scared that I wouldn't be able to get onto the trains

169

or that I would miss my connections, and worried, too, that I wouldn't be able to get off in time at the relevant station. As it turned out it was a breeze and I shouldn't have troubled my head about it at all. I guess your self-confidence and self-esteem take a crippling blow when you've been through what I have. But I am a pretty stoic chap and I'm now regaining much of what I may have lost.

Cathy and Angel met me at the station and took me to the Unit's Christmas party. All the loons were there and a fair few patients as well. Dave's had his knees broken so he didn't look like his legs were on display any more. He's overjoyed about that, you can see it in his eyes. After twenty years of waiting he has good reason to be. His feet are next. Marty recognised me so his cognition is improving and, although Phil still doesn't remember me, he is very pleasant and always acknowledges me. Kevin has left, an important event seeing that he has been there nearly two years. He was awaiting a bathroom extension being built and when that was finished he was out of there. He is still making improvement, albeit by very small increments and perhaps he will get better more quickly, as I have done, once he's home.

Cue Ball was still there, mouth agape, his bald head tilted right back. Jean has sadly gone into an old folks' home, even though she's not that old. It's just that her husband can't, or doesn't want to, look after her. I remember her family discussing what to do with her. Her daughter wasn't too happy with the arrangement, her son was accepting of it and her husband, who looked like a Nepali with a skull cap, was all for it.

The very first thing I did when I walked into the day room was check out the fishtank which was down to two angelfish and the ever-growing plec, which may or may not have eaten the others. Carol the secretary was busy serving tumblers of wine through the hatch while, on their second bottle of vodka, some nurses, the usual suspects, were trying to recreate the summer barbecue (and succeeding). I won a bottle of brandy on the tombola, which was the only prize suitable for me amidst a sea of pink

170

knitted toilet roll covers and baskets of soap. Cathy and I spent most of the time round the 'smokers' corner' having a crack with Joy, Mark, Lou, Jean, Dee and Shirley.

But the party was a little sad because I knew that that was it. I couldn't go on returning to Clatterbridge, so I was saying my farewells to the place. However much grief the actual building gave me I have very fond memories of the staff and patients there. They had become like family to me but when I walked into that day room my head filled with ghosts, so I have to divorce myself from it totally.

1st January, 1999

My New Year's resolution is simply to get down to some work again. I've been, how shall we say, 'on one' ever since I left Clatterbridge, celebrating, partying as if I'd just come out of the nick which is effectively where I'd been for nine months. OK, so I was allowed home at weekends but so are some prisoners; I still had to sign an 'out book' whenever I wanted to go to the canteen. Obviously there is a good reason for this as you couldn't have brain-damaged patients running amok all over the place. Clatterbridge was very conducive to writing; it was either watch the telly or sit at my computer and write, so there was really no choice. But my workrate has plummeted in the past ten weeks since leaving the Unit, there are so many diversions and distractions.

My friends have been talking, worriedly, about my consumption of alcohol and how that will mix with my anti-convulsants. I appreciate their concern but I have a good idea of what my limits are and the fact that I have lived through it and am back to writing now must surely count for something. It just felt like a thing I had to do, a blow out, and everyone's entitled to a blow out once in a while, especially if you've been locked up for ten months. I'm over it now.

V. S. Ramachandran writes in *Phantoms in the Brain*: 'The right

171

hemisphere [of the brain] is a left-wing revolutionary that generates paradigm shifts, whereas the left hemisphere is a die-hard conservative that clings to the status quo.' I have left hemisphere damage, which supposedly indicates that I cling less to the status quo and generate more paradigm shifts. I'll let you know when that happens.

3rd January

George Smith was 'commissioned' to make a virtual reality mirror box for me and it arrived today. It is a curious thing that attempts to trick the brain into thinking that one has two functioning hands. Placing a mirror vertically inside a cardboard box with the lid removed is all that it takes. The box then has two holes cut in the front through which I was to place my limp right hand and my strong left hand. The reflective side of the mirror is placed so that it faces my left hand and my right hand is hidden behind the mirror if I position my head properly.

The effect is that I see my actual left hand and the reflected image of it representing my right hand. If I were to try moving both hands in synchronicity, would I be able to hoodwink my brain and get my right hand to function again? It is an experiment that I read about in one of my neurology textbooks but in that case it was used for patients with phantom limbs and chronic phantom limb pain. I thought there was a small chance that it could be of some use in hemiplegia, though I couldn't find it documented anywhere. All I can report is that it didn't happen instantly but I expect it to take a few weeks, if it happens at all.

14th January

It is said that Shostakovich had a piece of shrapnel lodged in his brain by a shell explosion in the First World War and if he tilted his head to the right he began hearing incredible symphonies. The shard of metal shifted imperceptibly and stimulated an area of his brain that is geared to creating music. Another patient, at sixty-five, had a stroke and began to appreciate poetry for the first time in his life. Why can't I be like one of these patients whose lives are enhanced by their head injury instead of being beaten and battered? Sometimes I wake up and cannot get out of bed because I am so stiff.

Getting the bus from the station to Wirral Neuro, I suddenly became embarrassed. Maybe I'm hassling them too much. Maybe they don't want me hanging round all the time. There comes a time when you have to break free of these units, however long you've been there. There is the danger of clinging on to the nurses' apron strings when you are let out into the big open yonder. But I was only there to see my medical records and that is my right since the 1992 Medical Records Act.

Jill Chappel is now the head honcho of the physiotherapists. She totally surprised me when she said that we had mutual friends. We shared three friends, two of whom I knew very well. Did she know of me before my accident? I didn't ask her. For eight months she had kept a big secret from me. 'Patient confidentiality,' she answered simply.

In the office of the chief of medical records, Alison Whittlestone, I pored over my notes:

'No evidence of osteomyelitis' ... 'The right frontal bone extending inferiorly to the floor of the right anterior cranial fossa (superior orbital roof)' ... 'Frequent delta/theta appear maximal over left temporal region with maximal amplitudes occipitally.'

I had no idea what they were on about but I resolved to find out with the aid of my textbooks. The CT scans of my head from

Tasmania looked shocking. There was the thin skin of skull and the grey matter but then, there was a white fuzzy patch virtually covering the whole of the left hemisphere of my brain. This was the site of the impact of the rock and the contusion. I stared at it until I felt nauseous. I had numerous pages photocopied, thanked Ms Whittlestone, and left the office.

9

RETURN TO THE TOTE

People are greater than the arrangements of the world and more powerful than their psychological constituents. Will is all and if we can only realise this, a true transcendence or rising above the rules of the world is possible. In the face of total and moral relativity, the self is immanent, freedom to act is absolute.

Stanley Cohen and Laurie Taylor
Escape Attempts

Finding my air ticket lying on the doormat I was suddenly hit with the reality of my situation. I was going back, flying back to Tasmania, and on my own. If taking the train was new and intimidating, so would be negotiating airports and boarding aeroplanes. I had no idea how I would cope. But I just had to take the bull by the horns and go for it. Then there were the Tasmania Police Force who rescued me, the nurses, the therapists and surgeons to meet up with. I didn't know how I would feel about that; probably highly emotional.

But looming over all of this was the beast itself to confront. That was the real reason why I was going back to Tasmania. That was the essence of why I was flying halfway round the world. It was a pilgrimage and I could not relax until I had gone back to the place, seen the Totem Pole and, more than this, seen the scar that had been left by the rock when it parted company with the face to which it had been attached for a million years or more.

A recurring nightmare began plaguing me that the Totem Pole had turned into a giant sea snake or serpent, or maybe it was a dragon. It had taken on a live scaly appearance and it reared out of the sea in front of me. Its head was level with me as I stood at the rappel point, looking straight into its eyes, its mouth. I could see its fangs, could smell its warm sickly breath, it was so close. At that point I'm not scared as such but then it begins to grow and grow until, like the proverbial beanstalk, it seems to reach the sky. That's when I wake up sweating. I can interpret this dream; firstly, it is the one thing that has changed my life irrevocably and secondly, because I was writing a book about it I haven't had a chance to forget it for one moment. Thirdly, I was imminently returning to the scene of my accident and, not only that, but it would be exactly a year to the day that I would see it again. So it's hardly surprising that I should have such fevered dreams.

The taxi came at 8 a.m. on a drizzly day. The driver, who instantly struck up conversation, fascinated me. He told me he was struggling as an artist and that this job was only a way of making ends meet. He was skinny, middle-aged, had big grey side-burns that held on his mass of curly hair, also grey. During the hour and a half drive to the airport we never shut up and the areas we covered ranged wide.

He told me, when he was a boy he used to go out to Ynys Enlli, an island off the west tip of Gwynedd, for the family summer holiday. One afternoon whilst exploring he came across a nest of snakes and, although scared at first, felt impelled to put his hand into it. He received eight bites and became very ill. 'My parents thought they'd spawned a mad child,' he told me, 'but afterwards I felt strangely uplifted, like I could do anything, tackle anything. I felt invincible.' He said he'd been reading up about the therapeutic properties of snake venom and told me that that is why the British Medical Association have two snakes writhing together as their symbol. This story grabbed my imagination but all too soon we were at Manchester Airport.

No longer could I just sling a rucsac on my back and set off

around the world. I had had to buy a plastic suitcase that wheeled along. I felt extremely self-conscious rolling that thing through the airport with all the other business people. But I still managed to look different with my ungainly gait, my leg being thrown out to the right with every step. Occasionally I would stumble, almost fall, forcing passers by to attempt a catch. They would stagger this way and that like a goal keeper in a soccer match who doesn't know where the shot is going to come from, arms out wide. But I never fell. I even took to playing this game where I almost collapsed into the arms of people I knew I could get a reaction out of. An amusing way of meeting folk.

Because of my disability I had innocently assumed that the BBC would have forked out for a first-class ticket and have things laid on a plate for me, but that wasn't to be. I was left to fight my way onto the airliner with 300 other people. At first this really pissed me off but then I thought of it as occupational therapy. I didn't actually want different treatment to everyone else. I desperately wanted to be the same, even if that meant being the last one on and finding all the overhead lockers full. Anger and frustration gripped me in the beginning but towards the end of the flight I mellowed out and learned to relax.

In the departure lounge at Melbourne I was met by the whole film crew, seven in all, who had flown in from the States. The safety team of Mark Diggins, Dave Cuthbertson and John Whittle I know well, as I do the assistant producer, Brian Hall. The producers, Meg Wicks and Richard Else, and the cameraman, Keith Partridge, I have only met through this film. The scale of the operation hadn't really hit me until this moment; we would be ten when we met up with the climbers, Steve Monks and Enga Lokey. It was very apt that they were climbing the Totem Pole for the film because they were the last people Celia and I met before the accident.

I started to panic. What if I couldn't give insightful and interesting answers when interviewed? I often couldn't when I was nervous or put on the spot. I kept my doubts about it all well buried.

Richard and Meg are very professional, and have the knack of leading you on to interesting answers.

During the Melbourne to Hobart flight I sat next to Dan, a Vietnam War veteran from Paradise. Paradise, it turns out, is in Northern California. We got chatting and, after telling him why I was returning to Tasmania, the subject soon turned to near-death experiences. He told me of the time he was in the field and surrounded by Viet Cong guerrillas. It was late at night, he and a friend were keeping watch. They had strung out lines all around the camp and to these had attached tin cans to warn them if the 'commies' were trying to creep up on them. 'A gust of wind must have blown,' he told me, 'the cans rattled and this dude panicked.' Dan became strangely animated. 'He started shooting this Bren gun.' Dan was transported back in time right there. 'Rat tat tat tat tat.' It was as if he was the one firing the machine gun. 'That guy would have cut me in half if some invisible force hadn't pushed me to the ground just in time. To this day I do not know why I hit the deck that night.'

Enga and Steve were there to meet us at Hobart 'International' Airport in wild weather. It was the term 'international' that I found comical for a collection of sheds on a desolate runway. They weren't prepared for how I just sauntered down the steps off the aircraft and across the landing strip. The last time the two of them had seen me I was on my back with no movement or feeling in my right limbs, and only up to the odd grunt.

The last time I saw this patch of tarmac was from a stretcher, horizontal and melancholy, but content to be on my way home. It had started. The flood of memories. I felt like I was on the downstream side of a bursting dam, unable to hold the weight of memories that was cached behind it. I was happy to see Steve and Enga, though it didn't feel like one year since we had last met. It seemed like a lifetime ago since they had come to visit me in the hospital. We drove past familiar landmarks, Seven Mile Beach, the twin causeways out to Sorell and the wine glass stem of Eagle Hawk Neck. When Port Arthur was a penal settlement the guards

used to have mad dogs strung out between the two beaches, about a hundred yards apart, to deter escapers.

I allowed my mind to wander. I started to think about all the deaths, over the years, between the shores of this small island. Long before the term 'ethnic cleansing' was invented it took place here. There are no full-blooded aboriginals left to tell the long history of Van Dieman's Land, as it was previously known, just a handful of caves and tools, deep in the bush, to remind us that they once existed. And then there is Port Arthur itself with its Island of the Dead, home to 1700 convict graves. Once murderers and thieves would be sent there but now you pay twenty-five dollars to visit 'the Site'. I thought this ironic. In the ruins of the Broad Arrow cafe I even saw tourists photographing the bullet holes where Bryant let off. There are a lot of ghosts in Tassie.

We arrived at the Fox and Hounds in the dark. All done out like a Tudor mansion, you can visit 'Ye Olde Bottle Shoppe', which is drive through, and drink in the Robert Peel Bar. The hotel was in the grips of a power cut and candle flames danced and flickered in the squinting light. Waitresses like phantoms glided here and there in the semi-lit restaurant. We heard from the manager that the wind had ripped the roof off the house. 'Good timing for a film,' laughed Richard.

I awoke early, unable to lie in, to a morning as still as a moment, the Tasmania I remembered. I opened the back door of the 'cottage' and, bleary-eyed, surveyed the scene. Exotic birds were bleeping and whistling and making sounds that one would think only synthesisers capable of. The sun came up over the gum trees, which looked like giant broccoli spears with the bark hanging off them, like rags off a tramp. The inlet was so smooth and reflective that I felt as if I could take a step onto it and walk about on its salty water.

Although it was only twenty-one years old, the hotel seemed ancient, like one you would expect to find in the Highlands of Scotland. The obligatory coach party from Yorkshire, or in this case Melbourne, turned up for breakfast, all slacks and purple rinses.

We joined them, suffering from jet lag, in a scrum for the buffet. Then I made my way outside again.

The pulse of a helicopter, which was no stranger to me, only just perceptible to begin with, got louder and louder until it ruptured the tranquil atmosphere of the morning. A floatplane had to be moved and the machine landed by the loch-side. I was stunned to see that the name of the company was Helicopter Resources, the same people who had rescued me, though this was a different pilot and another machine. I was told that I was having a rest day after my arduous flight, while the others rigged the stack for filming. In the first foray were Steve and Enga who knew Cape Hauy very well. Hopefully they could find a spot, flat and clear of trees, to put the helicopter down.

After twenty minutes Bill the pilot returned with a worried look on his face.

'There's one landing place on the whole bloody peninsula and even that's crook. I just can't put her down there. I'll have to keep the rotor going and just sit the skis down on the rocks. Think you can handle that?'

Was he questioning me? I hadn't a clue whether I could handle escaping from a hovering helicopter. The nearest I'd come to that since my injury was getting out of the passenger door of a stationary Fiat Panda.

I mooched around for the day quite glad to have time to meditate on my position. I was sitting reading on the front doorstep when a pickup pulled up on the roadside in front of the cottage and out jumped a burly guy with tattoos on his arms. He pulled a spade from the back of the truck and with one scrape scooped up a wallaby corpse. There's a huge number of dead animals on the road in Tassie, echidnas, pademelons, poteroos and the famous Tassie devil. I thought what more satisfying job could one have than scraping road kill up for the council! That evening I realised just how film crews are forced to survive on BBC expense accounts.

Sleep wouldn't take me that whole long night, even though I

tried to anaesthetise myself with wine, knock myself out with brandy. In my mind I was running over the scene of the accident again and again, swinging in that long arc on the end of the rope and then . . . nothing. Celia's voice shouting to me, blood in the sea, being hauled up on the end of a cord eight millimetres thin, the struggling to get onto the ledge, fighting a losing battle to stay awake whilst the blood pooled on the shelf. I could still hear Neale's words, 'You'll be all right, cobber,' as he tried to comfort me. All these things, it seemed, only happened yesterday.

I was terrified of flying in the helicopter which in my imagination now represented a sinister menace. I had been only barely conscious the other three times I had flown in one, for they were all rescue operations. For the Gogarth incident and the Creagh Meghaidh accident I was in an extremely traumatised state and during my rescue from the Totem Pole I remember the incessant noise of the helicopter like some bad dream. So I associated that damn machine with suffering and pain and nightmares. Even though it had saved my life on three occasions and I felt eternally indebted to the pilots and flight crew, I was positively frightened of getting into one. And how I would perform dismounting from a hovering helicopter I could only guess.

Sleep overcame me just as dawn was breaking and the next thing a larger than life John Whittle was calling to me, 'It's blowing some but I think we'll fly.' Poet, philosopher and pianist, John Whittle has been described as the Leonard Cohen of British rock. As much at home playing classical or jazz, Bach or Gershwin, his stocky frame and stumpy fingers belie his charming nature. He has swept back white hair and a musical voice which can disarm even the hardest soul.

When the helicopter came in to land I realised why everyone was wearing long trousers. The sand blew up under the rotors and stung my legs something rotten. We waited for the rotor blades to stop before I was bundled in between Keith and Brian. Enga was up front next to Bill, the pilot. The engines started to roar and we lifted slowly out of the trees before accelerating over the

water. Each time we dropped, ten feet or more, my heart would jump into my mouth and my testicles would find their way into my stomach.

The first feature I recognised amidst the green blanket of gum trees was the crescent moon of white sand that is Fortescue Bay. We carried on across the bay and I could just make out the one bald patch amidst a forest of chest-high tea trees. Bill hovered the machine just long enough for Keith to jump out and get in position. This then meant that I could be filmed struggling to launch myself out of the helicopter.

We lifted off again for a flyby of the stack itself. In an instant we went from being ten feet above the forest to 400 feet above crashing waves battering against cliffs. This peninsula is like a piece of cheese. In the west it dips harmlessly into Fortescue Bay while in the east there are huge dizzying walls plunging menacingly into the Tasman Sea. Then there it was ... the Totem Pole. As a candle you would find on a child's birthday cake when viewed along side the real Candlestick, it didn't look impressive at all, like the runt of the litter among its giant family. No, from the air is not the ideal way to see the Tote. It hardly even looked real.

Richard and Keith were waiting for us when we came into hover. I had to wear a helmet 'to stop my head being cut off by the rotor blades' they said, and Brian was holding me on a leash like a pet dog. Jumping out of the helicopter wasn't as bad as I thought it was going to be. Having Richard right there in my face, asking me questions about what it was like seeing the tower again for the first time since my accident, however, was. How could I tell him that it didn't look very impressive at all? That wouldn't make very interesting TV, would it? I enthused. I lied.

It was about two kilometres from the landing site to the headland. Further than I had walked in the last year and then I would have to make it back again. The safety team had a stretcher on hand just in case I couldn't make it but I was determined. It was terrain that I wasn't used to, up and down steep hills and very rocky. If I had twisted an ankle, which was highly likely, that

would be it, end of my story for the television. I could only just lift my leg over some boulders or fallen tree trunks and in one place I even had to traverse a crag. The slabby wall was about ten foot high with a shelf, just wide enough to take a foot, running horizontally across it. I had to negotiate that with a combination of hopping and one-armed slaps and at one point I very nearly overbalanced and fell backwards. Brian, Digger and John were clinging onto my ankles with arms held high like footballers gathered around the FA Cup, while I teetered on the brink.

When I arrived at the end of the promontory I peered over the cliff edge and saw the Totem Pole. The updraft was as if you put your head out of a car window travelling at sixty miles per hour. I felt joyous and alive for the first time in a year. I saw little beautiful things this time around that in my selfish rush to achieve I had never even noticed before: the lone eucalyptus tree at the very edge of the cliff, the huge logan stone poised dangerously on the angle, the pouf cushion plants clinging to the vertical walls of the Candlestick. The banksia trees with their unmistakable hairy cones like faces. And the lichen hanging like green Rasta's dreadlocks from all the tree branches. Apparently the presence of these lichens indicates the purity of the atmosphere hereabouts, which is undeniable.

And then there was the Pole itself. How could I not have noticed that single flowering plant growing out of the bare rock, right on top? How could I not have noticed that the top half was a completely different colour to the bottom half? Yes, the upper one hundred feet is lichen-covered and orangey-grey, whereas the lower hundred feet, up to the ledge where I lay for almost ten hours, is black and wave-polished. I imagined the waves that must on occasion run through the narrows. When the wind is coming from the west and blowing with certain ferocity and a swell is running, one can picture the scene. Half the tower submerged, white water coming right up to that ledge.

All my climbing life I've been dedicated to the pursuit of climbing such needles. Like a hunter of pointed trophies I have ascended

towers from Pakistan to Patagonia, from the Arctic to the Equator, from the Utah Desert to the Himalaya. I suppose it is because there's no easy way up a tower, no path around the back. It is inaccessible without great skill and determination, on all sides. To quote the legend of pre-war climbing in Italy again, Comici has this to say:

> The climber who is able to divine the most logical and the most elegant way of reaching a summit, disdaining the easy slopes, and then follows that way, his nerves stretched to the limit, sensing his own inner conflict and aware of the effort needed to overcome the drag of the depths at his heels and the swirl of space around him . . . That climber is creating a true work of art, sometimes of exceptional quality; a product of the spirit, an aesthetic sense of man, which will last for ever, carved on the rock walls, as long as the mountains themselves have life.

Perhaps I wanted to save big walks up snowy mountains for when I was older, but judging by how well I had just performed on the path, I allowed myself the indulgence of dreaming that I could, possibly, do them in a couple of years.

Watching Enga and Steve climbing the Totem Pole I had a sad, silent feeling, like a memory, but also those adrenaline surges that would not abate. I began to feel jealous as Steve climbed with fluid movements, Enga thoughtfully paying out the rope from her belay, hanging on a bolt. Enviously, I watched his move around arêtes and, with the grace of a primate, up a hand jam crack. Enga couldn't see him any more and she had to pay the rope out by feel alone, blind. I observed quietly as he smoothly surmounted my ledge and for an instant, as if in a freeze frame, with feet and hands on the ledge, I had the impression of an ape more than ever.

He slipped a keyhole hanger over the carrot and roared, to reach above the noise of the sea and round the stack to his rope mate,

'OK, ENGA. I'M SAFE. TAKE – OFF – BELAY.' As Steve was taking in the slack the rope whipped about in the gale and I was joined in my viewing by a sea lion who was watching so intently it might have been taking lessons in rope work. Enga had been hanging in her harness for two hours by this time and, although stiff with cold, made a fine job of climbing after Steve. He was sitting with his legs dangling over the side of the ledge and, playfully, she fell upon him when she got there. For a moment, so brief, I saw Celia and myself down there on that same ledge having a laugh.

It was now Enga's turn to lead on the top arête and I gave myself some slack in the safety rope the team had put there for my benefit to get a better view. She stood on the ledge with her head bowed, the fingers of each hand touching, like a gymnast contemplating, about to commence her routine. Then she launched off up the edge with all the strength of a power lifter and the nimbleness of a ballet dancer. After clipping the rope into the first bolt she paused and groped blindly with her right hand to find the side-pull, which would enable further upward progress. Second bolt . . . Third bolt . . . One can divide a climb of this type up into the sections between each bolt, a bit like a dot to dot drawing. The rock was damp from recent rain and the wind was still gusting with a gale's force.

I could see her swinging like a barn door every time a new gust of wind came forcing its way through the channel. John, who was in charge of making me safe, said in mild-mannered amazement, 'That channel's the perfect shape for measuring the Venturi Effect! And the Totem Pole is smack bang in the middle of it.' I could make out the grimace on her face, even though I was a hundred yards away, as she fought to stay in contact with the rock. Enga was slowing down, fatigue was taking her, but she was still making upward progress. Clinging on still. Fourth bolt . . . Then, like a dandelion head being blown on by a child – one o'clock, two o'clock, three o'clock, four – she parted company with the rock. For a brief moment the dandelion clock stood still and Enga was neither in contact with the rock nor in the act of falling. She was

185

frozen in time and space, before the invisible thread that was suspending her broke and she plummeted, only a short fall. Enga lowered back down to the ledge dejected. I got the impression she had her heart set on this ascent. The wind and damp conditions and the stress of being filmed, and not being able to wait for calmer weather, had thwarted her.

Now Steve would try. He pulled the ropes through the karabiners and they swapped the ends around. Enga put the rope leading to him through the belay plate. I craned my neck over the cliff edge in the furious updraught but I couldn't see the rock scar from such a distance. I would have to wait for that until I could get a boat out, which we had planned for later. Steve's style of climbing was markedly different to Enga's. If Enga was a ballet dancer Steve was a boxer, hopping and prancing and snatching at hand holds. A skinny Mohamed Ali dancing and stinging. He paused where Enga had fallen and, obviously struggling, wiped the dampness off his hands onto his trouser leg. Then, reaching into the depths of his chalk bag with his right hand, he pulled out a small handful of the white powder to finish off the drying process. One's hands must be totally dry to climb well, as must be one's boot soles, which he kept wiping on the inside of his calf muscles in a kind of Irish jig.

Steve hung there, feet scrabbling, searching for a foot hold, almost off . . . Then he found one, a tiny rugosity and his feet stopped pedalling. If it wasn't for the gale you would have heard the producers, cameraman and safety crew breathe a sigh of relief. He regained his composure and clipped the rope into the fifth bolt. After resting on one toe for a couple of minutes he moved on up the arête with his customary ease. I could tell he was familiar with the climb when he reached up for a hand hold without even looking for its position. A good climber will always remember every important hold on a climb and that could be literally hundreds of holds. Now apply this to the thousands of routes Steve or Enga have done and that probably amounts to millions of holds all memorised and filed away for use at a later date. I considered

186

this fact for a moment and then came to the conclusion that climbers are just plain weird.

He cruised up the final few feet and clambered onto the summit somewhat less stylishly than when he had set off on the climb. He was quite obviously knackered from his ascent. I now felt joy not jealousy at their success as Enga followed him up the last pitch. She trailed a rope behind her, which was attached to the top of the mainland cliff, the one they had abseiled on. This allowed them to rig up the all important rope traverse so as not to leave them stranded on top of the Totem Pole. Steve later told me that it was very strange for them, too, this returning to the Tote. They had kayaked out there and retrieved the rucsac a year ago. They had helped us all they could. Now, in a filming situation, the two of them felt at odds with their genuine feelings when acting in front of the camera.

The hour was getting late and I had to get back to the helicopter pickup site. With my entourage looking after me, and making sure I didn't slip on my slow walk back along the path, I felt very important. I could hear Meg's laugh, like a kookaburra, as she came trotting along the path behind us, her silver hair pasted to her forehead with sweat and spectacles askew.

Dave Cuthbertson enquired after my wellbeing in his Highland accent. I replied with a positive affirmation and spent the rest of the hour stumbling and falling and ruminating on his skill as a climber. Cubby was one of the best climbers in the world in the late 'eighties. Small, with the forearms of Popeye and a braveness to match, he is immensely strong and at the same time a mild-mannered gentleman. The first time I had seen him he was on the famous Snell's Field Boulder in Chamonix doing all sorts of gymnastic contortions without using his feet. He didn't have any use for such things as feet. I was sixteen years old at the time and very shy with it and didn't dare approach him.

Although I felt exhausted I made the return journey without any assistance. This was very important to me, as it is to any pilgrim. For that is what it was, a pilgrimage to pay my last respects

187

to a lump of rock that had done me such damage. My journey had to be difficult and treacherous and scary for it to have any import, and it fulfilled my expectations admirably. I astonished myself how well I coped on this journey I was making, purely for sentimental reasons, to a sacred place. Forever onwards this place would be full of meaning for me, like hallowed ground. But I still had two more journeys to make; one to the Royal Hobart to visit all those nurses and therapists who brought me back into the land of the living, the other to see the rock scar that I hadn't been able to see from the cliff top.

I had a vivid and fevered dream that night in which I was climbing perfectly, high above the ocean. It could have been on any cliff but perhaps it was the Totem Pole. Anyway I was simply ascending without the least modicum of effort, occasionally using only the one finger of each hand, sitting my bum on my heels whilst dipping into my chalk bag. It was so realistic I could feel the wind in my hair, smell the sweetness of the salt and the ammonia of the bird shit upon the rock. It was seeing Enga and Steve climbing up that rock that did it, stirred in me passions for climbing that I wanted to forget about but, alas, they weren't very well buried.

Walking into the Royal Hobart Hospital I had the strangest feeling, that I was entering a grand museum or gallery because of the all-pervading echoing silence and the muted voices, which sounded like summer bumble-bees. I walked through the same door, took the same lift and walked down the same mile-long corridor, pausing only to study the picture of the child burn victim, still smiling. Stepping into reception of the Neuorological High Dependency Unit, I felt the adrenaline surge like I'd never felt on any rock climb. My gait went all to pot, stiff-legged and tiptoed with my arm raised up out to the side and bent, as if carrying an invisible bag of groceries.

Before, I hadn't noticed how little natural light there was in the reception area, only fluorescent lightbulbs, which cast a permanent

twilight over the scene. Nurses I could recognise but whose names I couldn't remember gazed on me in amazement. I felt like some kind of Lazarus man, back from the dead. 'Lazarus, arise,' said the therapists, nurses and doctors of the Royal Hobart and so I did. But, unlike Lazarus whose return to life took only a day, my return took a whole year. I had no qualms about asking a person's name on which to hang their features, so it was with no trouble that I enquired the name of the woman with the familiar face and blonde hair who was always smiling. 'Andrea,' she said with a half grin, half laugh. 'You're coming on, aren't you? There's someone else who should be very pleased to see you. I'll just get her.' She ambled off into the darkness of a ward which was reserved for patients with photosensitive eyes.

Jane Boucher was the nurse I first wanted to see. We hugged. She had been expecting my arrival but not so soon. Jane was as full of youthful energy as I remembered, all big eyes, pale green and full lips with a strong body belying gentleness and compassion. We arranged to meet up for a coffee in Salamanca. She said in her sweet Tassie cadence that she couldn't chat now, 'Some people have work to do.' I told her that I understood and took myself off to see whom else I recognised.

There was Ian and Alison and Denny and Dr Mujic, Kylie and Jenny and Moy . . . Moy of whom I had been so terrified! She was tiny, I towered above her now that I was on my own two feet, but she was still stocky. I stared at her, not believing how I could have been so scared of her, so deluded. And as I stared, Nurse Moy walked over my grave and I remembered back to that time in ICU as if it was yesterday. The child in the cupboard, the six Jews, the roses, the old woman, and Nurse Moy giving the lethal injection. And now as she looked up at me, with a beaming smile, saying 'I read your book,' in her awkward Hoken Chinese accent, my fear of a woman, that I had been harbouring somewhere at the back of my injured brain for a year, melted away and I knew I could lay that nightmare of my past behind me.

<center>★ ★ ★</center>

Some deeply buried memories were brought back during my visit to Sue Duff, in her new wooden house built on stilts, some traumatic, some pleasant. There, in the doorway, was exactly the woman I recalled – mature and beautiful for it, with tied-back fiery red hair. To see me walking down her steep driveway she described as 'A miracle. I mean, when I last saw you you were on your back and now, after a year, you come strolling down my drive.' Sue asked me, in her northern English-cum-Tasmanian lilt, 'D'you find that you're getting any more spiritual these days?'

And I replied that I know that I should be and it must seem that, after three major accidents and not copping it, somebody somewhere is looking out for me. But my rational brain keeps telling me that it's all horrific coincidence. We spent our time reminiscing over what had come to pass in the last year. She said that I'd been given an amazing challenge and had risen to it.

We played around with plans to take disabled people trekking in Tibet, especially around Mount Kailas, a sacred mountain. It is said that one circumambulation erases the sins of a lifetime and heals all ills. We'll have to wait and see whether anything comes of it.

Sue was easy to talk to, so relaxed and disarming. I remember telling her something that I had never told anyone else before. I recounted to her how our safety man John Whittle had been listening to the radio and had heard on the news of an avalanche in his home town of Chamonix in which twelve people had died. He immediately telephoned Cham where he learnt that there was no damage to his house but that the gendarmes still hadn't released the names of his dead neighbours. He discovered at the same time that a young man called Jamie Fisher had died on the Droite's North Face. 'Did you know him?' he asked.

I had a clear picture of Jamie's face as he approached me in the Vaynol Arms, a local pub. He had a baby's face. 'Hell, he was only twenty-two,' I related to Sue. 'He was looking for information on a mountain called Meru in the Garhwal Himalaya.'

'I know it,' said Sue.

'I had attempted it and told him all I knew, especially about the approach gully, which was really very prone to avalanche. He had those eyes, extreme eyes. I remember worrying when he left for Meru thinking they'll either climb the mother or die. Luckily they all came home.'

I didn't know Jamie that well. In fact that night in the pub was the only night we'd met, but somehow his death, frozen on a ledge close to the top of the Droites, touched me. Looking at him that evening in the pub was like looking in a mirror, seeing the same obsession and single-mindedness that I displayed. Perhaps I was going that way? 'Let's just say that this accident might have saved my life. I was taking too many risks, pulling too much rope out of the bag.' I went on, 'It took something this serious, this close to the edge to stop me. And now I have been forced to stop I don't know what to do with myself.'

The date was Saturday, the 13th February, exactly one year to the day since my accident, the Totem Pole and my paper anniversary. The date on which I was joined to that piece of rock by phenomenal yet painful ceremony. I had come to see the rock scar, that ineffable space that was my undoing.

Rod Staples, whom we had met briefly last trip, came with his motor boat on a trailer behind his four by four. We met him at the Fox and Hounds and bumped and ground down the forestry road to Fortescue Bay. We put into the still water of the bay amidst stair-rod rain and motored off into the clagg. Up ahead the velveteen surface of the bay was punctured by this downpour, whilst behind it was churned up by the deafening double outboards. Rod had to put the propellers into reverse occasionally to shed them of kelp.

Our pilot told me of how he had come into the hospital two days after the accident had happened. As I was unconscious still, he just stood there quietly at the bedside. So I didn't see those piercing green eyes, the slightly buck teeth and the beard, slowly turning to grey.

The Candlestick was shoring up the cloud base as if it was a ceiling in danger of collapse, as a Doric column braces a Greek temple. There was then a thin layer of wispy fog creeping round the sides of the boat and muffling the engines. Sandwiched between this was a bleak panorama of wet gum forest and dark cliff with Pacific gulls showing us how clever they were. We motored by the Totem Pole and I was gutted to find that this, a larger boat than the one that rescued me, couldn't fit through the narrow channel. Was I to be thwarted at the last hurdle? Then Rod, sensing my dismay, said, 'We could still git in there from the other side. Don't give up hope just yit.' He cruised out past the Candlestick and steered to the east between the island at the very end of the peninsula and the Hippolytes, a group of islands well off shore but of the same igneous intrusion as the Tote. We were now on the opposite side of the headland, the wrong side to be able to see the rock scar but at least we had an excellent view of the tower. It felt as if we were in open sea now with a swell running and the wind getting up, the rain had soaked through our clothes long ago.

There was a very narrow cleft between the island and the Candlestick. This fissure was about ten feet wide and the side walls were upwards of 330 feet high. If we could get through there we would be rewarded with a view of the whole Tote from the west but, more than that, perhaps a sight of the rock scar. Richard and Keith were keen to give it a try as they could film my reaction.

'Why don't we go for it,' said Rod, surprising himself perhaps more than us. 'If I reverse in there we cin zoom out if we git into deep shit.'

There was an eight-foot swell running through that gap and, as we went in there, backwards, I couldn't shake the impression of the Symplegades, the clashing rocks of Greek heroic legend. I was one of the Argonauts on the voyage to Colchis. It was a crazy stunt to pull but I felt exhilarated and excited at my imminent meeting with my 'maker' (in my present body).

As we entered the clashing rocks the swell threw us around like

a toy and it was with great skill that Rod avoided running the boat into the cliffs. Then, suddenly, there it was, pencil-thin and towering above the boat. One didn't need a magnifying glass to see the scar. It was dead obvious, about eighty feet up and on the left edge of a slanting crack. I thought it was going to be the size of a house brick. Steve and Enga had told me so, but the scar they had been looking at was on the opposite side of the Pole. The scar I was now seeing you could slot a television set into, a portable admittedly, but still huge. I was experiencing deep shock. How did that thing not kill me? It must have been travelling at the very least seventy miles an hour when it struck me! How did I avoid quadriplegia? A rock that size could have easily broken my neck. It's no surprise that I had whiplash for two whole months. I felt humbled and just happy to be alive.

Rod asked, 'Have you seen enough yit?' I replied that I had and he said, 'Good, thin, lit's git the hill outta here.' He revved up the outboards and sped off, bringing the boat perilously close to the side wall of the Candlestick.

Once out in the open ocean, chilled and wet through, I couldn't shake a grin off my face. As we motored in a westerly direction back past the Hippolytes I was thrilled to have executed my plan, finished my journey.

The torrent had subsided now and eased to sporadic spluttering showers that dripped off the plastic canopy of the boat. Back in the bay the water was glassy smooth, the ceiling of cloud had lifted to 600 feet and was a grey blanket covering the whole world, as far as we knew. The mist had dissipated off the sea. Amidst the roar of the outboards I looked left to see the Tote in all its glory, standing proud and erect and ankle deep in salty water. As we passed it by I was forced to twist my head ever backwards if I was to keep my eyes on it until the last. For I knew that this would be the final time we would meet.

This tower had been inextricably linked to my life for exactly a year now. There wasn't a day went by when I did not think about, analyse, dismantle or downright curse the day that I ever

heard of the Totem Pole. But now I saw it for what it was, the most slender and, dare I say it, beautiful sea stack on the planet. I held no animosity towards it. How can you hold a grudge against an inanimate object? A piece of rock! For God's sake that's all it was.

I gazed on as the Totem Pole slowly disappeared behind Cape Hauy and, as I sat shivering in my wet clothes, there was only warmth in my heart. I could only appreciate the top quarter of a stack now and, as I wound my head around even further, I could just make out its eccentric angles in the flat light. And when it was finally dissolved from view I found that I had broken into a broad smile within and without.

10

TASMANIAN REFLECTIONS

Sometimes difficulty is the greatest friend of the soul.

John O'Donohue,
Anam Cara

'Guess what? Enga got to lead the Totem Pole.' Steve gabbled in his excitement to give me the news and so failed to give me the opportunity of guessing. 'Yeah, she freed it all the way.' He now had a huge beam on his face as if to say, 'Go on ask me, ask me!' So, sipping my flat black, I questioned him as to what else he had done. 'Only free climbed the first pitch of the Murcian route up the Pole.' I didn't really understand where the Murcian route began and so asked him where it started.

'Where does it start? Where does it start? It just follows the crack that the block came from that spannered you in the head, that's all!'

Pete Steane was at the cafe with us and he knew exactly where the route lay.

'Did you drill many carrots in it?'

'Just three,' replied Steve.

Pete nodded silently. He hadn't changed, just as cool as ever.

'There was a ton of loose rock in there. Really weird for a wave blasted obelisk such as that. You actually use the rock scar as a hand hold now!'

'How hard is it?' asked Pete.

'Easier than the original free route. That's the amazing thing

about it. I mean why did I not look there when I did the first free ascent?' Steve shook his head, giggling.

There was something familiar about the music that was wafting over on the breeze to the tables outside the cafe. It took me a moment to place 'El Condor Pasa', and then I was transported back to the Salamanca of a year ago. It was the very same Peruvian pan pipe band that had played at the Saturday market twelve months since. All of a sudden Celia was there pushing me through the heaving throng of people, me staring at a mass of arses and bollocks. Myrtle bowls exquisitely turned, fiddleback Huon pine boxes, pepper mills, picture frames and spoons of sassafras, genuine Australian hats, jewellery and tasty food. All this stuff meant nothing to me then as I passed by a thousand crotches. Now I could rejoice with the many hippies in the park, saunter around perusing each stallholder's wares, tasting the free samples.

Leaving the table I went in search of the pipe band just so I could throw a dollar into the felt-lined guitar case, like I did a year ago. I wanted to shout to them there and then, over the sound of the music, 'DO YOU REMEMBER ME? THE GUY IN THE WHEELCHAIR FROM A YEAR AGO? THE ONE WITH A BALD HEAD? THE CRIPPLE? WELL, LOOK AT ME NOW! I'M WALKING! I'M WALKING!' But I luckily restrained myself.

I had never noticed so many hemiplegics before I had become one. At the Saturday market I saw one after another, most of them stallholders. Now that I was one I could instantly spy the telltale signs, the weak leg, the crooked arm, the slack arm. Most of them were moving on through the years and I guessed that their lives had been altered by strokes. There was the man dismantling the stall, removing the high crossbars by thrusting a specially developed pole upwards and tapping it, with amazing accuracy, onto the beams – like tossing the caber with one hand. Or the other bloke who was pinching heavy planks between the fingers and thumb of his one usable hand and loading them into a trailer. I could have said that they were suffering from the effects of a stroke, but I would be wrong. They aren't suffering any more. I'm not suffer-

ing any more. We have had our lives altered. We are just different.

Steve and I exchanged hugs and Pete and I left the table and walked across the street to his car. We must have looked a right sight, the two of us, him with his callipers and limbo walk and me with my stick and leg flying out to the right. All eyes were upon us and I said to Pete, 'I don't know about you but I feel like a rock star.' We were getting more attention than I'd ever had and I felt somehow special. 'You'll get used to that,' he replied.

The following night I arranged to meet Dawn and Nicola, my two physiotherapists, in a North Hobart bar. Jane Boucher and I went up there together and arrived before them. It was a crowded Irish theme pub just like every city has.

'Do you remember the very first sentence you strung together?' asked Nick, barely able to hold back a full belly laugh. 'It was "I'm dyin' for a dump,"' she said, mocking my broad Lancashire accent with a stand up comic's ease. 'We all cracked up.'

Dawn gave me a wallet of photographs which she had taken the previous year of the team and me in the physio gym. I was touched and horrified at the same time. Touched that she had thought of me and horrified to see myself and the state I was in. I hadn't seen photos of me a year ago and had forgotten just how ill I looked, gaunt with a skinhead, and skeletal. There was the one picture where I had both hands on a big gym ball, Nick supporting my right side, the scar clearly visible in my skull and I was trying to force a smile, drooping radically on the one side. It was as though a shadow had been removed and I perceived just how far I had travelled along the road of recovery.

The days all seem to blend into one another when I look back but one day, about lunchtime, Jane packed an old rusting blue Datsun saloon with enough food for three days, plus camping gear. We then took off for a three-hour drive to the Freycinet Peninsula on the east coast of Tasmania.

'I want to show you one of my special places,' Jane said. 'It's

called Wineglass Bay for obvious reasons. You'll see why when you get there.'

Motoring past a stretch of rocky coastline, I made the mistake of asking how far the walk to this Wineglass Bay actually was.

'Only three or four miles.'

I became seriously worried about my ability to walk four miles and very suspicious at the same moment. We drifted slowly past vineyards and along a coast arched with deserted white beaches.

'Look, there it is, the Freycinet.'

There in the distance, framed by the sun, was a mountainous peninsula with the thin white threads of breaking waves along its whole length.

We arrived at a car park in the late 'arvo' and set off walking almost immediately in a race to beat dusk. I was determined to walk over the Hazards, a bare granite mountain range rising straight up out of the ocean, in one push. It was the first time I'd worn a rucsac to walk further than the shops and it kept threatening to overbalance me, though Jane carried the bulk of the equipment.

'I feel like a back seat bush walker,' Jane said, 'every time I see you stumble I want to tell you where to put your foot.'

I had the feeling that I was performing graded moves on rock, bouldering, when in fact I was just staggering along a path, so heavy did my legs feel and so awkward were the uneven rocks under my feet. Giant and golden potato boulders lined the path and, as I passed them by, I fingered holes and felt edges, a subconscious habit that was proving hard to break. How I longed to climb upon them.

Harbingers of doom in the guise of innocent tourists came down the path towards us.

'It's a hell of a way,' said one red faced, overweight, middle-aged fellow.

Another, even bigger and gasping for his breath, told me, 'I don't fancy your chances, mate.'

I turned around astonished and said, 'Thanks for the vote of confidence.'

Coming over the pass between Mount Amos and Mount May-son was a very emotional moment. If I could achieve this in one year, nature only knows what I could achieve in two years or three. 'Bloody hell, I can do anything I want to now,' I said, amazed at my performance. Jane gave me a congratulatory peck on the cheek. I now knew that I would be able to go walking in my beloved hills, something which had been so doubtful for the last twelve months. I know of treks in the Himalayas, long treks, pilgrim trails that have been worn flat by thousands upon thousands of feet marching through time, that I could hike now. I choked up and a tear welled in my eye.

'I reckon this is a moment you should have to yourself, I'll leave you to your thoughts,' Jane offered. But I said that I could imagine no better company.

A little later she said, 'Now you see why it's called Wineglass Bay.'

It was a complete, perfect wineglass, the mouth being narrower than the bowl, which was trimmed with a bow of brilliant white sand. It seemed to take forever to stumble down the lee of the mountain to that beach and, in my state of fatigue, I slowly became aware that the forest had taken on a glowing, preternatural green-ness. This I had only felt at times of extreme exhaustion, when descending out of the mountains on the Baffin Island trip, or having spent twenty-one days on a vertical wall on the Central Tower of Paine, starved of colour except for the grey of new granite and the white of snow. Colours then take on a vividness which one wishes one could see throughout the whole of one's life. I fell on the path many times, sometimes without injury, sometimes with injury and so finally towed my spent body onto the beach.

Curious pademelons hopped down out of the foliage as Jane set up camp and cooked dinner. I felt feeble and emasculated. I tried to put the hoop tent up with one arm but you certainly need two arms to do that (some reckon two people). A storm was brewing and at one point the tent blew away down the beach in

the grey twilight in the rain. I was reduced to a spectator as Jane ran about attempting to seize the cursed thing. Instead I tottered around, searching for rocks to hold the flysheet down in the soft sand. Eventually I was ordered into the small tent under threat of no dinner. I complied and a rich meal of rehydrated broccoli, courgettes and noodles was delivered forthwith. Through the tent's entrance I couldn't see the bald skulls of Mount Parson and Mount Dove any more, they had their heads in the clouds.

I had spent months in tents in base camps around the world. But this was the first night I had spent under canvas for over a year and, with the rain pelting down and the wind blowing strong, it felt a joy to be back.

At the Retro Cafe in Salamanca I met Neale Smith, my paramedic rescuer. He was supposed to be interviewed for the television but had been taking a holiday in Fiji during the week of filming. We sat down at an outside table under an umbrella and drank a couple of cold Boags. His voice was so soft and kindly that it took me straight back to the accident – 'You'll be all right, cobber.' I said what a shame it was that he wasn't interviewed and he replied, 'That's too bad. I could have been a film star.'

Now was the first time that I got the story of my rescue at first hand, from a source other than that which my tormented mind had created. For all I knew this could have been completely fictitious, a bizarre construct of my imagination.

Neale began, 'We couldn't get near you in the chopper and the pilot had to put it down a couple of kliks away. Paul Steane and I hurried to you, not knowing what to expect.'

Meanwhile, Tom Jamieson had been sitting by me on that shelf, shivering in his impotence, for six hours, when Neale dropped in on the end of the rope.

'Blood had puddled to a depth of two millimetres all over the ledge,' grimaced Neale, 'and I was worried about moving your spine but I figured that if Celia had already hauled you up, then any damage that could have been done had been done already. I

put a surgical collar on you just in case.' I sat transfixed, ignoring my bottle of beer as he went on. 'I had to be fairly rough with you to get you clipped onto my helicopter harness and then, in the gathering gloom, we went over the side. You were like a sack of spuds with stigmata. Anyway, although the boat pilot was doing his best to keep her steady we missed the tinny on the first attempt and nearly ended up in the drink.' He took a sip from his bottle and so did I. Then he continued, 'On the second attempt I threw the end of the rope, which was dangling in the water, to the guys. They pulled me, with you attached, and I hooked my legs into the tinny for dear life. All that was left for them to do was to pull you in.'

I was shocked. I thought he'd been there by my side for hours and it turned out that the whole operation, once he had reached me, took only twenty minutes.

'Once in the tub we had to get out between the Candlestick and the island,' he told me. For some reason I imagined that we'd escaped to the Fortescue Bay side (the route we had taken with the Boy Racer) but the seventeen-foot tinny wouldn't fit through such a narrow gap, so we had taken the Clashing Rocks route we'd done with the film crew.

We paid up, left a dollar for the waitress, and drove up to Mount Nelson Semaphore Station. There, in the nineteenth century the keeper used to receive signals from Port Arthur penal institution, over one hundred kilometres distant, warning of escaped convicts. We sat on a bench overlooking the city with its huge natural harbour. Neale pointed out over the estuary to where he lived while the sun beat down with an intensity I hadn't felt before. There was a cruise ship clearly visible down in the port and the white-haired cruisers were climbing down off a coach into the car park of the Semaphore Station. They each had a large badge on their lapels with a name on it and we joked that if they forgot who they were they would only have to look down at their chests.

★ ★ ★

During the long flight home, in the dark of the night's cabin I lay awake, wide awake, motionless. With the griping of babies and the snoring of old men, all I could think about was the rugged coastline of Tasmania and how it knocked me into a new life. New adventures would be mine for the taking but I would have to be patient, a couple more years they tell me, before I can realise them. Two more years of brain plasticity in which to plan my escapades.

11

CELIA'S STORY

The best part of a year had gone by since Celia and I had seen each other. Sailing around the Falklands, South Georgia and Antarctica was how she had spent the last six months. After my return from Tasmania Celia came round to my little house in Llanberis. When I answered that familiar knock on the door we played off each other, two positively charged particles, not knowing how to treat one another. But that feeling wore off after just a few minutes and we were back to being the good friends we always should have been. I told her about Neale's account of the accident and begged her to fill in the last blank spots in my story.

'I remember the effort, the sheer physical effort of making that rope move the barest of fractions. I remember my incredulity at eventually achieving such a laborious task. I remember the deep wounds in my hands from pulling so frantically on the rope. I remember my back hurting like hell where the harness dug deep, bruising my waist. I know there are ways I could have done it faster, but this way was ingrained. I knew it worked as long as I had the brute strength in me.'

After a while she said, 'How differently you and I must view that day. Did you recall the time passing?' I shook my head. Celia continued, 'I had to forget about minutes and just function. It gave me strength being capable of functioning under that pressure. I think I've forgotten how much I hated it.'

I asked her what else she remembered of the rescue.

'I'm running and running, feet in sandals slapping the red earth, flashing beetle green. Running round rocks, leaping logs and brushing branches, running and breathing. I remember repeating like a

mantra, "Running saves lives – breathe – running saves lives – breathe – running saves lives".

'Somewhere behind me you were lying on a ledge halfway up the Totem Pole. I didn't know if you were bleeding to death. Had you slipped into unconsciousness? Had you fallen off the ledge and were now hanging helpless? Were you still alive? I had to stop thinking! Stop panicking. Just run and breathe.

'I was maybe halfway there when I met these two Aussie climbers. I must have looked a right state with blood all over me. I babbled at them "There's been an accident. There's a guy badly injured on the Totem Pole." I sent one of them to be near you but told him no way to cross the Tyrolean. I told the other one to come with me but he couldn't keep up with me. So I asked him to go back to his mate because I couldn't get the image out of my mind of that one guy trying to cross the Tyrolean and falling to his death. I had no idea how experienced they were. They could have been complete beginners for all I knew.'

These facts sent a wave of shivers down my spine. I was lucky that they disregarded Celia's order.

'It must have been between four and five in the afternoon now. I couldn't believe it was Friday the 13th. How could this day turn into this nightmare? I had blood on my hands, blood under my fingernails, red and crusty, blood streaked with sweat across my face and neck. Not my blood, your blood.'

I asked her about the actual technicalities of the rescue, the nuts and bolts, but she was hesitant, reluctant even, to discuss such trivialities with me. She would just say that any experienced mountaineer could effect such a rescue, preferring instead, to tell me how she felt on that awful day. So I left her to say what she felt, and she started at the beginning.

'A black square of rock.' She halted, seemingly confused by the English language. 'A bolt, a rusty peg.' Another long pause. 'Wire and karabiners, ropes tied in knots equalising the pull of the downward rope . . .' Again she stopped and I was hanging on her words . . . 'That you now climbed up from your sea-washed platform. I

remember a pillar just too wide to bear-hug. There was too much swell to climb the lower pitch and, to tell the truth, I was relieved. You were jumaring up the rope to this ledge where I crouched, perfecting the belay. I wasn't happy on that ledge. The Tyrolean onto that straw of rock, the abseil down to the ledge and the climbing ahead of me, that place made me nervous. I made you nervous, too. Do you remember telling me that I was freaking you out? They were the last normal words you said as you abseiled away from me.'

I sat, with moist eyes, feeling remorseful for the misery I had put everybody I loved through. I said simply, 'Sorry.'

Celia responded, 'Someone said when we were at Hobart Hospital that good would come out of all this misery and pain. They were right. The experience of the accident, your recovery, your will, determination and achievement . . . some memories so painful and yet I feel like I'm living life like never before. What was it that poet wrote? "Catch the joy as it flies by"?

'Then came the shouting to come down to the ledge, fix the rope, so that you could climb up and we could climb the top pitch. So down I slithered, breathing carefully. I set up a belay with many anchors. "OK, it's all ready for you to jumar up," I yelled. I concentrated on that belay, watching it closely as you weighted the rope, the responsibility of your safety weighing on my conscience. This was my last view of normality.'

With some effort I rose from my armchair and fell into the kitchen to make us a brew before returning to the bad dream, transfixed.

'And then it was shattered. The ugly tear and crash of a rock. I remember fear grabbing me. I shook it off and thought, no, it's not possible! Normality left me, sitting in that dark corner wretchedly observing those textbook knots. I had to pull my gaze away from the black rock and I stared down shouting, "Paul, Paul!"'

Afterwards, she told me, she wrote things down. She passed me a beaten up exercise book with some scribblings in it. If I didn't know her writing so well I would have had trouble reading it:

'He is there beneath me, hung by a thread of fate and nylon. He is suspended navel up ... Limbs thrown out. He is limp and lifeless, faded. Here are the dying petals of a once exuberant flower. Just beyond, the sea is drinking thirstily at his blood. Horror is roaring in my ears. These tentacles of seaweed, they're unfurling, they're stroking softly as the sacrificial red, beckoning him to join them in their sempiternal kingdom.'

At the same time she had to focus on the job in hand. 'Breathe, girl, breathe, I thought. Think. Think. I must be safe. If I fuck up now, that's it. We're both going to go. Tie in the rope. One time, two times, three times. I had to be safe. For all I knew you were dying down there. I was scared.'

It was self-evident by the way Celia was talking that she had to get things off her chest, too. It was as much a catharsis for her as it was for me.

She continued, 'I shouted again to you, "Paul, Paul – can you hear me? I'm coming down. I'll be with you soon. I won't be long, darling." Then I noticed the rope and I thought, fucking thing! I knew it would get tangled. I didn't need this. I remember thinking, Oh, come on. Slow down. Breathe.

'I remember the look on your face when I reached you. Eyes saying everything, I clasped your hand, exchanging hope ... and energy. I talked at you, assuming you knew where you were. Then you croaked, "What's happened?" and so I got you upright in an arrangement of slings and put my helmet on you. Then I jumared back to the ledge and set up a Yosemite haul. The rest you know ... apart from the drive!'

'Tell me about the drive.'

'I watched the helicopter rise steeply, zooming off towards Hobart Hospital. It was ten in the evening and at last you were off to safety. I could slump back and relinquish my responsibility. Despite the rescue team's efforts I had felt on standby, knowing I could still act if they failed. The ambulance team called it shock and protected me from what they called my superwoman persona. Now I wanted the hot drink and blanket, the arm around my shoulder.

206

'But you were 100 kilometres away by now and I was in the wrong place. I had to get to you. They let me go, their responsibility finished, too. It wasn't over for me though. It was only just beginning. I set off along dirt trails through the forest. Faster, faster. I just stared blankly through the windshield. I had to keep checking the speed, as I was unsure of my judgement. Not too fast . . . and keep awake. I turned on the radio but all the stations were playing Heavy Metal. Black Sabbath was churning out "Heaven n' Hell". Friday the 13th, you see. The miles drifted by in a daze, until "Welcome to Hobart" a sign said. But I was dreading this moment . . . the reception desk at Accident and Emergency, open a door and there you were. Alive!'

She paused and, with tears in her eyes, finished her story.

'"Paul," I whispered, holding your hand. We made eye contact. You forced me an imperceptible smile that only I could recognise. A pool of thick scarlet blood had collected on the floor beneath your head. Dripping off the end of the stretcher. Red . . . for Valentine's Day.'

After I had heard Celia out I knew I had laid my ghosts to rest. Though Tasmania hurt me so badly I have found curious atonement in writing this story down. It is catharsis like I have never felt before. With my last two accidents I had no repressed experiences but here, with the head injury, I had; namely the gruesome nightmare of the accident, my terrifying days in intensive care and the emotive parting with Celia. The only way to purge these events was to think about them for a year solidly, and that is what I have done. Every waking moment, and quite a few sleeping moments, have been spent thinking, studying and reworking the accident and its aftermath. Now it is time to move on. To forget, but yet learn from what is past, and has passed, as well as I am able and find a new way of living.

I have seen things with new eyes since my accident, especially the relative importance of acts such as climbing rocks, acts that I once thought I would rather die than do without. For mountains

and rocks don't care whether you climb them or not. Driving in the taxi past Llanfairfechan, with the man who put his hand into a nest of snakes, I was overjoyed to note that there on the central reservation was the same sight I had seen a year previously – ablaze, thousands of profound yellow as yolk daffodils, their bulbs invisible, deep in the dark Welsh earth.

The germ of a new life.

And the Winds Blew Cold

Stalinist Russia
as Experienced by an American Emigrant

by

Eva Stolar Meltz
and
Rae Gunter Osgood

DISCARD

The McDonald & Woodward Publishing Company
Blacksburg, Virginia
2000

The McDonald & Woodward Publishing Company
P. O. Box 10308, Blacksburg, Virginia 24062

And the Winds Blew Cold
Stalinist Russia as Experienced by an American Emigrant

Printed in the United States of America by
McNaughton & Gunn, Inc., Saline, Michigan

08 07 06 05 04 03 02 01 00 10 9 8 7 6 5 4 3 2 1

First printing May 2000

Library of Congress Cataloging-in-Publication Data

Meltz, Eva Stolar, d. 1979.
 And the winds blew cold : Stalinist Russia as experienced by an American
emigrant / by Eva Stolar Meltz and Rae Gunter Osgood.
 p. cm.
 Includes index.
 ISBN 0-939923-85-8; ISBN 0-939923-76-9 (pbk.) (alk. paper)
 1. Meltz, Eva Stolar, d. 1979. 2. Jews--Illinois--Chicago--Biography. 3. Jews,
American--Soviet Union--Biography. 4. Soviet Union--Biography. 5. Chicago
(Ill.)--Biography. I. Osgood, Rae Gunter. II. Title.

 F548.9.J5 M45 2000
 977.3'11004924'0092--dc21
 [B]

 99-053822

Contents

A promise kept, a story told

Esther, Morris, Alexandra, Gustav,
Valeria, Maxim, Alexander,
and the countless other victims
of twentieth-century tyranny

The Main Personalities in the Book

Eva Stolar Meltz	The central figure in the book, and coauthor of the book
Rae Gunter Osgood	Eva's friend since childhood, and coauthor of the book
Morris Stolar	Eva's father
Esther Stolar	Eva's mother
Abe (Abie) Stolar	Eva's younger brother
Maxim (Max) Meltz	Eva's husband
Gustav Meltz	Max's father
Alexandra Meltz	Max's mother
Alexander (Al) Meltz	Max's brother
Valeria (Valya) Meltz	Max's sister
Bob	Valeria's Russian husband
Tamara (Tommy) Meltz	Eva and Max's older daughter
Maxine (Maxie) Meltz	Eva and Max's younger daughter
Peter Patlogan	Esther Stolar's brother living in the US
David Patlogan	Esther Stolar's brother living in the USSR
Rose Patlogan	David's wife
Eda Patlogan	Rose and David's daughter
Zhora Patlogan	Rose and David's son
Natasha (Nata) Stolar	First wife of Abie Stolar
Sonya Stolar	Second wife of Abie Stolar
Mikhail Borodin (Berg)	Friend of Esther and Morris in the US and USSR; Editor-in-Chief of *Moscow News*

Fanya Borodin (Berg)	Borodin's wife; director of the Anglo-American school in Moscow
Abraham Mordish	Esther and Morris's friend in the US and USSR
Bluma Abramovna	Neighbor of the Stolars and Meltzes on Pestovaya Street in Moscow
Nyura	Neighbor of the Stolars and Meltzes on Pestovaya Street in Moscow
Zoya	Nyura's daughter
The Rubensteins	Esther and Morris's friends in the US and USSR
Miriam Rubenstein	The Rubenstein's daughter
Rose Wogman	Eva's acquaintance from Chicago, moved to Moscow
Sheva	American emigrant to USSR; Eva's close friend in Moscow
Jane Altman	Eva's friend in Moscow
Yelena Ivanovna	Head of foreign language department in the Institute of Cinematography
Vladimir Kovalyov	Interrogator of political prisoners at Lubyanka Prison; also known as "Vovochka"
Inga	German prisoner in labor camp who befriended Eva
Zina (Zinka Brigadierka)	Eva's Russian camp-mate and supervisor
Lyena Kuprianova	Eva's Russian camp-mate

Acknowledgments

Thanks . . .

To Teresa Roupe of White Meadows Press, Santa Barbara, California, for her creative editing and skillful, selective marketing of the manuscript;

To my son, Kenneth Osgood, for his insistence that Eva's story was too important for its pages to yellow and crumble in my desk drawer;

To Judy Moore of Abingdon, Virginia, my editor with McDonald & Woodward, for her attention to both the big picture and the details as this book was readied for publication.

Prologue
My Years with Eva

My Years with Eva

Rae Gunter Osgood

In Chicago where I grew up, the school spring holiday always fell during the week which included the first of May. We referred to this day as Moving Day. As each first of May approached, I took it for granted that our address would change.

In May, 1919, within two weeks of my ninth birthday and two months before I completed my fourth year of school, I made my third change of school and my fifth change of address — this time to the northwest side of the city, to 2509 West Division Street. The physical boundaries of my life became Western Avenue, a block east of my home, where the trolleys lined up to enter the cavernous car barn for their night's rest, and California Avenue, four blocks to the west but, in my young mind, miles away from my home. California Avenue, however, was the entrance to Humboldt Park where, on hot summer days, my mother and one or two others from the immigrant neighborhood would escape from the tenement housing with their children to gossip together on the bench bordering the vast, cool, green grass-covered areas dotted with dandelions. I would busy myself plucking the long stemmed yellow flowers to make a wreath for my head that I proudly displayed. On Sundays, my father would join us. My mother would set out the food on a clean white cloth and invite another family to share with us. When I reached what my parents felt was a sufficiently safe age for me to manipulate the oars, I often would maneuver a rowboat built for four passengers through the large pond. In winter, the water, thoroughly frozen, became the ice skating rink — there expressly for my pleasure.

Although my family moved again and again during my childhood

3

and adolescence, it was to the Humboldt Park area that I returned for my social life, for it was there that my best friend lived.

Our new flat on Division Street was elegant, my mother boasted, as we moved in. It was a "through" flat with a back porch at the kitchen end and a balcony extending from the parlor, where on humid summer nights I would sleep in a hammock swaying to the rumble of the trolley cars that passed regularly every few minutes on the tracks below. As she and my father lugged things into place, my mother commented that nobody anywhere had such a beautiful house. The cooking stove was a genuine gas range — all gas, no wood-burning attachments — and to keep us warm in winter there was a large pot-bellied coal stove with its black chimney pipe reaching through the ceiling. Another pot-bellied stove in the parlor would keep us warm when friends visited.

The kitchen was furnished with a marble-topped table surrounded by ice cream parlor chairs. Everybody would covet the chairs — the Jacob and Joseph Cohen Austrian bentwood chairs — in the parlor and the dining room. No other children ever had miniature Jacob and Joseph Cohen Austrian bentwood ice cream parlor chairs and rockers made just for them like the ones that belonged to me and my sister. During the war — World War I — Papa had had a good job in the cabinet shop of the distributors of Jacob and Joseph Cohen furniture, and he had brought all the beauty of his workplace home for us. Of course, there was also the upright piano, a household symbol of intellectualism. We were going to be the envy of all of our neighbors. And now Papa would get a good job again.

My sister and I ran from one end of the house to the other. Starting at opposite ends, we vied with each other to be the first to pass through the narrow hallway, shouting when we crashed elbow against elbow, screaming with delight if we reached the room at the end of the passageway without touching or having to hug the wall. The increasing momentum of our feet was halted swiftly, however, by a banging from the ceiling of the flat beneath us. My father issued a stern warning that in this flat we must walk — and on tip-toe — a restriction that would be repeated daily, after each thumping of the broom handle on the ceiling below.

One day, to my father's relief, we were drawn to the back porch by

voices in the courtyard below. I observed the scene beneath me by pushing myself against the wooden railing of the porch and lowering my head. My sister lifted herself just high enough above the railing to be within view of the children below. With the first invitation from them, she sped down. My confidence buoyed, I soon followed, skidding along the right angles from floor to floor, exhilarated by the sensation of barely skimming the solid ground beneath my feet.

I jumped from the last two steps onto the concrete courtyard. A dark-eyed young girl looked at me expectantly, then invited me to her birthday party. That day — the first of May — Eva Stolar became nine years old.

Eva's family lived in a flat in the building that paralleled ours. At the first landing of our respective porches, we were able to rest comfortably, our elbows on the railing, to chat and giggle as if we were on the same porch. With a little stretching, much to the horror of our mothers, we could touch fingertips as our arms bridged the narrow, three-floor-high passageway between our two buildings. In inclement weather, we could continue our childish prattle from the bay windows in our separate dining rooms.

I accepted the structure of Eva's household without curiosity, the furtive comments of my parents that her father and mother were not legally married remaining dormant in my mind. There were many adults in that home besides Eva's mother and father: two unmarried sisters close together in age, and their brother and his bride. All seemed to share responsibility in indulging and disciplining Eva and her brother, Abie.

I remember thinking that Eva's mother was very old, her hair a wispy, peppery gray and pulled away severely from her face. A black dress hung shapelessly from her shoulders, reaching almost to her ankles in disregard of the fashion of the day that called for shorter skirts. She almost always spoke in Yiddish and had difficulty making even simple statements in English. Her children, however, spoke both languages easily.

On the other hand, Eva's father, Morris Stolar, seemed young and contemporary in appearance, with a heavy reddish mustache which drooped slightly at the tips. Whenever he spoke with us, his beautiful ease with the English language awed me. There was a seriousness and

intensity about him when he spoke, as if he would break into a sermon at any moment. Indeed, I do not recall a laugh or light conversation ever emanating from him. When he spoke to us, it always seemed to be about something extremely grown up — about our making the world a good place for all living beings.

Early in my friendship with Eva, I was given to believe that there was something very special about her father. From Esther, his wife, he was accorded a deference which was far different from the treatment that my father received from my mother. On the many days and nights I spent in their house, I don't recall having a meal with him at the table. He always seemed to arrive home in the evening long past the meal hour. Eva's mother would set aside her own activities to serve him, and only after he left the table did she sit down to have her own dinner. This was the pattern at every meal. These children and their father, I began to realize, did not conform to traditional patterns of dining, as I assumed my own family did. The food on their table was vegetarian, for to eat of animal matter was inconsistent with the philosophy of making the world a good place for all living beings. For that reason, Eva never dined at my home, but I was free to eat at hers and to be in her house perhaps as many hours of the day and night as in my own.

That Eva's father was somebody special was confirmed in my impressionable mind one day in the winter of 1919. I called to Eva, who called back from her porch — and her response sent me rushing to her house. It was crowded with small groups of adults speaking in low voices. With excitement, fear, and anger, Eva told me that the police, in the early hours of the morning while she slept, had taken her father to jail because, she said in nine-year-old indignation and righteousness, "He did not want poor children to suffer." A wave of shock went through me. Jails were not only for thieves — as my mother had taught me to believe — but also for vegetarians! Thus was my introduction to political arrests, but this same scene would be repeated several times in the years to come. Each time Eva's father returned home, there would be great rejoicing and a big celebration. The smattering of talk that I heard from my own parents about these incidents was dotted with the word *Bolsheviki.*

Between Eva's ninth and eleventh birthdays, at which time my fam-

ily moved again, our friendship solidified. As a pair, we walked together the mile to and from school. On Saturday afternoons, with our six pennies clutched in our closed fists, we ran to the movie house to see the sequel to the previous week's serial, and during the summer, unmindful of the noise from the trolley cars on the street, we replayed the adventures of Neva Gerber and Ben Wilson, for whom my admiration was passion. Our hearts pounded in unison as we pushed our way through the crowds to touch Mary Pickford, who came all the way from California to make a personal appearance. We reported glowingly to the other youngsters how she spoke a few words with Eva's mother, who had agreed to let us attend this important occasion only if she could come with us. There was no separating us. With reverence, we introduced each other as "my best friend," and we became labeled as "best friends."

I was the first to have a crush on a boy. Together we shared my feelings, and after my first date with him — an early evening movie starring Mary Miles Minter — Eva shared my outrage and embarrassment at my mother's insistence that my kid sister tag along as a chaperon. In our adolescence, when Eva experienced the normal boy-girl relationships, I listened enraptured as she related detail after detail about how she warded off a kiss. In my imagination I helped rescue her from this beloved aggressor, wishing, of course, that I could have a duplicate experience.

One dimension of our friendship elevated our experiences beyond our years. Eva had a precocious political interest. She conducted herself as if she had been destined by the date of her birth — the anniversary of an event to improve the existence of the common worker, the eight hour day — to give of herself to the cause of the worker. I, too, accepted her thinking as an act of fate. The truth was that she was her father's daughter. I preferred not to immerse myself in the social and political turmoil of the adult world, but if she were to be involved, I would be with her — without question.

By the time we had finished the fifth grade, we were attending large gatherings in large halls, our dresses adorned by ribbons imprinted with "Russian Famine Relief." With piggybank cans in our hands, we moved from person to person asking for coins for the starving children in the new Soviet Republic. When her father enrolled her in a class to

learn the Russian language, I enrolled with her. We learned at least the alphabet — and to this day, if I do not hesitate after I utter the first letter, I can speed through it to the last letter.

It was about this time that I began to appreciate the goal of Eva's family. The language training was to prepare them for leaving the United States to help build socialism in the Soviet Union, which incorporated Russia, from which Eva's parents had fled a few months before her birth. Their plan to go to the Soviet Union explained why they shared a flat with others — they were saving money for the trip. The other flats into which they moved, almost as frequently as my own family but in the same neighborhood, lacked a feeling of permanence. There was no need, they often said, to purchase any long term furnishings, for next year they would be gone.

Whenever I was in their home, I looked on in wonder. There was a permissiveness and freedom, a frankness and a happy spirit that I envied. That Eva's parents did not require a marriage certificate to maintain their closely knit relationship was proudly acknowledged. My own family seemed disapproving.

Only on one issue were our fathers equally adamant: that a belief in God and a hereafter was sheer ignorance. However, each reacted differently to this philosophy. To my father, the proof of his point of view rested in the miseries, including his own, that existed in this world; there was nothing one could do about it except try to be satisfied, even if that meant with nothing more than survival. To Eva's father, the faith of the common people in God and in His mysterious ways was a tool used by the ruling class to prevent the masses from taking their destiny in their own hands to eradicate their poverty. Propagation of the existence of a God was evil and wrong, and Morris Stolar was destined to spread the truth.

Eva's house, as I saw it through my mother's eyes, seemed bare and unattractive as compared to my own, but I never witnessed the anxiety from lack of money for food and rent that was present in my home. The post-war economy lagging, with each passing day that my father reported failure to find work, we suffered the fear of homelessness and hunger — and he the loss of his self-respect when my mother found work as a seamstress in a factory and saved us from starvation.

In Eva's house, I forgot about the bickering and quarreling that occurred between my parents. I felt comfortable with the relationships within her family, the seemingly well-defined and non-competitive roles of her parents. The responsibilities they challenged their daughter to assume were less stringent and more flexible than those my mother assigned to me. Probably as a result of this atmosphere, Eva displayed a certain self-esteem under which I needed to take protective cover.

When we moved again after two years, it was out of the Humboldt Park area. My mother, giving up on her husband's employment stability, decided to take our financial future in her own hands and become her own boss — a "capitalist notion," Eva taught me to believe. She opened a sewing school and a ladies' garment store. During the day, one section of the shop took on the appearance of a bona fide business in ladies' wear, the shelves and display cases which my father had built sparsely stacked with boxes of hosiery and lingerie. The other section, originally a separate room, now accessible by a door cut through the wall, was our home and a sewing school. This one room held a sink with two spigots for hot and cold running water, the cooking stove, dining table, my mother's sewing machine, my parents' bed, a board propped up on the surface of a small table for cutting cloth, and of course, the piano. At night, after business hours, the shades were drawn on the large windows open to the street, and at bedtime a single rollaway bed was set up in the ladies' garment store for my sister and me. This became our sleeping quarters. For our baths we were sent off to the public bath house. Our beautiful Jacob and Joseph Cohen bentwood furniture was a thing of the past.

Eva's parents also moved, this time as a family unit without the four adults who had shared their previous flat. Their new flat was still located in the same neighborhood where we had met, within a block of the elementary school which we were both already attending. I was given a permit to complete my elementary school education there, and every morning I boarded the street car with the workers and enroute learned the skill of strap-hanging. I had my lunches daily in Eva's house, and several times a week I stayed overnight. When we graduated from the eighth grade, I automatically enrolled with Eva in the adjoining high school.

Although my father recovered his role as breadwinner, my mother felt the need to open a bigger and better establishment. So again we moved, farther from Eva's neighborhood. My father built a somewhat private flat behind the shop, partitioning the space into a living room, two bedrooms, and a kitchen. The public bath house remained a necessity. The more physically mature I grew, the more I resisted it and was glad for the hospitality of the Stolars who permitted me to indulge myself in the privacy of the bathroom in their flat.

Our high school years were flooded with one kind of learning in school and another out of school. I prided myself on knowing the dates of every milestone of our country as outlined in the American history textbooks. I was exposed to the literature that brought it to life, and I threw myself into the disappointment of Miles Standish and the joys of Priscilla and John Alden. I fought the Civil War with Abraham Lincoln and cried for the slaves. Inspired by my teachers, I started with "A" at the top of the fiction bookshelf in the public library and filled my soul with historical romances that became facts to me. The school day over, I walked the mile with Eva to her house where I boarded the street car for my own home. Our innocent chats generally ended with Eva's berating the ignorance of her teacher whom she had to correct for referring to the Soviet Republic as "Russia." I admired her for her daring even as I was afraid for her.

Eva joined the Young Pioneers and I joined with her. We sat around the kitchen table in her parents' house to listen to the preachings of the leader who had the same intensity of Eva's father. I was amazed that one, only two years older than me, knew so much about the evils of capitalistic wars and about courageous working men and women organizing labor unions despite police clubs. The terms "ruling class" and "classless society" dripped from his lips. The name of Lenin became synonymous with all that was soon to be good for all people. I came out of the sessions wallowing in self-pity, for I could only feel the pain of the here and the now, and for the now, I was among the unfortunates with three strikes against me: I was poor and I was Jewish and I was female. For Eva, it was different. The future had already appeared on the horizon and soon she would reach it — in the new land of Socialism. She would hasten its progress towards perfection.

As I changed from a skinny, lanky thirteen year old to a pimply, curvaceous fifteen year old, the insistent physical sensations that came over me were mystifying, but I was not curious enough to seek an explanation. These same changes occurred in Eva, but if they were problems for her, she never commented about them. She was too busy worrying about the world. She drew around herself a number of classmates, outside the social whirl of the school, who were attracted to her social and political views. As her best friend, I was included in her circle in the Communist youth organizations which included many recent immigrants who spoke English with strong foreign accents. Other participants, of American birth, like Eva, were extending the views of their parents. We met in basement rooms of the large, flat, three-storey buildings on Division Street, the same street over which projected the balcony where I had slept in a hammock. We held vehement discussions about social injustices and their causes and cures. We spent summer Sundays together with the adults on picnic grounds just outside of the city, our fun time intermingled with the speeches of the William Z. Fosters (leader of the Communist Party in the US) and Mother Bloors (a labor union organizer). At the end of the day, still stimulated, we would crowd onto the street cars, pushing and cheering and grabbing seats, shaking other passengers from their lethargy. When the car would begin to move, all strap-hangers firmly footed, we would raise our voices and call out:

> *Arise! Ye prisoners of starvation!*
> *Arise! Ye wretched of the earth!*
> *For justice thunders condemnation —*

and

> *Long haired preachers come out every night.*
> *Try to tell us what's wrong and what's right.*
> *But when asked how about something to eat*
> *They will answer in voices so sweet — oh, so sweet —*

> *You will eat — bye and bye*
> *In that glorious land above the sky*
> *Way up high!*

Come and pray; live on hay
You'll eat pie in the sky when you die!

Then in unison, loud and raucous, we would shout:

That's a lie!

If the other passengers were resentful, we did not notice. We were joyous in our openness.

On Saturday nights in the winter, with Eva's mother and other adults, we went to the privately rented community halls and danced for hours. Blonde, sturdily built young men of Russian, Finnish, and Ukrainian backgrounds whirled us around to the music and rhythm of polkas and waltzes. With the boys of our own "Yankee" generation we danced the style of the day. Sometimes a few black men would be among us, and unmindful and unaware of differences as we were taught, we swung in their arms also.

Our partying was mainly in Eva's house, but occasionally a gathering took place at my own family's new apartment, now temporarily affordable with income from my mother's business and my father's wages. As the political conversations between my friends became more heated, my mother probably wished that the young people would adjourn to Eva's flat. She would move from window to window, quietly, embarrassed, closing them to keep the "subversive" talk inside the house.

At school, I was envious of the girls with the painted faces whom the boys sought out. I envied listening to the girls talk about dates that they had or were going to have and tried intently to gain tips from them on how to develop a line that would keep a conversation going and the date interesting. From the school newspaper, I recognized the most popular of our classmates as they walked through the halls with the other "in" students and looked upon them as I did my favorite movie stars. I dreamed that I might be asked to the senior prom. I felt the pain of being different from my classmates and occasionally urged Eva to attend the school social functions with me. If she felt the same, she never let on.

There came a time when we had to stand up and be counted. Wearing specially prepared raincoats, our backs emblazoned with the words

"Free Sacco and Vanzetti!," we went to the pre-arranged meeting place on the busiest corner of downtown and waited for our comrades. When none of them appeared, we left the corner apprehensively and walked the crowded streets until we reached the public library. I imagined that thousands of eyes were fastened upon my back as we paraded in front of the entrance. Eva did not appear to be very comfortable either. Braced by each other, we withstood the torture of the glares for what seemed an eternity, and suddenly, at the first opportunity, we disappeared into an open doorway and quickly divested ourselves of Eva's first overt commitment to the class struggle.

By the time we completed our second year at the local junior college, Eva's decisions were firming. Much to the distress of her parents, she was finding her formal education irrelevant. Feeling a need to make her ideals a reality, she became more actively involved with people "of the proletariat" and those who had intentions of becoming proletariats. She worked briefly as a factory hand and a waitress. She went into the mining areas of southern Illinois to help organize a labor union. She was arrested during a street demonstration and came out of jail with sordid descriptions of female prisoners and their ingenious methods of concealing cigarettes from their jailers.

I still needed years to grow up and to come to terms with my own conflicts. My mother's influence was strong. Her goal was for me to complete my education to the baccalaureate, regardless of what it meant or where it would lead. Although the Depression of the thirties was at our heels, 1929 and 1930 were prosperous years — the only ones my mother ever knew — and they allowed me the opportunity to complete my college education.

I left home to attend the University of Illinois to begin my third year of college. I was an oddity among the young men and women on campus, at least among those with whom I had made more than a passing acquaintance. I had tremendous difficulty fitting into a society where the interests seemed intellectually dilettantish. My brand of philosophy was considered idealistic and immature, and to some I was "gray with virtue." On the other hand, there were those who found me refreshing, and I experienced for the first time the dating which I had yearned for in high school — and I liked it.

I wanted Eva to share this light-hearted way of life with me. Her parents, hopeful that she would wish to follow my course, were only too glad to give her the train fare to visit me. We had a pleasant week, painting our faces to look like the other girls and going out on double dates, but when it was over, she obviously felt relieved to be able to return to the "struggle" and to Max Meltz, her young Russian friend whom she had met through their involvement in the Young Communist League. Before my school term ended, she wrote that she was living with him in the flat they shared with his parents and brother.

In April, 1931, Max and Eva, her brother Abie, and her mother left the United States to join her father who had returned to the Soviet Union a few months earlier. Just four days after her twenty-first birthday, Eva was at the Kremlin.

Her first letters to me from Moscow were filled with enthusiasm and love for the people around her. She wrote in detail of the street scenes and the spontaneous dancing and singing of a free people. In the letters that followed, she deplored the unhappiness and suffering of those of us left behind to face the Depression. Finally, since I was among the suffering, her self-satisfaction became unbearable to me. I dropped the correspondence and we lost contact.

Several years later, I read a small item in the *Chicago Tribune* reporting that her father had been arrested. A decade later, shortly after World War II had ended, a letter from her arrived at my mother's address and we reestablished communication. Our correspondence was interrupted during highly charged political periods between the United States and the USSR, picking up when tensions eased and when we again located each other. Eva's letters were written in veiled language, giving hints of deep sorrow. In the summer of 1962, my husband and I, during our first travel abroad, included in our tour a two-week visit to the Soviet Union. I had to see Eva.

Eva was waiting for me, flowers in her hand, at the entrance to the Astor Hotel in Leningrad. During the first week, spent in Leningrad and bound by the logistics of INTOURIST, we could not free ourselves from the prearranged trips, although the guide graciously consented to Eva's accompanying us. However, when we arrived in Moscow, Eva's home territory, I chose to pass up the sight-seeing in order to spend

time just with Eva. As we had done in our youth, Eva and I, arms inter-twined, walked the streets for hours each day and she talked. Dispas-sionately, she related in broad outlines the events that had occurred since she left the United States in 1931, events that left her family decimated. On one of these walks, I wept as if it all had happened just the previous day. Once, when my vision was thoroughly blurred, she stopped short, gazed at me, and said, "You're crying for me. I have no more tears left."

In May, 1972, Eva followed her daughter to Israel. From the time that I received her cable notifying me of this move, I knew we would see each other again. A year later she came to the United States as my guest for six months, and again in November, 1976, to live in my home perma-nently — until her death, suddenly, in my arms, on March 12, 1979. Once during this second and final visit, as she was relating additional details of her life to me, her voice dropped. I interrupted her. "Eva, why are you whispering?" She looked up at me as if from a reverie, hesitated, smiled sheepishly and replied, "I'm afraid that I'll be heard. It's a habit."

Those last two and one-half years were not wasted. Together we wrote her story. I hope that it is heard.

Part One
The Early Years in Moscow

Chapter 1

It was early in the spring of 1931, and Eva felt good to be alive. The bits and pieces of her nearly twenty-one years were falling into place and her dream was about to be realized. She was moving to the Soviet Union. Now — in her lifetime — she was to live in a classless society free from hunger and want, and rich in its democracy. No longer would she have to endure the terror and humiliation, well-known to political protesters, from the Chicago Police Department's Make Mills and his Red Squad. No more would she have to experience the fear of being arrested and jailed for exercising her right and desire to publicly demonstrate and protest injustice.

She felt proud, being her father's daughter. He had made their impending move to the Soviet Union possible. She no longer would need to fear for his safety — the nightmares of early morning house raids that had always ended with his being taken off and incarcerated were fresh in her mind. In the "new" Russia, on the contrary, Morris Stolar's dedication and intelligence would be appreciated. Because of those qualities and his printing and writing skills, he had been asked to go to Moscow to help organize an English language newspaper to serve the many English-speaking foreigners living in the Soviet Union.

The invitation had been relayed to him by the most respected journalist and lecturer, Anna Louise Strong. Miss Strong, in whose presence Eva felt awed, was rapidly gaining fame as an authority on the progress the Soviet Union was making toward the realization of socialism. That a person of her renown should be in their plain house strengthened Eva's belief in the correctness of her own social philosophy. Miss Strong

had been sent to Eva's father by Mikhail Berg, a close friend of her parents. (Berg was the Americanized name for Mikhail Markovich Borodin who, late in the 1920s, had been chief advisor from the Soviet Union to the Chinese Kuomintang government.) Morris and Berg had enjoyed an earlier personal kinship when Berg lived in Chicago. Eva remembered Berg's wife, Fanya, with affection. On many a spring or summer day, Eva's mother and Fanya had gathered up their young children, Esther with Eva and brother Abie, Fanya with her two young sons of about the same age, and gone to the circus or the lake front beach or the Municipal Pier. More often, they had walked down Division Street to Humboldt Park either for a canoe ride on the lagoon or to let the children play on the cool, green grass while they chatted and supervised from the park bench.

Mr. Berg and Fanya had begun a business in Chicago which they called "The Berg School of English." At first it had been staffed only by the two of them, but with the wave of immigrants from the Eastern European countries, it had grown to become an institution of considerable importance in the community and offered an extensive program for the greenhorn.

When, in the summer of 1927, Mr. Berg had felt the compulsion to return to his Russian homeland, which was then in the beginning throes of revolution, Morris felt envy. Fanya had stayed behind with the children and continued with the school until 1929, when she joined her husband. Mr. Berg's occasional letters whetted Morris's desire to assist in the growth of a society that was moving in a direction of social change with which he was entirely in accord. After Mr. Berg was made advisor to China, Eva's family had received a photograph which Eva examined with curiosity. It showed Mr. Berg and Fanya, their young children in front of them standing stiff and straight, against a background poster of photographs of crowds of people wearing unfamiliar costumes. "They are living in China," her mother told her. "This is how the Chinese people dress."

After a short period of service in China, Berg was recalled to Moscow when the Kuomintang broke with the Communist Party. He was given an appointment as editor-in-chief of a prospective new publication, the *Moscow News*. Berg wanted his friend Morris to be executive

secretary in charge of the business section, with the expectation that he would organize the print shop and the editorial offices. Delighted at such an opportunity to return to the country which was paving the way for socialism, and having little hope that America would ever become socialist, Morris was eager to accept the challenge. After receiving assurance that their children would accompany them, Eva's mother assented. Eva's brother Abie, now eighteen and in training at the Art Institute on Michigan Boulevard, was confident that he could complete his education in Moscow.

For Eva, the opportunity to move to Russia was a tremendous relief. For some time, she had been seriously involved with Max Meltz. Max's parents, Alexandra and Gustav Meltz, had been debating the possibility of going to Moscow to join their eldest child, Valeria, who had already established residence there with her husband, Bob. Their second child, Al, was also seriously contemplating the same move. Unable to find employment in Chicago, Al had taken off for California where he was jobless, and his sister Valeria had written that unemployment was unheard of in the Soviet Union. After Alexandra had come to know the goals of Eva's family, she was certain that her son would eventually leave also to be with Eva.

Alexandra and Gustav had emigrated from Russia with their three children nineteen years before, had planted second roots, already deep, in Chicago, and had no regrets. In their community, they had been able to retain their cultural identity without the rigidity and conformity of the church that they had been glad to leave in the Old World. But she and Gustav were already in their middle fifties, and they would not have been able to tolerate an unquestionably permanent separation from their children. Even as they tossed about the question, "Shall we go back?," they knew that in the end they would return to Russia with Al. So it was with great relief that Eva pursued her plans for departure.

Eva's father had left the United States in time to reach Moscow for the 1930 celebration of the October Revolution. The frequent and enthusiastic letters showed Morris to be busy and happy. As plans for the newspaper progressed — it was expected to begin publication in the spring of 1931 — he urged his family to prepare to leave the United States. The construction of the house to which they were assigned would

be finished by April. Travel lightly, he advised, "No, don't ship the piano and the household furniture. We shall purchase what we need here. But bring clothing for severe weather and a Russian and English typewriter." In some letters, he suggested that they visit places of interest in the city that they had not previously found time to see. "I hear that the Adler Planetarium on the lake front is the only one of its kind in the world. I am sorry that I left without making a visit there," he wrote.

In the months between December and April, as the Great Depression set in, the Stolars' Chicago flat was dismantled. To Eva, this was a time to be generous to her friends who would be left to suffer the economic hard times. She and Abie carefully sorted out the items which were to go with them and gave away everything else, including the piano. At this moment of separation, they realized that all they really needed to take with them — photographs and snapshots, mementos of their school days, and their favorite phonograph records — were the few personal items that would link them with their former identities.

Esther Stolar had not forgotten the poverty of her own childhood in Kishenev, a place that would later become part of the Soviet Union. In spite of her husband's advice to travel lightly, she intended to be well supplied. She insisted on shopping sprees not only for a head-to-foot wardrobe for all seasons, but also for linens and every possible type of household item.

Morris wrote detailed travel instructions. Every step of the journey was prepaid — the train fare to New York, the steamship tickets, and the ground transportation from Hamburg through Berlin and Poland to the Soviet border and on into Moscow.

Once the necessary passports and visas were obtained, the partying and the farewells began. Most of this was held in the basement flat that Eva and Max now shared with his parents. Of all their intimates, only Al was not present to see them off. "He will be returning from California soon," Eva comforted her mother-in-law, "and then you will be following us." She felt that she should be the envy of all of her friends. However, there were times when anxiety crept over her, especially when Alexandra expressed doubts about the move and would repeat, some-

times in Russian, sometimes in a broken English for her daughter-in-law to catch its full significance, "Nothing good will come of it. I know Russia. I know the Russians. They can be satisfied only with idols." She would warn Max of slavery under military conscription and talk of her Estonian-born father who had been a stranger to her because of his infrequent stays at their home in Moscow, always on the move at the call of the military. Eva consoled herself by thinking, "But that was Old Russia."

As they were about to close their trunks with the last of their possessions, Esther's brother Peter turned up to tender his last good-by and to present his farewell gifts. To Eva he gave the finest of beautifully boxed face powders, lipsticks, and other cosmetics — over Esther's disapproval — and made certain that a place in the trunk would be found for them. He scolded Esther, "For young girls to use make-up isn't a sin. Be modern! You're going to a new society. When in Greece, you do what the Greeks do," was the gist of his sermon. As were many of the eastern European immigrants of the time, Esther was adamantly opposed to the young women of Eva's generation "artificially altering" their appearance. "Its dishonest," she said in Yiddish. In spite of Esther's mild rage, Uncle Peter's remarks brought a guffaw of approval from Eva and a "Thank you, Uncle. I love you for thinking of me — and for siding with me!"

On the fifteenth of April, Eva, Max, Esther, and Abie boarded the train for New York. Two days later, they began the ten day journey by ship for Hamburg. For Max and Esther, this was the return of a round trip. Max, who had been only three when he made his first crossing, had little memory of that westward journey. But Esther remembered those uncomfortable days when she and Morris had traveled steerage and she was pregnant. Now, she looked out on the vast expanse of water and said as if to herself, "Who can tell?" The ship's passage to Europe was uneventful, but the young people were excited. This was episode number one of their new life and they savored it as a one-time thing, one that might never be repeated. They lounged, walked the deck, read, and enjoyed the food. Reckless and naïve, the young people scoffed at Esther's suggestion that they bag the oranges, freely distributed among the passengers, for eating on their arrival in Moscow. "Like old peasants drag-

ging their spoons with them?," they asked, in reference to stories they had heard of immigrants in their parents' day taking a few precious but valueless heirlooms in their already overweight bundles. Instead, they used the fruit for sport, competing with each other to see who might throw them to the fish farthest from the ship. Little did they know that these would be the last oranges they would see for many years.

Upon reaching Hamburg, before disembarking, they raised wine-filled glasses to May Day and to Eva on her twenty-first birthday. Customs procedures went smoothly. Max and Eva took charge as the responsible adults, while Abie, condemned to the role of kid brother, sat on the bench with his mother, both pairs of eyes fixed on their hand luggage. Regrettably, there was little time to spend in Germany, but during the layover in Berlin they did manage a few hours' walk on Unter Den Linden and marveled at the beauty of its gardens. During the Second World War, when word was to reach Moscow of the bombing of Berlin, Eva was to recall this day and feel deeply dejected by the city's destruction.

From Negoralaya, they passed into the Soviet Union. After border control, an exchange of dollars for rubles, and payment for a *platz carta* (seating card), they were ushered to their seats. As they watched Poland disappear through the window, suddenly, with elation, Eva exclaimed, "Look! A Red Army soldier!" The object of her delight was standing there, stiff and unmoving. Her mother fell in with her mood. "Not in photographs; not in the movies! A very much alive Red Army soldier!" Both burst into tears.

They arrived at their destination on May 4 when the train stopped at the Moscow White Russian Railway Station. Looking upon the Arch of Triumph in front, to the square at the station on Tsverskaya Street (later renamed Gorky Street), they felt that the dream on which Morris had nurtured them had finally been fulfilled.

Although a telegram was to have preceded them, there were no welcoming, familiar faces. They searched the crowd for Eva's father and Max's sister Valeria. When neither appeared, Max inquired in his limited Russian as to the best way to get to Strastnoi Boulevard where the

Moscow News offices were located. They noticed a scarcity of automobiles, especially any which looked like a taxi. A *droshky,* an open horse-drawn carriage with space for only two passengers, was pointed out to them. Again Eva's mother and brother were sent to a bench to wait, while Eva and Max took their first ride through the streets of Moscow seated on the bench of the cart, the driver above and in front of them lashing his whip over the horse's body. They were thrilled at the experience in a world so different from Division Street. The driver was skillful and obviously acquainted with his city. He drove them directly to the building and, not satisfied that they could find their way alone, led them into the offices of the *Moscow News* and announced them as foreigners in search of someone there. When Eva and Max introduced themselves, there was a flurry of consternation. "Stolar has already left for the station!" They were invited to wait.

When Morris returned with Esther and Abie, Eva and Max felt a sense of relief and were glad to turn over further responsibilities for their needs to him. As all were hungry and looked forward to unloading and resting, Morris took them to the buffet connected with the office, explaining that restaurants were not common — yet — on the Moscow streets. Every place of work had an attached eating area. This one was better than most, he said, because there was a wider selection of food. Others had no choices.

Esther was as excited as she was hungry. Yiddish spilled from her. "Ah, now for a glass of tea! How many years, Morris, since I have had a real glass of tea?"

Her children laughed at her. "Yes, we know. How many years have we heard, 'Is this tea? Ah, at home we had tea! This is an apple? What kind of an apple is this? Ah, at home we had apples!' Now we will all taste your good old Russian tea."

Eva took one sip, grimaced, looked at her mother and asked, "This is your Russian tea? Keep it!"

Esther, accustomed to being teased by her children, ignored them and slowly brought the steaming cup to her lips. She, too, grimaced and turned to her husband. "This is not Russian tea."

He laughed and said that she would yet live to drink the kind of tea for which she yearned — soon. "We must sacrifice now and learn to

like the tea made from carrots, a small sacrifice, indeed, to make for a future of socialism. First things first. The growth of industry, factories to make machines, machines that will make dams and plow the soil — those are first. Do you know how much has been accomplished since the Five Year Plan began?" he asked. Eva stirred with patriotism. She was to be a part of this great plan, this chapter in history! Her yearning for a glass of Lipton's tea left her.

They were eager to see their new home, but that was not to be — yet. Morris told them that the construction of the building was not quite completed. Tonight they would stay with the Bergs. "You remember our old friends. They are known now by their Russian name, Borodin. Fanya and Borodin are looking forward to seeing you." The newcomers were told that they would stay in the House of the Red Army the next day, and then in a hotel — a very first-class hotel, the Europa — until their flat was ready. "Eva, the location is superb," her father added. The Europa stood right in the center of Moscow across the street from the Bolshoi Theater and just a few steps from the Kremlin! Eva could walk into Red Square and be in full view of the Kremlin. Two rooms had been assigned to them. There would be some inconvenience in getting food, but Fanya had expressed delight at the opportunity to offer her table to her old friend, Esther, and the children to whom she had become attached in Chicago.

This would have to be the arrangement until food cards could be issued. Every person in the country was issued ration booklets for the purchase of consumer commodities in specifically assigned stores. Foreigners were assigned to the distribution center called INSNAB, a contraction of the Russian words for "supplying foreigners," where translators were employed to assist them. Eva, Max, and Abie would receive cards once they began to work and Esther would get her rations as Morris's dependent. Esther agreed to the arrangement since even if the flat had been available, their trunks were not expected for quite a while and she would not be able to keep house without the necessary kitchen and bedroom items.

The Borodins occupied two rooms in a communal flat on Granofsky Street. Their kitchen and bathroom facilities were shared with eight families. Living with Fanya and Borodin were their younger son who

was a student; the wife of their older son, an officer in the army who was away on military assignment; and a houseworker who did the marketing and cooking. If anyone felt cramped for lack of space or privacy that first night, there were no complaints; indeed, much good cheer filled the apartment. The neighbors also were accommodating, with no one questioning if the strangers had been legally registered into the Borodins' rooms or grumbling because of the very limited toilet facilities.

But an incident occurred that night which left Eva with a vague feeling of disappointment, her idealism somewhat disturbed. She had left her ring, a keepsake of her high school graduation, on the washstand in the bathroom. In the half hour before she became aware that it was not on her finger, it had disappeared. Inquiries brought many excuses, but there was no trace of the ring. She preferred to accept the suggested possibility that it had been flushed down the commode, but doubt lingered. Thieves in the Soviet Union? In a shared communal flat one could not afford the risk of being careless with personal items? Impossible! But, her childlike faith, the rigid moral doctrine of her upbringing, was shaken.

The talk that night centered around the jobs that Eva, Max, and Abie were to have. Max, with his training and experience as a printer in Chicago, would teach and supervise the Russian workers on the English linotype in the shop where the English language publication was being printed. Abie's services could also be used there; the need for English-speaking personnel was inexhaustible. Abie's job at the print shop was to last until he was ready to prepare himself for the entrance exams into the Technicum of Art. For Eva, a teaching position was waiting in the English department at the Combinat, the foreign language school organized and directed by Fanya that would eventually become the prestigious Foreign Language Institute.

Eva was hesitant. "But I have no training for teaching," she said.

"You will be given all the help you will need," Fanya assured her.

As they discussed their futures, Max finally succeeded in contacting Valeria who rushed into the Borodin flat within minutes to take them to her own room. She and Bob, who was out of town on some government mission, lived on Tsverskaya Street, not too far from the Borodin's. Valeria had left home four years before, and although she was

becoming acclimated, homesickness often seized her. She needed not only to hug her younger sibling and become better acquainted with Eva — whom she had known only slightly as one of the teenagers active in the communist youth movements on Division Street — she also needed first-hand news of her parents. Remembering her mother's strong objections when she and Bob had left, Valeria asked her brother, "What are their plans? Have they decided to leave the States?"

"Yes," Max replied. "Al intends to come here. They will not want to remain there without us."

Eva's first request to Valeria was to be shown the Lenin Memorial. On the next day, Valeria took Eva and Max to Red Square. They entered the building as one does a museum or any other place of public interest. They turned to the right past four honor guards, stepped down about three steps, turned right again, and found themselves before the encasement with its glass top revealing Lenin's body. They lingered here for a long time. Eva saw the absence of ostentation and pomp and the easy access to the tomb as symbolic of the social philosophy of the government.

They exited onto the section of the square covered with benches used by guests invited during the holiday spectaculars and walked farther on to the Kremlin's plaque-covered walls, sauntering down the length of them to pay homage to John Reed, the American author of *Ten Days that Shook the World*, and others whose ashes were interred there. Just by reading the inscribed names they learned a little of the history of the country. They continued to walk for miles through the Moscow streets, Valeria animatedly pointing out places of interest and promising that her mother, when she arrived, would enhance the sights with tales from her childhood and from her own experiences.

On the third day, the family settled into the Europa Hotel where they were to live for several months. Within the week, Max and Abie were on the job, and the following week Eva began to teach English at the Combinat.

She was just beginning to feel her way into her work when Fanya asked her to consider accepting a position as assistant principal in a school for children of English-speaking foreigners that would open in the fall. Previously, many of the prospective students had been taught

sporadically by their parents; others had been entirely without school-
ing since their arrival in the country. For the most part, the youngsters
had some understanding of Russian, having picked it up from playmates
on the street or from a houseworker or a Russian parent.

In addition to having to prepare outlines for the courses of study
in separate fields, organize the schedule of classes, and interview and
recommend teachers for approval by the Board of Education, Eva would
have her own classes in English. Again, she was assured of help from
Fanya and the new principal, an Englishman who had remained in the
country after marrying a Russian girl ten years earlier.

The school in which Eva was to be assistant principal was under
the supervision of the MONO, the Moscow City Board of Education,
and it would follow the universal Soviet curriculum. Not until she plunged
into her task did Eva appreciate its enormity for one so inexperienced.
She spent the entire summer investigating and researching the Soviet
curriculum and courses of study, setting up schedules for teachers and
students that resolved conflict in timing and classroom space, and de-
signing plans based on her own interpretation of methods she had been
taught. Her difficulties were compounded by the lack of English text-
books. Fanya lived too far away to turn to for help, and Eva was not able
to locate the new principal.

Eva was grateful for occasional interruptions when she and Max
would leave their room in the hotel and wander into the Square. "Pinch
me! Is all this for real?" they would say, playfully nudging at each other.
They would walk past the Bolshoi Theater at show time and comment
on the unsophisticated appearance of the people, young and old, hurry-
ing to make the curtain opening, dressed as if they were just returning
from the factory or the fields. It was so unlike the sleek styling of the
theater goers at home who used such opportunities to wear their show
finery. During these walks, Eva would talk to Max of her problems. He
gave her support by his obvious pride in her having been asked to take
on these responsibilities. Refreshed, with renewed inspiration, she would
return to her study.

The Anglo-American School, consisting of several rooms at one
end of the corridor on the second floor of a Moscow school, opened in
September. The grade and age structure followed the Soviet system with

students ranging in age from eight to eighteen. Eva's first months, however, were disconcerting. Lack of discipline among the students had been intensified by their long months, and in some cases years, away from a controlled situation. Merely calling them from the corridor to gather together into the classroom was an ordeal. She was disheartened by the discourtesy and the impatience of the young teenagers whom she was expected to teach.

Fortunately, Eva received comfort from her associates. They were English and American with the exception of the teacher of Russian, a native, who handled her English-speaking classes very efficiently without help from Eva, in spite of her limited although adequate knowledge of English. All of the teachers were eager that the school maintain high standards. They refused to be discouraged by the lack of professional textbooks in English and developed their own materials which they shared with each other. Soon Eva was relieved of the task of planning lessons except her own and with the teachers' cooperation, other duties were redistributed. She developed many friendships among this dedicated faculty, particularly with the Americans.

Eva worked later than the other teachers in order to take care of her administrative responsibilities. Her principal was rarely in the school; he put in an appearance only twice a month, on payday. Eva was too harassed and busy to inquire into the reason. Her evenings were spent preparing for her own five classes, each of a different level and age group. She had no time to teach herself Russian and to become integrated into the Russian language community. When she did have leisure time, she felt more relaxed with those who knew her language.

Although the classes of the Anglo-American School were separate from the Soviet section, the students intermingled during the recess period and all received their free lunches in the same room, with every class seated at assigned tables headed by the teacher. Conversation flowed freely and reciprocal curiosity and interest was evident. When winter set in, however, resentment of the foreign students by the Russian children became apparent. One morning, after the arrival of the younger children, Eva heard shouting behind her as she was walking through the corridor. She turned to see one of her upper grade students pulling a child away from a youngster of the Russian school. Quickly, she came

between them. The scuffling immediately stopped, and as she grasped the arm of the Anglo child, the Russian boy lifted himself from the floor and sped away.

"If he doesn't stop pulling at my coat, I'll bloody him up," the little one said to Eva, threateningly.

"Nonsense," Eva responded harshly. "If I see that behavior once more, you will not be in school. It takes two to fight," and she sent him off.

During the next several days, the staff observed the Russian children touching and tugging at the jackets of the American students. The latter were increasingly reporting ugly remarks aimed at them. Eventually, the cause of the dissension came out. Unlike the Russians who wore cloth coats, the Americans — the majority in the Anglo-American school — wore sheepskin-lined leather jackets. Forewarned of Moscow's bitterly cold winter temperatures, they had come prepared. However, a rumor had spread that these jackets had been issued to the American students in Moscow through INSNAB and had been paid for by MONO! The Russian students were incensed, the rumor could not be quieted, and quarrels between the two groups continued. Eva felt hurt and confused to think that, at this age and in this country, children were so aware of material differences among themselves.

Once during her first year in Moscow Eva was drawn into a personal problem of one of her students. The girl, one of five children of Ukrainian parents who had emigrated to the United States and then had returned to Moscow in 1930, was crying in class. After class was over, Eva conferred with the child and learned that a dreadful family quarrel had kept her awake all the night before. Her parents were divorced and her father had remarried, but since his factory had not yet allotted him and his new wife another room, they were living in the same room with the former wife and the children. The sleeping arrangement — he and his new wife on the only available bed and the children's mother on a mattress on the floor — caused a violent eruption, the parents shouting at each other and the children weeping. Helpless, Eva sent the exhausted and emotionally drained child to the nurse.

Chapter 2

A few months after Eva, Max, and Abie settled into their jobs, the family sat down to discuss financial matters. Eva's father wanted them to understand thoroughly the economic policy of the country, not from the theoretical frame of reference which they had studied, but as it would affect them personally. Morris reminded them that the goal of the Communist Party was to move the country from a seriously underdeveloped agricultural economy to a great industrial power as rapidly as possible — both for the comfort of her people and defense against her enemies. There was to be no dependency upon capitalist governments. The Soviet people were going to accomplish this monumental task by themselves — they were going to supply their government with the money required to build the factories! Since the initiation of the Five Year Plan in 1928, the government had been soliciting ten-year loans from the people through voluntary salary deductions. Eva, Max, and Abie soon would be asked to participate in this program, so they needed to decide how much of their income they wanted to have withheld from their paychecks. Before they would make a commitment, Morris wanted them to understand that they were already assessed a tax, based upon marital and family status, and that this was automatically collected to be used for health care costs and rent subsidies.

"This is real democracy in action," Eva said vehemently. "As the factories belong to the people, only the people can pay to build them."

There were four wage earners in the Stolar family, their rent was expected to be low, and they had sufficient clothing and household supplies brought from home to take care of their needs for several years. From their combined wages they would have enough extra to buy fur-

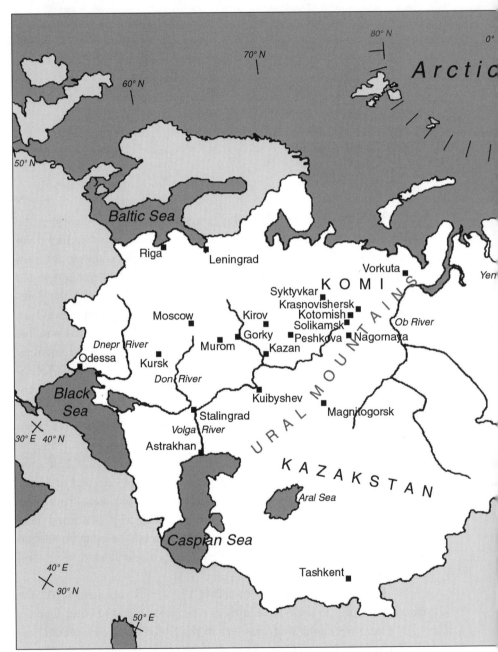

A map of the USSR showing the location of places of significance in the lives of
Eva Stolar Meltz, members of her family, and friends as mentioned in this book.

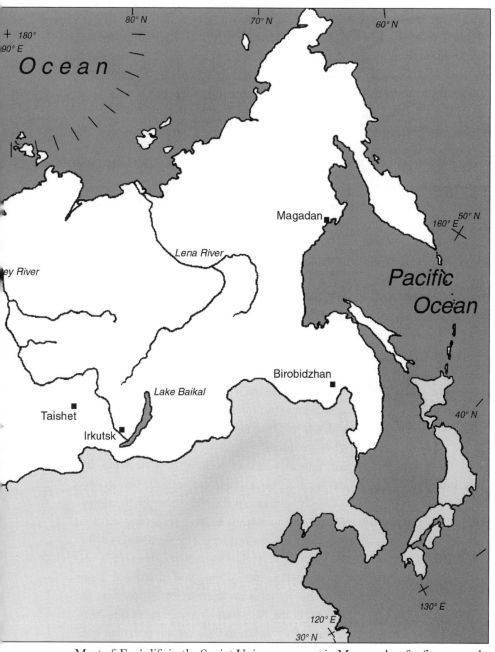

Most of Eva's life in the Soviet Union was spent in Moscow, but for five years she was interred in a number of labor camps centered on Solikamsk.

niture for their new flat and still have more than enough for everyday living expenses. Abie suggested that one eighth of their total annual wages should go for the loan, and the others agreed. Morris asked them to look at this loan as money in the bank, as sound as the American currency which he had deposited in the foreign currency bank. "Incidentally," he said, "this money in the foreign currency bank can take you home any time you wish to go."

So it was settled. They were ready with their commitment when they were approached. To Eva, the Russian greatness was symbolized by the willingness with which the people volunteered to make these loans, even among those families where wages were far lower than her own.

Valeria respected the dedication of her brother and sister-in-law, but, with good humor, reminded them that socialism could not be built by them alone. She urged Eva especially to get away from her work more often in order to become acquainted with the city. One evening, she insisted that both Max and Eva accompany her to the movies to see the screen adaptation of Sholokhov's novel *And Quiet Flows the Don*. It would be the first film they would see since leaving the States.

When they arrived at the theater, Eva expressed surprise as Valeria went to the box office to buy their tickets, remarking that she had been under the impression that such entertainment was free. Valeria answered, "Of course not. Where did you get that idea?"

"At home. This is what we heard!"

"If you and Max continue to work as you are now working, like one hundred mules," Valeria said, "your trade union may reward you with a free ticket. But by then, you may not have the energy to attend." Seriously, she mentioned that she had been to one screening without charge when her trade union had bought out an entire performance during the last holiday.

Eva felt somewhat chagrined at her naïveté and wondered if she had interpreted too literally the articles on the Soviet Union that she had read in *The Daily Worker* at home. "Live and learn," she said to Max. "Now I wonder about all those free vacations we are supposed to get." The conversation ended as the lights dimmed and the film flooded the screen; Valeria simultaneously whispered the translation of the captions.

Although this was a silent film ("talkies" had not yet been developed in the Soviet Union), Eva was impressed and glad that she had broken away from her work to attend.

The notice from customs that the trunks had arrived and could be claimed as soon as the owners appeared with the proper identification was well-timed, for the Stolars had received word that their flat would soon be ready. Eva and Esther found their way to the customs office with no problems. They felt secure, having mastered the intricacies of the public transportation system and having made their way through the city almost like natives.

The baggage was thoroughly inspected while Eva and Esther looked on, often glancing at each other questioningly. Every phonograph record was handled, its title called, and the names of the composers read aloud. "Tchaikovsky, Beethoven" The officers halted at "The Wedding of the Painted Doll" from the American musical film, *The Broadway Melody,* which was Esther's concession away from the classics at her children's coaxing. To describe it, Eva used the term "jazz." One inspector shook his head disapprovingly. "Anti-Soviet! Our people don't listen to cheap music," he said. It was confiscated. Eva thought her mother was pleased. Uncle Pete's farewell gift to Eva — the face powders, lipsticks and other cosmetics — was also confiscated, and Esther gloated. One of the inspectors remarked that such unnatural frivolity was not part of the Soviet lifestyle, smiling at Esther's apparent concurrence. With Eva's exalted faith in the judgment of the inspectors, as representatives of the USSR, she accepted their remarks. A few years later, when she heard "The Wedding of the Painted Doll" played repeatedly over public radio and wondered if the recording was her confiscated copy, she wished she had given them an argument.

The building on Pestsovaya Street where Eva and Max were to live with Eva's family was finally completed by the middle of summer. Eva's father was relieved. Their presence at the Europa had begun to annoy the management, who had been pressed with complaints that out-of-towners were being deprived of rooms. Authorities had decided that this family was to remain until their housing was ready, but Morris chafed

at being the cause of friction.

"We will be in a new, modern building," Morris told them. It had been built as a cooperative at the request of employees of a nearby factory who had collectively financed its construction through their trade union. The housing committee of the Moscow municipal government, under a regulation allotting a certain percentage of flats in such buildings to the city, designated one of the apartments for the Stolars. As long as they lived there, they were members of the cooperative. If they were to move, the money which they had put in as their share would be returned to them.

When the family went to examine the flat assigned to them, they found locating it to be an adventure. The building, situated on the outskirts of the city, towered above open fields dotted with corrals for horses and small farms where cows, pigs, and chickens roamed freely. On the right, separated by a space of land which was eventually to be a garden, another building was under construction. Eva discovered that the bricklayers were women. She barely controlled her elation that here, for all of them to observe, women were doing more than kitchen work — they were competently putting into practice the socialist doctrine of equality of the sexes. Abie, to her annoyance however, pointed out that men were supervising and directing them.

The third entrance that they investigated had the number of their new address. Plodding up five flights of stairs left them breathless. Eva's mother questioned how invigorating such daily exercise would be but made no other comment, leaving the others to wonder if Esther might have chosen a lower floor had the decision been hers to make. When she entered the flat, Esther was pleased. Here was the privacy which was missing at the Borodin's. Three rooms would allow for separate sleeping space for Morris and herself, for Abie, and for Eva and Max. The kitchen had good work space, and the foyer from which the bedrooms and bath and water closet fanned out could serve as the dining area.

"What more can we ask for?" Morris approved. Esther studied the wood-fired cooking stove with uncertainty. The others joined her, gazing at each other. After a moment's hesitation, Morris remarked, "Doesn't it look familiar, Esther? Once upon a time you made good meals with a wood fire."

Esther heaved a sigh. "We're going back to this?" she said, recalling the first year of their marriage when they lived in a village hut.

The summer was hard for Esther. First, wood was rationed and difficult to obtain. Then, she had difficulty lighting the fire in the stove — an innovation in the new buildings. On laundry days, when she needed more than a few kettles of hot water, Morris would start the fire before he left for work so that the water in the small tank attached to the stove would be hot by the time Esther was ready for it. She finally agreed to supplement the wood burner with a kerosene stove, a small round utensil with a plain wide wick only large enough to hold one cooking pot at a time. She needed to plan the use of these stoves carefully — she would cook meals for several days on the wood stove and use the kerosene stove for heating. The portable stove was the standard cooking implement among Esther's acquaintances, but the unpredictable spurting of the flame with a loud sizzle as it caught the benzene frightened her — and Eva. They had heard that many fires started from the improper use of these stoves.

Preserving food during the hot summers was another problem. Finding ice was difficult until Esther learned that by wheedling and coaxing she could get the druggist to sell her some. The ice was kept in the bathtub, and the family adjusted. "What else can we do?" they said patiently at bath time, removing the food and ice to the kitchen sink, thankful that they didn't have Esther's responsibilities.

Nor was the marketing simple. To get to INSNAB, they had to travel by street car and push through crowds and keep their balance while clutching packages in both hands. Unable to manage this, Esther had to depend entirely upon the others. Soon, imitating her neighbors, she did much of her shopping at the neighborhood open market where she learned some of the hard facts about the cost of living and what it meant for the ordinary Russian worker. She also rapidly concluded that the much-touted relief for the working wife and mother had not only not yet arrived, it had been neglected altogether.

In early fall, life became easier when the family hired someone to help with the housework. Morris, immediately elected to the house committee which managed the building, had developed a limited friendship with another member of the house committee, a Red Army officer whom

the neighbors respectfully addressed as "Comrade Commander." His family was the only other resident besides the Stolars not connected with the factory. Esther had become acquainted with his wife.

"Why don't you employ a houseworker?" the woman suggested. "Anya has a sister who is looking for a way to leave her village."

"Who is Anya?" Esther asked.

"My houseworker. You see her in my flat all the time. She is a great help to me."

"But that is like having a servant in the United States!" Esther replied, somewhat miffed, and pushed aside such a solution to her housekeeping problem.

But later, Anya had come to Esther. If Esther would hire her sister, she could get permission to leave the small village where she was very unhappy and come to Moscow.

"What wages does she want?" Esther asked.

Anya explained that the wages of the houseworker, like other workers, were regulated by the trade union and that, in addition to the payment of wages, the employer was expected to pay the union dues and income tax and provide a cot in the flat, which was subject to inspection for sanitary conditions. After further inquiries and a family conference, Esther, too, had a houseworker. Eva remarked, "We came to the Soviet Union to have a maid!"

About a month after arriving in Moscow, while they were still living at the Europa, Esther's oldest brother David visited them from Odessa. Esther had a special love for him and his wife, Rose. As young people, she and Rose had become close friends, drawn together by their political agreements and activity against the Tsarist regime. She had been delighted when her brother married Rose.

After a separation of almost twenty-two years, the reunion was charged with emotion. There was also the good-humored, "You haven't changed," and, "But why did you dye your hair gray?" David appraised his nephew and niece as their parents looked on tenderly and with pride.

Esther wanted to know, "Why didn't Rose and the children come with you?"

David answered, "Where would we all stay? We could not get space in a hotel. I managed to get myself sent on a business assignment and a place had to be found for me. They'll come when you move into your flat." He remembered to thank them for the many clothing parcels they had sent his family from America.

Esther replied, "Now we can send us each other instead of parcels. For Moscow is not to Odessa what America is to Odessa."

The next morning, before Eva left for work, she found the three of them still engrossed in talk. Her parents looked tired and troubled; she did not ask questions, and it was not until later, after Rose visited, that she learned why there had been so much gloom that morning.

Once in their flat, the family began an unsuccessful search for furnishings, the manufacture of which had been sharply curtailed under the Five Year Plan. They could not even find a bed as they knew a bed to be — set off the floor on legs, resting on a spring. Meanwhile, they were sleeping on thin, hard mattresses that Morris had borrowed from the Borodins who in turn had borrowed them from someone else. Esther was becoming annoyed and impatient. "Ask the Russians in your office," she pushed. "In two weeks Rose and her children will be here. They can't sleep on the bare floor." But they had to be satisfied with straw mattresses on the floor.

As word spread that they were in the market for chairs and a dining table, scores of neighbors appeared at their door, each carrying a piece of what they needed. So, paying seven of their neighbors prices that seemed unreasonably high to Esther, they put together a dining room set of one table and six chairs and squeezed them into the foyer. The household items that Esther had the vision to purchase before she left the States were unpacked and ready for use. When David's family — Rose, their thirteen-year-old son Zhora, and their twenty-four-year-old daughter Eda, who was just beginning her career as a teacher — arrived, Abie crowded into his parents' bedroom and sleeping space was made for the visitors on the borrowed mattresses set up in his room.

Eva's relationship with her relatives had a confused beginning. Hardly had they stepped into the flat and the door closed behind them

when Rose confronted them with troubling questions. "Why did you come here? Why didn't you heed David's advice? Aren't enough people here already suffering?"

Esther, astonished and perplexed, replied, "Rose! What are you saying? What has happened? Is this my old friend?"

Throughout the duration of the visit, communication with her cousins was difficult for Eva because they knew only Russian. Although Esther and Rose spoke to each other in Yiddish, Rose's Yiddish was interspersed with Russian just as Esther's was with English. It was a wonder that the two women understood each other at all. It took several days of Eva's hearing repetitive phrases for her to become attuned to her aunt's Yiddish. Rose carried on hysterically during meal preparation, over the cook stove or kerosene burner. "So! You are here!" she would say in a not particularly loving tone. Once she added, "And for nothing David sat in jail a second time. At least it would not have been for nothing if you had taken his advice and stayed in America. We thought you were clever people — but no — you came to this hell in spite of his warning!"

Shocked, Esther asked, "Again? In jail again? David told us about his arrest in 1918 after the Revolution began. We knew that he had been expelled from the Party for petty differences, but that was when the government was just being organized and differences were not tolerated. When again was he arrested?"

Rose reported bitterly that the OGPU (the initials of the security police at that time) had jailed David for a month and interrogated him about his letters to Esther and Morris. "He may not have written in language plain enough for you to understand. Do you think we could write openly? But the censor suspected something." She cried for the shattered ideals for which she had once been willing to give her life.

When she was not cursing the authorities, Rose agitated everyone with constant complaints and embarrassing, overbearing behavior. During one supper, Zhora asked his mother if he might have a slice of white bread, which was there for the taking. Esther broke in. "Why do you ask? It's on the table for everyone." Later, feeling somewhat insulted that her hospitality had been doubted, Esther said to Morris, "Rose made me feel like two cents by ignoring me and reluctantly giving the boy

permission for only one slice." Another time he wanted an apple and a pear, and again Esther urged him to help himself. "Thirteen-year-old boys have such appetites," she commented affectionately to her glowering sister-in-law. Encouraged, Zhora also reached for chocolates. Eda followed his lead and took a sweet, inquiring on what ration coupon it was purchased.

The question set Rose to ranting, insensitive to her hosts' feelings. "Don't get them used to such luxuries. On our cards we can't buy chocolate and candy — and white bread. I suppose a child will die without them! And where in Odessa will I buy him apples and pears? I have no friends with INSNAB books who can put white bread and fruit and chocolate on the table. Stop telling him he can have as much as he wants!"

Esther feebly protested. "Odessa is celebrated for its fruits and vegetables."

"Yes! Fruits and vegetables grow like weeds in Odessa!" Rose's voice was climbing to a shriek. "But who can buy them? On ration cards they're not sold. And where will the money come from to buy them at the market?"

Rose's negative attitude toward INSNAB struck Eva's family as being unjustified. True, foreigners traded there as assigned by the authorities. They needed the convenience of the translators to facilitate their marketing. They lauded such government consideration and efficiency.

The visit was a disappointment. Time had been too short for the cousins to break through the language barrier. Eva, bored with Rose's histrionics, controlled her tongue but wanted to ask, "Before the Revolution, would your daughter have been given the opportunity for an education? Would she have become a teacher?" She saw Rose as domineering, emotional, and somewhat irrational, and the antipathy Eva felt the first day Rose arrived had not gone away by the time she and her family left. All of them felt an uneasiness that they could not bring themselves to discuss. Clearly, Rose's cynicism clashed with the Stolars' comprehension of what life was like for the average citizen in the Soviet Union.

With her visitors now gone, Esther, living within the Russian community, came face to face with what was commonly referred to as "Soviet reality" long before the others in the household. A chivalrous act by Max had given her an opportunity to make a new friend. Returning home from the morning shift, he had noticed a woman near the entrance to their building laboring over a pile of wood, hacking at the wood with an ax. She seemed to him to be quite old and fragile. On an impulse, somewhat aghast that a woman, and a very elderly one at that, was chopping wood, Max stepped over to her and took the ax out of her hand. Realizing that he had frightened her, he tried to make amends in his limited Russian as he took over and finished what she had begun. "This is no work for a woman," he insisted. She stood off to one side, watching him, at first with curiosity; then laughing loudly she echoed his words, "No work for a woman!" She continued to chuckle as he gathered the pieces of wood into his arms and gestured to her to lead the way to her flat. They climbed the steps to the fourth floor and entered her room where he set down the wood.

"And I am too old and a woman — so I can't chop wood?" she smiled. "And who is to chop the wood for me? Am I to wait for a man to fill my cook stove? And starve waiting?" She laughed again. "You must be the foreigner who lives on the fifth floor."

Bluma Abramovna became a staunch neighbor. She enjoyed affectionately recalling the incident that led to her meeting Esther through "this crazy American" who said that women should not be chopping wood. She was a widow, born and raised in a small Ukrainian village which had been shunted between the Reds and the Whites during the Civil War. On one of the raids of the village, led by Petlura, the notorious anti-Semite, her husband had been murdered, leaving her to raise her three children alone. Two of them were now living with her. She had provided for her children by working as a seamstress in a dress factory. Now her children were supporting her. Both of them were working in the factory that entitled them to rooms in this cooperative. She supplemented their wages by sewing privately.

Esther and Eva would often turn to her for help in remodeling and repairing their American wardrobe, and when they could obtain cloth,

she designed and made them new garments. Esther also learned from her some other housewife tricks that made life easier. Bluma introduced her to the neighborhood market where she heard the groans about the prices of the non-rationed produce and came to understand — without knowing the reason — that Bluma Abramovna and her neighbors could not afford to buy any necessities — at least items she considered necessities. Weren't tomatoes necessities?

Through Bluma, Esther also began to understand the system of distributing food cards. She noticed the difference between marketing at INSNAB where her family shopped and the distribution center assigned to her neighbors. She would often see Bluma Abramovna arriving home, both arms laden, weary and grumbling about the crowds in the street cars, the hours spent — sometimes futilely — in long lines. Esther felt no shortages. Her family brought home from INSNAB everything on her shopping list. In fact, both Esther and Eva had been very much impressed with its efficiency. The government had been most considerate in making life for the foreigner relatively easy. A monitor stationed at the entrance admitted the shopper upon presentation of her ration book and relayed her to the appropriate translator, who was ready to transcribe the order in Russian. Before receiving the goods from a salesperson, the shopper went to the cashier's desk where the order and the prices, written in the book, were checked for accuracy before payment. Esther had only one complaint — the packaging. She could not accept butter wrapped in newspaper but soon corrected this little problem by making several cloth bags of varying sizes and shapes.

Although Esther developed many friendships in the building, Eva came to know only one other family rather well. Zoya was a young girl of about twelve, outgoing and aggressive, whom Eva had frequently noticed playing on the street, competing with the boys at their games and generally assuming the role of leader. Zoya often joined Eva on the stairs and invited herself into the Stolars' rooms. Soon she brought her two younger brothers. All of them brazenly examined the open dishes of candy and chocolates seeking an invitation to partake, or loitered as Esther was preparing to serve supper. They always seemed to be hungry.

From talking to Zoya, Esther learned that her father, a Party leader,

had been murdered by the *kulaks* (prosperous farmers with hired workers) while on a mission to organize a *kolkhoz* (a collective farm). The mother had been awarded a small pension, and with additional income from her employment, was managing to keep her family at least on a subsistence level. Daily, the mother, whom Esther familiarly called Nyura, would climb to the Stolars' flat to collect her children before stopping at her own room on the fourth floor. Esther appreciated how difficult life was for her. She could not take advantage of shopping nearby in the open market, convenient but over-priced. Instead, she needed to travel after working hours to her assigned distribution center to wait, like Bluma Abramovna, in long lines for whatever her ration card allowed, or what was available, or what she could afford. She could not plan meals in advance, for what she might place on a shopping list might not be on the shelves that day. Esther soon found herself pushing the candies on the children and querying Zoya, who supervised the younger siblings, about the cereals that they liked so that Eva might purchase them. Nyura accepted the food, which was still very reasonably within the Stolars' ration limits.

At first, Morris emphatically opposed this idea, standing on the principle against giving preferential treatment to anyone. When two of the neighbors had asked Esther to purchase cereal and sugar for them through INSNAB, and she had placed this order on her shopping list, he had been furious. "They have their own distribution centers and their own ration cards. They must want the extra supplies for speculation [one of the most heinous crimes possible in the Soviet Union, one punishable by long prison or camp sentences or even death]!" He quoted all the political cliches in which he passionately believed. "If they have a grievance, let them go to the Mestcom [a trade union committee]. Let them address the committee and tell them that they need more." But Esther was beginning to doubt that her neighbors had rations as good as her own family's. Rose's words kept coming back to her. Instead of arguing with Morris, Esther quietly continued to supplement Nyura's larder until Morris — and Eva — began to recognize that the system was not perfect, that inequities were bound to creep in, and that their thinking was much too simplistic.

Why, Eva and Max were beginning to ask themselves, even in the

offices of the *Moscow News* did the Russian workers manipulate procedures hoping that they might be issued the INSNAB books? Why did Nyura have so little, barely enough to satisfy the appetites of three growing children? Why must Bluma Abramovna and her family eat only the unappetizing black bread and never have a little more for an occasional loaf of white bread? They would not know why until INSNAB was closed down several years later and they no longer held the status of the privileged foreigner. Not until they joined Nyura and Bluma Abramovna in the lines at their kind of stores did they become aware that, as foreigners, they had received preferential treatment, that they had been deluded into thinking that the Russian people were obtaining the basic necessities that the system promised.

"We were living on the fat of the land," Abie would say, as they developed a better understanding of how difficult life really was for the Russians. But the hope remained with them that the time would not be too far off when the Soviet workers would have at least as much as they themselves had left in Chicago in April, 1931. "In two or three years," Morris would say. And Eva would add, "I suppose it is too much to expect that a government that is only fourteen years old can do better than it has for its people. Especially with the entire world against it. At least everyone here is working. Look what's happening at home — after 150 years of capitalism!"

On the issue of anti-Semitism, however, Eva refused to find rationalization. This was not the country of the Tsar! *Pogroms*, organized massacres and raids in which Jewish people were targeted, were in the past. From its inception, one of the main goals of the socialist government was the eradication of anti-Semitism. Eva remembered in particular one experience from her youth. She was twelve or thirteen years old and had been sitting in on a meeting of the Young Communist League in a basement meeting room on Division Street. The chairman was reading a statement from Kalinin, the president of the Soviet Union, printed in a publication of the Young Communist League. Kalinin had written in response to a letter from several young people asking for clarity on the national policy as it related to the Jewish people. In his response, Kalinin gave a short history of the Jews and of the rise of anti-Semitism and urged an end to racism. When the chairman finished reading, the

young people applauded. Soon after Eva had arrived in Moscow, she inquired in the library for a copy of this statement but was told it was not available. She was disappointed. She wanted it to be included in the required reading list for the members of the *Komsomol*, the Young Communist League of the Soviet Union, as a constant reminder that anti-Semitism was to become a thing of the past.

So, when three-year-old Petya responded to her cheery greeting as she passed him on the staircase with *"Zhidovka!"* ("Sheeny!", "Kike!"), she was stunned. Her reaction was — again? Here in the Soviet Union? She reported the incident to her father. Such a remark from a toddler was inexcusable; he had obviously heard it from his parents. The incident was duly recounted to the house committee and from there to the trade union in the factory. The parents were heavily fined but thankful to have avoided a jail sentence. The two-hundred-ruble penalty was severe, for the father could not have been earning more than the average worker, about sixty rubles a month. Perhaps now he would refrain from expressing his sentiments before his child and a racist upbringing might be averted. It didn't take money for the government to demand from its people expressions of self-worth and dignity. Just as she intended to expend her efforts for economic reforms through her full participation, so Eva intended to help her government educate those who had not rid themselves of anti-Semitism — and if education was slow, to demand that the letter of the law be followed. The new generation must not fall into the trap of using a scapegoat as a cover-up, but indeed recognize it as a warning signal of a collapse of progress. It would not be easy, but with anti-Semitism illegal, an alert citizenry could surely wipe out bigotry from even those Russians who had "taken it in with their mother's milk," in the words of a common Russian expression.

Eva's participation in the compulsory worker's demonstration on November 7, 1931, the anniversary of the successful Bolshevik Revolution of 1917 under Lenin's leadership, was to her an appropriate and exciting way to spend her first work holiday. With the exception of Esther, who as a housewife had nowhere to report, the family left the house early. Transportation was shut down. All of Moscow was on foot.

Eva, Max, Abie, and Morris separated at the crossing that led to the assigned meeting places of their respective colleagues. As Eva continued her stride on the cobblestone streets, she was joined by throngs of people, their flapping scarves wound around the collars of their shapeless great-coats. Children, their cheeks red from the nippy fall wind and their eyes shining, were perched on their fathers' shoulders and waved to anyone who smiled at them. Reaching her destination at the time planned, Eva stepped out of the way of those still walking and merged with the staff and students of her school.

For several hours, her contingent and others along the street waited for word to proceed to Red Square. Simultaneously, it seemed, they took from their pockets packets of food, and ate and socialized. Spontaneous singing and dancing erupted. People danced to keep warm and for the sheer joy of it, to the kind of music Eva had clapped her hands to in the dance hall in Chicago. Bodies bounced up, feet left the ground, and legs fanned out; then the dancers went down into a squat, with legs alternately stretched out horizontally. Eva marveled at the ease with which the Russians kept their balance. Everybody was in high spirits.

Finally, the signal was given. The first line of marchers filled the width of the street and, in an orderly column, the others fell in behind. That cohesive mass, each row lined together as one band, slowly approached Red Square and converged with columns of people from other districts of the city. Each was kept separated from the other by single files of Red Army soldiers, the rows of which stretched across the width of the Square. The mass of people marched past guests of the government, privileged Muscovites, and foreign trade union and Party delegations seated on benches positioned along the Kremlin wall. As the demonstrators moved close to the Lenin mausoleum, they waved and shouted and pushed into the line of soldiers struggling to prevent the ranks from breaking, hoping to get a glimpse of Stalin, Voroshilov, and Bukharin.

When Eva's line moved off the Square and the participants began to disperse, she looked back for a view of the columns which had been behind her. She saw posters that moved with the crowd, huge photographs of the Soviet leaders, and floats with satiric, cleverly made effigies of the heads of the Western European governments and the United

States — the capitalist world.

The following day, an extension of the anniversary celebration, was a day of rest. Eva spent it writing letters to her friends at home, wanting to share her excitement and the sentiments inspired by the spectacle. She felt that now she "belonged," that she was no longer a "foreigner."

Chapter 3

The first year in Moscow placed a strain on Esther's patience. The confusing work schedules of the others necessitated that, in addition to her other household tasks, she plan, prepare, and serve three meals on four days of every week — all under exceedingly uncomfortable conditions. A system had been devised to convert the seven day calendar week to a six day workers' week: five days of work and a sixth day of rest. Instead of using traditional names of days, this system used First Day, Second Day, and so on. Workers' weeks were staggered so that the factories never shut down and production never stopped. Eva, Max, Morris, and Abie all had different schedules, a circumstance which kept Esther in a quandary. She never knew who would be at home for the day of rest and which two days of the six she could set aside for her laundering, marketing, and accumulative cooking. "It's lucky they didn't decide to do away with the dates. We would lose the May First and November Seventh celebrations. Will that happen next?" she complained.

"But Ma. We get two extra days of rest within a four month time," they tried to comfort her.

"What good is that? None of you spend it together." Esther was harried by the fear that the family was disintegrating. Max and Eva saw each other rarely since Max's hours extended into the early mornings, and Esther wondered how satisfying their relationship could be under such circumstances. Morris and Abie were no closer than unrelated boarders. At least each knew his or her own schedule, and although on their days of rest none of them might know who else would be at home, all

reported to work responsibly as assigned. Esther was relieved when a few months later the traditional calendar was reestablished and, on Sundays, the entire family could eat at the supper table together.

Occasionally, Max and Eva would relax together, Max exchanging a day at work with a friend so that he and Eva could go to the Bolshoi or opera. Their pleasure was greatest when they joined the crowds on the street car headed for Strastnoi Square (now Pushkin Square) to read the updated report of that day's achievements posted on the bulletin board of the monastery — aptly named "The Monastery of the Passion." Their day was complete only if they could have the first news on the progress of "Magnitka," the huge plant being built as part of the massive new iron and steel production complex at Magnitogorsk in the Ural Mountains to the east. How many bricks had been laid? How much ground had been cleared that day? Like their compatriots who were pushing and shoving in front of the monastery, they were too impatient to wait and read this news in the next morning's issue of *Pravda* (*The Truth*, a newspaper of the Communist Party of the Soviet Union). The value and magnitude of the project had been heightened for them by the newsreels they had seen of peasants, bundled in ragged, cotton-stuffed jackets, their feet in *laptee* — bast slippers worn over footcloths — clearing the ground only with shovels, and, when there were not enough shovels, getting down on their knees to use their fingers to scratch into the earth.

Keeping up with each day's progress became a compulsion with Eva, each trip to the monastery symbolizing encouragement to all of those who were laying the foundation for the structure that would bring the country to rapid industrialization. Several days a week, with or without Max, sometimes stopping at Max's sister Valeria's to coax her to come along, she would take the two-hour round trip to the bulletin board, postponing work on her lessons until the early morning. Esther tried to slow Eva's pace with "Must you go now? Get some rest! You have put in a night and a day of work and have barely slept," but to no avail.

By spring, Eva had concluded that the teaching field was not for her. The children's unruly behavior tormented her and she resented the long hours required to prepare for her classes and fulfill her obligations as assistant principal. The examination period came none too soon. It

brought a break from the grind of planning lessons night after night and created a period of calm and seriousness among her students. For the remainder of the final month of the school term, Eva enjoyed several days a week out of the classroom. During that time she made her decision to resign, in spite of the gnawing feeling that she was running away.

When Borodin learned of her availability, he offered her a job as proofreader for the *Moscow News*. "I am told you have had experience," he said, referring to the work she had done in Chicago on the mail order catalogue for Sears Roebuck and the city telephone directory. It had been difficult to find a qualified person at ease with the English language to fill the position, so he suggested that she formally apply after her vacation.

Eva's first paid vacation was pleasant. The pressure of teaching was gone, and Max, too, was getting a vacation. In addition to the month's leave, he had earned a free pass to a rest home, an award which placed him in special esteem. "An *udarnik* [a worker, farmer, or student who exceeded his or her goal and set an example for others]. One of the most valued workers in the print shop! What a wonderful honor!" Eva boasted.

"But there are no special arrangements that we can make for you in the rest home," Max lamented.

Morris, with his usual optimism, remarked, "Next year both of you will be udarniks and there will be a place for you together. If not, by that time there will be plenty of rooms in the area for summer visitors. For now, the udarniks deserve to have the place for themselves."

"Then I'll wait for next year," Max countered. "Let's take the month as you planned and visit your uncle and his family in Odessa." But Eva felt that throwing away such a highly prized award would be unpatriotic. She persuaded Max to accept it. So, separately, they took their first vacations to places outside of Moscow.

Max's pass included his train ticket. But when Eva went down to the railway station to get her ticket, she was appalled. There seemed to be hundreds of people waiting in line. She soon learned that this line was a permanent part of the summer landscape, with most of the people spending part of their vacation in it — night and day, sleeping and eat-

ing, inching forward to get their tickets. Often a week would pass before some of these people reached the ticket office. Morris, however, by-passed this process and was able to secure tickets for Eva through sources accessible to him when he needed to leave the city on official business.

Odessa was a pleasant change from Moscow. It had the ambience of Chicago on a smaller scale, Eva told her cousin Eda. The walk to the beach on the tree-lined street through a park reminded her of Humboldt Park and made her a little homesick.

Aunt Rose treated Eva as a fairy-tale princess, setting on her plate foods that the others were not allowed to eat. When Eva asked that everyone share, she was given a scolding. "You are not a Russian and are not accustomed to our food. I am giving you what you need. No guest of mine will lose weight in my home." Thoroughly cowed, as everyone in her aunt's family seemed to be, Eva picked at her food but — as hard as she tried, fearful of wasting what was obviously a sacrifice for her aunt — she could not eat everything on her plate.

Eda, wanting to tone down her mother's behavior, was frank. "My mother is a proud woman. She is happy that you want to visit here with us and doesn't want you to be denied what you have at your own house. In Odessa, the ration card gives us not much more than bread — perhaps a little more. We are not permitted extra rations for visitors who, since they are not residents of the city, are not entitled to ration books. Any food that we cannot get on our cards must be bought on the open market where everything is at a luxury price. It was agreed that for your visit we would show some extravagance and make up for it later."

"What extravagance?" Eva asked.

"The meat. We never have it more than once a week. For you we shall have it every day."

Eva wanted to know more. "What is David's pay? What is your pay?" She was astounded to learn the difference in the salaries paid to them compared to those paid to her own family. Then she asked, "Why was Aunt Rose so angry when Esther encouraged Zhora to eat freely of the apples and the pears on our table?"

Eda took her to the open market where the summer fruit was spread out in abundance. "We cannot get them on our ration cards — besides,

they are too expensive for the income we take in. My mother buys enough so that Zhora may have only one-half of a fruit each day. When we were in your house, she lost patience with your mother who took it for granted that there is plenty for everybody and that everybody in the country shares alike. That was her way of expressing her contempt for your family's ignorance of our conditions. We have to sacrifice to industrialize the country, but Ma isn't satisfied with the reason. She only knows that fourteen years have passed since the Revolution, and we are not better off than before."

During her remaining weeks in Odessa, Eva accompanied Eda to the market. Budgeting herself carefully so that she would have sufficient money to return home, she insisted upon purchasing fruits and vegetables, overcoming her aunt's objections with threats of taking the next day's train back to Moscow. She took pleasure in watching Zhora consume as much as he obviously needed. She had developed a genuine affection for this alert, handsome fourteen-year-old and felt that it was important that he have proper nourishment — at least while she was there to see him enjoy it so thoroughly. Aunt Rose remained upset. "You are not my boarder. You are my niece and my guest. You insult me." But Eva persisted.

When Eva returned to Moscow, she asked Morris why the ration cards in Odessa weren't sufficient to provide for the nutritional needs of even the children. How could Zhora grow properly? His reply, vague sloganeering, was accepted because he was her father. "There must be sacrifices for the Five Year Plan. When we have the machinery, we can produce enough for everybody. For the present, we are better off than David's family because we earn more — and the four workers in our family support only one — Ma — while David and Eda have two — Rose and Zhora — to support."

Max returned from his vacation carrying a pail of fruit and a string of onions which he had bought from the vendors at the side of the railroad tracks at every stop. Joining him in this were other eager Muscovites hungry for the South's luscious harvest; all had loaded makeshift sacks with as much as they could carry to add to the generally meager produce available in the Moscow markets. "Business was booming," Max said.

"Did this cost a fortune?" Esther wondered.

"Fifty kopecks," Max answered.

"This pail for fifty kopecks? Not in the markets in Odessa!" Eva commented. And the harvest is just as ample!"

Max's fellow passengers had told him about the vendors and their produce. "This is the surplus from the private gardens of the peasants on the kolkhoz. They have no other marketplace but the railroad station." Then, Max went on to describe some disturbing observations. At the railroad stops he had seen beggars — men pushing among the passengers with palms upward, women carrying babies with abnormally distended bellies, people obviously dangerously undernourished, begging. "They looked just like we saw them in the photographs during the famine," Max added.

"Only more proof that 'when you chop trees, the chips fly,'" Morris quoted the Russian proverb. "The kulaks," the comparatively wealthy peasants, he said, "still have their hold on the poorer peasants who stubbornly refuse to accept collectivization in spite of the advantages to themselves."

"But we let them starve!" Eva answered in horror. "Wouldn't they join the collective farms, the *kolkhozes*, when they see what harm they are doing to their kids?"

"The government has not forgotten them. They do begin to see, but they are intimidated by the kulaks. Look. Read this article in *Pravda*. It tells about the kulaks burning the cottages of the peasants who are brave enough to join the kolkhozes. The kulaks are organized. How is it that our neighbor's child Zoya is without a father? When he was sent out to teach the peasants about the advantages of the collective farms for themselves and their families, he was murdered. It is a long, hard struggle, and there are not enough communists to reach the people overnight. But, it will come soon."

"Of course," Eva would ponder. "It does take time. Rockefeller wouldn't part easily with the profits that come from the sweat of the workers," she said as visions of newsreels of old J. D. passing out dimes to little children crossed her mind.

The December 25 following their arrival in Moscow was just an-

other work day. Eva had too recently left home; to her it was Christmas Day, definitely not a holiday for her to observe even in the United States, but she had lived with the celebration for almost twenty-one years. It had always been a time of vacation during her school years, with a tempo heightened by pre-holiday festivities, and carolers from the music classes increasing the joviality by strolling into her classrooms and performing. Sometimes she herself was selected to be among the group, and the melodies became part of her repertoire of song, although their tribute was lost to her just as the "Christ" in Christmas was concealed. The season symbolized only the lighted, fragrant pine tree with surprise gifts at its base in the living rooms of her Polish school friends. As a child, disavowal by her father could not dissolve the secret desire that this holiday could be hers. So, although Eva was at work, she felt somewhat nostalgic.

During a break in the morning classes, she was called to the telephone. There were a few seconds of fear, for telephones were rare and messages by telephone were even rarer. Personal phone calls were unheard of at school unless there was an emergency. The voice at the other end was vaguely familiar but too muffled by the poor connection for positive identification. "Eva! You'll never guess. Try!"

"Stop the game!" she was annoyed. "Who is this? What has happened?"

"It's me — Al. Nothing's happened. I frightened you. I'm sorry."

"Al? When did you come?" Her voice brightened. "Why didn't you let us know? Are your folks with you? Where are you?"

He laughed. "Hey! Wait a minute! One question at a time. The three of us arrived this morning. We wanted to surprise you. We're at Valya's [the diminutive for Valeria's] now." The tone of his voice changed to brotherly affection. "How are you, kid? How do you like it here? Can you get over here when you finish work? We sure want to see you. And will you phone Max to tell him to come here?"

"Al! I'm so glad you're here! We'll be there as soon as my classes are over. My love to the family!"

Eva had missed her husband's family. There surged within her love for her mother-in-law — feelings which had begun the morning following her unorthodox honeymoon in Chicago. In the very early hours, she

57

and Max had tiptoed through the Meltz's flat and into the bedroom where Max and Al slept. Al considerately had given up his side of the bed for the davenport in the living room. Eva and Max had arisen late. Max then had grasped her hand in his, opened the door, and led her to the dining area. Seated around the table, his family well into their breakfast, Max said, "I want you to meet my wife."

Alexandra had immediately stepped toward Eva and kissed her, gently and with full acceptance. Her fear of disapproval gave way to relief. Until then, she had known Alexandra slightly, only as the friendly woman who always made her children's guests feel welcome. With that greeting, Eva became part of the household, a very different one from that of her own parents. During the one and one-half years that she lived there prior to her departure from the States, she learned from Alexandra at least a little about sharing responsibilities of housekeeping. She developed a great admiration for Alexandra who possessed a wisdom in which Eva had confidence. Sometimes she felt a little unsteady in her own decisions when she swept aside Alexandra's advice.

Alexandra Meltz was Moscow born, of Polish and Estonian origin. She had been raised free of the provincialism that was so prevalent and had a respect for human worth without pretensions. Eva recognized this same quality in Max and in his sister Valeria and brother Al. Alexandra would speak of her heritage frequently, and Eva would listen with curiosity and interest as her mother-in-law would tell about her life in Moscow as a child and young woman. She would recite Russian classical poetry by the hour, and with appreciation for Eva's desire to know, would translate it and point out its beauty. She would tell of well-known actors who had made Russian theatrical history. In the years to come, when Eva would be unsuccessful in securing for Alexandra a ticket for the opening of the Moscow Art Theater — the demand was far greater than the supply, a problem compounded by the fact that whole blocks of seats were reserved for very important people — Eva could not hold back her anger and frustration that this woman who loved the stage had to be deprived of this enjoyment.

Now Alexandra was home. She had hesitated about returning to Russia. At the farewells for Eva's family and Max in Chicago, she had repeated, "I don't like it — the thought of returning — but with you

and Valya living in Moscow, and Al sure to follow, what will Gustav and I do here alone? When I left Moscow, I had forgotten Valya's white winter boots. The Russians are very superstitious. They say it is inevitable that one returns for what is forgotten. I am not superstitious, but for me it is turning out to be a truth."

But now, Alexandra was happy to see her entire family together once again. When the excitement of their reunion wore off, the family took walks along Tsverskoi Boulevard, and Alexandra pointed out those places she had so often spoken about in the basement flat in Chicago. Here was the bench on which Leo Tolstoi had sat, and with the innocence of the toddler that she was, at the amusement of her mother, she had sat next to him. This was his favorite promenade. Here, in front of the entrance to the Strastnoi Monastery, she had seen Anton Chekhov walking with his actress wife, Olga Knipper-Chekhova.

Gustav, Eva's father-in-law, was a tall, stocky, gentle Estonian, who was in love with his wife and his children. He had left his homeland for the United States at the very beginning of the new century to search for a more adequate way of making a living for his family. After sending for his family, they moved away from the ugly life of the city and rented a small piece of land in the country which Gustav had farmed. Over the years he had given his children his own sensitivity to the natural environment. However, when Valeria finished her secondary school training in business and could no longer be confined to rural life, the parents, unable to tolerate separation, reluctantly followed her to Chicago where Gustav took work as a mechanic. Now, two decades later, Valeria had taken the path away from home again, and the others had followed.

It was convenient for the young people to gather in the Stolars' flat since their other friends and acquaintances lived communally with strangers intolerant of the loud chatter long into the night that went with socializing. When the young people would gather, Morris would wrench himself away from his demanding work at the office and take Esther for a welcome outing to visit their own peers. Eva's parents resumed friendships, some among people who, like themselves, had left for the United States before the Revolution, and some whom they had known in the

early days in this city of their childhood.

Abraham Mordish was one of these. He had had difficulty adjusting to the "land where the sidewalks were paved with gold," and with the coming of the Revolution had returned home, eager to establish himself as a charter member in the regime that promised to accept him as a Russian as well as a Jew. His wife's role, like Esther's, was to keep food on the table for her husband. The intimate relationship begun in their youth continued, and throughout these first years in the Soviet Union it was a source of comfort and companionship for both couples. Esther particularly relied upon the Mordishes for a change of pace, since the Borodins, with whom she had expected an association similar to that which they had had in Chicago, were rarely free. Fanya, working in the Combinat, not only was deeply involved, but she also had a dedication that left no time for trivial relaxation. She casually acknowledged Esther's existence, but only between Morris and Borodin did the ties of friendship continue to be strong.

The Rubensteins were another family Morris and Esther had known in their late teens and early adulthood and with whom they renewed a friendship. Both couples had married at the same time and, soon thereafter, the Rubensteins left Russia and settled in Toledo, Ohio, where their son and two daughters were born. A year after the Stolars returned to Moscow and settled on Pestsovaya Street, Morris learned of the Rubensteins' arrival from their younger daughter, Miriam, who he discovered working at the *Moscow News*. Mrs. Rubenstein's activities, as confined as Esther's, resulted in their having common problems, dealing with which strengthened the strong bond of their youth.

While Esther and Morris renewed old friendships, Max and Eva formed new ones. Reggie Ryan from California taught the social sciences at the Anglo-American School. They had previously met Reggie and Tim, her husband, at Valeria and Bob's, and this friendship led to their inclusion in Valeria and Bob's social life. Frances Goldman of New York was also on the staff at the Anglo-American School. Frances, coincidentally, was a friend of Miriam Rubenstein whom she brought to the parties at the Stolars'. Miriam and Eva struck up a special friendship, and the two shopped together, accompanied each other to the cosmetician for hairstyling and manicures, consulted with each other on cloth-

ing styles, and generally had fun "woman style." This second generation friendship delighted both of their parents.

Max brought home several of his co-workers, among them a young Canadian, Tom Schwartz, who had changed his surname to "Black" and was immediately dubbed "Blackie." He was one of the few young people who came to the Soviet Union without his parents. Zealous in his belief in the socialist philosophy, he was a dedicated worker and rapidly became an excellent printer and linotypist under Max's tutelage. He became one of Max's closest friends.

Arnie, of American Lithuanian descent, also worked with Max. He had been brought to Moscow as a child. Although only eighteen years of age at this time, he was competent and valuable for his bilingual ability. Sam and Nathan Strekman were also linotypists who had recently moved to Moscow from the Jewish Autonomous Republic of Birobidzhan in the far eastern part of the Soviet Union where their parents, driven by their fervent desire to help establish a Jewish colony, had moved from New York. The Strekmans, with others, had migrated to Birobidzhan as a group, transporting farm machinery and equipment into which they had invested all their capital, only to disband after a year's trial because of insurmountable hardships. Most of the members of the group returned to the United States, as did their parents, but Sam and Nathan went to Moscow where they were recruited for work by the *Moscow News*.

Some of the Meltz's friends were not from America. Stephenson was a German who worked on the German edition of the newspaper. He was married to a Russian — Sanya — and they lived with her relatives. The spring of their first year in Moscow, Stephenson had taken the initiative to see Max socially by inviting Max and Eva to his home to celebrate the Lenten holiday. "Come for pancake time," he said. "Meet my wife and I'll meet yours." They had been delighted for the opportunity to broaden their reach into Russian life. Neither knew quite what form a Lenten celebration might take, wondering if they were to be witnesses to a religious rite. The small flat into which they were ushered was crowded with his wife's parents and several of her brothers and sisters and their families. The room was taken up almost completely with a table laden with platters of smoked fish, several varieties of caviar,

jams and curd cheese, sour cream and melted butter. Bottles of vodka, brandy, cognac, and wines were lavishly displayed between the platters. Eva gazed with frank amazement and enjoyment at the spread before her and could not refrain from complimenting the host, even before the introduction. The older woman whom Stephenson acknowledged as his mother-in-law beamed with pleasure.

Sanya was cordial and hospitable. She tried to greet them in English, but gave up with an embarrassed laugh. Max responded in his inadequate Russian and Eva in what German she could manage, and between them they put Sanya at ease. Stephenson's father-in-law filled the glasses, raised his own in a gesture of welcome, and the party was underway. Huge mounds of heavy pancakes covered the large dinner plates. First the fish and pancakes needed to be washed down with a large glass of wine or brandy or cognac. With each layer, the glasses were raised to toasts — to the house, to health, to the great Motherland. After the first course, Eva wondered how she could excuse herself from a second layer, appetizing as it looked, without hurting her hosts' feelings. By the end of the second layer, she could take no more and begged apologetically to be served no more. Max kept up with his hosts through the sixth pancake and the sixth drink, and then gave up. The laughing crowd chided them for their American "weakness" but excused them.

Some months later, when Sanya and Stephenson were among the group making merry at the Pestsovaya flat, Max, still glowing from the experience, described the evening to the other guests. Sanya said to Eva, "You may not believe this, but the Lenten feast was also my first. And it was the first for my parents since the Revolution thanks to the INSNAB book. How else could we have gotten the wines and the brandy and the cognac and caviar on our table?"

This was the beginning of another good relationship that continued over two years until Stephenson suddenly disappeared. Rumors had it that he had been deported from the USSR for shouting "Russian pigs" in a crowded street car. Both Eva and Max were shocked but never had the courage to discuss the question with Sanya, who was obviously reluctant to talk about it. Although she was invited as before to join in their social activities, she gradually withdrew.

Guerra, a co-worker of Max's, of Spanish background yet suffi-

ciently comfortable with the English language to be valuable to the *Moscow News*, and his Russian wife, Galya, who was a student of English at the Foreign Language Institute, also were among their friends. Eva and Max were often invited to the home of Galya's mother who had a house in Perova, just outside Moscow. Living in Perova was inconvenient for Galya's mother in winter because she needed to travel daily to Moscow where she was employed in a factory. In severe weather she could not get home and would spend a few days with Galya and Guerra in their dormitory room. Then she would like to have exchanged her house for a room in the city, but could find no taker. But in the summer, to Eva and Max, visiting there, even for a day, was like having a vacation in a *dacha* (a country home), with the forest almost at the back door and a river close by. It was a relief from the heat and humidity of Moscow. The four would catch the local train early in the morning and within an hour would be among the big trees, a short hike from the house. Eva and Max enjoyed this friendship. It compensated for those they had had in Chicago and for the summer Sunday picnics at the Indiana Dunes.

In the fall, when Eva joined the staff at the *Moscow News*, she made more friends. Two were Russians who knew how to read and speak English. One, Adler, had lived for many years in England. Although a printer, he was assigned to doing layout in Eva's department because his skill in this field was of greater value than his ability to work on the linotype. The other, Paula Zazovskaya, also worked on layout in Eva's brigade. Paula often said that she felt fortunate to have been assigned to an English-language job, having graduated from the Combinat in the field, since many of her classmates were wasting their training in unrelated areas.

Paula was addicted to the telephone. As soon as one became easily accessible to Eva and Max's room, she would ring up Eva after work almost daily to discuss work problems — or perhaps, Eva suggested to Max, just to practice her English. Sometimes she would talk on matters relatively unimportant that could have waited until the next working day. One conversation, however, slightly irritated Eva, and the date of the call — December 7, 1934 — remained with her only because for days afterwards the Russians around her, at home and in her office, talked about nothing else.

Paula had phoned Eva very early that morning, awakening her. "Have you heard the news on the radio?" she asked in a tight voice.

"Not yet, I'm not up."

"Then turn it on," she ordered.

"Tell me. I probably won't understand what they're saying." Eva still didn't know much Russian since her work had confined her to the English-language sector, and even her Russian friends, most like Paula, spoke English to her. The government also still conveniently provided translators for other business she needed to conduct, as at INSNAB.

Paula gave in. "Kirov was killed!"

"Who is Kirov?" Eva asked.

The tone of the response gave her the feeling that Paula was shocked at her ignorance. "You don't know! He was a member of the Central Committee of the Party and the Party Secretary of Leningrad! He was murdered! And now we are going to have a lot of trouble!" She was becoming somewhat hysterical.

Eva made light of it. "What do you mean — a lot of trouble? They'll find the person who did it and that will be that!"

"No, no! There will be a whole political case!"

Paula's prediction was correct, but Eva was not then alert to the signals. Within a few short years, however, Eva was to realize that Paula's fears were very much warranted — they were a warning that her dreams of spending the rest of her life in an idealized socialist state were to become illusions and that there would be tremendous tragedy in her own personal life. With Lenin safely dead and enshrined, the political power struggle had begun. Stalin secured his power over the secret police. The revered revolutionaries were liquidated as traitors to the Revolution, leaving only Stalin as the true defender of the Revolution and a populace shocked and confused. Then, Stalin skillfully re-introduced anti-Semitism and militant nationalism to an adoring people, after which the purges that followed sent untold numbers of ordinary citizens to the forced labor camps and their deaths.

Through her membership in the Anglo-American section of the Foreign Club, where regularly scheduled affairs of the English-speaking community were held, Eva made more acquaintances. She also associated with parents of some of her students, all eager to gather with

their own and to speak in their native language. They needed the social and cultural life offered, the concerts, the plays, and the dramatic and poetry readings. She met people outside of her own field of work — engineers, architects, and non-professionals — employed in construction and in the factories. There were also Russians who claimed to be eager to become part of the club so that they might "learn English" or extend their theoretical knowledge through "practice."

At the club, Eva was introduced to Russian literature. She learned to love the richness of some of it and to arrive at very definite conclusions on the worth of others. On her own, she had attempted to read Pushkin, the 19th century writer considered the father of Russian literature, but not until she heard the translations here did she fully appreciate the reason for his popularity. Then there was Mayakovsky about whom there seemed to be controversy. Lenin had not judged his work to be poetry, but Stalin had called him the "poet of the Revolution." As Stalin's favorite, his works were printed in the millions in all the languages of the Republic. Eva had mixed feelings. After her own reading, she could not identify it as poetry and labeled it as propaganda. But when Herbert Marshall, an Englishman famed for his translation of *Eugene Onegin*, gave a reading of his translation of Mayakovsky, Eva went into raptures. She tried again to read his works, both in Russian and in English, but didn't care for them. She decided that only Herbert Marshall's presentations brought out the splendor of Mayakovsky.

At the beginning of 1937, for unexplained reasons, the Foreign Club was closed down. With its demise, Eva's contacts disintegrated. More importantly, her urge to dig into Russia's roots went unfulfilled.

Rose Wogman, a young woman of Valeria's age, was among the Chicago acquaintances who had arrived in Moscow in these years. In the early 1920s, she had emigrated from the Soviet Union to the United States and off and on, through Valeria, had been a boarder in Max's parents' home. Characteristically, Alexandra accepted her as she accepted all of her children's friends, as a member of the family.

Rose had incurred Eva's contempt by her dilettantish activities and open discussions of her sexual adventures. With no training, and in

Eva's opinion no talent, Rose often had volunteered to sing and dance at various Russian-American cultural affairs in Chicago. At Alexandra's requests, Eva had sometimes been her reluctant piano accompanist.

Alexandra, in announcing Rose's arrival, expected that her own warm welcome would be echoed unanimously by her children, but Eva, not having overcome her bias, had no wish to include Rose in her colony. However, there was no way she could avoid all contact with her at the Meltzes, where Rose visited fairly often. Her tendency to build up her own importance and her gross exaggerations caused Eva not to trust her. When for some inscrutable reason Rose began to persist in flattering Eva excessively, embarrassing her, she made known to Max her deliberate intention to find reasons to be busy with other activities when Rose would be with the Meltzes. She once said to Max, "Given half a chance, that woman would stab her best friend in the back."

Suddenly, Rose's visits stopped. Alexandra became worried. "Something must have happened," she insisted. Valeria tried reaching her unsuccessfully. A year later, Rose reappeared. She shuffled into the Meltz's room, dragging her legs, supporting herself on a cane. She had been seriously injured in a street car accident and was told that she would be an invalid for the remainder of her life. The family was overcome with pity, Alexandra especially showering her with compassion and attention. At the initial shock of the news, Eva expressed sincere sympathy but she could not bring herself to work at deepening a personal relationship between them. They saw each other rarely.

Part Two
The First Wave of Terror

Chapter 4

During a rare evening when everybody was together, a serious and troubled Morris opened up the subject. "What do you think about the passports?" he asked as he thumbed through his own, holding the booklet between his fingers, letting it hit the edge of the table, again flipping the pages, then examining a page slowly.

"It bothers you, Morris?" Esther asked.

Abie said, "I don't know. I haven't thought too much about it. But it was a nuisance having to take the time from school to get it."

This was about the introduction of the new internal passport that was to be carried by everybody beyond the age of sixteen. The house committee was coordinating registration for and issuance of the passports, which would contain not only the name and address of the registrant, but also their date and place of birth, status of employment (blue collar or white collar), marital status, names and birthdates of minor children, and nationality.

"What is it all about, anyway?" Eva asked. She really wasn't expecting an answer. "Now we'll only have to worry that we won't lose it."

From Abie came, "We're already registered with the house committee. Even if we wanted another flat, we couldn't move without their knowing where we would be going — if we could get another flat. I can't understand why we need another registration bureau. It's one bureau on top of the other."

"Most of the people at the Komsomol meeting carried on as if this is a great political strategy, but I didn't catch it all. They talked too fast for me to understand," Eva commented.

"What's this nationality business? We're one country, aren't we? What are you, Eva — Jewish?" Max teased.

"Of course I'm Jewish and I'm not ashamed to have it written down. We're not in the United States."

With that, the younger people went their separate ways. But Morris remained quiet and thoughtful. The next day, he wrote to his close friends with whom he and his family had shared their Division Street flat. "You know that it is always a pleasure to hear from you and to know that you are well. It grieved us to hear of your mother's death. Esther repeats that she was a grandma to our children just as you were their uncle and aunts. You, too, deserve some credit for having had a hand in raising them. They have grown up to be intelligent and responsible citizens and you would be proud of them. If you join us as you presently plan, you will see for yourself.

"I am impressed with the useful work that you write you are doing and think it would be a pity if you left it. Think it over.

"Esther and the children send their best regards."

A month later he received their reply that, perhaps, on a visit some day in the future they would all see each other. He was content. His message had gotten through.

When Eva became pregnant, she was considered fortunate to have none of the complaints of so many women in their early months. She carried on with her normal work routine until she became eligible for the paid maternity leave which included the last two months of the pregnancy and the two months following. Adding her month's paid vacation time and the five months of leave without pay to which she was legally entitled, she would be able to stay home until the baby was about ten months old.

Max and Eva had many opportunities to rearrange their schedules so that they had more time to spend together. On one of these days, in the very early spring of 1935, they took a leisurely and relaxing walk. "Let's remember this day," Eva said. "I'm happy — and I know that I am happy. And why not? To have the good fortune — I, plain, ordinary little me — to be walking here with you on the streets of Moscow, to live at a time like this, to be able to feel, almost to touch the miraculous

and wonderful changes that are occurring within me. Do I deserve to be a part of all this?" She was bordering on euphoria.

The prenatal care that she received affirmed her faith in the system. She met women at the special women's consultation office who, like herself, were given regular appointments as directed by the obstetrician. They were encouraged to keep their dates in order that there be a systematic record of the progress of their pregnancies, and were cautioned about the importance of appearing as directed so that immediate steps could be taken if any special care might be necessary. Although several maternity homes were in every neighborhood, it was decided that Eva would apply to the Grauerman Maternity Home where most foreigners delivered their babies. With Morris's influence, a place was reserved for her there.

It was here on May 14, 1935, that Tamara was born. Eva had ten days of luxurious living. The doctors had the reputation of being the most skilled in Moscow, and the facilities and food were excellent. Telephones were at every bedside for the mothers to chat with their husbands to make up for the No Visitors policy. Max made his calls from Valeria and Bob's, who were among the few people he knew to have a phone in their rooms, or if he was passing the maternity home, he would step into the lobby, pick up the phone there, and listen to his wife's rapturous talk about their beautiful daughter. Sometimes on a prearranged signal, Eva would stand at the window of her ward that faced the Arbat and wave at him, and once she held Tamara up high so that he could see her. She had the usual motherly concerns about the health of her baby — in this case the condition of the baby's skin which was covered with hair. She wrote Max a note: "I'm afraid that we are going to be the only ones who will love this hairy infant. But all the women here say that she is lucky, that this is a sign that she will live a happy life."

Eva and Tamara went from the maternity home to Pestsovaya where, for the first two months, Esther doted on them while Morris looked on with wonder at this child of his prodigy. After returning from working the night shift, Max would take over from Esther, denying himself sleep and becoming as skilled in handling the infant as the women.

When Eva returned to work, Esther went to their room every day to oversee Max and to try to coax him to let her handle her grand-

71

daughter more often. Esther was delighted when they were all able to live together again, and Eva and Max had to admit that it was good to have her around.

As it turned out, about this time the publishers of the *Moscow News* were allotted a building for housing their employees. This building was within walking distance from the offices, and was equipped with telephones. Morris, as one of the editors requiring the telephone facilities, and Max and Eva, now both night workers, all qualified for rooms in this building. Morris arranged with his trade union for another employee of the *Moscow News* to occupy Esther's room in the cooperative. Now, only Abie remained in their first apartment, another couple having replaced Eva and Max when they moved to the dormitory. Abie was an ideal occupant in a communal flat, for he used his room only for sleeping, going directly to his parents' room where he had his meals and received the usual services that his mother gave her family.

The new building had four floors and some modern conveniences to make living easier — hot and cold running water and, on the floor close to their rooms, a bathroom with a shower. To Esther's relief, their rooms were on the second floor! Eva and Max were given one of the smaller rooms while Esther and Morris had a larger room — large enough to accommodate the baby, too. Their houseworker moved with them, and the neighbors agreed that she could sleep on a cot in the communal kitchen. The Borodins, living in a private flat on the fourth floor, became their neighbors.

So Max and Eva gave up their common apartment lifestyle and shared the upbringing of their daughter with Esther, for whom the baby gave a new zest to living. She re-lived the days when her own children were babies, adored her daughter's daughter with the consuming passion of a mother, offered up the child to the Mordishes and Rubensteins for praise and attention, and swelled with pride when they succumbed to her charms.

Eva considered the year of Tamara's birth to be the most gratifying since her arrival in the Soviet Union. Although on maternity leave, she was not left out of the activities of her office. She had a standing invitation to attend the Komsomol meetings whenever she wished. The

opportunity for discretionary attendance proved to be a decided advantage. She attended those sessions which interested her and avoided the ones that bored her, especially the compulsory group study of the text, *The Communist Party of the Soviet Union*. The study of this book was mandatory in every factory, every office, every place of employment — wherever there were workers. The sessions were repetitive and they never moved beyond chapter five; those early chapters dealt with the struggles between the Bolsheviks and the Mensheviks. Whenever the classes were interrupted by vacations or recesses, the leader would insist upon a review, so the first five chapters would be studied and discussed again. Eva could have recited them verbatim.

Eva and Max had more time together. With his working hours what they were — from late afternoon through midnight — he was at home during much of the day to share their first year of parenting. The grandparents reveled in hearing the compliments of friends and acquaintances, and their self-esteem soared when, uninvited, strangers peered into the carriage — an uncommon device in Moscow, where mothers typically toted infants close to their bodies — and commented about Tamara's eyes, almond shaped and dark velvet, and her soft and shiny hair.

When the end of rationing was announced to a jubilant people soon after Tamara's birth, Eva liked to think of Tamara's arrival as a symbol ushering in Morris's promise of the last five years. Now the workers were to have their rewards after their long years of sacrifice to the Five Year Plan. Now they would have sufficient and adequate food and clothing.

Immediately upon the end of rationing, Eva ventured into the neighborhood shops on Pestsovaya, territory unknown to her until now because she had been assigned to INSNAB. What an education this was! These shops were small, dark, and unattractive compared to the INSNAB shops at the Eleseyev (named after the pre-Revolutionary owner of the luxury food store on Gorky Street) and, later, at the Kuznetsky (named for its location on the street Kuznetsky Most, in the heart of Moscow) where her family had shopped all these years. The shelves, although adequately stocked, lacked the variety which she had taken for granted. When she shopped at these stores, it seemed that regardless of how

early she queued up for service, the supplies of white bread had already disappeared. The demand could never be satisfied.

INSNAB had been moved some years before from the Eleseyev to the Kuznetsky location. It had become the distribution center for another category of worker and was now open to the entire population. Foreign workers now needed to shift for themselves; special organizations and luxury rations for them were a thing of the past. Eva compared these stores as she had known them before and as they were now. She realized that, when they had catered to the foreigners during rationing, they had sold all kinds of foods unavailable to the general public. Now they were not as well stocked; yet, Nyura and Bluma Abramovna assured her, they had a much greater assortment than the vast majority of Russians had seen for years.

In a short time, conditions improved even more. The people were able to buy foods which the younger generation had not known existed and the older generation had not seen since the New Economic Policy, known as NEP, was implemented in 1921. (NEP had been a temporary measure that incorporated such strategies as private enterprise and freedom of trade to relieve the catastrophic economic conditions in the country. Many communists had considered NEP a reversion to capitalism, but it had ended in 1928 with the collectivization of farms.) As a much larger variety of goods became available, the Abramovnas — perhaps like other Russians — invaded the Eleseyev and Kuznetsky stores and recklessly bought the luxuries which they had seen on the Stolars' table: pastries of all shapes and flavors, cakes, sugar, meat, fresh and smoked fish, red and black caviar, all kinds of cereals, butter, oil, candies, apples, grapes, and different breads — white as well as the usual dark brown, and bread with raisins and without raisins. These were foods they had all but forgotten had ever existed. Even scented soaps were on sale, something that the Stolars had not seen since they used the last of their American supply. Soon, however, they came to settle for items priced within their budget, but at least goods were available to most people in sufficient quantities to meet basic requirements and to allow for an occasional extravagance.

Two things, however, remained the same: the long lines — longer than ever before, it seemed — and people having to bring their own

wrappings for their purchases. "We are finally Muscovites," the Stolars proudly stated as they waited patiently in the lines. Eva learned to slide from one to the other, each for a different item on her shopping list, politely asking that one shopper hold her place in one line while reserving another spot with another customer in another line. Each person showed the same courtesy to the one in front of her. Everybody's attention was focused on the movement of the lines in order that they might slip into their place when their turn was reached to give their order to the salesperson. And without translators, Eva found shopping more difficult than ever before. It finally occurred to her and her family that, for all the years of their residency in Moscow, they had been privileged foreigners with no realization of the deprivation that the native Russians were experiencing. "Even with wages like ours they could not buy what we got at INSNAB," Morris mused. "No wonder the Russians in our office wanted the INSNAB books."

"They must despise us. In their own country, they saw foreigners like us living off the fat of the land, and they couldn't get a bit of it," Eva said. "Those kids at the Anglo-American School — they knew what INSNAB was. They had a right not to believe us even when we swore that our jackets came from the United States." She ruefully added, "We made no sacrifices. I'm glad that INSNAB is closed. Now we are Russians."

"But be aware," Morris reminded her, "that communism is still far off. We have four workers on good pay. We can afford the best that is on the shelves. We are still in a money economy. As long as we earn more than others, we live better than they do."

"How could we have been so stupid?" Eva felt that she had been deceived. Almost five years in the Soviet Union and she had had only a glimpse of the reality of the living conditions of the Russians. Yet, even her father, whom she certainly considered knowledgeable of the system, hadn't noticed that he had been kept separate and apart from the people.

The letters that were sent to Chicago announcing Tamara's birth brought excited replies that made Eva nostalgic. She had felt envy when, from time to time, American friends working at the print shop or the

Anglo-American School or the Foreign Language Institute returned to the United States for their vacations. And now, these letters that Eva was receiving from the States brought on waves of homesickness. Letters arrived from cousins with whom Eva had been raised, all having lived in close proximity during their years in Chicago; from Uncle Peter, the sentimentalist in the family, ecstatic, offering to pay for transportation if only he might get a glance at his great-niece; from the extended "parents" of her childhood when she lived on Division Street; and from friends, some now married. "We can't afford to have a baby. We would love to gurgle over at least one from our crowd. Bring her home," one of them wrote.

Eva decided that she had to go home.

Max understood and agreed. Morris and Esther fussed, their parental instinct showing. "It will be too hard a trip for you with an infant." And, "How can you take care of her without help from Max and Ma?"

"I'm homesick," she kept repeating. "I need to hear English, to see English signs in the streets, to read the headlines on the newsstands! I want my friends to see my baby. Don't you remember how you felt?"

Morris finally relented. "I'll inquire for you at the OVIR, the Registration and Visa Office, and find out where you get the papers to travel out of the country," he promised.

He kept his word. A few weeks later when he returned from OVIR, he seemed troubled. "They claim you're a Russian citizen and can't go abroad. I had a quarrel about it, but it accomplished nothing."

"A Russian citizen? When did I go through those formalities? I'm an American citizen! And what difference does that make? Can't a Russian citizen go abroad?"

"I don't know how they did it. They wouldn't say. You received an internal passport and that's it."

"But I have the receipt that I was given for my American passport when we entered the country. That shows the number of my passport and the entrance visa. Where can we go with that?"

Morris anticipated his daughter's disappointment at his answer. "I did not have the receipt with me, but I did remind them of that. They told me that it is not a receipt. It is your identification card."

She sputtered in her wrath. "That is not what I was told when I gave my passport to the customs official. He said it was a resident permit and a receipt for my passport!" (Foreign citizens had residence permits stamped into their passports; all urban citizens of the USSR had internal passports showing in what city they were registered; peasants had no documents of any kind, and could not leave the collective farms.)

"We'll go to the OVIR together and show them your receipt," Morris said in an attempt to mollify her. "Tomorrow."

Eva presented her receipt at OVIR. "No, this is not a receipt for your United States passport," she was told. It was a permit for a Russian national planning to live in Moscow and was required of all citizens. In her case, it indicated that she was granted this permission when she submitted her American passport and entrance visa which had been taken from her at customs. Therefore, she was recognized as a citizen of the USSR with all of its rights, responsibilities, and privileges.

"I'll phone the US Embassy. This can certainly be cleared up there," she told Morris. When she could not locate the telephone number, the listing nowhere in any directory to which she had access, she personally went to Manyesh Square where, from next to the National Hotel, the United States Embassy was identifiable from a distance by the American flag waving high over its roof. As she walked towards the entrance, a Soviet guard stopped her, demanding her name and proof that she had a right to enter. She showed him her receipt for her passport and first in her broken Russian, then in her Chicago English, explained why she wanted to go in. He turned her away, insisting that the document was not sufficient to permit her to enter.

Arriving home somewhat confused, she asked Morris, "What do you make of all this?" He could only suggest that she try again another day. Perhaps the guard was overstepping his authority. Again Eva tried and again she was turned away. After a third attempt, the Soviet guard told her, "You have been here several times. We have our instructions as to who may enter." He was decidedly unpleasant. "If you annoy us again, we shall have to report you to the authorities." Sufficiently browbeaten, she withdrew quickly and never returned.

Her report of this confrontation perplexed the family. "I'll let it go for the present," she said. To Max, she thought aloud, "How could I have

been so naïve as to have thought — when I handed over my passport — that it would not be lost. I should have demanded immediately that it be handed back to me. Those people at OVIR must think that we Americans are a bunch of numbskulls if we expect them to hold onto the document of every person who arrives from abroad." Even though she had not been able to get her passport and she was barred from the embassy, Eva was not yet too critical of Soviet policy. The conformity that was demanded of her was becoming a way of life.

Chapter 5

About a month before Eva had taken her maternity leave, she witnessed an aspect of Soviet credo which was entirely alien to her. It had been preceded by a series of articles in *Pravda* that called for a revival of "cleansings" to remove ineffective and outdated elements from the Communist Party in order to insure that the organization remained healthy and strong. Morris had been reading the newspaper when he came upon the first of these articles, which he called to the attention of the others. Their reaction was, at first, only one of vague curiosity, but when the subject appeared again in the following issues, it took on a greater interest. "A cleansing? What does this mean?"

By this time, Morris was able to offer an opinion. "It can be compared to a production meeting [a part of all work programs in which evaluations were made of accomplishments and weaknesses to determine immediate guidelines for changes in procedure]. Party members as the ideological leaders of the country need to take a good look at themselves from time to time. What and how have they contributed to the progress of a socialist state? What more can they do? What more is expected of them?"

"Who is to decide this — for you, for example?" Eva asked.

"My Party unit, collectively. We have worked closely together in the unit and in our trade union, and for that matter in our daily work, so that we can evaluate each other's work and our combined accomplishments. Our comrades have the same goal, a socialist State."

Within a few days, signs were posted in the office and the print shop announcing a series of open Party meetings to be held in the large

hall at the Ogonyok Publishing House, the offices of the publishers of the *Moscow News*. Inasmuch as these meetings were to be an appraisal of the accomplishments of the local Party Unit, the employees, to whom it gave leadership, had the responsibility and the right to assist in assessing individual comrades. "Only in this way can the Party remain healthy and function effectively." The presidium would welcome the opinions of all persons present.

Since Eva and Max worked the shifts when the meetings were held, they were required to attend on their free evenings. The series of meetings were to continue as long as necessary for all Party members to account for themselves and be evaluated. After Eva's first meeting, she said to Max, "It's an exercise in exorcism! You should see the breast-beating. I felt uncomfortable. The hall was jammed with people. I'm surprised that the fire department permitted such a crowd. Every aisle was blocked by people sitting in extra chairs."

Each comrade had been called upon separately. All of them seemed to be prepared with an outline similar in organization, each beginning with an autobiographical statement: where they had been born, their parents' background, their own work background. Then they aired their philosophy, how and why they felt that membership in the Communist Party would fulfill their drives for expression of their beliefs, their desire to participate actively in building a socialist State, the degree of their participation, their analyses of their contributions, their successes, and their weaknesses and failures. But this was not the end, as Eva recounted to Max. "Poor Zaslov was really put in an embarrassing position. After the chairman called upon the visitors to make any comments of the appraisal that he had given of himself, one of his neighbors asked to speak. She said that a comrade, a member of the Party, should set an impeccable example in his personal life and she proceeded to relate that when Zaslov's wife had been on vacation, he brought to his room women who stayed the night. He turned all colors of the rainbow. Some people began to laugh but the chairman stopped them in a hurry and said that the complaint should be heard out, that immoral behavior in a Party member discredited the Party and was not to be tolerated. Nobody spoke against the irrelevancy of the criticism, not even the people who laughed. Things got a little tense."

"What about Zaslov," Max asked. "Did he answer?"

"He said that he agreed with the chairman, that he had been guilty of infidelity, thereby disgracing and dishonoring the Party and that he would not repeat such behavior. Then the comrades in the Party unit were called upon, one by one, to give their opinions of Zaslov's worth based on how he himself had estimated it and on their own observations as his co-worker. One praised him for his honesty in recognizing his weakness. When all the comrades had had their say, the chairman summarized and finished with Zaslov by concluding that he was a worthy and dedicated member of the unit. Then the voting followed, and from the count, the members concurred."

"I don't understand," she interrupted herself. "Not only the employees of the publishers' organizations were there, but also people not connected with the job. The chairman of our house committee was there, too. Could it be just because he is employed as the manager of the building owned by the publishers that he has a right to sit in judgment on the personal habits of the Party comrades of this unit, or of any person for that matter?" Max and Eva were in agreement that people unacquainted with the performance of comrades on their job had no basis for participating in such evaluations.

The next evening, Morris returned home distressed. Manov, an old-time Bolshevik, had been publicly disgraced and expelled from the Party. He had been accused of favoring Trotsky's policies some ten years before. "Manov has the respect of all of us. When I first arrived, he was introduced to me as a highly valuable comrade to whom I might look for assistance. I have had long and interesting talks with him many times on theoretical and political matters. His life's aim is the successful growth of socialism. He took it very hard."

"Didn't he even give an argument?" Eva asked.

"He reminded the old-timers of the heated and open discussions of those days. 'Without collective thinking, we could not come to decisions on policy and behavior that would be best for the workers and the peasants,' he said. 'No one man has all the answers. Our Party made some of our wisest and most successful plans from these frank expressions of all points of view. I have always followed the wishes of the majority, regardless of how I voted.'" Then Morris added, "I don't like

how this is going. It seems as if we have a feckless mob."

It was at the next meeting Eva attended that she grasped the meaning of Morris's fears. By the time she reached the hall, every chair had been taken and people were standing at the sides and rear of the room. She took a chair from an adjoining office and seated herself on the left side of the hall facing the row of chairs towards the front. Several other publishing house workers had followed her lead and had seated themselves beside her. Not an aisle was open for exit, and the murmuring of protest was passed off as unimportant.

The presidium was assembled and the chairman opened the meeting as he had on previous evenings, reviewing the purpose of the gathering and welcoming the participation of the non-Party comrades. He called on several Party comrades one by one. "Each did his exercise in breast-beating," Eva said later. Every talk was followed by the speakers being extolled for their accomplishments and commended for their promises to correct their errors. After the members of the Party unit voted in agreement with the chairman's remarks that here was a comrade of high quality, each was excused from further enunciations.

The meeting had been underway for about an hour when the chairman reached the name of James Noselton. A loud muttering was heard from among the people standing in the rear of the hall. A man pushed himself through the crowd and made himself visible to the chairman from behind the last row of chairs. "Give me the floor." he called. "I want to speak." The chairman reprimanded him for interrupting the routine. His face turned red as he persisted. "Give me the floor!"

There was an uproar from the audience, but he continued. "We don't have to hear him. He doesn't deserve to appear before us! He is a danger to young boys and doesn't belong with normal people!"

With the increased mumbling, the chairman's voice was lost. James, who had by now moved to the front of the hall, faced the people with anger. Eva could see him pointing his head to the chairman in a motion that indicated that the meeting needed to be controlled. She felt uncomfortable for him. He was known to the English-speaking employees as a genial, competent journalist who had always enjoyed their company.

When the assembly quieted down, James spoke. By his accent, it was obvious that he was not Russian. He talked of his home in England,

of his work as a laborer in many countries where he had lived and traveled, where he had received his training as a journalist, why he had decided to join the Party, how long he had been a member, and what kinds of work he had been given under Party direction. Before the chairman could ask for remarks, an angry man at the back of the room shouted, "Now let me speak. I am his landlord." He then accused James of being a homosexual, of his having performed perverted sexual acts with a young Englishman with whom he shared his room. In his rage, the man lost all control, describing, in language offensive to Eva, James' improper dress habits before the landlord's wife and his behavior when he walked in unannounced on his roommate who had brought a female to the room. As he ranted, spittle splattered from his mouth. Eva could not raise her eyes to look up at James. She was humiliated for him, for the speaker, for the chairman, and for herself for having to be present at such a demonstration. She felt as if she had fallen into a pit of sewage.

The chairman called upon James to answer the charges. He replied with strong emotion that he was not there to discuss his private life. There was a short period of outraged silence. Then the Party members began their speeches. No one remembered to speak favorably of Comrade Noselton, the Party member, as they had spoken of the others. Not one reviewed his contributions or mentioned that he was competent and hard working. Only the "disgrace" that he had "perpetrated" upon the Communist Party of the Soviet Union and upon this Party unit in particular was brought up. His immediate expulsion was recommended and accepted. The next day, James Noselton was fired from his job and soon afterward he left the country.

A short time after the "cleansings" had ended, Morris sorrowfully reported that Manov had committed suicide. "Did he kill himself to call our attention to the stupidity of these policies or because he felt betrayed?" Eva wondered. "If it is a protest, nobody is listening."

When the meetings had ended and her maternity leave had started, Eva began meeting with students who were the district activists of the Komsomol that met in her building. A representative of the district Komsomol Committee, employed by the publishers, invited her to attend one of the meetings where, he said, there was to be a discussion on the tasks of the youth in the district. He was certain, he emphasized,

that she would find the meeting stimulating, and it would give her a view of the breadth of the Komsomol movement that she was now experiencing only from the narrow confines of her work.

The meeting was very well attended. The young men and women greeted each other rapturously and loudly, and Eva was excited to be there. The chairman hailed people from the platform and, until the meeting began, he displayed an informal and breezy attitude. When it started, however, he dropped his casual bearing and commanded everybody's attention. He called for reports from the members of the presidium seated on the stage with him and asked for announcements from the floor. The chairman then introduced a member of the district Komsomol Bureau who was to talk on a matter which, he said, should be of grave concern to all. It had to do with Marya, a young woman who seemed to be known to everybody present.

"She is not with us tonight because of obvious embarrassment. Her father has been arrested by the security police." The silence in the room became heavy as the chairman continued. "Although the accusations are not yet known, it is absolutely certain that he is an enemy of the people, having committed anti-Soviet acts — acts of which our great leader, Comrade Stalin, disapproved."

With the mention of Comrade Stalin's name, the members of the presidium shot up from their chairs applauding and hurrahing, stretching their arms forward to motion for the comrades to rise. One by one, the members, caught up in the acclamation, got to their feet; some even stood on their chairs as they applauded. The chairman, smiling and patient, waited until the enthusiasm wore itself out.

The guest came forward and told them that Marya was, indeed, shaken. She had questioned the reliability of the information that the NKVD had and was insisting that her father could not be anti-Soviet. She had even gone to the NKVD offices and had challenged the authorities there to explain the arrest — naturally receiving no satisfaction. Marya had even gone so far as to demand that she be told what the accusation was. "We must see this action in its proper perspective," the speaker said. "A Komsomol activist, of all people, questioning the action of the security police, the arm of our Great Comrade Stalin — showing such disrespect for that protector of the Soviet State!" Again there was

fiery and prolonged applause, this one too led by the members of the presidium. Eva was bewildered.

That night, Eva spoke with her father. "The girl was expelled! I can't believe it! Can you believe it? Being condemned for inquiring about her own father! No questions, no comments except to judge her as a traitor to her motherland and to Stalin! I am shocked! I am shocked! Is Comrade Stalin a god?"

Morris heard her out. "So — it is filtering down to the young people. This noise has been going on for several weeks within the Party unit also!"

One national political crisis after another throughout 1936 shifted attention away from the local Komsomol and Party problems and, for Eva, marred the tranquility she had experienced with Tamara's birth. Her pride in the economic gains the system achieved for the workers, important for maintaining her faith in the government, dimmed. Max and Abie told of Komsomol meetings fraught increasingly with hysteria, and Morris mourned the suicides of two more of his co-workers after their expulsion from the Party. The newspapers announced to a bewildered people the counter-revolutionary conspiracy of two members of one of the most important national committees of the Soviet government, the Politburo — and then there were two more, and then even more until finally Stalin was the only remaining loyal member, free of taint. Shocking stories in *Pravda* and *Izvestia* reported the arrests of Kamenev and Zinoviev. On the heels of the exposures of their crimes came reports of the detainment of Bukharin and Rykov. Even Yagoda, the powerful chief of the security police, was replaced, charged with being a counter-revolutionary, and executed.

Kamenev and Zinoviev were the first to stand trial. During these procedures, parts of which were made public, they confessed that they had been spies for foreign countries. Soviet citizens were shocked and expressed their disbelief at this information. These men were among the heroes of the Revolution! They had made the Revolution! They were the great theoreticians and leaders and organizers of the Communist Party *before* the Revolution, and *after* the Revolution were Lenin's clos-

est colleagues! These were the men who had suffered the tortures of solitary confinement in Tsarist prisons — from whom false confessions could not be extracted. Conjecture about their guilt or innocence was the topic of conversation everywhere — on the streets, in the streetcars, in the markets. They must be false confessions! Men of such caliber would not turn against the Revolution! "But how could they be made to confess to that which must be absolutely untrue?" Whispered rumors suggested that they had been given a drug which had stupefied them so that they agreed to statements of which they were unaware.

The Stolars and the Meltzes also refused to believe that they had been told the truth, and events that occurred in December, following the executions of Kamenev and Zinoviev, lent credence to their doubts. The security police now started to move in on the little people, destroying family and faith. Ironically, the first of these blows came just a week after the celebration of the new Constitution, which gave promises of freedom of speech, press, and assembly and of the inviolability of the person and of the home. The new Constitution was commemorated on December 5, 1936, and that date was proclaimed a national holiday — one as important as May Day and the November holiday commemorating the October Revolution.

One evening in mid-December, Morris came home from work later than usual. He tapped at Eva's door and asked her and Max to follow him into his room. He was quite pale and looked fatigued. "Are you sick?" Esther asked in alarm.

Morris sat on their only soft chair and for a few moments sipped slowly from the cup of tea that Esther handed him. Then he told them that Jean, the editor of the French language edition of the *Moscow News* and one of the organizers of the French Communist Party, had been arrested. The chalkiness left his face with their outburst of outrage. They vocalized his wrath for him. Now he felt the embrace of his own family. Their response was not the affirmation of support for the NKVD that he had been hearing all day from his colleagues — that the NKVD could make no mistakes. His family rejected without question the possibility of Jean's guilt. They sensed the injustice of the accusation! "Colette is beside herself. She can't get information," Morris uttered.

"Even his own wife can't get information? Does she have a law-

yer?" Esther demanded, recalling the steps she had taken for Morris's defense in similar situations in the United States.

"What lawyer?" Morris answered bitterly. "The Party has already denounced and expelled him. No lawyer will take a political case. And it's no use for Colette to go to the union and ask for help. The union and the Party are one and the same. Gone are the days when its members could have a grievance acted upon without Party approval."

The next arrest, coming less than two weeks later, hit directly home. Alexandra left a message for Max and Eva that Max's sister, Valeria, needed them. Could they come without delay? She was leaving for Chelyabinsk tomorrow. "Could Bob be ill?" they wondered. Bob's work took him between Moscow and Chelyabinsk frequently. He had already been in Chelyabinsk a month, longer than usual. "Perhaps he is remaining longer than he expected and Valeria decided to spend a few days with him," Eva guessed.

When Max and Eva reached the building where Valeria lived, Gustav was waiting somberly for them outside. As they climbed the stairs to the room that he and Alexandra shared with Valeria and Bob, Gustav told them that Bob had been arrested. A friend who had that day returned from Chelyabinsk had rushed directly from the train station to Valeria to inform her. She had no more information than that.

Valeria was near hysteria. She immediately arranged for a short leave of absence from her work and planned to travel to Chelyabinsk on the next scheduled train. Alexandra and Gustav hoped that Max could persuade her to wait a few days. Perhaps there would be official notification, or even a letter from Bob. But Valeria could not be deterred. As she packed, she talked. Her conversation was erratic and sometimes she fumed with annoyance towards the messenger of this news, certain that this was malicious gossip. Then she would scream, "After all, we see what is going on around us. The NKVD is overdoing itself to fill its quota of arrests!"

Her mother tried to shock her into control. "Don't be foolish. You are speaking like one going out of your mind."

Max helped her fold into her suitcase the contents strewn over her bed. "Valya," he said softly, "Of course you must go. But you will accomplish nothing if you do not go with a clear head. Vyera may be telling

87

the truth or she may have heard only rumors. When did you last hear from Bob?"

She burst into tears, and after feeling a sense of relief, seemed to steady herself. "Yesterday. There was no mention of trouble. Another letter from him will take days to get here. I can get to Chelyabinsk faster than another letter will get here. I must know."

She returned home to Moscow two weeks later. The report had been correct. First she had inquired in the offices where Bob worked. Except for one friend who gave her sleeping accommodations, all of his colleagues of many years had received her coldly, some of them obviously avoiding her. Then she had wandered from the NKVD offices to the police stations asking where her husband had been taken, asking permission to see him, asking what the accusations were. Everywhere she received the same reply: "We have no record of him. Maybe at"

The following morning, two hours after Valeria left for work, she was home again. She had been fired and expelled from the Party.

Eva told Esther, "She just lies in bed. She refuses to get up." To her father, she said, "Bob, of all people! How dare they call him an enemy!"

Morris, too, was hit hard by this. "It's a mistake. The error will be corrected," he said to Esther, but his words lacked confidence.

Esther could only repeat, "Do they know who they are calling an 'enemy'? This boy who has given his whole life for his country — from childhood." At the age of fourteen, with the outbreak of the Revolution, Bob had run away from home to join the army. His maturity and motivation had been recognized at the end of the fighting, and he had been sent to a school specializing in political education, training that was so important for the economic and political growth of the nation. "And now this! What gratitude!"

January of the New Year passed with no word of Bob. Then, in the middle of February, 1937, Eva and Max got a telephone call from Alexandra. "Please, after work, come!"

Valeria had to be restrained from doing herself harm. A letter had come from Bob, Alexandra told them, written on a triangle, the combined envelope-stationery that was the popular and convenient letter writing paper of the time. The handwriting, in pencil, was not firm but was recognizable as Bob's. "I hope you get this. I shall drop it from the

car window of the train. I have been accused of spying. It is not true. I have never done anything that would undermine my country and the Party. I don't know where I am being taken." They could only surmise that the triangle had been picked up and posted by a stranger.

All the members of the family surrounded Valeria and kept a close watch, consoling her, assuring her that her grief was their grief, that she was not alone in her fear that Bob might never return. She was not alone in her despair at the turn the Party had taken to retain power. At the beginning of April, Al, who was working far away in Kazakstan as an automotive mechanic, spent his vacation in Moscow to help care for his sister. Because living conditions in Kazakstan were difficult, Al was allowed two months vacation instead of the usual one month. His gentle bearing and compassionate nature were a source of strength to Valeria and the rest of the Meltz family. Wherever his sister went, he was always near during this exceedingly confusing and trying time.

Chapter 6

Eva and Max were awakened about one o'clock in the morning of April 14, 1937, by an urgent, persistent knock on their door. Their first thought was about Tommy. Max jumped from the bed to open it. Olya, Esther's houseworker, pushed her way in. "Eva Moisseyevna! Come quickly! The NKVD!"

They slipped into houseshoes, threw on robes, and quietly walked past their neighbors' doors, past the kitchen from which they caught a glimpse of Olya's cot, and then came to Esther and Morris's door. As it swung open with only a light push, they saw Esther, her eyes fixed, huddled against the edge of the wardrobe which served as a divider between the nursery and the sleeping area of the adults. Morris was seated on the edge of the unmade bed, calmly observing three men delving through his desk drawers that had been set on the table. Papers were strewn all over the floor. As Max and Eva entered, one man approached them, ushered them into the room with a wave of his hand, closed the door behind them, and placed himself in front of it.

"My children," Morris announced them. "The security police," he said to them. "Don't be alarmed. It is all a mistake. They asked me to go with them for questioning. It will all be cleared up in the morning." The man at the door nodded as if in agreement and invited them to take chairs. But Morris broke in. "Why don't you go back to bed. You haven't gotten your night's rest."

The man at the door spoke. "Take chairs," he said firmly, and they understood that they would not be permitted to leave. Eva moved two chairs toward the open space next to the wardrobe, assured herself that

Tommy had not been awakened, sat down and motioned for her mother to sit next to her. Max joined his father-in-law on the edge of the bed.

The night was long. The men examined every scrap of paper as they removed it from the drawer; some were set aside carefully, while others were flung at their feet on the floor. One moved to the wardrobe. He opened the doors and systematically removed every hanging garment, felt through them, whisked his hands over any that had pockets, and after he finished, flung each on a chair close by, letting them drop to the floor when he missed. He then worked his way into the bureau drawers. When he finished with that, he politely asked Morris and Max to stand away from the bed, asked for assistance from the man still planted at the door, and both turned the mattresses and pillows. From there they moved to Esther and Eva, asked that the sleeping baby be lifted from the crib, and tore apart the sheet from the mattress and the mattress from the bed. They left the crib for Esther to straighten out and joined the third man who was intently thumbing through every book in the room. He dropped some on the floor and carefully stacked others on the table.

As the hours passed, no words were spoken, neither by the investigators nor the family. Weariness and panic were showing on Esther's face. Morris remained immobile, no emotion evident. Eva's thoughts returned to her childhood when she had awakened on a certain morning to find her house crowded with adults, speaking softly as if making plans. One of her household had greeted her warmly, took her aside to tell her of her father's having been taken to jail because he wanted a good world for the workers, and assured her that tomorrow he would be home again. But the promise that he would be home again tomorrow had not relieved the fear that she had felt nor did it prevent the sob deep down in her chest from breaking out. It was all coming back now — the fear and the tremendous desire to let out a cry. She caught Morris's eye. He gave her a smile, as if knowing that this is what she wanted to do, and she smiled in return.

Daybreak began to filter in between the window and the window shade. The men picked themselves up as if content that they had completed their search. One ordered Morris to prepare to leave with them, another opened a valise and removed a document for Morris to sign,

handing him a pen — one from among several American Shaefer pens and Eversharp pencils which he had taken from the desk and had placed in an orderly row on the table. Morris slowly read through the document, turned to his wife and children, and explained that it was a confirmation that there had been no ill treatment nor physical abuse during the search and arrest.

Another man scooped up the papers, pens, and pencils that had been set aside and placed them in his valise. The third man bent down to lift the portable typewriters. Eva protested. "Why are you taking those?"

"We don't answer questions," was the reply.

"But only the Russian typewriter belongs to my father. The English one is mine," she persisted, with anger in her voice.

"You will need proof," the man answered, and moved forward to the door, his fingers curled around the handle of each typewriter case.

Morris spoke to them. "You have the document in your valise. If you will be kind enough to take the time to look through the papers you have taken, you will find it."

One shouted back, "Fine. Then the typewriter will be returned to you when the investigation is completed." The typewriters were never seen again.

In her broken Russian, Esther finally spoke out. "Where are you taking him? Where shall we go to find out when he will come home?"

"To the office of the security police." Eva recorded the address that one dictated.

As Morris walked between them, he turned and said, "Esther, don't throw out any of these papers," pointing to the mess on the floor. "Put them together and when I come back, I'll set them in order. This is a mistake of some kind."

A mistake! Eva knew it was a mistake. Her father an "enemy?" It was just too ridiculous even to consider.

It seemed forever before the morning had sufficiently progressed for the first logical step to be taken. Borodin! He would settle the entire matter! It would not be proper to awaken him at the moment, for he had done the night shift and had probably only a short time ago gotten into his bed. They busied themselves automatically, numb and quiet, picking up from the floor, filling the drawers of Morris's desk, setting books on

the shelves, and rearranging the wardrobe under Esther's direction. With Tommy's first waking greeting, smiling and happy on seeing both of her parents, Max took over her care while Esther and Eva, with Olya's help, set about preparing some breakfast.

"What are we doing?" Eva thought. "As if this were an ordinary day. Why can't I scream or yell?" She then observed Esther. What was her mother thinking? She looked stooped and old, her face drawn, the scalp white between the thin strands of hair. She kept herself in motion in the room, from the communal kitchen back to the table with food, taking the child from her son-in-law, the protests ignored, and sitting herself next to the child, spoon-feeding her as she had done every day when Max was not home.

Borodin himself answered the knock. Fanya was already on her way to the institute. "The NKVD was here last night!" Eva blurted out. "Pa was arrested!" He stared at her, the words like an unexpected slap; then he drew her into his flat. "What shall I do?" she continued.

It took a few moments before he pulled his thoughts together. "Let me try to find out what happened," he said. He had known this girl since she was a baby and was like a second father to her. The sleepless night, the fear, and the anxiety were written all over her face, and she obviously needed comforting. "Don't worry. Please don't worry," he added, trying to alleviate her distress. "But don't mention this to anyone just now. Your father is not expected at work because he has been assigned to escort a foreign delegation to Leningrad for the May celebration there. So it is not necessary to excuse his absence."

With all the turbulence surrounding them — Bob's disappearance, Valeria's breakdown, and now the arrest of Morris — Eva and Max sought comfort from each other, even though they had to continue to work and otherwise go on with their lives. When Max informed his own family of Morris's arrest, they became increasingly baffled as to the motive of the Party in resorting to such intimidation, for no one thought that Morris could be guilty of any act against the Party and the country, no more than Bob could have been. Together, within their own family circle, already fearful of further reprisals, they commiserated with each other.

Although Eva tried to calm her mother and urged her to be patient

— Borodin needed time — by the end of the third day Esther could no longer restrain herself. She needed to seek out their good friend Mordish for help in trying to determine Morris's whereabouts and condition. Both Eva and Abie had been unsuccessful in getting any information and had agreed that Mordish, with his fluency in Russian, might make some headway where they had failed. With Tommy in her arms, Esther took streetcars to Mordish's room.

Mordish's face lit up when he saw them, his arms reaching out to relieve Esther of the child. For a brief moment, the heaviness that she had had in her chest disappeared as she sobbed out the news. Mordish was genuinely appalled that his friend, whom he knew to be a sincere Communist, could have been suspected of disloyalty. But he had little more to say. He kissed Tommy's little hands, stood up from his chair, considerately took hold of Esther's arm as a suggestion that she lift herself from the chair, and said, "Esther, go home now. It would be better if you didn't come here any more."

"Then, I will expect to hear from you soon?" she asked, appreciative of his concern. In her anxious state, the fact that he had not responded to her request for his assistance was completely lost to her.

Esther looked somewhat better to her children when she told them that Mordish would be by in a few days to help her find out what was happening to Morris. As days passed, and Mordish did not appear, she realized that in her desperation for his help she had misinterpreted his remarks. She never heard from or saw Mordish again.

Each morning, impatient at not having heard from Borodin, Eva would knock at the door of his flat and ask the same questions: Had he heard anything? Did he know where her father had been taken? Would he be released soon? His reply was always the same. He was still trying to get information, he didn't know where Morris had been taken, and he would let her know as soon as he knew.

Esther's patience was wearing out. Although her children pleaded with her to trust Borodin to secure Morris's release, she decided to go to the address on Kuznetski Most that the security officer had given her only to turn back, unable to find an entrance. She had asked strangers on the street to help her locate the address; some took the time to search with her but finally gave up, puzzled when she pointedly asked if they

knew where the NKVD office entrance was. Time and time again she tried asking for help, but she always returned home, unable to find the building.

~

At the office, Morris's absence required no explanation, particularly at this time of the year. Every April and October for almost as many years as he had been back in Moscow, he had been accompanying English-speaking foreign delegations, trade union groups, and others who were visiting the Soviet Union to observe the progress of the socialist movement. During these holiday periods, Morris served as a guide and toured with the visitors to significant places throughout the country.

Finally, the day after the May Day holiday ended, Borodin told Eva that he had some information. "He's guilty. I'm sorry." She expected him to continue, but when it was obvious that he had nothing more to add, she shouted, "Is that your only information? Of what is he guilty? Surely, there is more that you can tell me — you're our friend."

His answer was vague. "They assured me that he is guilty. I don't know more than that. Eva, for yourself, it would be better if you take Max's name. Why don't you and Max get yourselves registered as husband and wife?" Her astonishment was embarrassing to him and he seemed glad when he was called away. Why should she change her name? Common law marriage was socially acceptable and legal at this time.

Eva's shift that night seemed to have no end. Her preoccupation with Borodin's remarks paralyzed her, and when she turned in her work before leaving for home, she wondered how she had ever finished it. That Max shared her concern did not alleviate her shock. She felt the strongest bond toward Valeria, who was suffering the excruciating anguish of hearing the absurd condemnations about her husband being "an enemy of the people." Valeria also was enraged at Borodin's casual acceptance of Morris's guilt. To Eva, she spewed, "Do you really believe that he inquired about your father? Do you really think he would endanger his own position by challenging the powers? He understands their methods. Remember! He returned to the Soviet Union not too many years after the Bolshevik Revolution and has lived through other cleansings and arrests. After he had been recalled from China, way back

when, he was lucky to have gotten away with just a demotion to the position of editor of the *Moscow News*. He could have lost his life! Don't you believe that he knows nothing about the charges against your father! He's out to save his own skin, not yours or your father's."

Every place of work in the Soviet Union at this time had a Party unit that served as the educational and ideological leader to the workers. The Ogonyok Publishing House published three foreign language newspapers and a number of Russian magazines. Ogonyok had a central Party unit, and each publication within Ogonyok had its own Party member who served as liaison with the central unit of the work place. The afternoon after Borodin spoke with Eva, the secretary of the Ogonyok Party unit, Abolnikov — he, too, would be arrested within the year and later die in a prison camp — called a meeting which included the proofreaders working at the print shop.

Abolnikov opened the meeting with the harsh pronouncement: "Comrades! We have had a traitor in our midst! It is Morris Stolar!" His voice boomed crisp, loud, and angry, and it stung Eva like a whip. She heard gasps around her. Was her father really to be humiliated in this way? What words followed she did not hear. If the eyes of her fellow workers were upon her, she was not aware. She sat as long as they sat, and when they arose to leave, she moved along with them. Holding back tears, she would never understand how her father could have been humiliated this way. Only Morris's secretary stopped at her side for a fleeting moment. "Eva." she said, touching her arm lightly while her eyes seemed to show sympathy, "Take your father's typewriter," and she left. The advice did not penetrate. What was so important about his typewriter at such a time?

Hours passed and thoughts flitted through Eva's mind. How could he be a traitor? There had been no trial. Only words of accusation: "Anti-Soviet acts? Traitor?" When Jean, the editor-in-chief, had disappeared, the same words had been flung around in the same way. No one, but no one, came to Morris's defense! Not even Borodin. He must know that this was a lie! Had Morris been expelled from the Party? In her dazed and distracted condition, she had not heard. Jean had been read out of the Party — in public. Did Morris know, she wondered? The thought repeated itself: and nobody, but nobody, had come to Morris's defense.

How had this become possible? All of his comrades, sitting in the offices of the *Moscow News*, mute!

Fear and panic overcame her. Where was her father? What were they doing to him? He would not confess to an act of which he was innocent, as Kamenev and Zinoviev had done! Eventually, she convinced herself, a trial would prove him innocent.

Morris's arrest precipitated meetings — open Party and Komsomol meetings — to hash and rehash the exposé. Eva's Komsomol meetings were now presided over by Abolnikov, whose role as secretary of the Party unit of the entire Ogonyok publishing organization automatically made him chairman of the Party unit where the employees lived. Abnormally short of stature, he stood before the young people looking self-satisfied and sanctimonious. He blasted forth, "You had an enemy among you! He met with you and you consulted with him and now he is a recognized corrupter of the youth. And you failed to report his actions to us. You have not been vigilant!"

It was correct that Morris had worked closely with the young people. They had often sought him out for direction and advice because they had had a deep respect for him. He had liked working with them. He had frequently remarked that the success of this great socialist experiment depended upon them. He told them that he would have liked to have been of their generation so that he could live more years during the growth of socialism, years that he had had to spend struggling to bring it about. And now, here, standing on the platform before Eva was this pompous, self-righteous, scolding little man, screaming that her father had been "corrupting" them for so many years. A thaw settled upon her. She stood and asked to be heard.

"All right. Let's agree that Stolar is everything you claim. Let's agree that he contaminated us and that we were not alert and did not recognize his evil intent. But tell me why your Party unit, the unit of which he is a member, the unit made up of older and experienced Party members, the unit where you and the others had met with him hundreds of times and had worked and planned together with him, never discovered his traitorous plans? His assignment to work with our Komsomol unit came from you. Why would we younger people have seen what our elders were not able to see?"

The silence with which her remarks were received — by the very same young people who had always expressed only admiration for her father — caused her to freeze again. In agony, she wondered, "Where was the spirit? Only a few short months ago, someone would have sprung up to challenge me or support me. There would have been long discussions, and from collective thinking we would have come up with collective decisions as to what was appropriate in a socialist democratic society." But now the only response came from this horrible man who suddenly seemed to be very threatening. "Who are you," he blared out, "to express scorn for the Communist Party and for Stalin? It is clear to me that you do not know your duty, not to your own Komsomol unit nor to the Communist Party of this great Soviet Union, nor to the country. What right do you have, only a youngster, to question the circumspection of the members of this Party unit. We are aware that you are showing signs of sympathy for this traitor! Are you not aiding his wife by continuing to give her sympathy and support?"

Eva slumped back in her chair. What did he mean? Sympathy and support to Morris's wife? Her mother? Was she expected to abandon her mother as well as her father? She could not gather the courage to say more. This man was convincing these young adults, her friends sitting with her, that her father was guilty. No specific accusations. Just that he was guilty! She fled as soon as adjournment was called and raced to Valeria's flat, where Max was waiting.

After Eva told them about the meeting, Valeria predicted that Eva would quickly be expelled from the Komsomol and then she would lose her job. Borodin's suggestion that Max and Eva register immediately as man and wife for a change of name was then brought up. Alexandra and Gustav felt that this should be done as soon as possible. Al agreed, but Valeria was skeptical. "I shall be the next to disappear," she said, "and how safe will the name of Meltz be then? But perhaps for the moment it might be the safest thing to do." She herself had retained her family name, clinging to her philosophy that she had the same rights as a male to keep her birth identity. However, keeping her family name had not saved her from losing her job and being expelled from the Party.

Eva sought Esther's opinion. When she hastily agreed, hopeful that her daughter might avoid the torment she herself was undergoing,

Max and Eva immediately reported their marriage to ZAGS, the Bureau of Vital Statistics, and the name Stolar was erased from all of Eva's records. It was possible to make an application to secure only a legal name change; however, in Eva's case it was doubtful it would have been approved since her father was convicted as a "traitor" and the applications would have been recognized as a ruse to escape identification. Furthermore, the cost was about one hundred rubles instead of the three rubles it cost to register a marriage.

Within a few days, there was another emergency meeting of the Ogonyok Komsomol, and whatever hope Eva had had that the current frenetic atmosphere would end was shattered. As several others had been before her in the last few months, now she became the target. The meeting was wide open for an evaluation of her performance on the job and as a member of the Komsomol. Each comrade, called upon one by one to voice a criticism, echoed Abolnikov's words. Only Lennie and Jack, two Americans who like herself had grown up in the left radical movement in the United States, offered opinions based on their observations that they had always considered her an example of what an ideal Komsomol member should be — always helpful, always explaining patiently, and always willing to give her time to answer questions. When each of them had finished their remarks, there was an uncomfortable pause. A member of the presidium took up the slack, quickly rising, and recommended that the remaining members be called upon so that the vote on the subject of Eva's status in the organization could be taken. "The view of these two comrades will be discussed later with the members of the committee — when the meeting is over," he said.

To Eva's surprise, her friend Blackie, who had been sitting in the audience, arose. He was neither a member of this Komsomol unit nor an employee of the publishing house. The print shop was a separate organization that printed the newspaper on contract. He acknowledged his personal acquaintance with Eva as he introduced himself, and then proceeded to give terse and scathing criticisms of her — unrelated to her activities both in the Komsomol and on her job — that, he felt, made her unfit to be a Komsomol.

The vote to expel Eva was unanimous, the two dissenters abstaining. She was ordered to take her membership card to the chairman's

table and to leave the room since her presence at this closed meeting of the Komsomol was henceforth illegal. Because of her prior behavior, she had given up the right to be a member. To Eva, who had been raised to involve herself actively in political and social movements, this was, at this moment, worse than death itself.

The following day, she was replaced as head of the proofreading department at the print shop and was told to report to the offices of the publishing house. She was assigned to work as a copy reader. "At least," she said to Max, "I haven't been fired."

Max, as an employee of the print shop, had not been affected. But Abie was not that fortunate. He had not only been expelled from the Komsomol the day that Morris's arrest was announced, but he also lost his job as an illustrator. Eva realized that it would be useless to think that cautious behavior would ward off further reprisals, and in spite of her mother's protests for weeks and months, she accompanied Esther from one government office to another trying to get information about Morris. In long lines, they waited for hours with people on similar missions, no office claiming knowledge nor jurisdiction of his case. They were directed either to an office where they had previously been, or to others scattered throughout Moscow. Many months passed before they finally were told that Morris had been sentenced to ten years in a labor camp without the right of correspondence. Although Esther didn't know it at the time, rumor had it that this sentence meant that the prisoner would be or had already been executed.

"Where has he been sent?" Esther wanted to know.

The officer repeated, with emphasis, "Without the right of correspondence! Isn't that clear? If you can't correspond, you don't need to know where he is."

Esther was not to be turned off. "Then tell me, what is his crime?"

"He is a Trotskyite," he said, after shuffling through papers.

Hearing this, Esther's frayed nerves gave way to unrestrained laughter, and Eva feared that the officer would over react and do something terrible to Esther. However, he merely said, "It is nice that you find it so amusing. Why is this so funny to you?"

She controlled her laughter long enough to reply, "A Trotskyite! It is indeed amusing! Your bosses had better find some other excuse. This

is a trumped-up charge. He had been a staunch and steadfast opponent of Trotsky's theories since the 1920s!" and she turned her back on him, again laughing.

Eva, too, was struck by the irony of such an accusation. She recalled the days in Chicago, the crowded meetings of boys and girls in the rented basement rooms on Division Street, the heated arguments of the two hostile camps — the Stalinists and the Trotskyites — members of both groups breaking off long standing friendships, each allied depending upon the beliefs of their parents. It was funny! She had loyally agreed with her father that a Trotskyite was the arch-enemy of the working class.

Eva and Esther had no faith in this source and were still optimistic that there might be a record of a trial that would be favorable for Morris's release. Esther went to another office where she was again told that he had been given a ten-year sentence without right of correspondence, but to her insistent query of what "crime" he had committed, she was told that he was a Ukrainian nationalist. This time she did not laugh. She wanted the official to hear her plainly. "Is that what it says on the paper you have? You are misinformed. My husband is not a Ukrainian, he has never lived in the Ukraine."

Chapter 7

A week after Morris had been arrested, Abolnikov came to Esther and Eva and said brusquely, "You will need to vacate your rooms immediately. You know that this building belongs to the Ogonyok Publishers. Someone else has been assigned to these rooms," and he abruptly left.

Eva seethed. "No 'enemies' in these hallowed halls!" There seemed little point in confronting the members of the committee with the fact that she was still an employee of the *Moscow News,* one of the subsidiaries of the publishing firm, and could challenge the claim that she was not eligible for this housing.

Fortunately, the flat in the cooperative on Pestsovaya Street where Abie still lived had continued in the Stolars' possession. When Eva and Max had moved to the dormitory, Morris had contracted for their rooms to be temporarily rented to an American couple, one of whom was working for the *Moscow News.* When his parents moved to Ogonyok's dormitory, Abie had taken their room, and his room had been registered to Ed Falkovsky, an American, and his Russian wife Bernice. Their housekeeper had a cot in the kitchen. When Esther moved back to the flat on Pestsovaya, Abolnikov immediately moved into her vacated flat. He was the only Russian registered on the floor which up to this time had been exclusively for *Moscow News* employees.

Eva and Max were expecting to be re-registered at the Pestsovaya address and to be assigned in Esther's room. But for them, the move became a harrowing experience. After they had moved out three years ago, the district soviet, or council, had hired a new manager of the cooperative and the adjoining buildings. Her name was Galina Petrovna and

she was responsible for maintaining an orderly and respectable atmosphere, looking into complaints of the tenants, arranging for the upkeep of the buildings, and monitoring the tenancy to be sure that no unregistered person was sleeping in any of the rooms. She insisted that Eva and Max had no legal claim to space of their own or even to sharing a room with Abie or Esther.

With the house chairman's daily dunning, "Aren't you moved yet?" and finally his threatening that he had reported to the House Registration Office that they were no longer legally at this address, they begged Galina Petrovna to try to appreciate their dilemma. "If the police pick us up and find out that our internal passports do not have a registered address, we might be arrested — or exiled! We will have nothing to prove our right to be in Moscow! Why can't we be registered with my mother now? We were registered here as a family from 1931 to 1934 — and my mother is still an owner in this cooperative. What are we expected to do?" While waiting out this housing crisis, Eva's sleep was invaded by nightmares. She was bobbing up and down in a pool of shallow water, her feet unable to gain a firm hold on the bottom, her arms floundering. Every time she surfaced, she saw herself encircled by mute figures waist up from the water line who were gazing at her but ignoring her distress. She tried to call to them, but her lungs were flooded. She reached out to anchor herself onto them, but they slipped away from her. Gasping for air, she would awaken, and cry to Max, "What are we going to do? They can do anything they want to with us!"

Before the month was over, someone in authority relented, but they never learned who or why. They moved out of the publisher's dormitory with no sign of recognition from the Borodins; Fanya, too, was obviously keeping out of Esther's sight. Except for their passing each other occasionally in the office, since her transfer from the print shop, Borodin and Eva had not spoken. Neither he nor Fanya had taken the time to look in on Esther. To Eva this was an unforgivable breach of friendship, but she did have to seek out Borodin one more time. She recalled the advice of Morris's secretary that she should take her father's typewriter, and when she set about to do this, realizing its value, she was told that Borodin's permission was needed. He refused to give it to her on the grounds that it had been listed in the inventory of the office. She

glared at him, her voice choking, and said, "You know that this type-writer belongs to Pa. What has happened to you?" and turned her back on him and left.

Now they were back at the flat that they had occupied when they first arrived in Moscow years before. The physical conditions were not as comfortable and their privacy was a thing of the past, but Eva's night-mares had finally disappeared. Esther again used the wardrobe as a room divider to set up a private space for Abie, Eva and Max were back in their old room, a portion of it now set aside for Tommy's crib. The Falkovsky's and their child were in the third room. Esther remarked, "If we thought that we were cramped for space when we moved here in 1931, what can we say now? Maybe we are lucky that we can't afford to have Olya working for us anymore. Can you imagine two cots for two houseworkers in the kitchen?" However, when Bluma Abramovna greeted her warmly and expressed to her privately the outrage that she felt at Morris's arrest and disappearance, Esther felt at home again.

After Max and Eva were settled into their room on Pestsovaya, in early June, Max's brother Al left Moscow to return to his job. When a month passed without a letter from him, Alexandra pressed Valeria to write. "This is not like Al," she worried. When there was no reply, both Alexandra and Gustav wrote to him urging him to relieve their uneasi-ness by responding immediately. Before their communication could have reached him, Valeria's letter to him was returned and stamped, "Address Unknown." Alarm seized them, Valeria especially was unnerved. "It's happening again," she insisted. "It's happening again!" Her parents, fearful as they were for Al, were also concerned about their daughter, anticipat-ing another breakdown. They pleaded with her to retain her composure.

Max tried to reason with her and his parents. "The letter was just not delivered properly. It is not possible that an address is unknown. He's registered with the police."

But when, a few days later, their letter was returned and stamped the same way, they feared the worst. Sadly, Eva articulated their thoughts. "Al is not the kind of person who would move away without letting us know, even if he could get around the house registration laws. He must have been taken."

They didn't know to whom or where to turn, and the strain was beginning to show on Gustav. Alexandra was thankful that he had a job to go to each day. He was a gardener at the Lenin Library where she knew he found some solace among the flowers and plants. It was her strength that held her family together when, some months later, Valeria received a letter from a girl identifying herself only as a friend of her brother's; it informed them that, as Al stepped off the train, the security police were waiting for him. She regretted that she did not have more information to give.

"What a brave thing for her to do," Eva cried. "Only someone who loved him dearly would have taken the risk of writing to us."

The family was now cut off from human society. Eva and Max, who were once in the center of all the social events, were now shunned. The encounter one day with Reggie and Tim Ryan was their first realization of the effect the arrests had on their friends. The two couples met outside the gateway of the building where Max's parents lived with Valeria. Eva's face lighted up with cordiality as Max said, "Long time, no see." Reggie responded, "I cannot have among my friends those who are enemies of the people. I want to make that very clear to you."

Eva's face flushed. "Hold it, Reggie. How are you so certain that Bob, Al, and my father are enemies?"

"The NKVD arrested them, didn't they? Well then, they are guilty."

"But Reggie," Eva was quick to reply, "I'm surprised at your thinking. There have been no trials yet! We don't even know what the accusations are!"

Reggie answered with firmness. "The NKVD does not arrest innocent people," and the couple turned from them and left.

Probably the cut that was most painful to Eva came soon afterward. She was walking down the street pushing Tommy in her carriage when she saw Miriam walking directly toward them. Miriam slowed down, suddenly retreated to the other side of the street, and resumed her stride without a glimmer of recognition. Eva, aching from the rebuff, walked on as if she had not seen this woman whom she had regarded as her closest friend. She returned home shaking and close to tears. "And Tommy was wearing the beautiful little coat Miriam's mother had made for her. I wanted her to see Tommy in it." She appended her

remarks. "At least Reggie was honest. She told us frankly what her feelings were — none of this furtive crossing of the street to avoid me."

Esther replied, "I didn't want you to know, but now I can tell you. Mrs. Rubenstein believes that Pa is guilty, too."

Eva was aghast. "One of your closest friends! She and Mr. Rubenstein were practically raised with you and Pa! You were children together! What kind of people are these?" They consoled each other, but Eva was bitter. "I'll never forgive them! They know Pa well! How can they believe that he could be a traitor? Do they really believe that a mistake is not possible? Can't they see that the NKVD is made up of ordinary people, and plain, ordinary people can make mistakes? They could at least have shown confidence in Pa. They don't even give him the benefit of the doubt — someone they have known from childhood! They know how devoted he is to the cause of the working class — how hard he had worked to try to make things better for the worker." No matter how long she ranted, Eva could not forget that her friends had deserted her and her family.

Their friendship with Galya and Guerra had also ended abruptly, but not for the same reasons. The two families had happily celebrated together for the last time on New Year's Eve of 1936. The holiday season had been enhanced the previous year by the nationwide revival of some of the traditional Christmas festivities, Father Frost substituting for the religious symbols. The new parents — eager to stimulate Tommy, now six months of age — had set up a small tree, and Galya and Guerra had brought a gift of glass decorations that were manufactured in the factory where Galya's mother worked. They had lovingly painted bright colored trinkets to attract Tommy.

Early in the summer of 1937, after Morris's arrest, Max mentioned that Guerra had not been at work for several days and wondered if he had started his vacation. "But what about your plans to go together?" Eva asked. "That's strange. That's not like Guerra to change his plans and not let you know. He couldn't have succumbed to the 'enemy of the people' scare. He laughed at it. Do you think he might have been arrested?" she added, now with fear in her voice.

"When you have a chance, why don't you check with Galya," Max suggested.

Eva made several trips to their dormitory, but never found Galya at home. Finally, one day, the door was opened by Galya's mother who seemed genuinely pleased to see Eva. The child was busily playing. The visit was short, the grandmother apologizing for not being more hospitable, explaining that she had to be on her way to her own home with the child before dark. She was very vague in responding to Eva's questions. Yes, Guerra was on vacation and had not yet returned. She was not sure where he was — she thought in some rest home in the South. Galya did not go with him. Her trade union had sent her abroad to improve her English. The child was staying with her until their return. She expected to hear from them shortly — and the responses continued in this manner. Later, Eva said to Max, "I can't believe students are allowed to go abroad now with all this spy hysteria going on. Something's wrong!"

Max, too, was puzzled. "And it seems strange that they would not have stopped here to say goodbye."

Just after the New Year's Day, 1938, Galya appeared at Max and Eva's flat and told them that Guerra had been arrested two nights earlier. "I am out of my mind with fear. I can't find out where he has been taken and why!" She also explained their long absence. Both had volunteered to serve in Spain to assist the Republic in whatever way they were needed to defeat the armies of Generalissimo Franco. Guerra had even fought on the front line with the newly organized International Brigade. They had been home only a few days when the NKVD took Guerra.

The two young women promised to keep in touch, but when again a few weeks later Eva had not heard from Galya, she stopped by her room and was told that "no family by that name lives at this address" and that a forwarding address had not been left. The pattern was only too familiar. Max and Eva conjectured that Galya, too, had been arrested. They never again heard from either of these dear friends.

The social isolation brought the Meltz and Stolar families closer together. Esther turned to Alexandra, their dotage upon Tommy no longer the only topic of conversation. Valeria had been evicted from her desirable, conveniently located room and had relocated with Alexandra

and Gustav in quarters which, in pre-Revolutionary days, had housed hotel servants. She leaned toward Max and Eva for comfort and friendship. Abie drew closer to Eva and Max. Before these troubles, he had protected himself from their barbs by developing interests separate from theirs and becoming well integrated into the Russian community. He had been sought after socially, particularly by young girls, to the point where in his immaturity he resorted to a subtle elusiveness to escape the attentions of those whom he did not find attractive. And now he was a pariah. Esther wished for the days, only a few months before when she nagged at her children, "Stay home one night. You need to rest."

After each working day, Max and Eva's greetings to each other would begin with, "Well, who disappeared today?" and they would name people in their offices who had not turned up at work. With each name, they would gasp, "Adler an enemy! And Blackie! After his opportunistic public denunciation of me? How ridiculous! Where will this end? If they are all enemies, so is Stalin." And then they would lapse into dejection.

One evening, Max told Eva that Sam and Nathan Strekman had given notice that they were returning to the United States. "Lucky them! They knew how to hang onto their passports," was Eva's only reaction. She instantly regretted that she had uttered those words, realizing that she could never leave this country without her husband and her parents even if she had hers. Where could they go? Max, brought to the United States by his parents at the age of three, had never questioned his citizenship status, discovering only after he had applied for a passport to leave the United States that his father had never taken the necessary steps for naturalization for himself that would have automatically included his wife and children. So Max had left the country on a six month re-entry permit that had since expired. And Morris, having always looked upon his residency in the United States as temporary pending the time when he could return to his homeland, never seriously contemplated United States citizenship. Eva pushed this thought to the back of her mind, continuing the trend of the conversation which Max had begun. "What about Sam? His wife is a Russian."

"She got approval from the US Embassy to emigrate with him — and also permission for her daughter from her previous marriage, but

there is a battle for her child. OVIR argues that since the child was born of Russian parents, although divorced, she should remain here with her natural father."

"He hasn't seen the child since their divorce!"

"Their reasoning escapes the Strekmans, too. At least their boy is safe. Sam was smart enough to register him on his American passport when he renewed it."

Every day they heard updated news. The final word was that Sam Strekman was leaving with his wife and their infant son, but his wife's daughter from the previous marriage was to remain in Moscow under the custody of her father.

As arrest after arrest of people on the staff of the *Moscow News* followed on the heels of her father's, Eva repeated to Valeria, "These people they are arresting are not enemies. I know them. They have been our friends for years. They fought for the Revolution! They made the Revolution! What is wrong?" Of course, it was an academic question. The public acceptance of this horror, the silence of those not personally affected, shattered her. She heard rumors that anonymous notes to the security police were enough to ruin a family — the "facts" given in the notes never seemed to be verified. In many cases, they were sent maliciously, for revenge, or to obtain a room which would become vacant as a result of an arrest, or to get a job, or for no other reason than to show the informer's vigilance — when the note included the signature. Anonymous notes vilifying the government, or a leader, were tracked down and people were arrested as suspects without verification.

As a result of this insanity, the print shop became depleted of English-speaking personnel. Americans, intimidated by the arrests that they saw going on about them, were returning home in increasing numbers. The workload became heavier for Max who was now working two and one-half shifts, and at a time when he was needed by both his wife and his parents. Usually, he was home only long enough to get a few hours of sleep.

One morning, with even less sleep than usual, Max was awakened by shouting in the hallway which brought the Stolars and several of the neighbors from their rooms. Galina Petrovna was standing at the door of one of the flats, just outside the water closet, livid, her hand waving

a small square of newspaper, obviously torn from the nail that held other squares of paper for use in the toilet. "Who shows such disrespect for Comrade Stalin?" she was screaming. She flashed the torn photo of the First Secretary of the Party before the eyes of the surprised occupants of the flats to underscore her demand for an answer. A woman's small, timid voice was heard. "I suppose we did. It was our turn to provide the paper." Galina Petrovna threw an icy glance in her direction, began to speak, then with her lips taut, turned on her heels, the paper still waving in her hand, and stomped down the staircase.

The incident produced the first laughter in the house in months. "Do you suppose that she will report that there is a witch living in one of her buildings who is planning the demise and damnation of our Great Father via the plumbing system, with the expectation that the devil will get the message?" said Eva, again cracking up with laughter.

Max roared. "If Galina Petrovna continues to inspect the toilet paper, *Izvestia* and *Pravda* will gain some circulation."

"But what will we use in its place?" Abie countered.

Several days later, the episode took on a more serious overtone. The NKVD had taken away the husband of the woman who had admitted providing the paper. "It can't be," Eva stormed. There was tremendous sympathy for the wife who looked to them for advice on where she might find information about her spouse, only to be faced with the hard fact that she may have lost him permanently. A short time later, the woman and her children moved away from the flat. Bluma Abramovna said to Esther, "Poor woman! She and her children were probably sent off to Siberia. It is not enough that the husband will be sent to a labor camp. His family must also go into exile."

When Eva questioned the possibility of such government action, Alexandra agreed that Bluma Abramovna might very well have made the correct assumption. The practices of the judicial system were common knowledge. The Russians lived with it, but Eva could not accept that this might happen to her, too. It would take more than these six years she had lived here to condition her to endure fear as automatically as she drew a breath.

The turmoil in Eva's life disrupted her physical well-being. The

doctor observed her month after month and finally dismissed her, diagnosing a malfunction that would prevent her having more children. Max tried to hide his dejection, for in spite of the harried times, he found great joy in his little girl and wanted her to grow up with siblings, recalling his own rich childhood and youth with Valeria and Al. He was also conscious of the pleasure his parents had received from their children.

He wanted fiercely to give more of himself to Tommy than time allowed. He wrested himself from the few hours of sleep that his extended work assignment permitted so that he could be with her each morning when she awakened. Occasionally, when she would arise before he got home, she would send her Granny back to bed "to sleep more," promising that she would be "quiet, quiet" in her crib until daddy came home to dress her and to give her breakfast.

Before the end of February, Eva discovered that she was three months pregnant. The doctor conceded that she had misdiagnosed Eva's problems, which she had based on Eva's menstrual pattern of the past ten months. As elated as Max was on the one extreme, Eva was depressed on the other. She could not embrace his outlook. "How can you think this way? What future is there for our children — an orphan asylum upbringing?" She would become impatient with his optimism, adding scornfully, "Valya told you only last week that Energia — just three years old — had been taken to an orphanage when both of her parents were arrested at the same time, since there were no relatives. Energia they named her! They were so full of fervor and patriotism that they named her for the electrical energy for which her mother and father were committed to develop — for the sake of socialism! What irony!"

In the days that followed the announcement of her pregnancy, Eva would repeat, "If I had only known a few weeks earlier. An abortion might have been possible."

"Stop that talk," Esther scolded. "Even if you had known, abortions are illegal now," and Esther was happy that this was so, fearing that Eva might go as far as lying about the stage of her pregnancy had they been legal and available on demand. Illegal since the adoption of the Stalin constitution of 1936, to have an abortion was punishable by sentences to prison or labor camps.

One night late in the winter of 1938, Eva had returned from work at about eleven in the evening. As she ate her supper, Esther sat and chatted with her about Tommy's day. Abie interrupted with additional details that delighted her. The talk dissipated, with Eva and Abie immersing themselves in their books, and the room was now quiet. In spite of the closed windows, from the street below voices of neighbors entering and leaving the building drifted into the room. At intervals, Eva could hear the mooing of the cows grazing on the fields across the way and, occasionally, the neigh of horses in the corral at the side of the buildings.

There was a knock on the door. Abie opened it to two men, well-groomed and impressive in appearance. One of them smiled pleasantly and asked to speak to Max Gustavovitch. On hearing Max's name, Eva joined Abie at the door. Their manners suggested that the visitors were important people. Eva introduced herself as Max's wife, but something about their constrained behavior kept her from asking their identity. Abie had already informed the men that Max was at work. Eva volunteered the address of the print shop and gave them directions to it. The two strangers politely thanked her for her helpfulness, said they would have no difficulty finding it, and made their way through the hallway, dark because the electric bulb had blown. When one of them stumbled, Eva showed concern for his well-being, apologetically promising to report to the house manager that an injury could have occurred because of the manager's negligence. He assured her that there had been no harm. "I wonder who they are?"

Within an hour and a half she had her answer — and regretted that the man who stumbled had not fallen down the stairs and broken his neck. Max entered the flat followed by the same two men. They were from the NKVD. They were accompanied by a representative from the house committee. On March 14, 1938, eleven months to the day after Morris was taken, Max was arrested. Of all the arrests of this kind that had been described to them, they had never heard of anyone except Max who had been taken from work to his home before he was jailed. In other instances, where people had been arrested at work or on the street, they just disappeared, as Al and Bob had vanished. In some cases, Eva

had been told, searches were done without the presence of the accused and conducted before the family members or a representative of the house committee.

In Max's case, the search went on until the early morning. Again the rooms were torn apart, the wardrobe emptied, mattresses and pillows turned, and books and mementos of their past packed away into valises. The sleeping child was gently lifted by her father as the contents of her crib were thoroughly inspected. The police went about their business in silence, seemingly unconcerned that the eyes of four mute figures followed their every move. The crowing of the roosters signaled the end of the night, but the men had not yet completed their rummaging. At intervals, motors of automobiles starting up were heard from the street, and as the sound of the engines rumbled, the victims glanced questioningly at each other, each understanding what the other wanted to ask: Why were there so many automobiles? Rarely was even one private car seen in the vicinity of these two buildings. The sounds of the movements of the neighbors leaving the building on their way to work increased. Finally, when daylight was fully unfolded, the investigators finished. One of them spread before Max the paper for his signature to confirm that no cruel nor coercive tactics had been used in his arrest, handed Eva a paper with an address where she might inquire about his whereabouts, and ordered Max to leave with them.

As Max reached the door, he turned to the family and spoke to Abie. "You're the only male left in the family. Look after our women." Still the same chivalrous Max. He smiled wanly at his wife, waved his hand, turned his back on them and left the room with his captors, just as his little daughter was awakening.

As soon as the door closed behind them, Bernice opened her door. All night, awake and frightened, she had stayed in her room, not daring to open her door. She wanted only not to be noticed, fearful that she, too, might be apprehended. She was now living alone with her child. Her husband Ed, like so many other Americans, had returned to the States when the arrests were becoming epidemic.

Eva was sitting on the sofa, silent, tears streaming down her face. Esther had gone into her room, struggling to appear calm. Abie was in the kitchen, fighting his own private battle. Bernice sat down next to

Eva, gently embraced her and tried to comfort her. "I heard it all. I know that neither Max nor your father is guilty of anything. I have lived through so many purges, so much of this terror. Don't give up hope, and don't forget, you must think of Tommy and the new baby. You must be both mother and father to them until Max comes home. I'll help you in any way I can," she said, concealing every doubt of Max ever returning.

Gossip among the women of Moscow was rampant. Most of them were workers, but the compulsory movement in political circles seemed to have had little real influence on their interests outside of their jobs. They remained either deliberately naïve or politically unsophisticated and were uninhibited in the frankness with which they discussed their views and observations. But Bluma Abramovna knew the facts and was able to give Esther a strict accounting of the previous night's activities. Bluma reported that the farmers had counted fifty men and women being led, mostly from the two buildings of the cooperative but some from their farm huts, to waiting limousines of the NKVD — all between the hours of five and seven in the morning. "What a tragedy! First Morris, and now Max, the beautiful, crazy foreigner who wouldn't harm a fly. And poor Mrs. Neimann on the first floor. First she and her husband, an honest communist like Morris, are given refuge here in Russia from Hitler, and now they take him away and leave her alone to take care of their three small children. Will there never be peace for our people?" she moaned. Esther listened, stolidly tending to Tommy's needs.

The morning had been draining. Tommy had awakened smiling and bright-eyed, asking for her father and insisting that she could play quietly in her crib until he came home. Esther's coaxing that either she, Eva, or Abie be permitted to dress Tommy and give her breakfast sent Tommy into a tantrum. She adamantly refused to cooperate, and it wasn't until noon that she accepted food and agreed to be dressed. Eva was thankful that she did not have to work on this day.

When Tommy was settled and napping, Eva left to share the miserable news with Max's family. She didn't quite know how she was going to break it to them. The thought that she was to inflict more torment to their suffering seemed an unbearably painful task. She needed more time, additional minutes to brace herself. She left the street car a

mile before the stop that was closest to their building and walked the balance of the distance. At this moment, her sorrow was for Max's family.

Alexandra opened the door. Valeria looked up from her mending. "Again?" she said to Eva. All three conducted themselves with a stoicism that precluded any emotional eruption. "Raids have been going on in this building all through the night," Alexandra said.

They sat together to wait for Gustav to return from work. When told of the events, he moaned, let himself down heavily into a chair, and looked dismally at his wife. "Our two sons! Two such sons! What are they doing to our boys?" His shoulders dropping, he concealed his face in his hands and broke into convulsive sobbing that shook his entire frame. It was only the passivity of Valeria and Alexandra that forced Eva to contain herself.

As Eva started for home, her ears were ringing with Gustav's lament, "Our two sons! Two such sons!" His agonizing cries tortured her. Certain that distress was written all over her face, she was not ready to sit among strangers. She walked past bus stop after bus stop unconscious of time and distance, the words repeating themselves. Her pain— especially, at the moment, for Gustav — was intense.

Abruptly, her responsibility to her own child broke into her thoughts. How was she to protect Tommy from all this upheaval? She was determined to provide the normal environment that every child required. With that, she boarded the next bus. But when she returned home and was met by Tommy's crying that her father was not with her and Esther's complaint that the child would not eat her supper, her resolve to conceal her own despair broke down. She wept uncontrollably.

When Eva appeared at work the next afternoon, Sonia, the secretary, stopped her before she reached her worktable. "You're not to work here anymore." She had been fired, more or less as expected; nevertheless, Sonia's words came as a shock. She wondered, "How do they know already? I haven't been here to tell them." Sonia then said, "Mikhail Markovich wants to see you." It was four in the afternoon. Borodin usually came in at eight or nine in the evening. "Borodin came early today," she added, as if reading Eva's mind.

"So he wants to speak with me. Maybe" She was groping for

help and was reaching to him as her last hope, although since the incident with the typewriter she had distrusted him.

The new offices of the *Moscow News* had been moved from the Ogonyok Publishing House building on Strastnoi Boulevard to Petrovsky Lane across from the Bolshoi Theater affiliate. It was a one-story house of the pre-Revolutionary era, elegant in its time. On entering, one faced a short, wide marble staircase that led to a spacious room which had once served as the foyer of the house. Now the only furniture in this room was the desk of the receptionist. Borodin's office had evidently been the dining room of the family to whom the house had formerly belonged. It was a huge room, large enough to hold at least fifty people. The classical mantelpiece held a mirror that stretched to the ceiling.

Borodin's desk was set in front of the fireplace. He did not rise from his chair to greet Eva. His first words were, "With your father and Max both arrested, you can't work in publishing or teaching organizations." Not a word of sympathy, she noted to herself.

"Can you advise me where I can get work? If I can no longer work with publishers nor teach, can you suggest places where skill in English may be needed?" she persisted.

"I advise you to take on private lessons."

"Private lessons!" There was disgust in her voice. "That's illegal! You know of no collective work that I might get?"

"I know of no other places." He repeated, "The thing for you to do is to take on private lessons."

Eva turned her back on him and without another word left his office and the building.

Now, with no job, Eva's attempt to locate Max began. At the address given to her by the agent of the NKVD, and after hours of waiting in long lines, Eva was told that there was no record of his case. Upon her demand — the security police had taken him somewhere — she was sent to another office. This address was on the Arbat, an important and populous street flanked by small, neat, white buildings. Eva had walked this street at least twice a week in the years that she lived in Moscow, and like hundreds of other pedestrians, had not known that one of these structures, well-preserved, clean and attractive, housed the NKVD. She hesitated when she came to the building — it was much the

same as the others on the street. There was no response at the front entrance. She noticed a woman exploring at a gate just off the side street and followed her into a yard. People were queued up waiting to enter through an inner door. She was in her sixth month of pregnancy, and although her condition was very obvious, no one ahead of her offered her a place in line. People looked straight ahead, their faces expression-less, their eyes blank, preoccupied with their own reasons for being there. After several hours of waiting, Eva finally found herself facing an offi-cial, a red-haired, handsome man who observed her closely as she asked her question. He flicked through a file, then said to her, "Why would you want to know about the fate of a traitor and an enemy of the people?"

Rage surged within her and she lost her composure. "Who are you to call him a traitor? The jury? What do you know about him? Have you been at his trial? If you accuse him of being a traitor, prove it to me. I want proof!"

The man was momentarily flustered. He reddened then shouted, "You don't deserve an answer to your question. Get out and let me take care of the person behind you." He threatened to have her removed, with force if necessary.

Eyes blazing, Eva got in the last word. "The next time I come here, I won't be surprised to meet your wife in this line asking where you have been taken!" She was trembling with anger; only the energy generated by her wrath kept her on her feet.

A week passed before she had the courage to face that man again, but it was here that she had to return in order to find out where Max had been taken or where to inquire from there. He was not at the desk. When she asked for him as the colonel to whom she had originally been directed, the officer said, "He doesn't work here anymore." She thought to herself, "Good! He was arrested." It was common knowledge that the status of the security police did not permit transfers. If he "didn't work here anymore," it could only mean that he had fallen from their good graces and that he had been taken, just as her father had been taken, and Bob and Al and Max had been taken. He couldn't have been fired. Once a member of the security system, outside of the system he would be-come a risk. No other fate but arrest was possible. She was sufficiently bitter to feel sweet revenge. "Does he remember calling my husband an

enemy of the people? How does he feel knowing that his wife may be in this very line and may be hearing these same words from a former colleague?"

As she was leaving, again directed to another address, she walked past the women still in the line, glancing their way, thinking that perhaps one of them could be the wife. It occurred to her that hate was consuming her, but at this moment she was deriving satisfaction from the emotion. She stepped from the exit of the yard to the Arbat and was shaken from her musing by a scream. A woman whom she had seen in the line was on the walk in front of the building, her arms outstretched towards the upper window, her fingers pointing. "My husband! He's there!" A younger woman tried to calm her, but she continued to shout until people walking by began to encircle her, their eyes drawn in the direction of her extended fingers. Eva joined the group, scanning the windows of the facade, her breathing hurried, hoping that she might catch a glimpse of Max. But neither she nor the others saw anybody at the windows. Was it possible, she thought, that this house in the heart of one of the most fashionable streets in Moscow held prisoners? She walked along the avenue, her stride keeping pace with the other pedestrians, some of whom had been part of the group still crowding the agitated woman. They strode on beside her and in front of her, as if they had not been a witness to the scene. Perhaps they had the same problem.

Months passed before Eva learned that Max was in Taganka. It was an old prison, far from the center of town and a long distance from Pestsovaya. Alexandra went there with her, hopeful, only to be turned away because this was not the day when inquiries regarding prisoners whose names began with the letter "M" were accepted. So they returned on the scheduled date, again waited their turn in the long lines, to be told that there was no record of Max. Again, they went to the office where they originally had been told that he was at Taganka, and it was reiterated that, yes, he was at Taganka, and so, again, they went through the long ride and the long wait. The new interviewer was Max's investigator. "Of course he is here. I spoke to him yesterday." He seemed attentive and approachable. Eva's questions spilled over. "Is he all right? How is his morale? Does he need anything?" She was assured that he

was fine, that he didn't need nor want anything. No, it was against the rules for people still under investigation to have visitors. Yes, she may come again if she wished. He will be told that she and Alexandra had been here and if he wishes anything — food, money — she will be told. The tightness within her unlocked for the first time since her father's arrest. On the next scheduled date, she returned to be told that Max was no longer at Taganka, that he had been sentenced, he was to have correspondence privileges, and he would undoubtedly write her soon.

Chapter 8

During the last month of Eva's pregnancy, Valeria was always close by, ready to help and to accompany Eva to the neighborhood maternity home. A cot was set up for Valeria in the Meltz's flat; that she was the sixth adult in addition to the two young children and the houseworker in the all too tight flat seemed to disturb nobody. In fact, Valeria's presence was a welcome relief for Esther, and her willingness to take on the laundry and the scrubbing of the floors permitted Esther some precious time for other chores. Both Esther and Valeria were critical of Eva's attempts to help with the housework, certain that even moving a chair would result in premature delivery. Esther protected Abie from this kind of work, too; she had never expected the men to help with such tasks, and it never occurred to Abie to offer. It entered neither Esther nor Abie's minds that he could stay at home to take care of Tommy so that Esther might go with Eva to the maternity home, although his enforced idleness in addition to the loss of his social life had a denigrating effect on him. Fortunately, his natural inventiveness lured him to his drawing board where he spent hours each day, amusing Tommy with chalk talk and caricatures. He now had plenty of time to write in his diary which he had begun in high school. He also lost himself in reading — both English and Russian literature.

Eva, too, turned to books to escape from the long sleepless nights, the beginning of insomnia which was to afflict her for the rest of her life in the Soviet Union. Many were the nights that, unable to sleep, she would crawl out of the bed with as little movement as possible so as not to awaken Esther, tiptoe to the water closet, turn on the light, and lose

herself in a book. Contemporary English literature was not available in the bookstores and the libraries had withdrawn these books from circulation. While waiting with other patrons at the library, Eva had discovered that most other foreign books also were not available. Consequently, she now read and reread the English classics she had bought during her early years in Moscow as well as American literature that had been required reading during her school days. She read some of these books five or six times so that she was able to quote full passages without glancing at the pages. When the need for variety was strong, Eva plodded through Russian literature and, as an inevitable but beneficial result, she became more familiar with its vocabulary and cultivated an appreciation for its richness. Occasionally, she hunted for political literature on the theories of the Communist Revolution, those theories which her father had fed to her, in a last effort to try to understand what was happening around her. At the library, she once asked for Krupskaya's *Reminiscences of Lenin*, only to be told that it was out of circulation. "Imagine," she said to Valeria, "Lenin's wife Nadezhda Constantinova out of circulation!"

Valeria gave a disdainful snort. "Out of circulation, out of mind," she said, repeating a common proverb. "A good way to obliterate the persons who founded the Party and made the Revolution! And why not bury them also? Stalin wasn't given enough recognition in the book to satisfy his ego. Krupskaya speaks of him only as the nameless 'young Georgian Comrade' who gave a good report on the policy of Nationalities. If his name is not mentioned, he orders the book withdrawn, not content that it did bring him attention at the conference. He needed to be exalted even in those early days."

"The historians and the researchers must have copies in their private libraries," Eva surmised. "The book can't disappear altogether!"

"Hmmm." Valeria's disillusionment was complete. "The cooking stoves no longer need wood. Those books that are 'out of circulation' in the library are hardly the ones that the NKVD should find in private libraries. How brave do you expect people to be?"

In later years, Eva would say, "Some people turned to drink or to lovers or to both. I turned to books." They eased the pain of lack of companionship. She identified with the author's creations, living their

lives as they developed from page to page, hating with real hate, envying the hard-hearted their capacity to be hard-hearted, feeling empathy with the idealists and the weak. They compensated for the social life that had disappeared overnight. Now she preferred being alone, afraid to meet with people outside of her family, fearful of being her natural self with them. There came over her that terrible fear, "If they find out what happened to us, they will shun and report me!" That she and her family were not the only victims she did not appreciate, for those who were in the same circumstances carefully insulated themselves, hoping also to prevent more arrests and a complete annihilation of their families.

Valeria shared Eva's fears. She was always ready to be taken, always expecting a night raid. "Why do you have a bag packed?" her mother would ask. "Where are you going?"

"They'll be here," she insisted. "A change of clothing, to have my night clothes and my toothbrush with me will give me some dignity," she would respond. "Let them understand that I know I do not belong in a prison cell." Even in Eva's house, while awaiting Eva's labor pains, Valeria had a bag ready with overnight supplies. "When they come, we become distracted and forget to pack. They just say 'Come with us!' and do not consider that in their prisons we are looked upon as being no better than animals with only animal needs. I'll be ready as much as it is possible to be ready." Valeria's circle of friends had been thoroughly broken too. She had been isolated from most of her friends by their disappearances rather than by their fear to associate with her.

Eva's time came on the early morning of July 21, 1938. Valeria gave her over to the nurse, and recalling the procedures of the Grauerman Maternity Home where Tommy had been born, promised to phone her in her room. Maxine was born before noon without incident. It was when Eva was settled in the ward and wanted a telephone in order to give the family a report of herself and her baby that she realized that she was in a maternity home far different from the one where Tommy had been born. Not only was there no luxury of a telephone at her bedside, but the entire room was neither as pleasant nor as relaxing. Her ward held beds for many more mothers, the decor was drab, and the

service and food were inferior. When on the tenth day she and her baby were discharged, she learned of the hours of unnecessary anxiety that the family had suffered waiting to hear of the birth. Alexandra, usually calm and passive, heatedly gave an account of how, twelve hours after Eva's admittance, she extracted the news that the birth had been normal. "Every half hour we inquired and the answer was the same. 'No baby yet.' How could that be? The first child was born in four hours. Surely the second would come as fast or faster." The midwifery training of her youth had caused her extreme worry. "By seven o'clock in the evening, I feared the worst."

Valeria interrupted, pride in her voice. "Nobody could hold Ma back. She pushed her way into the office of the chief doctor. You wouldn't believe she could behave that way. There was no holding her back."

As Alexandra continued, her anger returned. "He wasn't in. But the head nurse heard from me — and she moved fast to find out what was going on. And what do you think? 'A mistake,' she told me. 'You were given the wrong information.' Our baby had been born hours before, and they were telling us about another woman in labor."

"Tommy came into this world in a hospital for the privileged, a showcase hospital. Our little Maxine is a Russian, born in a hospital for the ordinary Russian," Eva responded. "Each day that we live here now we learn how the Russians really live. The government seems to have needed a showcase for foreigners."

The months after Maxie's birth dragged, each twenty-four hours flowing into the other to make one endless day. Bob, Al, and Max were always in their thoughts. They hoped to hear from or about them, always expecting that they might suddenly appear — free. Morris's safety, and the anxieties he must be suffering where he was, separated so completely from them, pressed heavily upon them. Perhaps the most difficult reality for them to grasp was that of their being cast off as traitors by the society to which all of them had given their hearts and souls, their being unable to convince anybody that they had never renounced their beliefs, that they were not "enemies."

Tommy's behavior drove them to distraction. The child would awaken calling for her daddy. The long mornings were taken up with coaxing her to permit one or the other of the family to dress her and

feed her. She would often find contentment when she would sit next to Maxie, whose eyes were fixed upon her, and she would create stories of how things would be when their daddy came home. Eva felt she needed medical advice in handling Tommy and, with the concurrence of the others, she sought out a child specialist. To her amazement, she learned that treatment for this kind of problem was given only privately.

The doctor's fees for the treatment came from the money the family got from the sale of their household supplies, one at a time, sheet by sheet, towel by towel, for which there was no lack of customers from among the occupants of the building in the cooperative. When they sold as much of the extra household linens as they could spare, they set out their luxuries: an electric coffee set which had been a treasured farewell gift from friends back home, and a Shaeffer pen and pencil set that Uncle Peter had given Max as a parting remembrance. Next they dug into their wardrobes and were surprised that even Esther's and Eva's most heavily worn dresses and undergarments, and Abie's suits, all bought in the States, were in demand. The new owners gave them to Bluma Abramovna to alter. She ripped open the seams, reversed the fabric, and skillfully renovated them. She stroked the cloth as if it were a delicate painting, expressing amazement at the superiority of the texture over Moscow fabric. She also taught the Stolars a lesson in recycling the clothes they had left. "Little did I know when we prepared to come here that I was filling our trunks with money," Esther would say as she extracted from her neighbors enough to pay the doctor and to help sustain the family for the next few months.

Abie tracked down every lead that might offer any kind of employment, but the disgrace of the family automatically excluded him from obtaining work. Eva postponed looking for work until Maxie was weaned. During this lean period, when a neighbor asked her if she would be willing to tutor her daughter who was having difficulty in school with English, Eva recalled Borodin's counsel that she give private lessons. She hesitated, her first reaction being her hidebound antipathy to private enterprise, but more important was her fear of placing herself in jeopardy with the law. Valeria encouraged her to take the student, pointing out that many of their previous American and English acquaintances had always earned extra money this way, and that private tutor-

ing was apparently not frowned upon; in fact, it appeared that the authorities looked the other way. In the end, she agreed to work with the girl on a regular basis twice a week. A few months later, a student of the Foreign Language Institute sought her out asking if she would be willing to "just talk" once or twice a week to improve her English conversation.

This time Eva did not hesitate. She admitted that her devotion to "collective" work had been strait-laced and naïve. The money that she received for this work paid for necessary food for the children. It also enabled Esther to buy a large supply of wood all at one time for heating and cooking, which eliminated the hardship of her gathering small quantities of wood day in and day out.

Additional small help came from another unexpected source. "How long has it been since you have written to Aunt Rose?" Eva asked her mother one day.

"It is a long time. Shortly after Pa disappeared," Esther answered. "Maybe she, too, has deserted us, or maybe she is saying, 'I told you so.'"

"Don't carry on, Ma." Eva was impatient. "You know her better than that. Can't it be that she is afraid?"

"It can be. Not for herself but for her children. I don't blame her. I, too, want all of them to be safe. What happened to us should not happen to them."

Six months after Tommy's birth, in December 1935, Esther had taken the trip to Odessa to mourn with her sister-in-law her brother David's death. Now, a year and a half later, she was also without a husband, suspecting that he, too, was dead. She was unable to place much faith in the sentencing information given to her by the NKVD. She did not voice her fear to Eva, determined that Eva should have some hope that Max would return. To both of her children, she talked of better days ahead as soon as Morris and Max would be vindicated, but deep in her heart she had lost all confidence that this current regime was any better than the Tsar's under whom, as a child, she had witnessed pogroms and in her youth had heard of the punishment meted out to dissenters who were caught by the police. She had given up hope that political and human freedoms could ever be possible in this country, whatever the governing organization might be — that of the Tsar or of the

so-called working class. "Suppression is part of the culture. The Russians know no other way," she decided. Yet, she was a traditional wife of the old country, which required that she agree with her husband, stand by him, and give him the opportunity to fulfill his calling. She understood Morris well enough to know that, if he were still living, he would remain firm in his convictions. "Without ideals, there can never be change," he would say.

Esther needed her own peers to grieve with her. So, when a short time after this chat with Eva took place and a letter arrived from Rose, she felt less depressed. It was delivered by Olya, Rose's long-time friend who was living in Moscow and with whom Rose was staying. The envelope had no return address and the communication was without a signature. But the handwriting was recognizable. She asked that some member of the family — anyone — meet her on Gogolevsky Boulevard at three in the afternoon of the next day.

On summer evenings, Eva and Esther strolled the length of this wide, tree-lined boulevard. It was a favorite promenade with a grassy parkway dividing the two dirt-stomped walkways and benches spaced and plentiful. On the appointed evening, Rose and Esther embraced and wept when they met, each simultaneously expressing gratitude that David had not lived, for surely he would have been picked up in the scourge. Then, Rose outlined her plan to assist them financially. Through Olya, who was well able to circumvent the security police, having been trained as Rose and Esther had been in pre-Revolutionary Russia, Rose would find ways to deliver money to them. She apologized for her caution, fearful, as Eva had inferred, for her own family. Eda was now a mother and her husband a doctor. The chance that still other members of the family might be torn apart forced her to be cautious. The Stolars were thankful.

So Eva and Esther and Abie survived. In the Meltz household, fortunately, Gustav was still employed at the Lenin Library grounds doing maintenance jobs and gardening — work for which he earned sustenance, however slight, for Alexandra, Valeria, and himself.

However, there was no escaping, even for short periods in a day, reminders of their situation. Eva was on a street car, on her way home from the Meltz's flat, sitting facing the front of the car, with her eyes

focused on the pages of the book she was reading. An unusually long stop interrupted her concentration. She looked up and out of the window and placed the stop at the Butirsky prison building. A number of people were pushing their way from the rear, which was the entrance, into the car toward the front where they made their exit. Eva could see the backs of two men wearing the uniform of the security police standing on the street close to the exit waiting for the last of the passengers to leave the car. It was not uncommon for men in this uniform to enter from the front of the car. When the last of the passengers cleared the door, they boarded and sat on the vacant seats directly facing her. They were the officers who had arrested Max. She felt the blood rushing to her head and her heart pounded. They caught her gaze. They glanced at each other, both having obviously recognized her. The car was already moving. Suddenly, they jumped from their seats, rushed to the door which at that time always remained open, and just as the car slowed down at a dangerous curve, jumped off. This encounter brought on a tremor she could not control. The emotions that had engulfed her at the time of Max's arrest returned.

She said, when she related the incident to Esther and Abie, "I wonder what they thought. They probably were afraid that I would make a scene of some kind."

"And they will try to avoid a scene in public at any cost," Abie said. "How would it look, your shouting and screaming about where they took Max and the injustice of it all — I mean, about things that shouldn't be happening in this country of all places!"

Another time, she was on the street walking with Tommy when a huge billboard attracted her attention. It was a photo of a smiling Stalin holding a little girl in his arms. She was giving him a bunch of flowers. The caption read, "Thank you, Comrade Stalin, for a happy childhood."

"The sadism of that man! My children should thank him for a happy childhood! He takes their father, makes half-orphans of them, and they should thank him for a happy childhood! And sets before them a reminder of their misfortune on top of every building. A happy childhood for the babies of Efim and Musya Stepanov in an orphan asylum? They will never see their parents again. They will be taught to hate their mother and father!" It had been only a few days before that Valeria had

told her about the Stepanovs and that relatives had been unwilling to take the children, fearing the political consequences that might follow a display of compassion for "enemies." "If only I could look, but not see," Eva thought, "these posters, large and conspicuous, might not be so painful."

In the middle of October, a letter from Max addressed to Esther arrived. "I am writing from a transit prison. I do not know where I am being taken. You have not answered the letter that I wrote you from prison. Do you think that I wrote because I really needed the twenty-five rubles that I asked for? I want to know how you are. Are you alone, or are the others still with you? When you didn't send the money, I wondered why — what happened — were you still in Moscow or were you sent out somewhere. What has happened to Eva? I will write you again. I am told that I shall be away ten years with the right of correspondence."

Eva wept. "How he must be worrying!"

Esther's heart cried out for his suffering. To Eva she said, "Especially about you! The state you were in. Pa gone. Your desperation when you became pregnant!"

"For all we know, he thinks all of us have disappeared, too, and Tommy was taken away by strangers," Valeria conjectured. "And when he got no answer, it was more torture for him to have to hear from the NKVD that his family disowned him — that his wife didn't want to have anything to do with him. They are capable of such methods to bring a person down to his knees."

Alexandra replied, "Surely they can't torture him with that! Bob — maybe he believes such a story. He was the first to go. But Max knows the tricks. He suffered with us when Bob and Al and Papa Stolar were taken!"

She was right. A month later, Max wrote from Syktyvkar, the capital of the Komi Republic, refusing to give up on his attempts to get a letter to them. He had been sent to a labor camp in the Far North. From then on, there was regular correspondence. From letter to letter, with sentences disjointed, one piece at a time, he pierced through the censorship and eventually told them what he wanted them to know. He

smuggled out a few rare letters, a risk he took when on the work brigade he spotted a sympathetic "free worker" from the village, an exile from a European Soviet republic. From these, which were somewhat more coherent, they gleaned that he had been sentenced, without trial, on two charges — suspicion of being a spy and spreading anti-Soviet propaganda. During the long months at Taganka, during repeated interrogations, he had been questioned about charges against him made by George Relam that he had once commented that Marshal Tukhachevsky was "a good man."

"George Relam?" Eva expressed utter disbelief. "Max barely knew him! His wife should have lived to read this!"

Gustav wanted an answer. "How did Max know him?"

"He didn't really. George was an American from New York — he and his wife had come to Moscow to escape the Depression. His wife and I were good friends. She died three years ago in childbirth. George has a new wife, also American. Bernice told me that both of them returned to the States several months ago."

Valeria's laugh was not pleasant. "Marshal Tukhachevsky! Who is Max to know Marshal Tukhachevsky? Stalin himself? I'll bet even a Red Army private knows nothing about Marshal Tukhachevsky!"

"What is our government doing — making threats that bring from mouths words to be used and twisted?" Gustav spoke despairingly. "Nobody to stop it! How will it end? When will it end?"

With each letter, they culled more information about his camp mates. "You would be amazed if you knew what people I have come to know! I would never have been able to get near them outside!"

Abie sarcastically filled in a missing name which he probably picked up from *Pravda*'s occasional mention of military celebrities. "General Rokosovsky, perhaps?" revealing his awareness that high-ranking government and military officials were not beyond the reach of Stalin's cleansings. As it happened, General Rokosovsky escaped execution and, within a few years, would be freed — apparently, according to rumor, because of the catastrophic lack of experienced and knowledgeable military leaders available when the Soviet Union was drawn into World War II. General Rokosovsky played a decisive role in World War II and won several great victories.

Once correspondence with Max was established, every few months Eva sent him photographs of Tommy and Maxie. Her letters described their development and detailed anecdotes in which she knew he would revel. His last letter arrived a few days before the war began.

The sale of Esther's sealskin coat represented the last of the family's assets. The money that came in from Eva's two students and from Aunt Rose was barely keeping them fed. Abie's applications for any work, however menial, were rejected as soon as the questions concerning the reason for the loss of his employment needed to be answered. "Even as a ditch digger I am dangerous." But by early spring, there was a thaw in policy. As usual, Valeria recognized it first. *Pravda* carried an article promoting the idea that children should not have to pay for the sins of their fathers and suggesting that family members of "traitors" — those who were now repaying society for their crimes by working in the labor camps — should be given useful employment. "There are tremendous tasks to be completed. These people could prove themselves to be valuable citizens contributing to the progress of socialism," Valeria read from the paper.

"Ha!" Eva reacted. "Not a large enough labor force! They are either in jail or camp or on the shelf! The economy must be suffering!"

Valeria and Abie immediately set out to measure the value of *Pravda* as the Party's mouthpiece. Valeria reported success — a job as chief librarian in a print shop. Abie went first to the Komsomol district organization, then to the trade union to which he had been affiliated. He was given a job at the artel, a factory making dolls. As an artist, he was to paint faces on the heads of the dolls. "Very little pay," he said to his mother.

"Money, nevertheless." Esther doled out to him the kopecks for his transportation.

Valeria's and Abie's return to work on non-activist political levels gave them a popular perspective on the attitudes of the ordinary Russian towards the carefully constructed elitism of the governing socialist system. This view of the Russian working class gnawed deep into their disillusionment.

"How's this for respect for the Party?" Valeria related. "The chair-woman on my floor asked me today if I'm a Party member. I told her I wasn't and asked her why she wanted to know. I must have been quite emphatic in my reply. She apologized to me! Imagine! 'I didn't mean to insult you,' she said, 'There are some decent people in the Party!'"

Eva repeated, "Didn't mean her question as an insult? Party members are held up to us as being the cream of our society. This was dunned into our hearts."

"We were to be the model by our high principles and our integrity and diligence — to earn the respect of the masses!" Valeria laughed "And to think that I took it seriously!"

Abie spoke of another incident. "Even the members of the Komsomol ridicule the orders given them. The young woman working at the table next to me has been unusually friendly. She even told me that she has been assigned to 'keep my eyes on you, but I can tell just by talking to you how foolish it is for me to spy on you. You wouldn't harm a flea. I can't earn a medal being assigned to watch you!'"

For Abie, renewed social activity was a bonus of his being employed. Esther was happy when, after the evening meal, he left the house to spend a few hours with his friends. It wasn't very many weeks after he had started to work again that he had almost as busy a social life as he had had before Morris's disappearance. One evening, he came home with Natasha who worked at a table next to his, also painting faces on dolls. Everyone agreed that she was beautiful, her blue eyes a striking contrast to her long, glistening, black hair which draped over her shoulders and down her back almost to her waist. She was pleasant, made small talk easily, seemed at ease with both Eva and Esther, admired Maxie, and loved Tommy. After she left, Abie confided that she was the comrade who had been assigned to keep him under surveillance. From then on, she was a frequent guest at supper. It did not take long before she made herself quite at home, helping Esther in the kitchen and Eva with the children. Tommy, imitating Abie, addressed her by her shortened name of "Nata," and soon Eva and Esther felt comfortable enough to do the same.

By the beginning of summer, Abie and Nata registered with ZAGS as man and wife and Abie moved to her room. To his astonishment, he

discovered that he had become a stepfather as well as a husband. Natasha had a five-year-old daughter, Galina, from a previous marriage that had ended in divorce. Eva and Esther lifted eyebrows when they learned of the existence of the child, but when Abie appeared to accept the arrangement happily, they remained silent. Natasha's mother also lived with the couple. She was Esther's counterpart, her responsibilities somewhat easier because Galina was attending nursery school during the hours Natasha and Abie were at work.

Before the year was over, Abie asked to return home with Natasha and Galina. "My patience with Nata's mother has worn thin." Esther moved into the room with Eva, Tommy, and Maxie and made a place for them. As Abie had not registered out of the flat nor re-registered into Natasha's rooms, he had no trouble registering his new family into his old room.

Living with Natasha was not too difficult. She was willing, even eager, to accommodate herself to their habits, to Esther's food, and even to contribute her wages for their common needs. Her ebullience was a sharp contrast to Eva's despair. To Nata, everything in this foreign household brought extravagant admiration, particularly the American garments — those which had not been sold — and delicate rayon underwear which she believed to be pure silk.

"Do you like it so much?" Eva would ask. "Please accept it as a gift. I don't need it." She was convinced that, for her, life had ended. She could not contemplate a future when she would wish to look attractive. Nata was in love, happy, and desired her husband's praises, so Eva was generous. She gave away as much as she could spare, undergarments that her sister-in-law seemed specially to want, and all her dresses but one that was Max's favorite. Nata thanked her profusely and Eva was glad to see her face light up with pleasure. But she hinted for more. Finally she stopped being coy and spoke outright. "This dress. It is the nicest of all. You won't need it anymore. Will you give it to me?" She pouted at the refusal. Eva was upset at the ungracious way she took it and became suspicious that this Russian girl might not be totally sincere in her regard for Abie, but rather hoped that marriage to an American — fable had it that all Americans were rich — was opportunistic. She refrained from discussing her disappointment in Natasha even with

Valeria, who was her closest confidante, because Abie seemed to be genuinely content. Yet, Eva remained apprehensive and watchful.

The events that were destroying the family sealed them from the political problems of the country; their brooding was limited entirely to their own adversities. However, when they saw in the newspaper the photograph of Molotov, the Commissar of Foreign Affairs, and Von Ribbentrop, the Foreign Minister of Germany, together signing the Hitler-Stalin Non-aggression Pact of August 23, 1939, they were shaken with almost the same intensity as when Bob disappeared. Since Adolph Hitler had become chancellor and virtual ruler of Germany, his influence in Germany had spread a pall throughout Europe. The Soviet Union had been preparing its population for the inevitable war, hammering away day after day, week after week, month after month, year after year with warnings about the dangers of fascism and the German dictator. The Spanish Civil War had been very widely publicized, the heroism of the Republican Army dramatized in poetry and song. The degree of Soviet military involvement on the side of the Republican government was not made known to the Russian public, but many Russians knew "somebody" who had fought with the International Brigade.

"And now this!" Valeria emphatically dropped the newspaper on the table for all of them to see. "A slap in the face of every Russian. Are the people going to accept this?" This talk was only behind their own closed doors. The period of Yezhovshchina, although he was deceased, had not ended, and arrest for such conversation was too frightening a possibility. (Yezhov had become Commissar of Internal Affairs, chief of the security police, after Yagoda. The mass arrests of 1937 - 1938 were under his leadership and have come to be known as "Yezhovshchina," roughly translated as "the time and deeds of Yezhov." Yezhov was arrested in 1938 and executed.) "What is this?" they questioned. "We want to live in peace with all nations? With Hitler's Germany? Are we to believe that Hitler will keep his promises? Hasn't he done enough to prove that he will betray us as he betrayed his other neighbors?"

"Our beloved father Stalin wants more time to make our army stronger," was the explanation by apologists for the signing of the pact.

Opponents raved against Stalin. "First he kills off our best military leaders and now he needs more time to find new leaders?" they

exclaimed, alluding to the rumored rationale for the alliance.

When the Soviet Union attacked Finland the following November, the justifications for this action that were officially given were accepted with less emotion, but the grisliness of war began to surface as husbands, sons, and brothers froze to death on the battlefield.

Valeria encouraged Eva to apply to her District Board of Education, the RONO, which was accountable to the Moscow City Board of Education for a job as an English teacher, but Eva was pessimistic about the process. A reaction against the learning of foreign languages had followed the cleansings and purges. Often in the breast-beating sessions, accusations had been hurled at many of the Party members based solely on the fact that they spoke English or French or German. To know a foreign language had become a stigma of a bourgeois up-bringing, a relic of pre-Revolutionary days when wealthier families had employed foreign tutors for their children.

The popular attitude against the speaking of any language except Russian was brought home one day while Valeria and Eva were waiting for the bus on Gorky Street at a stop near the Meltz's home. They were speaking English, still the most comfortable and natural for them, and they were rudely interrupted. A tall, husky man standing behind them in the line began shouting obscenities. "Stop speaking in foreign gibberish on a Moscow street — so we can't understand you! We know anyway that you are scheming something. You rotten spies! Go back where you came from! We don't need rotten foreigners here!" He turned to the others in the line and tried to incite them.

In relating the incident at home, both Valeria and Eva agreed, "This was one time we were thankful for the apathy of the Russians. Nobody went along with him. They didn't take sides. They just let him curse. After all, they couldn't take a chance. He may have been an official provocateur, but so might we. They didn't know whether to support him or us. Nobody was willing to stick out their neck and then find themselves in trouble."

"But," Valeria reminded Eva, still trying to convince her to apply to teach English, "You still have your two students. And the Foreign

Language Institute hasn't been shut down."

Eva, however, did not feel confident enough to teach Russian children. Her one year at the Anglo-American School with the English-speaking children had been trying. "You had barely any training," Valeria countered. "If you had stuck it out, with that one year of experience, you could eventually have handled it. You know enough Russian now to take a teaching job. The tutoring you're doing should be proof of that. You have kept your students."

In December of 1939, with Valeria's prodding, her constant worry because of lack of money, and certainty that Esther could now manage both the care of the children and the household duties, Eva made an application at the neighborhood RONO. She was summarily rejected. "Try another district," Valeria persisted. "You are known here."

Applications at several districts some distance from her own neighborhood brought the same results, the first question requiring that she give information that revealed Max's arrest. The last try was at the Board of Education next to her neighborhood district. Here, an interview was granted before the application was offered. The inspector, who introduced herself as the person in charge of personnel employment and a supervisor of the instructional program, was delighted to find an English teacher. "We need you at School Number 183." The application was reviewed in Eva's presence. Her enthusiasm waned. "Your husband was arrested? Why?"

Eva tried to get around the question. "I don't know." But her inability to tell anything but the truth compelled her to add, "I think something political."

The interviewer became silent, continuing to inspect the application. Then she said, "I'm not sure. You may not be able to manage our children. They're not easy to work with and you don't speak Russian very well." Eva maintained a frigid silence. She had just been told that an English teacher was needed, yet it was obvious why the interviewer changed her mind. "Perhaps you'd better look for other kinds of work," said the interviewer, and with that, she dismissed Eva.

"I'm going to learn to lie," Eva announced to Esther. The next morning she returned to the same office taking the chance that she might see another interviewer. "Luck was with me this time," she told Esther.

"The lady that I had seen yesterday was not there — maybe somewhere visiting in a school." The formalities were the same. She was eagerly welcomed as a "find," so needed, especially at School 183. This time, when she filled in the application, she omitted the questions pertaining to her husband and any reference to her proofreading with the Ogonyok Publishing Company; she cited only her experience in teaching at the Anglo-American School and exaggerated the number of years she had worked there. This interviewer was no less curious than the other. "How old are your children? Who will take care of them? Will you need nursery school passes? What does your husband do?"

Eva had prepared herself but she was unable to answer with the firmness that she had planned. Her hesitancy, however, was interpreted as reticence which was received with sympathy. "He deserted me. He left me and the children for another woman," she finally uttered.

The response was compassion and pity. "Terrible! Doesn't he ever see the children?"

"He left Moscow and I don't know where he is living." She raised her voice in anger and added, "And I don't want to know. I don't want to see him again!" She was assigned to School 183 the same day.

During the first few months, Eva's fear that her lie might be discovered and the possibility that she might be arrested as a result never left her. This worry was aggravated by Sara Lvovna, a well-meaning colleague who, upon learning of Eva's marital problems, became outraged at the treatment that Eva, a foreigner, had suffered from a Russian husband. She couldn't drop the subject. "Go to the militia. They'll find him. They'll force him to give you alimony!" She had the bearing of a person of influence. It was well-known among the faculty that her brother was an important Red Army officer. Eva assured Sara of her "determination to raise my children without such a husband," and insisted, "I don't want him back. I don't care about him. I have some pride. Do you think I would want his money? I can support my children without him." But in spite of Eva's pleas, when they were thrown together at mealtimes or at meetings, Sara Lvovna could speak of nothing else. "Let's go to the militia together. I'll help you."

"I can't make her drop the subject," Eva would say, "I'll surely be in deep trouble. What will they do with me when they find out I'm the wife

of a 'traitor' and an 'enemy of the people' — and lied about it?"

With time, Sara Lvovna accepted Eva's situation as she had made it known to the district, and when Eva realized that the imperfect record-keeping would fail to reveal the truth, she relaxed and began to find pleasure in her work. Valeria stopped by each evening after finishing work at her own job to help with the children and to check through Eva's plans and papers for any errors in Russian which might cause embarrassment. There had already been one humiliating experience in the classroom that was a result of her improper pronunciation. "Of course, Valya, I can't take you into the room with me to speak for me, but didn't I wish I could for that lesson. Such a slip that taught me to think before I utter a word. What a wrong stress on a syllable can cause! My two devils made a whole thing of it." She repeated the word to Valeria and Abie and their laughter resounded into Bernice's room. "Only those boys didn't laugh! They behaved as if I had a filthy mind and was unfit to teach them. They wouldn't stop the commotion. The other children began to squirm and I was becoming embarrassed as well as angry. I knew I must have said something terrible. But when they could not refrain from making their rude remarks, one of the other boys came to my defense and soon the others joined in to help him. What respect I lost for the Russians, these children restored, at least a little.

"He turned to them and told them in plain language to shut up. 'You have no right to scoff. If she doesn't know Russian so well — so what?' And another said, 'When you can speak English as well as she does Russian, maybe then you will have a right to laugh, and even then you don't.' The others chimed in. 'You don't laugh at people's mistakes; you correct them.' It was so pleasant to hear them. I must admit that in this respect they are being educated in the right way. And I think that I'll have no more trouble with those *banditti.*"

She also gained some insights about her students from her own private tutoring with Tassia, and she avoided giving any assignments that did not require answers conforming to Party doctrine. During one of the lessons that was to include a conversation between Tassia and herself, she had asked the girl to prepare a report, which would include her opinion of Alexei Tolstoi's new novel *Bread,* a national favorite during the revolutionary times.

"What shall I prepare — the official criticism or my real thoughts?" Tassia asked her. For a moment Eva was thrown off guard, but then she quickly replied. "Prepare what you think will be a good subject for conversation between us, however you feel you want to do it," she directed.

"Imagine!" she said to Esther. "Even a child can't speak out as she feels about a piece of literature. Okay! So people are being persecuted and terrorized, but how terrible it is that this caution should filter down to children so that they must ask, 'Do you want my opinion or that of the government?' We are raising another generation of intimidated Russians. They will resort to hypocrisy and their minds will become dull in self defense."

Eva's own fears stifled frankness. She remained guarded in her classroom, both in her own expression of opinion and in the type of assignments she gave.

Each day Eva learned another lesson. At first she was discouraged by the annoying behavior of the children — their constant testing of her by interrupting the lessons and disrupting the tone of the class. She would send them, one by one, to Maria Petrovna, the principal, for punishment. Maria Petrovna was patient with her, relieved her of the youngsters who were the most troublesome, but always encouraged her to assert more authority. "They shall return to you tomorrow," she would say. "You yourself must face them. Until they know that you expect them to be responsible for their own progress and the progress of their classmates — that you yourself can handle their incorrigible behavior — you will not have their respect. This problem is not unique to you," Maria Petrovna would remind her. "I, too, had it as a beginner. Most new teachers are badgered with it."

This time she could not run away. There was no Morris and no Borodin to get her another job. Only her own resources could pull her through. As she became more honest with herself about her weaknesses, shifting the blame for the boisterous behavior from the students to her own lack of experience, the conditions became more favorable and she no longer had to place the emphasis of her teaching design on establishing order in the classroom. Gradually, the recurrent protests of the children, "Anna Nikolayevna did not teach us that way. Anna Nikolayeva did not give us homework," and similar complaints, stopped. Before the school

year ended, Maria Petrovna's praises offset to some degree her own feeling of failure. It was in her upbringing to give — not of herself — but of herself for the collective whole. She took on the accountability for the deficiencies or the successes of her students, spending long hours reviewing their work and developing ideas for increasing their skills in English. But she avoided discussions that might remotely be interpreted as "political." "I am hired to teach them English — not the abomination of capitalism nor the theories of Marxism-Leninism and the evils that result in their distortions."

Intent upon expanding her own skills, Eva attended the compulsory district seminars for English teachers held every other week at the offices of the district or city Board of Education; but these were not much help. "They are for teachers of English, but they speak only in Russian," she complained. "I don't understand them. How will I ever be able to improve myself?"

Maria Petrovna supported her. "Suggest to them that they speak in English. It will be good practice for them." When they agreed, reluctantly, it came to her why her advanced students knew so little English. The teachers expressed themselves inadequately. Their methods were mechanical and permitted their students no opportunity to work through the language themselves. Teachers read and translated while their students listened and took notes. Teachers did the work, writing on the board and pronouncing the vocabulary for the students to copy in notebooks. They dictated, while their "audience" phonetically transcribed. The final results were dissatisfying, and although she spoke out, her suggestions were ignored. "But luckily, nobody is stopping me from doing things as I think they should be done," she said to Valeria. "In fact, Maria Petrovna keeps complimenting me. At least I am teaching my kids to think for themselves. What chance do they have with the parroty methods that the others are using now?"

By the middle of the second term, Maria Petrovna was using Eva's classes for demonstrations. Student teachers from the Foreign Language Pedagogical Institute were being sent to observe her classes and to consult with her. Valeria gloated. "The wife and daughter of 'enemies' used as a shining example!"

"Don't be so proud. Who gets the credit? Not I — but the princi-

pal." Nevertheless, she would smile, pleased with herself. The reasons for the agony of the previous three years did not go away; yet, it was nice to have a little recognition, even if it was only from Maria Petrovna.

Her satisfaction in her work was often marred by the nagging thought that the district might ultimately reject her because she lacked the documents proving the educational training necessary for her eligibility. Her American diploma and transcript had been accepted, but each time that she was asked to submit it — and this was frequent — it had to be translated and each time the interpretation was different. By the time she discovered that foreign diplomas could be "legalized," she didn't need to bother. Finding the seminars lacking, she applied for permission to attend courses for the improvement of foreign language teaching. The completion of these sessions, offered at the Moscow Foreign Language Institute, would give her not only the eligibility documents, but, she hoped, a knowledge of the teaching practices in the Soviet schools. Her application for enrollment needed to be approved by the administration of RONO, the Party, and trade union officials. She was certain that she would be rejected, but that was not to be the case. When the sessions began, she understood why.

The vast majority of the teachers were women. In addition to their day's work in the classroom, the workload they faced after working hours imposed tremendous pressures on them and left little time for discretionary activities. As a result, year after year, the quotas established for enrollment were never attained, despite the fact that the school administrators and trade union officials accused the women of lacking dedication and professionalism.

Eva, however, enjoyed the classes. There were some fine teachers, among them an English and an American professor, both of whom had received their education in the Moscow Foreign Language Institute. The English language courses — those fields in which she wanted to develop proficiency — were conducted exclusively in English. She was stimulated by lively discussions with her phonetics teacher, Professor Trakhterov, the Soviet authority on English phonetics. They had several arguments on English versus American pronunciation, he insisting that American English was not a language and that she must take on the English accent through phonetic training if she were ever to be an ef-

fective teacher in the Soviet Union. "The King's English is the only real English!" he would doggedly assert. "Any other is the language of the illiterate!"

"Is Mr. Roosevelt illiterate?" she would retort. "The President of the United States? Are all the one hundred million Americans illiterate?" Although she did not change his thinking, she relished these heated encounters. They were an opportunity for controversy with no fear that they might be interpreted as political dissent.

Even after the war, when American English became preferred and was taught without prejudice, she heard that the professor had not accepted the change and was still persevering in his demand that only the British English be officially recognized for examination evaluations.

The political subjects, Marxism-Leninism and the History of the Communist Party of the Soviet Union, were taught in Russian. She was certain of passing the exam on Party history in Russian. This she had studied in the political circles during all of her years of employment since her arrival in Moscow. "After seven years of it, everywhere I've worked, I'd be an imbecile if I couldn't make it." But the theories of Marxism-Leninism — that could be an obstacle to her securing the documents. So she asked that the exams be given to her in English. Their attempts to be accommodating were sincere, but a teacher of this subject who would know English well enough could not be found. Their desire that she succeed in being certified was manifested by their offering her the summer for additional study so that by the fall she would be more proficient in Russian.

The tragedy of June 22, 1941, put a stop to that plan and Eva never secured her teaching certification documents, nor was she ever again asked to produce them.

Part Three
The War Years

Chapter 9

On the morning of June 22, 1941, Eva was awakened by a shout from Bernice. "Eva! Get up! The Germans have attacked us! We are at war!"

Eva first thought that Bernice was joking.

Bernice turned up the volume on the radio, and sure enough, Molotov was announcing that the Nazis were bombing the western frontier of the Soviet Union. He urged the people to remain calm and not to panic. There was sufficient food in storage to last eight years, he assured them, and the war would certainly be over long before then. He closed with, "Ours is a just cause! We shall win!"

Shock revived Eva. The entire building exploded with voices. People asked each other: "How could such an unwarranted and unexpected attack take place? We have the strongest and best army in the world. How could it be that it was unable to repel the invaders? How could it be that nothing was noticed at the borders? Surely the Nazis hadn't come directly from Germany that very night!"

Then there was the curiosity as to why it was Molotov, not Stalin, who announced the awful news. Eva heard the same question posed time after time in the ensuing months. Even after the shock and excitement abated a little, speculation and discussion continued to be rife and absorbing. It would be weeks before answers would be forthcoming.

On hearing that Odessa was one of the first cities to be attacked, concern about relatives in Odessa was one of the foremost personal subjects of discussion in Eva's household. Were they alive? Had they been able to leave the city? Were they safe somewhere — in a train or on a

ship? But with the bombing, how safe could they be in flight? Little Ena, Rose's nine year old granddaughter — what an effect this will have upon her! Telegrams were not being accepted. Only many years later, when the war ended, did Eva learn that Zhora — the erstwhile thirteen-year-old who had wanted more bread and fruit, now a handsome twenty-three-year-old engineering graduate of only two days — had managed to get his mother, sister, and niece on one of the last trains leaving the city before he reported to his army unit.

By mid-afternoon, when Eva went to the Eleseyev to buy bread and sugar, she looked about her in amazement. The store had most certainly been ransacked. The shelves and showcases were bare even of the usual varieties of the tasty breads and the plain toast, always in unfailing supply. To her, "I need bread! Why isn't there any?" the clerk replied, "You're too late. You should have been here in the morning. Everything is going to be rationed again." Eva returned home empty-handed, every store that she tried having been swept clean.

Esther pacified her. "Molotov said there is enough of everything for eight years. There'll be more bread and sugar tomorrow. Just wait." But the shelves were still empty the next morning.

The government may have failed to warn its people against ravaging the stores and hoarding food supplies but it was thoroughly successful in making them understand that in times of disaster they were to report to their places of work for information and instructions.

Eva, Abie, and Natasha speculated on what would take place. Esther predicted that the artel would be shut down. "Is painting dolls' faces so important for the war effort?!" she questioned. Abie was Esther's primary concern. Eva was certain that as the son of an "enemy," he would not be accepted into the army. Esther was certain that he would. "An enemy's son can always serve as cannon fodder. Don't you believe he will be anywhere but at the hottest places at the front," she anguished. She was inconsolable. Morris was gone. Next their son would be taken from her. "Leave him in Moscow? Never! They'll never trust him to work in a factory. Even though he is a Jew, they'll find an excuse to accuse him of spying for the Germans." Natasha listened to the laments, and although the words meant nothing to her since they were spoken in Yiddish, she understood Esther's cries.

Abie and Natasha were not to know immediately what was to be expected of them, but Eva received her briefing from Maria Petrovna the next morning. Most of the teachers and the auxiliary personnel were already at the school when she arrived. "All vacations are canceled," she announced. "Our school is being evacuated. We have not yet been told where we shall be going and when."

Eva asked, "What do you mean by 'our school'?"

Maria Petrovna stared at her. No one else had asked any questions. The others had seemed to take her announcement in stride. She answered, "Oh, yes. You are an American. You have never been in a war. Our staff and students, of course."

Eva's voice showed alarm. "But I can't leave my mother and children. My mother would not be able to manage them by herself."

"Who is asking you to leave them? They'll come with us. Dependents join us in the evacuation." She resumed her instructions to the staff. "Each of you is to give me a list of those who are going with you. Remember, only pre-school age children and old people."

Eva sighed a breath of relief. Going with the school would be the best solution but, she wondered, what about the school-aged children of other personnel? What would happen to them? Maria Petrovna's next comments answered her question. "Broadcasts are instructing parents to return their children to their schools. We'll need to occupy them somehow until we leave. We shall combine a study program with recreation. I am sure that collectively we shall come up with something worthwhile. You, Eva Moisseyevna, will have to take Belyaev's homeroom with yours. He is a reserve officer commander and was mobilized yesterday before the news was released."

On Thursday, Irena Gregoryevna, the music teacher, arrived at work in tears. Borya, her husband, had been drafted the previous night. That was to be expected. Whose husband of that age would not be drafted? "As if it isn't enough that he is gone, the NKVD phoned this morning and ordered me to be at Lubyanka at one o'clock. What could they want from me?" Eva shuddered at the mention of the political prison. She suspected that Irena Gregoryevna might have an "enemy" in her family. Irena left for her appointment with her four-year-old son, who had been coming to work with her since Monday.

Friday morning, Irena returned to the school to bid farewell. The NKVD was sending her away. Her ancestors had emigrated from Germany two hundred years ago, and although she had a purely Russian name and upbringing, point five (the nationality identification on the internal passport) revealed her German ties. "What kind of a German am I?" she cried. "I don't know the language — except for a song or two that we had to learn at the conservatory. My family has lived in Moscow for over one hundred twenty-five years. How can they claim that I am not a Russian!" She added, bitterly, "But the NKVD says I'm German and that makes me one!" She said to Maria Petrovna, "I'll write to you when I get to wherever they're sending me. If you're still here, please, let my husband Borya know what happened. His sister went to Yalta and I don't know how to reach her to tell her. Please, can you take the time to collect my letters at my building? I only hope Borya won't be harmed because they say I'm German." Irena Gregoryevna never returned to School 183 and no mention of her was ever made again.

On the fourth evening following the announcement of the invasion, a distressed Esther met Eva at the door. "Galina Petrovna stopped me while the children and I were on the walk outside. She said we are to prepare the children to leave the city with the next neighborhood group. If we are not willing to trust them to the care of the committee accompanying the children, we have the right to join the group."

Galina Petrovna was adamant. She refused to discuss the evacuation plan that had already been worked out for the teachers and their dependents, "Be ready to leave at ten in the morning, day after tomorrow," she demanded. "I don't know and don't care when your school is leaving. I have my orders. I refuse to be responsible for your children remaining in my house."

For the next three weeks, in their attempts to stall for time until Maria Petrovna would receive the evacuation orders for the school, Esther moved the children between their flat and Alexandra's. They managed not more than a few days' stay at any one time in each place before the managers of the respective houses discovered their presence and issued an order that they evacuate with another group preparing to leave. Finally, their patience exhausted, both house managers reported the family to their Children's Evacuation Center where the authorities took them

in hand and officially assigned them to a group that was preparing to leave on short notice. Maria Petrovna's attempt to intervene proved useless and Eva and Esther were forced to accede.

With the first air raid alarm shrieking throughout the neighborhood, they became convinced that it was necessary to get the children out of the city immediately. But now, without panic, they needed to get to one of the civil defense bomb shelters, and the shelter for their building was located on Butirskaya Street, about a twenty-minute walk at a crisp, adult pace. Luckily, Eva was at home when the first warning in Moscow sounded. Esther, firmly holding Tommy's hand, broke into a run. Eva, with heavy three-year-old Maxie in her arms, found herself unable to keep up. The siren's persistent wailing heightened her fear as people fled past her. She set Maxie down to grab Esther's hand, and she and Esther literally lifted the child off the ground. All four of them were breathless before they were half way to Butirskaya. They crossed the broad street, recently improved to take care of the increased traffic in the city, and at last reached the shelter, formerly a church converted into a warehouse, now a huge barn to hold the people. It had taken them forty-five minutes to get there!

At the door of the shelter, however, there was mass confusion; the adults were being prevented from entering. "This shelter is only for children four years and under!" the orderlies were shouting, insisting that the adults release their children, and they were shouting that older children were to be deposited in another shelter located in the opposite direction, and that adults were to take refuge in a third. The piercing noise of the sirens added to the pandemonium so the orderlies finally let the growing mob enter, but with the warning, "This will be the first and last time!"

Esther could not refrain from commenting. "Only the Soviets could devise such a system. We'll stay home in the future."

A few days later, when the family joined the group being evacuated, they heard that the absurd rule had been changed and that all shelters were open to everybody. Early in 1942, after their return from the evacuation center, they learned that in one of the first bombings of the city, a direct hit had struck the Butirskaya Street shelter and many women and children had been killed. Throughout the war, no alarm could frighten

them enough to leave their flat for refuge in another shelter.

The evacuees who gathered that day in 1941, however, were instructed, "Travel light. Take only a change of clothing for each person. Only one suitcase to a family. You will be home before the end of the summer; maybe earlier. And don't bring food. We'll provide the food."

Getting money on short notice was no easy matter. Only that which had not been spent from the weekly budget was on hand and the banks had not yet been issued the orders to release money from individual savings accounts. Valeria and Abie gathered what cash was available. Eva urged Valeria, Gustav, and Alexandra to accompany them but Valeria would not hear of it. "Pa and I will work here and send you money and parcels. You know that Ma won't go without us. You must go with Mother Stolar. You can't let her go alone with the children. Maybe you will find some work wherever you are being sent."

Eva grasped Valeria's hand. "What will I do without you? I have no words, Valya. The hardships you have faced have been no less than mine. And they're not over, but you continue to share my burden. I don't have a sister, but you are far more to me than any sister can be." Tears filled her eyes. She released her hold and flung her arms around Valeria in a gentle embrace.

Valeria, uncertain how to accept this sudden outburst of gratitude, could only say, "I cherish your support, too. Neither of us have had to say it. We know it." She embraced Eva even tighter.

Kazan, they were told, was their destination.

Kazan! Eva recalled with nostalgia the cruise on the Volga River that she, Max, Morris, and Esther had taken in the summer of 1934. One of the stops where they had a guided tour had been Kazan, capital of the Tartar Republic — a place so exotic to someone from Chicago. Max had bought Eva many Tartar gifts — red, pointed embroidered houseshoes, hand-painted vases, ashtrays, jewelry, and an exquisite, gold embroidered tablecloth which it had almost broken her heart to sell when their resources began to dwindle. So many beautiful things. She didn't want to have to return to this place that, because it held so many happy memories, would again bring on the depression and dark moods of the past few years. She was just beginning to come out of her numbness and despair. Eva asked to be assigned to some other location, but the com-

mittee interpreted her request as another attempt to postpone her evacu-
ation and refused to give it any consideration.

At eight o'clock on the morning of July 14, 1941, Eva, Esther,
Tommy, and Maxie, accompanied by Valeria who insisted upon seeing
them off, arrived as instructed at the meeting place with their one suit-
case. Hundreds of men, women, and children were swarming around
the rear of three huge trucks parked in the middle of the road. Suitcases
and bundles were being passed from the teeming, shouting, cursing crowd
to two men perched on each vehicle. They were insisting, "Only one
parcel for a family," and tried to refuse women in the crowd who tried to
pass more than one suitcase up to them. In defiance, some of the women
vaulted into the trucks, reached out for their baggage lifted up by the
others, and then threw them to the men. The men were forced to yield,
and set about neatly arranging the cargo so that there would be space
for the passengers.

Eva and Esther looked on in amazement. It was obvious that some
of the women had brought as many as four and five suitcases, most so
large that they needed help getting them onto the trucks. How undisci-
plined these people are, they said to each other. But in less than a month,
they regretted that they had been so disciplined. The Russians had lived
through other wars, through revolution and famine; they had had to flee
again and again. It was second nature to them to respond as they had as
soon as Molotov's announcement came, to strip the shelves of the stores
of salt, matches, soap, clothing, sheets, homemade toast that would hold
up without spoiling for weeks — everything and anything that might
be basic for their existence and which they might be able to barter or
sell. Esther and Eva, who had come to the Soviet Union with a commit-
ment to help build an ideal society, were to learn in a very short time
what the Russian people knew from tragic experience; in time of war,
money was valueless.

More chaos broke out when the passengers began climbing into
the trucks. They broke into the compactly stacked baggage, each scroung-
ing for her own possessions to use as a seat. To stand while the truck
would be in motion was unthinkable; to sit on the hard floor, the boards

separated from each other by wide gaps, was impossibly uncomfortable.

While waiting to board, Eva caught the glance of Tonya Neiman, the wife of the German refugee who had been arrested on the same night as Max. She was standing to one side, close to the vehicle where Eva's one suitcase had been stored, her two Moscow-born daughters of six and four clinging to her. They moved toward each other, and by mutual agreement the two families linked together for the next several weeks until the group's destination was reached, and then into the winter that followed. Tonya's eldest child, Marcus, nine years of age, had been evacuated separately with his school. Repeated requests had failed to persuade the committee to bend the regulations so that the child might be evacuated with his mother. As foreigners and wives of "enemies," Tonya and Eva had naturally been drawn together, although neither spoke nor inquired about each other's husbands. As they became closer friends during this period, Tonya broke down and once confided that she had not been able to obtain information about her husband and did not know if he were dead or alive. Eva shared her understanding in a few appropriate words that spoke volumes.

The roar of the engines struck up. Esther gazed into the distance, disappointment and sadness written all over her face. "Where is Abie? He said he would be here to see us off. But, now it's too late to say good bye." The cavalcade of trucks headed for Komsomolskaya Square, the site of three railroad stations including the Kazanskaya. The square was jammed with evacuees and soldiers, an agitated swarm. It seemed miraculous that the passengers made it to the freight cars with their own possessions.

The women and children were helped into the empty, dark cars. Tonya, much more aggressive and assertive than either Eva or Esther, fought for space for the two families close to the far side window, one of two, high up near the ceiling on the opposite sides of the car. Again, the women broke into the neatly stacked piles of suitcases and bundles and set them up to use for reclining and sleeping. After most of the families were settled, a committee member began giving instructions: "Lock the bolts that you see high up on the sliding doors. If any door is discovered to be unbolted, we will lock it from the outside. For the safety of the children, don't permit them to sit on the edges of the car. Any jolt of

the train will throw them forward and may cause injury. The train will stop three times a day at which time food will be served; no one is to leave the car at any stop except when permission is given for toilet privileges. Children are never to leave the car, even to accompany their mother; they might too easily be left behind. Potties — or if no potty is available, cooking vessels will do for the children — are to be emptied at specific stops. It is impossible to say at what intervals the train will stop since there is no announced schedule. Fires are not to be lit for warming foods because they might be sighted from the air."

The sliding doors were closed, the order given for them to be bolted, and the train chugged forward. The small windows, measuring probably one foot by one-and-one-half feet, let in no light; it was as if night had suddenly descended upon them. *Kopteelki* — wicks soaked and floating in a saucer of oil, kerosene, or other flammable liquid — came out of nowhere, and it immediately became evident that almost every woman in the car had a supply. The tiny flame that flickered from them was hardly worth the soot, smoke, and stench that only added to the misery created by the body heat generated by the human cargo. The closeness soon became overpowering. Tempers were short and quarrels broke out. The children became cranky and made impossible demands. Water was in short supply. The month of July was ordinarily the most pleasant, the season in which Muscovites most revel after the long winter, but this summer, with the weeks spent in the freight cars, was one Eva would never forget. The journey to Kazan, at another time only a day and a half from Moscow, took two weeks. Several times a day, the train was shunted to side tracks to make way for the fast trains going in the opposite direction carrying soldiers to the front. Eva, Esther, and even the children found the food — a mushy mixture called *kasha*, unlike the kasha with which they were familiar, served with a slice of dark brown bread — strange and difficult to eat. The children downed with relish the one glass of milk they were served each day, but the tea, served without sugar, was difficult for the adults to drink. These same meals, the variation only in the type of kasha, were served three times a day, with soup added to the evening meal.

When the train reached Kazan, the doors were opened, but the passengers were not permitted to leave until the escorts returned with

information about living quarters and transportation. Hours passed before they reappeared, dejected. They had hoped to get rid of their cargo and return to Moscow, but Kazan was not accepting any more evacuees. Once again, it was bolted doors, kopteelki, stench, and heat.

Three days and two hundred kilometers beyond Kazan, they were finally accepted by the Red Banner kolkhoz and were unloaded at a by-station. A reception committee helped unload the cars and led the group to a large square behind the station building. Trees and high bushes gave welcome protection from the glaring sun. While some of the women, Esther among them, looked after the screaming children, who were jumping and running with joy just to be out in the fresh air, others set about dragging the baggage from the station platform. The job finished, Eva sat on the grass with relief, her family an island in a sea of bundles, anticipating momentarily deliverance from the discomfort and distress of the railroad car.

Someone from the welcoming committee encouraged just a little more patience. Soon they would be able to rest in their temporary home, the Red Banner kolkhoz, which was a collective farm composed of both Russians and Tartars. Some of the women asked permission to walk to the kolkhoz to stretch their legs, but they were told that the distance was too great. Their spirits sank. Many among them had previously lived on kolkhozes and had been only too happy to defect from peasant life and take work temporarily as live-in domestics with Moscow families, certain that they would soon be relocated in factory jobs. No one seemed to want to work in the fields. One hoped that she might be assigned work in the kitchen, another to the nursery, a third as a milkmaid, any job but in the fields. Listening to their talk, Eva felt a wave of panic run through her. If these women, having lived most of their lives on a farm, were so unhappy, how would she, city born and bred, be able to adjust?

Finally, the refugees piled into horse-drawn wagons, and they steadied themselves for the final part of the journey. The Red Banner kolkhoz was about two hundred kilometers away; the journey would be long, hot, and dusty, and the landscape monotonous — just steppe, steppe, steppe all the way except for an occasional cultivated field. The road was narrow and deeply rutted, the slightest elevation or small hole making

itself uncomfortably felt as the horses pulled the wagons on and on. Every now and then, the children, and sometimes the women, jumped off to walk alongside the loaded, slow-moving carts.

The tedium of the sluggish, tiring ride was broken by the appearance of trees and rooftops in the far distance. The drivers announced, "We're home. That's our village." It was the first sign of human life the travelers had seen since leaving the station. A crowd of kolkhozniks was waiting as the wagons pulled in front of the village office building. Among the forty to fifty women were a dozen men, some elderly and others obviously disabled. The women wore ankle-length dresses of faded flowered prints and their heads were covered with brightly colored kerchiefs. Some in boots, others in laptee, they were gazing with unabashed curiosity at the newcomers in their city garments. The chairman of the kolkhoz, Petrov, was Russian. He was short, gray-haired, his small sharp eyes above a pinched nose and a straight severe mouth. He stood apart from the others by his clothing. He was by far the best-dressed person among the males. He wore a *kovboyka* — a large-checked, multi-colored shirt supposedly worn by American cowboys; very popular because of their short supply — and trousers that were tucked into high leather boots, obviously of good quality. He welcomed the Muscovites in a cold, formal speech and quickly got down to the business of assigning each family to a local kolkhoznik with whom each was to live.

When Eva and Esther drew a Tartar family, they heard commiseration from several of the others. "What's the difference?" Eva wanted to know. An irritation and embarrassment gnawed at her — here, again, the ideals of brotherhood and friendship to which the Soviets had laid such strong claim were being besmirched.

Their Tartar host, a tall spare man with slanted piercing eyes, a long patrician nose, and a small goatee, gave a short account of himself as he walked slightly ahead of them. He was well-to-do, he said, owned a goat, and lived in a hut that had two rooms. He, his wife, and Fatimah, their adopted daughter, would be sacrificing one of the rooms for use by his guests. They would not be asking for rent because the chairman had forbidden it.

An adolescent girl and a woman came from the hut to greet them. The woman, dark-skinned, deeply wrinkled, bent, and slow in her move-

ments, gave the first impression of being the grandmother in the household, but she was introduced as *Khozika*, Tartar for "wife." Eva later learned that this woman was only forty-one years old. The woman greeted them warmly. "My home is your home," she began in Russian, in an accent and pronunciation so distorted that even Eva, whose ear was not attuned to the language could recognize that it was a second language which she rarely used. "Sit down. Rest. Have a glass of tea with us," Khozika said, then informed them that *Khozyayin* — a term meaning "boss" or "master" that was used in everyday speech to designate a man in authority, including a husband — hadn't had his yet. "He has been at the office waiting for you almost all day." Eva thanked the woman for her hospitality, and so began their life in evacuation on the Red Banner kolkhoz.

Chapter 10

Not only were the customs of Eva's family and the Tartar family ethnically dissimilar, but the lifestyle of the kolkhozniks seemed separated from that of the cosmopolitan Muscovite by a hundred light years, and the first attempts to achieve rapport were awkward. As Khozika led the women into the hut, she paused in a long, narrow entry room into which was crammed a wide, wooden bench projecting from one wall. "This is your room," she said. She continued into a second room furnished with a long, wooden table and another very wide bench, also attached to the wall. A movable bench was on the opposite side.

Khozyayin then took his place at the table. Only when he was settled were the guests invited to be seated. Fatimah, a shy, pretty girl, brought in a huge, steaming samovar from the yard, where all of the meals were prepared, and set it on the table. A small teapot was plugged into the pipe outlet of the samovar, and Khozika set a pitcher of milk next to it. Eva and Esther were stunned by the beauty of the samovar. Eva had seen samovars on display in the antique shops on the Arbat, she told her hosts, always in plentiful supply because their outrageous prices meant that few people could afford one — but she had never actually seen one in use. Esther remarked with pleasure, "Now, at last, I'll have real tea — from a samovar. From a samovar the tastiest tea is made." However, it would be quite a while before she was to have her sip. The first glass was for Khozyayin, who sat back, self-confident, his right as a male openly expressed. Something about his expectations stopped even the children from complaining. His glass was filled again and again while the others waited. "I counted fourteen times," Eva said later to Esther. Finally, sa-

tiated, he relaxed, an indication to Khozika that the women might now have their turn.

The children took one gulp of the milk, puckered their noses in displeasure, and pushed their glasses to one side. Esther made a move to coax them until she herself tasted it and desisted, for she too could not tolerate more than a swallow of it. Eva was uneasy, certain that Khozyayin disapproved.

The tea was not at all similar to the kind to which they were accustomed. It was very dark and, when milk was added, it took on the color of a drink halfway between coffee and cocoa. It was served without sugar. With the first drink, Eva and Esther exchanged glances, unsure how they might politely refuse it. Eva asked, "What brand is this? It doesn't taste like the Georgian or Chinese tea we had in Moscow."

Khozyayin burst into laughter. "Georgian tea! That was sold only once in the village store but my Khozika didn't get there on time to get any. She was too far back in the line. The Russians were the first in line. When they heard it was in stock, they got it all."

"And the milk?" Eva asked hesitantly. "Could it be canned milk?"

This question angered Khozyayin. "Canned Milk? Whoever heard of canned milk? There is not such a thing. You Moscow *barinyi* must think we're absolute fools?"

Eva caught the insult head-on — a barinyi was the parasitic wife of a rich man in pre-Revolutionary Russia — and tried to apologize. She hadn't meant the question as an insult, she told him. Truly, milk in cans was available, not often, to be sure, but when the word spread that it was on the shelves, the people rushed to stock it in their cupboards because it was a fine substitute for fresh milk. She went on in laborious detail about how the Russian women used it. Only after he was convinced of the sincerity of her apology did he return to the question. They were drinking beet tea whitened with goat's milk. It was made by drying sliced raw beets in a very hot Russian oven, then crumpling them.

In time, Eva and the others became accustomed to the taste of the tea and the children developed a taste for the goat milk. When they returned to Moscow, they tried to make the beet tea in their own oven but never succeeded. The "Tartar tea," as they named it, eventually became a fond memory, one of the few, of their stay at the Red Banner.

As if he were glutted with talking to all of the women, Khozyayin left the table, stepped out of the room, and went outdoors "without so much as a 'please,'" Esther commented later, and Khozika resumed talking. Her eyes followed her husband's steps and her mien postured pride and admiration. "A wonderful man," she said. "What other man in the entire country would be a faithful Khozyayin to an infertile woman? There have been many divorces in this village because a wife could not give her husband children. But not my Khozyayin! Although I would have deserved such punishment."

Eva responded, "Did a doctor say that you are not able to bear children? Perhaps your husband is sterile?" Khozika could not grasp such a possibility. Only women could be sterile — and what had the doctor to do with such a problem anyway?

The conversation was interrupted by a messenger from Petrov. Eva and Esther were to return immediately to the village office with their baggage and Khozyayin was to accompany them.

A number of women were consoling Dunya, one of the evacuees, who was claiming to Petrov that one of her bundles had been stolen and was demanding that Eva and Esther's belongings be searched for the missing objects. She swore that she had seen Eva take the bundle and accused both Eva and Esther of having stolen other unspecified objects. The humiliation shocked them into silence.

Khozyayin came to their rescue. "It is not possible," he told Petrov. "They had only this one suitcase."

"One suitcase! They came with only one suitcase! How will they make do only with enough possessions to fill one suitcase?" interposed Petrov.

"I am a witness to the fact," responded Khozyayin.

Nevertheless, Petrov decreed that Dunya's demand that Eva's belongings be searched be met. By this time, Eva had regained her composure enough to ask that Dunya identify what she was missing before the suitcase was searched.

If Petrov felt any sympathy for the mortified women or was the least bit embarrassed by the incident, his perfunctory dismissal of the incident after the search belied it. But antagonism of the other evacuees

against Dunya developed and solidified, and Eva and Esther became accepted members of the Muscovite community. Two of the evacuees, Marusya and Motya, who had lived in the Pestsovaya building, seemed especially determined to protect Eva and Esther from further persecution.

A few days after the events of the first evening, Marusya told Esther that Dunya's stolen bundle had not been found, adding, "I'm sure she never had another bundle." Marusya had confronted Dunya with her disbelief of Dunya's claim, and Dunya sullenly replied, "They're Jews. All Jews are rich. They must have plenty extra with them, and everybody knows that Jews are thieves." Marusya threatened to report Dunya to the NKVD if she ever heard her repeat "such heresy," and Dunya, thinking it safer to retreat, responded, "I was only joking."

Motya had persisted, "We don't like such jokes. They're the only Jews here. I don't see them stealing and they have only one suitcase. Does that make them rich? How many bundles did you bring? I'm warning you," she added menacingly, "if Marusya doesn't report you, I will." It took Dunya's tears and pleading to stop the harassment.

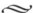

The search for Dunya's missing objects completed, Khozyayin returned to take Eva to the village office for her suitcase and then, once again, the two trudged back to the hut, Khozyayin's stride suggesting his impatience with her — but he did not offer to carry the baggage that was slowing them down. When Khozika explained the sleeping arrangements, Eva was unsure that she understood. The bench was to be a bed? Yes, just as the bench on which they had sat at the table for tea was to be the bed for Khozyayin, Khozika, and Fatimah. The bench was a bed at night and a place to sit during the day, and sometimes even a table. Her questions were received with such amazement that she was unwilling at the moment to ask about bedding, yet she realized that somehow she was going to have to adjust to these new Spartan living arrangements.

The realization came rapidly that they would be needing additional clothing and other basic items. A letter went off to Valeria and Natasha in the morning, ready for mailing by the time Petrov called the women together at the village office to take inventory of their experiences and

skills for work assignments. First, the nursery needed to be organized so that the children would be taken care of while their mothers were working. It was to be separate and apart from the nursery of the kolkhozniks. Eva, the only teacher in the group, was appointed director of both the *creche*, the infant nursery, and the nursery school. She was to have three other women assist her. Strangely, she was also assigned the task of supervising the nursery school kitchen. Petrov was not disturbed that she had no preschool training nor experience and knew nothing whatsoever about diet and nutrition. Fortunately, Ksenya, a woman who had worked in Moscow as an assistant chef in a factory dining hall, was given the job of cook. Capa, a healthy, vigorous young woman, was to be Ksenya's helper. Esther was excused from kolkhoz work. Petrov decided that she was too old, although, he said, women much older than she worked in the fields. But being a "white hand," a derogatory term meaning "a lady" who did no work, she would not even be useful in the nursery kitchen where food needed to be prepared daily for about seventy-five children. She was to remain at home to take care of her grandchildren who were not eligible for the nursery school because their mother might be accused of favoritism. "They will get the same food rations as all the other children, regardless."

The most coveted jobs were now filled. The other Muscovites were to work in the fields or on auxiliary teams. Eva was sorry that Tonya had not been assigned to the nursery, but had instead been sent to the vegetable fields. When Ksenya's son Yuri was assigned as a helper at MTS, the machine tractor station, the man in charge protested. To lift and carry weights was harmful for a growing child! But Petrov insisted, "He is strong enough to do this work." As time went by, Eva learned something about the value of this work. She appreciated the advantages this boy was getting in learning such a trade. It was considered an honor to be part of the MTS. Tractor and automobile drivers were the aristocrats and heroes of farm labor and received the best wages. Every farm boy dreamt of becoming an MTS man.

Gradually, as the summer progressed, the family adapted to life on the kolkhoz. Early every morning, Eva ran off to the nursery and Esther busied herself with Tommy and Maxie, who for the first time in their young lives touched a cat and a dog, watched the antics of the goat, and

chased after a live chicken as it grubbed around in the yard. It would have been a good, healthy life if only they had been given adequate nourishment, but there never seemed to be enough to eat.

Eva tried to help the women in their attempts to interest the children in educationally motivated activities. She devised educational games and taught them to her assistants to carry them out. Although her work was somewhat demanding, she found the extra time to read to the children from the only two children's books she found in the kolkhoz library. She also became the scribe for all the evacuees who came to her with letters that arrived from their families. Even though she didn't mind helping the others, it was disheartening that twenty-four years after the Revolution she was the only one among the evacuees who was able to read and write in Russian with ease, albeit with mistakes. Obviously, things hadn't gone as planned with soviet socialism.

The evacuees and the kolkhozniks did not mix with each other socially. The only friend the Muscovites developed among the kolkhoznitsas was the Russian village bookkeeper, Alexandra Nikolayevna — who usually went by her diminutive name Shura. She was regarded by her own villagers as being too wise in city ways, because in her youth she had been sent to Kazan where for eight months she attended a school for training as a bookkeeper. She was of considerable help to Eva in working out official supply lists and expense accounts for the nursery. "I am doing this for you as a friend; not out of duty," she would say to Eva. Short, squat, and warm-hearted, the forty-year-old spinster was indistinguishable in dress from the other farm women. Her long, blond hair was done up in a bun tied together by a ribbon and covered with the kerchief in the tradition of all the kolkhoznitse women. She walked with a waddling gait, the unfortunate result of a birth defect, one of her legs shorter than the other. Her own people taunted her unmercifully because of her "limping"; the children grew up knowing her only as "limping Shura."

"They are envious of me," she once told Eva, "because I have a better education than they. So they get even by calling me a name that never lets me forget I am a cripple."

Shura also told Eva that her people's aloofness to the Muscovites was probably due to envy. "They believe that you are rich Moscow women.

Only rich women, they say, would be so stylish. They're disgruntled because your husbands send you money," she would report, after the mail arrived. "They barely receive anything from theirs. Yet, their husbands, just like yours, are in faraway factories or at the front. Our women wear old ugly dresses and have only slippers, while Muscovite women have fashionable clothes and are fortunate enough to have real shoes."

Eva innocently asked Shura, "If the women here like our clothing so much, why don't they buy that kind instead of those long dresses?"

"Don't tell me you really don't know why?" Shura answered, unbelieving. "There are never such fabrics or dresses on sale at the cooperative. We make our things over and over again from old material, and if someone gets a chance to go to Kazan, she buys all that she is allowed to bring back to us. Besides, we have no fashion magazines, so we cut the same old patterns and sew our things as we always did. Only Petrov gets the latest fashions. He has the special right to buy things for himself at the special store in Kazan."

"Special stores?" Eva recalled that in Moscow they had been closed in 1935.

"Not those for the *bolshiye shiski*," the "very important people," she answered, using Russian slang.

When winter arrived, the kolkhoznitsas eyed the fur-collared coats and the ankle-length galoshes of the Muscovites. When they needed to barter their galoshes for food, however, the Muscovites felt that they had gotten the better deal, for this footwear was no protection in the deep snow. The village women also asked to exchange their worn handmade woolen head kerchiefs for the factory-made shawls, although they too were unfit for the cold weather.

"How strange!" Eva noted. "Can't they appreciate how much better off they are than we," as she observed the comfort of their clothing, the short sheepskin-lined jackets over their long dresses, the warm, woolen shawls on their heads, and stiff knee-high boots known as *valenki*. Petrov was the aristocrat among the men in his fine *tooloop* — a fur-lined, ankle-length coat, rough suede on the outside, with a round collar large enough to cover the head over a hat — valenki, fur mittens, and fur hat with earflaps, obviously made of quality fabrics. It wasn't long until Eva discovered the answer. One evening, summoned by Petrov to report

to his office, she wandered off the footpath into a ditch. One shoe of the only pair she owned, a closed-toe oxford, slipped off. She dug with her bare hands into the deep, wet snow. The kerosene lamps in the houses, set far behind their wooden fences, shed no glimmer of light on the path. She had to abandon the search when her hands began to grow numb, and she hobbled to her destination. The shoe was never found, so Khozyayin persuaded a friend, a valenki maker, to accept Eva's cash for a pair of laptee. But the more snowy and slippery the ground, the harder it was for Eva to walk in laptee because they had no traction. In the hut, the tap, tap, tap of every step she took, characteristic of the flapping of the laptee, at first amused her and then annoyed her. They wore out very quickly, but fortunately the cobbler did not insist upon an exchange of commodities and continued to accept money, and there was more than enough of that to pay for the many pairs she needed.

Like their women, the male kolkhozniks also had a bias toward the female evacuees. They addressed the Muscovites by the term *darmoyedi*. It was their opinion that these women "clung to their husbands' necks" like parasites, enjoying life at the expense of the workers, and they were now clinging to their necks, the producers of food, taking the bread out of their mouths. The Muscovites were incensed. Every one of them, with the exception of Esther, had shared in the economic burden with their spouses or other members in their household. "How do they think we can buy enough food and clothing for our families on the wage of only one worker in the family? Besides, do they think that we would suffer the indignities of ordinary housewives? Our country needs the women as well as the men to produce enough to keep it strong," and so the slogans fell from the lips of Eva and the others. They asked each other, "Do you know a woman who is not working?" Among the women Eva knew, except during the period of the arrests when women like herself had been fired because of their relationship or association with an "enemy," every one of her female acquaintances was employed. Esther and Alexandra, women of the pre-Revolutionary generation, were the only housewives she knew of who had not worked. Most of the evacuees at the Red Banner had been factory workers on conveyors or sewing machines.

It was no surprise, therefore, when word got around that Petrov

had gone to Kazan, the seat of the Tartar Republic, to ask that the evacuee bread allowance be revoked. His request was rejected since the rations had been established not by the Republic or kolkhoz officials but by the national government. Theoretically, evacuees were to have received in addition to a bread allowance a little butter, meat, fish, and milk on their ration cards. But since cards were not issued to workers in agriculture, only bread was sold at the Red Banner.

With this antagonism exposed, it was not difficult for Eva to believe that Khozyayin had been quite honest when he had said to her, a few days after their arrival at the kolkhoz, "You Moscow women think you are safe here. Don't you put much hope in it. You'll get yours when Hitler gets here. We'll point out every one of you and tell him how you ran from Moscow to escape from him. We here will have nothing to worry about when he gets here. We'll meet him with bread and salt" he predicted, invoking the ancient expression of Russian hospitality that showed the respect of a host for his guest.

Eva, appalled and unbelieving, had said to Khozyayin, "How can you talk this way? After all of the brutality of the Nazis to the Ukrainians? And as they advance farther, they murder people of other nationalities. What makes you think they will treat you any better?"

He had answered, "Did you read that in *Izvestia?* Enemies in war are always called murderers. Don't believe everything you read."

Unfortunately, the hostility expressed by Khozyayin was widespread among the villagers. The Muscovites covered up their anxieties and fears at the threats with laughter. "It will never get to that. In spite of the setbacks and defeats of our soldiers," they said confidently, "Hitler will never get to Moscow. Our Red Army will stop him." Some wanted Eva to write a collective letter to "our beloved Comrade Stalin" informing him of the disloyalty that pervaded the kolkhoz, but there was no universal agreement and while Eva was in the kolkhoz such a statement was never sent.

Both Eva and Esther had had firm faith in the theory that the kolkhoz movement was a necessary adjunct toward a successful socialist society. Their belief had been implanted by Morris's teachings over the years and from their own Marxist-Leninist studies. Although their own tragedy, the arrests and disappearances of the men in their family, had

convinced them of the hypocrisies and the outright falsifications printed in the official newspapers, they held fast to their adherence that the theoretical structure of the collective farms must be correct. But when they were faced with the reality of the kolkhoz, so different from the descriptions in *Pravda (The Truth)* and *Izvestia (The News)*, the underground joke that once annoyed them, "There's no truth in *Pravda* and no news in *Izvestia*," now gave them enjoyment.

Shura and Khozyayin taught them what collectivization meant, at least through the period that they lived at the Red Banner. The agricultural planning took place far away from the fields. Without being consulted, the farmers at the kolkhozes were told what to plant and how much to plant, and how much of the crop was to be turned over to the State. Very often the crops failed because the climate was unsuitable, or the goals could not be fulfilled because of excessive heat or cold, rain or drought. As a result, sometimes the entire harvest, only just meeting the goal, went to the State and often it could not even be delivered as ordered. Then the kolkhoz was compelled to buy produce from another area to make up for its inability to fulfill the goals. At the Red Banner, wheat was designated as the main crop with some land given over to buckwheat and a large acreage to sunflowers. Very little land was used for the planting of vegetables — cabbage, potatoes, cucumbers for pickling, beets, and carrots — which were grown mainly for payment to the farmers in lieu of money, the amounts calculated on the hours each spent on kolkhoz assignments. Occasionally, a little buckwheat was added to the pay. The farmers could acquire money only by selling surplus from their own small private plots which the government allowed. Their only market was the railway station two hundred kilometers from the kolkhoz, where they sold cooked foods to the passengers. But Petrov very rarely allowed them to take horses and wagons from the farms for such a long trip. Before the Muscovites had arrived, weekly markets closer by had been in existence and gave them an outlet for the sale of their handcrafted laptee and valenki. With the cash they received from these sales, the farmers had been able to purchase necessities such as clay pots for cooking and baking. These markets, however, were no longer in existence. "No wonder they truly believe that their dismal, frustrated lives will be improved with the coming of Hitler," Esther said.

Esther's speculation sent a little tremor through Eva. Was Esther conceding that Morris might have miscalculated the political doctrine to which he had devoted so much of his life? Even after having seen so much, it was still difficult for Eva to give up her own illusions, so she remained silent.

A month had passed before Eva received a response from her urgent letters to Moscow. Esther was becoming ill from anxiety over her uncertainty of Abie's whereabouts. At last, mail arrived from Valeria. Obviously, regular mail service had been disrupted for she wrote that the long delay in hearing from Eva had been very distressing to her and Alexandra and Gustav. The date of her letter suggested that the mail delivery from Moscow had also been held up. If the news was not jolly, at least they knew that they were to expect a parcel of clothing, including Eva's old fur coat and Esther's American winter coat. They took the news hard that the post office was not accepting mattresses, but they were going to receive blankets as soon as possible. Sleep had been fitful on the benches, with only the contents of their suitcases to soften them. Abie had been drafted a week after they had left the city. He asked Valeria to let them know that his boss would not permit him to leave work for even a couple of hours to see them off, and that he would write as soon as addresses between them could be exchanged. She and her parents were managing and were safe. There had been no bombings in their neighborhood. They would not stir from their room, would be the contact between the Stolars and the Meltzes, and would forward any communication that might arrive from Max and the family in Odessa. Natasha's artel had closed, but she had found other work. Natasha herself never acknowledged receiving Eva's letters.

The parcel of clothes arrived two weeks later. At night, the clothing was spread over the hard benches and they felt as if they were sleeping on feathers. The blankets never arrived; they later learned that the post office refused to accept them. With winter setting in, the fur coat became the mattress and Esther's coat was used as a cover for the four of them. The heating, ingenious to them, was adequate. Khozika did all of her winter cooking indoors in a huge kettle almost as high as Fatimah

was tall and as wide as a very stout man. It was boxed in cement-covered brick which held the heat in both rooms throughout the day and late into the night. Esther, Eva, and the children often watched, fascinated, as Khozika cleaned the hot kettle each evening, standing precariously on a stool, and dexterously swabbing the bottom of the kettle with what looked like a floor mop. They cautioned her against burning herself, but she only laughed as she went about her business.

Procuring sufficient food soon became the most pressing problem. Not until the fall harvest time would Eva receive her pay in the form of farm produce for her summer's work. Those who had brought extra bundles of clothing bartered them for eggs, whole milk, vegetables, and other farm food from individual kolkhozniks, but many of the Muscovites who had bartered all that they could, or, like Eva, had followed the instructions of the Evacuation Committee much too literally and brought only bare necessities, were very often hungry. Eva had been grateful that, although during the summer Tommy and Maxie were not permitted to attend the nursery school, at least they were getting the same rations during the day as all the other children. But the evening meal was scant; money was accepted only in exchange for bread, and sometimes, if it happened to be in good supply, they got a pail of skim milk which was left over after the pigs were fed. Eva and Esther gave part of their meager bread rations to the children. Eva was still too scrupulous to help herself from the nursery kitchen pots in spite of Ksenya's urgings to take enough for Esther and herself in addition to her children's portions. Once, after Tommy had finished her evening ration of bread, she said, "Mamma, what a fool I was. Remember how Babushka had to force me to eat white bread and cutlets and potatoes and milk and everything? I would eat them now and she wouldn't have to force me either. You know what? When the war will end, Babushka will put lots and lots of bread on the table and I'll eat and eat and eat and eat until I'm full and there'll still be bread left and I'll say, 'Honest, Babushka. I don't want any more. I can't eat any more. I'm not hungry.' You'll see. That's what is going to happen."

During the harvest, Tonya, their friend from the train, occasionally carried off a few potatoes, carrots, or beets and shared them with Eva and Esther. Eva, fearful of her being apprehended, cautioned her to

consider what might happen to her children, already fatherless, if their mother were caught stealing government property and sentenced to ten years to the prisons or labor camps. But Tonya would not stop. "The children need the food. If I don't fight for my children, nobody will. Don't worry. I'll make sure that I am not caught. The others have taught me the tricks." Eva gratefully accepted her offerings.

Several times, perhaps in pity, Khozika invited them to an evening meal of goat meat or a Tartar pancake, the size of a large round plate, topped with mashed potatoes. Once they ate a delicious meat dish which they later learned was horsemeat. They were grateful and tried to find a way to reciprocate, but rarely was there such an opportunity. Yet, one day, before the harvest but after most of the work in the fields was finished and the nursery school was closed, a period of idleness set in for everyone and Tonya suggested an outing for the two families. She had discovered a tiny orchard of mushrooms that made her homesick for a "mushroom gathering picnic like we used to have at home, in Germany." The day in the woods, a long hike that took them a distance from the village, was an interval that gave them enough privacy to release much of their common sorrow. Even the meager lunch did not mar the contentment they felt. Tonya taught Eva and Esther to recognize the edible mushrooms and they returned to the hut with a large supply of them — enough to share with Khozika and Khozyayin as a gesture of their appreciation.

The crops were harvested before the rains started. A hubbub of activity transformed the quiet village into a miniature industrial city, and enormous trucks lined up ready for the produce to be loaded. Every able-bodied person except for those who did kitchen or children's work helped to load them. After the drivers took them out of the village, Shura remarked to Eva and Tonya how different this harvest season was from last year and other past years when the country had not been at war. The delivery of the harvest to the government's agents had always been the occasion for a big celebration. Tremendous posters with slogans and pledges to harvest even more the next year had decorated the office buildings and the homes of the udarniks. Concerts and dances were held and movies were shown in the meeting hall of the office building converted into a clubroom. Following the festivities, the workers

were given their payment for the summer's labor. Shura theorized that if the rewards were to be given before the government allotment had been delivered, unpleasant feelings might be expressed by the kolkhozniks who never seemed satisfied with what they received. For her work this first summer of the war, Eva was paid half a sack of mixed vegetables.

Early in November, 1941, an epidemic of a children's disease raged throughout the village, striking without discrimination the families of the kolkhozniks and the evacuees. Petrov, righteously impartial, turned down everyone's pleas for the use of the horse and sleigh to take their stricken youngsters to the only *feldsher*, or medical assistant, in the entire district, based in a village eighteen kilometers away. All other medical personnel from the area had been drafted. He said that he could not take the chance of the horses being weakened by traveling such long distances, especially in the winter, every time a child came down with the disease. When even the villagers who were well acquainted with the roads would not chance walking the distance with their sick children in the heavy snow, the Muscovites gave up any hope of their children receiving care.

The deaths were mounting, and the atmosphere was heavy with grief. When days would pass without a sign of the illness among the children in any one hut, the mothers would feel a sense of relief from their fear. "Maybe it was luck that we have no winter clothes for the children," Esther commented. "It is hard on them, being cooped up, but they have been kept away from the other children and haven't caught the sickness yet." Eva concurred, but the epidemic was far from being over.

A few days later, Tommy got sick. For all that Esther scolded, Maxie would not stay at the opposite end of the bench from her sister. Then, as Tommy was recovering, Maxie became ill. The once mischievous, lively, talkative child became lethargic. No amount of coaxing induced her to take the bread and liquids. Eva was overwhelmed with helplessness. Every morning, following a difficult night of cradling her child, Eva inched her way on the icy walk to Petrov's office to try to persuade him to give her transport to the feldsher.

One afternoon, the sun filtering in from the tiny window, an un-usual hush in the room, with the children napping at each end of the bench and Eva and Esther relaxing between them, Maxie awakened with a cry. "Mamma! I'm afraid. It's so dark! Turn on the light." Eva shud-dered in horror, realizing that Maxie was blind. She sped, skidding on the soles of the laptee, only to return utterly frustrated. Petrov had again refused her request. Three days later, during the night of December 14, Maxie's breathing became shallow and labored. Eva's every attempt to resuscitate her failed, and her frantic sobbing awakened Esther. Together they gave way to their grief, quietly, so as not to awaken Tommy, and waited out the night. In spite of the anguish, they must have dozed off, for Tommy's shrieking awakened them to the sad reality. Tommy was standing upright on the bench, looking over them to the far side where Maxie lay. "Where's Maxie?" she screamed. "What is that? Take it away! Where's Maxie? What did you do with her? Bring back Maxie. I want my sister!" Her outcry brought the family from the next room. They understood instantly, and Fatimah, whom both children loved, ten-derly lifted the hysterical little girl into her arms and took her out of the room.

Esther carried on under Khozyayin's instructions. At the village office she sought out Petrov to request a horse and sleigh, now gra-ciously granted, and to arrange for the funeral. Numb, Eva prepared the little body. It was completely covered with black spots and she couldn't help but wonder, even in her distraught state, what illness had killed the child. As she sorted the garments in which to dress the body, her mind was racing ahead. The little shoes and the remainder of her clothing would be grabbed up by some kolkhoznik in exchange for nourishing food for Tommy. Waves of contrition distorted her sense of reason. She recalled her reaction at the doctor's announcement of her pregnancy with Maxie and she cried out to Esther that this death was her punish-ment — had it been because she had wished her dead before she was even born? Then there was the bitterness: Max had never gotten even a glimpse of his younger daughter.

In the same way that Eva and Esther had sought to comfort the other mothers, now the Muscovites came to them. They stepped into the hut to make their presence felt, to place a hand on Eva's shoulder, to

glance at Maxie. One was horrified when she saw Maxie without shoes. "Are you out of your mind?" she cried. "Do you want her to hurt her tender little feet — running around in heaven without shoes? Do you want the other children to tease her, to make her so miserable that she will not be happy in Heaven?" Eva, dazed and miserable, automatically reached for the shoes and slipped them on the stockinged feet. Throughout the lamentation, Tommy could not be comforted. She sobbed unrestrainedly.

The body lay on the bench until the next afternoon when the driver arrived with the horse and sleigh. Tommy could not be left, even with Fatimah. Esther sat alone on the sleigh next to the coffin and the driver signaled the horse into motion.

Forty-two of the evacuated children had died in the epidemic; Maxie was the last to fall victim to the disease that no one could name. Just before leaving the Red Banner, Eva and Esther went to the cemetery, but could not find Maxie's grave. The graves of the children of the evacuees had no markers.

Chapter 11

As the winter advanced, conditions became intolerable. Tommy's health was not improving, and their anxieties were wearing them down. Esther began to make a mental inventory of their possessions. "What do we have left to barter?" she asked.

Eva replied, "What is left is on our backs. We need to get back to Moscow."

Valeria had written that people attempting to return to the city without a permit were being held at the railroad stations and shipped right back on the next long-distance train. This was confirmed by several other Muscovites at the Red Banner from letters they were receiving from relatives. Nevertheless, Esther agreed that they had no choice, and both were determined to risk it and leave.

Eva found a co-conspirator in Masha, whom the villagers respectfully addressed by her formal name, Maria Alexandrovna, because she was the wife of a Red Army commander. Masha, too, was desperate to return to Moscow with her two children, but even she, with her prestigious status, had not been able to obtain a permit. She, Eva, and Esther spent hours scheming to get back home. Letters had been coming through that said some people from evacuation centers had succeeded in entering Moscow by disembarking at the last dacha stop — train stops in rural areas close to large cities where houses or rooms were rented to vacationers — before the train rolled into the station, where the guards were on alert. They would do the same, and from there, somehow, they would get home. Enroute, Masha would do all the talking and bargaining. Eva, with her distinct foreign accent, might be suspected of being a

spy and taken in for questioning. Masha would buy as much vodka in the village store as she could coax from the keeper. Hard liquor was very scarce; it would be useful to have in order to bribe train conductors and engineers who had the reputation of being hard drinkers. The vodka would come in handy, also, to buy off officials. Eva's money would pay for this.

Eva wrote out a request for a horse and sleigh, and Masha set it before Petrov, banging on his table, threatening him with dire consequences if he dared refuse her. Afraid of contradicting a commander's wife, he finally agreed, but offered transportation only for her and her children. Masha would not be satisfied, and refused to alter her demands. How did he expect her to manage alone with two children and so much baggage? Eva and Esther must go with her to give the assistance she needed. Again Masha hurled fearful threats, and Petrov finally gave in.

In mid-January, 1942, they set out, waved on by almost every Muscovite who pushed at them messages which they begged to be delivered. Foremost was the request to inform relatives of their hardships and of the abominable, treacherous kolkhoznik bias against them; they had been reluctant to express these views in their letters because of censorship and possible recriminations. The other requests were concerned with the kind of appeals Eva had been writing for them — begging relatives to send them permits so that they might return, getting permission to join husbands at resettled factories, and looking for addresses of husbands in the army. Tonya asked Eva to try to locate Marcus.

Eva was to follow through with her promise to Tonya, but was refused any information about the boy after she was forced to admit that she was not a relative. Her repeated entreaties that the evacuation committee send the information to Tonya elicited only the reply that the mother must request it personally. Correspondence between the two women ended after two letters. Eva's subsequent letters appealing for news from her were returned with the stamp, "Addressee unknown." They never met again.

In the sleigh, Esther and Tommy were wrapped in the warm blankets which Masha had lent them. Masha scolded, "You people are dupes! You don't know how to take care of yourselves. How could you have left Moscow with only the clothes on your backs? Did you really believe that

you would be back in a month? Don't you know yet that if they say a month you'll be lucky if it is a year? And to come to a village in wartime with nothing to barter! What good is all your money? Did you believe they would actually take us to a city to be evacuated? What sky did you drop from?"

The driver from time to time instructed one of the adults to get out of the wagon and walk alongside so as to lighten the load. Masha, in her fur coat, ear-flapped fur hat, muff, and valenki, was better equipped to take most of the walking than Eva in her tattered coat, laptee, and a remnant of a footcloth covering her head. In happier days, to ride in a horse-drawn sleigh had been one of Eva's ambitions. Now, she simply wanted it to take them quickly to their destination.

Masha had foreseen that tickets could not be purchased without traveling permits, so when a troop train going to the front via Moscow stopped at the station, she arranged with the commanding officer to allow them space in the cattle car, which had been converted into quarters for two officers and thirty privates. This only cost her three bottles of vodka. Half the soldiers were lying or sleeping on a shelf and the others were on the floor under it. A place was made on the shelf for the women and children.

The fast train seemed to have gone about halfway to Moscow when, at night, the two commanders asked Masha and Eva to grant them sexual favors under the shelf. Eva refused. The train slowed and came to a grinding stop. In the darkness, she, Esther, and the child were thrown out and left alongside the tracks. They huddled together as the train crawled past them, picked up speed, and disappeared. Terrified and cold, surrounded by black trunks of giant trees, they stood where they were until the first glimmer of daylight.

Time had seemed to stand still until dawn revealed a structure a few hundred yards ahead of them. As they wearily and clumsily walked toward the building, several people ran toward them. One lifted Tommy into his arms, another relieved Esther of the bundle that held their few possessions, and others solicitously led the two women to what was the Murom Railroad Station where they were encircled by inquisitive men, women, and children. They were in a community of like-minded people, all of whom were waiting — hoping to board trains. Many had permits

and tickets but no train that stopped had room for them. Some had already waited two or three weeks in the station.

A family of speculators adopted them. Alexander Andreyevich Kostikov, an elderly kolkhoznik, had somehow been granted a permit for his family to visit "relatives" and bring back a little food for personal consumption. He was nervous about smuggling his illegal purchases through Moscow — more than the allowance stipulated in his pass — and into the village where the family was headed. He made an agreement with Eva. In return for his providing them with food and taking them under his wing, she would claim to be a member of his family, thereby increasing the legal share of his provisions. In addition, Eva and Esther would be able to help guard his sack.

Alexander Andreyevich, in tooloop coat, cloth, ear-flapped cap, and valenki, was a tall, stately man with kind, twinkling eyes and a pleasant smile showing strong, white teeth. A long, gray and white beard covered his chest. He was so different from the bloodthirsty speculator Eva visualized from caricatures in the newspapers that she was hard pressed to accept the notion of his being a hardcore vulture sucking the blood from the Motherland.

His wife, Evdokia Tikhonovna, was dressed like her husband in tooloop and black valenki, her gray hair concealed by a thick woolen shawl. Their two daughters, Verya, about nineteen, and Lyuba, seventeen, were long-haired blondes. Evdokia Tikhonovna was troubled by their daughters having succumbed to the influences of the city, even wearing calf-length dresses instead of the decent ankle-length apparel. "Just look how shameless they are! And how careless of their health, wearing lisle stockings and thin rubber galoshes. And much too often they disobey their parents! We have two sons who are at the front. Who knows what godless habits they will bring back when the war is over. But better that they should come home with godless ways than not come home at all, God forbid!"

The Kostikovs followed their God's teaching to love and help their neighbors and the less fortunate. They offered food and real tea not only to their three protégées, but also to many of the others at the station who seemed to be in need. Verya and Lyuba often gathered together all the children, told them stories, played games, and occupied them in a

variety of ways, giving relief to the mothers who were grateful for the occasional rest.

During the first week here, lice became a problem and fighting them was an unending struggle. Children pleaded for their mothers to release them, their necks aching from the strain of being held in one position while fingers combed through their scalps. Not even Alexander Alexandreyevich's astute salesmanship enabled him to find soaps or other cleansers that might have prevented this condition. On this item alone he could have made a fortune of a lifetime. Cockroaches were another disgusting problem, but the children found amusement in chasing them, much to the disgust of the adults who were sufficiently plagued by them at night to want to forget their existence during the day.

Three weeks passed before the two families managed to fight their way into a cattle car. Passenger coaches seemed to have disappeared. On a slow train again, periodically stopped for cursory inspections during which Eva, Esther, and Tommy hid behind the sacks of the passengers to avoid being discovered without permits, they reached the outskirts of Moscow a week and a half later, in the middle of February, 1942. The two families sadly parted, and the women felt they were finally home when they discovered a street car connection that would take them directly to the Pestsovaya stop. None of the commuters seemed to take special notice of their disheveled, ragged appearance. Obviously, they were not an uncommon phenomena.

Their homecoming was unexpectedly eventful. The lock on the door had been changed and they had to wait for Natasha to come home to get into their room. Bluma Abramovna was the first to give them the news. "That Natasha!" she moaned. "Her husband is sacrificing his life for her at the front while she is taking up with Lev Nikolaevich — and without shame!" Lev Nikolaevich was the fourth floor neighbor whose wife was in evacuation with their two children. "And what unhappiness for his wife when she returns," she continued. Bluma cried when she learned about Maxie's death and begged them to relax and be comfortable in her room until Natasha returned.

Nyura also was solicitous. She rushed into Bluma Abramovna's flat as soon as she heard that Eva and Esther had returned. "You must stay with me until you are given a room," she said to the confused women.

"Galina Petrovna has sold your room and a great friendship has developed between Natasha and the new owner, a woman with a young child. Natasha has been wearing your clothing, Eva, and was living like a barinya until the decree came out that all unengaged women capable of working were going to be the first to be drafted for the labor front." Men and women had been drafted to dig trenches to prevent the passage of enemy tanks into vulnerable areas and to serve in any other capacity that civilians could do for the war effort. These people were drawn from all walks of life, but did not receive the rations allotted to the army for food or clothing. Women with children were not exempt; their children were temporarily placed in twenty-four-hour nursery schools. Natasha had applied for work immediately upon learning of the decree and was hired in a factory turning out military orders. Natasha seemed to enjoy shocking her neighbors. She had flaunted her relationship with Lev Nikolaevich and blatantly expressed her contempt for Eva and Esther, the wives of "enemies of the people."

When Natasha came home at last, they found that the talk was not idle gossip. She refused to let them into the flat and only the neighbors' intimidating remarks forced her to open the door. All signs of Esther and Eva's having ever occupied the room were gone, the possessions replaced by those of Natasha's new neighbor. Natasha had burned some of the furniture for heat, and she had sold the remainder and had been living on the money she collected. Eva's wardrobe had been moved into her and Abie's room. Maxie's white spring coat was the only garment hanging there. Everything else was gone: the children's library with so many books from America and Eva's own library — Natasha had used everything for fuel. The generally quiet Eva unleashed her fury. "How could you be so ignorant? Didn't you know how rare and valuable English books, especially children's, are in the Soviet Union? You burned far more rubles than you would have needed to pay for the fuel to heat the house and cook meals for a month! How could you have done this?"

"Galina Petrovna said you would never come back to Moscow. You're a family of enemies of the people. Abie will agree that I was forced to sell everything to live. I was unemployed." Eva's taunting, "Unemployed! Yes, until the labor front decree was published," went unanswered.

No threats moved Natasha and the new occupant to make sleeping space for them, and when the neighbors warned Esther that she could lose her right to own the two rooms if they moved in somewhere else, she was afraid to accept Nyura's offer or to ask Valeria and Gustav for shelter.

Appeals to Galina Petrovna were useless. "As house manager it is your job to get this woman out!" Eva and Esther complained. But she intimidated them by retorting, "You will never be permitted to remain in Moscow. Where is your permit? Ha! You don't have one! So, don't you tell me what I can do." So Eva and Esther slept in the kitchen, alternating between a makeshift bed made from a series of chairs which the neighbors donated and the top of the stove, next to Tommy. Fear that Galina Petrovna would immediately set out to notify the authorities of their illegal presence in Moscow plus their discomfort made for a sleepless first night at home.

The next morning, Eva proceeded directly to the authorities. For the next two and one-half months, she was shunted from one clerk to another in spite of the fact that the illegal occupant could show no proof of the sale and gave only her excuse that "the house manager sold it to me. It is mine. I won't get out." In the meantime, Eva, Esther, and Tommy lived as squatters in the kitchen, each day apprehensive that they might be asked to show their permit.

In addition to this distress at their homecoming, Eva had yet to face the Meltzes with the news of Maxie's death. When the two again came together, however, they knew immediately from Eva's demeanor that another tragedy had occurred. Allowing herself only a moment of shock, without a word, Valeria smiled wanly at Tommy and gave the child a long hug. Alexandra, realizing that to ask questions and openly mourn might upset the child, greeted Eva as if nothing more unusual had transpired than that her daughter-in-law and granddaughter had finally arrived home. There would be another time to ask questions. Eva interpreted their behavior correctly.

The conversation immediately opened with the problems at Pestsovaya. Valeria was well acquainted with the situation. She had kept this news from Eva and Esther in her letters. Natasha had changed the locks with the full agreement of the new occupant in order to prevent

Valeria from entering the flat. Bernice had not been there to protest, having been evacuated with Goga to Kuibyshev, formerly known as Samara, on the Volga River. Kuibyshev was the evacuation center for the employees of the *Moscow News*. Valeria had continued to pay the assessment for the two rooms, and the receipts were proof of Esther's ownership. On the other hand, Natasha had refused to pay her share. "I don't need to pay it," she insisted. "It's Abie's room; not mine. As a soldier, he won't lose it."

Late in April, the affair was settled — suddenly. The illegal owner was arrested for speculating in ration cards — she was selling extra coupons on the black market — and her daughter was taken by relatives. "How did Galina Petrovna escape punishment?" they asked themselves. Although they never learned the answer, she continued as house manager, but at least did not persecute them further. They guessed that she had not reported them to the authorities for fear that her own illegal activities might be discovered.

Through the generosity of their neighbors — a table from one, two chairs, a stool, some dishes and eating and cooking utensils from others — they put together a semblance of living quarters. Even Natasha condescendingly returned one of their own chairs. They made do with what was left of the garments that they had taken with them when they were evacuated. Everyone agreed that having peace was more important than suing Natasha, although it hurt when she walked past them in Eva's dresses. When Bernice returned from evacuation, she gave them her sofa bed on which all three slept with heavenly pleasure for several more years.

Another immediate need, equally as important as housing, was securing employment, and that would automatically get them a food ration book. Work in any industry supplying military orders, the kind of job Natasha was doing, would have been very desirable. Such factories were always short of hands and the rations provided were above the ordinary. "That is out of the question," Valeria said. "You will leave yourself open to trouble when they ask to see a Moscow permit; and besides, your accent will give you away as a foreigner and some super patriot will turn you in as a spy."

About two weeks after their return, Eva went to her old school

thinking that perhaps she could get some kind of work there even in the absence of staff and children. To her surprise, she found the school fully functioning, and they were just beginning a new semester. Their evacuation plans had never developed. The refugees had been turned back without a halt at Ryazan, about two hundred miles southwest of Moscow. Already news of casualties among former staff members had been received by the school. Belyaev, whose homeroom Eva had been asked to take with her own during the first week of the war, and Mark Yosefovich, the young math teacher of the higher grades, just out of the university and on his first assignment after graduation, had been killed at the front. Anton Sergeyevich, the elementary math teacher, had perished in a bombing. Sara Lvovna, the general's sister who had wanted so much for Eva to sue for child support, had also died of wounds sustained in a bombing. With most of the women evacuated and the rest of the men drafted, Maria Petrovna was delighted to have Eva back. She wrote at once to the authorities requesting that "this irreplaceable teacher be permitted to remain in Moscow." Within a month, permission was granted.

Until the permit arrived and with it the ration cards, neighbors gave them food although they themselves had little to spare. Valeria and Alexandra and Gustav also helped in spite of their own meager allotment. In the first months of the war, Zhora, Aunt Rose's son, had found the Meltzes in pitiful circumstances. A lieutenant, he was stationed with his corps in Moscow. He had sought them out in order to locate Esther and Eva. The condition in which he found them and also his mother's friend, Olya, shocked him. "The *politrook*," the political advisor in every army unit, "lectures us on how well we are prepared for war and repeats Comrade Molotov's assurances that the people can withstand a siege of eight years without going hungry," Zhora said to Valeria. "How can it be that you have not only insufficient fuel, but also so little food? Somebody must have it, but who?" His inexperienced young mind had not been able to absorb the inconsistency. He had rationalized some of it to the panic of the previous October 17 when rumors spread throughout the city that the fascists were at Khimki, then a suburb a few miles from Moscow. Managers of warehouses and stores had opened the doors. "Take what you need. Better you than the fascists." The streets were packed with dazed and confused people busily filling their sacks with food. It

was at this same time that Natasha, fearful of the Nazis discovering her marriage to a Jew, destroyed much of the Stolars' photographs and books.

On every weekly leave, Zhora had visited the Meltzes with his arms loaded with two loaves of bread, sugar, and canned food. They argued with him. "You are denying yourself." But, he insisted, "I have good rations. I can't use them all. To whom else shall I give them? My mother and sister? I don't even know if they are alive. Or to Aunt Esther? Neither the army nor the civilian post office will take food parcels."

At the end of the war, word arrived that Zhora had died a month after the war ended from wounds inflicted while in a small town near Berlin — just two days before the Germans capitulated. Alexandra mourned him deeply. "What a curse has been laid on this country," she cried. "The young and the best of men are either murdered by our own rulers or are killed at the battle front."

The suffering of Eva and her family as a result of the evacuation seemed to stretch the months into years: the misery in the cattle cars, the horror of the winter at the Red Banner where Maxie's life had ended, and the long wait at the Murom Railroad Station for transportation back to the city. Yet, when they returned, their absence did not seem to have been long enough for so many changes to have taken place during their absence. At Pestsovaya, some of the old neighbors had gone and new ones had moved in. Many of the boys the family had known as children were now soldiers. Zoya, the tomboy, had enlisted, and Nyura shared her letters with Esther. She was well and giving "the Nazi bastards hell," but she was unhappy because she was felling too few. Shelters had been dug in the cellar of the building and the children's well-equipped playgrounds were being prepared for conversion into vegetable patches. At school, the children and staff were regularly subjected to air raid drills. Coming home from work at night was a challenge. The blackout was complete; a person crossing the street could never be certain that some vehicle might not appear from out of the dark, and there was no use scratching through the film of frost on the windows of the bus because it was impossible to recognize any landmark. Eva wondered how the women bus drivers knew when to stop.

Again, just to survive was a struggle. Eva was a salaried teacher once more, with better than the average rations because of her position. She was assigned to a distribution center and a special teachers' restaurant where the quality and quantity of food were better than on other types of coupons. She was now entitled to extra living space and a larger ration of electricity so that she could do the thirty hours of preparation required by her teaching assignment of eighteen hours in the classroom. Of course, the additional few square meters of living space to which she was entitled for her work existed only on paper, for a change of housing was out of the question. Her work schedule was heavier than before the war. German had been thrown completely out of the curriculum and English was the only foreign language taught in her school. The demand for English teachers could not be met, even with those in positions taking on a double load.

During the winters of 1942 and 1943, in spite of the better than average salary and the better rations, there was a great lack of food. Esther as an elderly housewife had the lowest category of ration card and could redeem practically nothing but bread on it. Tommy, with a child's allowance, was entitled to small amounts of sugar, butter, milk, cereal, meat and fish, in addition to bread. Usually, however, only the bread was in the markets. The other foods were sold once every few months and in such small quantities as to be insufficient even if Esther were lucky enough to find a place near the head of the line where they were being given. For some reason, the term "sold" was never used in reference to the exchange of rationed items during the war. Eva felt most fortunate because, like most of the other teachers, she had the food from her lunches to take home to divide among the three of them.

A kilogram of frozen potatoes now sold for 150 rubles or more on the open market when they could be found. Alexandra gave Esther a recipe for cutlets made of potato peelings for an entree. It wasn't tasty but it filled the stomach and that was their main goal. For soup, two or three potatoes were boiled in four or five quarts of water, and salted only if one could get salt; the soup was served as the first course and a piece of potato was the second. Such a pot of soup had to last three or four days. "Tea" as dessert was any substitute issued on the ration cards. Bread, although on the shelves every day, was composed of very little

flour and contained many substitutes, making it not only tasteless but also very unsatisfying. It was so expensive that Eva and Esther would for days have discussions and debates on the question of buying it. They usually allowed themselves the luxury once a month. A coupon for vodka, the best commodity for selling and bartering, was included on the monthly ration card, but vodka was never available during the winters of 1942 and 1943. The coupon for fuel always went to waste, since government rations were never available and Esther had to haggle for every small bundle of wood she could get.

No one left the house without an *ahvozka*, a string shopping bag. What if something was in stock and you had no paper, bag, or ahvozka! People usually carried a homemade cloth sack or handed to the clerk a page of a newspaper that was folded into a funnel to hold their food. Selling old newspapers for this purpose was a lucrative enterprise.

The conditions under which the people lived in those dismal years prompted Eva to wonder why the Allies were delaying the opening of a second front in Western Europe in order to relieve the Red Army of some of the Nazi pressure along the Eastern Front. All of Moscow was asking the same question. The Soviet Union's "scorched earth" policy — the practice of destroying everything in the path of the advancing Nazis — had left the fields brown and unfertile and the storehouses bare. Manpower was needed in the ammunition factories; labor to plant crops in the recaptured territories was secondary. The war would end sooner if the Allies would only come in and help now. More Russians would be relieved to rebuild and to rehabilitate the kolkhozes. "What is keeping the Allies?" was heard daily. When, in the summer of 1944, the second front at last opened on the beaches of Normandy, there was general rejoicing.

Food shortage was less of a problem during the final year of the war. A greater variety of food was now sold on the ration cards, including, for the first time, cans of American Spam and other meats, as well as dried eggs, milk, and a variety of other staples. At about this time, Eva's relatives and childhood friends made contact with them. When their contact with America resumed, Eva and Esther came to realize how desperate the Russian people had become. There was a complaint in one letter from America that enraged them. "Imagine! The Americans

expect pity!" Eva said to Esther. "Coffee is rationed in the United States and they are upset! Bread can be bought without coupons, but coffee — which they seem to need more than bread — they can get only if they have a coupon! We haven't tasted coffee since the supply we brought from Chicago ran out years ago!" There was no coffee to be had in Moscow.

One evening at the end of February, 1942, Eva had walked in on a very agitated Valeria and Alexandra. Gustav, long overdue, had not returned from work. Informed that he had left for home as usual, Valeria, after two distraught sleepless nights and days of searching at clinics, hospitals and morgues, found him in a coma at a hospital at the other end of town. He had collapsed in front of Mossoviet, the Moscow City Hall on Gorky Street, about half a block from home. Without regaining consciousness, Gustav died the day Valeria located him. Malnutrition was listed as the cause of death. Between both families there was still not enough money for a private funeral, so Gustav's ashes were buried in a common grave.

The shock of Gustav's sudden and unexpected death was still fresh when Valeria was drafted into the labor front which the military had designated as the women's contribution to the war effort on the front. The women dug ditches and the men fought. All able-bodied women who were not directly involved in the war effort or who did not have family responsibilities, such as child care, were expected to be called up just as were the men.

The last letter from Max had come shortly before the war began. But, as soon as she had returned from evacuation, Eva had gone to the NKVD office to find out why there had been no letters or replies to her communications. She was curtly dismissed. "Our country is fighting for its very life! And you expect me to keep track of an enemy of the people!"

Triangles, letters written on brown pieces of wrapping paper cut in that shape, did, however, begin arriving from Abie about this time. From seeing his letters in the mailbox and memorizing the return address — a form of recreational pleasure of the times — neighbors were able to write to Abie and inform him of the circumstances at home involving Natasha's infidelity and that Maxie was gone. Abie wrote that

he was vigorously protesting the illegal occupancy of Esther's room —
all the way to top government and Party officials. Here he was on the
front lines of the battlefield, a Soviet soldier confronting the Nazis, with
the added burden of his mother and sister having no shelter! Perhaps,
he wrote, at least one of the leaders would respond.

His subsequent triangles, however, were a joy to receive. Many
were addressed directly to Tommy. On hers, he drew illustrations of
soldiers, animals, flowers, characters from Russian and English fairy tales
and nursery rhymes. She showed off her mail with great pride. Then, a
short time later, his letters stopped coming.

When Valeria returned to Moscow during the spring of 1942 fol-
lowing her release from the labor front, and appeared at the Stolar flat,
Tommy, with the normal candor of a child, cried out, "Valyachka! What
did the Nazis do to you? Only your face looks a little bit like you!" That
one month, digging into the frozen ground, on inadequate rations, had
reduced Valeria to a starveling, her arms and legs brown, dried out sticks.
It had been a month of suffering from extreme cold, sleeping in un-
heated huts, and working outdoors in the same clothing with which she
had left Moscow. Valeria's recovery was slow. Her thoughts made her
restless. The course of development of the country preyed upon her
mind. She was an egalitarian, and her firm commitment to her beliefs
had attracted her to socialism. But now, she was still witnessing deca-
dence, the same decadence that had eventually destroyed the Tsar: a
revival of a privileged class in all aspects of the society, if not of the
pre-Revolutionary variety, nevertheless a privileged class. It was present
in the military with its undemocratic rankings and pomp and ceremony,
the salutes and heraldry representing the power of the officers over the
private. The revival of the church brought prayers for "Our Father, Com-
rade Stalin" substituted for the pre-Revolutionary, "Our Father, the Tsar";
and vows pertaining to marriage relationships were once again taking
away a woman's independence. Overnight, it seemed, there was the re-
organization of education from coeducational to separate schools for
boys and girls that she considered an outrageous affront to women. The
promises made but not kept by the new "socialist" government enraged

her, even as they did Eva.

The survivors of these families, each originally from cultures vastly different than the other, became as one from the same womb. Meltz. Stolar. They were as closely bound as relatives from the same roots. When one confronted obstacles, they were equally obstacles for the other. They shared alike. The bond developed with no forethought. It had to be so. Between Esther and Alexandra language differences did not require an interpreter. Valya was the daughter of both. Eva was the daughter of both. Eva and Valya were as sisters.

Even when Eva and Valya had been strangers to each other, their environments had brought them to the same commitments. Neither Alexandra nor Esther had ever been political activists, but the circumstances under which they had lived in pre-war Eastern Europe made them vulnerable to influences that rebelled against the indignities that the society in which they were raised heaped upon them. Valya, who discovered socialism when she left her rural home for the urban centers of Illinois, was Alexandra's influence. She did nothing to prevent its being spread to her two sons. Morris, who discovered socialism early, was Esther's influence. After Esther and Morris linked up, she became the homekeeper for their children so that Morris might involve himself in spreading the word about the doctrine in which he so strongly believed, and Esther did not deter him from passing his beliefs on to their children.

In the end, even as strangers, Eva and Valya were sisters by virtue of their same strong ideals and commitments. Eva's ties to Max strengthened this link. When disaster struck, when one lost a loved one — a husband, a father, a brother — they grieved together as members of one family. When the ideals which gave their lives meaning turned sour and disillusionment set in, only each could give the other the genuine comfort they required. When Valeria could no longer face life with her ideals shattered, only Eva's just sharing in her misery gave her the strength to face the reality. They lived as under one roof. They shared the responsibilities and problems for keeping themselves and the other survivors alive.

Chapter 12

Levitan was a popular radio announcer who the fascists had pin-pointed as one of the "Jew Communists" they were going to get when they captured Moscow. At the beginning of the war, Levitan's serious, mournful voice had reported defeat after defeat. Then, following the battle of Stalingrad in February of 1943, when General Von Paulus surrendered, the news became more often good than bad, and Levitan began to bring joy and hope into the dreary lives of the Soviet people with his melodious, emotional baritone voice — now reporting victory after victory by the Soviet Army. An optimistic note crept into his voice after the successful counterattack at the gates of Moscow. Salutes fired from the roofs of tall buildings in the downtown area and on the out-skirts of Moscow marked the victory at Kursk, another milestone in the final rout of the Nazis. When the Germans were driven out of the country and the Soviet army began its battles on foreign soil, salvos were heard in and around Moscow almost every night.

Soon after the victory at Kursk, Levitan announced, simultaneously with the newspapers, an affirmation that the prisoners of war, enroute to internment camps, would be marched through designated streets of Moscow from the Kursk Railroad Station to another station. The instructions were clear that the people were to be by-standers; no demon-strations were to be held — the people were to be the silent but visible symbols of the Soviet victory over Hitler. Playground personnel were encouraged to escort the children to see the vanquished enemy. Kalayevskaya, the street on which Eva's school was located, was one of the streets on which the captives would be walking.

189

The prisoners, led by several columns of their officers, stretched from curb to curb. Some of the officers were still bedecked in the garb of their rank, medals across their chests. Most of the men, however, wore tattered remnants of uniforms, many with shawls or small baby blankets over their shoulders while others had scarves and rags covering their heads and faces. The only sound was the tramp of shuffling feet. Perhaps the absolute silence of the crowds lining each side of the street, down to the youngest children, disconcerted some and shamed others. An old woman standing near Eva behind the children was muttering under her breath what was probably on the minds of the onlookers: "Look at you, you murdering bastards! Aren't you the heroes! You're in Moscow all right, but not how you planned. Not so much as even a sight of the Kremlin! You'll pay now all right for our murdered sons and innocent women and children!" Eva wondered, "And these scarecrows claim to be the superior people and the masters of the human race?"

The walk-through continued for perhaps two hours. It seemed endless. When the last row of prisoners disappeared from sight, the street cleaners were behind them as if cleaning away excrement. Laughter broke out and the tension cracked. People turned toward each other, their excited voices filling the air. The children were taken into the schoolyard where they spontaneously broke into a dialogue among themselves and their teachers about the experience. All traces of discipline disappeared; it was too impressive an experience to carry on as if nothing had happened. The enemy, once feared and hated, was now the butt of their amusement. "They should have studied Russian history before they decided to invade our country. What did they think? They're so stupid they didn't learn anything from Napoleon's defeat in Moscow in 1812. A lot those fascists can do to a nation whose people eat Eskimo Pie in winter!"

Clothing had become a very serious problem. Consumer goods had been neglected in the pre-war five-year plans and very little had been manufactured for the general population throughout the war years. This shortage continued into the post-war period. Most people had a poor, seedy appearance, and Eva was no exception.

Civilians who were considered the best workers were allotted coupons for common necessities: shoes, stockings, underwear, cloth, and other commodities. Shortly before the war ended, Eva was awarded two clothing *taloni*, or coupons, one for cloth and the other for a pair of shoes. She bought some light blue fabric which Bluma Abramovna made into a plain and practical but very nice dress. With her new shoes and her custom-made dress, Eva felt very chic and human again. It was so long since she had been decently dressed.

A short time later, just before the victorious conclusion of the war, parcels of clothing arrived from close relatives and friends in the United States. Fortunately, most of the duty, which was very high, had been prepaid. If it hadn't been, Eva would not have been able to claim the parcels. As it was, on parcels where the duty had not been prepaid, Eva and Esther had to sell some of the contents at the second-hand commission store in order to have enough money to pay the duty on the balance. It was such a pleasure to have the luxury of choosing which dress suit, and even which coat to wear, and what a delight to feel the touch of the lightweight, smooth rayon next to their bodies.

Their "affluence" did not go unnoticed. One day Tommy, now in the third grade, came home from school with a note from her teacher demanding an immediate interview. All of Eva's questions to her evoked a defensive, "Honest, Mamma, I don't know why. I didn't talk or copy or do anything wrong." Eva soon learned the reason. The teacher, Tatyana Akimovna, criticized her sharply because Tommy was wearing "silk" underpanties. It was a good thing the children wore school uniforms, she said, for the outer clothing that she wore when she was not in school was the talk among her classmates. As it was, they had noticed her underwear. Eva was raising her daughter in the image of a spoiled, bourgeois, rich, western child and not as a Soviet child of a working woman. Tatyana Akimovna ordered that Eva get Tommy appropriate working class clothing immediately. Eva politely explained how the clothing had been obtained; however, she was willing to follow the teacher's advice. But when she looked for the clothes in the stores, Eva found that there were none available, so Tommy continued to wear rayon.

On May 7, 1945, rumors ran rife throughout an excited, joyous people that the Germans had capitulated. The rumors were started by people who owned their own radios and had received the news from BBC broadcasts. Neither the Soviet radio nor newspaper had yet made such announcements. At home, the loudspeaker was never turned off in anticipation that the news would be confirmed. Then came the voice of Levitan, blaring forth and awakening the entire household. Tommy could not be restrained. "What is it? Is the war over? Hurray! Now Daddy will come home! I'll see Daddy soon!" Eva and Esther were at a loss for words. After Max's arrest, Eva had told Tommy that her father had gone to a sanatorium and that she assumed he had joined the army from there. What could they tell the happy child? What would they say when month after month would pass and other daddies would be coming home? When Tommy did learn the truth later, from an outside source, that her father and grandfather had been arrested before the war, Eva was distressed at the necessity of placing upon her the burden of responsibility for keeping the secret. Eva's job was at stake. This revelation to Tommy would eventually take its toll. She became unsure and frightened whenever her mother was away from home, or when she would return home later than expected. Tommy became introverted and for many years avoided making friends.

At midnight on May 9, 1945, the official announcement of the end of the war came through in the usual stilted style of government declarations, giving the terms of the capitulation and the signatories and praising the Soviet army for its great victory. The stiffness of the announcement did not suppress the people. The neighborhood streets and the downtown area became the scene of buoyant rejoicing — crowds roaming in delirious jubilation; the people laughing, crying, dancing, kissing strangers, and almost tearing apart any soldier who happened to be there and shouting grateful thanks for his part in the victory and for the end of the war. Eva and Valeria cried to each other that they never would have expected to see the likes of such a spontaneous, joyful celebration in the Soviet Union.

At her school, all teachers were ordered to take part in the official victory demonstration. Everyone who had received a war medal was to report to work wearing the medal. Eva had received the coveted civilian

"Medal for Valorous Labor During the Great Patriotic War of 1941-1945," but had never worn it. Her enthusiasm and patriotic zeal of earlier years had disappeared. She felt that this planned demonstration, following the spontaneity of the previous night, was anti-climactic. To her, it was only another manifestation that to Soviet officials a peoples' impulsive, unrehearsed performance of free will and thinking, without government leadership and control, without its formalities and orderly sloganeering, was considered a dangerous transgression and precedent. She did not want to be part of this official demonstration, but Maria Petrovna refused her request. "You are a medal-bearer! You must go!" And so she went.

The next evening, at her first post-war meeting of the Moscow High School English teachers, Eva's social life began to improve following a conversation she had with Helen Eisenstein. Helen had been staring at Eva throughout the entire session. Eva could not place the woman and was beginning to feel more than uncomfortable, the old fear of exposure creeping over her by the time the meeting adjourned. Eva made her way quickly to the exit, but she was barely out of the door when she realized that the woman was following her. "Eva? Eva Stolar?" she inquired in American English. There was no avoiding her. "You don't remember me. I worked in the office of the *Moscow News*. I was hired just before Max left. I was fired a few weeks later after Abram, my husband, was arrested." Thus began a close friendship.

Helen also had gone through frightful experiences after her husband's arrest, having been thrown out of her job and evicted from her room, her possessions strewn out on the street. Some of her friends had put their own housing security at risk to give her shelter until she found work as an English teacher. Through Helen, Eva became reacquainted with Sheva, a former Chicagoan, who had recently returned to Moscow from the front. She had been with the Nursing Corps and had earned a military award for service in the field hospitals. Her courage extended beyond patriotism, Helen told Eva, relating how, when the news spread of the arrest of Abram, Sheva had rushed into the offices of the NKVD and insisted upon an interview to testify to her friend's integrity as a solid Soviet citizen.

Helen also introduced Eva to another friend, Jane Altman, whose

experiences paralleled Eva's. Like Eva, she had been brought to Moscow from the United States by her parents at the age of thirteen. At the same time that Morris had been taken, Jane's father was arrested and disappeared. Those left behind — Jane, her mother Sadie, and her brother — struggled to keep themselves together, much like the Stolars, until Jane maneuvered her way into the school system as an English teacher.

After Abram was released from the prison camps, Helen joined him in exile in Riga — he was not allowed to return to Moscow — Eva, Sheva, and Jane became a threesome, meeting at each other's homes to discuss books, listening in rapt attention to Jane's readings of her own original poetry written in both English and Yiddish, attending concerts, and particularly following the American films during those times when they were allowed to be shown.

These friendships gave Eva another outlet, in addition to Valeria, to vent her bottled-up anger, grief, and fears. It was now over eight years since Morris had been taken and seven since Max. Discussing their release was a constant topic of conjecture. Into what wilderness would they be exiled? Would Eva and Max find employment in exile? Perhaps with the uplifting emotions engendered by the ending of the war a month before, the NKVD would give her and her mother some information and addresses where they might write to Max. Esther and Eva were determined to try to extract something from the NKVD offices, but Alexandra and Valeria disapproved. Alexandra firmly believed, "We'll never see either of them again. It's a sadistic regime — for all of its fine slogans. You'll only have more pain and heartache and you've had more than enough. Eva, remember only how happy you were with Max and try to forget the rest. You're still young. You ought to marry again. I've been telling you this since Max's letters stopped coming. I'm sure he's dead. I feel it. You'll always be my daughter; but get married. You're too young to remain single. Valeria and I have accepted this fate! A child needs a father. Tommy will benefit, too."

Eva, however, needed to end the uncertainty so she started trying to get information. The waiting room at the NKVD office was crowded with people on the same mission. Esther was called into the office first. She was told that Morris was alive, that his sentence had not been eased, that correspondence was forbidden and she was refused an address. Eva

was instructed to return at an appointed time.

She returned alone, waited many hours as she expected, and finally was received by a woman officer who opened a drawer of the table at which she was sitting. She looked down into it and shuffled some papers. With an expression of impatience, she looked up. "Huh! How can he write when he is dead? Do you expect a dead man to write letters?"

Eva did not remember leaving the office nor how she got into the street car. When she returned to some sort of awareness, her sight was blurred by unrelenting tears. She dashed into the flat and gave way to her rage and grief. Esther and Tommy were also overwhelmed with sorrow. Alexandra, though, could only say, "Did you really need this aggravation? Will it make you happier?" A few days later, in better control, Eva returned to the NKVD to ask for the date of Max's death; she was told that he had died during July, 1943.

A year later, her grief somewhat subsided, she demanded a death certificate but was notified that the NKVD did not issue such documents. She was sent to the Moscow archives where she was directed to the Moscow Central ZAGS, the Bureau of Vital Statistics. On her first few visits there, the officials denied having records of prisoners outside of Moscow Province. Eva, at Helen's advice to "shout, make a lot of noise, raise hell," finally asserted herself. "My passport says I'm married. I want to remarry and can't. You know the new laws on marriage; common law marriage is not legal any more. How can I marry without proof that my husband is dead?" She was attracting the attention of many people standing in the office waiting for their own business dealings to begin. Some began to mutter about the injustices. "How dare they refuse her?" Encouraged, Eva's voice raised higher. "Either you or the NKVD is lying! They say you have the records!"

"Shh, shh," urged the official behind the desk. "Come next week and we'll try to have it for you."

"Ha," thought Eva, "they're afraid to let people know what they're doing. Our rulers will do anything to avoid that!"

A week later, she was given the record book for 1942 through 1945, but she could not find Max's name. She protested again; only then did she get to see his death certificate. "The notice was lost among other

papers" was the excuse for the long delay. The certificate gave the date of death as August, 1942, the cause pellagra. Eva, as well as her friends, felt that just getting the certificate, even if falsified, was a victory in itself.

"Now," she worried, "I hope they don't check to see if I marry. I'll be in a fine predicament if they discover that I used marriage as a ruse."

"Don't worry," were Sheva's and Helen's opinion. "They don't give a damn. They just want to show who's boss and they do this by giving people the runaround." They proved to be right. Eva was never contacted.

When the tenth year following Morris's disappearance had passed, Eva accompanied Esther to the NKVD offices, afraid that her mother might hear some devastating news in the same manner that she had. Esther came out of the room, a stunned expression on her face. The officer, a man this time, told her that Morris had died in 1943. He couldn't explain why she hadn't been informed when she inquired about him two years earlier. Although not too sympathetic, he at least had the decency to say that he was sorry to have to tell her that she was now a widow.

Life for Eva was slowly returning to normal. At school, the air raid drills had ended. There were no more lectures about the danger of touching strange objects on the streets that could be booby traps. There was a gradual settling down to the pre-war routine, but the reflex of fear lingered on.

In July, 1945, two months after the war had ended, Esther answered her doorbell and found her sister-in-law Rose with Eda and Ena. They were returning to Odessa from a small town in the Urals where they had been evacuated. The two families spent four days recounting and comparing their experiences and ordeals. Eda had worked as a teacher, Ena had been in school, and Rose had been the housekeeper. Although their lives had been far from comfortable, they had managed well. They had suffered from the hostilities of the local people who had resented their intrusion no less than the kolkhozniks had done at the Red Banner.

From her own family of seven sisters, a brother, and their children and grandchildren, only Rose and a niece had survived. The brother had

died of wounds during the 1941 retreat, and the others had been murdered by the Romanians in a bloody massacre. Grisha was now a major in the Army and was expected home soon. Rose was not sleeping nights worrying about Zhora whom they had not heard from since a month before the war ended. She was not to know until the following October that he was already dead, having succumbed from a head wound, and that he was buried in a town near Berlin. The official announcement was followed by the delivery of a parcel containing his belongings, including his bloodied shirt. Rose never appreciated the accompanying notice that read "died heroically, in the line of duty." For the remainder of her life, she was embittered and difficult. "He went through the whole war without a scratch and had to die when it was over!" was her ceaseless, heartrending wail.

In the autumn, there was another very welcome and long-awaited knock on the door. Abie was home for a two-week leave. His battalion had not been demobilized yet, and this was his first leave since he had been drafted in the summer of 1941. In 1943, after almost a year of silence, he had sent home a letter he had dictated to a stranger. He had been wounded and couldn't write. Esther had been beside herself. Was Abie without hands, or maybe without eyes? Who could have been so insensitive as to have permitted the letter to go out without telling her about his injuries? This had been the first of several such letters, but to all their questions, Abie's scribe had merely written, "Nothing serious; everything okay now." Now Abie was home and could tell them that grenade fragments had riddled the left side of his face, piercing his eye. Most of the fragments had been removed, leaving him scarred and blinded in the left eye. After more than a year in the hospital, he had been released as unfit for combat duty and was transferred to an auxiliary army labor battalion.

Esther tried hard to make his short visit comfortable, but she could not make it altogether pleasant for him since he had decided that his marriage to Natasha must end. During his stay, he secured a divorce and left Eva and Esther to confront an acrimonious ex-wife who vented her anger upon them. In addition, the room situation became even more complicated. When Abie married Natasha, by law, she and her daughter became entitled to two-thirds of the space in the room that he shared

with them. While Abie was still in the army, there was no problem, but when he returned, for all practical purposes, the remaining one-third was lost to him. Eva was left with the enormous task of arranging for a re-partitioning of the room that made Abie's one-third an extension of Esther's room.

Gradually, after demobilization, other parents in the Pestsovaya building were reunited with their children who survived the war. Nyura was in mourning for her son, her second child. Her youngest had served throughout the war as a private and was now being sent to an officer's training school. Only Zoya, her daughter and eldest child, who had enlisted as soon as she had reached the eligible age, would eventually come home. On New Year's Day of 1946, Eva saw a tall young woman in a captain's uniform bedecked with medals coming toward her. As they neared each other, the woman suddenly stopped and flung herself upon Eva, catching her up in a bear hug, kissing her repeatedly, and murmuring, "Eva Moisseyevna! Eva Moisseyevna! You've survived! How glad I am!" She laughed at Eva's bewilderment. "Surely you recognize me! I'm Zoya!" She bounded up the five flights of stairs pulling Eva with her, and bounced into the flat, the same flat where as a child her eyes had devoured the sweets that lay on the foreigner's table. She bestowed the same greeting upon Esther.

Her display of affection left a glow of good feeling. Eva remarked, "How changed she is. She has grown up. I barely recognized her. And how good her greeting felt. She was not the least bit troubled that everybody on the street was watching her, a captain, kissing and hugging the daughter and wife of 'an enemy of the people.'"

Eva's work at School 183 was mind consuming but it did not give her the comfort that she found in books. If books in English could have been easily obtained in the stores, she probably would have sacrificed much of her wages to buy them. Among the personnel at the Foreign Language Lending Library she had the reputation of being a voracious reader. Shortly before the end of the war, the allied relationship between the United States and the Soviet Union had brought with it a cordiality that included an influx of books written and printed in English. At about that time, Maria Emelyanovna, who had been one of the staff librarians, was promoted to the position of supervisor. It was natural

for her to come to know the habitual patrons, and she particularly singled out Eva. She set aside any recent book that she thought might be of interest. Some of them gave Eva an understanding of the trend of literature abroad and some were useful for her classes. The two women had become quite friendly.

During one of her visits to the library, Maria Emelyanovna asked if Eva would be willing to tutor her daughter, an honor student studying English at the Gorky Institute of Literature. At the same time, she mentioned that she had recommended Eva for a teaching position at the prestigious Institute of Cinematography where young people trained for work in all fields of the movie industry, and asked Eva's permission for her to arrange an immediate interview. Yelena Ivanovna, the head of the Foreign Language Department, desperately needed additional staff to teach English. Eva ran immediately to share this news with Valeria. "The pleasure that this compliment gave me must have been written all over my face," she said. "Of course I'll tutor her daughter; that I can handle — but to consider me capable of teaching at the institute — with absolutely no training at the higher educational level. I could never carry that off!"

She did not want to accept remuneration for the tutoring. She was happy to have the opportunity to show her appreciation to Maria Emelyanovna for all her kindness, especially for recommending her to a department head in the film institute, a compliment that made her feel like a respected member of society. Maria Emelyanovna would not hear of accepting her services without compensation. They finally reached a compromise; the tutoring was to be at half the usual fee.

Because of Eva's insecurity, she refused to consider the possibility of teaching at the institute level. Yet, Maria Emelyanovna persisted. "Only an interview! You really don't know what will be required of you." Eva finally consented.

Yelena Ivanovna was greatly amused at Eva's hesitation to accept the job and enjoyed her naïveté. "I have never before heard anyone say that she is not qualified for a job. You will never get very far with such candor. You're a teacher. English is your native language. You'll have only a few readjustments to make." A native American teacher was urgently needed on her staff and she persuaded Eva at least to try.

Yelena Ivanovna worked out a schedule that not only permitted Eva to continue teaching at School 183, but also accommodated a teaching obligation she had previously taken on at Helen's recommendation. The load was taxing. Several mornings a week on those days that she was not due at School 183, she traveled across town to the institute which was located across the street from the National Exhibition of Achievements, far from Pestsovaya. The evening courses were held on the other side of town near the Arbat, also far from home. Then she made time for Snezhinka, Maria Emelyanovna's daughter. Travel among these various places was slow, and Eva would not get home until nearly midnight. Esther insisted upon waiting up and fixing her the only decent meal of the day that she had the time to consume. Always, when she turned the key in the door, she expressed irritation with Esther. "Why do you wait up for me? Don't you think I am old enough to warm my own supper? In the morning you are up at six with me. Why? You know you need the rest." Esther let her complain and went about doing things as she wished. She did not go to bed until Eva had finished her supper and she cleared away the dishes. Then Eva would sit down to do her preparations for the next day's lessons or compose instructional aids which had been assigned to her at the institute. Sleep, it seems, would have come easily, but the insomnia that began with Morris's disappearance still plagued her and, rather than toss and turn until morning, she read — sometimes until dawn. By 6:30 AM she was up again, after only one to two hours of sleep, and on her way to work.

By the end of the 1946 school year, Eva was given full time work at the institute, allowing her to resign her position at School 183. The recognition that she was receiving at the institute was repairing her broken self-image and was helping to slowly bring her out of her shell. In her own department, her colleagues were impressed by her teaching methods and used them with their own students. The success that was achieved became evident and Yelena Ivanovna made sure that Eva was given the credit. Contrary to custom but because of the respect she commanded, post-graduates were assigned to her soon after she started work there. She enjoyed developing the instructional aids and felt good that the teachers appreciated having them.

She had a sincere and deep respect for the competent staff, particularly for Yelena Ivanovna and Dollie Felixovna, both of whom were remarkably fluent in English. She learned that Yelena Ivanovna, who also spoke a perfect French, had had a foreign speaking governess when she was a child, and Dollie Felixovna was a natural linguist. She had been certain that Dollie must have lived in the United States. "No," Dollie said, "I've never been out of the Soviet Union. My teacher at the institute was an American and I worked as a guide and interpreter to improve my language."

Eva established a friendly relationship with her colleagues, but it did not extend past the working day — not even with Dollie Felixovna who would later become her collaborator in writing an anthology of cinema texts for the English Department. Eva's reticence stemmed from her fear of exposure, and this prevented her from sharing any of her personal life beyond the fact that she was a widow with a daughter and mother to support. She would not even share her thoughts with her "foreign" friend Trudy Hantzovna, an Austrian, who was teaching German. Eva and Trudy had been drawn together because they both felt the stigma of not being a true Russian, neither having been made to feel fully welcome in the social life that automatically develops among staff members. About Trudy, Eva only knew that she and her husband with their two children had fled Austria during Hitler's reign of terror. They were neither Jewish nor communists. Her husband had "disappeared" in the purge that took Max, and Trudy had remarried, this time to a Ukrainian.

Eva anguished over having to attend the compulsory political meetings, but she found compensation in the compulsory but informal production meetings that were held in Yelena Ivanovna's home. Over a sandwich and a cup of tea, the women discussed and resolved the problems of the department. The minutes of these meetings, very formal as prescribed by protocol, gave no hint of how the meetings were conducted and how pleasant they really were.

During the period between Abie's leave and his demobilization in March of 1947, he announced in one of his letters that he was marrying Sonya, the widowed sister-in-law of a man named Itzhak who, for months,

had lain in the hospital bed next to his. Abie wanted his family to attend the wedding, which was to be held in Leningrad. Eva alone went; Esther did not want Tommy to miss school.

Eva could not define her first impression of Abie's new wife. She was not the least bit bothered that her new sister-in-law had a seven-year-old daughter. But that her first husband, who had been killed in the first weeks of the war during the defense of Leningrad, had been a public prosecutor, and that Sonya herself earned her living as a cashier, vaguely disturbed Eva. The favorite derisive expression that Russians in anger directed at each other was, "You cashier you!" or, "Salesman!" Cashiers and salespersons were believed to be the most suspect group of workers. They were known to short-weigh, short-change, overcharge, and sell low quality produce and other goods as though they were first quality, and then pocket the difference. Eva brooded, "How hateful and prejudiced I have become. Maybe her husband had not been a political prosecutor — only a criminal one. What if she says she doesn't know? It can be that she is telling the truth. All prosecutors, whatever kind they are, keep their classification secret. And what if she is a cashier? Maybe she is an honest one."

Eva's doubts were temporarily pushed aside by the generosity of Sonya's family. They went out of their way to make Eva's first visit to this beautiful city memorable. She visited the Hermitage where, although many of the exhibits were still in vaults where they had been stored during the war, she was thrilled to see original works by Rubens and Van Dykes. They took her to the Winter Palace and the gardens of the Summer Palace. She saw the Admiralty Building and the statue of the founder of the city, Peter the First. The memorial that made the deepest impact upon her was a simple plaque on the wall of a building on the Nevski, the main street in the heart of the city. It carried a warning for people to cross to the other side as this was the side most often hit during bombings. This plaque, evidently replacing the original crudely printed wooden sign, was to be a permanent reminder of the war. Only the sights of the *Aurora*, the ship from which the shot was fired that signaled the beginning of the Revolution, and Smolny, the scene of Lenin's takeover, both of which would have thrilled Eva in the past, left her cold.

When Eva later reviewed this journey with Valeria, she said, "How far I have moved from my father's teaching. Would he, too, have changed, I wonder? What would he think that I should not have felt the slightest excitement when standing before the *Aurora* and being at Smolny!"

After she returned from Leningrad, Eva at once set about looking for a different room. In the Room Exchange Bulletin she found an address on a side street off Red Square. She was ecstatic because it was exactly what she had dreamed of — a large, sunny room in a flat that had not only a bathtub but also a shower, and, glory of glories, she told Esther, "a telephone!" True, three families were living in the flat, but where would one find a private flat in Moscow? The exchange was mutually satisfactory. Both families filled out applications, went through other required formalities, and were told to return in two weeks. Both appeared at the appointed time expecting the exchange to be automatically completed. The official opened his remarks to Eva. "You can't move into that house! Why are you looking for a house in that neighborhood? You know that you are limited to a specific radius of Red Square." She was stunned into silence. He turned to her partner in the exchange. "Don't you know that you are dealing with the family of enemies of the people?" The lady paled.

Eva went to her defense. "I don't think it is necessary for me to tell strangers about my family affairs. Why should she need to know that my husband died in a camp?"

The official fumed, "Not only your husband. Your father, too," and lectured her on the baseness of attempting to conceal such damning facts. The lady, dumbfounded, turned on her heel and let Eva struggle on her own.

Sonya had agreed to remain in Leningrad until the housing situation was settled, but two months after Abie returned home permanently, she and her daughter appeared unannounced with all their possessions. They had come to stay. In order to accommodate the new family, a section of the room was divided by furniture and curtains.

In less than a month, tensions flourished. In spite of the fact that Sonya had made it clearly understood that she, her daughter, and Abie were to be a family unit separate from the others, and she expected no interference in her kitchen and in her home behind the curtain, Sonya

was underfoot looking over Esther's shoulder and suggesting how, in her opinion, Esther should prepare their meals and clean the house. Esther, quietly, listened and ignored her, and continued to function in her own accustomed manner. Sonya, not to be disregarded, soon insisted and then began demanding that Esther do things her way. In the end, she turned to the other neighbors to support her contention that she was the more competent. Natasha's first — and last — growl discouraged her from any more interference with her small family, but the other young neighbor, Lydia, a newlywed who had moved in after Bernice moved out, required a little more needling before she imitated Esther's approach. The friendly relations between Lydia and Esther added to Sonya's irritation and evoked harsh words from her.

Next, Sonya turned to nagging Eva. At first, beginning just a few days after her arrival, she observed gently, as if in wonder, "You sit and read every night," and then, as if in concern, "You should go to bed earlier." Gradually, her remarks became critical. "There is housework to do and you sit and read! You won't get any smarter by reading so much. Besides, you use too much light." With the passing of the months, the nagging increased. "You think you're smart because you're a university teacher. What good did your reading ever do you? Did you make any money during the war? You'd better be careful. The *domovoi* [evil spirit, bogeyman] doesn't like idle hands. That's why you lost everything."

Eva, incensed, would try to suppress a retort, but one time she replied, "Why don't you mind your own business? Do you mend my stockings or clothes? Do you cook for me or Tommy or my mother? Don't be so afraid of your domovoi. He'll punish me, not you."

Sonya was not about to allow Eva the last word. "But I live here and will become involved, whether you like it or not!"

Sonya became the focus of conversation between Esther and Eva. "Another failure of the Soviet system. Most of her life she was educated under the period of enlightenment, in the era of the Revolution, and she still believes in the domovoi! How is that possible?" they would say to each other. This woman was beyond their capacity to understand.

Their contempt for her intensified when she began to proclaim loudly and proudly that she was smarter and more ingenious than most and certainly more than her new in-laws, for she had accumulated 40,000

rubles during the war while most people had lost everything. She bemoaned that the war had come to an end; she had needed just half a year more and she would have made an even 50,000. She attained her wealth by bartering and selling merchandise between villages and the city, somehow managing to secure in the city products for which villagers yearned in exchange for produce impossible to purchase in the city, and then reselling it at astronomical prices. "Siege? Only fools suffered and died in the Siege."

Sonya was rapidly losing the respect of Abie, too. "Some help for the war effort," was all that he dared say in her defense in his effort to keep the peace. Eva and Esther were aghast. "She lost her husband in the Siege, but the war didn't last long enough for her! What kind of a person is she? Is this a human being?" Eva wanted to know. Sonya never disclosed to Abie nor to her in-laws how she had manipulated the travel between the city and the villages under the strict wartime controls of the railroads. Eva guessed that she had bribed someone, but Esther insisted, "No, she's too stingy to part with money that way. She must have found a way without it costing her a kopeck."

Esther recalled their weeks at the Murom Railroad Station where a family of speculators literally saved their lives. "Did we respect Alexander Andreyevich Kostikov any more than we do Sonya?"

Eva answered, "We did not want to think about what they were doing. They needed us and we them. They never flaunted their misdeeds at anybody there, and furthermore, they were generous to everybody. Their innate kindness softened the shock of the crime. But to have in our own family a war profiteer — and one who is proud of her crime! It's a terrible shame."

Esther finally felt compelled to say something to Abie, "You added a treasure to the family this time, a greater one than Natasha. Why don't you look before you leap? Didn't we have enough troubles without having to suffer with your wives?"

And Natasha's revenge was fulfilled! "Do you want me to win him back — away from that woman?" she asked Eva, in all seriousness.

Sonya's bragging about her fortune was no idle boast. During the money reforms which occurred soon after she came to Moscow, when one hundred rubles were reduced to the value of ten, she panicked and

could not conceal her fear of being questioned about the source of so much money. She redistributed it and deposited it in several banks, but she did not have sufficient time to make the rounds to all of them, causing her to lose a certain percentage of it. Although the prices were reduced at the same rate of exchange, she felt menaced by the threat of losing a large part of her fortune. If this indeed happened, neither Esther, Eva, nor Abie learned about it because she did not stop crowing about her wealth. Her habits did not cease when she obtained her cashier's job in Moscow. Her temperament at home was the barometer of the monetary success or failure of her day at work. Esther often would caution Eva. "Take care. Keep out of her way. She's in a vile temper. She must have stolen less than usual today."

During the draining, subsequent years, these circumstances continued unabated and were it not for the support Eva got from Sheva, Jane, and Valeria, and her ability to lose herself in a book and her work, Eva would have collapsed. Abie, as addicted to books as Eva, read surreptitiously when Sonya was out. At her insistence, he gave up his only other form of relaxation and escape, his trips to the art museums. What money did going to art galleries bring him?

About the same time as the money reforms, another government edict was announced. Rationing had been removed. Eva heard the news from a broadcast. "Ma! the war is really over. No more ration cards! No more having ration cards on our minds. No more fear of losing them! And prices! They're going down! No more restrictions on buying what we need!"

Esther was dubious. She did not respond jubilantly to anything any more, "I'll wait and see. I won't throw out the cards yet. It may be a propaganda trick. When I can buy what I want at cheaper prices without the cards, then I'll believe it."

A few days later she returned from her marketing to admit that the announcement was correct. "Maybe you should quit your night job," she said. "Something nice should happen here now that I can throw the cards away. You worry me, always on the run. You're becoming almost as bad-tempered as Sonya. Now we can manage. You have to let up. You can't go on this way much longer. Besides, we'll have more money when the government loans are repaid and that should be soon. They are long

past due."

Eva snorted bitterly at Esther's optimism, "In Stalin We Trust." Esther's hope that Eva might also drop the private tutoring evaporated when Eva made her aware that, following the additional economic news about the money reforms and the end of rationing, the date of repayment of the loans was extended another ten years. For the most part it appeared that no complaint came from the people. They reasoned, "The war took so much. Where would the government get enough to pay back the loans and at the same time repair all the damage caused by the bombings?" But Eva's patriotic fervor was gone. She resented having ever agreed to give this government a slice of her paycheck, at Morris's behest, "to hasten the industrialization of the country."

Yet, Eva was indeed exhausted. The rushing from one end of the city to the other — from the institute to the Arbat, and still meeting those night classes which she had taken on at Helen's recommendation while she was still at School 183 — was taking its toll. She agreed that the family could manage easily on her combined salary from the institute and the fees she was earning from an increasing number of private students. She enjoyed the latter and would not give them up. She took her mother's advice and reduced her work load.

Part Four
The Second Wave of Terror

Chapter 13

A sickness of anti-Semitism was spreading throughout the Soviet population. Jews like Eva believed it had been wiped out under the influence of the Communist Party of the Soviet Union, but in fact it had been lying dormant. Young Jews, growing up with the Revolution, had become assimilated — they had intermarried, integrated, and in their nationalistic fervor even Russified their names, happy to be in the mainstream of their land. But gradually, insidiously, anti-Semitism was reappearing.

On his first leave, Abie had brought home a firsthand account. He and Itzhak had been the only two Jews in the hospital ward of twenty patients. They were lying in their beds, Abie with his eyes and the left side of his face in bandages and Itzhak's right hand and left foot in slings hanging from ropes attached to rods along his bed. The soldiers in the adjoining beds, chafing from their wounds, broke out into obscenities and blasphemies aimed at Jews. "Those lousy kikes! They are all fighting on the money front in Tashkent. [Tashkent was the capital of the Uzbek Soviet Republic in southwest Asia. Many educational and cultural institutions where a large percentage of Jews were employed were evacuated to Tashkent.] Those rich Jew bastards — nothing but cowards. They live to spend their money while we Russians die for them." Every day Abie and Itzhak listened and bristled at their insults.

Esther and Eva, after listening to Abie's story, wanted to know, "How did you answer them?"

"Answer them? What can you say to idiots? Anything we would say would not prove a thing — anyhow, they could not be convinced."

211

"But they were wounded fighting against Hitler's belief that one race was superior to the others!"

"Aryan superiority, you mean? They know this. They know that to Germans the Russians are inferior. The Fascists were as brutal to them as they were to the Jews. But do you think for one minute that their anti-Semitic sentiments have disappeared now that their wounds have healed? In my unit, this kind of talk goes on every day."

Eva nodded with understanding, recalling the humiliation she and Esther had faced at the Red Banner kolkhoz when Dunya had accused them, because they were Jews, of stealing some of her belongings. Just like Dunya, Eva thought, millions of other Russians had taken in anti-Semitism "with their mother's milk."

More and more often Eva was now finding herself in the midst of this virulently poisonous environment. One evening, reading a book while she was waiting in line to buy food, she was shocked to hear a voice shouting. "Hitler didn't kill enough of you kikes! You're always trying to get things without waiting in line like the rest of us!"

A weak, frightened voice answered, "But I took a place. I asked this comrade here to remember me. I told her I would soon be back." "This comrade" gazed silently into the distance and the woman, tears in her eyes, had to move to a new spot far back in the line. Although agitated, Eva felt helpless to do anything.

While awaiting a trolley at the bus terminal in the Square of the Revolution, again, Eva witnessed the spreading disease. An elderly lady and a woman carrying an infant were queued up at the front of the line. Another woman holding tightly to the hand of a young child was edging her way behind them as the bus was rolling to a stop. The patrons behind her politely made room for her in accordance with the automatic rule that women with children, old people, and the disabled might board the bus first and be given a seat. A one-legged man in uniform, supporting himself on crutches, stepped up to the entrance just after the door opened and a man standing in the line shrieked out, "Hey, you, Sheeny! Get off and get back into the line! You damn kikes always break ahead of everybody else!"

The crippled man yelled back, "You Russian bastard! You're not even in uniform. You were making money and whoring around when I

lost my leg at the front!" Holding onto the railing and a crutch at the same time, with his other hand he raised the second crutch and swinging it, tried to strike his abuser. Most alarming and dismaying to Eva was not the Russian's continued provocation, "You yellow sheenies!" but that nobody uttered a word; not one voice was raised in defense of a man crippled in battle upon whom racist insults were being flung. She shrank, silent and frightened for her own physical safety; she did not dare raise a voice in his behalf. She was not only a Jew, but also a foreigner with a very distinct American accent, not to mention being the daughter and the wife of "enemies." Stories were spreading about victimized Jews who had had the courage to take the offenders to the police only to have their cases distorted so that they themselves were accused of being the provocateurs.

That anti-Semitic sentiments went beyond the street level was brought to her even more acutely in her school. Elizaveta Stepanovna, a young third grade teacher, and a Russian, who was born and raised under the Soviet regime, once in conversation with Eva made a derogatory remark about Jews. Eva said, "But Leezachka! I'm a Jewess." The young woman looked at Eva in disbelief. "You a Jew? You're an American, not a Jew!" On Eva's explanation that Americans were of many backgrounds and nationalities, including Jewish, Leezachka responded, "Well, if there are Jews in America, they're not really Jews, at least not like the pushy ones here. You don't look or act like a Jew." Eva was convinced that such a remark from her would never have occurred before the war.

What had set this off? Helen and Sheva and Jane and Eva would discuss this subject for hours. They wondered if Stalin's victory toast had shaken the minorities. "To the Great Russian People," he had said, lifting high his glass. This toast had been publicized throughout the country. Had only the Russians given their lives to defeat Hitler's armies? Was this the implication? What about the peoples of the other republics? What about the Jews?

Eva's identity as a Jew was being thrust upon her, and the recent founding of the State of Israel began to take on special significance. If the Soviet Union had failed so dismally to eradicate anti-Semitism, the only solution had to be a Jewish land, she was beginning to think. The increasing harassment of Jews, which Valeria and Alexandra called the

silent Soviet Jewish pogroms, accelerated and became more vicious after Golda Meier's arrival in Moscow, in 1948, as the first ambassador to the Soviet Union from Israel. She brought dignity with her and became a symbol for the Soviet Jews. After two thousand years, the Jews had a homeland again and she was a living personification of that fact. Even so, the newspapers did not report her coming nor print photographs of the reception she received. "But I'll wager the security police took plenty of photos," Helen said to Eva. Rumors spread like wildfire throughout Moscow that, when Meier appeared at the only synagogue on Fridays and on the Jewish holidays, she was mobbed by weeping Jews. For the first time, large numbers of them took the trouble to learn something about the holy days and attend the synagogue. Among Eva's close friends, all of them Jewish with the exception of Valeria who had been married to a Jew, the reason for the resurgence of interest in their Jewish ethnicity was clear. The Soviet Jews might not have been so enthusiastic if what they had been taught about Soviet ideals regarding their acceptance had been true, if Jews were not harassed, if they had been accepted as equals with all other Soviet citizens in reality — not in theory. Now the words "kike" or "zhid" and "Sarah" and "Abram," the ancient Hebrew names that had endured through the centuries in the ghettoes, were replaced with "Zionist."

At the same time that the revival of anti-Semitism was becoming more apparent, the government seemed to be encouraging an incredibly chauvinistic campaign of Russification. Eva's circle of friends decided that the authorities had become alarmed by the stories that the returned servicemen were telling of life abroad, which were quite the opposite of what they had been taught. Whatever the reason, distortion of history and scientific credits became the order of the times. Every great invention and discovery that had moved civilization forward was reputed to have been by a Russian. In the new approved textbooks, Russian names replaced the previously acknowledged discoverer of electricity and the inventors of the light bulb, radio, and wireless. Every genius in physics, chemistry, and math, it seemed, was a Russian. New interpretations of history and historical figures were given. Ivan IV, known for centuries as "The Terrible," was suddenly forgiven for his excesses, explained away as having been exaggerated by his enemies — his unification of the

dukedoms into one strong state and creation of a unified Russia was sufficient to make him a hero. The names of old Russian warriors, most of whom had been skeletons in the closet since the Revolution, popped up and their owners were hailed as the saviors of Russia in its various wars. "Why," Eva wanted to know, "have these stories about them not been told before?"

"Ask Stalin," Helen suggested.

Alexandra was disgusted and angry. "I'm ashamed to be a Russian when I read these adulterated, boasting lies. Look who's talking! They always accuse the capitalist countries of falsifying history, but who are better liars than we? Look how many different versions of Party history and the Revolution we have been fed. Only Papa Stalin was involved; he made the Revolution single-handedly. Oh, he'll grant there was a Lenin somewhere but the poor man must have had to ask Stalin for permission to blow his nose! Who heard of Stalin before Lenin died?"

Helen related reactions of her colleagues in the departments of physics, chemistry, and history belittling changes in their new textbooks. Eva echoed Helen's stories, but said, "I just listen. Who knows? Maybe in just such a session they will one day be pointed out as traitors. I'll follow the outline as instructed and laugh in the privacy of my own house."

Indications of another political upheaval were becoming unmistakable. One day Eva read a very conspicuous bulletin at work: "A meeting will be held at five o'clock in the large movie hall. All teachers and other employees are urged to attend." The boldness of the print made the announcement an order; attendance was obligatory.

The institute's Party leadership was hurling attacks of "cosmopolitanism" against several staff members, most of them actively engaged in filmmaking as well as teaching. The use of the expression launched a new hysteria. "It means kow-towing to the West by praising Western technology," Eva decided. The procedures were familiar, the accused being expelled from the Party and fired at the same time. Among them was a world famous film director, one of the founders of the Soviet cinema and the institute. He was forbidden by the Film Ministry to work in any field of the industry; his students protested the action, but

215

their rebellion was quickly quashed.

Within a few days, Sheva and Jane were reporting compulsory attendance at the same types of meetings. Soon, newspaper articles began to appear daily about the scheming activities of "rootless cosmopolitans" who "had no love, no feeling of patriotism, no loyalty to any country." The meaning of the phrase was at first puzzling, but as the theme reappeared and names were mentioned, Valeria suggested that this might be the beginning of an anti-Semitic campaign. At first, Eva denied that this could be so. "At the institute, gentiles as well as Jews have been accused and fired," she pointed out. "In fact, the most scandalous firing, the world-famous director, was not Jewish." But when other lists were published, with birth names easily identifiable as Jewish given in parentheses after the Russified names, she had to agree. Jews were losing their jobs in frightening numbers, and Eva began to fear that one day she would be told to go.

She was also increasingly concerned about Tommy. Was Tommy to suffer a lifetime of insecurity and inequity as the daughter and granddaughter of "enemies," to suffer as a Jewess, to be inhibited forever in her need to give expression to her own beliefs, to have to obey without questioning, to sit through years of schooling and finish with a meaningless education? She needed to find a way to give her daughter as normal a life as possible. After long tortured thoughts and self-evaluation, she decided, with Esther's approval, to make a dangerous move. She wrote to a close friend of her parents living in the United States, an attorney, and asked her in subtle language to try to get Tommy out of the Soviet Union. She knew that she herself would never be given permission to leave.

There was no answer, but she received a letter from her Uncle Pat and she knew he had been contacted. He wrote, "Pa and Max are gone and Abie is disabled. You have no reason to remain, especially after all that has happened. I am coming to take you all home." It hinted to Esther and Eva that their people knew what had happened. The blunt wording of Uncle Peter's letter caused more nervous and sleepless nights, always with the expectation of the after-midnight knock on their door. Uncle Peter never came.

Soon, Eva felt the first sting. One day, Maria Emelyanovna asked Eva for a moment of conversation. She said hesitantly, "Eva Moisseyevna, I must ask that you discontinue my daughter's lessons." She was apologetic. "It would be better that you do not come to our house anymore. I'm sorry. Rumors are that it is dangerous for us to associate with foreigners."

Maria Emelyanovna had recharged so much of Eva that had been dying. She had appreciated Eva's professional competence and special talent; she had given her the opportunity to secure the kind of work that not only suited her temperament and personality but also permitted her to achieve a certain degree of distinction, so vital in a society which had utterly rejected her. "And now again!" she cried to Abie, "We're foreigners. There is no way that we can prove ourselves as Russians. We're dangerous to the Russians! No more fraternizing for me. I can't take this!"

A week later, Sheva told Eva that Jack Simon, a friend in the early days before the war and one of the few Americans who had not returned to the United States during the raids of the thirties, had been arrested. A month later, Jane Altman whispered to Eva that Frances' husband, Joe Goldman, had been taken and that Frances had not only been fired, but was also being threatened with eviction. Frances and Eva had not communicated since Morris's arrest, and Eva had not taken the initiative to resume the friendship, unable to tolerate more rebuff. By the time of her husband's arrest, Frances was working in the Foreign Language Institute, the Anglo-American School no longer in existence. Eva had heard that Joe had entered the institute as a student, and after graduation, he, too, had been given work there. Their eldest daughter, Shura, had been among the first children to be born to a couple in the English-speaking colony, about two years before Tommy. Two other daughters had been born since Eva's last contact with them. Until this current year, apparently life for them had not been difficult. Their jobs seemed secure, housing in the dormitories owned by the institute was as comfortable and perhaps even more so for them than for the average Russian in Moscow, and the first wave of terror had passed them by. And, besides, any effort to return to the United States during those years would have been fraught with obstacles.

"She must be in a state," Jane said to Eva. "I'm sure she needs our help."

"What do we have to lose?" Eva remarked fatalistically. "We're on the MGB [formerly NKVD] list already. Until they come for us, we can do something for her."

Eva and Tommy visited Frances several times a week, Eva usually taking gifts of food and clothing — essentials for the children. Since Tommy had never known Joe, and it was obvious that Shura had been cautioned to be silent regarding him, no mention of his arrest was made to her. She was given the impression that he had been assigned work in another area of the country. With the resumption of contact between Eva and Frances, Esther was happy that her daughter was spending time with other people. She was also pleased that Tommy had been widening her all too limited circle of acquaintances by developing a friendship with Shura. Clearly, neither of them was as dependent on her as they had been in the past.

By mid-April, 1949, around Esther's sixtieth birthday, she began to complain that old age was upon her and she was feeling its infirmities. It was unlike her to ask for relief from the household chores and to turn inward to her own ailments, but she did not protest when Eva hired a day worker to do housework and, eventually, to help nurse her. When the news spread that arrests were again taking place, neither Eva nor Abie felt that she needed to be aggravated, and they concealed these renewed threats from her.

Each passing week brought increasing complaints from Esther, and she was finally persuaded to go to the medical clinic. After a series of tests, Eva was told that her mother had "galloping" rheumatism. Not until the last week of her life, when a group of doctors came to her bedside on a consultation request, did they make a final diagnosis of sarcoma.

For everyone, Esther's illness brought on a trying time of a different kind. It was hard watching her suffer through the severe pain and particularly to observe her rapid physical deterioration. Jane and Sadie were frequent and welcome visitors, offering badly needed distraction. Esther, particularly, was grateful to them, for she wanted company for Eva, who, after her day's work took over from the houseworker.

It was a rare break for Eva when she could spend a few hours with Jane and Helen and Sheva at Frances' house. They needed each other for support. Who would be arrested next? If Frances were to be taken, what would happen to her children? How might or should one behave to avoid arrest? Eva was warned that for her to continue to write to friends and relatives in the US would place the spotlight on her. She countered with the names of others whom they all knew or had been told were arrested — in spite of their having given up their communication with people in the States. It was suggested that those Americans who in the early thirties had registered as Jews for ethnic identification were targets. Up popped a name of one who had interpreted the question on nationality as place of birth and had registered as American. It was impossible to guess how the MGB made its selections.

Jane had a more pressing problem. She was on the verge of marriage but her fiancé was reluctant to proceed because he knew her family history. He even openly told her that should there be another arrest in her family — perhaps her brother, or perhaps her mother, or even herself — she should expect no admission from him that he ever knew any of them. But Jane would have little reason to worry about marriage.

A few days before the summer holidays of 1949, Eva stopped at Jane's room to pick her up for a prearranged outing. Her mother opened the door. She pushed Eva aside into the hallway and whispered frantically, "Go away! Go away quickly." Her face was ashen. She seemed desperate, looked ill.

"What is it?" Eva asked, clutching at the woman's arm to steady her. "Hold on to me. Let me help you."

"Jane was arrested!" she mouthed, looking around as if to run off from Eva should someone see them talking together. "Go! It is dangerous for you to be seen here."

"Sadie! You know that I am in no better position than Jane. Let me come in."

The room looked as if a cyclone had passed through it. "They went through everything. They took her notebooks of beautiful poetry. What chance will there ever be to get them published?"

Eva thought, "What chance will she have when they go through her writings — filled with tears and criticism of the establishment that

219

had killed her father?"

Sadie did not know more. She lived at another address and Jane's landlady had phoned her to tell her of this MGB visit. She had no idea where to begin her search for her daughter, yet much of her time came to be taken up with that very effort. Sadie apologized to Eva for discontinuing her visits, but both women realized that if she appeared at the Stolars' flat without Jane, Esther would need an explanation. It had already been decided that Esther would not be told about Jane; it would be better that Esther should not have to undergo the torment that her children, too, might die as Morris had.

Throughout the summer, the nurse made routine calls to give Esther her daily injections to ease her pain. Esther's only guest was Bluma Abramovna who, leaning heavily on a crutch, managed to hobble up the flight of stairs. Her own state of health was precarious, a leg amputation having been done a few years earlier to save her life.

Esther bemoaned Jane's and Sadie's lack of consideration and would bitterly repeat, "You spend all of your time looking after me. Now that you can't leave me, your friend and her mother don't come. Fine friends you have!" Often Eva was tempted to tell her the reason, if only to restore some of her faith in human beings while she was still alive. The additional tense relationship between them and Sonya, who sulked in the kitchen whenever she was not at work and who openly resented any attention Abie gave to his mother, added to the gloominess.

Esther, however, was never to suffer through the new terror which would soon enmesh her family. She died at midnight on September 1, 1949.

Chapter 15

As Eva grappled with her sadness over the growing number of arrests, she was being further worn down by her insomnia. The doctors continued to discourage her from using medication to induce sleep, warning her that its hazards outweighed its benefits. She followed their advice, fearing that a greater and more severe illness might incapacitate her completely and deprive fourteen-year-old Tommy of guardianship and supervision. The doctors urged her to take care of the one problem she was able to speak of that might be related to her tensions — the housing situation. "What can I do about that?" she asked. "We have tried to find separate rooms for years — since my brother's marriage." They could only be sympathetic, as if to say, "We understand. We are in similar situations."

Uncertainties associated with the renewed political arrests and the resulting changes she had to make in her relationships with her colleagues were problems Eva did not discuss with her doctors. Whatever satisfaction she got from her work before this new wave of raids and arrests was now completely gone. Since Maria Emelyanovna had dismissed her, Eva had changed her relationship with her co-workers. Whatever interaction her work required, she now conducted it in a formal, business-like manner. She said to Valeria, "No one seems to care. I think that they are relieved that I made the first move to keep them at a distance."

Eva's fatigue and depression did not put a stop to her search for new housing. She and Abie, who fully appreciated the hardship his marriages had placed upon his family, poured through the Exchange Bulletin and the Exchange Bureau files. Because this was their first attempt

at making a housing change on their own since they had arrived in the Soviet Union, they were not familiar with the procedures and ran into many difficulties. "After twenty years here, you would imagine the rules would be second nature to us," they remarked to each other. But, this experience — which dragged on for nearly two years — taught them all about the details and subtleties of the complex housing exchange policies.

Finally, it occurred to Eva and Abie that Sonya was withholding her approval in the hope of coercing yet additional space where she and Abie were living. Eva threatened her with a court order, a common action to force agreement from dissenters such as Sonya who for reasons quite like hers, or often for petty revenge, refused to give approval for room exchanges. This threat forced Sonya to acquiesce when the next favorable exchange opportunity came along.

When Esther died, Abie argued with Sonya that Tommy and Eva were entitled to the larger space because this had originally been their home and that the families that he had accumulated with his marriages had crowded them out. He demanded that Sonya do nothing to prevent Eva and Tommy from claiming this space. Then, almost miraculously, at the end of March, 1951, an exchange of rooms was agreed upon and was to take place within the month. She couldn't believe her good luck! For a short time her depression lifted.

It was two o'clock in the morning of April 4, 1951. Eva was reading in the kitchen under a dim light so as not to disturb those sleeping in the other room. Her concentration was occasionally broken by the somber thought that this day was her mother's birthday. In the stillness of the night, she heard the sound of an automobile, unusual in this vicinity and at this hour. When it came close to the house, the sound stopped. She sensed, "This is it!" There was a knock on the door. She opened it to three men, one flashing a warrant and an order for her arrest. She was grateful that Esther was not alive.

On the order that Eva immediately accompany the men, words came from Tommy's lips. At first they were muffled, then they became clear and unconstrained entreaties. "Where are you taking her?" She looked pitifully young, her face white and small between the long black

222

braids hanging from her head. The mist in her eyes, the same soft, deep, almond eyes of her infancy, raised a response. "Don't worry, little girl. There is nothing wrong. She'll be home in a few days."

She spotted the lie. "Like my father returned home?" she cried. The remark was ignored. She persisted. "Where shall I go to find out at least where she is and if she is alive?"

She was handed a strip of paper. "This is where you can go — ." And again, "Calm down, little girl. Nothing is wrong. Your mamma will be home in a few days."

Tommy was oblivious to Abie's attempts to restrain her from following them. Abruptly, she turned from him and sat on her bed. It was as if she were entirely alone. The others in the room faded from her consciousness and from that moment were to her no more than strangers by whom she and her mother had been ensnared into sharing their flat, strangers always restricting her need for privacy, crowding her, never offering her intimacy — first Natasha and her daughter Galina, then Sonya and her daughter Bronia. And now, without her mother, Tommy became the outsider in this flat where she had recollections — dim, but certainly real — of having been surrounded with affection. She had to escape. She didn't recall changing out of her night gown into other clothing. She was momentarily detached from reality. She heard someone say, "Let her go," and she found herself on the street, with more strangers crowding her on the walk.

Tommy saw a telephone booth. A name came to her of an acquaintance of her mother's, someone she had not seen for some time, whose son had been her playmate when they were younger. She had a telephone. Tommy needed to relieve herself of the heaviness in her chest. "Manya! This is Tommy." The pleasure that came across from the voice at the other end of the line gave her momentary comfort. "Manya! My mother was just arrested!"

The reply was a long silence. Tommy felt that she had done something terribly wrong — as when she had been a very little girl, not more than five years of age and her mother had taken her, with her mother's sixth-grade class, to the Moscow Art Theater to view a special performance of Maeterlinck's *The Blue Bird*. Tommy had been jubilant, basking in the admiration of the older girls, answering their questions proudly.

"My name is Tamara."

"Do you speak English, Tamara?"

"Yes, I speak English. I speak three languages!"

"Three languages! English? Russian? And — ?"

"I speak Russian and I speak English and —" She looked up proudly at her mother. "I also speak Yiddish." There was a look, a break in the attention that had been all hers. Suddenly she became confused as if she had said something terribly wrong. She knew that she had said something she should not have said.

Now the same blurred sensation came over Tommy. She quickly replaced the receiver on the hook. She realized that she must not talk. Nobody must hear from her lips that her mother had been taken away. Nobody wanted her to say this. Everybody was afraid to know. She broke into a run. A streetcar had moved parallel with her body and she accelerated to meet it. It would take her to Babushka Alexandra and Valya. She held herself firmly, swaying slightly with the motion of the car. Her head spun with thoughts. She was to conceal her mother's arrest as she had been warned to conceal her daddy's imprisonment. "Mamma! You lied to me!" Igor's taunting her that her father was an enemy of the people and had been condemned to a camp for traitors had sent her dashing into the house. "Mamma, you lied to me! You tell me I am never to tell a lie, but you lied to me. My daddy is not a soldier at the front! He is an enemy!"

Eva had knelt down to look her daughter in the eyes. She dried the tear-strained face. "No, your daddy is not an enemy!" she said firmly. "It is true that I lied to you. Your daddy is not a soldier. But he is not an enemy." Tommy still remembered the sense of relief that came over her. Her mother had spoken emphatically, lovingly, and reassuringly. Her instincts told her that she was speaking the truth — that her daddy was not an enemy. "I had to lie to you because you were too young to understand what had happened. But now I can talk with you and tell you what happened. I can talk with you because you are no longer a baby, and I can trust you to believe in me and in what I say, and for you to do what I am going to ask you to do. You must do what I ask for my sake and for Abie and your Babushka Esther and Babushka Alexandra and Valya — and for yourself."

It was then that Tommy became aware of the tragedy and the burden of secrecy that was borne by her family. Igor had heard about her father because his mother and father were living in the same building that night when the NKVD had knocked on many doors and had taken many fathers and even mothers to prison. Igor was lucky. Neither of his parents was taken. But her daddy was among those taken, although he had done nothing wrong. People were taken even if they did nothing wrong. He was loyal and he had been an udarnik. But the leaders of the country had made a mistake; they did not yet realize it but someday they would. Until they did, Tommy was not to talk about her daddy to strangers nor to answer any questions about him except to say, if she were asked, that she didn't know where he was. If Maria Petrovna knew that he was in a camp, her mother would lose her job and there would be no money for food, and they would again be hungry as they had been during the war. Mamma might even be arrested.

The child listened intently. She tried to grasp all that her mother was saying. The sober expression on her mother's face and the seriousness of her manner — her speaking to ten-year-old Tommy for the first time as an equal — held Tommy's attention and gave her the awareness that this was important. She was frightened. An awesome responsibility was now hers.

The names of Tommy's uncles and her grandfather Morris were frequently mentioned. Gradually, with the passing of months and years, there developed in Tommy the understanding of the envelopment of her family by the system under which she existed. She mouthed the slogans and the values that were held up to the children and young people by their teachers and in the compulsory Komsomol organization, but was careful to avoid making spontaneous statements that might reveal her anger. She never raised discussions with her peers that might require critical examination of their patriotic zeal, and was silent when they attempted to involve her in any of her feelings. Tommy now shuddered. How had she permitted herself to weaken! To have automatically sought comfort from Manya!

The streetcar seemed strangely empty of young people. School! This was a school day! She had forgotten completely. For a moment ambivalence clutched her. But her need for Alexandra and Valya was

desperate. She shrugged off her delinquency.

Grandmother and granddaughter wept together. But Alexandra did not weep long. She denied herself this release. She was now seventy-five years of age. Only her daughter and granddaughter were left to her and any day she might be totally alone. That Valeria would be taken — and soon — there was no question. This fifteen year old girl might also disappear. For now, however, the child needed her support. As though becoming a young mother again, she cradled Tommy as she had cradled her own to whom she had given birth. The tears spent, they waited for Valeria to come home from work.

Valeria, too, thrust aside thoughts of the inevitable and outlined for Tommy what she must immediately do. Tomorrow she must go to the address given to her by the MGB to get information, and she should take money and clothing with her. How could Eva have so utterly lost herself as to have gone without a bag of essentials — after all these years of anticipating this eventuality? She was so matter-of-fact in the manner with which she confronted Eva's arrest that for a few hours Tommy permitted herself to believe that the security officer might have spoken the truth — that her mother might indeed be home within a few days. But she balked when her aunt ordered her to return to school. "Not until my mother returns," she insisted.

"All right. Tomorrow you cannot go to school. You must go for the information. But after that you must go back. It would be foolish to lose an entire year for only a two month absence," both Valeria and Alexandra argued. "In two months, the vacation begins." But Tommy would not make any promises.

By bedtime, the realities returned and the tensions began to mount again. Tommy stayed the night and when she crept into bed, she hugged close to her grandmother. Exhaustion took its toll in deep and welcomed sleep.

On this first day following Eva's arrest, Tommy could not locate the entrance to the address which had been given to her. She searched around, found a gate, and pushed at it only to find it closed. The second day, the gate gave way to her slight pressure. She entered an enclosed yard, no different from other yards except that there were several men sitting around a small table comfortably shaded by a large tree. They

were playing dominoes. None of them gave the slightest nod. She looked around for a door or for some sign that might direct her into the building, and when she found nothing, she decided to leave. Suddenly, from the surface of the building, a wall slid open, exposing the outline of a room inside. A woman, her face pale, stepped out, her eyes squinting in the daylight. Tommy sensed that this woman must be on the same mission. Before she could ask the question, the woman on seeing her said, "That's what you are looking for. You must go in here."

The room was very dark and small. When her eyes became accustomed to the dimness, Tommy found herself among a great many other people. There were only a few chairs, occupied by people who were elderly. She took her place in line, standing, waiting to enter another room. The line moved slowly. Hours passed before her turn came. She gave her mother's name and received a terse answer. "We know nothing about her. Come next week."

Tommy returned to school within the week. While she waited out these first weeks after her mother's arrest, at each visit unable to wrest more of a response than, "Come next week," her schoolwork provided a diversion. She alternated her time between her own home and her grandmother's, settling herself in her own room only on the days when Sonya was at work. Soon after Abie's marriage, Tommy's relationship with him had become strained because of Sonya's determined possessiveness. She did not appreciate — until years later — that her uncle was also going through a bad time. He was suffering sleepless nights; first, anticipating at the slightest sound that the MGB was at the door to take him away, and then, broken, because his second marriage also was a failure.

During one of these first days, Sheva had appeared at the door. Tommy knew immediately from the frightened expression on her face that she had already learned of Eva's arrest. The children at the entry way, aware that she was a frequent visitor of Eva's, had greeted her with the news. In the following few weeks, she came frequently, her schedule timed to coincide with Sonya's working days. Together they would make supper, eating leisurely while Sheva drew out Tommy's fears and occasional optimistic hopes that this strange time would quickly pass. The day that the school principal had summoned Tommy to the office, early

in the second week, Sheva was there to share her rage and to offer comfort. "We know that your mother was arrested," the principal had announced. "I think you should drop out of school."

Tommy screamed to Sheva, "She doesn't want me to continue. Just drop out! Just like that! I asked her what she thought I was to do without an education, without a specialty. Where could I find work? Do you know what she answered? 'You are a clever student. You read and write very well. Anybody will be glad to give you work.' I didn't let on that I intended to drop anyway when the year ends. I didn't want to give her that satisfaction. I hope she is right that I can get a job. How else will I live?" she moaned. "She wanted me to drop out today — at the end of the day! When I asked to be able to finish out the year, she thought it through and finally said 'Yes!' But with the last words, 'Next year I would rather that you do not come back.'"

They had a long talk about the importance of finishing school, about Eva's hopes that Tommy would continue on through higher education. Sheva pointed out to her that she must not overlook the opportunities to complete secondary school in the evening sessions; getting a university education was still a possibility. Tommy appreciated this good advice and looked forward to more talks with her, but Sheva's visits soon stopped.

Three weeks after Eva's arrest, Valeria was taken. Every week for many weeks, Tommy returned to the MGB office, sometimes alone, sometimes with Alexandra who began her search for Valeria. This was the beginning of six years of waiting — waiting in lines to ask where Eva and Valeria were, waiting for the next week to go to this office or to that prison to ask how they were. When they asked if something could be left for them — food, clothes, or money — the window was slammed shut with no coherent answer. When Eva and Valeria were shipped out of Moscow, more waiting followed, waiting for letters, from Eva sometimes every two weeks, sometimes every month, and sometimes, when she was moved from one prison to another, even longer. From Valeria, who had been given a harsher sentence, waiting took even longer since correspondence was permitted only twice a year. Once the locations of Eva and Valeria were established, there was the waiting in long lines to mail parcels at designated post offices, all quite a distance from Moscow.

Tommy and Alexandra would send as much as they could. Without being told, they knew Eva and Valeria needed food. They couldn't send parcels as often as they wished since there was a special limit of about one parcel a month, and each parcel was supposed to weigh no more than eight kilos. Tommy would buy boxes in the Moscow post office and pack them at home. She would take an electric train to get to the post office from which parcels for camps were mailed, and then stand in a long line waiting her turn to reach the official. When Tommy's turn finally came to hand over the packages, the official untied them and examined them. They were weighed to be sure that the weight limit was met. If they were two hundred grams over the limit, something had to be taken out. After the inspection, she had to repack it. For five years she did this, since Alexandra was too old and there was nobody else to help her. Sometimes she would take two parcels at the same time, one for her mother and one for Valya. Sometimes she made two trips a month with one parcel at a time. And, sometimes she would go to different post offices also designated for sending parcels to camps in the hope that fewer people had discovered them. But, even those far from Moscow were always crowded.

It had never occurred to Tommy that Valya would be arrested, and now she guessed that Sheva, too, had been taken. Her concern about her mother had kept her too preoccupied to consider the possibility that a wider sweep was taking place. The evening Babushka had told her that Valeria would not be coming home, that the MGB had made its visit in their usual early hours of that morning, she understood that these raids were a repetition of those that she had slept through when first her grandfather, and then her father, had disappeared. That night, when sleep did come, it was fitful. In her dream she saw her Grandfather Gustav. He was standing over the bed. He did not speak, he just stood very still, tall and straight. She saw herself running into the room calling to Valya and Babushka Alexandra, asking where Dedyushka was. They looked at her sadly. She knew in her dream that he had died, that he had dropped dead on the street from hunger. They didn't need to answer. Dedyushka continued to stand, very still, looking down on the sleeping Tommy and Alexandra. She awakened with a start, frightened, uncomfortably aware that dead Dedyushka symbolized a dead Eva and Valeria and Sheva. She

was glad to be able to feel Babushka close to her. Again she fell off to sleep, this time awakened by a touch from Babushka, her soft voice urging, "Calm yourself, you have had a bad dream." She had been running, escaping, and close upon her heels was a big green truck catching up with her. She did not stop. She had to escape. This was the first instance of what became a recurring nightmare, one that she had almost weekly, always the same, either a truck or dogs or unidentifiable people chasing her. Later, with its repetition, she would know that it was a dream and would struggle desperately to awaken. During those years, although she felt certain that she, too, would be arrested and sent to a camp — it was only a matter of time — as she went about her daily living, it was not within her waking hours that she felt afraid; only in her sleep.

About the sixth week after Eva's arrest, Tommy and Alexandra were told that both Eva and Valya were at Malaye Lubyanka 8. Tommy left Alexandra and hurried to this address, but was unable to find a building marked with a number. She stopped a militiaman whose attention changed to gawking by the time she finished her query. He turned curtly from her to some other business as if he were afraid to talk with her, and left her to check aimlessly, building by building. Then, she caught the eye of an old woman who seemed to be observing her. By the glance, Tommy felt that this person knew what she wanted. "This is where you go," she said. "This is the Lubyanka prison. But not today. They receive inquiries only on Sundays."

Tommy reported to a disappointed Alexandra. "As usual. They give us only half of the information. It would be too generous of them to tell us on what day it is opened for receiving," she said with sharp sarcasm. "And that militiaman! He looked at me as if I had the plague! As if answering me would put him behind those walls. And," she added, "That woman It is strange how she knew — how she understood that each of us was there for the same reason."

Tommy returned on Sunday. When she knocked at the office window, it was opened and Tommy gave the names. "They ask for nothing and need nothing. Come next week," the officer said brusquely and snapped the window closed. "I wanted to tell him that they didn't have to ask, that I wanted to bring them some clothes or food or whatever is

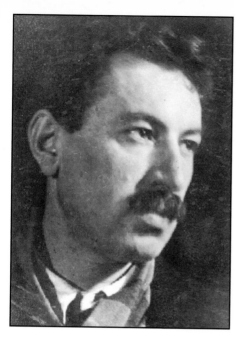

Morris Stolar, Eva's father, in 1930.

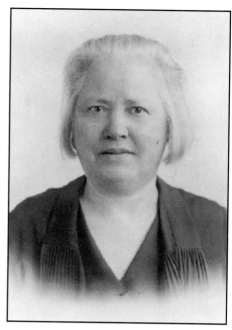

Esther Stolar, Eva's mother, in her passport photograph taken in Chicago about 1931.

Abie and Eva Stolar collecting money in Chicago for Russian famine relief, probably about 1920.

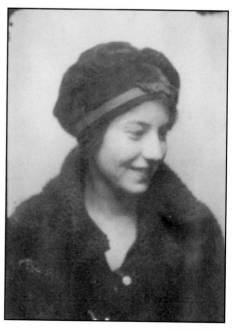

Eva as a teenager in Chicago during the 1920s.

The Young Pioneers in Chicago in the early 1920s. Eva is third from the left.

The Tuley High School girl's "captain ball" team, about 1926. Eva, a sophomore who played third base, is in the back row, at extreme right.

Eva's senior class portrait, autographed for her friend Rae Gunter. Eva was seventeen when this photograph was taken in 1927.

Eva's portrait for the Crane Junior College yearbook, taken in 1929 when she was nineteen.

Rae and Eva, 1926 or 1927, in Chicago.

Eva in her passport photograph taken just before she left for the Soviet Union in 1931.

Max and Eva in Chicago, late in 1930.

Alexander, Gustav, and Maxim Meltz in Humboldt Park, Chicago, in April, 1931.

Alexandra Meltz, Eva's mother-in-law, early in the 1930s.

Valeria Meltz, Eva's sister-in-law, about 1949, in Moscow.

Two-year-old Tommy, in 1937. "Daddy came home from the sanatorium in Kislovodsk and brought Tommy a Caucasian costume."

Eva and Tommy, 1939, when Tommy was four years old.

Maxie and Tommy, June 17, 1941. Valeria sent this photograph to Eva at the Red Banner kolkhoz following Maxie's death in 1941.

Tommy's internal passport photograph, 1951. She sent a copy to Eva in the camps, saying, "You will not ever be ashamed of me. I will try my best to be like you always."

"To Eva Moiseevna to remember me sometimes" — Katya Osina, April 22, 1954. Katya, a foreigner, was an uneducated servant and was looked down upon by most women in the labor camps, but Eva befriended her during their internment.

Eva in Camp Kotomish, July 5, 1955. Of all the camps at which Eva spent time, she probably was most comfortable at Kotomish. Here, less stringent supervision, more meaningful work, and greater responsibility appear to have made the stay more tolerable than at other camps.

Eva at Camp Peshkova, 1955, wearing clothes she received in a parcel from Tommy. Internees at labor camps were forbidden to have their photograph taken. This picture probably was taken by a free civilian near the camp.

Sheva, Eva's closest friend, in Moscow, August, 1962.

Eva in Moscow, August, 1962.

Tommy in Moscow, August, 1962.

Tommy and Eva in Moscow, August, 1962.

Rae and Eva at Las Vegas, New Mexico, Thanksgiving, 1976, while collaborating on the manuscript for And the Winds Blew Cold.

allowed. He didn't even keep the windows open long enough to listen to me." Tommy spoke with tears in her eyes.

And so it went, week after week. At last, almost two months later, she was told, "You can bring some clothes and some money."

"And what about food?"

"No food is allowed."

Tommy rushed home, then returned to the prison with the clothing — but she was too late. The doors were closed until the next Sunday. After several weeks, as she became acquainted with the routine, she was told that her mother had been moved. Where? The man didn't know. Where should she go to inquire? She started her rounds of the first office to be told that her questions could be answered at another office, very close to the Moscow Conservatory. It was near two popular bookstores. She had passed it several times a week but had never known what it was. It was hidden by the bookstores. The first time or two she got no answer. At last she was told that they were in another prison, Butirka prison. It was a very old prison. Alexandra remembered it from before the Revolution — it was the only tall building then. It was about a five minute walk from where they once had lived. Tommy was not received on her first visit and had to go back another time. It was very unpleasant there. Lubyanka was only for political prisoners, but at Butirka there were also criminals — thieves and murderers. Seeing the mother of a murderer or the wife of a thief was something very frightening for Tommy.

Then one day she was told that her mother was not there. Again, Tommy had to make the circuit of all the offices to find out that her mother had been transferred to the Taganka prison. The metro did not go there yet, and it took long streetcar rides for Tommy to get to the prison. Nobody bothered to tell her on what day the office was open for inquiries, so her first trip was useless. After that, she learned that inquiries about prisoners whose last names began with "M" were received on Tuesdays.

There were so many prisoners in Taganka prison, both political prisoners and criminals, that it took an entire day standing in line just to reach the window. Tommy stood with people who were there to arrange a meeting with a prisoner or to bring food. Some even managed to bring

231

vodka. Tommy was not able to see her mother, however, because political prisoners were not allowed to have visitors. She and her grandmother had to be satisfied with the information that Eva was there and alive. Tommy couldn't bring her even a piece of bread — only money and clothing, and they wouldn't tell her why. In the beginning Tommy had inquired, "Does she need food?" or "Shall I bring food?" but when they wouldn't answer, she thought to herself that she was just making a fool of herself by asking. They just closed the window in her face.

Most of the people who queued up in the lines were women. Tommy seldom saw the same faces; however, when she did see some of the same people on different visits, they did not share their stories, each reticent about spreading the family secret. Sometimes they would say "Hello" to each other, but generally there was no conversation. As a group, they were sensitive to each other's discomforts during the long hours of waiting, by mutual consent decent to those who seemed unable to tolerate the rigors to which they were subjected. When they saw an old person, they would say, "Go ahead to the beginning of the line." Once, a young woman appeared from the outdoors, and unlike the others who would hesitate to refocus their eyes to the darkness before taking a place in line, she walked straight on toward the head of the line, disregarding everyone, going directly for the door to the officials. The room was exceptionally crowded. An angry murmur spread throughout the room. People muttered, "Who does she think she is? Why does she feel that she is better than all of us that she should push her way ahead of us?" This did not stop her; she continued on, ignoring the protests. Walking quickly, in order to catch up with her, was an older woman. She caught hold of the younger woman's hand, stopped her, and with an apology to the others in the line led her to a corner of the room and respectfully asked someone to give up a chair to her. The older woman softly explained to those who were close by, Tommy among them, "Please don't be angry. She doesn't know what she is doing. It's her sickness. The shock of her father's arrest, her only remaining relative, caused her breakdown. When she walks, she walks until I stop her. She will not leave this chair until I help her. She needs to be led. She has no one to take care of her except me." The older woman had been the houseworker for many years, about twenty, and she could not now abandon her charge. The

younger woman was mute, seemingly unaware of the apology. After half an hour, during which eyes turned from time to time toward her, there was general agreement that she and her companion should be allowed to go in next.

"Babushka, just think," Tommy said later. "This woman who can't stop herself when she walks, who needs to be told what to do at every move — walk, don't walk, sit down, stand up — she became sick when her father was taken from her. She seems to be unaware of what is going on. And except for this maid, she has no one at all who cares about her. And how long can this old woman go on like this — staying on without wages? How will this woman survive? She'll sell everything they own — and then what?"

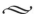

Through small gestures, people in this same deep trouble, although strangers to each other but recognizing each to be a cat's paw of an invisible force, reached out toward each other. Tommy had just left the prison office and, stunned by news that her mother had been sent elsewhere, destination unknown, she stood stock-still, uncertain as to which way to turn, what her next move should be. A woman's voice shook her out of her daze. "Don't worry," she was saying. "Don't be so depressed. My husband is also in prison and I also don't know what is happening to him or what his condition is, and what our future will be. We must wait until next week. When we come next week maybe we'll hear better news." Tommy had not seen her in the prison office and was sure that the woman had never seen her before. She had been waiting at the bus stop and noticed this forlorn girl. She knew that something very unpleasant was happening.

As Tommy never spoke with anyone voluntarily, at a time when people were afraid to talk, her encounter with this woman was comforting and she appreciated the kind words. They were exactly what Tommy needed to hear at that moment. With only a few words, they were able to understand one another since they both spoke the same language: their loved ones were political prisoners. Before they departed, Tommy told her that she would keep searching for her mother.

Tommy's visits to the prison stopped when she was told one day that Eva was no longer in Moscow and that she would have to wait for a

letter from her. For the remainder of the school session, Tommy's few close school friends stood by her. Perhaps they did not appraise the times correctly, if at all. Perhaps their youthful idealism gave them the courage that their parents lacked. If their parents made any attempts to prevent them from seeing her, they failed. Occasionally, she was invited to their rooms to study with them, and Nina, her closest friend, insisted several times that Tommy stay the night so that she might be with someone whom she felt cared. The parents asked no questions, avoiding any talk that might give away their curiosity. Although their kindness gave her reinforcement, these times might have been easier to bear had she known that some of her friends and her mother's friends were in similar predicaments.

It would be many years later, when the political climate was somewhat changed, before she learned that this same catastrophe had befallen other young people. During the raids of 1948 and 1949, when her mother's friends had been undergoing this terror, it had been concealed from her in the hope that ignorance would offer her and the family some protection. After Joe Goldman's arrest, Eva frequently took Tommy with her to visit Frances who was scrounging around trying to keep her three children adequately fed. Tommy had not known Joe; she had never even met him. In her presence, the adults had refrained from discussing him, and not even Shura, in their play, had told Tommy the reason for his absence. Nor had Eva told her about Jane. There was too much fear that the children's spontaneous disclosures might reach their places of employment and cause the loss of their jobs. A friend, later recalling this period, told her of a former acquaintance of both of theirs, a girl who had had this self-same horror in her home except that it had been her father who had been arrested. That fall, after the arrest, the girl, unlike Tommy, had been re-admitted to school, but only after she had made a public denouncement of her father at a Komsomol meeting called by the principal. Before the entire student population, she had been required to deliver a talk in which she spoke against him, accusing him of actions which were entirely false; this was the price she had to pay in order to be permitted to finish school.

It was now May, and Tommy's sixteenth birthday should have been a gala occasion. Instead, with the legal requirement that on reaching

that age she needed to apply for the compulsory internal passport, only the government recognized her transition into adulthood. As she stood before the militiaman, when the question about her national origin was asked, she panicked. Only a few days before, her friend Nina had commented that her mother, a placement interviewer for job applicants, had received an oral order to give priority to people who were not Jewish. It struck Tommy when she was faced with the question that she must somehow prevent its being documented. True, her father had been Russian, but her mother was a Jew; she quickly recalled her grandmother's words, "You know how it is! If your mother is Jewish, you are Jewish. If your father is Jewish, you are Jewish."

"Please," she said to the militiaman, "I am all alone and I want to survive. I have to survive! It won't cost you anything to write down that I am a Russian." It was her good fortune that he was compassionate; he submitted to her pleas.

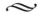

The summer passed. With the beginning of autumn, 1951, Tommy's direction changed. "I am no longer a school girl," she said emphatically to her grandmother. "I am not a school girl," she repeated, as if to confirm to herself a truth that she could not believe. From infancy, her mother had driven hard the idea that she was to be a student until her higher education was completed, that this was necessary if she were to be more than an ordinary, low-paid worker. At the moment, just to be an ordinary, low-paid worker would be an achievement, but the change in her goal created uncertainty and ambivalence within her.

The money Eva had left with Tommy was spent. Alexandra was bringing in a little, taking care of her neighbor's children. At the age of seventy-five, it was not worthwhile for her to secure documents in order to try to qualify for any other kind of work. She liked being occupied, and her neighbors sought her out for her gentle ways with the children. It would have been easier for her had she been able to have the children in her own room, but where she lived was not very pleasant. After Bob had been taken, the rooms originally assigned to Valeria and Bob as privileged members of the Communist Party were given to another. Valeria, with Gustav and Alexandra, had been shunted to their present room, tucked into a corner on the floor where no sunshine ever peeked

in; it was so dark, in fact, that they needed to have the electric lights on all day. So she took care of the children in their own homes until their parents returned from work.

Alexandra's earnings were hardly sufficient to keep both herself and Tommy even minimally supplied. Tommy was supplementing the income by selling what clothes and household items she could spare, and sometimes even what she could not spare, reasoning that she, too, would soon be arrested and would have no need of them. When she began to sell the books, she faced a difficult decision, for her mother had imbued her with the perspective that an empty bookshelf was more tragic than an empty cupboard.

Throughout the last part of the summer, on those days when Tommy was not in MGB offices, she spent her time looking for work. Although she changed her hair style to erase her schoolgirl image and always presented her passport to confirm her age, she was barely able to hold an interviewer's attention. The real obstacle, however, was the questioning related to her mother, always raised, probably because she looked so young. She was too unsophisticated to manage a lie, and when she spoke a half-truth — that she didn't know why her mother was arrested — whatever chance she had for a job was lost. Nina's mother finally coached her and found a position for her. "It is a dangerous thing for her to do," Tommy commented, but she was grateful. "I'm sure this woman who hired me knows that I am lying. She must know the truth about me, but she wrote down on the application whatever I told her and asked no more questions," she told Babushka.

For the next two and one-half years, Tommy worked in one of the offices of a factory where yarn was processed from raw cotton. Part of the office where she was assigned was set up for twenty-four hour housing for some of its employees caught in the housing shortage. Her work required only the simplest mathematical skills, she kept records of the rental charges and the housing assignments, and she had no difficulty pleasing her superiors. The six hours that she worked each day, the maximum permitted by law for a youth her age, paid her only enough — when combined with the money Alexandra was earning — to put food on the table. Later, when she needed more money to mail parcels for Eva and Valeria, Tommy asked to be transferred to work in the factory where

the wages were higher. "No," she was told. "You show pity for the factory workers who pass by your desk on their way to the toilets to retch because they get sick from the fumes in the processing room, and you think you are old enough to endure the stench and the heat? You would not last a day. They, at least, have the strength to accustom themselves to those conditions." She was looked upon as a child, most of her co-workers parents of children older than she. They said even had the labor laws permitted, "We would not allow it." She did, however, receive kind treatment, and permission was even granted for her to take time off when she needed to go to the Taganka prison offices.

"They must know, Babushka, why I ask for time off," Tommy remarked later to Alexandra, "but they let me go without asking any questions. I just say that I have a very urgent matter to take care of. If they asked me what kind of business, what could I answer? They'd surely have to fire me." But, they never asked, and Tommy was grateful for what little consideration she got.

Tommy reached the age when the law permitted her working day to increase to eight hours. Although every extra ruble helped, she decided she needed to train for work which would pay more. She found someone who taught typing privately and with Alexandra's clever budgeting, they paid for enough lessons to enable Tommy to qualify as a typist. Once again, Nina's mother referred her successfully, and she held this job until the staff was cut. As last hired, she was the first to be fired.

Soon after Tommy had started to work, Abie finally succeeded in securing an exchange of rooms. Although there was no possibility that Tommy could be completely separated from Abie and Sonya, the new arrangement did allow her to have a separate room in a communal flat with them. That Eva had been part of the household and would need space, assuming that she would survive and return, was ignored. The housing office had no record of her; to the housing authority, it was as if she were dead.

Abie's marital life deteriorated rapidly soon after the move to the new address. Divorce was inevitable, but in the interim they came to be physically separated by only a partition. Abie had asked only for enough space to hold a cot and a bookshelf. Sonya immediately instituted a court suit for Tommy's room, which was larger than the remainder of the

space that was left for both her and her daughter. The case was decided in Tommy's favor; in fact, the officer scolded Sonya for instituting the suit against a "parentless child, an innocent bystander" of her own messy marriage that had crowded this young person out of the very room that had been owned by her own grandparents, and which had been her home since birth.

As Tommy's need for money increased, so did her sophistication in how to make it. Before two years had passed, she discovered the method used by so many others of deriving extra income from her room. Space, however small, was always in demand by military men for their families. Tommy rented her room to an officer whose assignments between his field duties required study in Moscow to complete his education. He needed space for his wife and child. He offered a sum equivalent to Tommy's wages, and although she was apprehensive that she might lose the room if it were discovered that she was not physically occupying it, she agreed to the officer's family officially registering themselves into her room as temporary residents sharing the space with her. She would live with her grandmother. So that the neighbors would see her about, she made weekly appearances, had tea with the officer's wife and spent an occasional evening in small talk. So her financial problems eased.

When Tommy was eighteen, she decided to enroll in evening school, and she had to lie to be accepted. The school in the district where she was known would not accept her, so she applied to attend classes in the school district of her new address. She was asked where she lived and how, and she needed to show her identification booklet verifying her right to the room. She told them that her mother was in the Urals where she was working and that was why she was living alone, and that she needed to work and could attend school only in the evening. She wasn't questioned further. She was twenty years old when she finally finished her secondary school education.

Chapter 15

When the MGB apprehended Eva and led her away from her home, she descended the stairs, keenly conscious of being a prisoner. One officer was on the step below her, slowing down her own steps by his cautious stride, and two were single file behind her. It occurred to her that, thirteen years ago, Max had walked these same stairs for his last time in just the same way. The memory of that scene sent a shiver through her body. From landing to landing, voices behind the doors of the flats ushered in the morning. Eva hoped that nobody would open a door, but by the time she reached the third landing, a child, dressed in her school uniform, was peering upward in anticipation of a greeting from a neighbor or playmate. The girl politely stepped aside to make room in the passageway for the first officer, then looked at Eva with a curious smile. Several children were already inspecting the limousine. Their inquisitiveness was restrained by the strange scene. While Eva was chivalrously directed into the back seat, they remained silent.

In spite of the circumstances, the luxuriousness of the interior did not escape Eva as she sank into the soft upholstery behind the driver. No one spoke. The silence made her feel as if she were in limbo until they arrived at the gates which clanged shut upon entering Lubyanka Prison. She was ordered out of the automobile, and with a curse she was pushed toward the door, into the building, and into a box-like cell. She was alone. The cell was small and narrow, its depth too tight to permit her to stretch her arms or her legs. A lighted bulb hung from the ceiling barely a head above her. Sitting down on the built-in wooden bench, she faced the solid piece of steel broken only by a peephole.

She had no concept of time. Hours or days may have passed. She was dazed and terrified. Only when she was forced by the stiffness of her muscles to stand away from the bench did she arouse herself long enough to wonder how long she had been there and to think about what might happen to her. The shadow that at intervals darkened the peephole frightened her until she realized someone was watching her. With her privacy so invaded, the misery written over her face so nakedly exposed, she turned her back to the door, but in the end gave in to weariness and sat hunched forward, thoroughly despondent.

The door opened; a guard motioned for her to follow. She was taken to an official sitting at a desk cluttered with paper. She was ordered to come close and face him. He stretched his hand across the desk for one of many pens, made himself a writing space, stretched again for a printed form on the opposite end of the desk and began to interrogate her. What was her name, when and where was she born, what was her mother's name, place of birth and death, date of death, cause of death, what was her father's name the same questions about him. Eva wasn't certain that she understood. It was strange, she thought, as she concentrated on the questions, how her thinking in her adopted language was failing her. She asked that the last question be repeated. She listened intently. "I don't know," she answered.

"What kind of an answer is that?" the official glanced up at her. "You must know."

"I must know?" the absurdity of such a question to her in this place shook her out of her daze. She moved toward him and exclaimed, "I must know?"

The interrogator was apparently accustomed to hysteria. " I am demanding that you answer. When and where and how did your father die?"

Her fear vanished. "You should know where and when and how he died! It was after your organization took him that he died. You tell me. I want to know!"

He persisted, but Eva stubbornly repeated, "Tell me! I want to know!"

He went to his next question. "Your husband." Then again, "place of birth, place of death, date of death, cause of death — " Again she

said, "Why do you ask me? Your organization knows more than I about my husband's death." The volume of the officer's voice was increasing and he was beginning to chafe with annoyance. "I can't tell you what I don't know!" she continued. He had to accept her word that for Max's death she had been given two different dates, one orally, and one in writing. The final word was hers. "Whatever date they gave me, I am sure neither is correct."

An interminable period of silence followed. Her eyes did not leave his face as he pored over his papers, sometimes filling in sections of what seemed to be blank space, sometimes resting his chin in the palm of his hand as if in deep thought, then rapidly writing in other blank spaces. At last he stood up, went to the door and called the guard. She was led through the corridor to another room where a woman met her. The room was bare except for a chair and a narrow table that Eva recognized as a medical examining table. To her question, "Are you a doctor?" there was only an affirmative nod. She was directed to stand in front of the woman who felt her face, poked her eyes, pressed her neck, gagged her with a tongue depressor, forced her head backward to look up her nostrils, rolled her fingers along the inside of her cheek, and removed her dental bridge. She was told to undress and mount the table. Another woman entered the room, picked up Eva's clothing, left with it, and shortly returned. Together, both prodded every orifice of her body. If this was meant to be a legitimate physical examination, Eva did not recognize it as such.

"What are you looking for?" she asked. They did not answer. They meant to dehumanize her, and her humiliation was complete. They must have known that even had she been clever enough to conceal something inside her body there would have been no time to do so. When the MGB had entered her house, she was still fully dressed. During the hours that they ransacked her room, she had not been permitted to leave their presence, even to go to the toilet. "What could I be hiding?" she demanded to know. "I didn't even know your police were coming." The women continued their examination as if she had not spoken. She had to assume that they were looking for something specific.

The second woman again left the room and in a few moments re-entered with Eva's clothing. As she dressed, she discovered that the elastic

of her undergarments had been removed and the laces of her shoes were missing. "You can get along without them," she was told.

When Eva asked for her dental bridge, the second woman answered, "You'll have to manage without it. You'll get it back when you leave." With this act that would deprive her of her right to look human, to keep her mouth from sagging, to chew her food, Eva screamed so loudly that she must have been heard throughout the prison. The doctor ordered the woman to return the bridge. Then, with one hand clutching at her waist to hold up her underpants, Eva followed the guard back to her box.

She did not know how long she was kept there. The door may have been opened once or twice or more for food which was set on the floor and removed — untouched. At last, she heard increasing movements and saw a glimmer of light through the crack between the box frame and the door. She decided it was morning. The door was opened. She was led to a small office where a short, stocky man, dressed in civilian clothing, introduced himself. He was sitting at a desk at the far corner of the room. The guard pointed to a seat for her at the opposite corner.

"I am your investigator," the man said. "My name is Kovalyov — Vladimir Kovalyov." He didn't stop for Eva's acknowledgment. He continued, "Let us not waste time — my time, your time, everybody's time. You know why you are here and I know why you are here. You will save yourself much anguish if you confess now."

"What am I accused of? What am I to confess to?"

Her interrogator jumped from his seat and stalked towards her. Eva was not certain if his rage was genuine, but his shouting sent her into a panic. "You know what crimes you have committed. I don't have to tell you. I advise you to confess without a fuss."

She was beginning to lose his meaning; in her confused state, she could not fully understand his Russian. This wild man didn't know English, and it would have been suicide to communicate with him in meaningless sounds. Theoretically, she knew Russian very well, but her ability to speak the language was still very much flawed. She knew that, if she were to use a wrong ending to a verb, a wrong prefix or suffix to a word, the entire meaning might be distorted, might take on the exact opposite of what she intended. She also knew better than to ask for an

attorney — she had learned that when Morris and Max had been arrested. Civil lawyers would not defend political cases for fear of jeopardizing their careers as well as their lives. Calming herself, her request came out in Russian. "I should like to have an interpreter so that I may understand you and you may understand me."

She received a categorical refusal. "In due time you will have a public defender. For now, you can defend yourself without difficulty. Your Russian is good enough. I understand what you are saying."

"When may I see him?"

He ignored her and continued his shouting, "Confess!"

"Confess to what? Tell me what I am supposed to be guilty of?" Eva challenged him again and again until he became so impatient that she feared he would physically harm her. She was quiet for a few moments. In a low voice she finally spoke. "I know that when one is grabbed by your paws there's no hope of tearing oneself away. If you will tell me what you want of me, I shall be able to talk intelligently to you."

Eva's words forced a change in his tone. "Well! I am glad you realize the serious predicament you are in. You're right. No one gets out of here. Our security police know all about you. You'll never see Moscow again when we're finished with you. We'll send you where the white bears live. No one keeps secrets from us." Eva shuddered; this was no idle threat. The power of the ubiquitous secret police had been common knowledge among her most personal acquaintances. They had felt surrounded by agents and wondered often how so many could be recruited, one agent to one private citizen.

Kovalyov returned to his desk at the far end of the room and picked up some papers. He read aloud from one of them. "You are accused under the criminal code, article 58.1 of spying, for which the punishment is the maximum of twenty-five years in prison or labor camps with confiscation of all property; and you are also accused under the criminal code, article 58.10 of anti-Soviet propaganda and agitation, for which the maximum penalty is seven years in prison or in a labor camp." He set a paper before her with the order that she sign it as verification that she had been informed of the reason for her arrest. She read through the statements slowly, assuring herself that her Russian was adequate enough to catch any misinterpretation the investigator might slip into it.

Again to the box, but not for long. A guard opened the door wide, handed her a towel, a pillow, and bed linens, and directed her to follow him. He unlocked a door, indicated that she was to enter, and locked it behind her. She was in a prison cell. Daylight, barely recognizable from the small clear glass windows set high on the wall, was deflected by permanent black metal awnings hung on the outside. The eye-level grated windows were opaqued by white paint. A lighted bulb on the ceiling gave a night brightness to the room.

Five women looked up at her. Most of them were sitting, slouched, on separate cots neatly made up, blankets securely tucked under thin mattresses. Two cots were vacant; on one was a large, fat sack. The only other objects in the room were a table and a *parrasha* — a large, narrow boiler used as a urinal.

One younger woman, standing in the middle of the room, a leg almost horizontal to the floor and an arm outstretched, was balancing herself with a light touch of her fingertips on the bar of the cot jutting out from the wall.

Four of the women immediately came alive. One who completely disregarded Eva's entrance, remained sitting on her cot, position un-changed, her back arched and supported by the wall, her feet hanging from the bed. A woman sitting on the first cot of the three lining the right wall, a cigarette in her mouth, reached Eva first. "Here," she said, "this is your bed." She took the pillow and other bed supplies from Eva and set them on the one vacant cot on her side of the wall. They took no time for introductions. Questions poured from them, even as to what day this was. What was *Pravda* printing about the exposés within the Politburo? Eva was puzzled by the question and later decided that one woman was connecting the current mass arrests with accusations against high government officials. What was the latest news in *Izvestia* about the arrests? Was war imminent? Had she seen any of the recent perfor-mances at the Bolshoi Theater or the Moscow Art Theater, and what principal performers seemed to be missing? Surely there were arrests among them! Did Eva know any of their family or friends? The ques-tions came at her endlessly. Their hunger for news depressed her. They were so completely isolated, having neither radio, not even the com-pletely controlled government loudspeaker, nor newspapers. How long

can social animals tolerate such a condition, she wondered. But now, she was too tired to think that far into the future.

Eva focused on the lighted cigarette. It had been torture for her to be without one for so long. She dared to ask if the smoker had another. The woman was gracious. "Of course. I should have offered one to you. I know how it is."

One by one, the women introduced themselves to her. "Nina S. This is my 'home,'" she said, seating herself on a cot in the first row to the left of the door.

"Olya" was opposite Nina's cot, to the right of the door. "I have more cigarettes if you want another."

"Anya" occupied the cot between Olya and Eva. "Auntie Anya, because I am older than anyone here."

"And I am Nina Fetterman." Her cot was behind Eva's, the head abutting the wall, the foot of the bed jutting out toward the middle of the room, the entire length touching the sill at the painted panes of the window. "Very convenient," she added, as she assumed again the stance of a ballet dancer.

"Nina, the ballerina, we call her," Auntie Anya said. "She performs with the Bolshoi Ballet."

The woman on the cot behind Nina S. ignored them. "She's Doonya," Olya offered.

"And that cot?" Eva asked, pointing to the one behind Doonya's on which there was the large sack.

"That's Laura's. She was taken to the dentist."

"Who is your investigator?" one wanted to know.

His name slipped Eva's tired mind. "A short, stocky man." She tried to describe him. "He has fingers like half-sized thick knockwurst."

Her description brought a burst of laughter. "Vovochka! Vovochka is your investigator, too! The Hero ["hero" was the highest government award] General of women!" they mocked. "Vladimir Kovalyov! Our Vovochka! This is the 'Vovochka' cell. He sees all of us!"

They asked what charges he had brought against her. When she answered, "Spying and anti-Soviet propaganda and agitation," there was more good-natured laughter.

"Those are the most popular," Nina the Ballerina said, "It seems

245

that all Russians are becoming spies and agitators."

Olya turned serious. "They will try to get you to confess to spying. Be careful. There will be no picnic here. Whatever you do, try to get that spy accusation dropped. Agree to anti-Soviet agitation."

"Why should I confess to any charge?" Eva countered, astonished. "I didn't agitate anybody."

"They will get you on something, whatever you say or don't say," Olya and Nina the Ballerina warned. "It will be easier on you if you agree to agitation. Vovochka will make life miserable for you if you deny agitation and will sentence you anyway. A lighter sentence will be for agitation. For spying there is a much harsher sentence and a lot of additional problems. Do everything you can to have the spying charge dropped."

The chatter did not cease, as if with the new inmate among them they needed to rehash their own admission ordeals from the time of the shutting of the gates from the life on the street. Eva spoke of her medical examination, and the others agreed with her that theirs, too, had been a demoralizing experience. Auntie Anya had already noticed Eva's discomfort as she tried to move about, manipulating clumsily at her waist to hold up her panties. She taught Eva how to twist the top to hold it at the waist, "As long as you don't move about too much. They think that they are preventing you from hanging yourself. No shoelaces and no elastic. They probably wanted the bridge in your mouth for fear you might discover that you can kill yourself by swallowing it!"

"But why should they care if we commit suicide? No one would ever know how we died." Eva would never figure out the irony of the guards worrying about the prisoners committing suicide.

Eva felt as if she were with sisters. They listened as her words spilled over, not to be held back any longer after all these years. She spoke of the arrests of Morris and Max, of their deaths. And now she, too, had been taken from her home — leaving a fifteen-year-old daughter alone. The others lamented with her. The pattern was similar, with one or two of the members of their families having been previously arrested, and now they, the surviving relatives, taken, the accusations against them as ridiculous as those which earlier had sent the fathers or husbands or brothers or sisters into oblivion. "Now they are ridding

themselves of those who escaped in the thirties," one said bitterly.

A derisive interruption came from Doonya. "So! All of you are innocent!" These were her first words since Eva's entrance. "You! Wife of a Christ killer! You, too, are innocent, I suppose!"

Eva stared at her in horror. Doonya was pointing to Nina, the Ballerina.

Olya said, "Don't pay any attention to her. Everybody is guilty but her. All of us here are 'enemies of the people' except her. Only she has been wrongly accused. She is a bigoted ignoramus!"

The sound of a key turning in the lock caught their attention. The door opened and Laura entered. Her appearance was a striking contrast to the others who looked sallow and exhausted. She was young, between twenty and twenty-five, rosy-cheeked, and fairly well-groomed. Vivacious, she gave the details of her visit to the prison dentist, the sympathy he extended to her, the sincerity he showed in attempting to alleviate her pain. Eva listened with relief. She, herself, might need a dentist; her own dental problems were always a matter of concern.

Laura wanted to be filled in about the new prisoner. When Eva was vague on how long it had been since she was brought to the prison, Laura said, very knowledgeably, "It may have seemed like days, but it has actually been only twenty-four hours since your arrest." She let it be known that her long internment, almost a year, her case still undecided, had taught her a great deal about the legal aspects of a prisoner's rights.

Eva was drained. She needed another cigarette. "How may I get my own supply?"

"Don't concern yourself about that," Laura assured her. "Olya and I will have enough to share with you. Only after Vovochka gets a confession out of you will you be rewarded with the right to ask your relatives for money and some other small items that you may need. Olya and I are now able to get some essential clothing and other items and some money."

Olya clarified this comment further. "My mother delivers money for my use to the prison office and the guards purchase the cigarettes for me at the prison store. They also buy for me food that tastes especially good compared to the prison food."

Eva's education about prison life had begun and it advanced rap-

idly. Since the knock on the door of her flat, she had had no sleep. No sooner had she laid down on her cot when a loud banging and shouting from the other side of the cell door frightened her. Someone was yelling, "No sleeping! Get up! No sleeping!" The eye on the other side of the peephole took in everything. Eva quickly learned that the first rule of transition to prison life was no confessions, no parcels, and no money. The second rule during the day, no sleeping and no lying down, not even with your eyes open.

The darkness of night would barely pass when the guards would give the morning wake-up call; prisoners would then rush to dress, make up their cots, and line up in pairs for the one trek of the day to the water closet. From that moment on, for the balance of the day and evening, they were forbidden to lie down or to sleep; several women sat on one bed, side by side, waiting out the instructions of the prison authorities.

Cleaning duties — polishing the parquet cell floor, scrubbing the lavatory, maintaining the parrasha — were rotated among the prisoners according to a schedule. On Eva's day, she and one other woman would lift the huge parrasha and, following the other women being marched to the water closet at the end of the long corridor, empty and clean it and carry it back after ablutions at the sink were finished. Her one dress, the blue one she had custom-made from the bonus Maria Petrovna had given her, now was a rag. When the seams split open, the guards obligingly supplied black thread, apparently not worried that the inmates might use the needle that went with it to inflict mortal wounds upon themselves.

The women, when marching to the water closet, were not allowed to talk or even to whisper for fear, they speculated, that their voices might be heard in other cells. Expressionless, the male guard waiting at the water closet door handed each woman a scrap of newspaper. When the last woman in the line passed him, he closed the door after her. But his presence was immediately confirmed when any one of them attempted to sponge the sweat from their bodies. "Forbidden," he would shout from the peephole. Eva would mutter, "What baser act of humiliation can they torment us with? How better to let us know that they consider us the crud of humanity than to keep their eyes on us while we squat or are half-naked in this stink hole?" Only twice during her months at Lubyanka

were women guards on duty.

It seemed to Eva that in all her years in Moscow, this summer was the hottest and most humid, causing irritability that strained tempers. An occasional understanding guard looked the other way when the women, against regulations, defiantly rinsed their clothing and sponged off their bodies. He was an exception, however, since most of them, their vocal chords scratching from incessantly shrieking, "Forbidden!" rushed them in order that inmates from other cells might have their turn, hardly giving them time even to rinse their mouths.

The weekly journey to the prison bathhouse was a pleasant adventure in spite of the fact that the room was too small for the number of women crammed into it. The guards, female, gave each woman a basin as she entered. The water flowed freely at comfortable temperatures which lessened their discomfort from the summer heat. The guards pretended not to notice when Eva soaped and rinsed her underwear. "They do have a drop of human kindness in their veins," she charitably acknowledged. Sometimes Vovochka would hold her over for interrogation on a bath day, and on her return to the cell she would lash out in anger, in language she picked up from him, for having missed her moment to feel human.

No mirrors were in the lavatories nor in the bathhouse and any that the prisoners might have brought with them when arrested were confiscated. Items of glass were never part of the dishes sent into the cells. It would be too easy for a prisoner to slash a wrist. The last glimpse Eva was to have of herself until almost six years later took place the evening before her arrest. In the last weeks at Lubyanka, one day she saw on her dress what she thought was a long white thread. "Did anybody coax a piece from the guard?" she asked.

"Nobody gets white thread," they answered. "You know that."

"Then where did this come from?" she wanted to know.

"It's not thread. It's your hair." It had started to change color as soon as she was arrested, and she never knew it.

Pangs of hunger inured new inmates to the food. The first days, each would nibble at it and turn it away. When it was sent in again, they would ask the guard to give their rations to the men prisoners, who, they were sure, would be depleted of energy if the same small rations

were being meted out to them, but they were certain that their requests were ignored. Soon, their natural need for nourishment had them eating whatever was in their bowl, three times daily. Only Laura never seemed to require the full ration, as meager as that seemed to be for the others, and she generously urged them to divide her portions among themselves.

After breakfast, they would sit on their cots, aimlessly, until the guard unlocked the door and led them out, down the stairs and into the open court for exercise. Like robots, they walked in a circle, their hands behind their backs, round and round, with only shouts from the yard guards that they be silent breaking the monotony. Regardless of one's physical distress, a bad cold, or just plain weariness after an all night interrogation, no one could beg off from the daily airing. Through the gap between the bottom of the fence and the ground, they could see moving feet but could not determine if these were other prisoners or free people on the city street. Imagining what "free people" were doing was one good way to break up the boredom of this routine.

Among them, the cellmates prevented an unwholesome gloominess from settling in. Those who were permitted parcels and money usually shared these privileges freely. They were allowed one hundred rubles a month from relatives or friends to spend in the prison store. Those who did not smoke sent the guards for their ration of cigarettes to give to the women from whom Vovochka had not yet obtained a satisfactory confession. The money also purchased supplementary food — butter, a little more bread. Whatever the one prisoner who had "earned the right" bought, she shared.

Each prisoner was permitted one book a week from the library and she exchanged it willingly with the others. Eva, to whom reading was as much of an addiction as cigarettes, was grateful. Many of the women, after intense all night inquisitions, were unable to keep their eyes open long enough to finish a page, and during the day, they used the book as a ruse, holding it as if they were reading to deceive the guards — while they slept. Board games also helped to break the boredom.

Laura, the expert on rights of prisoners, successfully demanded checkers and a checker board, and she taught the others a game called Gallah. Gallah was a game, apparently developed in jails, that utilized

checkers and a checker board but with its own set of rules.

Sometimes Nina S. would sing old romantic Russian songs and the others would join in. When frequently the silence in the cell made the city noises distinct, bitter reminders of their isolation, she would sing mournfully:

> *Lubyanka, the nights are aglare with your lights,*
> *Lubyanka, why did you destroy me?*
> *Lubyanka, I'm your prisoner forever* — .

Her song brought on melancholia and tears.

And, at times, they even gossiped. The guards were a conversation piece and a source of amusement, used by the prisoners as redress for their hate and the means by which they retained their sense of humor. Not one of the guards would speak to the prisoners except to issue orders, and never, even in jest, would any succumb to coaxing that they reveal their names. So the women gave each one a nick-name, and the one who invented a name that was the most descriptive was applauded for her creativity. There was "Chaliapin," the internationally known opera star, who had a deep beautiful bass voice so inconsistent with his bilious behavior and short, squat figure. "Zloi," the Angry One, was always in a rage, always threatening. They sometimes feared that in a frenzy he would use his heavy hands on them. "Dandy" bared his vanity by the odor of his heavy perfume. "Do you think he believes he is God's gift, even to us, in our present condition?" they would ask each other. They had to admit, however, that he was one of the more decent guards at the water closet. Then there was "Vertoohi," a name suggested by Tamara Viktoryevna, who was moved into the cell when Doonya left. Vertoohi had a double connotation, she said, recalling tales to the others of her previous ten years in labor camps. The men who voluntarily sought jobs as guards were generally unskilled and could not secure work in other sectors that offered comparable wages and conditions. Their corruption of the language was a constant source of ridicule by the political prisoners, most of them highly literate and well-educated. At the morning roll call, these guards would roar at the prisoners lined up before them, "Nye vertoohisia," a malapropism of "Nye vertyetsia," which meant "don't turn; stand still!" "What better name," her cellmates howled.

He was the guard who was assigned the task of marching a prisoner to night interrogation. Vertoohi would be close on her heels, his mouth to her ear, whispering, so that his voice would not carry through the doors of the cells, "Eyes straight ahead. Don't turn. Eyes straight ahead," snapping his fingers crisply so that the guard coming with a prisoner from the opposite direction could be alerted; then, as the two prisoners were about to meet, he would swing alongside his own prisoner, order her to face the wall of the narrow corridor, and with his body shield each from the view of the other.

The women guards received no more respect than did the male guards. One became "Dahma," or Lady, her make-up so unsuited to the type of work she did and the uniform she wore. She was the overseer at the bathhouse and barked out the orders on the courtyard. The second guard was designated as "Dahmochka," the young newlywed, because although she was probably fifty, the hem of her uniform was above her knees, her face was over-painted, and she tried to behave as if she were a teenager. One of the detainees uttered a derisive snicker, "What kind of male would put up with a dog like that?" A loud laugh erupted. "Quiet," warned the Ballerina, "The guard's ears are at the peephole. Do you want more time in this hell?"

Ten o'clock was bedtime. The guards repeatedly called through the peephole, "Hands outside of the blankets," intent upon enforcing the rule that made it impossible for the prisoners to shield their eyes from the constant glare of the bright light from the electric bulb on the ceiling. Under such regulations, sleeping was difficult enough, but just as sleep did come, a guard would call out again from the peephole, awaken everybody, and order all the inmates whose surnames began with such and such a letter to dress and line up at the door. He would ask each one separately for her given and surname and when the one on his list responded, he would open the door and have her exit. The others would wearily undress and creep back into bed, so thoroughly awakened that sleep did not return until just before the morning wake-up call. Often this interruption occurred several times a night.

Eva was still in this same cell when most of her first cellmates were called out with their things. She assumed they were sent somewhere — to the labor camps she had thought. She learned later from

new cellmates that some may have been taken to other cells in an exchange, or for some other perverse reason.

In her six and one-half months at the Lubyanka prison, the first four months spent in this same cell, Eva became intimately acquainted with Russians, ironically an opportunity she had not had before her arrest. Some she remembered for the rest of her life because their tragedies were the same as her own; others for incidents that broke the monotony of prison life or gave her an understanding of the madness of the times.

Nina Fetterman — Nina the Ballerina — was the wife of an engineer in the Stalin Automobile Works. Eva recalled the publicity that had been in the newspapers in connection with this plant. Many engineers had been charged with sabotage and conspiracy to blow up the Kremlin. The notice of the arrests had touched her, convinced as she was by her own experience that the accusations were fabrications and excuses for intimidation. The whole affair became known as the Stalin Works Jewish Engineers Plot because most of the engineers indicted were Jewish. Nina's husband was among those arrested, and Nina herself was picked up by the MGB soon after, allegedly for anti-Soviet agitation. Her faith that she would be released amazed Eva. Regularly she did her exercises, determined to keep herself fit. "Why?" Eva would think. "Her life, like mine, is ended."

Nina S. was a vocalist in a variety group with the Moscow Philharmonic, popular for its interpretation of Russian romantic and gypsy songs. Her first husband had been arrested and had disappeared in 1937, the same year as Morris. A short time later, she divorced him and married again, this time to a general who had earned many honors and awards during the war for his valorous deeds. During the interval between the two waves of arrests, laws that were enacted a few years after the raids of the thirties prohibiting arrests merely on grounds of a family relationship to political "criminals," and her new name and status as the wife of an army officer, apparently insulated her from the surveillance of the security police. As a result, she escaped the fate of so many wives of the professionals arrested and sentenced merely because they were spouses. With the terror now being repeated, this husband was also arrested

"and I am sure stripped of all his medals and awards." She had not even had time to inquire about the accusations against him when she, too, was arrested on charges of spying. "What am I supposed to have done? You won't believe it!" A few years after the war had ended, her musical organization had been chosen to give some concerts in Japan. For reasons unknown to her, her name had been stricken from the list of members selected to make the trip. "I was charged with wanting to go with my troupe to take classified information to the Japanese!"

Auntie Anya was in her middle fifties. She was a devout Baptist — a Pentecostal. "Auntie Anya, the Baptist," Doonya regularly smirked at her, in hate. She would reply, not to be ruffled, "Yes, I am a Baptist — a Christian, just like you." Doonya would snort back, "A Baptist who practices religion like a heathen." The charge against Anya was very serious and carried with it severe penalties because of the unorthodox nature of the rituals of her sect. Its members conducted their services under the open sky, abandoning the traditional roofed house of worship which "keeps God from us." They prayed in tongues and were accused of alluding to the Soviet leaders in animal terms, using such labels as "Wolf" or "Leopard" or "Hyena" — each supposedly denoting a specific member of the Politburo and others in leading positions.

Anya was kind and gentle, and more concerned about the distress and possible fate of her cellmates than herself. A few days after her own imprisonment, Eva was sitting on Olya's bed, reading, when Auntie Anya suddenly grasped her by the arm, holding Eva so tightly that she could not shake herself free. Anya began to speak in tongues, all of which sounded like gibberish to Eva. The woman seemed to fall into a trance, making strange motions over Eva's head with her other arm. Eva struggled to free herself from the hold. The others signaled her to sit quietly and seemed not at all alarmed, as if they had seen this phenomenon before. Eva submitted to the incantations until Anya had finished. Anya, from the goodness of her heart, had been asking God's mercy for this lost soul, this disbeliever, upon whom His wrath had fallen. She was being made to suffer for her sins, her punishment her daughter's suffering, this only child left alone to make her own way in this difficult life.

Doonya, a Russian of Polish descent, also a fervent believer but of another sect, was a fanatic uncaged. She never revealed the reason she

had been arrested, and Eva had seen too many anti-Semitic outbursts among the populace go unpunished to hope that her bigotry might have been the charge. This woman was frank and outspoken on her hatred of Jews. "I will not touch anything that a dirty Jew has handled," she would hiss on those days when it was Eva's turn to take the bowls of food from the guard and serve them to the women. Laura would upbraid Doonya for making more work for everybody. Several times everyone else would refuse to pass her bowl on to her. Only the hunger that she anticipated having to undergo until the next meal brought her to her feet to fetch it for herself. The impatient guard would scold her for keeping him waiting. Eva felt good toward her cellmates who did not conceal their contempt for Doonya. They did not speak to her except when there was vociferous quarreling because of her behavior. After Nina the Ballerina left with her things, Eva became the primary target of Doonya's repetitive, wrathful slur, "Christ killer!"

Laura claimed to be the wife of a young, very important engineer. She told a vague, involved, and strange story of why she was arrested, a story that was in fact so complicated that Eva could not follow it so she let it rest. Laura was good to have as a cellmate. Her sack was filled with dresses and houserobes and undergarments, and she was generous in sharing them, reminding Eva, on a trip to the lavatory, to slip on an item of hers to temporarily replace one of Eva's own that needed to be washed. Cleaning the cell floors and the prison toilets had rapidly reduced her dress to a rag, and Eva appreciated Laura's gesture. She was equally gracious to anyone else who needed a temporary change. No one envied nor questioned her for having such large packages. They felt pity for her because she was undergoing such an unfair and long investigation. But whatever her "crime," the treatment she received was different from the others. She was rarely called out for interrogation at night, and then only for short periods of time. She was most often interrogated when meals were brought into the cells; on those occasions, out of compassion, the others begged the guards to leave the bowl of food so that she could eat after she returned. Several times she was brought back to the cell with her eyes red from weeping. A few months after Eva's arrest, she came back to the cell and announced that her investigation was finally over and she could soon expect to be moved. During the interval,

while she awaited sentencing — which did not happen during Eva's time in this cell — she was receiving parcels and money from her family, and twice, on returning from a summons, she gleefully reported that she had had a short visit with her parents and a sister, a privilege none of the others after their sentencing had ever been permitted.

Another inmate, whose name Eva never learned, appeared to be demented. Her eyes roamed incessantly from one prisoner to another as if she were paranoid. Her long fingers were always pressed nervously around the knuckles of her hands or were pulling at the fingers of the opposite hand, stretched so that it seemed they would come out of her skin. Her hair was unkempt and knotted; her speech boastful. "They're not going to kill me with their poisons," she would repeat. "I know what they're up to. They would like to kill all of us with the poisons they pour into our water." She ranted about letters she had mailed to authorities accusing them of wanting to murder the Russian people, but "they're not going to kill me. I won't touch their water. They can't force it down my throat," and she would caution anyone lifting a cup against drinking. To everyone's relief, she was removed from the cell within days of her arrival, but the blessing was short-lived. About a week later she was returned, laughing, victorious. "Those crazy people! They put me in a madhouse — a prison for the mentally ill. Can you imagine?" She had been taken to the Serbsky Institute, a prison hospital for the mentally ill. "They found out soon enough who was crazy! Those white-gowned whores belong there, not me." Having been returned to the cell, she must have been diagnosed as normal, and she was still there when Eva was transferred.

Karen, in her early thirties, was married and the mother of a young child. Her disinterest in the politics of the country and her complete lack of knowledge of the most elementary theories of communism amused Eva, particularly since she was the daughter of a government official who had been in the diplomatic offices assigned to Italy. She gave the impression of being a social butterfly, her main ambition to live a socially satisfying existence. Most of her youth had been spent with her father in Italy where she had been educated in a convent. When her family returned to the Soviet Union, Karen was an adult, accustomed to a freer life than she found in Moscow. She took a job as an interpreter for

Italian engineers working at a Moscow ball bearing plant and through them became acquainted with other foreigners, among them Americans. Both she and her sister were more comfortable in these circles than with Russians, with whose culture they barely identified. She was so utterly naïve about the political environment and ignorant of the arrests of more than a decade before that she was bewildered by her own arrest and incompetent in coping with the accusations of spying made by Vovochka. Whatever advice her cellmates gave her evoked only innocent comments, which if she were to have made to Vovochka would certainly have convicted her. Once, her cellmates devised a story which was simple enough for her to carry through if the investigator had been as stupid as they considered Vovochka to be — and which they thought might bring the interrogations to an end, since it was a very minor misdeed. "Look, say 'yes,' you spied. You spied for an American but didn't realize you were spying. Give his name as — what is a common American name, Eva Moisseyevna? John Smith? All right. You told John Smith that the ball bearing plant produced ball bearings of different sizes." The room echoed with laughter. That following morning, a frightened Karen was returned to her cell. Vovochka had seen through the "confession" and threatened her with solitary confinement. From then on, they decided against advising her and she was on her own.

Ekaterina Bukharina, a medical doctor about forty-five years of age, was the daughter of a first cousin of Bukharin. Katya, as she was called, had seen Bukharin only three times in her life, once before the Revolution when she was a young child at a wedding of a member of the family, once at the funeral of her mother, and the last time when she was nineteen years old, at the funeral of her father. He was a stranger to her, the only words exchanged between them the usual greetings at such affairs. Now more than twenty years later, she and her sister, a widow and mother of two children, were accused of peddling anti-Soviet propaganda. "We are not even politically active people," she said. There was no question in her mind, nor those of her cellmates, that her distant relationship to a former member of the Politburo, executed for treason, was the reason for her and her sister's arrest. "Why didn't you change your name?" Eva asked her. "What point would there have been to that? They could find us any time they wished. My sister's name isn't

Bukharina; yet she was taken. Besides, I am not ashamed of my name. I didn't know my father's cousin, and if he were truly an enemy of the people, we had nothing to do with it. I'm not even sure he was an enemy." Later, when Eva learned about *stookachka* — informers — planted in the cells, Eva feared for Katya's safety, knowing that her frankness must have cost her dearly.

Also among Eva's cellmates were two lawyers. The one, Anna Mironovna, a Jewess, was well into her sixties. She had been accused of agitation. Her answer to Vovochka, at the first interrogation before she had been brought into the cell, was a cool disagreement with the charge. "Wanting to improve a condition or correct a wrong cannot be interpreted that way," she said. She compared wanting to remove an injustice committed by the government as being no different from raising children whom one loved very much but nevertheless might have to scold to make them understand the error they were committing. Vovochka accused her of arrogance. "Don't repeat to me your idiotic anti-Soviet ideas," he stormed at her, "and in all places here, the stronghold of the Soviet defense system!"

The other lawyer, Elizaveta, a young Armenian and permanent resident in Moscow, who had been taken from her young son, naïvely argued with Vovochka at her first interrogation about the illegal aspects of the treatment of the prisoners and the unconstitutionality of the charges against her. He told her that it would be in her interest to be quiet and forget what she had learned in school. "We have our own laws here. The laws that you have learned have nothing to do with what is going on here." If lawyers had no recourse to the law, Eva thought, what hope did someone like her have in this crazy, irrational system?

Tamara Viktoryevna did not wait for the cell door to be closed behind her to issue a dire warning. "Don't say anything in this room that you'll be sorry for. Every word you say here is reported to the MGB. Don't trust anybody. There is at least one stookachka in every cell!" Everyone gasped. This was a startling introduction to a stranger — one who like themselves was thrown into fearful incarceration. "Take my word for it. I know. This isn't my first time in these holes. Believe me, I know," Tamara Viktoryevna persisted. "There was a time when I trusted everybody who was in a cell with me. I felt sorry for all of them as I felt

sorry for myself. I listened to all of their sorrows and I talked. The investigators then turned every word I said to them against me." At first, Eva thought she was as crazy as that other demented soul, but after hearing Tamara's story, she was convinced that, indeed, Tamara Viktoryevna probably was telling the truth.

Tamara Viktoryevna did indeed know what went on inside the prisons! This interruption of her free life was her second. Early in 1937, she had also been arrested. All the women in her cell had been charged with the same crime — they were wives of "enemies." The questioning they received was an attempt to worm information that would damage their husbands. She was convicted and sentenced to serve ten years in a labor camp.

Tamara was born in Russia of parents of the minor aristocracy. Her father, an engineer, had worked as a designer and supervisor of the Trans-Siberian Railroad until its completion in 1915. He decided to live permanently in the area where the railroad ended and sent for his wife and young daughter. The family settled in Harbin and lived in a Russian colony as on an island — separate and apart from the Chinese. Here she was raised, educated, married, and gave birth to her only child, Alla.

In 1935, when the Harbin line became part of the Trans-Siberian Railroad, the government urged the Russians to return to the Soviet Union. By this time, Tamara Viktoryevna had divorced her husband and remarried a musician, Troitsky, who, like her, was the child of Russian emigrants. At the beginning of 1936, she, Troitsky, and Alla, now thirteen, moved to Moscow. Troitsky was given an assignment with an orchestral group situated outside of Moscow where the family settled.

Before a year had passed, within two days of each other, first Troitsky, then Tamara Viktoryevna, were arrested, and they never saw each other again. Alla was left with strangers but later made contact with her stepfather's brother who assumed responsibility for her.

Tamara Viktoryevna, uncooperative both in prison and in camp, suffered severe punishment. When she served her term and was released, her passport did not permit her return to Moscow. This regulation, however, did not stop her from returning to look for her daughter, Alla. She was met with hostility, Alla's guardians having thoroughly alienated the girl from her mother, persuading Alla that both her mother and step-

father were "enemies of the people" because they had "worked as spies" for the Chinese. She refused to be discouraged. Determined that her daughter would get to know her, she took housing in Moscow without legal registration, placing herself in great personal jeopardy of another arrest. She bootlegged work as a typist at a wage which barely left her with sufficient money for food after she paid out the high rent for an unauthorized room. Gradually, she brought about some slight change in her daughter's attitude and was even given permission to visit with her from time to time. Just a few months before Tamara's arrest in this second wave of terror, Alla had married and was expecting her first child.

In the prison for the second time, Tamara Viktoryevna became the advisor and counselor to the struggling prisoners who were exhausted through all-night interrogations. She enlivened their spirits with jokes and anecdotes that she had learned in her first years of incarceration. When the women would complain about the prison conditions, she told them that things could be worse. "In 1937, there were so many of us in one bed that when one of us turned from one side to the other in our sleep, all had to turn at the same time. We needed to take turns during the day just to sit down." They admired her courage to retain her dignity, which the jailers called "arrogance," and to resist Vovochka. "What more can you do to me that you have not already done? Kill me? Then kill me! Yes, I lived illegally in Moscow!" One day she was called out with her things. After she left, everyone heeded her warnings and their talk became guarded under the suspicion that a stookachka might be among them.

Tamara Viktoryevna and Eva met again in another cell at Lubyanka. During their months together, as Tamara Viktoryevna's story unfolded, Eva could at least be thankful that the wives of Bob, Morris, and Max had been spared arrest and imprisonment during the first reign of terror. She could at least be thankful that she had been able to be a mother to her daughter — something Tamara would never know. Subsequently, she was placed in prison cells and camps with Valeria, and when all were freed, they remained friends for the rest of their lives.

Chapter 16

\mathbf{A} week after her arrival at the prison, Eva was called out the first time for interrogation. With her arms behind her back as instructed, her fingers clutching at the waist of her dress to hold the undergarment that had loosed itself from the knot that Auntie Anya had shown her how to make, she walked in front of the guard who was so close to her that she felt his breath on her neck. He was snapping his fingers as if to inspire a rhythm to the walk. From a distance she heard hands clapping and footsteps, and she soon grasped that another guard was signaling his coming. The footsteps ceased and in a moment she passed him, standing directly behind a man facing the wall to her left. There was no way that she could have caught even a glimpse of a face. When she passed them, she heard their footsteps moving on in the opposite direction. At a turn in the corridor, the guard stopped her at a small table holding a ledger. He glanced at his wrist watch and made a mark in the book. They continued down the corridor and into the office of the investigator.

Vovochka "the Hero" was waiting for her. He directed her to sit on the chair in the corner of the room, and from his own chair at a large desk in the opposite corner near a window he gave her the rules. "You are to remain seated during our interview, answer my questions, and do not sleep." His first questions were strictly biographical, "as if he didn't know it all from our first interview," she said when she was returned to her cell. Then he began with the spying charge which Eva vigorously denied. He grabbed a sheaf of papers from his desk, waved them at her, and in a loud voice declared, "Here is the proof! In your own handwrit-

ing! Proof that you are a traitor to your Soviet Fatherland!"

Eva stared at him. He proceeded to read to her a Russian translation of a letter she had written years before to her cousin living in the United States. It was newsy and friendly, but it had been many years ago and Eva did not recall the letter. She listened with a feeling of nostalgia. As he reached the end, his pace changed, and slowly, with emphasis, he read, "Send my regards to the gang!" He stopped as if to give her an opportunity to reconsider her denial. She was silent, waiting for his next statement. "Well? What more proof do we need? Now will you confess?"

She was perplexed. "Confess to what?"

"Here is proof. You belonged to a gang!"

Already exhausted from the anticipation of this first interrogation, Eva looked at Vovochka, open-mouthed. " I will try to explain it," she said to him. He seemed pleased. Patiently, as if he were her student, she talked about idiomatic language and English slang, but he didn't listen long.

"I don't want to hear your explanations. We have translators who know English as well as you. Don't try to put anything over on us. Just admit that you are a member of a spy ring."

It seemed like hours that he had her there, at first appearing only annoyed that she refused to name the gang who, he insisted, was part of an American organization which planted spies in the Soviet Union. Gradually, he transformed himself into a maniac. He threatened her with exile to places whose names were notorious. "I warn you. If you do not tell the truth you will get the whole spool. You will get the maximum years of sentence in the most severe places of internment from which survival is highly questionable." Eva, dumb-struck by his seriousness, was afraid to say anything more. The two just glared at each other.

Finally, he turned his attention to his desk, sifted through papers, and came up with a folder. One by one he lifted out photographs and snapshots — the loot from the raid in her room. "Who is this woman? Who is that man?" These were what were left of the mementos of her childhood and youth in the United States. Others had been confiscated, along with the cameras which the family had brought from Chicago, when Morris and Max had been arrested. She felt that luck was with her

that there were no photos of Russians or of her English-speaking friends who had lived or were still in Moscow. Following the confiscation of the cameras, they had never had another one.

"They live in the United States," she said. "You cannot get your paws on them."

He set aside the photographs and centered his attention on two books Eva recognized as her high school and college graduation books. Behaving as if he were alone in his own office, completely ignoring her presence, for an interminable amount of time he slowly thumbed the pages, studying the tiny squares of photographs. When he reached the last page, he started again from the beginning, and facing the pages toward her, he asked how well she was acquainted with the persons in the books. On her reply that they had only been members of her graduating class, most strangers to her, he looked dubious. "Members of one graduating class — so many?" Again he lowered his head into the pages.

These books were to be the subject of hours and hours of questioning. Even with the evidence before him, he refused to believe there were so many graduates of one single high school or college. Later, when Eva became bolder and impatient with his insinuations that she was exaggerating, for some reason only he knew, she would taunt him and reply sarcastically, "Of course there are not that many graduates in a class. I personally snapped the photos of many people on my street and I personally printed the books. Of course so many boys and girls cannot possibly have graduated with me. There cannot possibly be more graduating in American schools than in Soviet schools, can there?"

After hours of this first night of interrogation, with Vovochka engrossed in the photographs, Eva began to doze off. "Wake up," he shouted. "I told you the rules. No sleeping here." Again, starting from the first page of photographs, he pointed to each one separately and demanded that she identify them in some way. Finally he shoved a paper at her. "Sign the protocol." She was fully awake now. This was the first of the protocols she was to sign, page by page, signifying her agreement to the accuracy of the interview. Slowly, deliberately, she read through the statement which covered his questions and her responses. She immediately understood the absolute need to examine and think through every sentence so that there could be no interpretation of a

confession of guilt. In spite of her weakness and lack of facility with the language, she found grammatical and spelling errors so glaring that the teacher in her surfaced automatically, and she called them to his attention. Surprisingly, he accepted her editing. (From time to time at the end of several other interrogation sessions, she would continue to correct the errors. She would return to her cell and say, "Damn! I did it again. I meant to let his illiterate protocols go into the files as he wrote them for future generations to know what ignoramuses worked for the Terror." However, that she could recognize such errors made her confident that she could pick up any misinterpretations and often she would refuse to sign some protocol until he changed the wording, wherever she could manage to manipulate him into doing so.)

Finally, Eva was dismissed. She followed the guard who stopped first at the small table apparently to clock her out, and she was returned to the cell. She crawled onto her cot. It seemed that she slept only minutes before the wake-up call came.

Hour after hour, night after night, week after week Vovochka harassed her on the subject of spying for the United States. In the early days of the interrogation, she naïvely answered his questions honestly and sincerely, the same questions thrown at her at every session. He would fume and fuss, sometimes working himself into such a rage that she surmised he was trying to frighten her into confessing. He would wave more of her letters at her, always from a distance, never permitting her to review them herself, implying that their contents were damning. He also thumbed through Abie's diaries, which she easily identified, that contained almost thirty years of his thoughts.

"How ridiculous," she thought "This moron can't read English." If he had a translation, it wasn't evident. To Vovochka, she remarked, "Your MGB agents had no right to take anything that didn't belong to me."

"We take whatever we wish," he replied.

His demand that she reveal how the spy ring operated and who the leaders of the gang were enraged, then tired, her. Sometimes, feeling drugged from lack of sleep, she saw only his lips, opening and closing, until they spread and shut out his entire face. She would have invented a story if she had been familiar with even a foundation for one. If spy

stories were popular literature of the day, she had not yet been introduced to them. The hours he spent wearing her down apparently even bored him at times. He would either run out of questions or would try another strategy to tear away at her. For hours he would give her the silent treatment. She would be sitting in the chair in the far corner while at his desk he shuffled papers from one side to the other or leaned back in his chair, relaxing with a newspaper or a book; or he would get on the phone and have a lengthy conversation with another investigator — it had to be another investigator, for who else would be awake at this time of the night? There would be no attempt to keep the substance of his parley from her — about a ballgame or some other light subject as if to demonstrate that a world of people still enjoyed life. When he would see her head beginning to nod, he would boom out, "No sleeping. You know the rules!" and go back to his diversions. Sometimes he would call the guard to stay with Eva, reminding him that the no sleeping regulation was to be strictly observed, and he himself would leave. Hours later he would return, looking smug and content, obviously having managed to find for himself a soft bed. Rested, he would begin the harassment again. Since the other prisoners reported the same behavior, all of them came to the conclusion that the investigators were required to put in a specific number of hours for base pay and earned extra if they stayed overtime on the job. Who would dare to report that his overtime was spent sleeping?

After two weeks or so had passed, Eva was becoming enfeebled by lack of sleep. She felt herself almost willing to agree to anything that he wished. "I don't know anything about spying. You must know a great deal about it. Write up a story. I'll sign it."

But he answered, "No! You must tell us yourself what you did. We want only truth."

She began to scream. "I don't know anything about it. How can I tell you anything about spying when I never did any, and I don't know how it is done, how to become involved in it, where one goes or whom to see." In despair, she added, "You really don't want to hear the truth, do you?"

This session led to a visit, the first, of the public defender, "In order that you may submit your complaints and get legal advice,"

Vovochka explained. With Vovochka present, Eva objected to his allegations and his refusal to tell her what specific act she was accused of. She even thanked the man for appearing in her behalf.

"I can only advise you," he said. "I have examined the protocols and from these reports I urge you to confess." Again the vague "confess!" "You are being very recalcitrant and are only making things difficult for the investigator to help you. It is in your own best interest that I give you this suggestion." Eva realized that her depleted state had given her false hope that he might truly defend her. From then on, whenever he sat in on the interrogation, she behaved towards him as if he were not present, wanting desperately to demean him.

Derision, Vovochka's stock in trade, got a rise out of her during another extended period without sleep. He held up her war medal. "You, too, were awarded one of these? Obviously a mistake — to an enemy of the people — to a spy?" He followed with compulsive shouts of "Traitor to your Soviet Fatherland," a droning repetition of every session.

"Of course I am a traitor." Her shout was an echo of his. His eyes lit up. He was beside himself with eagerness; her words were swiftly transcribed to the protocol. "I left my Motherland to come here. Your precious Fatherland is not mine."

A confession at last! She was aghast by what she had allowed to slip from her. She insisted that he hadn't understood her. Nevertheless, it had been written down. Demanding to see her public defender, she refused to sign the protocols unless he softened her words. Vovochka now had a real case against her, and it was straight out of her own mouth — smirking at the Soviet Union. She knew that there was little chance that the public defender would regard this as a deliberate misinterpretation of the investigator, but for some unknown reason, he deleted it.

Still shaking when she was returned to the cell, she cried to the others, "Either he really thought the public defender might see it my way, or he was very careless. I just can't believe what I did!" They all wondered whether he could turn in that page of the protocol without her knowledge.

Vovochka's methods and routines remained the same. His questioning would proceed where he had left off the previous night. Some-

times he would have her sit for a while as if she were part of the inanimate objects in the room; then suddenly he would talk, without looking at her, as he shifted materials on his desk from one side to the other. Once he asked, "Do you know Tim Ryan?"

"I knew him many years ago."

"When?"

"During my first years in Moscow. I haven't seen him in thirteen or more years."

He raised his eyes from his desk, and keeping a steady gaze on her, said, "He is a spy."

This apparent attempt to shock her with a revelation made her laugh. "My, my!" she mocked him. "How remiss you are. Why don't you arrest him?" Then angrily, "You know as well as I that he is the leader of the Communist Party in the United States." (Tim and Reggie Ryan had returned to the United States where Tim became secretary of the Communist Party. Caught up in the hysteria of the fifties during the McCarthy period, he was tried and convicted, and spent many years in prison as a political prisoner. He died in 1961.)

He dropped his eyes to his papers and went on to his next question as if he had never mentioned Tim Ryan. "You know Yevgheni Vostokov?" The name was unknown to Eva, but he insisted that she must know him and nagged at her for hours to confess the fact.

"Well then, tell me," he asked, "Who are some of your friends? Who are your co-workers?" Eva knew that any name she might mention meant another suspect for the MGB. Although there was no proof, everyone had decided that the investigators had quotas to be fulfilled, just as the administrators in the factories. The more names, the more arrests, which meant more bonuses and honors for the inspectors. Eva remembered rumors about informers and about people who, during interrogation, had answered seemingly innocent questions of the investigator when a name was mentioned. Often an innocuous statement made at a convivial gathering would lead to an arrest. It took all of Eva's ingenuity to speak around names.

Vovochka would then go back to names he had previously questioned her about. "Vostokov. Don't lie to me. You must know him. Rosa Mikhaelevna, you know her, don't you? Don't lie to me!" Night after

night, week after week, these same two names were mentioned as a pair, and her same negative reply brought on his wrathful ire. "You are lying," he insisted. "I don't know them," she replied in her own display of impatience. And on and on it went.

One night he asked her if she knew Sheva and to her truthful reply, alert to the possibility that she might be setting a trap for a loving friend, he followed with "Do you know Rose Wogman?"

"I am acquainted with Rose Wogman," she answered, "but only casually. I have never been on more than a nodding relationship with her nor she with me."

"Then you did lie. You told me that you did not know her." He scooped the protocols from his desk and waved them in the air.

"You have never asked me about Rose Wogman," she said stonily.

He sifted through the protocols. "I have asked you yesterday and the day before that, and every day for weeks." He read from the protocols: "Rosa Mikhaelevna, Rosa Mikhaelevna."

Then it came to her. "I know her only as Rose Wogman. Americans do not use the patronymic. I did not know that you were asking about Rose Wogman. The name Rose is very common. I myself am acquainted with several women who have that name." He let that pass, taking time to write his notes for the night's protocol.

"If you know her, you also know Vostokov." He observed her closely for a reaction.

"If you are trying to tell me that they are friends, I do not know her friends. I know nothing about Rose Wogman except what I told you. She is not a friend of mine and I do not know anything about her nor her friends," Eva persisted.

He used every trick to wear her down in order to force from her an admission that she was a friend of Rose Wogman's and a Russian by the name of Vostokov. Again and again he mentioned Sheva's name also, demanding confirmation from her that Rose and Sheva were confidantes. "That is impossible," she would repeat. "Sheva is a dear friend of mine. I would know if she and Rose were acquainted. Why do you persist in trying to make a connection between the two of them?"

"It is not for me to answer your question!" he boomed. "It is enough that I know that you lie."

On reviewing that evening's protocol, Eva emphatically protested his having written that she admitted to lying — that she had known Rosa Mikhaelyevna, but only now agreed to divulge it. Even her refusal to sign that page and her demand to see the public defender did not dissuade him from leaving the information in her statement.

After the wake-up call and a night of interrogation that had ended only just before breakfast, Eva was summoned again for questioning. She hoped this might be the end of the night ordeals. To her surprise, she was told to seat herself next to Vovochka's table, a good distance from the papers on his desk. The few silent minutes between them were broken by a knock on the door. A guard admitted Rose Wogman, who, supporting herself on her cane, shuffled to the chair in the far corner that Eva usually occupied. As if she were at home and with the closest of friends, she greeted Eva enthusiastically. Her first words to her were, "How is Tommy?"

Eva could barely conceal her astonishment at Rose's seeming nonchalance. She answered bitterly, "I don't know."

Vovochka became livid with rage. "Enough of this society talk! You, Rosa Mikhaelyevna! Have you no shame? What concern do you have for Eva Moisseyevna's daughter? That girl would not now be without her mother if not for you!" At this outburst hinting of compassion, he glanced at Eva, and she detected a pleased look in his face. "The fool," she reported later to her cellmates. "He believes that I fell for this sudden sympathy towards me. What a hypocrite!"

The interrogation continued, and Vovochka lowered his voice. "Now get down to business," he demanded of Rose. "Are you lying or is she lying? Do you know Sheva?"

"Eva! I met Sheva at your flat. How can you deny it?" She prodded at Eva's memory. "Don't you remember? When your mother died, when I stopped in to see you? Sheva came in a few minutes after me. You must remember. She went into your kitchen to start the supper as if she lived with you."

The scene came back to Eva — her pondering Rose's visit. "Oh, oh! I remember. It was thoughtful of you to drop in to offer your sympathy. But — about Sheva. She never mentioned you. I didn't know you were good friends."

"We're not." Her casualness was irritating. "I never saw her again, but I always remembered her because her name is so unusual. What is her last name?"

"What kind of comedy is this?" Eva turned to Vovochka. He was deep into the protocol. "What is he getting at? Why is Sheva being brought into this?" she wondered.

"She lies about Vostokov, too," he said to Rose. "Maybe you can shake her memory about him." There was sarcasm in his tone.

Rose concentrated on Eva. "Surely you remember him. I told you that I was becoming friendly with my first husband's nephew."

Eva admitted this. "Yes. You had mentioned to all of us that you had met someone of your husband's family whom you were seeing frequently, but what has that to do with me and this Vostokov?"

"He's Vostokov. You never met him." Eva glanced at Vovochka with a smirk.

The confrontation between Eva and Rose ended with Eva leaving very troubled. Vovochka now had his evidence that Eva had been "lying" about both Rose and Sheva being acquainted with each other and her being aware of Rose's friendship with Vostokov. But why the emphasis upon Sheva?

Rose signed the protocol and was led away. Eva's insistence that the wording in the protocol be changed from "lied" to "she had forgotten" passed unnoticed, but she would not agree to sign that page.

Another morning summons a few days later disclosed the answer to Eva's question. Whom shall I see now, she wondered. When Sheva entered the room, Eva became agitated. That Sheva, too, had been arrested was distressing enough, but it was her physical appearance that was most upsetting. She was benumbed and trembling. Eva made a move as if to rush towards her. "Shevochka! How long have you been here?"

Vovochka interrupted. "It's none of your business! You'll speak when I ask you to speak!"

The purpose of this confrontation was for Vovochka to secure evidence against Sheva — to be able to write in his protocol that she had lied — that she had denied knowing a woman, other than her own aunt, named Rose. Now Eva recalled for her the chance meeting she had had with Rose Wogman. Only Eva's description, "the woman who walked

with a cane," brought her memory back, but vaguely. "She wasn't in Eva's flat long enough for me to speak with her beyond the introduction. I wouldn't know her now if I saw her," Sheva said. The interpretation in the protocol was that Sheva had deliberately told an untruth.

One morning, just before Eva's investigation was begun in earnest, Nina S. had not been returned to the cell. "Yet," Laura said, "she could not have been sent away. Her things are still here." Three days later she was brought back looking like a corpse. She had been placed in solitary confinement. Her feet were swollen to twice their normal size.

The women sat her on the floor, her back toward the peephole with her legs outstretched to ease the pressure on her feet. The guards would have prohibited her from lying down, and for her to sit with her legs hanging from the side of the cot would have aggravated the swelling. As she slept, each took a turn kneeling or squatting, facing her and the peephole, pretending to be her partner at a game of gallah while the others, some standing, some sitting on their knees, surrounded the two of them. The "partner," full-face within the guard's vision through the peephole, would feign reactions to the on-going game with statements like: "Say, what kind of a move is that? You are playing gallah, not checkers," or "Bravo! that was an excellent move." From the others, there were loud words of advice and encouragement. If the guards knew what was going on, they gave no sign of it; they merely peered into the room every few minutes and appeared to be satisfied with the behavior in the cell.

It took many hours before Nina was sufficiently recovered to tell what had happened. Vovochka had badgered her incessantly, hurling insults, flinging at her that she was unfit to be a Soviet citizen because she had divorced and remarried to hide her relationship with an "enemy." Nights and days with little sleep and many hours of interrogation had weakened her and her self control cracked. She screeched at him, "I have done nothing to harm our people. You are the enemy of the people!"

"Vovochka towered over me. His bellows to the guard deafened me. He commanded, 'To solitary! To solitary!' I was lifted off my feet, two guards at my side, and dragged to a box that was no bigger than I am. I couldn't sit or squat. I could only lean against the walls, but not for long because they were so damp and cold. My food was bread and cold

271

water. I cannot recall if they fed me once or twice a day or if they even took me to the water closet." She thought she might have lapsed into subconciousness in the cell.

Nina's painful disability did not excuse her from the daily exercise in the courtyard. She was a large woman and every step was agony. The heaviest of her cellmates defied the guards and walked on either side of her and held her arms firmly so that she could support herself and step as lightly as possible to try to ease the pain. Eva thought it interesting that the guards did not try to stop them. Once, one of the female guards, apparently moved by the sight of Nina's swollen feet and enfeebled posture, even slipped a chair to her.

One day, not that long after her solitary confinement, Nina S. was called from the cell and ordered to take her things. Her traumatic experience stripped everyone of their courage. From that moment, whenever called for interrogation, Eva was determined to be more alert to avoid Nina's devastating fate.

Now, the fear of isolation as well as the fear of physical harm was always with Eva. Abram, Helen's husband, had once described in such detail what had been done to him that she begged him to stop, and the thought that Max might also have been subjected to torture brought on frightening dreams in which he stood before her, torn apart. When a week of her own imprisonment had passed and she had not been touched, her hope that such practices were now illegal was reflected in a dream where Max came to her cot, sat down, and stroking her head, said, "See, you little fool! All these years you were having these terrible nightmares — and for nothing. Look, sweetheart. I'm whole — not crippled, and I never have been. I'm still as you have always known me." But several times, while she was sitting in her far corner, Vovochka at his desk under the window in the corner opposite her, the two of them either glaring at each other or he questioning her, a frightful noise could be heard from the adjoining room. Eva would hear groaning and sounds as if chairs were being thrown about. She would become tense and Vovochka would look up slyly saying that Abie or Helen or Abram or some other person she knew was getting what they deserved. Tamara Viktoryevna pooh-poohed her reports. "They're just trying to frighten us into saying what they want to hear." Eva, however, was not convinced of this. Once, a

man — apparently a man because of the heaviness of the step — was being dragged along the corridor to the door of the cell opposite theirs. They heard the door open, loud cursing, and men's voices — very unusual because the guards were always careful to conduct their activities quietly. They were sure that the man had been tortured.

Once, after what seemed like hours of silence, Vovochka opened with, "Do you know your Borodin died here last year?" Her response was quick, "And do you know how shameful of you it is to have tortured a sick old man to death? What a thing to boast of." But later she wondered if he had spoken the truth and her thoughts now only brought on unspoken words, "You stupid and arrogant beast! You'll never do one hundredth of what Borodin did for the revolutionary movement. You will never be worth the little fingernail he cut off and threw away." But with the thoughts came the fear that he was warning her that she might never leave Lubyanka alive.

The frequency of the interrogations had increased about two weeks after they started, and for the next two months Eva had been called out almost every night only to be returned to her cell after her cellmates had been fed and made their journey to the water closet. Then, one night, there was a change in the procedure. Vovochka did not wait for her to take her place in the chair in the corner. He picked himself up from his chair at the desk and ordered her to follow him, a guard walking behind her. As soon as she entered the room into which he led her, she knew that she was in the office of the chief of the entire investigation department of the Lubyanka Prison. She was left alone with a man whom Vovochka addressed as "Comrade General Gerassimov." The meeting was short but terrifying. He ordered her to sit in the one chair directly in the center of the vast room. With his arms waving, saliva dribbling from the corners of his mouth, and his colorless eyes bulging, he walked around and around her like a wild, stalking animal — slowly — then gradually speeding up almost to a run. He hurled words at her, none of which she understood. Suddenly, he stopped and fixed his eyes upon her. "You call yourself a woman? You are a nothing! You are a floor rag." She never saw him again.

As each woman in the cell reported the same kind of visit to his

office, he became the topic of conversation. Ostensibly, his main task was to observe every prisoner. Eva was perhaps fortunate that her knowledge of Russian did not include profanity. "That one is a real virtuoso in combing Russian for obscenities," Laura told her.

Tamara Viktoryevna summed him up. "It is his task to humiliate us. If he can make us see ourselves as he sees us — as worthless — what easier way to degrade us? Then we are putty in the hands of the secret police."

Eva wondered how he arrived at the fever pitch that she had witnessed. "Only one way. He must take a drug," they answered.

Another interruption to Vovochka's interrogations with which the women without exception experienced, each one many times, was from a little man whom they dubbed "Shorty." He was apparently Vovochka's superior and was directly accountable to Gerassimov. He would enter the investigating room unannounced, his hands in his pockets, and join in on the interrogation. When he questioned Eva, she was again certain that in spite of her long years in the Soviet Union, in spite of her years in the classroom with Russian students, she did not know the language. He needed to repeat himself before his words penetrated. "You have been without a man for a long time, haven't you?" She stared at him, her look making it quite clear that she was puzzled by the question. He rephrased it. "Your husband has been gone a long time. How many men have you had since he left?"

"That is none of your business!" she bluntly answered.

He was good-natured. With a laugh he said, "But it is our business. Come now! Who was your last lover? Did he satisfy you?"

She was learning courage. "I repeat. My sex life is none of your business. If you have a question to ask me about my case, I'll try to answer truthfully, but such questions I refuse to talk with you about."

He seemed amused. "My question has to do with your case. Your sexual behavior reveals your character, and I want to know your character."

Eva adamantly refused to talk further with him, and finally, with his hands still in his pockets, he abruptly left. He returned many times, always the same way. The door would open and there he was, taking over the questioning from Vovochka, her refusal to talk to him not dis-

suading him from suggesting erotic sex acts with which he implied she must be familiar. She heard from the younger women who would return to the cell in hysterics that he had forced from them minute detailed descriptions of their sexual experiences by threats of solitary confinement. Eva concluded that her age saved her from this mortification. There was unanimous agreement that Shorty was deriving his only sensual pleasures from these interviews, his hand never leaving the pocket of his pants.

Vovochka, too, indulged, but he used Gerassimov's methods — foul and obscene language — which were lost on Eva. In her world, during the first years in the print shop, her co-workers, the majority of them men, did not speak in obscenities, at least before women. At school and at the institute, the workers were among the intellectuals, and although they might have been familiar with lewd expressions, they were well able to express themselves without resorting to that language. That she did not react to his taunting did not stop Vovochka. During one long night, he repeated one expression several times, seeming to enjoy himself, waiting for a counter remark. She finally said to him, "I don't understand what you are saying. Please speak slowly and use more simple language." His outburst of laughter annoyed her. "What is the joke?" she asked.

"Ask the women in your cell." Eva had Vovochka repeat his words and painstakingly imitated him again and again, each time to his great enjoyment. When she returned to her cell and detailed the interview and secured a translation, she joined the women in their hilarity.

The follow-up with Vovochka gave Eva a new lease on life. She said to him, indignantly, "Are you behaving as a Soviet investigator should? In my opinion such language should be in the vocabulary of investigators in fascist and capitalist countries, not of Soviet investigators."

He flushed. "Enemies deserve no better treatment," he answered.

Eva was not put off, and she taunted him, "How do you know I am an enemy? Your investigation has only just begun."

"Oh, no! We never make an arrest unless the person is guilty. We don't make such mistakes," was his reply.

Eva buckled and shouted. "Then why the farce of an investigation?" She was certain he was going to slap her, he became so enraged.

Inadvertently he shouted, "If only the doctor would let me put you into solitary!" He abruptly stopped, with a look of consternation on his face. He let her sit for the balance of the night with a guard standing over her to keep her from dozing off. It was worth it! She now knew that he could not put her into solitary confinement — because, she was to learn years later, she had a heart problem. Furthermore, since Vovochka could get no reactions to his obscenities, his use of them ended. But after the many lessons she received from the other prisoners after their own interrogations, she then understood enough to appreciate the indignities and insults that his words were meant to convey.

As the weeks extended into months, Eva thought she was losing her sanity. During the long days in the cell she would try to concentrate on her reading. As she did so, the room would begin to spin and she would lose touch with the others. From the blank wall above the cots across from hers and on the ceiling, a moving head gawked at her. It was an old woman, her mouth a thin line in perpetual motion as if cursing and threatening, the tips of her abnormally large nose and chin touching. The apparition, a three dimensional image, returned day after day for weeks on end bringing on a panic that Eva concealed from the others; she feared that, if it were known, someone would report her and she would be taken to the Serbsky Institute, for who would tolerate a mad woman among them? Less frequently, other pictures danced before her eyes that would give her a pleasant and restful sensation. One was of a lovely child wearing a ruffled dress and a charming bonnet, garments of the last century, jumping rope and skipping across the wall and ceiling. Sometimes a group of young men and women rowed happily together in a canoe, the body of water filling the entire wall. She never lost the reality of her physical presence in the cell; yet the scene was so real that she wanted to cross the room to touch the water. Only that her aberration might expose her stopped her. She knew that she was not dreaming, but what she saw was a reality — impossible as it might seem.

The mirage appeared less frequently when she was able to get sufficient sleep — when Vovochka was spending his nights interrogating someone else. Only months later did she realize that she was not alone in suffering these hallucinations. Karen, staring fixedly at the wall, was

softly weeping. "God, I am going crazy," she said, begging the women to remove the slimy creatures that she saw crawling from one end of the room to the other. Her appeal brought out admissions from the others that they, too, had or were having hallucinations. From then on, every new prisoner was warned of the possibility of such a reaction to lack of sleep and was assured that such an anomaly was common to many. The compassion and co-operation of the group as a whole sustained each of them individually, physically and morally, each managing to steal some blissful moments of sleep fostered by friends surrounding them, concealing them from the guard at the peephole as they staged a game of gallah.

<center>∾</center>

One night, about three months after Eva's arrest, the guard awakened everyone by yelling through the peepholes, "M?" When Eva responded, his voice called through, "Meltz? Good. Yes — what is your name and patronymic?"

"Eva Moisseyevna."

He hesitated as if he were perusing his list, and repeated, "Eva Moisseyevna? No, not you." Her heart raced. She needed to know. She pressed her ear close to the crack of the door and at the peephole and called to several of the women to join her hoping that between them they might discover whom the guard wanted. They heard him walk to the next cell, call out, "M?" then say, "Good," in his characteristic way and asked for the name and patronymic. That was all. Could he be asking for Valeria? The name Meltz was very uncommon.

The next morning, one of the old timers demonstrated a simple system of communicating between cells by tapping on the wall, tedious but effective. Each letter was identified by the number of taps equivalent to its place in the alphabet; the first letter "a" was identified by one tap, "b" by two taps, and so on. Each word was spelled out, letter by letter, until the word was finished, then the next word would be spelled out, and so it would progress until the message was completed.

The signal was received! Yes, it was Valeria and she returned the taps. Long conversations ensued until, a month later, Eva was transferred to another cell. It would be many years before Eva and Valeria were this close to each other again and be aware of the fact.

<center>277</center>

Chapter 17

The time finally arrived when Vovochka's questions about spying ceased and he got down to the business of attempting to prove that Eva had been engaging in anti-Soviet agitation. His inadvertent disclosure that Eva could not be sent to solitary confinement as punishment emboldened her to give deliberately brazen retorts that enlivened their encounters. He claimed that her irreverence for the Soviet Union was evident by her lack of confidence in the "organs," the backbone of the country, in this case, the security police. "Tell me how I flaunted my opinions," she demanded. "Bring me one witness from my place of work to prove that I have ever made a derogatory comment." He could never use against her the charge that she had courted the sympathies of her co-workers to "agitate" them against the MGB. To them, she was always known as a very private person, dedicated to her work, her personal life not open to gossip.

"No, no!" he said as if contemptuous of her attempts to use him for her purposes. "You are too cunning to agitate among people with whom you work."

"Then tell me! Who was I agitating? What have I said?"

"Do you deny that you kept your mother and your mother-in-law and your sister-in-law in perpetual turmoil with your never-ending accusations against the MGB — saying that they had unjustly arrested the traitors in your family?"

"The traitors? Do you mean my father and my husband and his brother? No, I do not deny that. I insist they were not traitors and they were unjustly repressed. And I do not call that agitation. You arrested

279

our men without cause and if we can't forget it, that is your fault! And that is what you call agitation?" All of this rapidly went into the protocol. She continued, "What confidence and respect can I have for an organization that has its ears even on my family's private conversations?"

"Private conversations? What about Rosa Mikhailovna?"

Eva was puzzled by the squinty look of his eyes when he brought up that name — again. "Rosa Mikhailovna? What about her? Aren't we finished with her?"

"Is Rosa Mikhailovna a member of your family, too?" he asked. "When you engage in your anti-Soviet talk before Rosa Mikhailovna, you consider you are taking up a private family matter?"

So consumed was Eva with loathing for this woman that it penetrated her deepest sleep. Sometimes, in a dream-like state, she would talk to Alexandra who had welcomed Rose to her home with kindness and generosity. "What do you think of this vile creature now?" the words would then repeat themselves. "This loose tongued wretch!" Sometimes Eva would shout at Rose that when she would be free, she, Eva, would expose Rose's duplicity and deceit to the world. Eva begrudged any trace of pity she had ever expressed for this person, that which had come only as a courtesy to Alexandra. Her need to seek revenge was so strong that she played it out until finally sleep overcame her — only to have it interrupted all too soon by the wake-up call.

Vovochka well knew how infrequent Eva's contacts with Rose Wogman had been, but he was intent upon getting any information about the relationship he could. Eva, however, tried to ignore any reference Vovochka made to Rose, realizing that the hatred she now felt for Rose was exhausting her to the extent that she could barely survive the next day. "It is not your business what I say to my mother or mother-in-law or any member of my family," was her refrain.

Vovochka was not to be stopped. His goading persisted, reopening wounds. "You encouraged your mother to denounce the judgments of the security police against an enemy of the people."

"Do you mean her husband and my father? She didn't need any encouragement," Eva flaunted.

"You lie! Do you want me to bring your husband here to prove that you are lying?"

Her heart pounded, her face flushed, and her eyes became glazed. She thought, "Can Max be alive after all? He wouldn't know that I have a death certificate." Yet, the possibility that she might have been given the wrong information and that Max might truly be alive unnerved her. She said to him, "You read our minds about our private conversations and now you can also raise the dead. Are you people here miracle workers?" He was becoming confused. Eva persisted, "You know very well that my husband is dead."

"Who told you such a lie?" he said, resorting again to the favorite word in his vocabulary.

"You killed him. He died of starvation in your camps," she said with clenched teeth, trying to calm the ache in her chest.

He was on the defensive. "Don't try that anti-Soviet agitation on me. Who told you that your husband is dead?"

"You!"

He was forgetting his role, allowing their positions to be reversed. "I never told you such a thing."

"Not you personally. But aren't you the heart of the Soviet Union? You are a representative of our glorious organization. You should know that I have a death certificate — that my husband died in your camps." Her tone was acrimonious.

She was shaken by the momentary hope that Max might really be alive and drifted off, away from this room, away from Vovochka. If he spoke to her within the minutes that followed, she was not aware. The night seemed never to end. She was feeling uncomfortably wet. She realized that for the first time since she was taken, now several months, she was menstruating. How was she to handle this emergency, her modesty restraining her from mentioning it to a man? She squirmed, embarrassment adding to her discomfort. The blood dripped to the floor which caught Vovochka's attention. The hypocrisy of his concern aggravated her. "Why didn't you tell me?" he scolded her, gently. "We're not animals here. We are nice to women here. We are human beings." He sent her off with a guard to the water closet, and a woman followed her in and handed her a piece of cotton. (This was to be Eva's last menstrual period for many years. During the time she was in the camps, she learned that this condition was a curious phenomenon common to most of the

women, explained away as the effect of the shock and trauma, yet a relief considering the physical environment they endured.)

Once back in the interrogation room, Vovochka changed subjects and questioned Eva about her national spirit. "Aren't you proud of the accomplishments of our country?" he asked her.

"In my history book, Edison invented the electric bulb and the Wright Brothers were the first to fly," she answered him, rejecting his claims that Popov invented the electric light and that the radio and the airplane were created first by the Russians. He noted her contradictions in the protocol as evidence of her cosmopolitanism and lack of national pride. "What difference does it make who invented these things? Why must this government distort history? Isn't the main thing that through these inventions civilization has advanced?" she concluded.

There was the accusation that she had no respect for Stalin. "That's true," she admitted. "For shame! Russian soldiers going into battle from which thousands never returned alive with the cry on their lips, 'For Stalin' first; then 'For my country!' For shame." Her critical admission angered him and again he turned to the protocols. "Write it down," she challenged him. "That is the truth! That is how I feel! Hero worship is not part of the socialist philosophy!" The consequences of such evidence from her own mouth did not frighten her. Regardless, she would be convicted of anti-Soviet sentiment, for Vovochka was the surrogate for the system that forcibly set her before him, and he was the judge — and his judgment would be based entirely upon his own beliefs. Differences of opinion were not tolerated. She would find herself charged not only with besmirching Stalin's name, but — if she could not agree to conform — also with heresy.

Vovochka didn't give up an opportunity for a rebuttal. "Stalin represents the face of the Soviet Union," quoting the propaganda slogan, "So Stalin is the Soviet Union."

However exasperated she became, when the interview was finished for that night and the protocols turned over to her for her signature, Eva calmed herself, carefully read every item, and insisted on changes that she feared might be interpreted as harmful to her. She was often surprised that as ineffective as the public defender had been in her behalf, when she demanded a hearing in his presence, Vovochka seemed

threatened and would sometimes submit and make the changes.

A few nights later, Vovochka began with, "You have good times with the women in your cell. Lots of laughter is heard from your cell. Do you enjoy the stories of each other's crimes?"

"Crimes?" she scoffed. "No one among us is guilty of a crime. For no legitimate reason you have dragged us from our families and from our work." Why not, she thought, tell it to him straight. No solitary for her.

He spoke on as if he hadn't heard her. "What is there to laugh about? What jokes do you tell each other? Of whom do you make a laughing stock — your Fatherland?" He was as persistent on this subject as any other in his repertoire.

"What jokes I hear are of brief and fleeting amusement to me. I do not consider them of sufficient importance to write them down in my mind." The answer did not please him. He tried to cajole her into telling him one of the jokes she knew.

Eva quickly remembered Tamara Viktoryevna's warning, "He's fishing for something more to prove anti-Soviet agitation. An anti-Soviet joke is used against you. Be careful. Tell him a joke and off goes ten years of freedom — and somebody else's as well when you slip on the next question, 'Where did you hear it? Who told it to you?'"

"Then, you might enjoy this one," she said to Vovochka as if she were imparting confidential, classified information. "In Bug-house Square in Chicago, a worker took advantage of the opportunity to make a speech. It was a very good speech that drew quite a large audience from among the loiterers and pedestrians. Their attention encouraged him to seek their active participation. 'Who builds the railroads?' he asked them. They shouted the answer to him: 'The workers!' 'But who rides on them?' 'The rich!' they roared. 'Who builds these magnificent mansions?' 'The poor!' 'Who lives in them?' 'The rich!' 'Who eats strawberries and cream in winter?' 'The rich!' 'And who gathers them and prepares them for the rich?' 'The workers!' The speaker was pleased with himself. 'Comes the Revolution, we, the workers, will live in these magnificent buildings and travel to far and beautiful places in this country on the trains that we build, and we, the workers, will eat the strawberries with cream in winter,' he promised them. From his audience came a voice. 'But Mister, I

don't like strawberries and cream.' The speaker had reached a frenzy of excitement. His arms stretched up towards the sky and he answered, 'Comes the Revolution, you'll like strawberries and cream.'"

Eva closely watched Vovochka's stoic face from her corner. "What is the joke?" he asked, "Who told you such a joke?"

"Who remembers?" she said as it had been rehearsed. "Everybody tells jokes. This one I remember." She noticed that none of it went down into the protocol. She would have wished to give way to her mirth, but didn't have the courage.

Valeria was seated in a chair near Vovochka. He kept himself in the background for a few minutes seeming respectful of the need for the sisters-in-law to convey to each other their concern for Tommy and Alexandra. Then he began. What might Valeria add to his understanding that Eva distrusted the decision of the MGB, that she stubbornly maintained that this highest level organ of the Soviet Union had unjustly convicted the four men of the two families? Valeria did not mince words, unconcerned that this meeting was arranged to convict her also. Vovochka conscientiously transcribed her contempt for him and the MGB. "I am not able to say which surviving member of our family first expressed this belief; you may write down that all of us are in agreement. My husband and brothers are dead. Eva Moisseyevna's father and husband are dead. They were all loyal Marxist Leninists and dedicated believers in the socialist system. They committed no crime against the Soviet Union. The government committed a crime against them!"

"Eva Moisseyevna had connections with the United States Embassy, didn't she?"

"Do you mean did she know where the Embassy here in Moscow is located? That I assume she knows. The flag on the building easily identifies it for everyone, for Eva Moisseyevna, for me, for you. That is her connection with it."

"Eva Moisseyevna had wanted to escape from the Soviet Union. Do you refuse to confirm that?"

"Had she?" Eva feared that Valeria's cutting sarcasm could only result in disaster. "I have never heard such a wish from her, and if, by chance, she had such an unexpressed thought, do you blame her? She

has indeed received very gentle treatment from our government, hasn't she? Will you say that she has no cause to want to return to her own Motherland?"

Her reply prompted his letting the needle fall on the broken record. "For workers there is only one Fatherland — the land that is governed by the worker. The United States is a capitalist country ruled by the rich for their benefit through the exploitation of the workers."

Other allegations were made, some with Eva to be a witness against Valeria and others with Valeria the witness against Eva, all related to disloyalty and anti-Soviet sentiments. The meeting was short, a sign that Vovochka recognized the impossibility of securing satisfaction from either of them. He handed them the protocol for their signatures, Valeria noting that her statement about the "gentle treatment" Eva had received was omitted. Each called out a goodbye to the other, and it was the last time they were to see each other for five years.

Finally, there was enough information in the protocols for Vovochka to make his case that Eva had confessed. The interrogations were less frequent and Eva was permitted parcels of clothing and other small necessities as she requested them. Tommy delivered these as well as money to the prison office. Now she would ask the guard to buy cigarettes and food for her to be shared, and with each delivery she knew at least Tommy was still at home. Supported by Valeria during their wall-tapping conversations, she also suspected that Vovochka's inferring that Abie, too, had been arrested had only been a ruse to undermine her morale.

One day, she was called out with her things. This was the signal that she would be permanently leaving her current cell and the women with whom she had shared it. These women had endured together a life-shattering experience, but Eva would never see any of them again.

This was not, however, the end of Eva's stay in Lubyanka Prison. She was taken to another cell, very small, with room for only four cots. Tamara Viktoryevna occupied one of them. "I wondered if you would be in that cell much longer," she said to Eva. "That stookachka Laura let it be known that you were speaking with your sister-in-law, I am sure."

"Laura?" Eva gasped.

"Yes, Laura. She is the informer in that cell. So you thought she

was just a good, generous soul?"

It didn't take much reviewing of the difference in Laura's treatment from that of the others for Eva to agree. "Isn't she usually called out for interrogation before sleeping time and returned to the cell for a good night's sleep? Or before meals during the day — or early evening? How do you think she keeps her good complexion? On the prison meals we are served? And why is she permitted visits from her family? Do any of us have such privileges? You have been in that cell four months. Have you been permitted more than a change of clothing in a parcel from your daughter? And why has she not been sent to a labor camp after more than a year in Lubyanka? This is the third cell I have been thrown into since my arrest, and in each cell at least one prisoner knows Laura, not by name, but by the sack of clothing she so freely shares with those who come in as you had. What a fine way to make friends for the MGB's vicious purposes and to avoid the slave camps" Tamara spewed.

"But she must have been given some hard times," Eva recollected. "Do you remember that several evenings she returned from Vovochka's office in tears?"

Tamara Viktoryevna scoffed. "She probably wasn't collecting the kind of information about us that suited him." Tamara's indictment of Laura was certainly believable, and Eva's suspicion was aroused, but she still naïvely clung to a bit of doubt that her trust in Laura had been betrayed.

Anyachka, one of the other inmates in Eva's new cell, was a young woman in her early twenties. Her beauty dressed up the drab cell. She was also a teacher, and both were drawn to each other by their common interests. It was not long before a friendship sprang up between the two of them. She had been born and raised in Moscow and had married a Ukrainian. Her husband had been arrested on charges of conspiracy with Ukrainian nationalists and of favoring an independent Ukraine. She was arrested on the same allegations.

The two women derived comfort from each other, Eva unburdening herself as she had not been able to do with anyone except Valeria. She cried over her lost ideals, the savagery that decimated her family, her disillusionment, her anxieties for Tommy and Alexandra, her dread that Abie — as far as she now knew the remaining adult in the family still

free — might also be rubbed out. Each sympathized and grieved with the other. Anyachka, the younger, as if seeking an explanation in her own search for identification, asked her, "Wasn't it hard for you to change your entire philosophy — to become anti-Soviet?"

Eva answered, "I'm not anti-Soviet but I am against the men who have distorted its meaning and are committing crimes in the name of socialism. These so-called Soviet leaders have turned the terms 'Soviet' and 'socialist' into a mockery for the world to fear, not follow."

After Anyachka was called out with her things, Eva felt an acute loneliness, much stronger than the departure earlier of Tamara Viktoryevna. But it was at her final interrogation that she realized that even the astute and perceptive Tamara had failed to recognize this informer. Vovochka asked Eva, "Wasn't it hard for you to change your opinions — to become anti-Soviet?" No one with whom Eva compared notes in Butirka where she was subsequently sent had heard of Anyachka by name but they recognized descriptions of her, her clothing, and the suspicious questions she asked.

At long last, in October, it was over. Mounds of paper, the protocols that had her signature on page after page, and some that she had refused to sign, in addition to piles of documents which she had not previously seen were handed to her. "These are a summary of the investigation," Vovochka told her. "It is your right to read them."

While she read, he sat at his desk, another paper in his hand as if in readiness to be presented to her. His impatience was distracting. She turned the pages of the documents, first reading slowly almost as if to annoy him. Her eyes moved from line to line, anger and hate bringing a rush of blood to her head. In print were names of people whom she had not seen in years, each having added a little something about her that the MGB chose to use against her. The futility of reading further closed in on her after she finished Sonya's statement that she had wanted to escape from the Soviet Union. She read no further, allowing herself to be pressured by Vovochka's fixed gaze. What gain would there be in her recording in her mind their names and their statements, she thought. She took the paper and pen that Vovochka pushed at her, noted the statement advising her that "this is to inform you that the investigation is

287

completed" and that she was to set down her signature as confirmation that she was so informed. What a mockery — all this formality!

Vovochka asked her one last question. He was holding her bankbook. "What do you want done with this?" She was surprised and worried, surprised because he had threatened confiscation of all her property as part of the punishment, and worried because she had thought that on the night of her arrest the police had honored her request and had arranged that Tommy be given access to whatever resources she still had. Now she learned that her bankbook, too, had been seized that night. He had her sign a prepared form and notarized her wish that the book be turned over for Tommy's use.

How had Tommy been able to live?

The next day Eva was called out with her things and for a short time was locked in the box. From there she was led into the Black Maria, the "Paddy Wagon," which as a child she and the other children at play on the sidewalks of Chicago had singled out from the other vehicles passing them on the street as the carrier of jailbirds. She climbed aboard, holding her small sack of personal items, and shivered slightly, the light coat which Tommy had left for her at the prison office not adequate against the fall weather that had already set in. The interior was a room of back to back boxes, four on each side. Eva was put into the last of the cells next to a heavy door which separated the compartments from the cab and the driver. It was windowless and tiny. The seat, a built-in board, was so very narrow that she felt squeezed. She heard six other persons enter, some shushed by the guards when they attempted to ask a question. "Quiet! No talking! No talking!"

When the car was finally in motion, except for the swaying indicating the directions of straight ahead or left or right turns, the streets of Moscow were sealed off from her. She heard a kick at the bottom of her box. "Who's there?" It was a man. His voice was picked up with a flurry of responses. Perhaps the heavy door, or the noise of the motor, prevented them from being heard, or perhaps the guards in the cab of the truck realized the helplessness in preventing it; the talk did not stop until the sound of the motor ceased. There was a voluntary roll call of

names from both women and men. When Eva announced herself, a man said, "Hello! I am supposed to know you. Vostokov." So here was Rose Wogman's friend! He was a young military man who had been arrested after Rose named him. Now it became clear why there had been a spying charge against Eva, why Vovochka had persisted in pressing her for a link between her and Vostokov — a military man with Americans! He told Eva that he, too, had been relentlessly questioned about her. Neither Eva nor Vostokov could guess at this point if they were to be convicted of spying. Yet, in spite of the difficulties in which he was finding himself because of Rose, he asked kindly about her, "Do you know? Is she all right? With her handicap, how can she survive?" Of course, Eva could tell him nothing — except that some months ago they had seen each other during an arranged confrontation that partially involved him. The group was disassembled at the Butirskaya Prison.

After Lubyanka, Butirka was like a vacation resort — beginning with the bath which was the first stop after the box. Although several other women had been in the Black Maria with her, also on their way to Butirka, Eva was alone in the bathhouse. It was very elaborate, with marble benches and floors, a miniature of one of the luxury bathhouses in downtown Moscow patronized by the more affluent. It was good to be able to fill and refill the basin, the warm water slipping from the top of her head and sliding down her body. Even the box, where she needed to wait again, was more comfortable, not so stuffy, a bit wider, the bench more ample, the ceiling from which hung the electric bulb almost high enough for Eva to raise her arms full length.

Her new cell was more than ample for the thirty beds — fifteen on each side and all of them were occupied. A narrow table almost the length of the room standing between the feet of the cots was covered with books and games and food belonging to individual prisoners. At the far end of the cell was the familiar parrasha. As before, lying down or sleeping during the day was forbidden. The intense chilliness was a constant cause for complaint. Although the snows had not yet begun, everyone felt winter coming on, and the cement walls and floors added to the discomfort.

Nevertheless, Eva felt a sense of freedom. There were no restrictions regarding the games the women wished to play and they had many to choose from besides gallah. In general, the meals were tastier than those at Lubyanka. Tommy brought her money regularly, and she ordered additional bread and sugar and foods from the prison store. Even the cottage cheese, on which she would never have spent even so much as a kopek at home, tasted delicious to her. Conversation among the women flowed freely without interference from the guards, and a good supply of books was always on hand for those who wanted to read. They were allowed two trips to the water closet each day, once in the morning and once in the evening, a genuine relief compared to the once-a-day trek at Lubyanka. Cleaning tasks, mainly in the lavatories, were less frequent and were shared by many more women. During the first two weeks, after the first money arrived from Tommy, Eva lay on her cot, just falling into sleep, and chuckled to herself, "That I should compare all this to heaven! Everything is so relative!"

As the newcomer, the women stormed Eva with questions about the "outside," hoping to hear that she might be the exception among them, and perhaps not brought in, as they had been, from Lubyanka. No one had the answer to "What next?" All everybody knew was that from Lubyanka one went to Butirka — and that the sentencing would be made here, for one woman had been read hers only the day before and had been called out with her things that morning. There could only be conjecture about what awaited them next and where it would happen.

Much of the talk that first day was an attempt of each to identify with Eva in some small way: "Who had been in your cell?" "Yes, I know her, too." "She was also in my cell for a few weeks." "Did you know Dasha? She was so giving, so generous with her possessions. She was such a pitiful person, in jail over a year and her case still not settled."

"Dasha?" asked Eva. "Did she have an unusually large sack of clothes? Was she young?" They were describing Laura. Some recognized her under other aliases. There was complete horror among the women when the pieces finally fit together; it was agreed that she must have been an informer. Eva was to hear about her in the cells yet to come and in the railroad coaches enroute to the labor camp.

Two of the women had been in the same cell with Rose Wogman.

Eva had commented about seeing a cane lying on the corridor floor when she passed the cell to the right of theirs. "It must be hers," she said.

"Of course. Only Rosa had a cane." They told how it had been taken from her, for use only under strict supervision, after, in a fit of anger, she attacked Vovochka with it. Only the full strength of several guards prevented her from doing him serious injury.

"How I could have used that cane in a cell on a Jew-hater like Doonya!" she thought.

So she knew that Rose was also in the Butirka prison. She didn't know, however, that Valeria and Tamara Viktoryevna were together in the cell to the left of hers.

Every prisoner in this cell was a political case, all educated beyond the secondary tenth year. One woman was a writer who entertained everybody with her poetry. Another was a teacher of the History of the Communist Party of the Soviet Union, an old Bolshevik. She looked as if she must have been eighty years of age, but when anybody asked her, she replied that she was only sixty-six. No one believed her, especially when they saw her naked body in the bath, it as shriveled as her face was wrinkled. She said that she had been very stout but had dropped too many kilos too fast at Lubyanka. Her semi-invalid condition wrung concern from all of them.

Marusya was a lovely looking young girl who had been brought in from a labor camp up North, somewhere at Kolima, an infamous camp in Siberia. She had suffered through the complete cycle — arrest, interrogation, and a twenty-five year sentence of which she had done two years. From her, the women got a preview of what was in store for them. She had been returned to Moscow to be a witness in some political case and frankly admitted being happy for even a temporary respite from the hard labor. She swore that she was innocent of any of the charges for which she was being punished, and the pattern of her story was similar to so many of the others about which Eva had heard. As a student in the Institute of Physical Education preparing to be a teacher, she had successfully competed for membership in one of the All-Union sports teams of the country. At an official banquet during an international sports event held in Moscow, she had been seated next to a foreign sportsman. A short time later, she was arrested for allegedly having given security

information to him. "Try to prove you are not a camel!" she said to the women. Her comment referred to a common Russian joke of tsarist times: A Jew leaving Russia met a Jew entering Russia at the border. One asked the other why he was leaving in such a hurry and without baggage. The other said that the tsar had ordered all camels to be castrated. The first Jew said, "So what?" to which the other replied, "Prove you're not a camel."

Much of what Marusya related about life in camp Tamara Viktoryevna had already spoken about — the severe weather and the very harsh conditions under which the prisoners worked. She told also of the kind of work that was meted out, and of the personalities of the guards, but what frightened her listeners most were her stories of what many of the prisoners themselves became. Men and women sought to survive however possible, some by turning stookachki in order to curry special favors only to be crippled or murdered by the inmates when they were discovered, the conspiracy against them so cleverly enacted that the camp guards would never be able to apprehend the violators. "Do not be tempted," she warned. "The stookachki get what they deserve in the end. And smell them out fast. They are troublemakers."

At the beginning of November, Eva was summoned, placed again in the box for a length of time which seemed like hours but was probably less than thirty minutes, and was taken before an official who notified her of her sentencing by the OSO, a special section of the security police empowered by the Stalinist government to conduct trials in absentia or pass sentences without trials. "How can I have been sentenced without a trial?" she asked.

"The OSO is the special committee who has jurisdiction in cases such as yours — where no trial is applicable." She stood before him silently. There was no redress. She was convicted as an anti-Soviet agitator and sentenced to seven years to be spent in a rehabilitation labor camp. She lowered her eyes so that he would not see the glow of happiness. Yes, everything was relative. Vovochka had been threatening the whole spool — twenty-five years — and she was getting only seven. There would still be enough years for her to live a little. True, she would never be permitted to return to Moscow, but at least it would be only for

seven years that she would need to endure those harsh working conditions and the severe northern weather. After these long months, she now knew what lay ahead.

When she was returned to her cell, she told the others — and they were glad for her. One other woman who had been called out with her had been given ten years. The next morning, both women were taken down to separate boxes to wait for the Black Maria that was to take them to the next stop.

Eva stumbled as she climbed into the patrol car. This prompted an unflattering remark from the guard and an insolent retort from her. The guard had no time to show offense for from one of the boxes came a cry in English, "Eva, is that you?" He yelled out, "No talking! No talking!"

She was pushed into the box as far from Rose Wogman's as possible, and when the hum of the motor began and Rose repeated her call, Eva did not respond. There was nothing to say to her. She could only hope that their paths would never cross, for she would never forgive Rose for creating the problems that she and Sheva were now facing. Then, her thoughts turned to more immediate matters of concern. Where would this ride end? Was this the last trip through Moscow for the next seven years of her life? Or forever?

The truck stopped. One by one, separately, so that each would not see the other, the prisoners entered the walls of Taganskaya Prison. They were still in Moscow. First, there was a bath; a female guard led Eva, alone, into the shower and then back to a box. From there, she was taken up one flight of stairs from which she heard men's voices. On this second tier, a male guard took her into an unoccupied cell containing two cots. There was nothing to do but to wait for another woman to join her. The rules that were posted on the wall suggested a pleasant change, and certainly nothing that had been permitted at Lubyanka and Butirka. Many more parcels, and visits, were allowed! Within a short time a guard entered, removed the sign and replaced it with the itemized list of rules and regulations with which she was very familiar.

When the day ended, Eva was still alone in the cell. She shrugged off her uneasiness, confident that with their numerous arrests she would soon have a cellmate. The overcrowding in the prisons required the use of every available space and here was a vacant cot. In the morning the

same male guard took her to the lavatory. She followed the procedures which had been customary at Butirka and stripped to the waist to sponge. Suddenly the guard burst into the room and shrieked at her, "When you are to have a bath I will let you know. Others are waiting. You were brought here first — ahead of them. Be grateful. What special privileges are you expecting?" His entrance was unexpected, and her state of undress embarrassing to her. She should have been accustomed to this, but it had been easier to bear when she had been with a group of women to help her laugh off the eye at the peephole. He was standing full face before her, shouting so that he must have been heard in every cell in the prison.

On her return to her cell, the guard took a different path. She passed barred cells, one after another, from which groups of men gawked and hurled unimaginable epithets at her. Eva was frozen with fear. After her cell door was closed, she heard men in small groups walking past her door. Throughout the day she heard their grumbling and shouting and singing, "Give us the woman! We want the woman!" and other words so obscene that her terror continued undiminished.

She wanted so desperately to know — to assuage the panic that gripped her. Was she in solitary as punishment for some reason? Why was she in a prison with all these men? Whenever the guards entered the cell, on holding the bowls of food or removing them while the other held the door open for him, she pleaded for answers, but was ignored.

The days stretched to a week and another and another, unchanged. She had finally concluded that she was the only woman in the criminal prison block for men. Many years later, when she was home again with Valeria and Tamara Viktoryevna, did she finally get an explanation. It appeared that there had been only two women's cells located on the main floor in Taganka. Rose Wogman had been placed in one while Valeria and Tamara Viktoryevna were in the second. It was to separate Eva from Rose and Valeria, and Rose from Valeria, that Eva had been placed in the only other vacant cell, alone, in the prison block on the second floor with men who were convicted criminals.

This was the one time when she appreciated the watchful eye of the guards — on her and on the men. In general, they were more gentle than the guards at Lubyanka, although they continued to watch her

undress and shower. She would scream at them that she would not take her shower until they removed themselves. Once a guard pushed open the door and threatened her. "Get on with it unless you want me to shove you under the water as you are." Each subsequent shower day left her depressed and bitter. She could not shrug off their close scrutiny without feeling deep humiliation.

While at Taganka, Eva developed a tooth infection. The dentist told her that some extractions would be necessary and that they would be done without anesthesia. She rejected the treatment and decided to live with the pain until it dissipated.

The long, sleepless nights, in pain from her rotting teeth, in terror, always imagining that the men would break into her cell, drove her to further despair. She saw ahead of her seven years in hell, far away from her beloved Tommy, starved and worked to death. Even if she were physically able to survive, she had heard enough over the years to know what the future would hold for her. Sentenced for political reasons, her life after release would be bleak exile. Tommy must never be sacrificed by joining her in a faraway, cold, drab, desolate area. Long before the war, all her ideals had been dispelled, her hopes burned out. Only her love and responsibility for her daughter had sustained her, and now this, too, had been taken from her. What use to drag out such a life. Killing herself would not be cowardly, but courageous. Night after night she twisted and turned, her mind in a whirl, mulling over the prospect of suicide. One night she made the decision. The guard stopped her as she was tying one end of a stocking around her neck; she had already tied the other end to the bar of a window. From then on his eyes were fastened upon her every move.

The day arrived when she took her things and again waited in the box. Certainly the only place left to be moved must be to camp, she conjectured. There were several more political prisons in Moscow, Lefortova for one, but it had been her impression that Lefortova was designated for military "enemies." There was also Matrosskaya Tishina Prison. Years and years ago, Eva had been directed there to inquire about Max, but had been told his name was not among the prisoners.

When she started to climb into the police truck, terror struck again.

There were no box cells. It was packed with men — men sitting on the two long benches on each side, some balancing other men on their laps, others standing. She didn't see a single woman.

Someone asked her under what code she had been sentenced, and when she fearfully said, "Fifty-eight-ten," all who were seated, as one body, stood up in a display of respect and, as one, bowed before her graciously and said, "Join us." There was a rush to make a place for her on the bench. She was with the fifty-eight tens, fifty-eight eights, fifty-eight sevens all "terrorists" and "spies." The quarrel among them was good-natured, each vying with the other for the privilege of giving up their seats for her. Eva, for the first time in years, felt comfortable with these true "comrades." They wanted to know every detail of her harrowing months, who her interrogator had been, what women she had met. It seemed that every one was worried about a wife, a mother, a son, or a daughter. She was able to give information to several of them, and they, in turn, told of their experiences. She expected to hear stories of tortures, but not one recounted such horror.

This ride was an unexpectedly pleasant interlude. As they talked, she looked through the barred but clear windows, saw people walking normally on the streets, and recognized the path the truck was traveling. It was going toward the railroad station on Komsomolskaya Square. It continued on past the Kazansky station entrance, to the area where coaches of the long passenger trains were being coupled. They boarded a car which at first glance looked like any other train coach, one toilet at the far end and the tank of boiling water at the disposal of the passengers for making tea.

The men entered two of the compartments, and she was taken into another. The hard seats, two on each side, reminded her of the first Soviet train that had taken her and Max and Esther and Abie into Moscow from the Polish border. With the two overhanging bunks, one above each lower bench, there should be space for twelve women if they did not lie down, she figured. The outer window was covered with a coat of thick, white paint and had bars on the inside. The inner window alongside the coach corridor was also barred. A young woman was already seated in the compartment when she entered. More and more women were brought in until fifteen were crowded into the twelve spaces. The

door to the compartment was shut tight. During the long wait while the regular passengers boarded in the other coaches, the women disclosed that they were all political prisoners. Finally, the wheels started turning and the train departed Moscow.

The journey was not pleasant. At first when the food was brought in, the women were delighted. It was the hard, dry, salted fish that was a favorite among the Russians, but this fish was too hard, too dry, and too salted. Very soon the women were demanding water to quench their thirst. Initially the guards were agreeable, but the continuing calls for water led them to grumble, then insult and finally ignore the prisoners.

However horrible the women knew their destination was going to be, they were glad when, late at night, they arrived. They were in Gorky on the Volga River. Eva had been to Gorky twice during her first years in the Soviet Union, but even if it had been daylight she wouldn't have recognized it. The prison cars were detached from the train, which stopped before it reached the main station, and the women were herded into open trucks that were driven along the back streets to another prison. Deep winter had already set in and Eva was bitterly cold. She had only her light coat and no boots, just the oxfords she was wearing the day she had been arrested. They seemed to attract little attention from the few people on the streets. Workers in open trucks being transported to or from their job locations were a common sight, the rough roads unsatisfactory for routine runs. It had been so long since Eva had made the slightest move without prison guards eyeing her that, as the truck passed by the people on the street, the thought flashed across her mind that not every human being in this world was under lock and key.

As soon as the women were inside the walls of the prison, the first of the transit prisons where Eva was to spend several days, male guards barked out orders. Undress, form a line for disinfecting, turn over all clothing including shoes for decontamination. Naked, they were led through several corridors to a place where they retrieved their clothing, wrinkled, shapeless, and unfit except as rags to cover their nudity. Eva had not too much to complain about since her one dress had deteriorated a long time ago, but when she slipped on her garments, still unclean however much disinfected, she forgot the minute or so of pleasure she had felt during the bath from the warm water sliding across her

skin.

At Kirov, the second transit prison, the routine was about the same, but here, the women were lined up naked at the sinks where the male guards doled out water into the basins. These same men watched them at the so-called water closets as the women squatted over the holes on the filthy wooden platforms, the stench so powerful that everyone gagged uncontrollably.

Eva's only pleasant remembrance of these prisons was the platter of tiny, fried fish which she pushed into her mouth by the fistful and ate as if they were candy. She often thought in later years that perhaps it was the hunger that gnawed at her that gave them their delicious taste.

~

In the transit prisons, Eva was to begin her orientation as to what life was going to be like in the camps. In the cell, when the inmates learned that she was a "political," they branded her a "fascist." "For this, my brother was blinded and my young cousin died?" she thought in disgust. Eventually, she was to become hardened to the word, directed as it was to all political prisoners by the other categories of prisoners, who were thoroughly inbred with the belief that whoever was sentenced on political grounds must be "enemies of the people," and therefore, fascists.

The other groups of prisoners were referred to as "civils" and "criminals." Among the "civils" whom Eva met was one who had been convicted of taking a few hog skins and selling them on the black market — a fifteen year sentence. Another "made a bookkeeping error," and another from a kolkhoz "stole three potatoes," but whether the numbers had been three or thirty, for having illegally expropriated government property, she received a ten year sentence. The "criminals" were convicted for "anti-social" behavior against their fellow man — murder and thievery. The civils in the Gorky prison warned the fascists, "Keep out of the way of the 'criminals.' They steal from anybody and everybody. When you get to camp, they will gang up on you. Be on guard, they will even kill you!"

From Kirov Prison, the women again rode in open trucks to the railroad sidings where the political prisoners were put in compartments separate from the others. The farther north the train traveled, the more

intense the cold became. In Molotov, all the political prisoners were taken off of the train and ordered onto another open truck. On the grounds of the prison, Eva was told to remain in the truck while the others were marched into the structure. Then, the truck moved off again with her as the only passenger. She was taken back to the railroad coach where, now, she sat alone in the compartment listening to the wheels turn as the train moved even farther along the track. Then, the train stopped and she was ordered to get out.

Part Five
In the Labor Camps

Chapter 18

Eva cried out as she touched the ground; she had landed on the side of her foot and turned one of her ankles. When the train, with only Eva and her guard left aboard, had stopped at its terminal, the usual three-step passenger stairs had not been put into place. Unbalanced by the weight of her bag, she had leapt to the gravel path. Now, led by the guard, she painfully hobbled the short distance to a one-story white stone hut. Inside a small room empty of anything but a bench, the guard told her to sit and wait, and he entered an adjoining enclosed office. Foot throbbing, bare hands growing numb from the freezing December weather outside, Eva sat, miserable, wondering where she was and what was to happen next.

After an interminable length of time, the guard came out, curtly told her again to wait, and left. Following another long wait, a different soldier appeared — bringing a blast of freezing air with him — and went into the office. He soon reemerged carrying a folder, and rudely said to her, "Let's go."

"Go where?"

"To your camp. We'll walk. It is only eighteen kilometers from here."

"I'm not walking anywhere with my injured foot. I can't walk so far." Arguing with him, she finally got her way. A horse and sleigh were supplied and together they rode off.

On the short journey, her custodian shed his belligerent behavior to that of an ordinary young man, the rancor he had shown before now gone. For the first time since her arrest, a guard was answering her

questions. He told her that she was in the Urals and that they had just left the office of the chief of the Solikamsk camp complex in the town of Solikamsk. The high fence with its regularly placed watchtowers that they were passing enclosed the Men's Central Camp. The prisoners here, he continued, were lucky and unlucky; lucky because, living on the outskirts of the city, they had easier access to the extras than did men in the outlying camps; unlucky because they had to work in the most dangerous sections of the salt mines from which the city got its name.

She was being taken to the Central Women's Camp of the complex where, if she was fortunate, she would work in the zone, the area encircled by the fence. This was the best of the women's camps. Otherwise, she would be sent to lumbering.

"Lumbering?"

"To the forest to fell the trees."

Eva shuddered. "Women do this work?"

It was already dark when they reached their destination. Her amiable companion reverted to the surly guard she had first met. He gave her folder to the sentry, got a receipt for the folder and his charge, and without glancing at Eva, left. "So," she thought. "I'm now a piece of goods."

The sentry, noticing Eva's difficulty in standing, allowed her to sit, and asking another guard to keep watch, went off into the next room. He returned with a woman guard who, to Eva's amazement, took her bundle. The woman helped her struggle along to a low, long, white-painted wooden building.

"This is the infirmary. Don't worry about your things. I'll take them to the *koptyorka* [storage room]. Your bundle will be safer there. It may be stolen if you keep it with you."

After a laborious walk through a long, narrow corridor, Eva was pleasantly surprised to find herself in a small, clean room with only two cots, one of which was occupied. The walls were whitewashed and the floors shone. A nurse, into whose custody the guard had transferred her, helped her undress, looked at her swelling ankle, and tucked her into the vacant bed. Too tired and aching to notice or care who was in the next cot, she fell asleep.

"You poor thing," the nurse lamented when she awakened Eva the

next morning. "Olga told me you're a first-time fascist. I'll try to keep you here as long as I can. The doctor hardly ever shows up. You're going to the bathhouse after breakfast."

"Don't be touchy." A tall blond, her long legs hanging over the side of the cot, calmed Eva in labored Russian in response to Eva's look of fury when the nurse called her "fascist." "All politicals are called fascists. That's our nickname here. I'm Inga." Dark-eyed and good-looking despite her haggard features, she appeared to be in her late twenties.

Eva acknowledged Inga's gesture, and introduced herself as an American Jewess.

The nurse returned, interrupting the conversation. Behind her was a big, burly guard. She instructed him to carry Eva to the bathhouse, where he gently set her down on a bench in the dressing room and left.

The caretaker of the bathhouse, grasping Eva's arm firmly to reduce the pressure on her foot, led her into the washing room. She prepared two basins of water while commenting, "We have very few patients in the infirmary today. Ordinarily, only one basin per prisoner is permitted." The washing finished, the woman helped Eva dress and called the guard to carry her back to the infirmary. Again handling her gently, he set her on the bed where the nurse rebandaged the injured foot.

Looking about her at the snow-white sheets and pillow cases, the clean blankets, the neatly arranged soap dishes and toothbrushes on the sink in the room, content after a very adequate breakfast, Eva remarked to Inga, "What a fool I was to be so afraid. Such a decent nurse, good food when I expected starvation rations, such good care, a guard carrying even a despised prisoner! And no cursing! Not a curse since I left Molotov! I'm a human being again!" After the months of severe abuse she had endured, this humane treatment moved her to tears.

Inga gazed at her sadly, and softly said, "Remember, the infirmary is not camp." Then, as if there had been no interruption to their first words, she asked in English, "Why did they put you here? Oh! I learned English in school. I'm German, from Dresden, in the Russian zone."

Stunned at the disclosure, Eva, for the first time in months, spoke in English, "A German! You must have been a spy!"

Inga laughed. "You have lived in Russia too long! With my Russian

— a spy? No, I lived with a Russian occupation officer. We loved each other but couldn't get married. You know — anti-fraternization laws. We got twenty-five years for having lived together. There are a lot of Germans here. Not all for having lived with Russians, however. All of us were arrested and tried at home — in Germany — but our sentences are to be served out here." She spoke so candidly to Eva, a stranger, she said, because Eva was an American.

"Jewess," Eva interjected.

"But not Russian," replied Inga emphatically. "I know. You are going to tell me our soldiers brutalized the Jews. These stories are exaggerated. Our men are God-fearing, decent and kind. They couldn't do such horrible things. It's all Jewish and Russian propaganda."

Eva insisted, "I have first-hand proof My relatives ," which brought from Inga only a dubious smile, the same response Eva was to receive from other German prisoners.

The nurse appeared in the distance, causing Inga to lower her voice to a whisper. "We are not permitted to speak any language but Russian — one of the rules," and reverting to Russian, she continued with small talk.

Eva's initiation into camp life would not begin until two weeks after she arrived, when the nurse finally deemed her ankle healed. However, the days in the infirmary with Inga prepared her somewhat for what lay ahead. Inga confirmed that the main work for women was lumbering, and she guessed that in all likelihood Eva would be spending most of her days in the forest felling trees. "Only if one is a severe invalid or near death," Inga said sarcastically, "is a political prisoner given easy work — work in the zone or behind the fence — and some of those jobs, like Katya's, are even too difficult for a sick person to do. Katya? She's like a janitress or maid in my barracks. She cleans and keeps our barracks warm and sees that the water tubs are always full and takes our outer clothing to the dryers after we return from the forest. You can imagine how soaked they get after our working in the snow and rain. With the state of her health, it's a miracle that she manages those chores. Even if we were willing, none of us is allowed to help her — she runs back and forth and in and out to the drying hut with clothing for one hundred women. Then in the morning, long before the rest of us are

awake — she brings them in so that they will be on hand for us when we go to work. That's soft work in the zone. Don't hope for zone work. Fascists never get it, except, as I said, when they're half dead. Only civils, like our nurse. And the *bantiki* have it easiest of all. They refuse to work and they get away with it. They don't need prison food to live. I don't know who gets food to them — probably criminals on the outside. Or they steal it from other prisoners' parcels. The rest of us, to get enough food to keep us alive, need to fulfill our work quotas."

So by the time Inga was discharged from the infirmary, Eva had learned that she would be working and living with three classes of *zekas* (prisoners) — politicals, civils, and criminals. Politicals were contemptuously dubbed "fascists" whether they were from Germany or the Soviet republics. On analyzing the zekas in Inga's barracks, she and Eva had concluded that the politicals were subdivided into "real Russians" and "foreigners" and were housed separately from each other. In Inga's barracks were the "foreigners" — the Germans, the Soviets from the Volga German area whose descendants had lived there for centuries and who had retained the German language, Poles from that region of Poland taken over by the USSR from the East when Hitler had invaded it from the West, Western Ukrainians, and Latvians. The only "real Russians" in the barracks were women who had served on the German front in the war and had been forced into slave labor in Germany. It would seem that since the latter had been out of the country, regardless of the reason or the length of time — some of them nurses, some interpreters — they were apparently "foreigners."

"I'll probably be with the 'foreigners'" Eva said. "I'm Russian only when it suits their purposes, when I need an interpreter," referring to her request for one at Lubyanka. Inga agreed and surmised that Eva would be assigned to her barracks.

"As for us Germans, although all the politicals in the camp have the same keepers, we are despised most heartily by everybody. We are denied even correspondence with our families in Germany. We are not permitted any correspondence. You will be writing to your daughter and will get gifts of parcels. Every day I thank God that I have no children. If you are sent to my barracks, you will meet Erna and Annaliza. There is no end to their pain and misery. Both have children in Ger-

many and don't know what has become of them."

The civils were sentenced for crimes such as embezzling, discovered by shortages on the books and in cash drawers or farm crops. The criminals had committed crimes ranging from theft to murder. The criminals in this camp seemed to be among the most hardened, and were called the *bantiki* (bow) because of the large bow of ribbon which their chief wore in her hair. "They sincerely believe they are what they say they are, friends of the people. They live under certain self-established rules and, like religious zealots, are committed to follow them. Among their laws is refusal to work and they get away with it. They call themselves *zakonnika*, guardians of the laws of the criminals. They run the camp, get whatever is the best. I think the *nachalnik*, the chief of the guards, is afraid of them. Never, never tangle with the bantiki. Do whatever they tell you." Inga added, bitterly, "The Russians don't seem to think the crimes of these zekas are as serious as fraternizing between Germans and Russians or taking a few potatoes from a field to feed a hungry child."

During these two weeks, Inga had listened to Eva, comforted her, and pulled her out of a quagmire of despair and grief. "Things can't go on this way. We'll all be free some day. We won't have to serve these outrageous sentences in full. You'll be home with your daughter again," she had offered.

In the wildest stretch of her imagination, Eva would never have believed that she could have developed a warm friendship with a German. Yet, here, as a prisoner at the Women's Central Camp at Solikamsk, in the infirmary, it happened. Many years later, when she was released, she openly acceded that she owed her survival in large part to Inga and the several other German prisoners who took her into their clique.

Early one sunny, crisp afternoon in January, after regaining most of her physical strength, Eva was discharged from the infirmary. Following the nurse's directions, she found her assigned barracks, one in a neat succession of long, rectangular, one-story wooden buildings, each row separated from the other by a wide, snow-covered, dirt path. Several small windows dotted each side. Eva stepped up onto a porch-like extension and entered a little square passage way. She hesitated before

two closed doors and decided first on a door to her right that turned out to be the washroom and the water closet. The toilets were just holes in the floor. On opening the other door, she found herself standing on a broad threshold of a huge room, surprisingly warm. In the center was a long board table flanked by two benches. Reaching to a boundless distance going from the door to the farthest end of the room were four rows of double-decker wooden bunks. Puttering at a tiny wooden stove set up at one side of the room was a middle-aged woman with graying hair combed into a bun at the top of her head and kept in place with sewing tape. She turned at the sound of the door opening and gazed at Eva, weariness written on her face, with its watery blue eyes above a turned-up nose. Fallen, hollow cheeks indicated her lack of teeth.

Answering Eva's stare, she smiled and said in a soft-spoken voice, "You're Eva Moisseyevna Meltz. You've just come from the outside. I've been expecting you today. I'm Katya. Come, I'll show you to your 'nest,'" and she lead Eva to a bunk near a window on the right wall. "Your 'castle' is next to Inga's. She's told us about you. When she heard you were to be in our barracks, she changed her bunk to be next to you."

Setting Eva's small bundle on the bunk, she continued. "Now we'll go for your bedding and work clothes. You can't go to the *taiga* [forest] in the clothes you're wearing. You'd freeze before you got there. Besides, you'd ruin that nice dress and coat. They wouldn't last half a day."

"Nice dress and coat? Look how shabby they are."

"You won't get anything that nice here."

Eva followed Katya out of the barracks to a bungalow. They entered a brightly lit room where a woman was sitting at a counter. Behind her were shelves stacked with supplies. Katya said, pointing to Eva, "She's new. She needs everything." The woman stomped from her chair and made several trips to the shelves, each time returning with her arms full. She threw onto the counter-top a long, dark, narrow cloth sack, a pillow case, two dirty-looking gray sheets, a small towel, and a threadbare flannel blanket. Then she set down one by one articles of personal clothing: a rough, black, oft-washed bra, obvious to Eva that it would be much too large for her; an unbleached linen slip; two pairs of black bloomers; two pairs of thin, black cotton stockings; a heavy gray linen dress; a padded jacket and trousers, both with dirty, gray cotton poking

through holes; torn mittens; two ragged footcloths; a man's cloth cap with ear flaps; and a *chooni*, a strange pair of rubber slippers shaped like boats that were made from discarded tires. Crossed strings wound around the soles and ankles held the chooni onto the feet.

She placed three sheets of paper before Eva for her signature, one an acknowledgment for the bedclothing, another an acknowledgment for the personal items, and the third a form indicating she understood that the clothing she was just issued was to be returned when the time came to get the next season's supplies and that punitive measures would result if she failed to return any of it. "These clothes are lent to you. They don't belong to you. You will be fined and punished if you fail to return this property," the caretaker snapped.

Before she signed, Eva timidly asked, "Isn't there something cleaner?"

The woman's eyes opened wide. "You are new! You are a fascist and you want first term? Ha!"

Katya hurriedly broke in. "These are all clean. Everything is disinfected before it is given out." Eva signed the papers.

How the clothing was distributed was another lesson about life in the camps for Eva. Except for *pervee srok*, the first use of new clothing, prisoners were given hand-me-downs, seasons after season, from prisoner to prisoner. The criminals were given the first usage and the civils received *vtoroi srok*, the second usage. By the time the clothes were distributed to the politicals, they had already gone through three or four seasons of wear.

As they left the storehouse, Katya unceremoniously took all of Eva's supplies. "While we're stuffing your sack, I'll hide them. A bantiki may see us leaving and get itchy fingers," she explained. "Nothing is safe from them." She took them to someplace Eva could not see. Then they walked through the zone, Katya pointing out, as they went along the mess hall, the bathhouse, the medical center, the cultural center and library, the kiosk — a store where Eva might be able to purchase some necessary supplies when she received her pay for her work — and the maternity hospital and nursery where pregnant prisoners and mothers, called *mamki* in camp, and their illegitimate children lived.

Katya stopped Eva at the far end of the zone before a barn-like

structure. Inside, they reached into a huge pile of straw and filled the sack which was to be Eva's mattress. Back at the barracks, Katya lifted it on to the bunk. "Up in heaven," Katya said, with a breathless laugh. "But it's really hell," she added in a somber tone.

Heeding Katya's advice, Eva changed her clothes and, with her own possessions in hand, following the directions given to her, she found her way to the storage room. The attendant, hearing her name, said, "You're our new fascist, aren't you?" and she handed Eva the bundle which the nurse had taken from her when she first arrived. "Put all your things in this bag and I'll store it away again. It's quite safe here. Even bantiki are severely punished if they try to steal from the koptyorka. If you need any of these things, we are open every day between nine and twelve and in the evening from eight to bedtime." Eva wondered how the woman knew the time as no clock or watch was visible.

When she returned to the barracks, exhausted, she climbed up to her bunk and fell asleep. A gust of cold air, loud thumps, and shouting awakened her to a veritable bedlam. Before her paraded a mass of scarecrows, women crowding through what now seemed an exceptionally small doorway, women being shoved from behind by innumerable others. Some threw small logs on a steadily growing pile in the open space before the door; others removed their jackets and trousers and flung them on the floor next to the pile of wood. All around, there were women arguing, women talking, women laughing.

As the clothing accumulated into small heaps, Katya quickly carried each of them to another building that held the racks for hanging, and then returned for another stack. Blaring, ear-splitting orchestral music from a loudspeaker added to the din. Many women rushed to their bunks, hurriedly grabbed soap and towels, and rushed back to the door to push against the incoming mob in their attempt to get in and out of the washroom.

Eva saw Inga's friendly face among the shoving mass. "Frightening at first, isn't it?" she called out. "Never mind; you'll get used to it," and off she rushed to join the cursing women trying to get into the washroom — the room contained only six doorless stalls and six basins with two gallon dispensers, hardly enough to adequately handle what were more than one hundred women. Finally, the last woman returning

from work came through the door, but the scene of confusion continued.

An ever-expanding group of women began to swarm around Eva. Questions came at her in a rash of accents, in Russian and in German. She answered in her own accented Russian and to the Germans in her limited German, aware and amused that she was ignoring Inga's previous warning to her that all foreign languages were prohibited. Among each other, women turned to repeat Eva's replies in Ukrainian and in Polish.

"What article are you in for?" "What sentence did you get?" On her answer, "Fifty-eight ten, seven years," the invariable response was, "Oh, then you're innocent. Up to ten years means no crime committed, but once one is arrested, how can they admit to that? Ten to twenty years, they're suspicious but have no proof. Twenty to twenty-five years, a misdemeanor."

The next question was, "What court tried you?"

"Tried me? Politicals don't have trials," she responded, surprised at the question.

"Then you were sentenced by the OSO," someone commented. For the first time Eva became aware that politicals sometimes did have trials. She was the only one among her new companions not to have had one. She noticed that several of them looked away from her and gave knowing glances at each other. She didn't gather their meaning until several weeks later when she heard that OSOers were sometimes not released at the end of their terms and that some waited it out in the camps, at the usual hard labor, for "special instructions." (She was, in later years, and at another camp, to meet one such prisoner who had been languishing, still at hard labor, far past the years to which she had been sentenced.) "You had so many new bewildering things to contend with. How could we tell you on your first day?" one sympathetic woman in her barracks later said to Eva.

Next, they insisted that Eva tell them of the latest news from the outside world. "What latest news? I haven't heard any news since last spring. If we turn down the volume of that loudspeaker, maybe when the news comes on we'll hear it." She heard nothing but guffaws. "We don't control the radio; we have to hear the programs and at the volume

Koom decides on. The only news we hear has to do with over-fulfillment in production and agricultural plans. He never permits any other news broadcasts, and at the *kultpoonkt* [cultural center] all the political news stories are cut out of the papers and magazines."

"Koom?" In Eva's Russian that word meant "godfather." "A godfather in a labor camp?" Her comment brought on more laughter. "He's our godfather, damn his soul," one enlightened her. "He's the MGB man in charge here. He's our great director — You'll soon see what business a godfather has in a labor camp!" Eva was embarrassed by her ignorance and despaired that there was so much to learn in order to survive in the camp. In every camp where Eva was to be, the director, whether or not from the security police, was called "Koom."

One woman who was obviously a Russian interrupted the discussion to comment, "You don't speak like a Russian. Your accent seems to be Latvian." Upon Eva's explanation that she was an American, soon afterwards, several women withdrew from the group. After this first meeting, most of the "real" Russians kept their distance from her and she was to hear their suspicions that she could not be a fifty-eight tenner. "An American come voluntarily to the Soviet Union? She must be lying. She is probably a fifty-eight sixer — a spy." The fear of foreigners, a continuation of the attitude under which Eva had suffered in Moscow since the arrests began, as early as 1936, followed her even to the prison camps. Her only comfort from the pain of this gossip was that the Russians also did not associate with the other "foreigners" — the Western Ukrainians, the Germans, and the Poles. Among the "foreigners," the only women who seemed to take an immediate dislike to Eva were two Germans. One made the immediate pronouncement, "I have nothing against Jews, but I'm a pure-blooded Aryan." The other, the mother of two children from whom she had been taken, refused to resign herself to her imprisonment and preferred to brood rather than to socialize with anyone.

The barrage of questioning ended with the appearance of a young, short, attractive blonde, who had astonishingly large eyes, a long patrician nose, and full smiling lips. "Zina! Zinka Brigadierka!" several shouted to her. "How did you make out? Will we have sugar tomorrow?"

"Leave it to me, gals. We're having full rations," came her jovial

reply. "Make way, fascists," she called out, approaching the women surrounding Eva. "I want to see our new comrade."

"Zina!" a voice reproached her. "You want to make me puke? You call her 'comrade'?" Eva, on the other hand, jarred by the term fascist, grimaced.

Zina replied, "Such an expression! 'Comrade' or 'fascist'? I prefer to be called 'fascist' here in this lousy set-up where murderers and thieves are 'friends of the people.' 'Fascist' means a political opponent of things as they are. That's how I define it."

Eva told Zina of her teaching background and asked what work she would get. "A teacher? An intellectual?" Zina laughed. "Fascists are not allowed zone work. You'll have to go on lumber. You'll get underfulfillment for a week or two, but I'll rate you more than you do. Don't be upset. They'll never believe an intellectual newcomer could make the quota. Maybe I can get you full rations anyway as a learner. Enough gabbing!" She stopped the conversation. "Girls, let's go eat. We'll save places for the slow-pokes." She obviously was in charge in the barracks. It turned out that she had the position of accounting for the prisoners and their work fulfillment in this building, all of whom, with the exception of Katya, were on the lumbering detail — hence the name Brigadierka, "head of the little brigade," with a modest derogatory implication in the diminutive.

The women hurried off to the mess hall, a large room with rows and rows of board tables and benches stretching across its entire length. A platform rose at one end. Zina at once fell into line at one of the two service windows which paralleled the tables. The noise of women screaming, quarreling, yelling across the tables to each other, and clattering empty aluminum bowls and mugs on their trays was deafening, overpowering Eva. In a daze, she saw her new roommates remove spoons from their upper footcloths as they pushed and fought to grab seats from the women of the other barracks intent on sitting at the same table.

Inga had been among the first to rush in and capture a few places. Eva sat down beside her as Zina passed full trays down the aisles. Each prisoner took two aluminum bowls and a mug. One bowl contained soup made of unchaffed oats and water; the other held a cereal concoction of

the same ingredients but with a minute piece of fish in it. The smell and taste of fish, which had always repulsed her, now nauseated her. She gave her portion to Inga, surprised at Inga's gratitude. As hungry as she would become in the ensuing months, Eva could never force herself to put the fish, served twice weekly, into her mouth. The mug was filled with what the authorities called tea and the prisoners called dishwater. Both the bowls and the mug were too hot to sip from. Eva asked for a spoon. "Spoon?" asked a woman near her. "The mess hall doesn't provide them. You have to get your own."

Eva turned to Inga. "What do I do? Would you have enough money to lend me so that I can buy a spoon at the kiosk? I'll write to my daughter to send money and I'll repay you as soon as I get it from her." Everyone within hearing burst into laughter. "Did you hear that? The new fascist wants to buy a spoon." Dumbfounded again, Eva was to learn that the government kiosk was a standing joke; it didn't have a single necessary item on sale, and nobody traded there. It was closed most of the time. When Katya had pointed out the kiosk that morning, she had failed to tell these things to Eva. Prisoners bought and bartered from each other — an extra ration of bread for some, *makhorka* (poor grade coarse tobacco), or whatever for others. But a spoon could not be bought at any price.

As Eva worried how she would eat until Tommy got her request, Inga, finishing her meal, wiped her spoon on her dress and offered it to Eva. She felt squeamish about eating from the unwashed spoon but with no other choice, in time she became used to it.

She found the soup, possessing a taste she would never be able to describe, difficult to swallow. The slice of bread, which she alone received because she had missed the day's ration in the morning, had the consistency of paste and was hard to chew. She soon followed the example of the others — they wet the bread and used it as paste to seal letters. The only time she enjoyed it as food was in the winter at lunch break in the forest where, in its frozen state, it was toasted over the open fire.

When the women completed their meals, some of them strolled to the barracks, and others, free to move about the zone except between ten o'clock at night and reveille, sauntered off to visit people in other

barracks. When Eva re-entered her building, two women rushed over to her. "Do you know 'Sonny Boy'?" one asked.

"'Sonny Boy'? What Sonny Boy?" Eva looked puzzled. The women began to hum the song popularized by Al Jolson in the film *The Jazz Singer*, one of the first sound pictures Eva had seen so long ago in Chicago, a time that now seemed like a wonderful dream. "Where did you hear that song? I have not heard it since I left home." The women, two young Polish Jewesses, had seen the film in 1939 before "the communists came to liberate us from butter, meat, milk and a few other things." Eva, spurred on by the melody, searched her memory and gradually the lyrics came to her. In a few weeks, both women were able to sing this song in English.

The other women, most outstretched on their bunks from utter exhaustion, one by one prepared themselves for bed. A small group, huddled together on their knees, whispering, had their hands formed in prayer. One, no older than Tommy, was so beautiful that Eva could not draw her gaze away. "Sixteen," Inga said. "Marusya. They are Western Ukrainians. They arrived three months ago. Except for the older woman and Marusya, the others are between the ages of nineteen and twenty-one. They all look to the older one as if to their mother. She's Auntie Anya." Eva settled herself to write to Tommy, the first letter she was permitted to send in the ten months since her arrest. Her allotment would be two a month; however, Zina told her she would be able to receive unlimited letters and parcels, but only from relatives.

A voice from the loudspeaker boomed, "Bedtime!" From where Eva sat, it appeared that every woman was already in deep sleep. The lighted filaments in the electric bulbs hanging from the ceiling flickered, casting shadows on the walls. They were on all night, as in the prison cells. The impressions of her first day kept her tossing and turning for a long time. The vision of the young girl, Marusya, gnawed at her. She was proof that one's youth was no protection from arrest. She worried about Tommy's fate. At last, she fell asleep.

A blast of noise from the loudspeaker awakened her. Although it was still dark outside, women were already moving about to identify and disentangle clothing from the disorderly pile Katya had hastily thrown on the floor near the stove. On this first morning, wide-eyed,

Eva watched the prisoners extricate their garments. The air rang with curses while they quickly dressed. When she tried to wind the unyielding footcloths around her feet, she, too, cursed, but to herself, as the strings kept knotting and slipping off as her inexperienced fingers tied them around her chooni. She heard an occasional, "Ninka! Here's your jacket. Come and get it before it's pushed back to the bottom of the pile." Beginning the next morning when she would be joining the battle for clothes, she would be able to distinguish her own by the distinct pattern made by the cotton poking through the holes.

A woman carted bread into the barracks and distributed to each person a chunk of about eight hundred grams, a little over one and one-half pounds. Immediately, some women, their chunks in their arms, paired off, and grasping the end of two slivers of sticks held together at each end by nylon threads, together sawed each other's bread into three parts. Some hid one portion and took two to the mess hall; others took the whole ration with them. The usefulness of the nylon from the pre-arrest torn hosiery impressed upon her the need to hoard every shred of her worn out garments; often she would tie them around her ankles to keep her footcloths in place.

Inga advised her to take all of her bread, warning, "It might get stolen if you leave it. There is no good hiding place. When Katya goes out of the barracks for water, the bantiki will come in to search the place. Besides, you'll need it for lunch."

In the confusing hubbub similar to that of the previous night, women pushed to get out of doors and to the mess hall. At breakfast, a duplicate of the previous night's soup and tea, Inga again offered her the unwashed spoon. Eva was grateful for Inga's patience. Just as she was beginning to eat, the others were already hurrying from the room.

She clung to Inga who led her to her brigade lining up in front of the zone gates for roll call. Zina announced to a guard, who appeared to be the one in charge, the number of prisoners out on sick leave and the total he was to expect in the line. He was flanked by a young woman, neatly dressed in new camp clothes that fit her perfectly. "The chief brigadier," Inga told Eva. In the subsequent weeks, Eva learned that this young woman and Koom decided on the daily work for each brigade. She was a *sooka* (a criminal) who had defied the laws of the zakonnika;

317

yet, although she was a traitor, having cooperated with the authorities by submitting to their work orders, the bantiki fully understood her influence and did not cross her. She never assigned them to labor, thereby avoiding for them the need to organize and protest. Like them, she loathed the politicals in an ironic way, regarding them as "enemies of the people." This all-powerful forewoman could make or break a prisoner.

The guard passed up and down the rows, counting each prisoner. Repeatedly he shouted, "Don't move! Stand still!" If his total didn't tally with Zina's, he started counting again. It took him as much as five times to come up with the right number. Eva wondered how a guard so illiterate that he couldn't count was selected for the job. Inga whispered, "Some say he does it deliberately, as a punishment. Some say he's too dumb to count to three without doing it twenty times."

At last the count was completed. "Now the daily prayer." Inga said, sarcastically. Before Eva, dumbfounded and shivering from the cold, could consider the remark, the guard began mumbling in a non-stop monotone, "Prisoners will march in straight formation. One step to the right or one step to the left will constitute an attempt to escape and the guard will shoot without warning." Any move out of line would have taken a prisoner into a three-meter-wide clearing in front of the wooden fence enclosing the camp. "It's forbidden territory," cautioned Inga. "If you put even a toe into it, the guard in the tower is supposed to give a warning shot, but I heard that some shoot without warning. Never go near it."

While listening to the guard giving the women their daily instructions, Eva saw some other prisoners in the area passing through a gate after showing a card to the guards. These were *propooshknitsi*, civil prisoners with passes that allowed them to leave the compound without guards, to mingle among the free people on the outside, and to trade in their well-supplied stores. "Don't hope to get a pass," Inga sneered. "Only civils get them. Politicals aren't allowed any."

When the "prayer" ended, Eva's brigade was marched through the gates to a huge, open square facing the zone. A pretty, dark-haired, brown-eyed woman approached the guard. Giving him a form, she turned to Zina and asked for eight women to prepare wood for the guards' houses. Zina chose Eva among the eight. "Lyena Kuprianova, she's new and just

out of the infirmary," Zina said. "She's an intellectual. Show her the ropes." With that, the guard marched the rest of the prisoners off, four in a row. More guards in the front, at the sides, and in the rear were clutching leashes that restrained the dogs.

Lyena Kuprianova was the general brigadier for politicals. On occasional jobs, she could requisition any number of women she needed. She took Eva under her wing, helping her to get tools, and showing her how to chop logs without injuring herself. Those first few days she did more work than Eva. "I'll ask for you as long as I can find excuses to need extra women." The two began to develop a friendship as they both had similar backgrounds. Lyena was a graduate from a well-known institute of foreign languages. Considering the alternatives, she was quite satisfied with her job, always working just outside of the zone, rarely going into the forest. "I feel almost like a propoosknitsa — and my quotas are always fulfilled. At least, that's what the boss thinks." Why she was accorded this privilege, Eva never ascertained. She was to be the one of only two Russian women in Eva's years in camp who sought her friendship and to whom, in addition to the Germans, Eva gave thanks for her survival. The other Russian was Zina.

At lunch time, a huge boiler of hot soup was brought to the workers, and the women had as many bowls as they wanted. Unfortunately, it had the same ingredients as that of the day before — and of the current day's breakfast. Indeed, this was almost the only kind of soup Eva was to have in all of her years at camp. This time Eva was able to drink it from the bowl, the cold temperature — minus twenty-five degrees Celsius — cooling it down quickly. Just before dark of this first day, the two guards on duty marched Lyena and her brigade back into the zone. Each prisoner carried two logs for the guardhouses.

For two weeks, Lyena continued to ask for Eva. Finally the comparatively easy work came to an end. Not until her reassignment did she understand her luck in having had light work and full food rations. On the morning of her first full day with the detail that was felling trees, after the "prayer," the brigade marched to the tool shed and, with their saws and axes, again formed rows with the other brigades. After a quick recount, every brigade, with a leader in front and surrounded by guards and their dogs, marched up a slope to a boardwalk. From there several

hundred prisoners, each brigade a distance from each other, started off to their work. Cracks between the slippery boards made walking hazardous. After a tortuous fifteen minute walk, the first brigade turned off on a trampled road. The others continued, until, a short distance away, another group broke off. When Eva's brigade reached its destination, the women removed their jackets and set to work. Some gathered twigs and logs to make a bonfire for the guards; others trimmed trees left unfinished from the day before; still others started felling trees that were chalk-marked or pointed out by a guard.

From the moment that she stepped up to the tree towering over her, Eva was shocked by one event after another on this first day of work in the forest. Inga, at her own request, was Eva's first partner. Zina made the initial cut with her ax; then she and Inga started to fell the tree with a double-handled saw. Zina then directed Eva to take her place at the saw and left her to continue working with Inga. Eva was certain that the giant tree she was working on, or those of her neighbors, would fall directly on her. "If it falls on me, let it kill me — not cripple me, Please, I don't want to be a cripple for the rest of my days." It would take several weeks with both Zina and Inga cautioning her about safety and offering her encouragement before she was to overcome this fear enough to look beyond her work area out into her surroundings.

On this first day of work in the forest, Eva became exhausted very quickly and the lunch break came as a welcome relief. She ached all over and could barely move. Because the work area was too far from camp, and the weather too cold, for hot food to be brought out, lunch consisted only of the bread, frozen by now, toasted at the bonfire. Eva would have liked to have rested longer, but the other women quickly ate their lunches and resumed their work. Their food rations depended upon them meeting their quota of timber.

At the first hint of darkness, the guard halted the work, and each prisoner, picking up two logs, got into formation. Again the "prayer," and off they marched, less lively and talkative than in the morning. As they neared the gates, Eva heard Inga's angry voice. "Damn! Meanie is on duty. Just one log." She now noticed the heap of logs set down by the women entering the zone before her. Meanie allowed just the one log

prescribed by the *nachalnik*, the supervisor. "We have to carry logs this distance for them," grumbled Inga. "As if they didn't get enough wood from Lyena." The rule was one log per prisoner to heat the barracks, but some of the more decent guards would sometimes permit the women to keep the two logs that they were required to carry from the forest.

At the gates, the march was halted for the sentries to search every woman before she could enter the zone. For the first time, Eva joined the battle for the washroom. Returning to her bunk, she lay down, too weary to go to the mess hall and battle for a table. "Little Inga and I will bring supper here. We'll make a party of it," said Gerta. "Zina won't object."

"Count me in," said Inga and Little Inga, so named as not to confuse the two of them.

Some days later, a fifth member invited herself into the group. Approaching Eva and Inga in the forest, a robust, sturdy woman of about forty-five abruptly introduced herself. "I'm Emma. I'm German — Volga German." She said to Eva, "You white-hand, you will never be a good logger. Inga needs full rations and will never get them with you as a team-mate. Even with your puny help, I'll make enough for the three of us. If not, it doesn't matter. My husband sends me salt-pork and sausage regularly. The bantiki leave me enough so I can live without the slop they give us here. I'll give you some, too. You already look too weak to work." She was known to be a diligent and good laborer and her inclusion into the clique was a gain. She had traced her ancestry to Germans who had settled along the Russian Volga some two hundred years ago and had become prosperous farmers. During collectivization, they were integrated into the kolkhozes where they had lived and worked peacefully. With the Nazi attack on the Soviet Union in 1941, they were deported as a group to Siberia. Emma's protests resulted in her ten year sentence for anti-Soviet propaganda. She always kept the group in good spirits with her biting, humorous comments, often directed at herself as well as one of her four companions.

As Emma promised, she took up the slack in Eva's output, particularly during the first several weeks when Eva was hampered in the handling of the saw by a swelling in the wrist of her left hand. It had been permanently deformed from a fracture after a fall on a slippery walk

about three years before her arrest. The pain was so bad, even keeping her awake at night, that Eva took Inga's advice and went to the medical center. When her turn came, the doctor, a young woman, asked her, "What statute are you in for?" With Eva's reply, "Fifty-eight ten," she bellowed, "Get out of here. I don't treat traitors. It's enough that we let you live."

Chapter 19

As time marched on, Eva was automatically propelled forward, eternally exhausted, her hunger undiminished by the lack of proper food. The zone, becoming a refuge from the forest, was always seen from the perspective of the star light or moon's glimmer or the gray night clouds, and the barracks would be in shadows cast by the electric bulb. The brigades worked seven days a week from dawn to dark, the only days off being May 1 and November 7. Although May 2 and November 8 were also legal holidays, the camp administration ignored them. The thrust of camp life kept Eva instinctively attuned to her environment. During the first months, every twenty-four hours was an experience like none other in her lifetime. In the forest, her senses were sufficiently acute to cause her outrage at the sight of eight women dragging a huge felled tree to a clearing without any mechanical help, then lifting it into a horse-drawn sleigh. "How can this be permitted?" she whispered to Inga, whose nonchalance disturbed her.

"That is their punishment for being the strongest women in the brigade," Inga replied. "They do only this type of work."

During the marches to and from work, Eva found herself watching, with equanimity, women squatting on the boardwalk to relieve themselves. Hearing, "Wait a minute," the women in front of her would signal for the line to halt in defiance of the rule requiring that they ask permission of the guards. "I have to take a 'leak' or 'shit.'" Her companions advised, "Don't pay any attention to the guards. They're not human. They're insensitive robots. Since they don't let us go to the bushes, we have to do our business here — and on their orders we don't take a

step to the left or to the right doing it either." Contempt swelled in Eva's chest for the camp custodians who forced such measures. With snow thigh high and locations impossible to determine, where could the prisoners escape to?

Then there were the middle of the night searches. After the first few, she responded without panic. The guards would rush into the barracks shouting, "Up! Up! Outside!" awakening the women from the deepest sleep of the night. The prisoners dropped nylon, knives, cosmetics, pieces of broken mirror, needles, and other forbidden articles to the floor as they hastily dressed and left the barracks after a personal inspection, to stand in the freezing temperatures while the searches took place. Those not quick enough to be dressed by the time the room was expected to be cleared had to go as they were. Very few had their jackets and pants, as these were usually in the dryer. When the searches ended, the women had to spend the rest of the night looking for their personal belongings thrown helter-skelter as far away as four or five bunks from their own. By the time order was made from the shambles, they needed to hurry off for breakfast and roll call. The searches were routine in every camp, taking place every two or three months. Confiscation of articles served no purpose as the women always found ways to replace them.

The possibility of dying from a lack of adequate nutrition was always on Eva's mind. Zinka Brigadierka's frank confession of falsifying the production reports, at first alarming her that possible reprisals would affect every prisoner in the barracks, finally lulled her fears. At first her guilt drove her to saw away at the trunks of the trees beyond her physical endurance, so certain was she that she only was the reason for the lack of the quota fulfillment. But soon she put her trust in Zina upon whom the full or partial rations of bread and sugar depended. "The SOBs know that even men can't carry out such norms, so if they're so considerate of us, I'll be as considerate of them," she assured Eva. "I can't manage one hundred percent reports every day, but I've never yet given a true one and they'll never get one out of me." Laughing at the obvious signs of fright on Eva's face, she added, "Don't worry. No one will inform on me. No one, not even stookachka, will risk her rations."

Full rations or no, Eva never had enough makhorka or bread. During the first few months, many was the time that, lying on her bed, she

could not sleep for the pangs of hunger, intensified by the odors of food that some of the prisoners were cooking up, because they had managed to bargain with a propoosknitsi who brought back something from the free stores in the village. "Don't the morons realize that by reducing our already insufficient rations, they're just weakening us and making it impossible for us to fulfil their quotas?" Eva would moan to her friends.

"And are you a moron, too," one would answer, "not to realize that it's their policy? For accidental death in camp they are accountable, but when we sicken and die of 'natural' causes, they are not responsible. Did you ever taste a piece of meat in your soup? Did you ever taste butter or oil here? Where do you think they go? The cook sells them to the guards."

These conditions forced Eva to tolerate the dog-eat-dog philosophy of the inmates, so completely in contrast with the helpful comradeship in the prisons. Here it was an animal struggle for survival. Being a member of a tightly bonded clique helped. The Germans in Eva's group, crafty in their skill in bartering for items which would appear useless to anybody else, or bargaining for food in exchange for their meager monthly wage, sometimes would come up with a one-time, mouth-watering delicacy such as a lick of sausage, or some makhorka. They would also exchange with her some food of theirs for the fish which she could not stomach.

Prisoners were paid monthly for their work, but after deductions for food, clothing, and services (Eva was never able to ascertain what the latter were), she received so little — an average of one and one-half rubles — that she could not buy anything with it. She placed her earnings into her bag in the koptyorka until she could save enough to purchase something. One month she received two rubles and fifty kopecks (then equal to about seventy-five cents), and this windfall created a dilemma. For days, she and her friends discussed whether she should buy a piece of bread or a half-ration of makhorka. In the end, they decided that makhorka would last longer and she could share it with the others.

The power of the bantiki was so chimerical that in spite of Eva being a victim of their games, with the authorities looking on, in her weariness she often doubted her own credibility. Her first contact with them came when she left Koom's office, having been called by the loud speaker to collect a parcel that arrived from Tommy. Eva could hardly

contain her excitement at the sight of the package. However, before her eyes, the parcel was slashed and opened and some prohibited items, tea one of them, were confiscated. Already disappointed, she stepped out of the doorway with the box, expecting to take it to the koptyorka, only to be encircled by five women. She immediately identified them as the bantiki by the girl who approached her and took the box from her arms. She was a squat, stubby figure, wearing a short, thigh-length sleeveless dress and white stockings and sneakers. A Buster Brown haircut over a broad face, a huge bow standing stiffly on top of her head, gave the total effect of a perfect kewpie doll that Eva remembered from her childhood; but the arrogance of the look in her small, merciless, piercing eyes and cruel, thin-lipped mouth made a mockery of the cherubic symbol. Here was the infamous chief of the bantiki, the only one of the tribe having the right by the law of the ape criminals, to wear a ribbon in her hair. All of them began examining what was left of the contents. They returned to her a few lumps of sugar, one of five packages of butter, and some stamps and envelopes. Everything else they kept. Trembling, Eva asked if she might have the anxiously awaited spoon, and despite its value, after some discussion, they decided she could keep it.

When she told her friends about the incident, Inga observed, "God looks after babies and fools. Do you realize that you could have gotten a knife in your back even for asking? It would have been better to bargain to buy it back without taking such a risk. Don't ever do such a danger-ous thing again. Don't forget you are a 'fascist' and they are 'friends!'"

After the rifling of her parcel for a third time, she wrote Tommy that she was earning enough to support herself and had no need for any more packages. Aware that Tommy and Alexandra must be denying themselves many necessities, Eva had no desire to supply the bantiki at their expense.

Thus she avoided further individual confrontation. But the one encounter, during her second month in camp, that most indelibly exem-plified the brutish nature of this band, was to remain with her every night for years. As the women were preparing for bed, a woman guard dashed into the barracks, whispered something to Katya, and rushed out. Katya at once shouted "Quiet!" Her unusually agitated voice silenced the women, most of whom had not noticed the guard. "The bantiki are

raiding us tonight," she announced. "If any of you recognized who warned us, keep your mouths shut or we'll never be warned again. You know what will happen to her if the bantiki find out."

She ordered the emaciated women, Eva among these, to the top bunks. The others, each gripping a log, placed themselves at the door, along the aisles, and between the bunks. In a moment, it became so quiet that the barracks appeared enveloped in slumber. Hours seemed to have passed. Finally, slowly, noiselessly, the door was opened from the outside. Several bantiki entered. They were met by shouts and swinging logs. The shock did not deter them; they put up a terrific battle. The screaming, panting enemies attacked each other with fury.

Through the windows Eva saw women outside, brought out of the neighboring barracks by the noise. She wondered where the guards were and why they hadn't come to stop the fight. She watched several bantiki attack with knives, which, fortunately, were knocked out of their hands. Having wrought havoc, being fewer in number than the politicals, they were forced to retreat, but they threatened dire revenge.

"The guards?" Katya answered Eva. "They don't dare come in when bantiki are fighting. It's too dangerous for them. If the bantiki don't stab or hurt them inside, they get them outside some other time. We have only ourselves to defend us. Tonight we were lucky. We were prepared. That doesn't happen often."

The rest of the night the women slept with logs at hand while a few stayed awake, guarding against a possible second raid. In the morning, not even the few who had sustained knife injuries asked for treatment, which they claimed would be denied them anyway. Eva, recalling the incident between herself and the doctor, believed them. Nobody was excused from work.

The inconceivable domination of the prisoners and authorities by these criminals was demonstrated time and again. One evening as the weary women were returning from work, they heard laughter from earlier arrivals inside the zone. After the search at the gate by unusually subdued sentries, they joined in the hilarity. The only prisoners inside that day had been four civils on sick leave and the bantiki. When a guard had entered the bantiki barracks with a request — not an order — for them to repair the walk, a twenty minute job, he was rudely told to go

elsewhere. Zakonnika did not work! The guard returned with two more guards as reinforcements, but hastily retreated when they were threatened by the criminals. Koom was rash, or brave, enough to try next. He got no farther than the door when he was met by a barrage of pots, pans, bowls, and everything else short of knives that the bantiki could use as weapons. The insulted criminals chased him almost halfway through the zone. The first brigade to return carried out the repair job. None of the bantiki was punished.

In the early spring, a new group of prisoners arrived in the barracks. "The nuns!" Groans of displeasure greeted them, embarrassing Eva. "I am an atheist, but I say, 'Live and let live,'" she derided her friends. "They want to believe and pray? Let them. What harm do these poor women do?"

"Wait and see what you will think of them when you get short rations because of these parasites," several voices answered. "Many of us are believers, too, but we don't impose upon our companions in misfortune. God ordered us to earn our bread by the sweat of our own brow. Those holier than thou hypocrites don't earn their bread except by the sweat of our brow."

Sentenced for their religious activities, they were dubbed "nuns" regardless of their denomination or whether or not they had taken vows. They were easily recognizable by their conspicuously different clothing, their long, black dresses often dragging on the floor covering neck to ankle, hiding their arms to below their wrists. Their heads were wrapped in black shawls with only their eyes, nose, and mouths exposed. Only the bantiki treated them with respect, even allowing them to pass through their circle with parcels untouched. Their creed did not allow them to work for "Satan," and they maintained that the philosophy of the Soviet government was inspired in Hell. No punishment swayed them from their determination not to work, and the authorities finally stopped trying to force them. Their refusal to accept camp food caused the other inmates to speculate on how they remained in such excellent physical condition.

Eva was quick to change her tune after having the bad luck to be paired off at felling timber with one who would occasionally consent to

leave the zone with the brigade "for the walk." Sister Agatha would come as far as the clearing and sit herself down. On some weekdays when no other nun was in sight, she would pick up her end of the saw, crying that she knew she was sinning, but, "If God punishes me for doing Satan's work, perhaps he won't be too harsh. I just cannot look on and watch you, you poor misguided soul, struggle alone with those trees. I'm only being compassionate to a fellow creature." On Sundays, or on rare occasions when another nun might have decided to come out with the brigade, she calmly sat on a stump near the bonfire until the end of the day. And Eva couldn't fell a tree by herself.

On the Eve of the Russian Orthodox Easter, with supper hardly over, the nuns, sitting on their bunks as a group in the far corner, began to pray loudly in unison and sing hymns for God to bring light to the sinners in the Kremlin and to the sinners in camps and jails — and to relieve the burden and sorrows of their fellow prisoners and of all His children everywhere. They kept up the loud sing-song chants for two nights, making sleep impossible. The lack of sleep, the hard work during the day, and the shortened rations did not help soothe the frayed nerves and tempers of the other inmates.

If there was any question in Eva's mind that the authorities condoned discrimination in the enforcement of work practices, it was dispelled following a meeting Koom called soon after the arrival of the nuns. Responding to instructions through the loudspeaker, all prisoners poured into the mess hall, now transformed, all the tables stacked at the back of the room and the rows of chairs facing the platform. A tall stout man in military dress, walking with the aid of a cane, appeared on the stage accompanied by a smart, trim man in the gray uniform of the secret service. Murmurs of "Kommandant," and "Koom! What's up?" rippled through the hall. The speculation ended at once when the kommandant raised his arm. He began to speak, saying the prisoners were lazy shirkers and malingerers who didn't work hard enough and that he knew of the *toofta*, the cheating, especially by the fascists. He went into a fanatical diatribe against "You damned traitors who stabbed us in the back while we were shedding our blood at the war front. I lost a leg there for you scum, while you were doing your dirty work in the rear. You were ready to sell our country out to the Nazis," he went on.

Then Koom took over, urging the prisoners to work harder and better, not to allow toofta and to report to him those engaged in anti-Soviet talk and those who made out false reports. "Work honestly because we feed and clothe you; our country needs your help," he implored. He did not seem to be bothered by the jeers, catcalls, and whistling, as he continued with his message.

Several such assemblies were called for the same purpose during Eva's internment at Women's Central. After each, the women would say, "There's one good thing about camp. We don't have to worry about a thing. Everything is decided for us: what to think, what to say, when to get up, when to go to bed, how to dress, when and what to eat, and we don't even have to shop and prepare our food. Plus we don't have to look for jobs. A real heaven on earth. Ask Koom. He'll tell you."

By the middle of spring, however apathetic she was, Eva was beginning to feel like an old-timer and was finding small satisfactions and comfort in her ties with the Germans who had helped her to resign herself to her new life. Once correspondence with Tommy had begun, everything being relative, she realized her good fortune compared with theirs. Also, she, Lyena Kuprianova, and Zinka Brigadierka, both of them Russians, had become a separate threesome. Their common interests might have stemmed from all three being "intellectuals," all of them having had an education beyond the secondary school level. Zina was a graduate of an institute of nursing. "A nurse?" Eva asked Zina, who had been with the medical corps in Germany. "Then why are you on lumber — why not in the infirmary? Nurses are needed there."

"You innocent child, I'm a political, a fascist. Fascists don't get cozy zone jobs. There are two doctors in one of the other brigades and they're on lumber," Zina answered.

Zina always held the upper hand in this friendship, but at times Eva was puzzled by her actions. Once, Tommy had sent Eva a *kubanka*, a typical Russian-style winter hat of imitation karakul fur, which for some curious reason passed the search of the bantiki. Zina had asked if she might try it on. When it was on her head, she said, "I like it. I think I'll keep it," and she walked off. Inga, who was standing next to Eva, motioned to her to say nothing and later told her that anything anyone in a

position of authority, great or small, demanded, she was to submit to if she wanted to avoid trouble. Zinka Brigadierka had been kind and helpful to Eva, and Eva might not have survived without Zina's intercession in her work assignments. Now she knew she had done the right thing by following Inga's advice and letting Zina keep the kubanka.

Lyena, through her position of authority, somehow always knew the "right" people and for many years used this privilege to help Eva whenever she was able. Once, when at the Nagornaya camp, she had introduced Eva to Mark Rubin, a Jew and a military man with the rank of major in the Soviet Army at the time of his arrest. His job in camp had brought him to the women's work area often. Koom agreed with his request for Eva to be assigned to a very important position. She was taken off felling and became a *normirovshchik*, the chief checker and grader of all lumber produced in the camp, a position held until now only by highly trusted civils. Mark taught her how to assess the felled trees and showed her the tricks of the toofta. Eva became adept at manipulating quantity with classification of the lumber so that the books would always show a quota fulfillment equal to the most adequate food rations that she could manage without becoming suspect.

A strong and comforting friendship that they both needed developed. They shared their stories and their despair. At the peak of the war, Mark had been relieved of his command for calling his commanding officer an incompetent showpiece. "He really was. He was a relative of a high ranking official, you know, and he was assigned not on ability but because of his family connections. Somebody reported that I said relatives could lose us the war. In no time, the tribunal sent me to camp as a panic-spreading defeatist. That was when we were still retreating and losing battles and land." Soon after he arrived in camp, he had received another blow, an official notice of his divorce and a letter from his wife forbidding him to communicate with "her" two sons. "We had a good marriage," he lamented. "Then she writes such a letter. As if they're not my sons anymore." The older boy was only three and the younger merely an infant. He read Eva a letter he had received recently from the older, now fourteen. It read, "I am ashamed to be your son and to bear your name. I want nothing to do with a fascist enemy of my country. You are no father of mine. I have taken the name of my real father whom I love

331

and respect." The younger boy had added, "I feel the same way." Both signed their stepfather's surname.

"She did a good hatchet job on them," Mark said sadly. "I have no sons now. Her new husband has adopted them." In spite of the new post-war laws making divorce more difficult and costly, mates of prisoners having proof of arrest and sentencing of their spouses, were granted divorces free of charge.

As life in the camp unfolded over the years, Eva was to touch many other lives, and vice-versa. Some apparently good relationships, however, turned sour. She concluded that the camp environment led people, herself included, to exhibit and resort to behavior deeply rooted in their upbringing, their current deprivation and loss of dignity adding little to their intellectual growth and change. An instance of this type occurred when Eva was assigned to a small island farming camp in Kotomish. The only other prisoners at this camp were six Western Ukrainians and one Polish woman, all of whom had been in her barracks from her first day at Women's Central. At Kotomish, they were supposed to live together harmoniously, as a family, in a home-like cottage under the supervision of a compassionate Koom. When parcels began to arrive, almost all of those from Abie included chocolates. As they began to accumulate, Eva kept a bag full in the drawer of her night table and distributed them among her companions in exchange for their salt pork, sausage, and fatback, which she considered a delicacy. One evening she came home from work to find all the candy gone. Yadviga, the Pole, on seeing Eva's astonished and disappointed look, said to her, "It's a crying shame! I told them I didn't approve and didn't take even one. Only me and Auntie Anya did not take any. Auntie Anya had even accused them of stealing and warned them that stealing was a sin. One of them smiled and replied, 'Father Afanasy says it's not a sin to take from Jews. If it's from Jews, it's not stealing.'" After giving Eva the full details, Yadviga added, "I can't take anything from you, Eva Moisseyevna, without permission. You're kind and generous — and you're not a real Jew anyway."

"A Jew. So that is how they see me," thought Eva, the pain of the rebuff lingering until she needed to isolate herself from them, difficult to do under the physical circumstances. When she was alone with them,

she turned vigorously to whatever reading material was available, or left the camp to spend longer time with the free citizens in the village, where, at this stage, she was free to come and go after work. The others made no attempt to heal the breach, pretending nothing had occurred, indicating no understanding of why she continued to be upset, and showing no remorse at the anguish they were causing her. Until the end of their confinement at Kotomish, they seemed utterly unaware of the contradiction between the teachings of their religion and their bigotry. Not even the suffering, which all of them experienced together, made a change in their thinking.

As her irritation persisted, Eva would scold herself for not heeding the advice of a woman she had met at another camp — an uneducated but natively intelligent Polish peasant, a deeply religious Catholic for whom Eva developed a great respect and admiration. Once, while the two had been working together, Eva mentioned a very painful festering finger. "Remember once and for always, Eva Moisseyevna," Nika emphasized, "You're finger hurts you — not me or anyone else. Nobody will cry because your finger hurts you. People cry only over their own worries and pains." At the time, this comment jolted Eva from her Utopian ideas on the innate goodness of man. She decided that most people do not sacrifice the good things of life in order to correct social ills and injustices. The people she had known and respected for their recognition that economic and political and social injustices eventually in some form touched everybody, were the exception, not the rule. The pre-war purges were the first incidents that channeled her thinking along these lines. Life in camp gave her conclusive proof of this — as did Nika. Good-hearted, an honest and hard worker, she, too, helped only her friends and had no interest or desire to strive to improve the lot of all prisoners.

It would seem that prisoners who shared the same Jewish heritage — who for centuries had been subjected to ridicule, persecution, and degradation in the ghettoes — might have bonded together under the harsh camp regimen. But not even the two Polish Jewesses, Panna Anyuta and Panna Rosalia, could look to each other for comfort. Panna Anyuta repeatedly let it be known that she had been born into wealth. She persisted in calling attention first to the large factory that her family presumably had owned before the Russians took over; then that the Rus-

sians had arrested her because she was a member of an elite. She made no secret of her contempt for Panna Rosalia. "Rosalia, indeed! She's plain 'Rose' — just Jewish trash."

~

By the middle of May, some five months into this existence, Eva's robotic responses were indistinguishable from those of the others. She awakened at the call and stirred about in the same rhythm as the women in the bunks around her as she readied herself for the march to the forest. She wormed her way in and out of the doors, pushing and squeezing as efficiently as any veteran. By day's end, the momentum from the others kept her going through the supper in the mess hall or sometimes in the barracks on her bunk with Inga, Little Inga, Gerta, and Emma, actually enjoying the time to chat and socialize. Sometimes women from other cliques would stop on by. Conversation would change from ordinary gossip or trivia to descriptions of camps that existed throughout the country. The worst camps were in the very far distant, coldest regions. The women referred to them as camps of slow, drawn-out death where the prisoners were far more overworked and underfed than they felt they were. "We live in a health resort compared to them," they would say as they mentioned the dreaded names of Magadan, Kolima, Vorkuta — all in the arctic and sub-arctic regions. Eva recalled that Max constantly changed addresses, beginning with Kotlas, the transit prison in Komi, and decided that he must have been one of the unfortunates who had laid tracks from Kotlas through Syktyvkar, the capital of the Komi Republic, into Vorkuta, a terrible camp in central north Siberia. Her thoughts gave her no peace as she had excruciating nightmares imagining Max performing hard labor outside in the unbearable cold, improperly clothed and fed. From letters she was now receiving from Tommy, she knew that Valeria was in Taishet, one of the worst camps for political prisoners, in the Irkutsk region. Frightened and scared for Valeria, Eva wrote to her, but the censors returned the letter with the notation "Prisoners may not correspond with each other."

Tommy's letters were now arriving with increasing frequency, the letters containing news about her successes at her studies, the kind of employment she had, and about the possibility of Alexandra's securing a job as a babysitter with a family they knew in the Lux, the hotel for

representatives of foreign Communist parties and some Russian workers in the Comintern. Tommy also wanted Eva to know that Abie, without Sonya's knowledge, was giving her a little money to spend for parcels for her and Valeria.

It was about this time that Eva's life was abruptly altered, again. The chief brigadier shouted out her name along with twenty-five civils and ordered them to pack their belongings; they were to be on a transport that was leaving within an hour. If the women weren't ready by then, they would go without their possessions. As the brigades marched off to work, Eva, the only one from her building to be called, stayed behind with the other designated women.

It was only much later that Eva learned the reason for this action. Since her arrival in the camp, Eva had not been seen by a doctor for classification, but Lyena and Zina had successfully maneuvered to have her transferred from lumber to lighter work. They had called to the chief's attention the fact that Eva had become too emaciated to continue working in the forest and insisted that she should be given *de facto* invalid status without waiting for the medical commission to make its routine stop at Women's Central and rule on Eva's condition. (The traveling commission of one to three free doctors determined which of three categories of work a prisoner's health allowed: the first category was hard labor; the second, light work, preferably in the zone; and the third acknowledged the inmate to be an invalid, unfit for any work. Until some time after Stalin's death, Eva had not known of any political, except for the custodian Katya, who had been classified for second or third category work.)

Of the twenty-six women ordered to leave immediately on the transport, all but Eva were listed as second category workers. The women were taken by truck to a small farming camp with only one barracks and one hut of punishment cells. They and their custodians were the only inhabitants. Eight guards were considered necessary to tend to them. In exchange for their winter clothing and chooni shoes, they were issued one pair of cotton summer pants, light jackets, and heavy men's shoes. As the weather became hot, standard clothing for work was changed to only a bra and pants.

Eva found farming to be less demanding than felling trees, but she

often moaned, "If this category is 'light,' I'll live longer, perhaps by a week, than if I had continued in lumbering." It was back-breaking work. Each seed had to be planted and watered separately and every weed pulled by hand. The women worked all day with backs bent or crawling on their knees, a position which tore their only pair of pants into shreds. Haymaking, during which bits of reed and dead leaves would stick to their sweaty bodies, was the most unpleasant job, particularly since baths were permitted only once a week. It was on this job that Eva, in self-preservation, learned to partake in the deceptive practice of *toofta*. In order to rapidly fill the huge pits where the hay was supposed to be stored, she joined the others in filling the lower half of the gaping holes with tree stumps and other extraneous matter mixed with the hay. The upper half was filled entirely with hay, and probing and poking through it would not reveal the hard debris underneath. The toofta wouldn't be discovered until later when the top half of the hay pit was removed.

With the passing of the short, hot summer, the harvesting of cabbage, potatoes, beets, and carrots began. Lugging the heavy sacks of potatoes on her back from the field to the trucks wore Eva down. Yet, this — her first experience working on a farm — gave her an appreciation as to why, when other transports unloaded her crew at farm camps (they were never told where their destination would be), they expressed satisfaction. For a short period, before heavy, cold rain and sleet made life miserable and bonfires impossible, the women roasted vegetables for their lunch, with permission and without permission, and carried back to their barracks a supply to supplement, or substitute for, the eternal and infernal oatmeal kasha. Sometimes the guard at the gate would allow them to smuggle vegetables into the camp. The first few rows of workers to reach the gate would warn the women in the rows marching behind if the guards on duty were the kind who were known to send prisoners to the punishment cells for stealing camp property. A signal would alert everyone to drop whatever vegetable she was carrying. The guards might rant and rave but could never identify or punish those who had dropped the forbidden produce. The inmates would glare and mumble curses while the guards gathered their edibles and carried them off to the guard house kitchen. Even worse was the sudden appearance into the barracks of the kommandant and guards who would command

that the food, already cooking on the stove, be thrown into the yard.

No one felt any guilt for what the camp officials termed "stealing government property." Eva often laughed at the irony; she was in prison for a crime she didn't commit, yet she was forced to lie and steal in order to survive in the camps. Although they planted the vegetables and nourished their growth, all that prisoners ever received — sometimes only in soup on holidays — was spoiled cabbage, forbidden to be sold to the free public. No produce of any kind was available for sale to even those inmates who had the money to pay for it. It went to the free administrators and workers of the Solikamsk camp complex and the stores catering to the free people throughout the cities and towns of the Urals.

With such impoverishment, it was not strange what excitement the sight of a field of mushrooms could generate. The mushrooms seemed to have grown overnight and were spotted by the workers on their way to the fields. Eva suggested that they ask the kommandant for permission to gather some. "If we add mushrooms to that camp soup, maybe it will be easier to swallow — and it will be a good change." To the women who feared reprisals for asking, she answered, "What can we lose? We're in hell already." Her argument prevailed, and they chose a delegation to speak to the supervisor. They decided that Eva should not be included as she would be picked out as a foreigner right away and might be framed as a ringleader and trouble-maker. "You're a political," they said. "If he sees you among us, he'll know you suggested it. He thinks we civils are too dumb to think up such things ourselves." Eva was pleased to see this change in attitude of these civils towards a political. The supervisor granted permission providing that the quotas of the two women who were to leave their field work to join the cook on the unofficial mushroom gathering brigade be fulfilled by the others. Soup at camp that night was like nectar!

After the harvest, the twenty-six prisoners were returned to Women's Central. Eva's friends greeted her with outcries on how well she looked. The extra food and lighter work undoubtedly did the trick. Soon it was as if she had never been separated from her group of friends. Offered a lower bunk, she refused it so that she could once again be next to Inga.

Chapter 20

Before long, Eva was again to be separated from her friends. From Women's Central, the hub of the Solikamsk camps, she was to be sent from one camp to another, back to the one she had left a few weeks or a month before, or to an entirely new one. She might stay in one place for the season's work or for a five to six month period. Sometimes her friends would be moved along with her; other times, she would not be among friends.

In the five and one-half years she spent in the labor camps, Eva was shuffled from camp to camp nineteen times. In later years, after her release, she would try to recall the names, but only a few remained with her: Vishera; Verkanaya, towered by the wall of the Ural Mountains which, although many kilometers away, seemed to be within walking distance; then Kotomish; Peshkova; Krasnovishersk; Nagornaya; and one called "The Seventh Kilometer." Some of these were lumbering camps, some peat camps, and some — the ones Eva preferred — farming camps. Some were as far away from each other as two hundred kilometers. Most of the time, the prisoners were transferred by open trucks, not an unpleasant way to travel in summer but miserable during the winter.

Eva's stays were longest at Nagornaya, a lumbering site. It was larger than most of the camps, a modest copy of Women's Central with fewer and smaller buildings. Thirty to fifty prisoners lived in a barracks. The bantiki, the only criminals moved from Central, occupied one of the barracks and, of course, they brought their thieving, parasitic behavior with them.

At one of the larger farming camps, Eva credited the administra-

339

tion with adding insult to injury when they forced all inmates to attend lectures on politics and political events as interpreted by Koom. As if these boring evenings were not enough, three additional two-hour classes were added after work for compulsory agriculture lessons. Everyone, city as well as village women, were compelled to study the Lysenko theories of farming — a faulted theory followed for years in Soviet agriculture which held that environment and behavior could change hereditary characteristics. This practice was responsible for the endemic critical shortages of farm produce that plagued the Soviet Union. The disinterested captives were taught the Lysenko checker-square method of cultivation. "Aren't the agronomists responsible for telling us what to do?" Eva timidly protested. "We don't do as we like anyway. So why must we learn about Lysenko and his methods?"

Koom patiently gave an explanation. "Lysenko influences all science. If you know his theories, you will be able to cope with everything and do things right. When and if you are freed, you'll never live in cities again. So you better learn how to manage when there is no agronomist around to help you. We're preparing you for life as free people."

The kolkhoz women ridiculed Koom and his teaching about Lysenko. "It's easy for that white-hand to talk. He and his Lysenko know as much about farming as kolkhozniks know about engineering," they laughed.

Working in the peat bog was indeed hard labor — worse, Eva decided, than felling trees. After hours of clearing the ground and digging with a heavy, dull-edged shovel, she found the damp peat too heavy to lift. As the pit grew deeper and deeper, it became more and more difficult to raise even a half-loaded shovel. By the time she made it back to the zone, she was too exhausted to eat or even to sleep. Neither she nor anybody else could begin to fulfill the quotas required for a decent allotment of food.

One of the sites to which Eva had been sent early in her internment was a camp where timber was put into the river to be floated downstream. The women worked together with the men's brigades in a series of bizarre antics. The weaker group of members of both sexes, in which Eva was included, was assigned the "light work," rolling and pushing the felled trees into the water with their bare hands. The "stronger" men

and women, wearing chooni or heavy shoes and carrying big poles, leaped from tree to tree in the cascade to shove the lumber along, separating the huge logs that clogged the river. Untrained for this dangerous work, the improperly shod workers often got into each other's way as they jumped from log to log, trying to keep their balance. Losing their balances, they would reach out for one another or for poles thrust out to them to prevent their slipping or falling and being crushed to death. Eva heard of many such accidents. She was not long at this camp; the people in charge quickly recognized that she was not up to the task of rolling trees.

At another camp, Eva once witnessed an accident which she had feared some day might happen to her. She and Inga were felling a tree at the bottom of a hill. They were working opposite a civil and the chief bantiki, whose hair bow was unshaken from the top of her head. It was the one and only time a zakonnika was seen in the forest with the other prisoners, and it was well known that this civil had cracked the bantiki ranks to become the "wife" of the chief. Suddenly, the tree that they were felling toppled over onto a deadwood tree which careened directly on these two, killing both of them instantly.

With such dangerous and difficult work, it was no wonder that the prisoners resorted to malingering, which was almost as popular as toofta. Desperately in want of rest, if for no other reason than to be alert at work, many prisoners inflicted wounds on themselves in order to be exempted from work. Some even went so far as to infect self-inflicted cuts with foul matter — dirt, garbage, feces — that would cause the wound to fester, hoping that the doctor who saw them might order a few days of rest — painful, but worth it nevertheless. If the doctor was a conscientious patriot, such as the young woman physician Eva had seen about her tortured wrist, the infection might or might not be treated, and even if it were, the time spent recovering might be added to the total sentence. Women would risk their already poor health further by brewing their tea so strong that it caused heart arrhythmia, a condition that forced the most patriotic doctor to order bed rest for the patient. This practice became so widespread among the prisoners that all tea was forbidden and was confiscated when found.

There was no job that the prisoners were not expected to tackle.

One night, back at Women's Central, all the brigades were awakened and sent to fight a forest fire near one of the lumber camps. Digging trenches, the women came so close to the fire that they were threatened by the leaping tongues of flame. Racing ahead of the pursuing inferno, they managed to escape serious injury, although some women received slight burns. Infuriated at having been sent out to perform such work unprepared and unprotected, they abandoned the area unnoticed and wandered off to a less dangerous location where they waited for dawn. Men prisoners, the first men besides guards and camp authorities that Eva had seen in years, also ran from the burning forest and joined them. They were as sorry a sight and as ill-prepared as the women. "Let the forest burn to the ground," said one. "Yeah," cheered the others. "Then the sadistic bastards won't be able to think up more torture."

The assembled group of politicals were all eager for fresh conversation and information about each other's conditions. Eva shuddered upon hearing the stories of some of the men. In the men's camps, too, the prisoners were divided into fascists, civils, and criminals; but the "ape" criminals were much more brutal than their female counterparts. The men used the expression, "So-and-so was lost by cards," referring to a game the criminals played in which the loser was required to kill another prisoner just for the sport of it. Most men "lost by cards" were politicals — very rarely a recalcitrant criminal. The authorities knew of the gambling but took no steps to stop it.

The women returned to camp before the fire was extinguished. In spite of her fright and the hazards of the night, Eva felt a welcome pleasure in having had, for a change, an encounter with men who were not barking orders at her.

Before many more transfers and many more months of living and working under intimate conditions with different prisoners, Eva discerned, without making judgments, the ways some individuals adjusted circumstances to meet their personal needs. Lesbian relationships were one of these, since so many were carried on openly, even among prisoners who normally would have scorned homosexuality. Eva was convinced that most of these women had not been lesbians before being imprisoned, but had been forced into it by prison life. Camp life was so cruel

and unjust that many felt they would never again return to society. They gave way to their suspicion that they had become contaminated as by a disease from which no cure was possible. They were certain that even if freedom became a reality, they would be exiled to a continuation of their current sordid existence. Some of the civils, and even a few of the politicals, in their need for slightly easier conditions and better food, flirted with the bantiki, aping their foul language and brazen behavior, openly offering themselves as "wives." A few of the civils who worked hard at it broke through the hatred and contempt this element had for any except their own cult and the nuns.

In a few camps that were located fairly close to men's camps, heterosexual relationships occurred among some unpoliced propooscknitsi. They met outside the zone on those occasions when men prisoners worked near the women's camp. When a pregnancy resulted, the women were brought to Women's Central, given work close to the zone, and set up in the nursery where they took care of their infants' needs. The pregnant and nursing mamkas were allotted special rations of milk which some traded for makhorka. When the infant was weaned, it was moved to a special children's camp and the mother was again rotated to the various Solikamsk camps as before.

Some promiscuous heterosexual relationships, Eva concluded, began through a seduction or a violent act such as a rape. She was convinced that Marusya, the pious sixteen-year-old Western Ukrainian, whose youth and beauty had caught Eva's attention that first night in the barracks, was one such victim. The first time that the Western Ukrainians were packed into trucks and moved together to another camp, Marusya remained behind. It was an open secret that the free men gave her jobs to keep her among them.

Every few months, the contingency of soldiers reinforcing the permanent guards would change. The first time Eva was sent to the camp at Nagornaya, she became aware of the differences between the permanent and temporary guards. The former were free men, uneducated and unskilled, having volunteered to do this work for the good wages which they could not earn elsewhere. Most of them were unfeeling and sadistic; many took sexual advantage of the women. The camp

343

internees, contemptuous of the women who submitted to the free guards, would beat and boycott any known to have sex with them.

The soldiers were young conscripts from the minority republics, some from Uzbek, others from Kirghiz. Under the direct supervision of the security police, these soldiers were more of a menace than the free guards during the first month of their assignment. Watching everyone with hawk eyes and raising their rifles at the least movement, they wouldn't allow the women to as much as turn their heads or talk on the long, tiring march to and from work. Luckily, they never fired their weapons. The young men soon realized that the "dangerous fascists" were merely harmless, exhausted, overworked women going quietly and peaceably about their business. As fear of their charges disappeared, their attitude became more humane. Ibrahim, the head of the new group of soldiers, began to walk among them on their way to work. "You, Mother," he addressed Eva, "are no more a fascist terrorist than I am. You'd never kill anyone, not even in self-defense."

Eva, more shocked than amused, asked him, "Wherever did you get the crazy idea that I or any of us are killers?"

"The chief guard told us that all the fascists are killers and warned us to be especially vigilant with State enemies," he answered. "We were afraid, and none of us wanted duty with you. We believed them. My cousin and uncle were arrested as political enemies. I know them. They are not murderers or enemies; they are decent men. But who the devil can know who are real enemies and who are not? I bet you are as decent and innocent as my relatives are," he continued. "I thought service in the army was learning to fight — getting a military education. I never thought I would be guarding women, especially old ones, like you. Why, in age you are my mother. How can I insult and dishonor you?"

Ibrahim empathized with Eva. He gave her packs of real cigarettes that were such a welcome relief from the awful makhorka, he brought her sweets his mother had sent, and he offered to mail uncensored letters. Distrustful of all individuals working for the establishment, Eva did not take advantage of this last offer.

Roll call with the conscripts became fun, a cheerful start for the gloomy day ahead. As soon as the numerical call was over and the women left the zone, Ibrahim led the brigade far from the gate and the ears of

the guards in the camp. He admitted to Eva that he found it hard to decipher and pronounce the strange Russian, Ukrainian, and other foreign names; so he invented an ingenious method to substitute for them. "Anyone may step to the other side when I call out a name, but one at a time," he announced. Then he called the first name, "Beauty." When on the first day nobody stepped out, he ordered, "Come on! Come on! It doesn't matter if you're a beauty or not. We have to finish roll call and get a move on." One emaciated woman stepped out. In quick succession came "Shorty! Tall one! Old one! Young one! Hunchback! Cripple! One-legged! One-armed! Bab!" and so on. He never seemed to run out of epithets for the twenty-five to thirty women in the brigade. Pretending anger at the women's gay laughter, he would shout, "Is the roll call so funny? You want all of us in the cooler? Shut up and step into formation." Toward the end of the roll call, several women might step out at the same time, and he would yell, "Get back. The sentries are watching, and even they know I can't call six names at once."

Out in the forest, work became almost a picnic when the young men would, for short periods, take over the work of felling the trees and urge the women to relax a bit. "This is men's work. Guarding helpless women is not," Eva heard them say to each other.

One day in early spring, on the march to the forest, the women screamed with delight at the sight of bushes blooming with wild raspberries. It didn't take much coaxing for the young men to agree to their taking a few minutes before and after work to pick and eat them. For several days they savored the delicacy like starving children. This ended one evening when three women failed to respond to the whistle. The panic was as great among the prisoners as the guards. The women appeared at last, explaining that they had wandered so far into the bushes that they had gotten lost. The shouts, which they faintly heard, had to their relief directed them back. Nothing could sway the guards from their decision to stop the picking. "We're not being court-martialed for disobeying orders," they said. "If you get lost once, it can happen again, and we're not joining you in camp as pals. It's bad enough to be your guards."

The friendship that developed between the recruits and their prisoners remained a well-kept secret from the camp authorities. On Eva's

345

return to Nagornaya after a few months in another camp, she was greatly disappointed to find these kind-hearted, compassionate young men gone, transferred to no one knew where.

Eva's naïve respect for the ideals of the Soviet brand of socialism — ideals she once believed were democratic and humane — had long ago been dispelled by the reality of the first purges. As she moved among the camps in the Urals and heard stories from the many prisoners she met — and her own ordeal was justification enough to believe every- thing she heard — the harshness of the Soviet justice system continued to dismay and offend her. She was convinced that the abuse of once loyal and innocent citizens was sick and malevolent, that the system itself had made enemies of its own people.

In her friend Katya's case, just having been a POW in Germany was cause enough to consider her to have become "infected" with an ideology that might be harmful to the motherland.

Lyena Kuprianova had been sent to Germany during the war as an interpreter. She and her new German husband were both sentenced to twenty-five years. Their son, born in camp in 1946, had been adopted by his Russian grandparents after a long legal battle. They had taken the child home just after he was weaned. As for her husband, he was never heard from again.

Zinka Brigadierka had been a nurse with the medical corps in Ger- many, where she became friendly with several German girls. "I thought I might improve my German," she told Eva. "I got fifteen years for frat- ernizing."

Among the German nationals, Inga and Little Inga were sentenced to twenty-five years for fraternizing — they had both married Russians. Gerta got eight years for anti-Soviet propaganda. "One of the Russians taught me a song. I was told it was a patriotic song. I liked the tune and the swing of it. When I sang it to some Russian soldiers, I was arrested. No, I won't sing it to you. I don't want another eight added here."

Emma, the Volga German whose ancestors had lived in Russia for two hundred years, was given ten years for anti-Soviet propaganda when, after the German invasion, she dared to protest the deportation of her people to Siberia.

In 1955, in the camp at Peshkova, located near a men's camp, Eva met two Soviet army officers. On the battlefield, wounded and unconscious, they had been captured by the Nazis. When they were liberated by the Soviet army, they were arrested and sentenced, accused of being deserters. "German POW concentration camps weren't enough," they said bitterly. "We have to taste twenty-five more years in Soviet concentration camps with bandits and murderers." The last time they had seen their families was when they were drafted at the beginning of the war — nearly fifteen years ago — and they had not been given the privilege of communication when they were sentenced. Mark Rubin, Eva recalled, had been sentenced to twenty-five years for having exercised his right to express a critical opinion that he felt was in the best interest of the military.

Among the few Russian civils Eva made friends with was a mother of two children who had been arrested for having had an abortion, a routine punishment redeemable in ten years. In her case, it was extended to fifteen because she refused to name the person who performed the operation.

Prisoners from other Soviet republics fared no better. A young Ukrainian woman, about thirty when Eva met her, had been a Komsomol leader. During the evacuation of officials and personnel at the time of the Nazi invasion, she had been one of four members ordered to remain in the occupied territory to carry out a dangerous spying mission. As instructed, she worked within the German ranks, regularly reporting to the Party leader on their plans. She was unfairly accused of collaborating with the enemy and sentenced to twenty-five years.

A Tartar had been given a ten year sentence for "anti-Soviet propaganda." A Russian soldier had approached her for sexual favors, the ultimate insult to a Tartar woman. Screaming that he was a "no-good Russian," she slapped him in the face. In retaliation, he reported that she had said, "Russians are nothing but animals." Her insistence that his improper advances had prompted her outburst — against him personally, not against the Russians nor the army — went disregarded, and she was sentenced to the labor camps.

Frieda, a Latvian, whom Eva had met at Peshkova, was the sister of a militant nationalist who during the war had distinguished himself

in the Soviet Army. After the war, however, opposed to both the German and Soviet occupation of his country, he took up arms against the Russians. He was eventually captured, tried, and sentenced. On grounds that, as his sister, she must have been supportive of him, Frieda, too, was arrested and sentenced.

Putting the Western Ukrainians away for twenty-five years struck Eva as an especially asinine act. She was together with them, with the exception of Marusya, from her first day in Women's Central until her release. They had come from a small village around Lvov, one of the larger cities ceded to the USSR in a secret agreement at the time of the Soviet-German pact. They lived as their ancestors had for generations before them. Their lives centered around the church. They had inflexible opinions about what was "right" and "wrong," the teachings of their priest being taken literally. Industrial changes and modernization barely had reached them. Only two had ever visited a city; the others had not yet seen the automobiles and tractors that were beginning to appear in the rural areas. All were arrested "for obeying God's law to share with those poorer than we were." Marusya, age fourteen at the time, had responded to the pleas of a beggar who had come to her door for a drink of water. They were all accused and convicted of aiding and abetting the *Benderovtsi,* a movement named for the followers of Stepan Bendera, an anti-Soviet leader of the Ukrainian nationalists who would be assassinated in Munich in 1959. Not one of the nuns claimed to have had any knowledge of the man or the organization. They accepted their arrest and sentence as an act of God. Their only protest was the harshness of the punishment, about which they affirmed, "God will punish these Russian heretics for what they are doing to us. They were hungry and we gave them food." When Eva would occasionally break into a bitter tirade against the political nature of her own convictions, they would say, "Let the leaders worry about politics. It's not the business of us little people. What does it matter if you don't know the real facts behind what Koom tells us? Can you do anything about it? God sent you here. It's not your right to ask why. He knows why."

Like the others, Auntie Anya, in her early forties, had not been able to take advantage of the government's basic educational goals to wipe out illiteracy. She had been content to live out her life serving God and

her immediate family, in that order. Until her ride to the Lvov prison in the Black Maria, she had never been away from her village. Upon seeing her first streetcar, she said, "I saw funny long *khatti* [Ukrainian for "huts"] with lots of windows. They were set on small wheels. I don't understand how they rolled so fast-fast-fast," she continued, her voice rising and her speech quickening to imitate the speed of the vehicle. "No horses, no oxen were pulling them." Electricity was a phenomenon that to the end of her camp years she would talk about in wonder. The apartment buildings of the city dwellers puzzled her. Once, at the camp in Kotomish, Anya took Eva aside. Red-faced and embarrassed, she said, "I have an intimate question, too personal to talk about with the girls. They are very young. Old people don't discuss such things with children. In Lvov," she continued, "I saw khatta on top of another, even four khatti together. How do the people get to the outhouse on time if they live in the top khatta?" The concepts of toilets with flushing water and indoor plumbing was impossible to get through to her. "Now that is nasty," she insisted. Auntie Anya, like the other Ukrainians, are indeed dangerous political enemies, Eva thought.

On New Year's Eve, 1952, at Nagornaya, one of the Ukrainians, Ksana, who had stepped outdoors a moment for a breath of air before going to bed, rushed back, pale and frenzied, barely able to gasp out, "The sky! Quick! Go outside!" The sky was clear and bright; the northern lights spread over it in the form of a huge, white cross. The Ukrainians fell to their knees and began to pray. They were joined by the Poles and a few of the Russians. Auntie Anya murmured as she crossed herself, "It's a sign! Something terrible is going to happen this year. Dear God, please, please not another war!" Prayers, from the Russians, most of whom claimed no religious faith, called for God to mete out any punishment but, "Please, no more war!" Eva's attempts to explain the natural phenomenon were of no avail. They persisted. "There is going to be a war or all the prisoners are going to be liquidated or some other disaster will take place this coming year. The cross is God's warning!"

Something significant did happen in 1953, and when the announcement was made, the Western Ukrainians were sure to remind Eva of this night.

Chapter 21

During roll call one morning at Nagornaya, early in March, 1953, Inga whispered to Eva, "Your Stalin is dead!"

Eva, horrified, whispered back, "Shut up! Don't let your fantasies run away with you. Do you want twenty-five years added to both of our terms as terrorists? Besides, don't call him 'mine.' I love him like you do!"

Inga answered quietly, "I tell you I heard it on the radio when I passed Koom's office just now. Look at the guards. They're worried."

Eva repeated her warning, thinking them lucky that no one around understood English. They dropped the dangerous subject and the next few days passed as usual. Four days later, at early roll call, Koom bellowed, "Silence," in his usual commanding voice, and he announced gravely and sadly, "I have some very bad news for you. Our Beloved Father, Teacher and Guide, the Light of the World, the Wisest Man of all time, the Leader of World Communism, Comrade Stalin is dead. Our Generalissimo is gone."

Eva was overcome with joy. "Maybe something good will come out of the death of that butcher." But the obituary, full of glorification and hosannas for the man who personified for her the arch tyrant and destroyer of all hope for the Utopia she had once conceived possible, triggered a much different reaction from the prisoners around her, including the politicals. Except for the few foreigners and a small number of Russians, the women began weeping and wailing. "Oh, Beloved Father. To whom are you leaving your orphaned children? How will we live without you? Who will take care of us? Who will worry about us?" The

351

women seemed sincere, as if they really loved Stalin, and behaved as if they were devastated by his death. Ksana, the Western Ukrainian who had initiated the hysteria on New Year's Eve over the cross formed by the Northern Lights, went into seizures and had to be taken to the infirmary where she remained for two days. Eva could only mutter, "Don't they realize that he is the cause of all our tears and suffering?" At work that day, the Ukrainians reproached Eva. "Do you understand now? Weren't we right? Hasn't a calamity befallen us? The cross was a warning."

"Did they really love Stalin so much? Was his death such a tragedy for them?" she needed to know.

Their reasoning astonished her. "Of course we never loved him. Who could love that devil? But now we'll get a worse tsar. That's what the cross meant," they answered.

By fall, in the wake of Stalin's death, changes were beginning to take place in the camp routine. The prisoners were granted reprieve from work on the two other national holidays, May 2 and November 8, and were given Sundays as days of rest. When the women weren't spending these days sleeping off their eternal exhaustion, they roamed around the zone to examine it in daylight and visited with friends, both previously unknown luxuries. On the free days, they were also shown movies selected by Koom. First these were screened once a month; later twice monthly. And searches were discontinued! News of the outside world, however, was still kept from them and the low quality food and poor pay continued.

One change of policy that Eva especially valued was that members of families and friends in different camps were now permitted to correspond with each other. With overwhelming joy, Eva and Valeria began to exchange letters. They still had to be more cautious than free people in the content and choice of words they used. But, they were too pleased at being permitted to communicate with one another to express any anger about the restrictions they needed to place upon themselves. They did not, however, write about their hardships in order to spare the other the dismay this might bring on, and fully believed the cheerful depictions contained in each other's letters.

Rumors ran wild that a general amnesty for prisoners would fol-

low the easing of the harsh rules. "Everybody knows that there was always an amnesty when tsars died," some of the women said. "We'll get amnesty, too."

"So! Stalin was a tsar?" Eva retorted.

"What's the difference?" they answered, "He was our ruler. And he died, didn't he? New rulers always freed prisoners. So will ours."

As they predicted, the announcement of an amnesty came — but only for prisoners with terms up to five years. The news agitated the politicals and swelled Eva's enmity. Ksana, whose frenzy on hearing of Stalin's death caused her such a crisis that she was in the infirmary for two days, was dismayed. "Why, none of us politicals will be free," she figured out. "No one has only five years."

Hostile and glowering, the politicals watched as a few civils and many thieves, prostitutes, swindlers, and others who had engaged in a variety of criminal activities triumphantly walked out of the zone as free people.

Within the next few months, as stories crept into the camp of the widespread increase of crime in Ural cities, the inmates gloated. The citizens of Solikamsk were demanding that these recently released lawbreakers be apprehended or sent to other cities. But the return to camp, within two months, of eight criminals freed by the amnesty did not dissipate the general gloom of the internees.

At the camp in Normirovchik, among the other changes was a softening in Koom's attitude toward the women. But at the same time, after five years of incarceration, Eva finally began unleashing her temper. In the past, she would have been thrown into the punishment cell for such behavior. This first happened after a disagreement over the amount of lumber Eva credited to one of the brigades. This dispute brought on an eruption of angry curses from some of the tougher civils. Out of character, tired and beside herself with rage, Eva spewed such a stream of vulgarities that she horrified even herself. The complainers, struck dumb, burst into laughter. "Why! Eva Moisseyevna! You're not a sissy after all," they exclaimed. "You can compete with the best of us. Just for that, you can put down even less than you allotted for today's fulfillment. Hearing you is worth a little less food."

By the time Eva got back to the zone, the story of her outburst

had already spread and been exaggerated. Koom, meeting her, asked, "What is this I hear? One of our most decent and modest zekas taking after the scum. Don't tell me they're influencing even you!"

Eva, angry and ashamed at having lost her temper, forgot her place and answered him. "Afraid your record will be spoiled by one or more intellectuals turning into scum? Nice way to speak of your charges." The words were out and fear took hold of her. But Koom only laughed.

Another incident happened on a cold autumn evening. After all the other workers had returned to the zone, Eva and three women were held up by a discrepancy in the accounts. The guard, as frantic to get back as the prisoners, was savage with resentment, swearing and rushing the women. At last, the books straightened out, they started off on the muddy road home. On reaching the first ice-covered puddle along the way, the guard shouted, "Halt!" and pointed his rifle at the four women. "Fall flat on your faces," he ordered. The frightened women obeyed. With each puddle, he gave the same order, always pointing his rifle at them. Dirty, wet, frozen, and venomous with defiance, Eva marched straight into Koom's office and demanded that disciplinary action be taken against the guard, even threatening, empty as she knew it to be, to let the gulag authorities in Moscow hear of it if Koom did nothing. She was supported by the other victims waiting outside who were shouting deprecations so loudly that a number of zekas left their barracks to inquire about the commotion. The next evening after work, Koom called a meeting. He gave a public apology, criticizing the behavior as dishonorable for a Soviet guard, although failing to mention the guard by name. The next day the guard was gone.

One morning in late winter, the prisoners were just starting their work in the forest when a messenger appeared and spoke to the head guard of Eva's brigade. The latter, blowing his whistle to get the attention of the women, announced, "Well, women! Pick up your tools and put them into the sleigh. No more lumberjacking for you. We're going back to the zone. Women are not to work on lumber anymore! Never!"

The women jumped with delight and moved from one to the other, hugging each other. "Citizen Guard," said one. "Please! Let us ride through this accursed forest to celebrate. We're not as heavy as the loads the horses drag, and it will be a fitting farewell for us. Please, Citizen

Guard!" they pleaded.

Permission granted, the women piled into the three sleighs and, riding up and down the paths, rejoicing, yelling, singing, tears streaming down their faces, they were driven to the zone gate. Emotions spent at last, they fell into formation and marched into the zone, their last time from the forest, to join the other brigades that had returned in the same jubilant spirit.

With lumbering banned for women — and, it was rumored, also peat digging — only farming was left. No official reason for these changes were ever given, but some of the women speculated that it was because the heavy work caused too many miscarriages.

Many of the politicals were now assigned so-called easy zone jobs. Some doctors and nurses among them were given work appropriate to their training in medical centers and infirmaries, assuring their patients that unbiased treatment would now be given.

Late in 1954, all but one of the Germans were returned to their own country. For the first time, officials told prisoners their general destination, but they did not specify whether they were going to another prison, another camp, or freedom. "Don't be upset," Inga told Eva on parting. "I'm sure we're not going to prison or other camps. We're going home to be freed. I know you will be free soon, too."

Gerta embraced Eva tightly and presented her with a little gift, a hand-embroidered change purse which she herself had made. "Dear Evachka," she said. "It's not much, but perhaps it will remind you of Gerta, your German friend. I am grateful to you. You never looked down on me as my countrywomen do because I am an uneducated, coarse maid. If not for you, I would have led a lonely life here."

Eva was happy for them but sorry to lose her friends. It amused her that she, a Jew, should value these Germans as friends. But they had been the only ones, with the exception of the Russians Lyena, Zina, and Mark — those whose encouragement and efforts on her behalf allowed her to survive the camps.

On the day they left Nagornaya, Ursula — the sole remaining German — was sent off in a one-woman transport to some special camp. Replacing Inga in the bunk was Anka, the bantiki and so-called political terrorist who had murdered a political prisoner in a show of disciplin-

ary defiance. She said to Eva as she threw her belongings on Inga's bunk, "I told Katya that I wanted this bunk or else! I knew that you and that German bitch were buddies, so I didn't bother while she was here. I warned everybody not to steal from either of you or to beat you or I would take care of them. They know I can do it, too! I like you. You are a real human being. You don't ape anyone, and you don't take any shit from no one neither. I heard all about your fight with the civils. I hear and know everything."

Anka would help herself to anything of Eva's that she found in their shared night table. Eva would come from work to Anka's greeting, "Welcome home, fascist. I smoked all your makhorka," or "I ate up the bread you left today. But don't worry. I'll get more." She got these by stealing from the other barracks; stealing in one's own barracks — even for a criminal — would be punishable by severe beatings and ostracism. In turn, she shared her own special resources — makhorka, newspapers to roll cigarettes, bread, a real knife, cosmetics — with Eva. She announced loudly for all to hear that only Eva, and no one else, might take anything from the nightstand. She was feared enough so that her warning was heeded. Knowing how her goods were obtained, Eva was reluctant to take advantage of Anka's generosity, but when Anka used all of her tobacco and she needed a smoke, she had no other choice. The two would discuss the morality of Anka's activities, but Anka could not appreciate Eva's philosophy. In spite of her rough kindness, she became an added burden to Eva.

Following the amnesty and the dispersal of most of the other prisoners, with only Eva's brigade left, Nagornaya became a ghost camp. At the beginning of spring, they, too, were moved. Some were packed off to an unknown destination while Eva, one Pole, and the six Western Ukrainians were taken by truck about 125 miles to another camp. The Polish girl, Yadviga, a good-looking twenty-one-year-old blonde, was serving a twenty-five year term for the most serious charge among the eight — terrorism. Her brother had been a partisan with the Poles who refused to submit to the Russian takeover. Yadviga had upheld and supported them, and had been caught red-handed taking ammunition and food to their hideout. The six Ukrainians were Auntie Anya; Ksana, who was to be Eva's cot neighbor; Nina, from a family who had been consid-

ered financially affluent; Shura, a White Russian whose family had found refuge in western Ukraine when the Revolution disrupted their way of life; Pasha, an unpleasant, whining girl; and nondescript Ksenia.

Eva's group arrived late at night; the light from the sky was blocked out by low clouds and no lights were discernible from the camp. Lined up, holding their bundles, the women were led to a pontoon bridge, which, in the darkness seemed to have no end. The bridge sank into the water with their weight so that the crossing was trying and precarious. Unaware of the width of the river, the nervous women moved along at a snail's pace, testing each step before advancing, fearful of plunging into the water. They finally reached the other end, their feet soaking wet, and followed the guard into a tiny, brightly lit entryway of a typical Russian village cabin. Dropping their bundles and removing their footwear as directed, they moved into a room furnished with eight neatly made-up cots forming an L around a rectangular table with eight stools. A night stand adjoined every bed. The women, wide-eyed and open-mouthed, crowded the entrance and gazed incredulously at their guide, a short, stocky man dressed in ordinary civilian garb. "Are we going to live here — in a house — and sleep on real beds, not bunks?" they wanted to know. He introduced himself as Franz Hantsovich, and informed them that he was in charge of the camp. Without hesitation, he said, "I am a recently released prisoner so you can be fully assured that I am not a member of the security police. I would be deeply offended if I were suspected of being one. You're on the island in Kotomish," he continued. "You are probably more worn out from crossing that bridge than from your long trip. Go to bed now. Tomorrow I'll tell you anything you wish to know." At the door, he turned to them, smiled, and added, "You may turn off the lights if you wish." For the first time since their arrests, they slept in a darkened room.

In the morning, awakening without the usual blare of the loud speaker, they stepped out of the doorway to look for the mess hall when Franz Hantsovich appeared from one of the three small buildings. "Vanya's wife will bring you your breakfast right away," he told them. "Vanya is your guard. He is the only one in the village." The surprised expression on their faces and their murmurs barely gone, he said, "They told you at Nagornaya that you're now propooksnitsi, didn't they?" They

stared at him, then shouted with joy, "Propooosknitsi! Politicals propooosknitsi?"

Franz Hantsovich's face grew white with anger. "They will never give an ounce of pleasure, will they?" he hissed. "Well, I'm telling you. You cross the bridge and work without a guard. You can visit with the people on the other side and can trade at the general store as well as in that one there," he said, as he pointed to a building set on wooden posts. Motioning to another building, he added, "That is the medical center. Akim Feodorovich, the feldsher, lives there. You can go to him whenever you need him, any time, day or night.

"You will be doing agricultural work here. I, myself, am an agronomist and will assign you your tasks. I am going to try to make your stay here as pleasant as I can.

"Akim was a Vlassovits [a follower of Andrei Andreyevich Vlassov, a Soviet general during World War II who defected to the German side and organized an army of Russians; thousands of his soldiers were later sent to camps]. I am a Volga German. Neither of us can ever return to our homes. We chose this work to try to make it easier on politicals. All I ask is that you don't betray our trust in you. Maybe if things work out here others will get the same chance. You, Akim and I, with Vanya and his wife are the only ones who live here on the island."

Medical examinations took up the first day. As Franz Hantsovich wanted to reclassify the health status of his workers, he and Akim Feodorovich had decided that the women were to have the kind of checkup that would reflect each prisoner's genuine state of health. "To hell with their fake medical findings," they said quite openly.

Eva, the first to be examined, was pleasantly surprised to find that she was to be examined without the presence of a guard — male or female. "I'm a one-man commission," Akim announced. "Neither Franz nor Vanya are medics and I will have no lay men around as witness while I work." When he finished examining Eva, he called Franz from the next room. "Under no circumstances is Eva Moisseyevna to do any strenuous work," he reported. "She is very weak and has heart trouble. She should get invalid status, but with so few to work here, I'll put her down as second category. But remember, Franz, if I find her at hard work, I'll transfer her to invalid at once, and she won't work at all."

"Okay! Okay! Don't get into a sweat. I hear you. I'll put her in the greenhouse or at sorting. Can she do that?"

"Yes. That will be all right. But not too many hours in the hothouse, do you hear?"

Eva became supervisor of the hothouse where tomatoes, cucumbers, lettuce, and onions were the chief crops. She quickly learned when and which vegetables were to ripen inside, when they were ready to be transplanted into the open fields, and how to pack the tender vegetables without bruising them. She became quite an expert at determining the exact time during the day and in the evening to remove and replace the glass frames in order to maintain the desired temperature and humidity. The work was not arduous and she enjoyed it.

Whoever worked in the hothouse was given free access to the vegetables grown there, but they could not take any out of the building. "The watchdogs have calculated exactly how much of a crop we'll gather and may some day make an unexpected inspection. Former prisoners are not to be trusted, you know," Franz told her. To give the other women the opportunity to enjoy the advantage of additional food, Eva pretended to need the help of one or the other almost daily when the vegetables were ripe. Although Franz knew what she was up to, he went along with her game.

The eight women lived as a family and, for the most part, in harmony. They usually spent their evenings reminiscing of happier times and singing Ukrainian folk songs, among the most beautiful in the world, Eva thought. Sometimes they would sing comic songs, and sometimes the beautiful, heartrending ballads, so well known and popular throughout the Soviet Union, which usually made them weep. Once, Franz Hantsovich came in at such a moment. "Girls," he said, "you think you'll never have a happy moment or laugh again. That's not true. There will come a time when you'll be happy and enjoy life again. Believe me, I know. Look at me. I spent ten years in the camps. Akim and I also once thought our laughing days were over. Now we are both exiled, I, from my native home on the Volga, and he from his Don. And yet we find lots of funny little things that happened in camp to remember and laugh about. I know you don't believe me. But the days will come when you, too, will recall some pleasantry in your camp life. Of course, we don't

burn with nostalgia for camp and neither will you, but you will find some pleasant moments to remember."

Asserting herself, Eva answered angrily, "Franz Hantsovich, how will we ever enjoy life or laugh with real appreciation after what we went through and maybe will go through again? You're no representative camp boss. Who knows who and what kind our next bosses will be? Sure, you had a hard time. Who denies it? But you had it easier than we did any way you look at it. Did anybody ever take advantage of you because of your sex? Did women hand you paper for the toilet and watch you squat over a hole to do your stinking business? Did women guards stare at your nakedness as you tried to wash the filth off of your body? Your guards, did they ever proposition you, call you a whore, strip you and then rape you? For years, we have endured all of this and more. We have borne the double burden of being both women and prisoners. We have been degraded, terrorized, humiliated, as you, a man, could never have been."

And no one said a word. Only Yadviga's head bobbed up and down vigorously in approval.

In winter, when the greenhouse did not require enough work to keep a staff, Eva worked on the mainland sorting the hardier vegetables with the villagers, all of whom were exiles or descendants of exiles from a single village. Working side by side with them, the free people became more and more friendly to her and she became familiar with their history. They had been "rich kulaks" who, in 1939, had refused to join the kolkhozes. In truth, most had been poor peasants; by the standards of the time, only one man among them might have been labeled affluent. He had owned a horse, two cows, several pigs, and farmyard fowl. In contrast to the other peasants whose animals, if they had any, lived with them in their huts, this one man had had a barn for his animals and kept them out of his clean, well-ordered house. As a group, the Russians had given them twelve hours to pack and leave their homes, and they were dumped here in the middle of the forest to manage as best they could. Before the tents could be set up, most of the very old and very young had died of exposure and hunger. The survivors had built the hamlet where they now lived.

A strong friendship grew between Eva and one villager, Frossya, who was thirty-eight years of age and a war widow. Eva and Frossya became acquainted when Eva rather regularly purchased from Frossya baked milk, a novelty food that Eva enjoyed, and occasionally fresh meat. Frossya had been fifteen years old when her family — her parents, a grandmother, and two younger siblings — was exiled. The latter three had succumbed to the elements.

Eva's heart ached for this woman who lamented that life held no future for her child, a fifteen-year-old, for whom she had fantasies of a good education and a professional career. "What chance has a child of a kulak?" she would cry. Just commiserating together was sufficient to cement a bond between them.

For Eva it was more. It was an opportunity to expiate the guilt she felt about her early hostility toward these people. She recalled Max's description, after his return from his first vacation, of the beggars at the railroad station — whimpering children, bellies distended from malnutrition, clinging to their mothers. Morris, she remembered, had piously quoted the proverb, "When you chop trees, the chips fly," and explained with certainty in his voice, "The kulaks still have their hold on these peasants who refuse to accept collectivization for fear of reprisals." Eva would dream that she and her father were together in this kulak hamlet, experiencing what she was now discovering first-hand — the government agents had confiscated grain and seeds, leaving little for the peasants and perpetuating the poverty. Seeing, and sharing the conditions of these people's lives, and realizing the circumstances into which they were locked, made Eva sensitive to their plight and ever more aware of the failure of the Soviet system to achieve its purported social and economic goals.

Towards the end of 1955, the eight prisoners were moved once again. Eva went to Peshkova, a camp farther north. Her seven companions, she later learned, were returned to Women's Central. The camp at Peshkova was small. Although it was not enclosed by a fence and had no watchtowers, just the sight of the one dormitory with the bunks and the mess hall dampened Eva's spirits.

Several huts near the barracks served as homes for Kommandant

Konstantine Mitrofanovich, who also functioned as Koom; one guard who did both day and night duty; and many free, childless families. Eva joined the brigade of twenty-five women who had already been there for several months. Except for one political prisoner, the inmates were civils and petty criminals. Every prisoner in the camp was propoosknitsi. The political, Frieda, a Latvian, delighted to have another fifty-eight tenner in the brigade, immediately took Eva into her clique that included Sophya, a former food store manager. Both Frieda and Sophya were in their early forties. Eva's work here was not strenuous; she was the only woman with second classification, so she was given the odd jobs of sorting vegetables, helping the cook, preparing wood, or running errands for Konstantine.

About four miles from Peshkova was a men's camp, and some men and women exchanged visits. Where there were monogamous relationships, the women called their lovers "husbands." When the men slept in the women's barracks, a cloth was hung between bunks to provide privacy. Each morning, these men left in time to get to work. No amount of harassment by the camp authorities could stop the practice.

Frieda and Sophya had camp husbands, both politicals. Sophya, whose bunk was attached to Eva's, had a separate space next to the wall which she enclosed with a fabric panel for herself and her husband Borya. With a night table between their beds, Eva and Frieda shared a "room," a cloth separating them so that Frieda and Genya might make love in privacy. Eva was often awakened by the shaking of her bunk. As embarrassed as she was by the noise on both sides of her, nevertheless she did not condemn this public behavior. "Where else can they go? They're young and want to live," she thought. "Why shouldn't they?"

Borya, whose wife back home had denounced and divorced him, planned to marry Sophya some day and hoped his son was not so alienated from him that he would not want to share in this new marriage which did, in fact, come to be. Sophya, whose husband had also divorced her when she was arrested, had no children. Frieda and Genya, on the other hand, knew theirs was a temporary affair. "I'm going home if I ever get out of here," she said. "Can you imagine how my family will feel if I bring along a Russian? Besides, his wife is waiting for him. He's crazy about her and certainly won't divorce her for me. We're both sat-

isfied with things as they are. It is convenient for both of us."

The two couples included Eva in their leisure activities and she spent many pleasant evenings with them. The men told her that the other politicals in the men's camp preferred celibacy to the "sluts." "They've heard of you, Evachka," Genya once said. "We have an offer for you from a young naval officer, but he's not a political. He's thirty-two years old and wants a clean, healthy camp wife who doesn't play around. You fill the bill."

They would joke and laugh about Eva's suitor, thirteen years her junior. "Tell him I am flattered that a handsome young officer finds me suitable. Also tell him he doesn't fill *my* bill," she joked back.

One dark, moonless night, Eva was grateful for Genya's and Borya's presence. The barracks was already enveloped in silence, which was suddenly broken by a group of about fifteen men who rushed in shouting. "Up whores! You're ours tonight." For the first time in her life, Eva understood the meaning of cold-sweat fear. She had never before felt such panic as she did upon hearing the screams of the women, the cursing and grunting of the men, the sounds of curtains being ripped off, and furniture being overturned. Lilya, one of the leaders of the criminals, was screaming in an inhuman voice which changed to groans. Whenever one of the brutes tried to claim the bunks of Sophya, Frieda, or Eva, Genya threatened, "Out! Get your ass away from here. These are *my* women," and Borya shouted, "You touch my women and I'll kill you." The rapists backed off.

Despite the chaos, Koom and the guard did not appear until it was too late; besides, neither could have prevented the carnage and both might have been murdered. The barracks was in a shambles. Lilya, who had refused to submit, lay on the floor unconscious, blood seeping from her wounds. Several of the free people, roused by the noise, arrived to help the terrified, beaten and bleeding women. The boss sent someone to phone for an ambulance to take Lilya away. No one heard of her again; no one who might have known would say if she survived.

Konstantine Mitrofanovich was obviously upset by the assault which had caught him so unprepared. He had proved to be inept at defending his camp, State property, and his prisoners, many of whom were now temporarily unfit for work. The lack of fences or watchtowers, and

the inability of two unarmed men to cope with a determined, knife-bearing mob, would not excuse him in the eyes of his superiors. On Eva's shocked protest, he said, "You needn't worry. It won't happen again. I notified Koom at the men's camp, and every man who participated in this is having his propooski revoked." A month later, the camp was closed and the civils and politicals were moved back to Women's Central.

It was now the early spring of 1956. Eva was returning to Women's Central after more than one and one-half years in the outlying camps. The transport stopped just outside the gate, dropped the women off, and left. They huddled together a few moments, waiting for a guard to meet them. When no one appeared, they walked into the zone. Scrutinizing a meager number of prisoners greeting them, Eva picked out her six companions from Kotomish but no other familiar faces — no Lyena, no Zina. Not even a sign of a nun among them. Most amazing of all, not a bantiki in sight, no watchful eyes looking for what might be worth stealing from her.

Assigned to a barracks, Eva once more found herself with Yadviga and the Ukrainians. Only eighteen politicals, including Eva and Frieda, now lived in the huge space meant to hold one hundred prisoners. A few civils occupied a second barracks. All the other barracks in the zone were vacant. The watchtowers were empty of guards and there were no signs of them in the once crowded bustling camp. Rumor had it that they had accompanied the criminals to special camps in Siberia.

"Where is Lyena Kuprianova?" was Eva's first question. "And Zina?"

"Lyena? She's free. Went home last November. So did Zina and most of the others," Yadviga told her. "Mark, too, is free. He married someone he met at Nagornaya and they left together."

"Free? Went home? Are you crazy? Whole-spoolers released when they didn't even sit out half their terms?"

"They sent appeals and their cases were reviewed."

"Appeals? Appeals accepted from politicals?" Eva heard Yadviga's replies to her questions but remained incredulous. In her first year at Women's Central, she had been told that it was useless to send an appeal, that Koom would only throw it into the wastebasket. Several of the civils who did work cleaning offices had seen them lying there. "En-

emies have no right to appeal," he would say, in spite of such a right being legal.

"Where have you been?" Yadviga asked Eva. "Weren't you told everyone can send appeals these days, even politicals? Didn't you hear of Kruschev's speech? He made a speech at the last Party Congress in which he disclosed the unlawful acts of the great father who, it seems, is no longer great and no longer THE father. Now there are thousands of requests from the so-called enemies of the people for reconsideration of their cases." Eva and Frieda were vehement in their indignation that for one and one-half years they had been kept uninformed of these developments. They immediately composed an appeal and addressed it to the Supreme Soviet, the legislature of the Soviet Union.

A few days after their return to Women's Central, the kommandant called a meeting. He stepped onto the platform in the mess hall, without the supporting figure of Koom, and faced the small group of women. In a complete turnabout from his former attitude, he began his speech with a statement about Stalin's "misdeeds," as he called them. "None of us knew that so many innocent people were being persecuted and sent here to us. I imagine you now all know of the existence of the commission. It should soon arrive here to review your appeals. Many of you will surely be freed. But think. What awaits you back in your homes? With reputations as former prisoners your future is uncertain. Here we always need people. As free workers, you will have very good pay and good living conditions. You will also get big bonuses. I assure you, life as free people here is not at all like the life you had as prisoners. I urge you to show our Party and government how grateful you are for being pardoned by settling here. If all of you go home, we will not have enough people to fulfill the plan on lumber and agriculture in the Urals."

His voice was drowned out by catcalls, whistling, shouting, and crude obscenities. The formerly silent and obedient "fascists," voicing their fury, left the hall without his permission before he finished his plea. "The sanctimonious SOB," they muttered. "What nerve! How dare he! After the years of mistreatment and harassment and prejudice. After nothing but curses and contempt! *We* should help *him?* The government is pardoning us for having done nothing to deserve the living death we were forced to endure! Maybe we should thank him for our freedom. He

sure would let us go if it depended upon him, wouldn't he? Like hell! The devil with him and his plans! Let his beloved bantiki and zakonnika fulfill his quotas."

The next day, the women were transferred to two large cabins that had been converted into small, cozy barracks, one for politicals and one for civils. For the first time in Eva's camp years, the civils and politicals worked amicably together, with no more quarreling and no more name-calling of "lousy fascists" or "government thieves." One of the civils, previously a most vocal enemy of the politicals, said to her, "You know, Eva Moisseyevna, I can't help but respect you fascists. What are we civils? Neither fish nor fowl. Petty thieves, stealing a few potatoes or falsifying accounts. I was the manager of a distribution center and took three pelts home. A thief — nothing more. But you! I have to respect all you fascists," she repeated. "You're idealists. You were opposed to Stalin's crimes."

Eva thought, "There is the Soviet mentality for you. The people have been conditioned to sail whichever way the wind blows. Let her make us idealists and martyrs if she wants to. It's the new style. She doesn't realize it's not only politicals who are victimized; what an excess it is to give her fifteen years in such camps as this for three pelts. We're being released, but those poor devils have to stay."

Rumors were spreading that a special commission with the authority to free prisoners on site was traveling throughout Siberia and would soon be in the Urals to review the cases of the politicals. Soon, a letter from Valeria arrived that confirmed this. It also said that, almost a year earlier, she had been released from camp because of her invalid status. Now, Eva worried about her, conjecturing that she must have been close to death to have been released for health reasons. In another letter, Valeria wrote that she was running from one KGB (formerly MGB) office to another applying for exoneration for herself and for Eva. "We'll see who gets you out sooner — the commission or me. Eva, did you ever dream it would come to pass — that they would exonerate us and let us come home? We'll all soon be together again. Times have changed." She continued, "Tamara has grown into a beautiful young lady. You don't need to worry about her. When you get home, you will see that she has a good head on her shoulders."

In April of 1956, letters from Tommy and Valeria announced that Abie had married again. Eva groaned, "Oh, no, not again. A third time?" On reading further, they assured her that "Abie's wife is a very pleasant, sensible woman and I think this time he's lucky. She's no Natasha or Sonya." Valeria added, "You know how I behave to people I don't like, and it will tell you a lot that I respect her very highly and am very friendly with her. You will be, too." Tommy added, "I think Abie will again become my wonderful uncle with such a wife as Gita. She has no ulterior motives in marrying him. She's marvelous."

In a separate note, Tommy wrote, "Valya looks like a very, very, old, sick woman, but Babushka and I will soon have her on her feet again. She'll be in shape when you come home and we'll all get cock-eyed drunk to celebrate. What's left of us will all be together again. It once seemed such a hopeless dream, but now it's a reality and I'm not afraid to hope any more. How I wish Daddy and Babushka Esther and both dedyushkas were alive to share our joy."

When time passed with no word of the arrival of the commission, the politicals became more and more impatient. Someone started the rumor that the kommandant had asked for a delay until the harvest season was over. "Surely such a judicial body would not take orders from a mere camp boss," Eva argued, but she began to think it possible when news leaked out that all cases in the Siberian camps had been completed and that at that moment the Solikamsk men were being interrogated and freed. With only eighteen appeals from the women, it would have seemed to make more sense to review their cases first and let them go.

At long last, in the middle of August, 1956, Koom came to the barracks to announce that the commission was ready for them. He read the names of those who were to go to Solikamsk the next morning. Seventeen were called. Eva's name was the only one missing. "You left mine out by mistake, didn't you?" she protested. "I'm to go too, aren't I?"

He asked her to report to his office in half an hour. There he casually informed her that as a foreigner she was not on the list. Moscow had not sent instructions about foreigners. Eva's temper flared. "A foreigner? Now I'm a foreigner! I wasn't a foreigner when I was arrested. I wasn't a foreigner when I needed an interpreter. Why have I been a Russian until now? When it comes to freedom, I'm not a Russian anymore?" she

shouted. Rapidly losing control of herself, she attacked Koom with a barrage of accusations. The once quiet, respectable Eva, turned into a tempest; shocked, he promised to call Moscow about her case the first thing in the morning, and he personally escorted the weeping woman back to her barracks.

In the morning the elated prisoners waited for the truck to take them to Solikamsk and freedom. Eva ran to Koom's office. He was not there. Raging, she stood aside from the lucky ones, looking on miserably, when the truck rolled up. When Koom followed with the paper listing the names in his hand, she assailed him. "Did you call Moscow? What did they say? I'm getting on that truck with or without permission and I will raise hell in Solikamsk. I'm never going to work here again."

"Shut up," he shouted angrily. "You're going, too. Moscow said your case is to be reviewed with the rest."

As the truck began to move, in an entirely unexpected demonstration of good will, the civils — who had refused to go to work until after the truck left — shouted, "Good luck!"

The truck stopped in front of a plain, one-story brick building. A sentry conducted the women into a large waiting room from which each prisoner was called into a temporary courtroom, one by one. The first few returned to the waiting room in a daze. Although they were expecting a positive response to their appeals, they repeated over and over to those who sat silently awaiting their turn, "I'm free! I'm going home!" Toward evening only three women were left, and Eva was beginning to suspect that Koom had let her go along with the others just to quiet her. Then her name was called.

Inside a large room, a group of men were seated at a green, woolen-covered rectangular table. Tense and agitated, Eva couldn't discern their number clearly; perhaps there were five. They asked her to sit on a chair slightly removed from the table. She was shaken by their courteous reception, so different from the interrogators at her arrest. "Don't be nervous," they reassured her kindly. "We're not here to railroad you. We just want to get at the facts. Take your time. Think your answers over carefully." Each member asked questions separately. After some answers, they whispered among themselves; after others, they asked for an elaboration.

"Are you anti-Soviet?" they asked.

Eva answered, "No. I'm against those who are betraying and distorting the meaning of 'Soviet.'" One asked if she had repented. "I don't know what you mean by repent. I cannot deny that I still insist that my husband and my father were innocent. I don't believe that it was a crime for me to think and say so. As to agitation — what is agitation? I understand it to mean trying to make people dissatisfied with the status quo, to convince them to take action against it. I cannot consider discussing the guilt or innocence of our men with the mother and sister of my husband as agitation. I never raised this question with any other than my family. Even my investigator had to admit that. I cannot consider myself an anti-Soviet agitator."

When the questioning was finished, she was asked to move her chair to another part of the room while they conferred. In a short time, the leader of the group delivered a lecture on the duties of a good Soviet citizen and informed her that the commission had decided to forgive her, that she was now free. As a pardoned prisoner, she could be registered to live in Moscow. Ignoring the "pardoned," Eva fixed on the important word, "free," and she, too, left the room in a daze.

Yadviga, the last to be called, was questioned longer than the others. She came out pale and disturbed. "I'm not free. I have to sit out my twenty-five years." They had asked if she still believed that she was correct in fighting against the Soviets. "What would you do now?" Her answer had sealed her fate. "I think I was right then," she told them. "My people wanted independence. We didn't want to be ruled by the Russians again. Can only the Soviets love their country? I was arrested before I could know what Soviet rule would mean for us. I would have to see how they live now and if they're happy before I can answer what I would do now."

The decision dampened the rejoicing of the others. Yet, back in camp, their commiseration with Yadviga did not prevent them from unrestrained jubilation and their anticipation of the very near future. The years of humiliation, contempt, and involuntary back-breaking toil were behind them.

The women spent the next days sewing, primping, and talking of their plans. Nina would be marrying Petya, the propooknitsi from the

men's camp. He had been taken from the adjoining village during the raids on the Western Ukrainians by Russians looking for Benderovitse — followers of Stepan Bendera, the anti-Soviet Ukrainian nationalist leader. Nina added that Petya was deeply repentant about not having been able to control his sexual impulses until after they were married. Her concern was about what she would wear at the wedding. If she wore white, the symbol of the virgin bride, God would know she was lying. If she didn't, everyone, most importantly her mother and grandmother, would know that she was a sinner.

Nina's problem reminded someone of Maryusia. At the mention of her name, Auntie Anya spat in disgust and the others looked shamefaced. "She's a sinner. God will punish her."

Eva felt compelled to respond. "You were glad when I told Franz Hantsovitz about the treatment the women politicals got from the guards — that many were raped. Maryusia was one of them. Now you call HER the sinner. Why don't you call the guard a sinner?"

At this, Yadviga, who could only sit silently by, mournful that she was not being released, shouted at them. "When the guards waited for the chance to pass a hand over your naked bottom while you pulled down your pants at the side of the walkway to relieve yourselves of the water just about to burst your insides, did you sin?"

Miffed, Nina said, "Maryusia is a whore! She sleeps around. The guards give her jobs in the zone to keep her among them. When one is finished with her, he passes her on to another. She has shamed us all. Petya and I love each other. God knows that and will forgive us." She finished with, "God should not have made her so beautiful."

Auntie Anya made the final pronouncement. "Maryusia is a sinner." Her fate was sealed. Whenever she was to get her freedom, she could never go home again.

This talk deepened Eva's disillusionment in the Soviet experiment that she had hoped would become the shining example for all mankind. The system never had looked for a substitute to take into account the spiritual needs of its people except by trying to wipe out their faith by coercion and bestiality.

On the third day after receiving the news of their imminent freedom, the women were taken to Solikamsk to get their passport photo-

graphs. When her picture was handed to her, Eva was horrified by the image of a gray-haired, gaunt, and emaciated old woman staring back at her. She shuddered.

Before they left camp for the last time, they were issued first term clothing. On receiving snow-white, heavy winter footcloths, Eva thought, "If only I had had such a pair at least once when I needed it." Ksenia saw Eva packing away her aluminum spoon. Her agitated exclamation brought the other women to Eva's side. "Are you crazy?" Ksenia shouted. "Spit on that spoon and toss it over your left shoulder! Throw it away or it will bring you back to camp." The civils, too, on hearing of Eva's folly, tried to convince her to discard it. But Eva was determined to keep the celebrated spoon as a memento.

At Solikamsk, for the first time in almost six years, Eva saw militiamen in regular civil police uniforms instead of the despised dress of the secret police. Koom handled all the details of collecting the photos, distributing the applications for the internal passports, commanding each to place her signature as designated, laboriously filling in all the personal data required without consulting them, and turning them in to the militia for processing. The women, in their elation, submitted and asked no questions. From the militia station, they were escorted to the head office of the KGB where Eva was handed — of all things — her war medal and her bankbook which Vovochka had never sent to Tommy. Other items confiscated on her arrest, and used as evidence during the interrogation — family and personal photographs and her diplomas — were never returned.

As the women boarded the carriage, Koom handed each one her railroad ticket and wished her well, to which not one responded. They settled in with their bundles and paper bags of food rations. Auntie Anya, relaxing in an uncrowded compartment, commented that now she could well believe Eva's fairy tale of seats which turned into beds.

At the stop in Molotov to change trains, they hurried to the refreshment stand where they gaped at the abundance of delicacies — a slice of cake, a sweet roll, a sandwich flavored with mustard — they had not seen in years. Only the fear that the train would leave without them forced them to decide among so many choices.

Their uniform clothing, different from the other passengers,

brought stares. Before long, whispers ran through the carriage, "Stalin victims." Soon they were receiving offerings. "Have a chicken leg. We owe you a lot for all you have suffered."

The train seemed to take forever to get to Moscow. The interminable journey of the last few hours seemed longer and harder to bear than the last six years. Finally, four hours later, it slowly chugged into the station. The excited women made room for Eva at the window to scan the platform for her waiting relatives.

Part Six
Freedom

Chapter 22

Eva felt a rush of love when she sighted her family at the train station that day in 1956. Her first words to her daughter, "You cut off your braids! You are grown up!" came out in English — a language which she had neither heard nor spoken, for all practical purposes, in more than five years. English! Oh yes — now she would practice thinking aloud in English, fearful that she might have lost it completely. However, when she met Gita, who had taken the day off from work to meet her, she reverted to Russian which, after the years in camp, she now spoke with ease.

The sight of Valeria sent a shock wave through Eva. What hell had she gone through? She was an old woman with weariness and pain written on her face that even her eyes, shining brightly on this happy occasion, could not conceal. Eva, however, had failed to notice that her own appearance had brought a shudder among family and acquaintances when they saw her. Her awareness of the changes she had undergone was slight. During the five and one-half years she had lived in prison and the camps, she saw herself only rarely — once in a passport photo taken in Solikamsk and twice in photos taken in 1955 on days when the camp administration looked the other way when village photographers came into camp hoping to earn some extra money. For one of these photographs, Eva had posed in new clothes that Tommy had sent.

Later, when she had time to ruminate, Eva considered herself more fortunate than Valeria, who for the first two years had been in the Irkutsk area of Soviet Asia near Lake Baikal, well-known for its intensely cold

climate. She had worked out of the large camp of Taishet around Bratsk, within the forest flippantly referred to as "the Russian jungle." The government was building a tremendous power station there, and politicals had been sent to prepare the foundation. Throughout her imprisonment in the camps, Valeria had been moved several times, from Irkutsk to Astrakhan, on the Volga River where it joins the Caspian Sea, a place notorious for its extreme heat. "Once," Tommy told Eva, "when she was being shipped to the opposite corner of the country, she was even in Moscow. We received a postcard from her telling us that she was in some transit prison — I don't remember which one — and that we would be able to visit her and bring her food. Babushka and I ran like crazy people to this prison only to be told that she had left — that she was not there any longer. Later on, from her letters, we calculated that the prison authorities had sent out the card after she had left!"

Eva's initial excitement about her return to Moscow diminished gradually. She now had a room of her own, the five square meters which were officially registered with the House Registration Office to Abie until he and Gita could move to a permanent flat. Life was now easier for Abie. He had obtained work as a translator, and the wages were above average. Gita, a university educated professional, was also earning a substantial salary, and between them they could afford more comfortable living quarters. In fact, Abie said, he could now repay Eva for the help she had given him in the past — first when he was in art school and she had supplemented the small allowance paid him by the government; then supporting him not only after the first arrests when he had been thrown out of a job, but also after his demobilization until he was back at work. He insisted that Eva was not to worry about finding work for at least a year, that she was to rest, relax, regain her health and begin to look like herself again. He was giving her an allowance of forty rubles a month. Eva objected, but Gita would not listen to her protests, assuring her that she and Abie had agreed on this action.

Eva's readjustment to city life was unpredicted. She, who had lived all of her life in the large, urban, bustling, noisy cities of Chicago and Moscow, found herself, upon returning from camp, terrified by the traffic and the turmoil. For several weeks she needed to have Tommy accompany her until she had the courage to venture out into the streets

alone. Sleep would not come until almost daybreak, and when she would finally doze off, she would be plagued by nightmares. In one of them, she would be crawling on her hands and knees to the peat bogs on an icy, weak, rotting board bridge over a deep ravine. She was calling for her partner, who was already safely on the other side, to hold out to her a log that she might use as a handle for her to reach solid ground, a method which she had actually experienced often in the camps. In another, while tramping with her brigade on this same bridge, falling behind the others while she tried to tie the flapping sole of her two-sizes too-large footcloth with a torn stocking or string which refused to hold its knot, she would find herself alone and lost.

Other dreams, however, were more pleasant. Sometimes she would be walking at dawn, her work partner at her side, toward a vast, hoarfrosted circle formed by the branches of motionless trees. In the distance would be a clearing in the forest. Together, they would slow down to take in the sight of the rising sun, slowly inching into the ring, and Eva would feel joy and embrace her partner. The next morning after such a dream she would remark to Tommy, "Only this dream proves that Franz Hantsovich was right — that a time would come after our freedom when we would recall some pleasantry about camp life."

Eva was uneasy when she was alone in her room. She was uncomfortably conscious of Sonya's close proximity in the room to her left, and at the same time she was contented knowing that Tommy slept in the room to her right. She felt immensely fortunate that, as horrendous as had been the past six years, during the period when Max and Morris and Al and Bob had been taken, she had been spared. Had she been taken then, in all probability all the adults in the family — Esther and Abie and Valeria and even Alexandra and Gustav — would also have disappeared. Assuming she would have survived the ordeal, what might the future have held for her? Tommy would have been lost to her, probably raised as an orphan in an institution, her true identity unknown even to the child. Little Maxie might have lived but on the decision of an official that the infant had had enough of her mother's milk, she would have been taken from Eva and also institutionalized. Stalin's timing left her at least one child. Her heart reached out for Efim and Musya Stepanov, both close friends of Valeria and Bob's. They had been arrested and

their children taken to orphanages — a boy of three and the other an infant not yet twelve months old. Since their release from camp, two years earlier, they had not yet located the children — and never would. There flashed before Eva that monstrous poster that had been displayed on a rooftop at the beginning of the era of the personality cult — the beginning of the terror — of a smiling Stalin holding a little girl in his arms as she presented him with a bouquet of flowers. Hatred swelled up in her for a people who could submit, without protest, to leaders capable of perpetrating such acts upon their people.

Eva did manage to keep Sonya's harassment somewhat in check. There was no stopping this woman from turning up both her television set and radio at the same time at the loudest volume, but when she took to reviling Eva, jeering at her, "You are nothing but a jailbird," the lessons Eva had learned from the camp bullies sent her into action. "I learned to deal with people who annoyed me," she said, fixing a gaze that caused Sonya to freeze. "I have nothing more to lose and getting rid of you will be worth another stint in camp," she threatened. The bluff worked. Sonya, who construed prison only in terms of violent inmates in spite of her knowing Eva, retreated. However, soured that the courts had ruled against her during the dispute over the larger room, she would often spew her venom on Tommy. It took another threat from Eva — this time to report her to the police for baiting and name calling — to stop her.

Eva was anxious to be financially independent and could not be persuaded to give herself time "to rest and relax and begin to look like yourself." She was appalled at the impoverished condition in which she had found Tommy, who because of lay-offs had been without work for a month when Eva returned. The girl did not even have a change of clothing; each night she needed to launder her one dress and one piece of underwear. Throughout the years, most of her wages and extra income from her rented room had gone to pay for parcels for Eva and Valeria, and she had kept just enough to meet her and Alexandra's subsistence needs. Aunt Rose had sent unexpected supplements to them from time to time — for which they had been very grateful. When Tommy told of the back door visits of Rose's emissary, the same Olya who had slipped money to Esther after Morris's arrest, Eva, in her letters to her relatives

in Odessa, could find no adequate words to express her own appreciation. Abie also told of Rose's insistence on sending him money that helped to pay for the parcels and added to what he had been sending surreptitiously to avoid arguments with Sonya.

Eva also wanted Tommy to prepare herself for a higher education as soon as possible and had no intention to permit this dream, equally shared by Tommy, to go unfulfilled. Too many years had been taken from them; too many years had gone to waste. Tommy, however, wanted to work somewhere for another year before going back to school.

Valeria soon informed Eva that exonerated political prisoners were receiving two month's pay to compensate for their years in the prisons and camps, so Eva immediately phoned the institute to inquire about procedures. Yelena Ivanovna sounded delighted to hear from Eva when she identified herself, and without hesitation asked if she would be willing to take on some work as soon as possible. "Although the assignment of permanent staff for the fall has been finished and there is no full-time opening for next year, I can find at least one group for you, and next year I shall recommend that you be placed on the permanent staff. Will you agree to such an arrangement?" Eva was overjoyed. She had been dreading having to hunt for work, having no idea where she might begin. This part-time plan would not include vacation or sick leave, but "at least I shall have a foot into the institute," she said to Tommy.

The next afternoon, not only Yelena Ivanovna greeted her, but so did all the teachers of the Foreign Language Department. It was difficult for Eva to repress the well of emotion that sprang within her at the warm welcome. Yelena Ivanovna took her aside at an appropriate moment and wanted to know, "Is one of our teachers responsible for your arrest?" Dollie Felixovna asked the same question. Both seemed relieved when she answered that no one at the institute had been involved, and when Dollie said that suspicion had been cast on one person, Eva did not care enough to ask the name.

Dollie also mentioned a book Eva had loaned her before Eva's sudden disappearance — that she had failed to return it — and she apologized for its loss. Her husband, fearful that it might be incriminating should the MGB have invaded their flat, had burned it along with all their foreign language books and novels by all authors who had fallen

into disrepute under the Stalin regime. "We have left only dictionaries, and a few books on teaching methods and phonetics and grammar that I need for my work," she added. Her frankness pleased Eva. Perhaps the era of the last twenty years had truly passed. Yet, leashed by suspicion, she was restrained in commenting. Caution was now very much a habit.

By the beginning of October, Eva had her foot back in the door at the institute, and when the 1957-1958 school year started she was again a full time staff member. In the meantime, she earned additional money through occasional work as a proofreader on an on-call basis for the English edition of *Sovietskaya Literatura*. So Tommy and she managed.

The horrors of the prisons and the camps, however, were not quickly pushed into the past.

In order to make herself eligible for work again, it had been necessary for Eva to report to the security police office at the Lubyanka Prison to obtain the papers giving the exact dates of her arrest and release and to secure a written statement, referred to as a "characteristic," drawn up by the camp officials detailing her behavior. Standing among a crowd of men and women making an appearance for the same purpose, she made an ironic comment loud enough to be heard by a man next to her. "Well! I was a good girl in camp," she said, "That is the best recommendation that they could find in their hearts to give me. It would be too much for them to write that I am, after all, a good Soviet citizen. But who cares? At the moment it is enough for me to be free from jails and camps."

The man chuckled. "I'm with you on that," he answered. Eva noticed disfiguring scars on his cheek. In response to her curious expression, he said, "A souvenir from Gerassimov." With the mention of the name, the beat of her heart quickened. The story was that the "Commander General" as Kovalyov had addressed him, had pressed lit cigarettes to this man's face, and without medical attention the wound festered. "I'm sorry they shot the bastard. My hope for revenge kept me alive during those years of hell. I wanted nothing more than to expose his perversity and sadism to the whole country. But the damned MGB shot him before I was given the chance — and naturally they forgot to tell the people why. He was a drug addict and already insane before he got that job. The security police have much to answer for in putting

such a maniac in control of the lives of thousands — all innocent!"

The man walked out of the office with her, in his possession also the certificate of the dates of his arrest and release, his characteristic, and notice of "unjustified repression."

"Sounds nicer than 'arrested and sentenced without trial and forced into slave labor,' doesn't it?" Eva commented.

This was a period of finding old friends.

Tommy had dashed into the flat calling to Eva, eagerness in her voice. "I have a surprise. Open your door. We have a visitor." Sheva was with her. They had passed each other on the street. "She walked right by me. She didn't recognize me. But how could I ever forget her! I called after her."

Tears filled Sheva's eyes. "We cried and we hugged and I couldn't let her go," she said. "I couldn't believe that the young woman who stopped me was the same little girl I last saw six years ago."

The years in camp had taken their toll. Sheva was not well. She had required surgery in camp to remove a growth on her back. After her release, before Eva's, her doctor had ordered six months in a sanatorium and she was expecting daily to receive her orders. "He said that as one who had suffered unjustly at the hands of the government, I had a legal right to a rest pass. First they almost kill you and then they want to make it up to you! Let's hope that six months of medically supervised rest will cure me," she added. When Tommy stopped her on the street, she had been returning from the offices where she was pushing with vigor her request for the pass, already several months under consideration. Sheva would die of cancer in 1966.

Jack Simons, Joe Goldman, and Jane Altman had also been released before Eva. Together they compared their corrosive ordeals, and were drawn closer by their common tribulations which those who had escaped them could never comprehend. With each camp reminiscence, the wonder came to them that they lived to return. All of them had known starvation, had been worked beyond human endurance, had suffered abuse, or had narrowly missed violent injury or death. Jack had lived through the torments not only of being a political prisoner but also of being a Jew. He had worked in the mines up north in Kolima and had

been assailed by guards and officials and prisoners.

They relived their interrogations. The confrontation that Kovalyov had set up between Eva and Sheva was relived. Although her mind had been dulled by lack of sleep, Sheva recalled, she had withstood months of questioning about the home influences upon Tommy that might offer evidence of anti-Soviet propaganda. She replied, again and again, "I don't talk politics with children!" As these recollections of past traumas resurfaced, they would send Eva into terror and she would toss in her bed, falling off into a half-sleep, dreaming that Tommy, too, had been taken.

Pieces of incidents came together. Valeria and Eva were supposed to be moved from Butirskaya to Taganskaya on the same day, and had in fact been in the same Black Maria. But, when the guards realized that two people of the same name and from the same family were in boxes almost next to each other, Valeria had been removed and returned to Butirskaya, only to be brought again to Taganskaya the following day. Valeria surmised that it was because of her benumbed state that she had not heard Rose Wogman calling out Eva's name.

The bond of common experience was strong and welded this group, including their families, where families survived, into an exclusive social unit. They called themselves "The Graduates of the University of Life" or the "Real University." They were "foreigners," not of their own volition, but by the fact that they were rejected by the Russians — still fearful of the consequences of associating with them or rebuffing them as an expression of Stalinistic chauvinism. As closely as Eva worked with Yelena Ivanovna and Dollie Felixovna at the institute, the latter her coauthor on an anthology for the study of English at the institute, and both Jews as well as Russians, she never developed a relationship with them outside of their work. They could not pierce her wall of distrust. She had been too deeply hurt.

Tamara Viktoryevna was the one Russian among "The Graduates." "But even you are a foreigner," Eva said to her. "You had not lived in the Russian sector long enough to reestablish your roots before you were seized." Tamara and Valeria had been thrown together in the prisons and the camps and had been given the same severe punishment. The support they gave each other had helped them to survive. In the years following their release, Tamara — all but rejected as an enemy of the

state by her daughter Alla — continued to depend upon Valeria for con-solation and comfort. Tamara became as close as one of Eva's family; in fact, for several years, at their suggestion, she took on the management of the household duties as a regular houseworker, freeing both Eva and Tommy to devote their time to their work and study respectively.

Once, soon after the news was received that Eva was being re-leased, Mordish, her parents' old friend to whom Esther had turned when Morris had disappeared, met Abie on the street, embraced him and deluged him with questions. He seemed genuinely shocked and grieved on learning of the death of Esther and Morris and Max, and hung on to Abie's arm until a promise was forthcoming that when Eva returned to Moscow, he would bring her and Tommy to visit him. The anger was still deep, but in deference to Mordish's age, Eva agreed to see him. Tommy, however, was unrelenting and would not see him. She barely remembered him for she had been a toddler when he had deserted Esther; yet she had heard enough talk during the years to know that this had been a friendship grounded only in wet clay, and "certainly I have no obligation to give him any satisfaction," she said.

After two or three visits, Eva could not stomach his monologue and his moaning. She would leave his room feeling physically and emo-tionally ill, his evocations opening old wounds — all about her happy childhood and what a wonderful, intelligent, remarkable man her father had been, "so honest, so decent, truly a human being." At the end of each visit, he would urge her to allow him to introduce Tommy to his nephew "to make a match." At her final visit, only pity for this old man stopped her from lashing out, "Are you trying to convince me that my father was an honest man, dedicated to improving the lot of the workers and the peasants, always selfless, his life taken in spite of his devotion to the cause of socialism by a government which claimed it was socialist?" In the darkness of her room, unable to sleep after the agonizing visits, she would repeat to herself, "Where were you when my mother needed you? Who are you to tell me what fine people my parents were? I did not see you at my mother's funeral. Only her children and the family of her son-in-law were there to say goodbye to her. Why was she without a single friend after Pa was arrested? My mother, whom you profess to honor, you sent away when in desperate need she came to you for help!"

383

But what good would it do to upset a tired old man whose conscience evidently weighed heavily upon himself?

Yet, from Mordish, Eva had learned how the Borodins had fared the storms. Fred, the older son, who had become a career military officer, had been killed during the first few days of the war. Norman survived the war but was arrested in the second purge and, like Eva, was released and exonerated after the changes brought about by the Twentieth Congress. Borodin had escaped the arrests of the thirties only to be taken in 1949. He died in Lubyanka Prison in 1950. Thus Eva got confirmation that, on this matter, Kovalyov had spoken the truth.

Mordish wanted to arrange a get-together to include Fanya Semyonovna, Eva, and Abie. Eva told him that she would speak with Abie and let him know, but she was not enthusiastic and was glad when Abie did not pursue the suggestion. Neither had been courageous enough to refuse Mordish face to face and to let him know that they had no desire to see this compatriot of their parents. Time had eased the pain; they had shut out these old acquaintances who had been part of their childhood and wanted no more reminders of their repudiation during those terrible years. Both of them were determined to push far into the background of their memories everything between the time they left Chicago, when they had looked forward with so much hope to the future, and the present. A year had passed after her final visit to Mordish when Eva read an obituary notice that he had died.

Over a period of months and years Eva learned through hearsay that she was entitled to a number of privileges above and beyond the two months' compensation which she had already collected. Neither she nor anybody she knew ever received an official statement or instructions on their eligibility for benefits. As the widow and daughter of exonerated and deceased political prisoners, two months of each of their salaries were due her (one-half of Morris's would go to Abie). From Sheva, she earlier had become aware of her right to a period of convalescence, a minimum time of one month at a rest home or sanatorium if a doctor recommended it. Through gossip, she also heard that the prison and camp years, plus six months for a recuperative period, were to be computed as part of the total working time for pension benefits. The

exonerated were also to be given priority rights in housing, for their names had been erased from the books of the Housing Registration Office as if they had never existed. The housing was to be separate flats if they wished, without neighbors, and it was mainly for single people of which there were many — men whose wives had divorced them or whose wives had died in prisons and camps, women whose husbands had divorced them while they were in prisons and camps. Finally, their sentences were never to be held against them. That they had once been considered "enemies of the people" and had been put away as "undesirables" was never to be part of their record. "One catch," Eva discovered later, was that "the place of issue and number on my passport gives me away as a former 'political.' If they really wanted those years to be buried, they should have postponed issuing my passport until I returned to Moscow."

She seriously considered applying for a summer's rest in a sanatorium, delaying until Sheva would be given a place, but when Sheva's persistence wore down after a two and a half year wait, Eva gave up on the idea. She had heard of only one person who had succeeded in taking advantage of the privilege.

Eva was determined to collect the money due her and Abie from the fund for Max's and Morris's compensation. While she struggled through the red tape for Max's wages, Abie applied for Morris's, which he received and gave to her. When she was handed only Max's base pay of two months, her bitterness resurfaced; the overtime that he had given to the print shop in order to get the newspaper out had been ignored. "His reward? Death from slave labor."

From the time that she realized that her desire for improved housing, particularly a non-communal flat, was a real possibility, Eva thought constantly about making an application. Getting away from Sonya provided an overwhelming motivation. That Sonya had been dropped into her lap — and Tommy's — while Abie had extricated himself from her was a miserable irony. The flat, too, was quite inadequate. The two-story frame building of the late 1800s had meager and clumsy facilities. Each flat was supplied with a small water closet for all of the occupants, and in the communal kitchen there was one spigot with only cold running water in the sink. The central heating was the only up-to-date

installation.

The building was scheduled to be demolished and replaced by a modern structure. The out-dated houses in the vicinity were disappearing and skyscraper apartment houses were sprouting up. Eva feared that waiting for demolition might result in her being automatically relocated to the outskirts of the city where much of the new construction was taking place; transportation from there would be inconvenient and limited.

Eva procrastinated, putting herself at risk of being relocated to an unacceptable area, but she was willing to wait until she was ordered to move so that she would not be separated from Tommy. Tommy, although a member of a family who had suffered from the Stalin excesses, was not entitled to special privileges. The advisability of including her in Eva's housing plans was questionable. "If I ask for two rooms, one for you and one for me," she speculated, "I might very well be told to move now into your room until they find something for me alone. They can tell us that yours is large enough for two. I'll lose my room — better additional space even if it is only a hole in the wall — and when they find something for me, they might say your room should hold two people and you will have to move."

One day, within minutes after starting to think about the matter again, Eva made a decision about her search for new housing. An inspector had knocked on the door to inquire what the number of the house was. On receiving the answer, he said, puzzled, as he thumbed through the form in his hand, "That number cannot be correct. My records show that this building had been demolished a few years ago."

"Don't tell us that the wrong house has been torn down!" Eva exclaimed, her hope of getting into better housing in the foreseeable future shattered. Thoroughly frustrated, she said to Tommy, "There goes our hope for improved housing in this century! As long as this building stands, they will say we should be happy in it. What would Esther have said? I can hear her." And continuing, mimicking Esther in Yiddish, she said, "Leave it to the Russians to tear down the wrong house!"

On the following day she filed her application along with all required documents to prove her eligibility for a space in newer housing. She was promised a one-room apartment with no neighbors and was

deluded into believing that her request to be alone could be granted because of lack of demand. The population was accustomed to the communal arrangement, and although conflicts among neighbors created anguish — young children stifled by older adults begging for tranquility, divorced persons unable to escape the bitterness of their former spouses, young married couples longing for privacy, ordinary good people involved in petty quarrels that reached monumental proportions — the concept of being alone nevertheless was threatening to them. No one would be able to keep an eye out for robbers while the other was away at work, and the loss of human contact might even result. Eva was actually asked to specify a location, so she chose one near the university in the southwest side of the city in a new development where Abie and Gita, Valeria, and Alexandra were already living.

It was in the first part of 1963 that Eva finally moved, but not until after she demanded the change forcefully, with boldness bordering on the brazen. "I learn slowly," she smiled, reporting success, not entirely as she had planned, but "a five hundred percent improvement. They couldn't find me a private flat, but I couldn't refuse this one. The room is a lovely one on Lenin Prospect, the most modern and fashionable new district in the city. My neighbor is also a single woman. That should be much better than what we are suffering through now. Besides, who knows when the bureaucracy will change its mind and deprive me of the benefit entirely." And, she was now away from Sonya forever.

Tommy, for all practical purposes, moved in with Eva. Both enjoyed the space and the sunshine that poured in on those days when the sun shone in Moscow. Neither the new neighbor nor the house manager seemed to notice Tommy's presence. Tommy returned to her own apartment frequently enough to make her neighbors aware of her existence. They lived together in this way until the old house was demolished and Tommy was reassigned, not in a new building, but to one which she willingly accepted because of its very convenient location in the middle of the city near a subway. Both Eva and Tommy were pleased with their new accommodations.

For those who had been free to come and go, to live in their own rooms and to walk the streets, the events between 1951 and 1956 be-

came history and the shock of the Twentieth Congress — the legislative denouncement and reversal of Stalinism — had subsided. But to Eva, each and every reference to events of the past six years was a current event and she lived it as if it were happening on the spot.

"There was a period of Jew arresting," Tommy related. "Some gentiles, but mostly Jews. They went after the Jewish doctors. They made up a story that they discovered a plot to kill Stalin. And they published the names — most of them typical Jewish names. And you know, Mamma, very many doctors are Jews." In her clipped, rapid English, the inflection very Russian, the years with Alexandra having erased her mother's Midwest American accent and intonation, she expressed her hatred in sarcasm. "So they started grabbing doctors something fiercely, and there were very many of them good specialists and they had high posts, many outstanding doctors, not plain practitioners. And there were many suicides. It was publicized and scandalized in the newspapers, about the plots and the traitors, and all kinds of labels were pinned on them. It's a long story. Now that the truth is out you can find plenty of material on it. And the one who started all of this — who said that she discovered this plot — she became one of the 'heroes' of the Soviet Union. But later, after Stalin died, they saw it was a fake. You know, when he died they had trains ready to deport all Moscow Jews. It was supposed to save them from the wrath of the Russians who were incited by this fake doctor plot."

She continued. "You remember Masha and Dima."

Eva dug into her memory from the days before her arrest. "Masha? Do you mean whose husband got a Stalin prize for improving cars or buses or something like that? Is that Dima? Doesn't he work at the Stalin Auto Plant?"

"Yes. I met her once during this period. She spoke as if she would have a nervous breakdown on the spot. She was worried about Dima."

"But he isn't a doctor. He's a talented engineer. Why was she so afraid?"

"What difference does it make what his profession is? I told you they were grabbing Jews. Yes, mostly doctors, but they were arresting not only doctors. Jews! They were simply arresting Jews, and a few gentiles thrown in, but mostly Jews. Masha told me she called Dima up at

work several times a day just to hear his voice, to know that he was not arrested yet. It was understood that when she called, whoever answered the phone would tell her, 'He's here' or 'There' or 'He's eating.' This is how she knew that he was still there."

When Tommy told of the death of Beria — a Georgian who had replaced Yezhov in 1938 as the Commissar of Internal Affairs; it was claimed that he influenced Stalin to such a degree that some said Stalin was "under his thumb" — Eva reacted as if it had happened yesterday. She ranted: "Stalin under his thumb? He was just another scapegoat to whitewash Stalin's crimes. After all, how much disillusionment could a people tolerate? Even after the truth is finally out, the Russians still want to believe that their idol could do no wrong. The orders came from Stalin — not from Beria — nor for that matter from Yezhov!"

Eva wasn't confident that the current leaders in the Politburo and the government and the Party were sincere, that they were willing to assume responsibility for their errors, for they were the self-same people who had participated in the "personality cult" purges and who had stepped into the shoes of Politburo members whose murders they had condoned. They held on to their positions for the remainder of Stalin's lifetime, throughout the terror. Kruschev himself had taken part in the blood-letting and now he was being extolled and heading the government. They were making no laws to punish those whose names were strewn among the pages of her protocols, those who in their haste to protect themselves had let their vocal chords sing out, allowing the security police to put words in their mouths, giving back to them what they wanted to hear, words that were excuses that took almost six years from her life, and from countless thousands of other lives. Stalin was reviled now, blamed for everything, while they were alive and running the country as if they were blameless. Wouldn't the change which they claimed to be making be more genuine if they resigned in favor of those who had had no part in the murders and the terror?

The Soviet invasion of Hungary occurred almost immediately after Eva arrived home. That was not history, but the fact that she had only recently been set free herself made her insensitive to the foreign adventures of the Soviet Union. She was still wrestling with the idea that her government had been so quick to pluck citizens from their homes

and families on little more than a whim. To protect herself, she now drew the blinds with more care than she had before 1951. When she wanted to comment critically about anything but a very personal matter, she would automatically look around to avoid being within earshot of strangers and her voice would drop to a whisper, a trait that remained with her the rest of her life. The fact was that her arrest and imprisonment had made a coward of her.

Chapter 23

There were many signs that a new era, late in coming and long awaited, had arrived. It was to be an era without terror, within a democratic framework, with the participation of the people in the local government. People, unafraid to express themselves critically and creatively, were becoming involved in making decisions that profoundly affected their own lives and convictions, with orders from above a thing of the past.

A year after Eva's release, gossip raged through Moscow about a rebellion of workers in a factory located outside of Moscow. It seemed that they were challenging a decision that ostensibly had been made locally but, in fact, had been arrived at through the manipulation of local workers by the highest level of the Communist Party Committee. The controlled press notwithstanding, such news could not be suppressed and the rumors persisted. The decision was that the workers supported the expulsion of Molotov, Kaganovich, and Malenkov from the Politburo because they were an anti-Party group partly responsible for propagating the personality cult and, in part, were opposed to the disclosure of Stalin's crimes. The workers, however, had had enough of being told how they were to think! They were demanding the details of the issues and the problems, as well as the accusations and the counter-arguments, so that they could arrive at their own decisions as to whether or not these comrades should be expelled!

The tactic of feigning democratic participation was coming home to roost! Time and again, this method had been used as a pretext to postpone payment of government loans just as they were to become

due, and in the thirties to declare abortions illegal as if with the consent of the women themselves. Always, the publicity announcing the enactment of the legislation as the mandate of the people became the joke of the month.

When Konstantin Simonov's trilogy of the war *The Living and the Dead* and the West German film *Who Are You, Professor Sorge?* were shown in Russian cinemas, Eva became optimistic. The people were becoming aware of Stalin's indecisiveness and confusion during the first weeks of the war, of his ignoring the repeated warnings of his own secret police that the German armies were marching toward the western borders of the country, and of the resulting huge loss of life among Soviet civilians and soldiers. When this information was revealed, Eva recalled Sara Lvovna's advice to her on the eve of the war to give up a plan to visit her Aunt Rose in Odessa. "Her brother, the general, already knew that Hitler's advances were a reality; only Stalin, the genius, could not be convinced. And I was so certain that Sara Lvovna was merely boasting about her brother, the important military man!" Only after the release of the West German film about the Soviet agent Richard Sorge did Soviet newspapers admit that Sorge had warned Stalin of the Germans' impending attack.

Other signs of positive change surfaced. Frequently an article appeared in *Pravda* and *Izvestia* on the anniversary of the birth of an old Bolshevik or another well-known leader of the Revolution or of the Party, who had been murdered in the purge of the thirties. "I consider it murder," Eva persisted when a friend raised an eyebrow at the harshness of her language. It was a tribute and a recognition that the person had perished on such and such a date during the period of the Stalin personality cult.

The Foreign Language Library now offered works by modern English, French, and German authors. "Imagine!" Eva would remark to Valeria, "printed as recently as three or four years ago." She was well-known to the library personnel because of her frequent appearances. They always set aside the newly arrived books and broke the rules for her, permitting her to fill her tote bag with as many as ten books at a visit when the rule was no more than two. Never again would she have to read and re-read Thackeray and Dickens and George Elliot!

Then, gradually, there appeared articles and novels by Russians with the central theme being the life in the prisons and the labor camps and the injustices suffered during the period of the personality cult. About this time, Solzhenitsyn's story "One Day in the Life of Ivan Denisovitch" was published in *Novy Mir*, the popular Russian literary magazine, and it became a sensation. Eva and her friends hastened to read it. They were critical. "What is all the excitement all about?" those who had had the firsthand experience wanted to know. Each was able to relate incidents that were far more inhumane than the descriptions set down in the story. They felt that Solzhenitsyn had used undue restraint in depicting the horrors. "Many things much worse than those he told about in Ivan Denisovitch's life happened." Eva added, "They should have been female. Hey, which one of us should write about one day in a woman's life in the labor camp?" and each recounted at least one dastardly act "for the book" still in want of an author.

As Yelena Ivanovna promised, Eva returned to work on a permanent basis for the 1957–1958 school year. The environment of the cinema arts remained as exciting for her as before she was forced out of it. Eva's own specialty required her to teach in all the departments, to work among actors, directors, scenario writers, cameramen, artists, historians, and critics. She was surrounded by the masters in all the fields. She confessed to being thrilled with the respect she received from her students. One demonstration of their esteem for her, for example, occurred when she would enter the projection room for special showings of foreign films which she had assigned; they would automatically reserve exclusively for her the first seat next to the aisle. Eva also had access to the screenings of current foreign films, most of which never appeared in the public movie houses. She greatly appreciated the opportunity of seeing these films because they kept her somewhat in touch with the United States. Next to reading, the cinema became her closest interest and distraction.

Yelena Ivanovna inspired self-assurance. She drew her staff around her in a partnership arrangement for planning and decision-making. It was a pleasure to work with her and when she asked Eva to write and prepare English texts and articles on the various specialties of the institute for all the English teachers to use with their students, although it

needed to be done on her own time at home or at the library, Eva interpreted the request to be a compliment. Since she used the material that she developed for her own classes with only slight modification, she did not consider the assignment as a task far removed from her individual preparations. Besides, the additional research taught her a great deal that was helpful in her own teaching.

After Yelena Ivanovna's retirement, when a new head from outside the institute was appointed, a rigid structure replaced Yelena's fluid informality. In a department composed entirely of women, an important change was having a male head. It was rare for men to take an interest in languages as a profession; most men at Eva's institute taught the cinema specialties, political theory, and sports. Ivan Ivanovich Kastigan, a Russian, instituted changes with the enthusiasm and rashness of a young, new administrator. At first he did not appreciate that many students coming from the minority republics, where Russian was a second language, needed an individualized approach. He also did not realize that for students majoring in other specialties, foreign language competency was of secondary importance. He wanted every student to follow a uniform program. Fortunately, he had the intelligence and sensitivity to recognize the imprudence of some of these innovations and, in bending his demands, made life easier for the teachers. Eva learned to admire him as a fine theoretician as well as a practical teacher in the classroom.

Ivan Ivanovich also made changes which required that his staff use their talents beyond their immediate classroom. One year he called upon Eva to plan and organize a program for teaching English on television. The time was strictly allotted, her total of 1550 hours of work for the year including 840 hours of teaching. She needed more time and again willingly gave it outside of the established hours. She finished her report on schedule, noting with satisfaction Ivan Ivanovich's commendation. Another assignment which he gave her was the development of a program for the evening school and correspondence departments of the institute, both accredited training centers for the cinema industry.

Her final task was co-authoring the anthology of film texts with Dollie Felixovna to be used for the entire course of foreign language study. It took two and one-half years of work, one and one-half years of which Eva gave on her own time. It was completed a few years before

she retired. During the writing of this book, Dollie Felixovna, who was inherently attuned to Soviet reality, often needed to repress Eva's instincts. In her eagerness that the content interest the students, Eva would suggest inclusion of well-known living Russians and foreigners in the cinema world. "Eva Moisseyevna," Dollie would say, "that's not wise; we can't use such contemporaries. So today he's okay. But who knows if he'll be okay tomorrow? It is safest to write only about the dead."

Eva had to submit. "I'm losing myself in this work," she said to Tommy. "Our book would be out-of-date before the last page is off the press. We can't write about living people. Remember Priestley? He was a god until he said something that the authorities thought was derogatory to the country and now he is poison. And Howard Fast? You can imagine what would happen if someone like Priestley or Fast, someone designated as non-friendly, turns up in our book!"

Nevertheless, when the book was completed and published, she felt a glow of pride seeing her name — E. Meltz — printed on the face page.

After Eva's position at the institute was firmly established, requests from private citizens that she tutor them began to come in. American English had become very popular, and she had gained a reputation as being one of the finest teachers in the field. She turned away many students, accepting only the serious and mature ones. While admitting a lack of patience to teach children, she accepted an occasional tenth grader and those preparing for entrance to institutes of higher education. Her work with the latter was particularly satisfying because without fail every candidate whom she tutored passed the exams. She also had students who wanted to improve their conversational skills, among them several professors who often went abroad to deliver lectures at international congresses. Although these professors understood English, they were not able to speak it well enough to be understood. Then there were also young men and women who wanted to learn the language for the sheer pleasure of it.

The fact that she could earn more money teaching privately than she received as her salary eventually influenced Eva's decision to retire at the earliest possible legal age — fifty-five. "What a change in my attitude!" she said to Abie. In the meantime, until that time arrived, she

took on as many students as she could easily manage. Her good relationship with the administration at the institute, and her efficient and effective teaching skills, allowed her to carry on both her work at the institute and with her private students.

Eva's work at the institute accidentally opened an opportunity for a job for Tommy and eventually gained her priority for admission as a student. Tommy had become very interested in cinema arts. She herself would have chosen some specialization in the field had she the slightest chance of working in the profession. It so happened that Ekaterina Mikhailovna, a graduate of the Foreign Language Institute and a former postgraduate student of Eva's, was now a professor in film history at the Cinema Institute. She invited Eva to preview an American film for possible booking for the students and mentioned that she might bring a guest. This was an unusual and special privilege, the film showings ordinarily limited only to staff. But Ekaterina Mikhailovna had sufficient influence to make her own decisions as she saw fit. So Eva brought Tommy. The members of the staff had never met Eva's daughter and were only casually aware of her existence because of the privacy which Eva maintained.

Before the film showing began, when Eva introduced Tommy to Ekaterina Mikhailovna, there was a courteous and hasty conversation between them in English. At that point, Ekaterina Mikhailovna asked Tommy if she would undertake to translate the film synchronically for her own guest with a caution that this particular film was considered to be difficult to interpret. Tommy hesitantly agreed.

Eva herself was pleasantly surprised at the spontaneity and accuracy with which Tommy whispered the interpretation. After the screening, Ekaterina Mikhailovna suggested that Tommy immediately apply for the vacancy in the Foreign Language Reading Room for a synchronic translator for which there had been a long search. Maya Alexandrovna, who before Eva's arrest had been a member of the teaching staff, was now head of the Foreign Language Reading Room. She hired Tommy, first of all because she trusted Ekaterina's judgment, and also, she told Eva, because Eva herself was entitled to special consideration to make up for the years of injustice that she had endured.

Tommy soon became known to the professors and other faculty personnel as a skilled translator and was called upon to do translations of articles on a variety of subjects. She also had her foot in the door for admission as a student. In 1961, she took the examinations. This period was fraught with anxiety. The most difficult portion was the orals which included a discussion between the individual candidates and the members of the staff from all departments except the foreign language department. This portion of the exams was the final screening of candidates in all the Soviet institutes of higher education, and the common complaint of the candidates was that even the teachers on these committees could not have given a suitable answer to some of the questions. Tommy returned from these orals in tears. Apparently things had been going quite well until Professor Korshunov's turn came. He said to her, "Look. Your mother was repressed. What is your attitude on this? What do you think about your mother's having been released?"

Eva gasped. "The gall!" she exploded. This man had himself been expelled from the Party and had been fired during the tyranny. His daughter was now one of their students. He should have known about the political hazards of such a question.

Tommy continued. "The other committee members gasped also. And I thought, to hell with all of you. If I don't get in, I don't, and I answered that I was refusing to discuss the question."

Eva's rage was mixed with fear. She was sure that all chances for Tommy's being admitted were gone. "Was there no response from the others besides astonishment? He had no right to bring up such a subject."

"Ekaterina Mikhailovna and one other professor said that they felt this question was absolutely irrelevant and that it should be stricken from the minutes and that Professor Korshunov should be reprimanded for asking such a question."

"I can just see his getting a reprimand. Such a step would be too serious a matter," Eva said, defeated.

"The committee decided to disregard the question — even the professor of Marxism-Leninism — but it was also decided not to follow through on the reprimand. But what chance is there for me now?" Tommy moaned.

It was a time for rejoicing, however, when word was received that she had passed the examinations. Although she had applied for the day courses, she was happy to be admitted to the evening section. The competition for both the regular day section and the evening section was keen, with an extra handicap placed upon the candidates by their being pushed down on the lists by the children of the political and intellectual elite throughout the entire country. It had been to her advantage that she had done two years of work in the industry, one of the new requirements for eligibility.

Under Ekaterina Mikhailovna's influence and guidance, Tommy specialized in foreign film history. Ekaterina Mikhailovna predicted for her a career as a research worker and teacher in that field, Tommy having already shown a talent for making presentations before other students. The years that followed, with her working during the day, attending school in the evening, and studying in between, were difficult but fulfilling. After her graduation, Tommy became eligible for work as a film critic, film historian, and editor.

Chapter 24

As the camp years faded into the past, gradually and subtly the progressive changes disappeared. References to the camps were discouraged. Probably only those who had themselves been the victims took notice that news reports paying special tribute on the anniversary of the death of a well-known individual omitted information that the person had died in prison or in camp during the era of the personality cult. About a year after Ivan Ivanovich became head of the Film Institute, a tightening up from the Party required stringent adherence to attendance in the political circles. The format of meetings was changed, and instead of the perpetual review of the *History of the Communist Party of the Soviet Union*, it emphasized current events, those from abroad as well as in the USSR. The speeches of the government and Party leaders had to be analyzed with a fine-tooth comb and the people in charge of the groups would have a question for every sentence in the speech until they were satisfied that every nuance was "correctly" interpreted and everyone knew the latest task for Soviet citizens. "Like a believer studying the Bible," Eva said. She gritted her teeth whenever her turn came to present a report. Very valuable time that she needed for her classes was wasted. However, she dared not ignore the assignment as an occasional more courageous person sometimes did, being afraid to incur the outspoken disapproval of the secretary of the Party unit who monitored the political education at the institute. She should have hardened herself to the political circles which were a fact of life, but they were too closely associated with her own personal tragedy and her disillusionment with the Soviet experiment. The disparity between the theoreti-

cal, as she had understood Morris's interpretation, and the reality she knew were too great for her to embrace the system.

The first frank sign of a return of the pre-camp days, albeit without the terror, was the unpublished move by a group of historians to reestablish Stalin to a position of reverence. Debates transpired as to how he should be treated in the history books but his worshippers appeared to be having their way. The injuries that had been inflicted during his reign were still too recently publicized to restore him to adulation. His photograph did not loom stories-high on rooftops, but pictures of him reappeared and old films, especially war pictures showing him in central roles, were shown more and more frequently — particularly after Kruschev was removed from leadership.

Student unrest was beginning to be felt. Tommy reflected some of the excitement one day. She shut the door behind her, and with barely a greeting stepped close to where her mother was reading. She said softly, "There is trouble at Moscow University. Some of the students have been arrested!"

"What kind of trouble? How do you know?"

"Our own students are buzzing around with all kinds of rumors," Tommy answered. "Some sort of demands for more democracy. I don't know exactly what."

The influences of the stories told by soldiers who had returned from abroad during the occupation years after the war had not disappeared, and with the freer exchange of literature and films and the increase in the number of foreign tourists, the young people were breaking out into a lifestyle that was imitative as far as it could be of the young people in the West. They were listening to BBC and Voice of America and were developing a fascination for American music. Now they were seriously interested in foreign languages, American English being the favorite. They were skeptical, scorning the ideals of their parents and doubting the stories of the heroics of the Revolution. Once Eva witnessed their reactions to a screening of the documentary *Unforgettable Years*, which depicted in part the dedication of the workers at Magnitogorsk. Unable to convince them of the truth of the sacrifices, a sadness crept over her. They insisted it was wild propaganda and refused to believe that a people could have felt so deeply about their coun-

try. She couldn't convince them that these were not shots from a fictionalized film. They listened to her politely as she described her trips every night after work on crowded street cars to Strastnoi Square to read the message on the bulletin board about the day's headway towards the completion of "Magnitka." She realized that this same disbelief and cynicism carried over to all of the history of the Revolution which they were rigidly required to study.

The tensions among her own students were obvious. Whatever the rebellion at Moscow University, it was spreading to the other institutions of higher education. She never learned if any students were expelled. The incident was not officially raised and any discussion her colleagues might have had with each other on an individual basis never reached her.

In 1970, the trials of two Jewish writers, Andrei Sinyavsky and Yuri Daniel, accused and convicted of anti-Soviet propaganda and "distorting Soviet reality," a cliche, were given wide publicity in the press. These trials and the resulting attention dispelled any illusions Eva may have been developing that the government seriously intended to initiate a sincere policy of free speech and free press. Their writings earned them the disapproval of the Writers Union which prevented their works from being published in the country. Under pseudonyms, they sent their manuscripts abroad to be printed. The conviction was received with indignation among the population as a whole and several workers in the creative fields — writers, musicians, artists — protested. It didn't take very long for these people to be out of favor with their respective unions, and their works, too, were suppressed.

Anti-Semitism, although not as crude and virulent as was uttered on the streets, was becoming official policy, even at the institute. The first time it had come to Eva's attention was when a disturbed Yelena Ivanovna told her that the administration had criticized her for having so many Jewish teachers in her department, "as if they weren't Russians also." Yelena Ivanovna seemed stunned. This was a period when the staff assignments had been stable for several years and there were no openings for new teachers. If the plans were to replace Jews there would have been problems, for the procedures for dismissal were complicated, and anyone contemplating such a change would be inviting scrutiny.

Eva felt pity for Yelena Ivanovna. She couldn't avoid wondering if a shiver — a dread — was passing through Yelena's heart. The term "rootless cosmopolitan" was not popularly heard any more, but was she wondering as Eva was — with this frank exhibition of Jewish discrimination being advanced even here at the institute — if the terror of the previous two decades was returning. It usually followed. First a scapegoat, then Eva also wondered how the other Jewish members on the staff were looking at these signs. To her, they had been Russians, their nationality notwithstanding, and she had always been perceived by them as the foreigner. She had never given any thought to her Jewishness as a religion, but from her early childhood her parents had made certain that she would have pride in her Jewish ethnicity. The traditions of the ancient Hebrews had not been a part of her own culture. As a child in the United States, in her home, the holy days had gone uncelebrated, prayers a ritual scorned as superstition, but Yiddish was passed on to her as a second language. The name-calling and derision heaped upon the Jewish people were an affront to her dignity. She was beginning to yearn for an identity, a form of security. On one of the high Jewish holidays, she had gone so far as to seek out the one synagogue in Moscow and was surprised to find herself in a tremendous crowd. When she discovered that admission was by pre-paid reservation, that she could not just enter and observe the services, she left. The urge was not strong enough for her to return another time, but when anti-Semitism increased, she felt more strongly drawn and curious about the history of her people. Valeria was sympathetic: "They destroy their own goals. The more they encourage hate for the Jews, the more the Jews turn away from atheism."

The whole ugly matter of anti-Semitism at the institute did not come up again until about a year after Yelena Ivanovna retired and a larger staff was necessary for Ivan Ivanovich's extended program. The first new teacher he hired for the German section was Jewish. The details were not revealed but, from the gossip among the clerks, the staff heard that Ivan Ivanovich had been called in by his chief and told that there were already enough Jews on the faculty and to cease hiring more. One of the staff told Eva, "He let them know that he was the boss in his department and would choose his own teachers based on their qualifications and their competency as teachers, whether they were Jew or Chi-

nese or any other nationality. And he is getting his way!" Anti-Semitism was increasing, however, and it was uncertain how long he would be able to stand by his convictions.

Anna Vladimerovna was a stranger when she approached Eva late in the summer of 1959. She had promised her cousin from Los Angeles, who recently had been visiting in the Soviet Union, to find Eva and to deliver a message to her from Eva's childhood friend, Rae Osgood. She kept her word, and the exchange of correspondence between Eva and Rae was revived. These letters precipitated contacts between Eva and tourists from the United States, the first of which was a friend of Rae's whose account of the visit stimulated Rae and her husband, Eddie, to visit Eva. Letters were filled with plans, mainly Rae's. "We are making a summer of it. We are picking up a car in Brussels and hope to travel as far as we have time, and we will be camping in the Soviet Union for at least a month. A friend of ours had traveled this way two years ago and urges us to do the same — says it is the only meaningful way to see the country — and it will be very reasonable, within our financial means. I have sent off our inquiries to Intourist. Will you join us, perhaps in Brussels, and will you travel with us? I am so excited about the possibility of spending the summer with you," she wrote.

Eva read Rae's letters in bewilderment. "Can she be that naïve?" she said to Abie. "Does she really believe that we can pick up and leave the country — as she can?"

Intourist quashed Rae's hope of camping in the Soviet Union, that class of tourism having been discontinued. So, Eddie and Rae changed their plans to a two-week trip to Leningrad and Moscow via ship from Sweden.

Eva arrived in Leningrad a day before the tour group disembarked. Reserving a hotel room was not possible. She rented a cot in the room of a family friend of one of her private students. When she was settled, she headed directly for Intourist for information on the arrival of Rae's tour. She was told that she could not meet the ship at the dock, although after much persistence and patience the clerk did give her the name of the hotel where the group would be staying. Fear swept over Eva at the questioning to which she was subjected: "What is the name of the tour-

ist? What is your relationship to this tourist? What is your name? Where is your home?" The clerk disappeared up a flight of stairs, returned after an interminable wait, and said, "I can find no such name on the list of this group. Come tomorrow."

Apprehension building, Eva returned the next day. She had not told the exact truth the day before. She had said the tourist was her sister, certain after the interrogation that the clerk would dismiss her without giving her the information unless she claimed a family connection. Would she miss this meeting which she had been anticipating for more than a year? The same line of questioning and the same behavior followed. By this time she was certain that the clerk's notes were being stored away — with her name and address as someone who was inquiring about a foreign tourist. She was thankful, at least, that she hadn't been asked to show her passport. Finally, she was told that the group would be staying at the Astor Hotel.

From this experience Eva learned how to proceed and what to expect when, in the years to follow, she needed to inquire about other foreign tourists, several of whom were other girlhood friends. Rae would ask her to see some visitors, and they always brought a greeting and a gift. But Eva would always begin her inquiries fearfully, worried that she was being observed and that records were being kept. She did not mention her problem to her guests, realizing that it would be pointless since they could not give her the address of their hotel, never knowing until Intourist deposited them where they were to stay. "Do we have cousins and aunts!" she would laugh it off. "If those pieces of paper ever land in one drawer, the truth will out! But for sure I would not be given any information of their whereabouts if they were not related to me!" She was willing to suffer the anxiety because she enjoyed spending time with the Americans, hearing them talk and noting their style, although when the visit ended, her yearning to see the faces and places of her youth brought on a deep depression.

In Leningrad, the tour leader granted Rae's request that Eva accompany the group on their daily tours and have the three meals with them. Eva was a curiosity to the other tour members, but in consideration or in wisdom they curbed their desire to intrude upon her privacy. There was little opportunity for intimate talk between them. When the

group reached Moscow, Rae and Eddie deserted the tour over the protest of the Moscow tour leader, an attractive blonde in her middle twenties who barked orders like a sergeant in the army. Eva and Rae spent this second week together, along with Tommy, Valeria, Alexandra, Abie, and his three-year-old son, Misha. Abie's wife Gita was at the dacha but had allowed Abie to bring the child to the city for Rae to admire. Although no words were said, Eva felt that Rae and Eddie sensed Gita's fear of meeting with foreigners.

For hours, Eva and Rae walked the streets, Eva talking on, dry-eyed, and Rae weeping as if Eva were still in the throes of the terror and as if Max and Morris and Esther and Maxie had died only yesterday. As the busload of tourists with Rae and Eddie moved away from the curb for the airport, the pain and pressure in Eva's chest were unbearable.

When Eva announced to Ivan Ivanovich that she was going on pension at the end of the school term, in the spring of 1965, he tried to persuade her to stay, giving her many reasons. She would be happier at work than at home; the institute needed her talents; she had an obligation to the country. He confided that he had recommended that she be given an honorary Candidate's Degree which, he believed, she had earned with the publication of her textbook. "You know that this will mean a big raise in your salary," he had said. "I hadn't told you earlier because I didn't want you to be disappointed if my recommendation was not accepted." Eva did not promise that she would definitely remain, and when in May she handed him her resignation, he expressed deep frustration that his arguments had not convinced her to see retirement his way; yet he was honest enough to tell her that his recommendation that she receive an honorary degree had been rejected. She responded that she "would have been very much surprised if it hadn't," and was amused when he answered, "You deserved this award; I am surprised that you did not get it."

He had no answer for her when she said, "You must remember who I am. I had been once labeled an 'enemy of the people'; I was arrested, jailed, and spent more than five years in labor camps. Furthermore, I am a foreigner. Exoneration or no, do you honestly believe that the govern-

ment would go that far?"

She was given a beautiful and touching send-off that forced her to admit that although her colleagues had always kept her at arm's length, they had a genuine respect for her.

Soon after Eva's retirement, Tommy surprised her with some exciting news. She was getting married. She had met her future husband, an Israeli, some years ago when he visited the Soviet Union through a cultural program. He had returned to Russia several times throughout the years to try to convince Tommy to marry him, and she finally agreed. She would be moving to Israel.

After Tommy's marriage, while the application for the exit visa was being processed, Eva stayed temporarily with Abie and Gita, leaving her flat to the newlyweds. Six months passed before the visa was granted. Securing final approval was exasperating and sometimes Tommy wondered why her husband did not leave without her. When she was told that she would need her mother's written agreement to her leaving, and in addition, to marry a foreigner, she hit the ceiling. "I am thirty-three years old! When will this government ever grow up? I need my mother's approval not only to get married but also to leave her! I am almost middle-aged, but to them the cord has not yet been severed. What excuse will they find next to keep me here!"

Until the time when her first grandchild was born on the first of May, 1970 —her own birthday — Eva barely voiced any thought about joining Tommy, for she did not believe she would be granted permission to leave the country. "What use is there to apply?" she insisted. "Just to waste my time and money and to go through a year of aggravation waiting for an answer? Do you remember what happened when I turned in the applications to visit the United States?" Rae had initiated an invitation for Eva to visit the United States after she had met Helen and Sheva in Los Angeles, both of whom had secured visas to visit relatives in the United States; the invitation originated with Eva's first cousin. Sheva had been pleading for years for permission to visit her sister and bed-ridden mother and was finally granted the visa. She arrived in Los Angeles two weeks after her mother's death. Encouraged by her cousin's invitation and the success of Helen and Sheva, Eva had submitted her

application with the required four rubles, but nine months later she was unceremoniously refused, no reason offered. The next year, when her cousin sent another invitation, she tried again, but with the fee increased to forty rubles, Eva decided to ask some questions before turning over the money. "What are the chances of my request being granted?" The official frankly replied, "Slight." When she asked why, he told her that a first cousin wasn't a close enough relative. "But there — on your bulletin board, it is written that a *vyzov* [an official invitation from a resident in the country of destination] even from a friend will be sufficient." He hesitated, thought a moment, and answered, "That is from people in socialist countries." She did not turn in her application. There seemed little point in throwing away almost half of one month's pension.

True, she had some ambivalent feelings about leaving the Soviet Union. To uproot herself at this stage of her life was frightening. She was well occupied, had a good social life within her limited circle, entertained her friends in her luxurious new flat which she had been permitted to keep for additional payment after Tommy left, and involved herself with the family affairs of Valeria and Alexandra and Abie and Gita to compensate for her loneliness. She supplemented her pension with income from private teaching and did occasional work for the institute, this contact keeping her abreast of the foreign films which she enjoyed so much. After Alexandra's death on September 2, 1971, four days before her ninety-fifth birthday, Eva and Valeria leaned upon each other more than ever, ringing up each other daily to be sure that the other was not in need, and exchanging door keys — just in case. If Eva were to go to Israel, she would be exchanging financial security for dependence; at her age, it was hardly likely that she could find work, especially since she didn't know Hebrew. She also might lose the privacy for which she had waited a quarter of a century, for what certainty was there that she would have a flat of her own in Israel? To be crowding into Tommy's family life would be no improvement on conditions young married couples endured in the Soviet Union. On the other hand, to be alone in one's old age, with all its infirmities? That would not be good either.

She had heard of very few people who were being permitted to leave for Israel after having filed many applications, but she was not aware of the large numbers who were queued up in the OVIR offices

day after day, week after week — in fact, year after year — asking for exit visas. This dilemma was not publicized. If the information was in broadcasts of the BBC and Voice of Israel, the jamming effectively kept her and the rest of the population ignorant of it.

Rumors had been spreading that Jews from the Baltic region were leaving for Israel in large numbers. By 1972, the exodus had increased into the thousands. Abie, who was sensitive to the temperamental trends of the government, wrote Tommy suggesting that it was time that she send her mother an invitation and he coaxed Eva into seriously considering trying to get a visa. In the middle of April, Eva submitted her application with Tommy's invitation, forty rubles, and a "characteristic" (shades of the day when she needed to get a characteristic at the Lubyanka Prison) from her house manager who didn't know her at all.

On May 31, 1973, as Eva passed through Israeli customs, she heard a joyful chorus of songs. On the balcony at the top of the staircase, a group of young people was looking down at her, clapping hands, singing, and throwing flowers in her path. Tears came to her eyes, the first in many years. She was being welcomed as if she were coming home. She was no longer a foreigner.

Epilogue

Epilogue I

Rae Gunter Osgood

The envelope was addressed to Eva Stolar Meltz. I could guess from the return address and from the feel of the contents that it was the United States passport for which she had applied almost as soon as she was settled in my home. At the passport office, she had had to undergo a very lengthy interrogation and we feared that her claim to United States citizenship might be denied.

I was impatient for her to return home. I wanted to see her reaction. I recalled her response to a letter that I had written years ago telling her that I had had a dream that she was home again. "About your dream — my dearest dream is that just that will happen, but unfortunately, it doesn't depend upon me, and the fear that it will remain only a dream adds greatly to my pessimistic and unhappy frame of mind. I think only THAT may cure my depression and pessimism."

On hearing the fumbling of the key in the lock, I flung the door open and before she crossed the threshold, handed her the letter. She looked at me quizzically, stepped inside and tore open the flap. She turned the page of the book. Her expression of joy could not be contained. "I'm an American!" She hugged me and kissed me, so uncharacteristic of Eva. "Thanks! Thanks!" she exclaimed. I expected her to cry, but such release was not possible for her. She waved the book high and literally danced around the room. "Thank your senator for me!" I had appealed to Senator Cranston for assistance in rushing the process since her stay in the country had legally ended — and, equally important to both of us, the retelling of her story was far from complete. We needed more time. Again she hugged me. "I'm an American now. Just like you."

Upon hearing Eva speak, one would clearly have identified her as a Midwesterner, a Chicagoan, just as I was. Yet, in the two and one-half years that we were secluded together, deep into writing her story, I had come to the conclusion that she was more like a recently arrived immigrant, much like the immigrants in my parents' days, struggling to understand the strange traits in a new country but still clinging to the pattern and behavior of the old country. Acculturation is a natural process for anyone making one's home for as long as forty years in an adopted land. In spite of the rejection, oppression, and devastation Eva had suffered, she could not escape it. She needed to be with people who had lived in that self-same environment, those who had been familiar with the customs and habits and reactions she had come to make her own. She also needed to be with those who had experienced a lifetime of repression and understood the damage it did to the soul and human spirit. She needed Valeria, Max's sister. She needed Sheva, now deceased. She even went so far as to forgive Miriam, the fair-weather friend who had crossed the street to avoid her after Morris had been arrested. This was the same Miriam, whose parents, close friends of Morris and Esther in Moscow, had reputedly said that Morris was "guilty." Somehow, Miriam's family escaped the conflagration. I, however, could not cast aside what Miriam had done to my friend, and I despised her for having done it. Sheva was my hero.

Miriam turned up in Los Angeles with her children and their spouses. The two women took to each other like long lost friends. She would boast that her family was prospering in the American way. I was irked that she and her family took, but could not give back in the advertised American way. I could not forgive her having abandoned my best friend, so unlike Sheva. I once spitefully suggested to Eva behind Miriam's back that, yes, they were prospering — via those "capitalistic American strategies that they had once decried." She ignored my remark.

The two women resumed their earlier close friendship. In this land foreign to both of them, they needed each other. It was on listening to their chatter that I realized that our separation of forty years, each of us in a different world, had created a natural breach between Eva and me. She could never have accepted the kind of principles that I lived by, the very same that I learned from her. To use the cliché, my life had been no

"bed of roses," certainly no less so than most lives, but hers had been too harsh. She was permanently traumatized. The tears that I had shed while I sat at the typewriter transcribing the tapes from cassette after cassette as she filled them were for the grief I shared with my "best friend," the feisty radical upon whom I had leaned in my youth. If she had continued to live, I believe that she would have sought the comfort she needed from roommates among the émigrés. I was as much a stranger to her as she was to me. Of the ideals that she carried with her to Moscow in 1931 and which since had been reduced to delusions, at least some of them had rubbed off onto me, and for that I thank her.

Epilogue II

ABIE

In July, 1975, a headline article appeared in the English publication of the *Jerusalem Post*, "KGB Snatches Jewish Emigrants from Plane." The story detailed how Abie Stolar and his family, who were carrying legal exit visas, had been removed from an airplane that was to take them to Israel.

It took an additional fourteen years of frustrating attempts for Abie and his family to finally receive government permission to leave the Soviet Union. The turning point came when President Reagan visited the Soviet Union for a diplomatic conference with President Gorbachev. During this trip, President Reagan met with a group of dissenters that included Abie. Photographs in US newspapers showed Abie, acting as a translator, sitting next to President Reagan. Abie's family's departure from the Soviet Union in the spring of 1989 made headlines in newspapers around the world.

When Abie, Gita, their son Misha, daughter-in-law Julia, and two young grandchildren arrived in Israel, they were assigned to small apartments in a government absorption center where new arrivals spent about three months for orientation to their new surroundings. Because housing was scarce, they remained in these crowded conditions for three more years. With the completion of a condominium complex in a new Israeli settlement in East Jerusalem, they finally moved into permanent homes. For the first time since Abie's arrival in Moscow in 1931, he was living in an apartment with modern conveniences; he and Gita still reside there.

His son's family occupies an apartment below his. Both families have relative financial security; although Abie's and Gita's Soviet pensions were cancelled on their departure, Abie was granted the equivalent of his employment pension and military service pension by the Israeli government. His son and daughter-in-law are also employed.

Since his departure from the Soviet Union, Abie has been to the United States twice, the second time to raise money for Israel. During his first trip, sponsored by the Jewish Action Committee of Chicago, Abie was met at the airport in Chicago by US Senator Paul Simon of Illinois, who had intervened on his behalf several times on learning of his plight. Senator Simon arranged for Abie to be escorted to the neighborhood and school of his childhood and youth.

During this trip to the US, Abie and Gita visited Los Angeles and were Rae Osgood's guests. At an open house that Rae held for them, he renewed his acquaintance with about fifty people whom both he and Eva had known in Chicago.

TAMARA

On Eva's arrival in Israel, she bypassed the orientation in an absorption center and immediately took up residence in Tamara and Akram's home. Tamara returned to work feeling secure that under Eva's care her two young boys would be adequately supervised. This arrangement continued until Eva decided to accept an invitation from Rae to be her guest, during which time they could work on her memoirs. After nearly two years had passed, Eva returned to Israel on hearing that Tamara was taking chemotherapy treatments for breast cancer. Eva returned to Rae's home in December of 1978 to complete her memoirs. When Eva died suddenly of a heart attack on March 12, 1979, Tamara came to the United States for her mother's funeral. After Tamara returned to Israel, Rae was to see her one last time when the two of them traveled to Egypt together in the spring of 1981. Two years later, Tamara died.

TAMARA'S HUSBAND AND CHILDREN

Tamara's sons, Morris and Maxim, were ten and twelve years of age respectively when their mother died. Their father, Akram Horesh,

never remarried, and raised his sons alone. The three continue to live at the same address, separated only when the boys were called up for three years of service in the Israeli army. Both boys are now employed and financially self-sufficient. They hope one day to go on to higher education.

VALERIA

Valeria never left the Soviet Union. Correspondence between her and Eva was frequent and regular to the end of their lives. Valeria's remaining years were difficult; she was alone and in poor health. She died on March 12, 1979 — the same day that Eva died.

Letters from Eva

The Early Years

Eva arrived in the USSR in 1931 and began a correspondence with Rae Osgood that lasted the next four decades. Her early letters, sent from Moscow when she was between twenty-one and twenty-four years old, reflect her optimism and joy at being in the Soviet Union.

October 16, 1932

Dear Rae,

I received both of your letters. Yes, my vacation days are over. I've almost forgotten them and am already planning for my next vacation!

I believe I wrote you that I detest teaching and have decided to look for another profession or trade. Two days after I returned from Odessa, I was offered work on the *Moscow Daily News* as a proofreader and am now working on it. I've decided to stay at this until next vacation and perhaps transfer to something more interesting, as here one can take a choice in work and doesn't have to take what one doesn't like. After a rather hectic year at teaching, proofreading seems calm and peaceful and so far I enjoy it.

I spent a month of my vacation in Moscow, and a month and a half in Odessa. I went there because my relatives live there and they would have been quite hurt if I'd gone anywhere else. Max and Abie spent a month each at a rest home in the Crimea. We all enjoyed our vacations. For me, it was a month and a half of real rest and amusement at the same time. Odessa is a beautiful city, nicely planned, with beautiful natu-

ral surroundings. The sea reminded me very much of Lake Michigan — until I went swimming in it and found it a bit too salty for my taste. I saw some good plays there, both in Russian and in Jewish. I also saw the musical *Rosemary* there. I missed it when it was performed in Chicago. In the last few weeks here in Moscow I have seen several fine plays and operas.

If one has foreign currency, one can spend his vacation outside of the Soviet Union if he wishes. One must have foreign currency because our Russian currency, though more stable than any in the world today, is not accepted outside of our country. Having no dollars or other foreign currency, I, for one, can't go out — unless in the future our currency is accepted elsewhere. I make plenty of it, so I am rather angry that it is not accepted anywhere else as I could live quite comfortably on my vacation money for a month — especially outside of here — as the cost of living in the Soviet Union is rather high.

How do you get along? I've heard that school teachers haven't gotten their salaries since April of 1931. Is this so? If it is, what's the use of working? Though I suppose it does keep one from thinking too much. Wouldn't it be pleasant to have nothing to do but sit and think of how miserable one is! I understand that prices on commodities in every field have dropped to unbelievably low rates. Of course, I read of all the firms closing or going bankrupt. However, it was an awful shock to me when a friend told me last August that the Chicago Opera and Symphony have closed. Some people who just arrived from the States tell me that regardless of how bad I imagine the state of affairs to be there now, I can't imagine it as it really is. That is a rather depressing statement, isn't it?

I'm surprised at your not receiving the cable I sent on your birthday. I guess I'm a little to blame, though, for your not getting the book. I had some doubts as to the wrapping and feared it might not arrive. It was a book of pictures of various phases of Soviet life. It was in German, English, and French. If I can find another copy, I'll take more care in sending it — but I did want you to get it for your birthday. Books here disappear very quickly, as there's great demand for them, especially foreign language ones.

Best regards to your folks from all of us.

Eva

P.S. Abie attends an art school here. Out of the three hundred who took the exams to enter, thirty were chosen, and Abie was among them. I think it's quite an accomplishment, especially when one considers his handicap in the knowledge of the language. Luckily, most of the exams were on drawings of one kind or another.

December 10, 1932

Dear Rae,

I now have more time to write since I gave up teaching. You know, it seems to me that teaching is as monotonous as any other work. Semester after semester one has to teach the same thing. Of course, there are little variations in the students and their questions and attitudes, but it all boils down to about the same thing anyway. I don't think I could get excited by a discussion on Victorian and modern literature as one has to teach it in the States. To tell you the truth, when I was teaching English, I had to force myself to go to work. If I were in the States now, and I could teach, I would choose history and current events. I'd love that — but even then, I wouldn't want to teach a bunch of kids. I'd choose either seniors in high school or adults.

I don't mind proofreading at all. Firstly, I work only six hours a day and am free to do as I please with the rest of my time. At school, I worked about seven or eight hours and another five to eight outside of school. We had such a shortage of teachers and books that we couldn't work any other way, although it's against the law here to work so many hours, especially for young workers. More of my time was spent in preparatory work than in all the hours in class. Now in the shop I work on shifts. There are two brigades working all the time, two of us in each brigade. For ten days each brigade works from 10:30 to 2:30 during the day, with lunch included. The next ten days, we work from 4:30 to 10:30 in the evening, but when we work on the night shift, we work every other day, making it five days of actual work out of ten. Besides this, I

423

read the whole paper every day right at work. What more can one want?

Now that I have more time, I'm seriously intending to study here. I hope to be able to attend an English-speaking school where mostly social sciences are taught, especially in the night school which is where I would be attending. I hear that the courses cover the history of the world generally from primitive communism to modern society, history of the Communist Party of the Soviet Union, geography, and economics. I'll be too disappointed for words if I don't get back into school.

In the meantime, I'm doing a little studying on my own, but it's not a regular systematized outlined course of study. I dig a little into this and a little into that. The only books I have been able to buy here so far are non-fiction books and my choice has been on the various social sciences. There is very little fiction to be bought, and so I must admit that I'm almost illiterate as far as the newest literary works are concerned.

Did you vote in this election? I wish I'd been there during the elections to cast my first presidential vote. Do you know what the Communist Party vote was? We can't seem to get the final number here yet.

Aren't you working at the junior high school anymore? I can't understand why the teachers are so passive when the rest of the workers are up in arms. Why don't they fight against getting paid in warrants instead of cash, and against enlarging the classes to fifty and sixty pupils, as I've recently read? There is money in America — in Chicago — but who has it?

I just saw Bernie [*a college roommate of Rae's future husband*] a few days ago. He isn't working with us anymore. He went on vacation and just returned. On the fourteenth he's leaving, I think for the States. He said he wasn't sure whether he'd go back to Chicago or live in New York. If I see him again before he goes, I'm going to give him the book I promised to get to you. If not, I'll send it by mail and be more careful this time.

Regards to your family from all of us. My best regards to Eddie [*Rae's future husband*] and you, and Max said not to forget to include him in the regards to you.

Eva

April 27, 1933

Dear Rae,

Happy birthday to you! May Day greetings to you!

I hadn't heard from you in so long that I had just about decided that something dreadful had happened and I was planning to write tonight.

Some months ago Jennie wrote that she met you in the El train and that you told her you are working in the Unemployment Relief Service, the same organization where she was working. In a letter I received from her last week, she wrote that her brother had also gotten work there and that since two persons in the same family are not allowed to work in the same place, their family had decided that he was to stay on because he made $10.00 a month more. So that's what even $10.00 a month means nowadays!

How do you like such work? Is it bearable? I imagine it must be interesting to visit so many people and see how they live, but I suppose you know what my attitude to the state-controlled relief agencies is. I do suppose you would prefer teaching. Did Eddie get a job there, too?

Say, I must hand it to your sister! However does she manage! Will she be able to stay in school until she gets her degree? It seems to me it would be quite a trick on $3.00 a week.

It seems a shame that you and Eddie cannot get married, but I hope you won't need to wait much longer. I wish for you to have as pleasant and happy a married life as I've had so far. I'm not a bit sorry I married. Max and I are awfully happy, but I won't say anything more because it seems like gloating about it over one who's less fortunate.

Say, I certainly admire your father's spirit. He probably feels he's doing something in trying to overcome the miserable state where millions have to be idle and starve through no fault of their own. With what organization is he connected? With our Communist-led unemployed councils?

You write as if you thought the worst of the crisis is over. I'm

afraid you'll be disappointed if you do. The crisis is not over by a long shot, and won't be for a long time. And I'm very much pleased to see that you recognize where it's all leading — war! It will come, of course, but every country is a bit afraid to start it because of the certainty that at least one more country will go Bolshevik as a result. That's one of the reasons they're holding out, but how long will they hold out? Things are getting more and more desperate for the capitalist world. What do you think, for instance, of Hitler's fascism in Germany? And England's embargo on Soviet goods?

As to myself, I've been "promoted," I suppose one would call it. I've been placed as "responsible worker" (I guess it's what is equivalent in capitalist terminology to foreman) over a brigade of our proofreaders. It's rather hard work, but I like it, and it gives me very good conditions. I work every other day, excluding general rest days, from 4:30 to 12 or 1. We are supposed to work only until 10:30, but we lack English-speaking workers, and Russians do most of the make-up, so that's the reason we have to work later. The *Moscow News* hires taxis to take us home since street cars do not run after midnight. The pay is also rather good. (I don't get more than the kids I'm in charge of, thank goodness.) So you see I have a day and half off in between work always, besides the regular day off. Max works three shifts and is on my shift every alternate three weeks. Most of the linotypists are Russians and they don't know English. So Max needs to be there to give them lots of help. He is what you might call the head linotypist. He teaches the Russians the English linotyping. Since I have so much leisure time, I attend Russian classes in the morning and some social science classes in the evening, so that I really don't waste my time. I do all my studying during the day.

About three weeks ago Max and I got a room away from his family or mine for the first time since we've been together. It's a lovely room, right downtown, within walking distance of all the important places in town. It is also closer to the print shop than our flat had been. We live in what one might call a "common apartment hotel" which belongs to the publishers of the *Moscow Daily News*. There are only four couples living here. All the rooms are furnished — down to an ink stand and pens and an ashtray! We have a housekeeper who does our shopping and makes the meals for all of us, and a domestic worker (one's called a servant or

maid in the United States) who cleans our rooms and keeps everything neat. There's a common kitchen, dining room, and club room. If one doesn't want to eat the meal that's served, he may go and cook his own (catch me doing it!). So far, all of us like being together. We eat in a large dining room. We have a victrola and piano and sometimes eat our meals to music. We often entertain each other; I play the piano and another friend recites poetry. We enjoy very much listening to records together. I think it's all very great!

Lena, our housekeeper, is a riot. She is a middle-aged American from New York whom we all love to tease. Whenever we complain about something or tease her with some tall story, she gets angry and answers the same way all the time in a genuine Yiddish accent: "It's a ting from de impossible!" Can't you just hear her? This expression has become a favorite of ours and we all mimic her.

Our library isn't much yet since English fiction is so hard to get here, but we're all donating what we have and are trying to build it up. I've taken seriously to music again and practice a few hours every day. I missed our piano very much. You may remember that we gave it away when we left Chicago when my father wrote that we would have no problem getting one here. Little did he know! The cost is too much even for us with our three salaries and there is no such thing as buying on the installment plan here. So you can guess how happy I am that there is a piano in our building. I don't interfere with anyone, and no one interferes with me, because everybody who lives here is at work during the day.

I start off on vacation on May 7. I've decided not to go anywhere because both schools I attend won't be over 'til the end of June, and I'm afraid it would be too hard to catch up on a whole month's work. Max, of course, is raising the dickens. He wants me to go to a rest home. His vacation was also to be in May, but it was postponed until June because the chap that's to substitute for our linotypist won't arrive until the end of May. I'm trying to convince Max to go to the Caucasus this year since he was out at the Crimea last year. However, he swears he won't go anywhere at all if I don't go anywhere. I think I'll manage to bring him around to my way of thinking.

Abie's at school and enjoys it very much. His work is improving a

great deal.

Regards to Eddie and the folks from all of us. Do write sooner than you did after my last letter.

Eva

March 17, 1934

Dear Rae,

I was very glad to get your letter. It's what I call a real newsy one. I myself have been rather sick the last seven months and I didn't write to anyone during that time. I'm a bit better now, and I had planned to start writing again to all with whom I had kept up a correspondence.

I congratulate both you and Eddie on your marriage. I'm glad you are both content with things, but I do think it's a shame that you have to live from hand to mouth, as it were. It's a shame that young folks in America haven't the same chances that we have here. Max and I also live in a furnished room, but what a difference! We don't worry about anything. I think I wrote you of our room. We're very happy here. I've fixed the place up so nice and cozy. People always think we're married about a month or two by how we feel about each other and by our enthusiasm about our home.

How do you manage about food? Don't tell me you do the shopping and cooking! Generally, please write me how you live nowadays during the Depression era. I can't imagine, no matter how I try. I suppose living here has spoiled me, what with social insurance and sick benefits. I simply can't picture worrying about food or rent. I can't seem to understand it, and I'd like to know how one actually lives in the States now, for not only you, but Jennie also writes that one doesn't involve himself seriously about things. It seems you've all gotten used to it, according to what you both write and what people here tell me they also hear from abroad. Jennie writes that she and Gil are planning a trip throughout the States this summer, although it means that Gil has to quit his job. So to us here it seems as if you folks on the other side of the ocean have a devil-may-care attitude to life and things in general.

I suppose you and Eddie are considered a lucky couple these days, what with both of you working, or perhaps it is your parents who are

lucky to have you working so that they won't starve? Since I still work on the *Moscow Daily*, I know more or less of what's going on, and in yesterday's paper I read that due to mass protest, the CWA will not be discontinued. Maybe that means then that Eddie will still have work after May Day. Is working in the CWA supposed to mean less than working in the Relief Service? And are people of the same family allowed to work in the Relief Service, or don't you use your married name? Will you describe your work as a social worker? Just what does it mean? Going to places and seeing whether the people there need relief or not, or handing out things or what?

I'm sure you visited the World Fair. What were your impressions of it?

Abie is doing very well in school. He seems to be making very much progress and is a very good student — in fact, an udarnik, which my proud mamma is sure to tell anyone who wants to know. In factories, udarniks are quite common, but not so in the schools. He has made many friends from school and is learning to speak a really native Russian from them — while I, much to my sorrow, am afraid to say, will never do well. Abie is also doing a bit of outside work, drawing. He is well satisfied here.

People say I've changed quite a bit as far as appearance goes. I've lost an awful lot of weight and am very thin. People take me for 17 or 18 at the oldest. I don't know whether I ought to be glad or sorry. Max insists on having my high school graduation picture on our writing desk and a few days ago, when our houseworker was cleaning our room, she asked me if that were a picture of an American or Russian friend and why doesn't she ever see her here. She didn't believe me when I told her it was a photo of me.

I've changed a lot in other ways too. You'd be surprised if you saw me. I take manicures regularly, fiddle around with my hair, and Max swears it takes me at least an hour to fix my face. I'm very touchy about the clothes I wear and how they fit. Quite a change from the Eva of Chicago, eh? I must confess that one of my new friends has influenced me greatly. You would like her. She is living in our dormitory with a young American man. Officially, she is his housekeeper. Under this arrangement, she can use his ration book. (We still have ration books. This

is the fairest system so that there will be enough food and clothing for everybody.) Anyhow, Khalima — isn't that a beautiful name? — is a very beautiful, sweet Uzbek girl. She has kind of taken me under her wing and gives me many hints on how to use cosmetics and fix my hair. Because we work in a field where English is required, we do not know a great many Russians, as Abie does, so I really take advantage of Khalima to help me get acquainted with Soviet ways.

Just a short while ago, I was promoted to head of our department. About two months ago, I got a raise of 100 rubles and now, as head, my pay is being raised again. Today I get my first pay since my promotion. I don't know how much of a raise it will be this time. In a way, I'm glad of the promotion for it shows that the comrades have confidence in me and my work, but in another way, I'm not so glad as it means that I can't represent our department in the union. Heads of departments are considered administrators, and administrators cannot be members of the trade union committees. But we're all members of the union!

I find the work very interesting. I read all kinds of news before it goes to the public. I not only do the routine proofreading, but I also correct grammatical mistakes — and there are quite a few because we have many foreign correspondents who work as reporters on the *Moscow News*. I need to correct factual errors that I find, too. So you see, I do copyreading as well as proofreading.

Last November we had a fire. Our two-story house burned over four hours from 3:00 a.m. until 7:30 a.m. We had lots of excitement. I was still rather sick and Max was on the night shift, so imagine poor me running around trying to save our things! Nothing in our room was burned, but if not for the firemen many of my things would have been gone. We stood out in the bitter cold all night and I was sure I'd catch my death of cold.

Our organization got rooms for us in one of Moscow's best hotels across the river from the Kremlin — the New Moscow, which was completed about a year after we arrived. They were short of rooms, so I was given one with a single girl, and Max got one with a fellow whose wife left for the States about a month before. It would have been heaven there in the hotel during the three months if Max and I could have been together, for I found it very hard to get along with my roommate. We've

been back in our own room only twenty days, so it's almost like a second honeymoon (even if we didn't get a first one)!

During the November holidays, we had invited some friends up to see the anniversary celebration in Red Square from the window of our hotel room. This time I saw the whole thing, from the military parade on. It didn't seem quite as exciting to me as the first time when I was in it, but maybe that's because the people's demonstration was toned down. The trade unions are finding this quite an extravagance when sacrifices need to be made if the Five Year Plan is to be a success. But it seems a shame that for such an occasion they have to do away with the artistic posters and floats and caricatures that add such humor. I suppose the signmakers must have their day, too. The statistics that they lettered were plenty impressive, showing how much all the factory and trade unions increased their percentages of production above and beyond last year's and since the initiation of the most recent Five Year Plan, and how much they pledge to do in the future. Maybe it's not as picturesque or gay, but it is all too serious a matter to take lightly.

I guess I've written enough for one sitting. Try to answer soon. Regards from my folks and Abie to your folks and Gertie [*Rae's sister*]. Regards also from Max.

Eva

The Post-War Years

Shortly after the war ended, Eva and Rae renewed their correspondence, at first communicating through Rae's mother. By now Eva had been in the Soviet Union fourteen years. During this time, her father and husband had both been arrested, and Eva had only recently learned of Max's death. Her second daughter, Maxie, was also gone, having died during the war when Eva and her family were evacuated to the Red Banner kolkhoz. These letters were written when Eva was between thirty-four and thirty-eight years old.

September 14, 1945

Dear Mrs. Gunter,

How can you think that we could have forgotten you! One doesn't forget people associated with the happiest years of one's life — childhood and youth! I can't begin to tell you how pleased and happy we were to get your letter. I wrote several times to the States asking to find Rae's address to send me. Would you please ask her to write me? I hope she's forgiven some of my foolishness and stupidity of those early years. This letter I write to both you and her — just as a sort of picking up of threads, so to speak.

About your sister, in order to help you find her, I must have the following information: full name, place, and date of birth. It would also help if you could give me an idea of what she was doing, if working. Send this information as soon as possible, and I'll try my best to locate her and her family if any are still living. It is not enough for us to know only that she is in Kiev.

433

Yes, we paid, and paid plenty in this war. l am a soured old woman — in spirit I mean. The war cost me the lives of my younger daughter and my husband. Max died over two years ago, but I was notified only about three weeks ago. It is still too painful for me to think or write about. We've heard that Pa's alive, but so far I don't know where he is, or how. Abie is still in the army but hasn't been in active service since 1942 when he was badly wounded. He lost the sight of one eye, but the doctors are hopeful that he will regain full vision in his other eye and that he will return home to live a normal life.

My mother has aged. But she's a brick. I don't know how I could have lived through those awful years without her. Instead of my encouraging her, she kept me on my feet. I've one daughter now. Her name is Tamara and she's ten years old. People say she is beautiful, and I don't care to contradict them. She almost died also, but through some miracle she remained alive. She's now in the third grade. Children here start school at eight years of age.

I teach English in what corresponds to the American high school and college. Thanks for your kind offer to send me something. If books are allowed, I'd be so grateful. My Tommy speaks and understands English and I want to teach her to read and write. The textbooks we have here are for school children beginning to study English and are not the kind she needs. They begin on phonetics and grammar rules which are of no value to her. So I'd like to get some American textbooks to teach her from. As for me, I need advanced grammars, dictionaries, and any other books necessary for an English teacher. Besides these, I'd like something of new American writers. I'm completely out of touch and know nothing about new American literature. I'm more or less acquainted with English literature of the last few years.

Now for a few questions: How are you getting along? How is Rae getting on and what is she doing? Do write all about everything. Ask Rae to write. How's Ed?

Best regards from us all. We're expecting Abie on leave any day now, and I know he'll be as pleased as we were to have received your letter. Regards to all of you. Please write.

Eva

November 27, 1945

Dear Rae,

It was with such a warm, pleasant feeling that I read your letter, which arrived today.

Just as you know nothing much of me and my life these last few years, I know nothing except what your mother and you wrote me. Is Eddie in architectural work? What do you teach? Where and with whom does your child stay while you are at work? And so on ad infinitum!

Of course I hope now that we've started corresponding we'll keep it up. I flatter myself that I've got lots and lots more sense now than I had in the old days. And, of course, I hope to hear of the new little Osgood. When are you expecting?

As to us, there's so much to tell when you consider that it's fourteen years that we're here, and still longer since you and I grew rather cold.

As to what I referred to — I mean some of the things we used to discuss and disagree about. I wish to God I had had your sense then and not now — when it's too late. I refer especially to the sort of people you considered worthless in opposition to my ideas.

About my private life — I've never for a moment regretted my life with Max. Remember you once taunted me about my being more conventionally married than Joanie and Harry with their legal certificate of marriage? We lived very, very happily for the short time we were together, and he was an exceptional husband and father.

I've had a rather bad time of it since before the war and it seemed that each blow I got was more unbearable. Now this last blow of his death, when I had hoped so much to see him again, was the worst, and made me feel more hopeless than any other. I just found out this last August that he had died as early as 1942. So you see, I hoped that with the war over my personal life might be happy again. As it is, thank goodness at least one of my children is left me. She forces me to pick up the pieces, so to speak, and limp on somehow.

My daughter, Tamara (Tommy for short), is ten years old. Everybody says she is beautiful and who am I to gainsay it? Even if I say so myself, she's a sweet kid. She doesn't know that Daddy is dead and ex-

pects him home any day. She became too closely acquainted with death when my baby, Maxine, died at three and one-half years of age in 1941. I try not to spoil Tommy, but I'm afraid she isn't altogether unspoiled. Both her grannies and Aunt Val (do you remember Valeria, Max's sister?) as well as Uncle Abie think there's nobody on earth like our Tommy, and naturally she knows it. But she's okay. She speaks English. That was why I wanted primers for her. The books we use in teaching the children here English aren't of any use for her because she knows the spoken language. I have to give her reading, writing, and theory. She's in the third grade. Children here used to start school at eight. Now, this last year, they start at seven. By the way, the school system here is entirely different from that in the States, or I should say Chicago, as that's the only system I'm acquainted with. I'll describe it some day.

I teach in what could be the American equivalent of the high school and the university. I have the grades of the last three years at the high school and the freshies and postgraduates at the Cinema University where I've really just begun to teach. I'm still too dazed and numb to really make out what I'm doing. When I get to be more myself, I suppose I'll enjoy the work at the university. The students are interesting, and one has a chance to see many old and new American movies which one can't get to see in any other place. I suppose and hope that some day I'll find an interest in something outside of my own tough luck and then maybe I, too, will go to those movies.

My mother had raised Tommy since I returned to work at the end of 1939. Before the war we had a maid, so though there were two children to take care of, it wasn't so bad. Since the war began, a maid has been out of the question, and so all the work falls on my mother. I don't do anything at home because I go to work very early and come home very late. In fact, I see Tommy only on Sundays. She's always sleeping when I'm home.

Abie just left yesterday after a two week leave. He's quite all right now, although definitely blind in one eye. His other eye was saved. His face is hardly marred, though he isn't as handsome as he had been. He made a very unfortunate marriage three years before the war and divorced his wife just now, while he was on leave. It's a rather unpleasant business as we have to live together because of the shortage of rooms in

Moscow. However, I hope that will straighten itself out. Too bad his marriage wasn't as happy as mine. He swears, "Never again! Once was enough!"

Though I'm sorry I spent my adolescence and youth as I did, I remember those years with pleasure — it was good while it lasted. Now I'm such a terrible grouch that those years seem wonderful. But it's no use crying over spilt milk — one can't relive and remake the past. The real tragedy of youth is in not knowing enough of life and the world to be able to make correct decisions on one's future. One's outlook isn't, and very seldom can be, broad enough and understanding enough. As a result, your whole future may be ruined.

Well, with my present pessimistic view of everything, I'd better stop now. I suppose time will heal all wounds somehow, and perhaps then the future will have a brighter view.

Could you write me of the American and English literary world? I understand there are many new good writers in the States now. Who are they? What are the new books? I've become an addict of the detective novel! Really! There's great difficulty in getting really up-to-date literature in English and you grab what you can get. I've been using books as a medicine since Max is gone. Since the day he left, I must read at least for half an hour in order to be able to sleep. If I don't read, I can't sleep, but toss and turn all night and get up unrefreshed and tired out. Since I've known of his death, it is still worse. As a result, I've read extensively over the years and not having much choice in reading matter, have become really interested in detective stories. It's fun to try to guess the solution and see if you're wrong or not and where you made your mistake in deduction. Imagine, I'm crazy about detective stories! Sayer, Van Dine, Christie, and the rest!

Well, look how much I've written! As soon as I can, I'll have Tommy photographed. Everybody back home asks for her picture, but I have none right now. The last I took of her was in 1941, just before the war, together with her sister. But I'd love to have a picture of you and your son.

I hope to hear from you soon. Do be a good girl and write. Regards to the folks and Eddie.

Eva

July 11, 1946

Dear Rae,

I've written you so many letters in my mind that I've forgotten what I actually did write and what I meant to write. I'm really ashamed that I haven't written for so long, but part of the time I really was in no condition to write, and when I was in the mood, I had no time. I've been ill twice since I last wrote — the last time pretty badly — just got up a few days ago. The first time was during the school year, and I had to make up for lost hours both at school and the university. This last time I became ill during my last exam at the university and barely managed to finish it. But I lost the first ten days of vacation by staying in bed. Please, Rae, try not to mind my irregular correspondence. When I'm in a bad fit of the blues, which sometimes lasts for months on end, I don't dare write. I don't think you can understand what your letters mean to me. It's not mere sentimentalism, but though we know so little of each other's lives, I somehow feel that you, of all people, can understand me better than anyone, just because we were so close for so many years, and such important years. And I know I understand you. I see that from your letters, and I understand what you say about our upbringing and all else that you touch on. I understand, I mean to say, your meaning, and funny as it may seem to you, I somehow feel closer to you than to any of the others.

Oh, dear, there's so much I want to write about, to answer, that I know I won't manage at one sitting. But now that I have a little more time, I'll be able to write more often. And you, please Rae, try not to mind my irregularity and write to me. I can imagine how busy you must be now with your new baby, but I'm sure you will be able to manage a few lines now and then.

Firstly, I thank you from the bottom of my heart for the books you sent for Tommy. We're going to begin our English lesson in a day or two. You can imagine how badly I want Tommy to know and love English. Sad to say, her English was much better before, when we were all together. Max and Abie made a big fuss over her and were always teaching her poems and songs. And then we always spoke English at home.

For the first three years of her life, she knew only English, as we didn't let the maid near her and Max and I did the upbringing between us. One or the other of us was always at home with her — I, when he was at work, and he, when I was. We prepared very carefully for her coming, reading up on all the child psychology books we could lay our hands on, and as far as she knew, Daddy and Mama were always of one opinion. She never heard any disagreements there may have been between us in regard to her. He was a wonderful husband and father. While he was with us, the only times my mother was near Tommy were in the evenings when she was asleep and we went out. He used to bathe, dress, and feed her. He took the nightshift especially so as to be with her during the day, and he was a much better mother to her than I could ever hope to be. He was one of those "born" fathers. She was only three — not quite that — when we were left without him, and I was in my fourth month of pregnancy with Maxie. We lost him so suddenly and tragically that we all went to pieces. Up to the war, Valeria practically lived with us and helped with the children, especially with Tommy. She was afraid to handle Maxie as an infant, but as soon as Maxie was a year or so old, she took them both off my hands. Then when the war came and I was forced to evacuate, my mother took care of the children while I was at work, and she's had the care of Tommy since.

Can you imagine, Rae, that in my married life, Max and I lived alone, away from my mother, for only three short years? I think you can understand what that means. She and I do not agree on how to raise Tommy. At first I used to quarrel with her, but now I've given up. It's no use. I'm a nervous wreck and so is she — and we sometimes quarrel in Tommy's presence about her. You know what that means. But what can I do? I go to work at 6:30 or 7:00 a.m. and come home at 10:00, 11:00, or later at night. Regardless of our quarrels and my demands, my mother does as she thinks fit. She thinks she did a wonderful job with Abie and me and is very proud of her work. You can imagine, Rae, if you see your child only once a week, you don't want to spend that once in scolding and finding fault where she's not to blame, and though I know it's wrong, I'm so afraid of her growing up to dislike me. So you see why I'm all in a sweat. Nothing came out right in my life, and I consider myself a failure with a capital "F." Tommy never went to a kindergarten or nurs-

ery. I couldn't have gotten her in if I wanted to, and to tell the truth, I didn't.

The Meltzes live about a half-hour's ride from us, but since the war, Valeria also works from early morning to late night and has no time to come here. Her husband also is gone, as are Al and my father.

Thank you for sending me *Freedom Road.* To tell the truth, I think it okay, but it didn't touch me like *Gone With the Wind.* That's my favorite. There are only a few copies in Moscow, and nobody I know who has one is willing to sell it. I won't die happy unless I have a copy of my own. If you could send it, I'd appreciate it ever so much. I'm in love with Scarlett and my heart beats a bit faster when I think of Rhett. In all the years Max is gone, I've read thousands of books, most of them nothing to write home about. There have been just a mere handful of good ones: Cronin's, some of Priestley's, and one or two of Aldington's. I've had to fall back on the classics until I can't bear them anymore.

I was so pleased to get your pictures. You don't seem to have changed much excepting in hair style. Kenneth seems to be a pocket edition of Ed. As for Eleanor, I can't make up my mind. She doesn't seem to be like either of you. But she's such a lovely all-alive looking baby in the picture you sent. She must be quite the little lady by now, sitting up and taking notice, besides needing loads of care. Does Kenneth try to help "take care" of his little sister? Tommy at three was impossible. She wanted to take care of "little sister" and it used to break my heart when she used to tell Maxie what a wonderful daddy they have and "wait — when he comes home, you'll see for yourself." Maxie at this time was about a month or so old.

I've put aside the only picture I have of both of them taken just a few days before the war began and will send it in a separate envelope. I haven't been able to take any of Tommy since the war. Maybe I can manage this summer. She is said to be very, very beautiful. Her face is a bit Mongolian in type because of her eyes which are shaped like the Asian. They're a dark, dark brown, almost black, and shaded by long, black eyelashes. Her hair, unfortunately, is of my color and texture — thin and straight. She has a little round face, our nose, and a big mouth. When she was first born, at the maternity home, all the women thought her father to be Japanese or Chinese.

Maxie wasn't beautiful. I never saw such a homely newborn as she was. While Tommy was born with brown eyes, Maxie's were green, and I was happy that she had at least Max's color eyes, but after a short time, they, too, turned brown. She also took after my family. They say that Tommy is a picture of Abie when he was her age, while Maxie was like my father. She had curly, auburn hair (how Tommy's heart broke because little sister's hair was curly and her own straight). Maxie wasn't as pretty as Tommy, but had much more spirit. She was such a handful! I'm still bitter, and can't forget the fact that poor Max, who was such an ideal father, never even saw his second daughter and knew her only through photography. He died just a few months after her, not knowing that she was already dead. That's very hard to remember. I don't know what she died of. Tommy got some children's contagious disease and Maxie caught it from her. Maxie died within fourteen days. Tommy lay more dead than alive for over a week, and altogether she was sick for two and one-half months. It was some children's disease with complications I suppose. She had a terrible relapse when she found that beloved little sister was dead, and I almost lost her too.

I've written so much, I think I'd better stop now. I'll continue in another letter soon. There's so much more I want to write you, but I'm tired now, and so thick a letter will have difficulty getting to you.

Our best regards to all of you. Please tell your mother I've heard nothing yet of her relatives. As soon as I do, I'll let her know.

Eva

August 28, 1946

Dear Rae,

This morning I received your letter telling me of your plan to move to Los Angeles. I hope everything works out as you like and you can settle down there. There's no denying that the climate is better than that of Chicago.

I am sure that by now you got the letters and pictures I sent you before I left for vacation in the middle of July. For the first time since my father and Max have been gone — almost ten years — I've had a real

vacation and I think it did me lots of good. For over a month I did nothing but sleep and eat, and for the first time since before Tommy's birth, I went swimming. I was in Odessa which reminded me so much of home that I was reluctant to return to Moscow. Tommy also fell in love with Odessa and didn't want to come back here, but she became too lonesome for Granny, and so consented to return. She can get along without me, but not without Granny. I can't blame her, of course. Granny's raised her since Daddy is gone and since I've had to be working all the time.

When I returned a few days ago, I found two copies of the speller which you sent. They came later than the books I've written you about. Thanks ever so much. It'll help a lot in my work.

I've dropped the work at school, by the way, and I am staying on only at the university. I hope that with the university work and private lessons I'll manage not too badly. I found it too much of a strain working at both places.

To go on with some of the questions you raised in your last letter — about the relationship between Abie and me. If not for the war, Abie and I would probably be on the same terms that you remember. Of course, our upbringing was responsible for the jealousy and mistrust of each other. The war and our separate as well as common troubles brought us so closely together that we're more than the best of friends. I wish I could show you the letter he wrote when I told him about Maxie's death. I was so touched by it that I couldn't then, nor can I even now, express my feelings about it, and I'm sure you, too, would be surprised to learn how he felt — and suffered with me. He's crazy about Tommy and was terribly broken up by Maxine's death — which wouldn't have occurred if not for the war.

Tommy saved my sanity when I lost both my Maxes — the little and big — and is the only reason for my existence now. Isn't that a selfish reason to want a child — just to save yourself?

I'll stop for now and continue with some of the other subjects you bring up in my next letter.

Best regards to Ed. Abie sends his regards.

Eva

October 4, 1946

Dear Rae,

I got your letter letting me know of your arrival in Los Angeles. Oh, I do envy you that lovely climate and city, if one is to believe what one reads. Our long, dreary winter has started. There's no snow yet, but it's rain, rain, rain all the time — and cold! We feel it right to our bones. We've had no sun for I don't remember since when. And it's damp and depressing everywhere and all the time. How I hate the Moscow climate! We have only three months of what approximates warmth, and the rest is rain or snow and cold all the time! During our evacuation, we lived in a hut and had a nice, large yard such as you describe yours. You couldn't really call it a garden. The few short months of summer, the kids spent playing there all day. We even used to warm up water in a tub in the yard and bathe them there. Of course it was a far cry from what I imagine your place is like, but under the circumstances it wasn't so bad, I suppose. The trouble was that the war counteracted any good the kids could get out of the fresh air and lovely yard. The cows, sheep, and other animals all shared the space with the kids! They need food, too. However, our landlord let the kids do as they pleased and play where they wanted to.

We're expecting Abie home by the middle or end of November. At last he's being demobilized!

Now that you are in L.A., I'll have to write to your mother in Chicago that so far I've not been able to find out anything about her sister. There are so many people not yet accounted for. I hope to hear soon if she's alive, and where she is.

I hope you get this letter in time to receive my heartiest congratulations on your thirteenth wedding anniversary, and my very best wishes. I don't know if you've received any more of my letters after the pictures. I'm impatiently waiting for your letter, or I should say, letters. I know how busy you must be with two children and a house to look after. Just imagine, Rae, I know no more about housework and its duties than I did at 19. I don't think I could cook a meal to save my life.

Well, enough now. Regards to Eddie and kiss the kiddies for me. Regards from all of us.

Eva

~

November 9, 1946

Dear Rae,

I've been wanting to sit down and write you since receiving your letter a few days ago, but simply didn't have the time, not even during these three days of holiday. Valeria came over and stayed for two of them, and even with her here I've been preparing for the exams, which I had on the eleventh. My Juniors are going off on practice work and are having their exams now instead of at the end of the term. That means that all last week we had written tests on the semester's work, and now I'm preparing my exam cards. So this letter is really only a note.

About your dream — my dearest dream is that just that will happen, but unfortunately it doesn't depend upon me, and the fear that it'll remain only a dream adds greatly to my pessimistic and unhappy frame of mind. I think only that may cure my depression and pessimism [*Eva is referring to her desire to return to the United States*].

Darling, you mustn't believe everything you hear and read! What stuff and nonsense about working mothers! And tell Eddie, on the value of architect's work, his idea is all wrong. He doesn't know what he is talking about. I do. Let well enough alone. Tell him for me.

I couldn't have gotten Tommy into a kindergarten because I have a mother to care for her in the first place, and because, secondly, both her parents were highly paid workers who could afford a maid. Having both a maid and a mother meant it was out of the question to get her in. Even before the war, there weren't enough kindergartens to go round, especially after the repeal of the abortion law. First choice went to those who had absolutely no one to leave a child with, and secondly, to those who were worse off financially. During the war, this also held true. Kindergartens keep children up to seven years of age and there are so many children that all this must be taken into consideration. I had a little luck in this respect during the summers. During evacuation, I worked as di-

rector of a combined nursery and kindergarten in a village. Nurseries are for infants from a few weeks old to three years; kindergartens from three to seven. At that time (during the war) the most important worry for us was food. So though neither of my children actually went there, they were rationed food from there. Unfortunately, we had no trained teachers there outside of myself, and I was always busy with the administrative work. My mother was at home with the kids. When I returned to Moscow from the evacuation center and began working at my old school again, my summer job was being a teacher. We had no vacations then and each teacher had some sort of work assigned her. I don't know the English for this kind of work. Actually, it was not teaching. I was in charge of the preschool age group in the summer playground attached to our school. 1 hated it, but my principal was wild about me at that work, considering me the best of all her teachers, and she always gave me the little tots instead of the older children as I asked. So, working in the summer playground, I was able to have Tommy accepted there although it was not in the district where we lived. She was fed there like I couldn't even dream of feeding her at home at that time. She went there two summers, the first summer altogether free of charge since I was pretty badly off; the second time at a nominal cost to me. Later on I had an argument with my principal and didn't have the nerve to ask her to let Tommy go to the playground again.

The fight was on the subject of my working in the playground for the third summer. I demanded other work because I was beginning to go batty from steady work with children since before the war without a rest for several years running. You see, I had just gone on vacation and was out only six days when the war began and all our vacations were, of course, immediately canceled. I was at last given work as a secretary at school during the third summer, and after our quarrel was settled, the principal herself suggested that Tommy go to camp instead of to the playground. The camp didn't turn out as well as the playground because it was the first time Tommy had spent more than a day away from us, and she suffered greatly. Her great dread to this day is that Mama may disappear like Daddy did, and she was worried all the time she was there that she might come home to find me gone. I went to visit her at camp once, but she had such hysterics that I thought it better not to go again.

Did I say this was to be a note? Now it'll be "continued in my next" as it's already 4:00 a.m., and I have to be up early to finish my cards before I go to work.

Eva

∽

November 13, 1946

Dear Rae,

Here's my "continued from last issue."

I can't agree with you on *Gone With the Wind*. One of my greatest wishes is to get to see it in the movies, although I am afraid that the picture is not as powerful as the book. It seems to be so bigoted — just like I was as a youngster — to condemn the whole thing because I may not particularly agree with every word in it. Personally, I think it is one of the most powerfully written books I have ever read, and so far, everyone here, that is the English-reading people who have read it, agree that it is a wonderful bit of literature. I know nothing at all of the author outside of her name, but I'm willing to stake plenty that she's a Southerner. I must admit I envy Scarlett her unscrupulousness and wish I could be as decisive as she in that when she wanted something, she just went out and got it and didn't care whom she trampled on her way. As for Rhett, I have nothing but admiration for him — a wide-awake man who took his opportunities as he found them and didn't let himself be bound by any traditions. He changed with the times and didn't sit around and mope and wish for the old days as Ashley did. And how I sympathize with Ashley! He finds his world gone to pieces and knows he is helpless to stay time and the march of events. On the question of the Negroes — I didn't find myself hating them after I read the book. It was only natural that those uneducated, ignorant, simple people could so easily be made the dupes and tools of political adventurers, which, you will have to admit, made the Reconstruction Period so much harder and brought more confusion than was actually necessary. And don't forget that quite a great section of the U.S. population feels about it all as the author does. They can't help feeling even now that the Emancipation Proclamation and the Civil War ruined their lives. And is it wrong

for an author to picture and explain the attitude of a great part of the population? What is the author's job if not to picture events as he sees and understands them?

For the time being, Rae, don't send any books until I write to you, as I haven't received the two yet. When I get them I will let you know. I am very grateful to you for sending them. I don't know many people, and no one has any new books at all. But I hate to have you spend your money on them unless I'm sure I get them.

I agree with you on your analysis of failure, but you see, Rae, that's just why I am one. I was too dumb in my youth to understand lots that I understand now, and if I had my life to live over again (oh, how many failures have said that and wished it), I would certainly spend my school and college days altogether differently than I did. The only thing I would repeat is my marriage. It was wonderful while it lasted. I would try to live a more normal life — to be a flapper, etc. I spent my youth and energy in the wrong direction. But it's no use crying over spilt milk, though that's what I do day and night. By the way, it may interest you to know that some of my first quarrels with Max were over you. He didn't care much for the kinds of activities I had chosen to do and thought I was making a terrible mistake in not keeping and being closer to you than I was. He respected you more than any one of my other friends and wanted very badly that I be more influenced by you than by those who influenced me in another direction. Now, of course, I see and understand much better in that respect. I wish I had then.

Tommy was thrilled to note in one of Kenneth's pictures that American children also have Christmas trees. My telling her didn't mean as much as her actually seeing even a tiny part of one. She's been busy this last week preparing toys for the tree. Here we put it up for New Year's Day. Christmas is unknown except by the old religious people. And even for them it doesn't mean much — just a plain holiday. The big religious holiday for believers is Easter. I haven't been to a service yet, though for years I've wanted to go. They say Easter service is extraordinarily beautiful.

I wonder if you could do me a favor. The fad now for girls of Tommy's age is collecting pretty picture postcards. Could you send a few suitable ones for her? Little cute girls and boys and dogs and cats

and bunnies. As soon as she can write decently, she intends to write to Auntie Rae. Auntie Rae is remarkable because her birthday comes on the next day to Tommy's own. Old sentiment, you know. Ever since she can remember, on her birthday she's heard, "Tomorrow is Rae's birthday. I wonder what she's doing and what she's like." When she got old enough to be interested, she asked about you and of course I told her. So she feels especially close to you. I suppose she pictures you as a kid. She's seen many pictures of you, long before I'd heard from you, and she used to ask me to tell her about when I was a little girl, and naturally she heard of you. It's strange, but she's more interested in you than in Kenneth, although I suppose not so strange, as she's seen you as a little girl in pictures and I suppose her mind can't make you grown up like I am. She doesn't care for the last picture you sent — that's not Rae. Rae is a little girl. But she knows you in other pictures, too, as an adolescent. She calls you Auntie Rae because I preface any grownup who is closer than an acquaintance with "auntie" or "uncle." I don't like children calling their elders by given names without prefacing it with something. Maybe that's the effect the Russian language has on me, with polite and familiar "you" like German "du" and "sie," and children are not encouraged to call adults by given names, but instead either by name and patronymic or "aunt" and "uncle."

Well! I think this is enough for this time. There are still many unanswered questions, but I'll try them in the next letter as I want to send this off.

Best regards to all.

<div align="right">Eva</div>

~

<div align="right">January 12, 1947</div>

Dear Rae,

This is starting out as a short letter. I haven't had the time recently to write, and I want to finish this in one sitting. I'm a little more free now as the examining session is on and I've already had two of mine. I have only one more left. After that we have the midwinter vacation. That's why I hope to be able to write again soon.

I want to thank you in Tommy's name as well as mine for the lovely Christmas card. She thinks it's lovely and is as proud as Punch to have it sent in her name. Since we have neither Christmas nor New Year's cards here, she's decided to draw one for you for next New Year! Our Granddad Frost is what American kids call Santa Claus and she intends to have his figure in the drawing.

She's doing rather nicely with the books you've sent but unfortunately I haven't the time to check her regularly, so the going's slow. I am thinking over what your wrote in regard to my attitude to Tommy. I've decided that you analyzed it rather accurately. There are two reasons I want her to know English. The first is as you say, although I must admit being stupid enough not to have realized it myself — or was it that I didn't want to realize it [*Eva is referring to her homesickness*]? The second is that with the knowledge of a foreign language here, one is always assured of his bread. I hope to be able to put Tommy through college, but if anything should happen to prevent me, I can feel that she will be able to support herself until she manages to do whatever she decides on. And then, English is handy to have at one's disposal and one can never know how useful it may be. Here the knowledge of languages is very, very important. She herself is ashamed at not being able to write to anybody after what they've done for her. She thinks she ought to write herself, and not to have to depend only on me. That's why she wants very much to learn to read and write. I feel guilty every time she asks me when I'll have enough time to give her a lesson.

I see that you understand me quite well. We'll have to let the whys and wherefores ride awhile.

Abie isn't home yet. In his last letter, he wrote that he hoped he'll come home. I do hope he will — it'll be a change from this deathly rut I've got into. So far we've heard nothing.

Will you please write your mother for me that I haven't had any luck so far in finding out about her people. I'll write her myself, too.

This will be all tonight. I'll try to write again soon. Best regards to Ed.

I'm a bit late, but as we say, better late than never. Best wishes for a really good year to you all.

Eva

February 8, 1947

Dear Rae,

It's so long since I last heard from you that I'm wondering if everything is okay with you and yours. I hope the kids are all right and the same holds true for you and Ed. Not having heard from you for so long, I don't know whether you got my last few letters, so won't write much now.

I'm ashamed to say that I still haven't got around to taking Tommy's picture. However, sooner or later I'll get around to it.

The latest from Abie is that he'll be home by the end of this month. Well, I've turned skeptical. Seeing's believing, and I'll believe it when I see him. By the way, in spite of all of his vows to the contrary, he seems to have found a lady friend in Leningrad.

Tomorrow's Election Day. We're voting for the bloc of Communists and non-Party member Communists.

I haven't received the books you've sent. Who are the authors of *Deep River* and *The Folded Leaf*?

Our new term started yesterday, and so into the rut again.

Well, enough for now. Best regards from us all to all of you.

Eva

March 23, 1947

Dear Rae,

There are two of your letters, one received quite recently, which I've been wanting to answer for quite a while, but I know my letter should be a long one and I can't somehow find the time to sit down and write a long letter. So I've decided to write as much as I can manage now, and if I don't finish, I can continue it later, or send it as is. So here goes.

First, I want to tell you how grateful I am for the two books I've received, *Deep River* and *The Golden Leaf.* I enjoyed *Deep River* and hope to manage to read the other one soon. Of course the movie magnets would never dream of using *Deep River.* It shows up too much of what

was — and is — doing, but I should think that the descendants of that "poor white trash" should be among the proudest Americans today, and in the forefront of the fight for Negroes' rights. And there should be quite a number of them. Those mountaineers were heroes, fighting for the real and true American ideology and spirit.

But still, I think that though the book is strong and true, it's not as strongly and emotionally written as *Gone With the Wind.* You seem to think I agree with the ideas promulgated in the latter. Not at all. I merely insist that it's one of the strongest, most emotionally written books I've ever read, and I repeat that I enjoyed reading it and would enjoy reading it again. I think that the language and depiction of the characters are much stronger than in any of the other books we've discussed and the poignancy of certain situations is so sharply done that you can't help but sympathize. As for the ideas it contains, both history and other writers have shown where it's all wet. The reason I admire Scarlett and Rhett is because they're so unscrupulous. They know what they want and go out for it — the end justifies the means. They're not bothered by morals and considerations of right and wrong. Perhaps the last few years of my life have forced such admiration on me. Perhaps it's mere envy that someone else had the courage which I lack. I could never, given the opportunity, act as they did to achieve my ends, to fall so, morally. My conscience wouldn't allow me. They had none! So you see, I'm not so admirable a person!

On the subject of the Jewish problem — that is a real shock to me. I don't remember any such problem as being vivid and important to us. Hitler seems to have done part of his work only too well. You know Tommy's parentage, but nevertheless, she suffers dreadfully from the same complaints, and not only she, all do, and in a very crude and rude form. Do Jews still congregate in Jewish neighborhoods, each nationality sticking to itself? I should think that the great melting pot that is America should have managed by now to assimilate all nationalities, including Jews, into one — the children born of immigrants. I suppose there are very few immigrants there now, I mean on a mass scale, newly arrived, and their children certainly have nothing in common with old tradition and history, not to speak of the language. He's just an American kid [*it is not clear here to whom Eva is referring*]. I'm really terribly

shocked over it. It doesn't seem possible in a modern enlightened world. But again, there's a reason, and it is divide and rule. Will the Jews have that hatred and stigma until the end of time?

Why was my father a little God to us? Because he was, and still is one to my mother. She really considered him the wisest and cleverest man in the world. Oh, maybe Lenin was a bit brighter, but not much! In our very early childhood we saw very little of him, but were imbued with that high opinion of him by my mother. I don't think he realized what he was doing when he encouraged such an attitude. He really believed he was liberal and let us come to our own conclusions on all questions. And such was our respect for him that we really thought he did so. Of course he failed us. I'd like to discuss it with him and get his viewpoint on both our lives and on the raising and education of children.

As for Abie, he's not home yet but is due any day. He's already demobilized, but is spending a little time in Leningrad. He's grown to be a man. Two factors caused that. One, of course, was the war. The other, before that, was when we bade Max farewell knowing we'd never see him again. His last words to Abie were, "You're the only male left in the family to take care of our women." Abie evidently took it to heart. His marriage was very unfortunate. It's a long story as to how and why it came about, and certainly understandable and excusable when you know the facts, but, as you know, he always had more girlfriends than boyfriends and should have been able to judge. As it was, she made as bad a mistake as he did. She took him for a rich American. I'm almost certain there was no love involved. During the short period before the war, she was more or less satisfied, but she'd already realized her mistake. During the war it became worse. He a private throughout the war, without rank, and not so rich as she'd thought. She didn't act very decently while he was at the front and "kind" friends let him know. She hasn't a single interest in common with him. So he decided it was better to cut it off entirely than to go on as they were.

Dear Rae, you have such funny ideas on things here. You mustn't believe everything you read and hear.

I think this will do for now. Will try to write soon again. Perhaps it's better to write oftener and shorter letters. Write about yourselves. How's Eddie's job coming on? Is he still working? And how are the

kids? Would it be easy for you to get a job? I think you once wrote you'd have to take State exams to be allowed to teach in California.

Well, enough. Best regards to all.

Eva

~

March 29, 1947

Dear Rae,

We got your photographs this week and Tommy asked me to write and thank you in her name as she's not yet up to writing a letter in English herself. Unfortunately the valentine was missing [*removed by the censors*].

The kids are lovely. I'm crazy about Eleanor. She must be the kind you like to cuddle. As for Kenneth, my mother says, "Why, there's Rae. You couldn't mistake him for anybody else's child!" I can't quite make up my mind. In most of the pictures of him that you sent, his eyes seem to be very serious, as if he's quite a serious little man. You must tell him that as soon as he is able, he should write to Tommy. She makes out quite well with printed matter already, but writing English is still difficult for her.

Your sending me so many photos makes me feel like a real slacker. I've been promising so long, but still have nothing to send. I have no camera of my own, and going to the photographer's means time and opportunity. But I hope that the snow will be finally melted in a week or two and it will be a bit warmer. Then we'll go down and get it done.

So far there's nothing new here. The long winter seems to be coming to an end at last, and then perhaps my mood may improve. You know what your letters mean to me, so do try to write whenever you get a chance. Regards to Eddie and the kids.

Eva

~

April 20, 1947

Dear Rae,

I've been wanting to write for quite a while now, but have been

badly pressed for time. Abie has come home at last and there's so much to discuss and settle after this six year separation. And as if on spite, I'm so overloaded with work now that I have scarcely time to breathe. All in all, we're having a rather exciting time at home now, what with Abie's matrimonial affairs and my work.

To tell about Abie, in some way he seems to be changed, in others just as he was. I wrote you that he'd divorced his wife. She's a rather nasty type, and since we all live together you can imagine the fun. Life is a bit less monotonous now with her scandals. She wanted him to return to her; husbands are hard to get now. But when she saw that he is quite determined to have nothing to do with her, she began storming. But the beauty of it all is that though he at first said he was through with marriage, he's decided to marry a widow he met in Leningrad while serving in the army there. He wants to live with us and tried to convince us to move to Leningrad, which he likes much better than Moscow. Neither my mother nor I want to move there. I'm more or less settled here, have quite a reputation in my profession, and am used to Moscow and its ways. I don't feel young or energetic enough to start all over again — which such a move would mean. The trouble is there's no room to bring his new wife here and it's obvious we can't all live together in one room. So now we have to try to change rooms. In the meantime, Sonya, his new flame, keeps on inviting my mother and me to Leningrad. So I may run over for a few days during the May holidays to get acquainted and, incidentally, to see the city. I've never been there, and it's supposed to be the most beautiful city in the country as well as one of the few European-type ones. But you can see what a mess it all is, how exciting and unsettling. If there's anything I hate, it's this fish-market kind of screeching and yelling and scandalizing.

I have recently read a book which impressed me so that I haven't been able to come to yet. I seem to be in a haze. Nothing seems actual or real to me. I find it hard to concentrate on anything and work is agony. I want only to sit and think for the time being until I find myself again. Unfortunately, I had the book for only a few days and didn't have time to read it as thoroughly and carefully as necessary. If you haven't read it, you must. It's Joseph Freeman's *Never Call Retreat*. I feel it's one of the few really great, outstanding, and important books of our century, and

I'm certain it will live and live. I had thought I was so deeply affected by it because of my present psychological state of mind, but an acquaintance of mine is reading it now, and though she hasn't finished it yet, she's in the same state as I. Rae, you must read it. Every person interested in a secure, happy life for mankind must know this novel. I'm certain that as soon as it's discovered here it will be translated into Russian.

Which all brings me to a rather delicate question. I've read about the new measures in regard to government employees in your end of the world. How it was allowed is beyond me. Can it be that the public is still blind after this horror of years? At any rate, if our correspondence in any way jeopardizes you or Eddie, I won't feel hurt if you let me know and will understand. I haven't heard from you for a long time and don't know if it's to do with your personal affairs or this big one [*Eva is referring to the anti-Communist hysteria of the McCarthy era*].

And now Rae, I'll finish. I hope you get this letter in time to get my heartiest congratulations and best wishes on your birthday. We're not so young as we were, but you're not among those who want to hide that awful 37! Anyway, my best, best wishes, Rae, and hopes of seeing you have the kind of life you want for yourself and yours.

Regards from Abie and my mother.

Eva

~

May 25, 1947

Dear Rae,

There are two of your letters I want to answer now if I can manage to get it all in one letter. My very busiest season has begun. I have to sit days listening to reports on outside reading (of course the damn students always leave that to the last day as if putting it off that way makes it any easier for them or me!) and also examining. I hope to have the brunt of it over by the first of June and think my vacation will begin on July 1.

I've received *Gone With the Wind* at last and have read it much more critically than before. Of course, there's no disputing it, the whole thing is just permeated with out and out frank hatred, and reading it

with so different an attitude now, I'm terribly shocked at the idea that almost one hundred years after it happened, there can still be such bitterness about the South's defeat and such hatred of the North. After all, the actual men and women who lived through it are dead and gone, but they certainly managed to convey their feelings and impregnate their children and children's children! The first time I read it was years and years ago, shortly after I had lost Max and my whole world had crashed about my ears. I still haven't gotten over the latter tragedy, but *Never Call Retreat,* which I wrote you about, has helped me a little, though not even that has cured me entirely. But strange as it may seem, I still like the book, and its plain bare story of Scarlett and her struggles and life; and Rhett with his practicality, even though he is such an out and out opportunist. After all, Rae, one must change with the changing times and not be downed. As far as Scarlett's life is concerned, her unscrupulousness and devil-take-the-hindmost attitude helped her to get on her feet. The fact that she was a bitch, well, there's where we people of principle and sense of decency and honesty are at a disadvantage! Not knowing me now and the whole cause for the change in me — it's so long a story to write — you won't be able to understand my comparing myself to Ashley. But in spite of my contempt for him, I understand him perfectly because we are both of the same cut. When you read Freeman's book, it may be a bit clearer. I was lost and heartbroken when I read *Gone With the Wind* first, and it affected me so because there was so much, it seemed to me, that was analogous to my unhappiness and loneliness, and I suppose that's one of the reasons I still like it. It was a bit soothing at the time. I didn't go in for drink or love affairs. I went in for books. In *Never Call Retreat,* he went in for movies. You see, each seeks some escape. Mine was and is books and because *Gone with the Wind* helped me so in one of my darkest hours, I suppose I still have a sneaking affection for it.

June 7

This is turning into a diary. I haven't had a minute since I started this letter and I won't finish it now either, but I'll try to send it out anyway, finishing when I can.

You have a clear picture of our domestic affairs. We had two rooms, one in which Abie and Natasha with her daughter lived; and in the other my mother, my kids, and I lived. Abie married after Max and my father were gone. According to Soviet law, because of the room shortage, when people divorce the room is divided between the husband and wife, each child also getting an equal share. If it is of such construction that a partition can be put in to make separate rooms, that's usually done, but if not, the court "suggests" that the room be changed for two, together making the same size as the one being changed. Ours cannot have a partition be put in. Natasha didn't marry for love — I'm certain of that. She thought Abie was a rich American. She pauperized us, as she was home throughout the war and sold and used not only Abie's clothes, which legally she had a right to do so, but ours also, which she had no right to do. However, being what we are, we never sued her nor said a word. We came home literally naked, and neighbors collected and gave us clothes to wear so that I could at least leave the house and look for work. It was rather painful to see her wearing our things while we had to accept charity. But she was Abie's wife and we didn't want any scandals or quarrels. Now, though she has a room to go to, she wants her pound of flesh — for two reasons. First, a room, even a part of one, is a fortune here, and she's certainly not giving away a fortune. That's what she married for, to get what she could out of it. Secondly, she hates our guts and wants to make things as nasty as she can for us. But she isn't satisfied with only her two shares. She wants the whole room, so she changed the lock on the door and locked us out of our own room. Now we're suing to get our part opened. I don't know how it will all end. The court decisions, according to law, should force her to open and let one of us in. Imagine how nice it would be to live with her! So we're trying to change both rooms for three small ones, one for her and two for us. Abie's new wife will be coming soon. She's still in Leningrad, and we certainly can't all be in one room as we are now. We haven't been able to reach that level yet and to look at it as natural. If I ever get ambitious enough, I may write a novel some day about Natasha, Abie's first wife. I swear you have to see and know such a person to be able to believe there can be anyone like that. Maybe I'll describe her to you some day. Now it would take too much time, and you couldn't believe half of it anyway.

All in all, she tries to make things as unpleasant as possible, by doing petty things such as throwing garbage on the kitchen floor. We think it beneath our dignity to quarrel with her, but are sore as hell. Generally, home "ain't" home anymore. It's hell!

Besides all this unpleasantness, I have a personal, private trouble of my own, which I haven't told at home. It's unpleasant enough at home without my adding to it. The fact is that one of my post-graduates pretends to be in love with me, and in spite of my very plain and clear explanation of my opinion of him, he persists in his lovemaking, which nauseates me. I know him to be a skirtchaser, and my being a widow, still comparatively young, and so "stand-offish," showing no interest in men, intrigues him. He's supposed to be quite an important poet, and women run after him, so I suppose I'm more interesting since I have no use for him. He's tried physical force on me and I'm terrified of him. I'm afraid I may not be able to fight him off some day, and I can't bear him. As a person I didn't like him much before, but now I actively hate and fear him. I have to work with him until July 1 and can't say anything at work. I'm not a defenseless eighteen-year-old, and I'm certain if I speak to my boss of it she'll only think I led the man on. But it all adds to the unpleasantness and hatefulness of life these days. If I were a Natasha, I suppose I'd become his mistress. He's a well-known poet and writer, has two rooms right in the very center of town, and a country house. Just imagine, all that but for a mere little detail as dislike, both moral and physical, for a man!

Well, I have to go to work now, so I'll stop. As you see, this letter is all about poor me and my troubles! I must seem an awful whining type of good-for-nothing. But I hope you understand, Rae, that I have no friends here, and somehow it seems to ease me a bit to discuss my troubles with you. I hope to have a little more time soon, and then I'll write again and try to make it a more cheerful letter and to answer your two, which, as you see, I still haven't managed to do in these four pages.

Best regards to all of you.

Eva

July 4, 1947

Dear Rae,

The rush is over and I'm on vacation at last. Just two more evenings at the night school and then I'm altogether free until August 26. Great, eh?

I have loads I want to write you about, and I think I'll be able to do it gradually now. The trouble is that when I get your letters, I imagine the answers I'm going to write and then I begin to forget what I did write and what I had only thought of writing.

As usual, I'll begin with your last letter which I received a few days ago. Our rooming situation is a pain in the neck. The trial took place last week and Natasha was ordered to let us into our own room. So far, she refuses. That means that we have to get an official to come and open the door. Next week I'm beginning the merry-go-round to see if we can't change our rooms. It's impossible to keep on living this way. But changing is also no joke, with so much red tape to go through before you get permission to change, and then it's hard to find what you want. The people who have the sort of thing we want aren't likely to want to change. Things, as far as I know, have always been this way in regard to housing. So all in all it's a grand mess.

As to my poet and my attitude to men and love, I'm not so naïve and foolish as to think I can be unfaithful to a dead man. If I could bring him back to life by continued "faithfulness," I should certainly go on forever. But I look at the whole question practically, as my poet says, with the too practical mind of the American. I have an idea of the sort of man I would be willing to marry — oh, I don't mean school girl ideas and such nonsense — but one who could be a real comrade and companion to me as I to him, one to whom my ideas, thoughts, and feelings would not be foreign and would be understandable. I understand, of course, that I could never love again as I did before, but I could have a more mature feeling of respect and affection, if not wild passion. That kind of man may be somewhere. But I'm not in a position to go places and meet people where I could become acquainted with such a person. I don't want to marry badly enough to turn to matchmakers, who have come back into style again. Imagine the indignity of turning to them! Theoretically, I don't see anything dreadful in a woman in my position

taking lovers if nothing more permanent is in the offing. Practically, I find I can't do it without at least some mutual respect and a little affection. Besides, looking practically at things, abortions are illegal here now and cost a small fortune if you do find someone to perform one. This is a very important factor when you know the attitude of men here nowadays to lovemaking. There are dozens of women to one man. But putting all this aside, it wouldn't matter if I cared enough for a man. It cost me years of torture to train my body to its present state of calm celibacy. It wasn't what one could call a pleasant struggle, but for the last few years I'm evidently okay in this respect. I don't need a man anymore, at least, not consciously. I don't want to upset this hard-won calm to go through all the torture again, and it would be inevitable if I took a lover. That's why I've never had a lover and am afraid of my poet. I'm certain he doesn't love me. He's merely intrigued. He knows my reputation as a very formal, cold woman, rather an automaton, who doesn't seem to have any personal life as far as anyone knows. It would be a feather in his cap if he could bring me out of my state of ice. He's a skirtchaser and has many women, in fact, he boasts that women run after him. I can well believe it, but I don't care to be one in a collection. I don't respect him in the least. We haven't a common idea between us. I have no use for his philosophy of life while he doesn't even know mine at all — what I think, what I want, what I feel. And I don't think he cares. I can't believe a man is in love if he doesn't try to find out and understand the woman he claims he loves. I could respect him more if he frankly said he wants me as a woman, but all this bunk about spring and love and the beauty of life — bah! Why, he doesn't know me. How can he love me? If he really cared, he'd try to make me love him by other means, not physical rape. To me, the physical act of love is the final expression of all feeling between a man and a woman. Otherwise, it's mere animalism, which is what my poet is interested in. Have I still too many unreal ideals left? I don't know. Maybe. But I must have some ideals left to make it possible to go on living. I knew his wife. She seemed a very pleasant person, but I remember always feeling sorry for her. She was such a quiet, beaten-looking creature. I may, of course, be mistaken. He acted very terribly upset at her death. I hope it was really sincere. I don't know.

I gather you have read Freeman's novel. Do you remember the life of the poet in the German concentration camp just before his execution? That sort of thing is very, very hard to forget and it leaves a mark on me that isn't easy to erase. The knack of making friends is lost in spite of all efforts. You see, one loses all confidence in people.

The constant bickering between my Uncles Red and Sam also make life much harder for me. Red just can't understand that one can see both bad and good points in both of them. So as a result, the breach never, never narrows and the wounds never heal.

No, neither Tommy's gift nor the book has arrived yet. I hope we get them.

I'll finish this now. There's loads more I'm going to write about, but I'd rather do it in shorter letters and more often. Best regards to Ed and the kids. I'll write again soon, and hope to be hearing from you soon, too.

<div align="right">Eva</div>

~

<div align="right">July 20, 1947</div>

Dear Rae,

Here I am again like the proverbial bad penny. I've begun several letters to you since my last of July 4, but I never got around to finishing any. So here goes, and let's hope this time I finish. I was pleasantly surprised that you had heard of our room trouble and my "love affair" as I didn't expect you'd get to hear of them. I wrote more about them in my last letter. Did you get it? In it I explained the reasons for my turning from life itself to books. If you got it, I think you will be better able to understand me and my present attitude to things, and my apathy to everyone and everything. You wrote you hope I won't be hurt by your analysis. No, Rae, I can't be hurt by it. First, I know you say and think it all for my own good. Then, what's so terrible for me is that I'm not so dumb. I know what's happening to me, and know what the probable result of such a dead, apathetic existence may lead to. But my misfortune is that I have no such friends as Paul (in *Never Call Retreat*) had to help him snap out of it. The only friend I have, Valeria, is in a worse state than I. Perhaps, understanding this, you can imagine what impor-

tance I attach to Kenneth's question about me [*Eva is referring to Kenneth's asking when Eva will visit them*]. I consider that my only salvation, and I'm doubly apathetic and unhappy because though I see in that at least a solution in part to my troubles, it doesn't depend on me in the least to carry it out. I might get a new lease on life if it were possible to realize it. But it's hopeless, and so that's that.

Luckily I have a few private lessons this summer, and I'm very glad of it. It's very important materially, but still more important for me morally. I dread my free days. There's nothing to do and nowhere to go, and I get so on my own nerves I don't see how the family can bear me! And horror of horror, books — the kind I like — are increasingly hard to get, and I seem to be overstuffed with trash. I simply can't read it anymore. At the same time, I'm tired of reading my beloved books for the twelfth and thirteenth time each. Having nothing to read — that will be the final calamity! I don't care for the movies, and I don't go to the theaters because I don't like to go alone. That's one thing my "boy-friend" would have been a blessing for, but I don't care to pay the price he demands for such "service."

My, what a whining letter! But don't pay too much attention to it. I've got a dreadful fit of the blues. Today is Sunday, and no one wants lessons on Sunday, so I've been home all day and have just finished a book that was terribly depressing in my present mood. It's *The Street of the Fishing Cat* by Jolan Foldes, translated into English probably from Hungarian. It's about a family of Hungarian emigrants in Paris, and their nostalgia and other troubles — quite close to home, eh?

We've settled the room question temporarily. We took down the wall separating the two rooms and put a new one up so that Natasha has her room space as a separate room and we have ours. Now it's an immense, barny-looking thing. However, when we get around to buying furniture, perhaps it'll look a bit more cozy. We haven't decided yet how we'll manage when Abie's wife comes. We just can't imagine all living in one room, though now it's so large a room. It's built in such a way that we can't make two small ones out of it. I'm afraid we'll have to winter here, as even if we do find someone willing to change two rooms for one, the red tape will take months to overcome, and winter is not the time for moving.

One thing I'm in a hurry for Abie's wife to come for is that she has a piano. Neither she nor her daughter play. However, both kids, that is, hers and mine, will have music lessons and I intend to try to start again. Perhaps it will replace books, though even I can't imagine carrying a piano with me on street cars to drown out surroundings! Books are handy that way! You read and don't know or care what's going on around you.

Tommy's leaving tomorrow for a five day camping trip with her school. To tell the truth, I'm a little nervous about her going out camping. I feel I have no right not to allow her. She's going with responsible adults and teachers. They're to study nature at first hand. Then, what do I give her at home? Thank goodness in addition to the one girlfriend she's had since infancy, she now has two more school friends and all four girls go places together and even go to the bath together. I'm very pleased as I realize that our absolutely abnormal way of living doesn't do Tommy any good. It isn't very healthy for a kid to grow up among a bunch of grouchy, neurotic crabs, which is what we have all become in our family. That's why I anxiously await Abie's wife, too. First, it'll be a change after all these years, and perhaps she'll bring a little normal life among us. Abie isn't like I am. He's much more normal and healthy mentally, but as he admits when he begins bawling me out, he wasn't as hard hit as I was. Perhaps between them, Abie and his wife can help me back to normalcy. Surely they'll have friends, and having people come here to the house — well, you just can't be a boor, can you? You see, I want friends. I really do, but I've lost the knack of making any because of my conscious or unconscious lack of faith and confidence in people.

Well, I wonder if I ought to send this out after all. Nothing but complaints! My mother has just come in and we're going to have our supper, so I'll close. Please write, Rae, without necessarily waiting for my answers. Perhaps you can understand why my child- and girlhood friends are still closest to me. I'll write again soon, and try to make it more cheerful. I'm a regular Calamity Jane, aren't I? These fits come on less and less often now than they used to, but you see, tomorrow, July 21, my Maxie would have had her ninth birthday, and I'm always in bad moods around that date. Max died in July, too.

Best regards to all of you there.

Eva

March 5, 1948

Dear Rae,

Got your letters quite a while ago, but somehow just couldn't manage to answer.

As you see, we're all right. Tommy had grippe and a sore throat, but got over both and is getting along nicely.

Oh, my dear, it's awful — much worse than his first marriage. I'm referring, of course, to Abie. His wife is impossible, and I imagine she finds my mother and me just as impossible. We were never on such terms with his first wife as we are with this one. I, for one, have very little to do with her. I don't remember the last time I spoke to her, not because we're angry at each other formally, but because there's absolutely nothing to talk about. I can't even describe her to you because you've never seen or met such a type and simply couldn't picture her. So we're working as fast and as hard as possible to separate — they alone, and we alone.

His first wife is much more clever than this one, and though the second tries, the first sees to it that there are no scandals. She told me frankly it's because she doesn't want to hurt me in the first place, and my mother in the second. All of a sudden she's fallen in love with my mother and me!

This heavy atmosphere of course colors my moods, and until I got a little more back to normal I didn't write anybody. I had hoped too much for an entirely different thing.

No, Rae, not Paul, but the poet [*characters in* Never Call Retreat] is my favorite. I feel closer to him because we both had the same experiences, except the last ultimate one. I may envy Paul, but love the other. So that's that.

This is just a note to let you know that we're all well and why I didn't write before. Will write again soon. Our best to all of you.

Eva

Between the Labor Camps and Emigration to Israel

Another break of several years in the correspondence between Eva and Rae occurred during the years of Eva's incarceration. They begin writing again after Rae, fearing that something might have happened to Eva, asked a friend traveling to Moscow to look up Eva. These letters span the last nine years of Eva's life in the Soviet Union, from when she was forty-nine until she was fifty-eight years of age. ⁓

October 18, 1959

Dear Rae,

It was one of the pleasantest surprises of the last few years to get your message. I was away on vacation in the South, and after I got back it was some time before I heard of your friend's visit here. I'm awfully sorry to have missed her. I'd have loved to hear all about you, the kids, and Eddie. So I'll be awaiting a letter with all the news. Kenneth and Eleanor must be quite big by now. How are your parents and your sister Gertie?

I live with Tommy. She's twenty-four now, not married, and says she doesn't want to be. I'm working at the same place — the Cinema Institute — still teaching English.

Abie is the father now of a four-month-old baby and is very happy. His son seems to take after our family, in appearance anyway. It's too

465

early to say what he's like otherwise. Abie works as a translator.

Well, I think this is enough for the time being. Please write soon, I'm very impatient to hear from you.

Best regards from Abie and Tommy.

Eva

P.S. My mother-in-law, 82 now, says she remembers you and also sends regards. She's a remarkable lady!

January 12, 1960

Dear Rae,

I can't say how glad I was to get your letter. I was afraid you might not have received mine and I knew of no other way to reach you than through your friend. At any rate, I'm grateful to her for sending my note on to you. Please give her my thanks and regards. Also, Anna Vladimirovna, with whom your friend left your message, was so kind as to hunt me up when I got home, and asks to be remembered to your friend.

As I think I wrote you, I wasn't in Moscow when your friend was here. I was on my vacation down South for the first time in years, and I'm very sorry to have missed her. Now my fantasy is meeting you when you come during your next sabbatical leave. I know quite well nothing is decided yet for you and that you may not come at all, but I like to think that you will.

I can't gaze enough at the photographs you sent. It's remarkable — even to me — how much Kenneth looks like you. As a small child he looked like you too, but not to the extent he does now. Of course, I can only judge by the pictures. He seems to have nothing of Eddie in appearance. Eleanor has something of you, too, but is not quite so only Rae.

Abie and I are the best of friends. If you remember, we didn't get on too well when we were kids, and even the first years here we were just acquaintances. But now, and for the last twenty years or so, we're very close. There was a time not very long ago when I was pretty badly

off spiritually, physically, and materially, and if not for him, I don't know how I should have come out. He is a very devoted brother and from his wife I found out that he thinks the world of me and respects me very much. He actually saved my life. And neither his wife nor he are quite happy unless they are sure that everything is all right with me. There was a time when I almost hated him. It's a long story to tell, let alone write about. You know, living conditions were pretty hard here at one time, especially right after the war when so much had been destroyed and houses couldn't be put right over night. Well, I was fool enough to sign his second wife into my room (we had lost two rooms — one to his first wife) before I knew her. Tommy, my mother, Abie, and I were all living in that one room. She was (and is) a difficult person and has made life miserable for us since we've known her. Though my common sense tells me it is probably not so, I blame her for my mother's hard death. My mother died in 1949 from sarcoma (I don't know if it's the same in English — it's a sort of lighter form of cancer, just as painful and as hopeless as cancer). It was a painful, drawn-out death. She was laid up for ten months and the doctors said the illness was caused by nervous tension.

At any rate, I was away from home for a few years and during this time Abie divorced his wife. Just a few months before I returned, he married a third time, but for a change, very happily. His present wife is an exceptionally fine woman. Misha is Abie's first born. Both his former wives had daughters from their first husbands. Misha was born when Abie was 47 and his wife 41. He's her first child.

Sometimes Abie and I laugh at the way we reacted to each other during childhood and early youth. I suppose it was our mutual and separate troubles that brought us closer to each other. I have very little free time, but go up to Abie's at least once a week. He changed rooms when I was away and saw to it that Tommy got one alone and he another, separate from Sonya (his second wife), although all the rooms are in the same flat. Since he got three rooms for one, you can imagine it's not a new flat or big rooms. Now he and Gita, his present wife, have two very nice large rooms in the new southwest district near the new university. Tommy and I are on the list to get new rooms, too, and hope soon to be moved out of here to a new place. I don't know when or where we'll get

rooms, but we hope to get a two room apartment, as we each have a room now and the law says that one must get not less than what one has had.

Valeria and Mrs. Meltz, who is now eighty-two and a wonderful lady, got a lovely room across from the new university. They had lived right in the center of town — I suppose you've read of Gorky Street. But they're much happier in the new neighborhood than they were on Gorky Street as the room is much better and it is not so crowded as downtown, although crowded enough.

Tommy is in her last (third) year at the Courses of Foreign Languages — in the English department, of course. She wants to take up French when she graduates. She has a practical knowledge of English since we've always spoken English at home. She's getting a theoretical basis and when she finishes she hopes to get some work where a knowledge of English and Russian is necessary. She doesn't want to teach and that's why she didn't want to try for the Foreign Language Institute. Most graduates of that institute become teachers as it's a pedagogical institute.

We have no pictures taken recently and are planning to be photographed as everyone is asking for photos. I'll send some as soon as we get around to taking them.

Are you still teaching? Please write me about your work. As to my personal life, it's the same as it was. My only real relaxation and enjoyment are books.

This letter is getting too long. I'll write again soon, and please, will you write again also very soon? My best regards to all.

Eva

August 17, 1960

Dear Rae,

I'm an awful pig — I know I am. I got your interesting letter long ago, and I wanted to write a real letter in answer. But due to a slight attack of laziness at the beginning of the last school year, I was overwhelmed with work at the end and hadn't a moment to spare. And about

468

two weeks before I was to go on vacation, Tommy had an acute attack of appendicitis (the first in her life) and was taken to the hospital from work. Because of complications after her operation, she was in the hospital three weeks instead of the usual eight days for such an illness, and after the hospital was on sick list until last week — two months in all. I suppose I should have written at least a note, but somehow didn't get round to it.

I'm a rotten housekeeper (I hate housekeeping) and what should take an hour or two takes me three or more. As a result, I was kept busy all the time, what with running to the market, back home to cook, then off to the hospital to take the stuff to Tommy. After her return from the hospital, there doesn't seem to be more time either, as I try to follow the doctor's instructions on feeding Tommy, and am kept busy in the kitchen all the time. So you really must excuse my delay in answering.

When Tommy wasn't working, she did all the housework (she's a marvelous cook, by the way). I'm trying to find someone to come in two or three times a week to do all those dreary chores that I dislike so much and have so little time for when I work. All in all, I really had no vacation at all, and have to go back to work next week.

Tommy began working recently at my institute. I don't know what her job would be called in English. She works in the foreign film reading room. She translates articles in full into Russian from English or writes Russian summaries of English articles, does cataloguing, and translates movies from the screen — English into Russian.

She's terribly upset about her exams. She had taken two before her illness and had three more to take. She was too ill to take them while she was in the hospital (that is sometimes done — examiners come to the hospital in such cases). The point is that it's her last year and she was to get her diploma at the end of June. She's had "A"s in all subjects in all exams from the beginning, and now she's afraid of spoiling her record! She'll take the three remaining exams in September. Of course, I don't care if she doesn't get all "A"s. I'm happy to have her on her feet again.

My texts aren't anything to write home about. Some are based on grammar rules, others are informative, with movie terms as a basis. I must say that I find that texts, grammar and lexical exercises, examination papers, etc., add to my interest in teaching. What I don't like is

teachers giving me an order for a text or test on some special grammar rule to be done at short notice. I'm never proud of the result. But that happens very seldom, thank goodness. It's seldom that they can't find ready material without coming to me.

You, know, I get a real thrill when some student who knew practically nothing as a freshman reads and translates fairly well by the time I'm finished with him, and some manage to do a wonderful job even without the dictionary. At such times I feel as if I'm not altogether useless. As a rule, we get our groups in their first year and carry them through until graduation. Luckily, our institute doesn't have large language groups. You get to know each student, his abilities, his peculiarities, etc., and can really work out methods of getting the best out of him, of putting your material across. Unfortunately, not all language teachers have the same conditions and luck we have at our institute.

As to what authors and titles to suggest that you send me — I don't know. I'd like anything interesting. Reading is still a disease with me, you know. You have a better idea than I could have of what's what in literature there now.

Regards from Abie and family and Val and Babushka. She'll be 83 on September 5! My best to Ed and the children.

<div align="right">Eva</div>

P.S. No, Rae, I wouldn't say "reconciled," but resigned. But we'll let that go. It's no good talking about what can't be helped.

<div align="right">September 3, 1960</div>

Dear Rae,

I got your letter of July 31. You must have got the letter by now where I wrote about Tommy's illness and convalescence. She claims that she feels fine now. To me she seems to be all right, too. This week she'll take her last exams and have that off her mind, and then, I hope, everything will be back to normal again.

What you write about your trip to Chicago interests me very much. Sometimes I wonder what it would be like to visit places where my child-

hood and youth were spent. Of course, I can never do that. I see them as I remember them, having no idea of what they're like now. Perhaps it would cure me of the nostalgia (it seems so weak a word for the feelings aroused) which sometimes attacks me. On sleepless nights, much more rare now, thank goodness, I see Division Street, Humboldt Park, the Lincoln Park beach, the children we played with (do you remember the Weisses and the Teitlebaums?), high school, Max, and youth — in short, much too much. I understand there's a subway in Chicago, and like to imagine where it runs, what the stations are like. Oh, well — .

We're back at work now. I'll have an easy time this month and hope to make up time lost during the summer when I did absolutely nothing. I have only two classes in September. The rest of my students will come back in October. They're on what we call practical work now. I believe it's called laboratory work in the States. They're in all parts of the country. The artists are out doing autumn sketches, painting, I suppose. I don't know why the cameramen are out and what they're doing, though the third and fourth years cameramen always begin formal studying later and end earlier than other departments. This year I have no actors. My last graduated in June and I begged to be freed of them for at least one year.

I'm expecting your letter any day now in answer to mine. Best regards to Eddie and the children. Tommy asks to be remembered. I'm awaiting your trip impatiently!

<div style="text-align:right">Eva</div>

P.S. We're celebrating Mrs. Meltz's 83rd birthday on the 5th, but we're having a little family party tonight. She says she's beginning to feel old!! She still does all the housework — refuses to let up.

<div style="text-align:right">November 7, 1960</div>

Dear Rae,

I wrote you the loveliest letter last night in bed, but I can't remember half of what I wanted to say now that I've gotten as far as pen and paper.

I've received the books you sent, including Faulkner. I find the *English Through Pictures* very interesting. From a superficial examination, it seems to me probably a very good way, not so torturous as it was in our day, to teach and to learn to read. Is this the method generally used in schools now or is it still in the experimental stage? I should like to try the method, using these books, with some child, but I don't take children on. I haven't the patience anymore, and I've been working with adults too long. Perhaps I'll try it with some adult, though I'm not certain how it would work out.

The head of our foreign language department (called "chair" here) was hospitalized at the end of September and she is expected to be away from work for at least another two months. She's very seriously ill. Our director (heads of higher educational institutions here are called "director" instead of "president") appointed me to substitute for her. Right now it's rather a serious job as we're in a state of reorganization, and there couldn't possibly be a worse time for our chief to be away. I don't know how she'll react to my work and arrangements in regard to new methods and plans, although she thinks highly of me. It's not so bad as far as English goes, as even if I do say it myself, I do know something about teaching English to Russians, but when it comes to German and French, that's a horse of another color. I have no time to get down and do a thorough review of their grammar and vocabulary from the point of view of teaching. It's a good thing we have such experienced, excellent teachers and I can depend on them. I barely have time to prepare for my own classes. It's not so bad with freshman and sophomores, but for the third and fourth years I have to be sure of my Russian, as it's mostly translating English texts into Russian, and with the new program I also have to work out plans on conversation on general subjects, something I haven't done for years, for class lectures. The trouble is that I have to do it not only for my own classes but for our English section.

Besides all of this, another teacher and I have to prepare an *English Reader* with vocabulary and exercises for our own institute. Many of the texts and exercises are done, but we have to decide what to include and what new ones to do. The other teacher goes on pension in June of 1961 or February of 1962, and she's a whiz at vocabulary. She has translated many books on the cinema from English and I'll be lost

without her, so we want to finish it by June, though we haven't been told yet what the time limit is. It may be June, 1962, but she'll be on pension by then.

All in all, I'm kept pretty busy and I don't think even our head herself is as anxious to be back at work as I am to have her back. I don't know if it's age or something else, but at any rate, I find it hard to do all my work and the housework, too. A few years ago I could make do with only five to six hours of sleep. Now less than eight makes me a useless wreck the next day. Tommy is an excellent cook, much better than I am, but since her illness she tires so easily that I don't want her to do anything in the house. As it is, by the time she comes home from work, she is already tired. She seems to be all right again except for tiring so quickly. Her tests show better and better results, though not quite normal yet. The doctors say not to worry, that sometimes it takes a long time to get back to normal again. I try not to worry.

It's almost impossible to get a woman to do for one. One of my friends promised to bring one up here after the holidays. It'll be a blessing if she does; then I'll have a little time for just breathing and not having to think of plans and texts while watching the meat or thinking of what to make while at work at plans and texts!

There's so much to write that I think would interest you, but I'm afraid it would result in a book instead of a letter. If the woman does come, I'll write again soon and tell you about our new system in the freshman courses. I find it interesting, though sometimes annoying.

We really must get around to taking pictures. Everyone asks for one and I have had none at all taken in the last twenty years or so. To tell the truth, I'm a little afraid of what I may look like in a picture now. I guess you wouldn't see much resemblance between me when I was twenty and at fifty. Though people say I look young for my age, I've changed a lot, and you can imagine not for the better. I laugh at us women. What difference does it make at our age how young or old we look? But just the same, we all want to look young. One blessing is that my face, except for the crow's feet, is not wrinkled. Well, we really will have ourselves taken and then you'll see for yourself.

But, you know, you've sent pictures of only Kenneth and Eleanor. What are you and Ed like now?

I really think it's time I finished. I'm hoping to hear very soon from you again. Love and regards to you both and the kids.

Eva

~

April 23, 1961

Dear Rae,

You can't curse me as much as I do myself. When getting out paper to write to you today, I found two letters — one to you and one to my uncle — that I was certain I had sent off months ago. I'm sending yours off now anyway, just adding a little. Better late than never, they say.

Our chief has been back at work a month now, but she resigned as head of the department because of her health. She's staying on as a plain teacher until her pension this summer. As a result, I have to carry on until the end of the school year when our director has promised to get a permanent chief. Our teachers are all asking me to continue as head. I don't know if it's flattery or really a fear of what the new head may be like. But I don't want to. I prefer being just a plain senior teacher and worrying about just the English section and my own classes. So that's that.

Tommy is back to normal though she still does tire very easily. She likes her work and is happy at it. She doesn't do subtitles for our pictures; she translates from English into Russian from the screen or printed material. She translates from pictures shown to our students that haven't been dubbed into Russian and have no subtitles.

Our *Reader* is coming along slowly but surely. My partner in writing it has promised not to go on pension until it's done. It's to be ready for the printers by June, 1962.

We've found a woman at last to do our housework, so now we're free from that worry. She comes three times a week and I feel immeasurably lucky.

You asked about Ronia [*Rae's first cousin who had left the US for Moscow during the Depression. She died in the labor camps*]. She died many years ago. I don't know exactly when and under what circumstances. As

474

for your mother's relatives, I think it should be possible to find out about them. There are more or less reliable means of finding out what happened to those people who were in Nazi-occupied territories.

I'll end this now. I'm afraid of not sending the letters again. One would think I'm a professor by my absent-mindedness! Forgive me for being such a pig. I'll try to reform.

Regards from Abie and his family to all of you, as well as from my in-laws. (It sounds funny to call them that. We're very close friends, both Mrs. Meltz and Valeria, and I.)

Eva

~

Palanga
July 27, 1961

Dear Rae,

I was so terribly busy the last two months of work that I had no time for anything, and the last three weeks I even begrudged the time for meals. I had all my work as a teacher, reports and all, finished on time, but my work as head tied me into knots. In fact, I thought I'd be finished with everything by July 14 and get a train ticket (in summer, during the vacation season, it's hard to get tickets for any means of transport out of or into Moscow). But oh, horror! I still had a good week's work to do! So I took it with me and finished it here. I sent it off a few days ago and am still coming to.

I had thought of spending my vacation here from the beginning of July to the end of August, but I got here on the 15th and am planning to leave the 24th or 25th of August. A new head was hired. He hasn't ever worked at an institute of our kind, and I'll have to help him for the first few weeks. The new term begins in September, so we have to be there earlier.

This is a lovely little resort town in Lithuania on the Baltic Sea. I always used to go south for vacation to the Black Sea, but some friends of mine, whose health doesn't allow them the heat of the South, discovered this place a few years ago, have been coming here regularly for the last few years, and convinced me to try it. Last year I didn't come because of Tommy's illness, but his year I made it. It's a lovely little place,

taken right out of a fairy tale — cute, cozy-looking little "Hansel and Gretel" houses. I haven't seen as huge and beautiful a park and forest as the ones here in I don't know how many years. As for the beach, it has a sandy bottom, and is enormous, with plenty of room for everybody here. The only drawback is the climate. It's much too cold to suit me. Now that I have the time and can begin to rest, I certainly feel the lack of being able to go swimming. The waterfall is wonderful, but the air is so cold — five to ten degrees colder than the water — that you can't laze around on the beach and must dress at once. That isn't my idea of enjoying a beach! You can't lie in the sun, and so far there has been none to lie in! The only thing we can do is take long walks in the park and forest.

I've begun to gain weight the last few months. Up to then I was as slim as you remember me, and now suddenly I've begun to grow sideways. Since I can't go swimming to take it off, I go walking.

Tommy was planning to go to the Caucausus for her vacation. She was to order tickets the day after I left, but as I've not heard anything yet, I don't know if she managed. She was working very hard during the movie festival. Unfortunately, I was so busy that I had no time to see a single one of the foreign movies.

I think I've received all the books you sent. Rae, I want to send you some books, but I don't know what to do. Some of your people say not to send books or gifts by post; other say it's all right to do so. Let me know what to do. I don't know what kind of books you get at your courses [*Rae was taking Russian language classes*], but I can send a textbook or two that are used here in teaching foreigners Russian, and some stories, both classics and modern. Can you use such books and shall I send them? And dictionaries?

I also thought the children might be interested in views of Moscow. We have cards here printed in English so they would know what places are shown in the picture.

I'll end for the time being. I will write again when I get home. I expect to be busy for the first month or so, and then should have a little time to spare. Our book is to be ready by June, 1962. The first half of the first part is ready, and though only typewritten will be used for the first semester. The second half is to be ready for typing by November 1. Both parts have to be given to the printers by summer. Outside of that,

476

I hope to have only my regular teaching duties to attend to, so I should have more time.

My best to Ed and the children.

Eva

March 19, 1962

Dear Rae,

I've been expecting your answer for a while now. Have you applied for your visas yet? Do you know definite dates already? I can't try to make sure of being free all the time you're here until I know definite dates. How long do you plan to stay in England, where do you go after that, and when exactly do you arrive here? So far, as I've already written, I expect to go on vacation on July 1. If I knew definitely when you were arriving, I might be able to arrange not to do the exams this year. So please answer as quickly as you can, as I don't want to start any vacation discussions until I know for certain. It'll be awkward to try to change later.

We haven't started on the second part of the *Reader* yet. Now, my co-author is laid up. Talk of luck! By now we were to be into the middle of the second part with the first ready for publication. As it is, the first is to be discussed in only a week or so. Our chief insists on both parts being ready by the middle of June, though he agrees to putting off the notes and vocabulary for next semester. I'll have less class work after April and shall have more time for work on the book, but my partner has more work then. I'm terribly worried that may also hold up my vacation, though we'll try, of course, to get an extension of time. Yes — don't forget to let me know your phone number in case it's too late to write and I have to call you up.

This is all for now. Perhaps your answer to my last letter will come before you get this. I'm getting anxious about not hearing. By my figuring, I should have had the answer about a week or so ago.

Best regards to all.

Eva

April 11, 1962

Dear Rae,

Whoopee!

I'm so happy at the prospect of seeing you that I find it hard to express. I'm planning to meet you in Leningrad on your arrival, though I have no friends there and they say that hotel accommodations in Leningrad are especially difficult for individuals in summer, just as they are in Moscow. I'll manage somehow. Then to Moscow with you until you leave.

I hope that by now you got the missing letter. In case you didn't, I'll repeat the essentials. As a rule, my vacation is from July 1 to August 26. But since last summer we have entrance exams in language and I may have to be examiner this year, though I hope not. I have no classes in June, as my last finishes at the end of April. Our *Reader* should be in by the middle of June but will probably not be ready by then. I should be free in July, certainly by the 15th.

As for the rest of the letter, it's not worth repeating, as it was about the advantages and disadvantages as I see them of the places you were interested in.

We're hoping that this spring or summer we'll finally move. In our yard one house had already been built, and people have already been moved in, while the other house is nearing completion. That doesn't mean we'll be moved into it, though I wish we could. We may get rooms in an entirely different district.

If it wouldn't be too much expense and trouble, I'd like to have a course in English by record — a full course if possible. Also the recordings of *My Fair Lady* and *Oklahoma.* I don't remember if I wrote you or not that we saw *My Fair Lady* on its tour here. We went to see it several times. It was the first musical in English that I saw here and I don't suppose you can even imagine what seeing it meant to me. There were some recordings made here, but Abie managed to get only one each for himself and me. The songs aren't all on one long-playing one. I saw the screen version of *Oklahoma.* The operetta itself was not given here on the stage. The movie didn't have much success, but I did enjoy it and I'd like to have the music if possible. But remember, if it's too much expense or bother, let it go.

Is your mother still with you? I just don't get around to writing. About her request — I've asked some friends of mine who have relatives in Kiev to see what they can do to locate your mother's people. It's more certain than letters, but it may take a long time. The war has left many families separated. Very often there are articles in the papers and magazines of parents finding their children lost during the war and "vice versa" even now, so many years after the war has ended.

Everybody sends their regards. I'm terribly impatient for July to be here.

Eva

P.S. Keep me posted as to what's what. I can't give you a phone number, having no phone. I think calls can be made through the Central Telegraph, but I have to be notified in advance. One of my friends speaks to her people that way every once in a while. But I understand it's very expensive. At any rate, I'll find out the details and let you know.

September 18, 1962

Dear Rae,

This is just a short note to let you know I received the three books you sent from Brentanos in Paris. Of course I'm terribly pleased, but you must have spent a fortune on them. I had expected paperbacks. One of my friends got a paperback Webster and it was what I'd been thinking of. But of course though it must be so expensive, I'm tickled pink about them — in fact, I envy myself for having them!

I'd wanted to have a welcoming home letter for you, but I never got around to writing it. I'm terribly busy now, working out both my own and the department plans taking up practically all my time. As luck would have it, my houseworker got sick and after only one week at work quit, so I have to do the housework now too. I'm looking around but it's hard to get anyone. Tommy leaves very early and comes home very late and though she's a better housekeeper than I, she has no time at all except on Sundays.

Now, though I know you must both be pretty busy getting back

into the rut, please write and tell me all about the rest of your trip. I got your notes from Paris and the letter from Geneva at the same time. The books came about a week before the letters. How was your homecoming? How did you find Kenneth and Eleanor? Did they manage well without you?

About your visit here and my having seen you — well, I suppose you understand all it meant to me. It was very hard to see you go. Well, enough.

My best regards to all and try to write soon.

Love,

Eva

P.S. Tommy will "knock my block off" if I don't send her love — so let's say I sent it.

July 20, 1963

Dear Rae,

I'm terribly shocked and feel deeply for you. I got your letter a few days ago but couldn't answer at once. I needed time to realize the fact. What can one say? My sorrow and concern can't change things for you, and words of condolence can merely brush the surface of the pain.

It's a good thing you'd arranged for summer work before Eddie died. Work is the best antidote there is — I know from bitter experience.

Of course, the whole course of your life will be changed now. When you feel up to it write and tell me what you have decided. Will you manage with the education of the children? It's too bad they'll both be away from home. Their being at home would help you through the first year or so. I imagine they took it badly. I do wish I could be with you.

I'm leaving for an eighteen day boat trip on the Volga August 1. I'll write again before I leave or during the trip. Right now I don't feel like writing of other things.

I do feel very deeply for you, Rae, and hope you adjust to your new life as painlessly as possible for both you and the children.

Love,

Eva and Tommy

October 24, 1965

Dear Rae,

I'm retired! I have never understood retired people complaining they never had time for anything. Now I do. I really don't know where the time goes, but it certainly flies! I had planned to start going regularly to the theater, concerts, to visit friends, and so on. So far, I have gone only to the National Theatre of Great Britain on its tour here. I saw all three of their performances, two with Laurence Olivier, one of my favorites.

I didn't want to cut myself off entirely from work on retiring, and so agreed to do some work for the Institute. I'm doing the proofs on our first reader — the book I was still working on when you were here. It's taken all this time to get it to a print shop. Now we hope to have it ready by the end of the year. Three other books were printed and are now in use, and now I'm working on the fifth, which is also to be printed. It was to have been finished before my retiring, but I simply couldn't manage and so have to do it now. But at least I can work only on this, not worrying about everybody's lesson plans and going to the Institute everyday.

Tommy is now in her fourth year, with one more year to go. She had a lot of interesting work during the International Film School Congress and the festival which followed it, and was excused from her regular work and studies during this period. She went to the other cities in connection with the festival. She's already begun work on her "diploma." Students here must write a sort of thesis for graduation from any institution of higher learning. It's called "diploma work." Post-graduate work is called dissertation. Tommy's theme is a comparison of the screen adaptations with their original works: *Grapes of Wrath, Tobacco Road, Farewell to Arms*, etc. She says it may be changed yet, but as she's interested, she's preparing for it anyway. Officially, she's to begin working on it at the end of her first semester of the fifth year. Working students are given several months off — I think three or four — with half pay for their diploma work.

I still don't feel retired but just on vacation, and have a tendency to think about work, then I remember I'm not going back. The summer

was a hard one. The exams were harder and there were many more students to be examined than I'd expected.

Please try not to be too angry about my not having written for so long. Now I can and will write more regularly. I'm sure I'll bring some sort of order to my present disorganized time, and will gradually get used to being "on pension."

Best regards from Tommy, and from me to all.

Eva

∿

August 1, 1968

Dear Rae,

I have such lovely news! Tommy is getting married in a few days!

It seems all so sudden. Her husband is an Israeli. They had met several years ago when he visited here on some kind of a cultural program. She tells me that he had wanted her to marry him then and go back with him to his home, but she had had mixed feelings about leaving me — and he had not wanted to remain in Moscow. He had returned several times throughout the years to try to convince her and now she has agreed. I am so happy for her. She is making application for an exit visa next week. I thought you would want to know.

Eva

∿

CABLE TO RAE OSGOOD
DATE: MAY 15, 1972
HAPPY BIRTHDAY. AM GOING TO TOMMY. EVA.

Index

7350

486